HENDRIK NEUBAUER

60 YEARS OF
PHOTOJOURNALISM

BLACK STAR PICTURE COLLECTION

KÖNEMANN

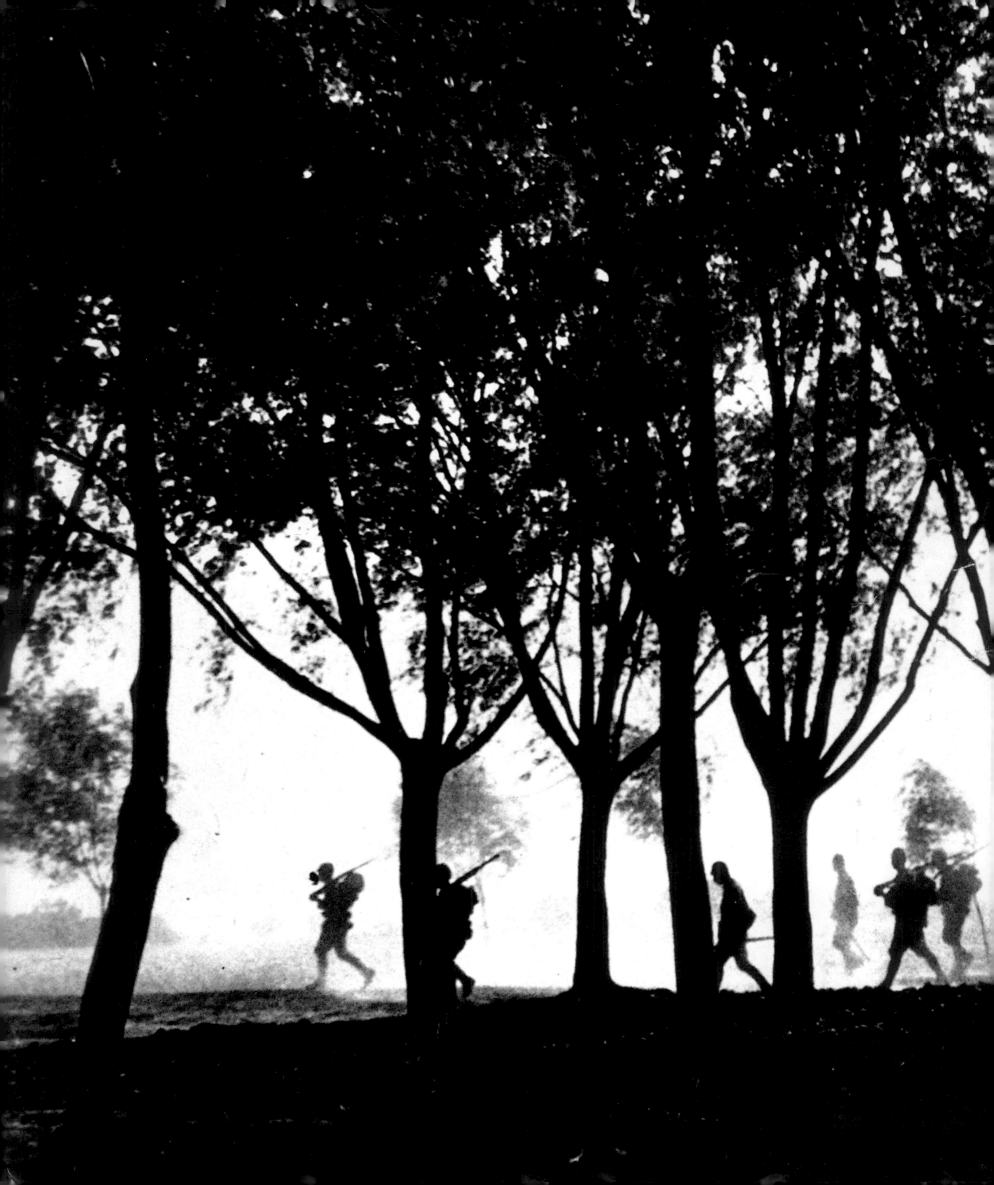

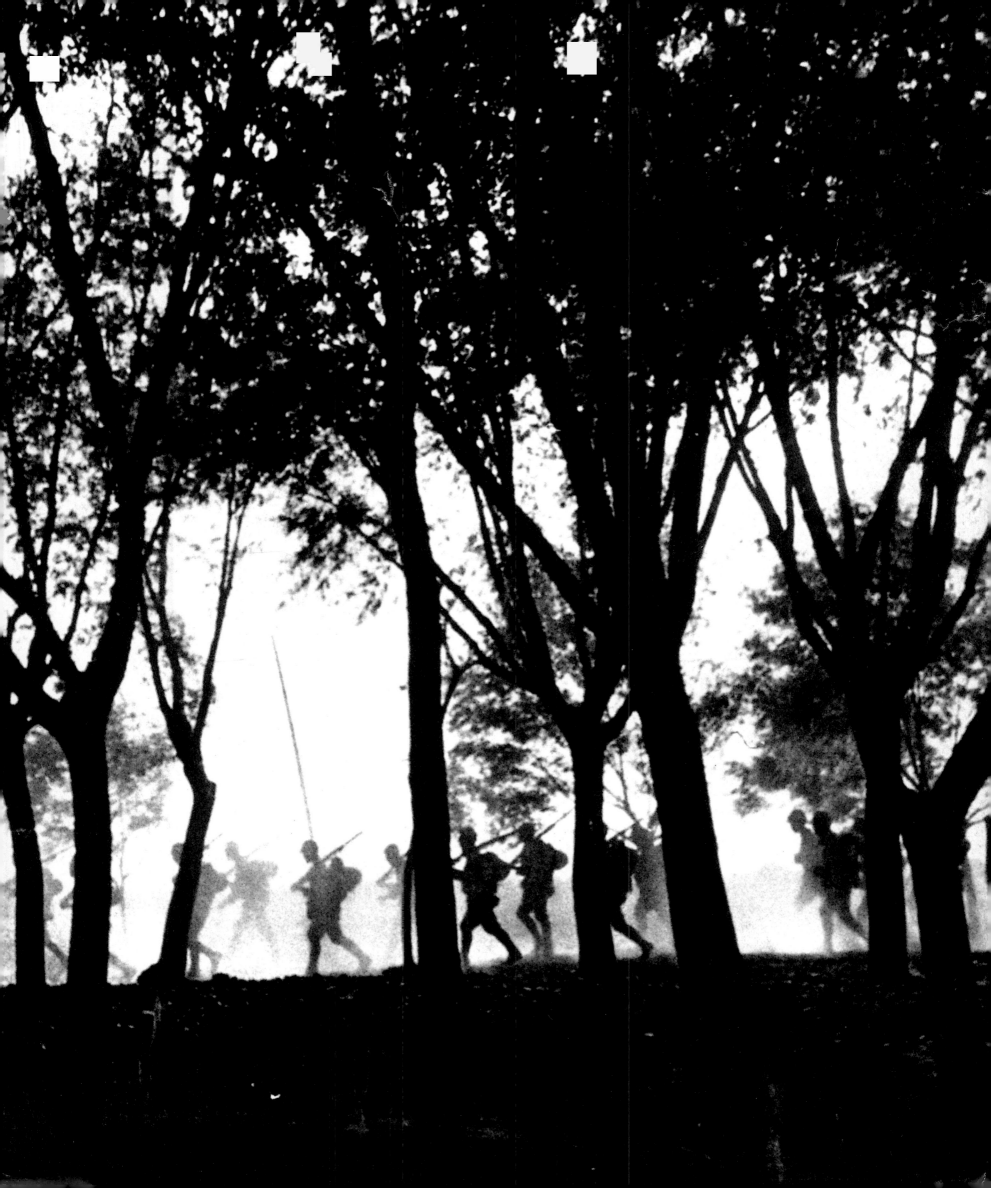

ACKNOWLEDGMENTS · DANKSAGUNG · REMERCIEMENTS

I would like to thank the following people:

all Black Star photographers whose work is published here; Black Star president Benjamin Chapnick, who opened all possible doors for me in New York and was always willing to provide further information; Anh Stack, Rose Magno and Rebecca Ames of Black Star's editorial department; Henning Christoph for his support and patience; Dr Volker Guckel, Michael Kneffel, Heiko Kügler and Dr Dirk Levsen for their advice and help; and last but not least "the two women in my life", Regina Berkowitz and Nora Neubauer.

Danken möchte ich:

allen Black-Star-Fotografen, deren Arbeiten hier abgedruckt sind; Black-Star-Präsident Benjamin Chapnick, der mir in New York alle Türen geöffnet hat und der jederzeit auskunftsbereit war; Anh Stack, Rose Magno und Rebecca Ames im Black Star Editorial Department; Henning Christoph für seine Unterstützung und Geduld; Dr. Volker Guckel, Michael Kneffel, Heiko Kügler und Dr. Dirk Levsen für Rat und Tat; last but not least »meinen beiden Frauen« Regina Berkowitz und Nora Neubauer.

Je désirerais remercier

tous les photographes de Black Star dont les travaux sont reproduits ici ; Benjamin Chapnick, le Président de Black Star, qui m'a ouvert toutes les portes à New York et donné à tout moment les renseignements souhaités ; Anh Stack, Rose Magno et Rebecca Ames du service éditorial de Black Star ; Henning Christoph pour son soutien et sa patience ; Dr. Volker Guckel, Heiko Kügler et Dr. Dirk Levsen pour leurs conseils et leur aide pratique ; last but not least « mes deux femmes » Regina Berkowitz et Nora Neubauer.

BIBLIOGRAPHY · BIBLIOGRAPHIE

The introductory essay is largely based on Howard Chapnick's book "Truth Needs No Ally" and C. Zoe Smith's dissertation "Emigré Photography in America". It also draws heavily on interviews conducted in New York and extensive correspondence with Benjamin Chapnick. The following bibliography includes all literature utilized in the writing of this book as well as references for all quotations.

Der einleitende Essay basiert wesentlich auf dem Buch von Howard Chapnick »Truth Needs No Ally« und der Dissertation von C. Zoe Smith »Emigré Photography in America«, sowie auf Interviews, die ich in New York geführt habe, und dem intensiven Briefwechsel mit Benjamin Chapnick. Die folgende Bibliographie nennt sowohl alle für meine Arbeit grundlegende Literatur, als auch die im Text zitierten Quellen.

L'introduction est basée essentiellement sur le livre de Howard Chapnick « Truth Needs No Ally » et la dissertation de C. Zoe Smith « Emigré Photography in America », ainsi que sur des interviews faites à New York et l'échange épistolaire intense avec Benjamin Chapnick. La bibliographie suivante mentionne aussi bien les ouvrages sur lesquels repose mon travail que les sources citées dans le texte.

Hendrik Neubauer

CHAPNICK, HOWARD: Truth Needs No Ally. Inside Photojournalism. Columbia and London, 1994.

ECO, UMBERTO: Der Mythos von Superman. In: Eco, Umberto. Apokalyptiker und Integrierte. Frankfurt a.M., 1984.

FREUND, GISELE: Photographie und Gesellschaft. München, 1976.

FULTON, MARIANNE: Eyes of Time. Photojournalism in America. New York, 1988.

GELATT, DOROTHY: Inside Black Star. In: *Popular Photography.* March 1968.

GIDAL, TIM: Modern Photojournalism. Origin and Evolution, 1910–1933. New York, 1973.

GOETHE, JOHANN WOLFGANG: Aus meinem Leben. Dichtung und Wahrheit. Berlin und Weimar, 1984.

GOLDBERG, VICKI: The Power of Photography. How Photography changed our lives. New York, 1991.

HICKS, WILSON: Words and Pictures. An Introduction to Photojournalism. New York, 1952.

HUGHES, JIM: W. Eugene Smith. The Life and Work of an American Photographer. New York, 1989.

OWEN, WILLIAM: Modern Magazine Design. New York, 1991.

RAEITHEL, GERT: Geschichte der Nordamerikanischen Kultur. 3 Bde. Frankfurt a.M., 1995.

ROSENBLUM, NAOMI: A World History of Photography. New York, 1984.

SMITH, C. ZOE: Emigré Photography in America. Contributions of German Photojournalism from Black Star Picture Agency to *Life* Magazine, 1933–1938. The University of Iowa, 1983.

SMOLTCZYK, ALEXANDER: Der Blues des Jägers. In: *Geo extra* Fotografie. Hamburg, 1996.

SONTAG, SUSAN: On Photography. New York, 1977.

WAINWRIGHT, LOUDON: The Great American Magazine. An Inside History of *Life*. New York, 1986.

Photo page 2/3: Younosuke Natori, 1938, Japanese soldiers moving along the Yangtze River

Photo page 4/5: Steve Shelton, 1996, Irwin Youth Development Campus, Ocilla, Georgia

© 1997 Könemann Verlagsgesellschaft mbH
Bonner Str. 126, D-50968 Köln
© for the photographs: Black Star Publishing Co. Inc , 116 East 27th Street, New York NY 10016

Text and Concept: Hendrik Neubauer/Das Fotoarchiv, Essen
Art Direction and Design: Peter Feierabend
Layout: Erill Vinzenz Fritz, Oliver Hessmann, Christian Maiwurm
Project coordinator: Sally Bald
Translation into English: Adri van der Colff, Philip Jenkins
Translation into French: Joëlle Marelli, Jean-Marc Nothias
Translation into German (biographies): Marion Satzler Charnitzky
Contributing editors: Jochen Dilling, Susanne Hergarden, Kirsten E. Lehmann
Typesetting: Erill Vinzenz Fritz, Oliver Hessmann
Production Manager: Detlev Schaper
Reproductions: CLG Fotolito
Printing and Binding: Partenaires Livres
Printed in France

ISBN 3-89508-250-3

10 9 8 7 6 5 4 3 2

CONTENTS

INHALT

SOMMAIRE

INSIDE BLACK STAR

THE HISTORY OF AN AMERICAN PHOTOJOURNALISTIC AGENCY

*"If I could tell the story in words, I would not need
to drag a camera around with me."*

Lewis W. Hine

*"World photojournalism in the 1990s is dominated
by the picture agency, an amorphous unstructured kind
of business that was seeded in Germany in the 1920s,
transplanted to England, France, and the United States
in the 1930s, blossomed internationally in the 1940s
and 1950s, and exploded into unprecedented growth
in the ensuing decades. Little do the readers
of publications throughout the world realize that
the pictures they see and the photojournalism
that moves them are being distributed through
a complex network of photographers,
agents and publications."*

Howard Chapnick,
Black Star President 1964–1989

INSIDE BLACK STAR

DIE GESCHICHTE EINER AMERIKANISCHEN FOTOAGENTUR

*»Wenn ich die Geschichte in Worten erzählen könnte, brauchte
ich keine Kamera herumzuschleppen.«*

Lewis W. Hine

*»Der Fotojournalismus der 1990er Jahre wird weltweit
von Bildagenturen beherrscht. Dieses unstrukturierte,
amorphe Gewerbe entstand in den 20er Jahren in
Deutschland, verlagerte sich in den 30er Jahren nach England,
Frankreich und in die USA, florierte international in den
40er und 50er Jahren und erlebte in den darauffolgenden
Jahrzehnten ein bis dahin nicht gekanntes Wachstum. Die
Leser von Zeitungen und Zeitschriften überall auf dem Globus
sind sich wohl kaum bewußt, daß die Bilder, die sie sehen und
die fotojournalistische Arbeit, die in ihnen Reaktionen auslöst,
über ein weitgespanntes Netz von Fotografen, Agenten und
Publikationen zu ihnen kommt.«*

Howard Chapnick,
Präsident von Black Star 1964–1989

BLACK STAR VUE DE L'INTERIEUR

L'HISTOIRE D'UNE AGENCE DE PHOTOJOURNALISME AMERICAINE

*« Si je pouvais raconter l'histoire avec des mots,
je n'aurais pas besoin de trimballer un appareil photo! »*

Lewis W. Hine

*« Le photojournalisme à l'échelle mondiale est dominé
dans les années 1990 par l'agence photographique,
une structure informe et amorphe créée en Allemagne dans
les années 1920, transplantée en Angleterre, en France et
aux Etats-Unis dans les années 1930, qui se répandit
dans le monde entier dans les années 1940–1950 et
qui connut une croissance explosive et sans précédent
au cours des décennies suivantes. Peu de lecteurs se rendent
compte que les photos qu'ils voient à travers le monde entier
et les reportages qui les intéressent sont produits et distribués
par un réseau complexe de photographes, d'agents
et de publications. »*

Howard Chapnick,
président de Black Star 1964–1989

The Black Star picture agency and the history of photojournalism have been inseparable for decades. Photojournalists condense "decisive moments" into dramatic and complex symbols. Black Star photographers have seen themselves in this tradition since the mid-1930s. They travel around the globe in order to be present constantly where world events are happening, to tell stories with their pictures, to lend a voice to the silent and oppressed and to capture situations and atmospheres in unique and powerfully expressive images.

However, behind each of these brave, fearless men and women, whom the long-standing President of Black Star – Howard Chapnick, who died in 1996 – described as the modern nomads of the 20th century, lies an organization which has taken on the unspectacular work for these nomads for decades. Black Star is one of these organizations, and furthermore is one of the most successful in the world. Photojournalistic agencies do not only manage and sell their photographers' products. They have always suggested ideas for stories. They inspire and finance long-term and costly projects. However, agencies are saviors in times of need and claques at times of the greatest joy. They are buffers for furious editors and lightning conductors for frustrated photographers.

Nonetheless photographers often wonder: "Why do I really need an agent?" Even Howard Chapnick has never found a conclusive answer to this question over the years: "Like everything else in life, when it comes to the relations between photographers and picture

Die Bildagentur Black Star und die Geschichte des Fotojournalismus sind seit Jahrzehnten untrennbar miteinander verbunden. Fotojournalisten verdichten die »entscheidenden Momente« zu dramatischen und komplexen Sinnbildern. Black-Star-Fotografen verstehen sich seit Mitte der 30er Jahre in dieser Tradition. Sie reisen um den Globus, um stets am Ort des Weltgeschehens zu sein. Um mit ihren Bildern Geschichten zu erzählen. Um wortlosen und bedrängten Kreaturen eine Stimme zu verleihen. Um Situationen und Stimmungen in einmaligen und aussagekräftigen Momentaufnahmen zu bannen.

Doch hinter diesen mutigen, unerschrockenen Männern und Frauen, die der langjährige Präsident Black Stars – Howard Chapnick, der 1996 verstorben ist – als die modernen Nomaden des 20. Jahrhunderts bezeichnet hat, verbirgt sich ein Apparat, der über Jahrzehnte die unspektakuläre Arbeit für die Nomaden übernimmt. Black Star ist einer dieser Apparate, darüber hinaus einer der erfolgreichsten der Welt. Fotojournalistische Agenturen verwalten und verkaufen jedoch nicht nur die Produkte ihrer Fotografen. Seit jeher regen sie auch Reportageideen an. Sie inspirieren und finanzieren langfristige und kostspielige Projekte. Agenten sind aber auch Retter in der Not und Claqueure in Momenten höchster Freude. Puffer für erboste oder enttäuschte Redakteure und Blitzableiter für frustrierte Fotografen.

Dennoch fragen sich Fotografen oft: »Warum brauche ich eigentlich einen Agenten?« Auf diese Frage hat auch Howard Chapnick über die Jahre keine endgültige Anwort gefunden: »Wie bei allen Dingen im Leben, wäre

L'agence photographique Black Star et l'histoire du photojournalisme sont intimement liées l'une à l'autre depuis des décennies. Les photojournalistes transforment les «moments cruciaux» en images emblématiques complexes à fort pouvoir émotionnel. Les photographes de Black Star font partie intégrante de cette tradition depuis le milieu des années 1930. Toujours présents sur les lieux de l'événement, ils circulent en permanence autour du globe … Pour élaborer des récits par leurs images. Pour donner une voix à ceux qui sont menacés et contraints au silence. Pour rendre captivantes par des images uniques et chargées de sens les situations et les événements auxquels ils assistent.

Pourtant, derrière ces hommes et ces femmes courageux et intrépides que Howard Chapnick, longtemps président du Black Star et décédé en 1996, appelait les nouveaux nomades du 20ᵉ siècle, se cache une organisation discrète chargée d'accomplir pour eux tout le travail le moins spectaculaire. Black Star est l'une de ces structures, une agence devenue par ses succès l'une des toutes premières du monde. Les agences photographiques ne se contentent pas de gérer et de diffuser les reportages de leurs photographes. Elles ont aussi toujours su lancer des idées de sujets. Elles inspirent et financent des projets coûteux et de longue haleine mais sont là également pour tendre la main en cas de besoin et applaudir quant tout va pour le mieux. Elles permettent aux reporters déçus ou aigris de se défouler et servent de paratonnerre aux photographes frustrés …

Pourtant, les photographes se demandent souvent pourquoi ils ont besoin d'un agent. Malgré son expé-

agencies it is hazardous to generalize. For some photographers, such a relationship works; for others it doesn't. And for still others, it sometimes works and sometimes doesn't. The important thing for a photographer contemplating working with a photographic agency is for that photographer to define his or her goals, to understand what an agency can or cannot do in helping achieve them, and to utilize the agency's strength to the maximum in fulfilling those goals." Many talented and renowned photographers have chosen Black Star at some time or other, and many of them have left the agency again after some considerable time. What is the attraction of Black Star? Where do its strengths and its weaknesses lie? A look at the history of the agency and of photojournalism itself ought to help provide an answer to these questions.

THE BIG ENTRANCE
THE AGENCY BLACK STAR AND THE MAGAZINE *LIFE*

New York. Early 1936. The city was virtually overflowing with emigrants from Europe. Amongst them were Kurt Safranski, Ernest Mayer and Kurt Kornfeld. A few years before they were still successful professionals in the flourishing world of publishing and newspapers in the Weimar Republic. Safranski had been an editor at the publishing house Ullstein, Mayer had been a picture agent, whilst Kornfeld had been a literary agent. The Berlin Jews were fleeing from the Nazi terror to New York. Here they sought to gain a foothold in the American press. The economy was still suffering from the consequences of the great Wall Street Crash of 1929. However, the three were fortunate. Ernest Mayer recalled the fateful first

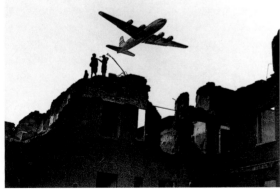

CHARLES FENNO JACOBS 1948

The western Allies' response to the Berlin blockade by the Soviets was to create an airlift from 26 June 1948 onwards. The blockade ended in May 1949 and shortly afterwards the FRG in the west and GDR in the east were founded.

Die Blockade Berlins durch die Sowjets beantworteten die anderen Alliierten am 26. Juni 1948 mit der Errichtung einer Luftbrücke. Im Mai 1949 endete die Blockade, kurz darauf wurden BRD und DDR gegründet.

Au blocus de Berlin par les Soviétiques, les autres pays alliés répondirent le 26 juin 1948 par un pont aérien. Le blocus prit fin en mai 49 et peu après étaient créées la RFA et la RDA.

es auch beim Verhältnis der Fotografen und Bildagenturen leichtfertig, wollte man hier verallgemeinern. Für manche Fotografen funktioniert dieses Verhältnis gut, für andere nicht. Bei wieder anderen klappt es manchmal, und manchmal auch nicht. Wenn ein Fotograf die Zusammenarbeit mit einer Agentur in Erwägung zieht, ist es wichtig für ihn, daß er seine Ziele kennt, daß er sich darüber im klaren ist, was eine Agentur für ihn leisten bzw. nicht leisten kann, und daß er die Stärke der Agentur möglichst effizient nutzt, um seine Ziele zu erreichen.« Viele talentierte und renommierte Fotografen haben sich irgendwann für Black Star entschieden, viele von ihnen haben die Agentur nach geraumer Zeit auch wieder verlassen. Was macht die Anziehungskraft von Black Star aus? Wo liegen ihre Stärken, wo ihre Schwächen? Ein Sprung in die Geschichte der Agentur und des Fotojournalismus soll bei der Beantwortung dieser Fragen helfen.

DER GROSSE AUFTRITT
DIE AGENTUR BLACK STAR UND DAS MAGAZIN *LIFE*

New York. Anfang 1936. Die Stadt quoll vor Emigranten aus Europa fast über. Unter ihnen befanden sich Kurt Safranski, Ernest Mayer und Kurt Kornfeld. Vor wenigen Jahren waren sie noch erfolgreiche Profis im florierenden Verlags- und Pressewesen der Weimarer Republik. Safranski als Herausgeber im Verlagshaus Ullstein, Mayer als Bild- und Kornfeld als Literaturagent. Die Berliner Juden flohen vor dem Terror der Nationalsozialisten nach New York. Hier versuchten sie, in der amerikanischen Presselandschaft Fuß zu fassen. Die Wirtschaft litt immer noch unter den Folgen des großen Börsencrashs an der Wall Street 1929. Doch die drei hatten Glück. Ernest Mayer erinnert sich an die schicksalhaften ersten Jahre des Exils: »(…) uns stand ein weites Tätigkeitsfeld offen, und damit war die große Chance gegeben, rasch ein Geschäft aufzubauen und etwas Lohnenswertes zu schaffen, nicht bloß Geld zu verdienen.« In diesen Worten Mayers klingt noch heute eine Vision nach: Fotojournalismus. Die Gründer von Black Star deuteten die Zeichen der Zeit richtig und bauten im Graybar Building in der Grand Central Station unter den primitivsten Bedingungen eine fotojournalistische Agentur auf. In den Setzkästen der amerikanischen Drucker fiel Safranski ein schwarzer Stern auf. Sofort schwebte ihm vor, daß ebendieser Stern zum Markenzeichen der Agentur in den amerikanischen Publikationen werden sollte – nach dem Vorbild der Eule des Verlags Ullstein in Berlin. Der Name »Black Star« und das Warenzeichen waren geboren.

Unweit der beiden Büroräume im Graybar Building arbeitete zur gleichen Zeit die Entwicklungsredaktion der Time Inc. unter der Leitung des Herausgebers Henry Luce und des Chefberaters Daniel Longwell an einem neuen Bildmagazin. Das Magazin erschien in seiner ersten Ausgabe unter dem Titel *Life* im Dezember 1936. Bereits ein Jahr später erkannte Longwell in einer Notiz an den Chef Luce: Black Star ist »…unsere beste Bildagentur und ein verläßliches Team, das guten europäischen Fotojournalismus in unser Land gebracht hat.«

rience, Howard Chapnick n'a pas trouvé de réponse définitive à cette question : «Comme pour tout dans la vie, il est difficile de généraliser quand il s'agit d'évoquer les relations entre les agences et les photographes. Cela fonctionne dans certains cas, dans d'autres non. Pour quelques photographes, cela marche à certains moments, à d'autres non. Le plus important pour un ou une photographe qui souhaite travailler avec une agence est de définir son but, de bien comprendre ce qu'une agence peut faire ou pas pour l'aider à l'atteindre, et d'utiliser au maximum la puissance de l'agence pour réaliser ses objectifs.» De nombreux photographes célèbres et talentueux se sont décidés un jour pour Black Star ; plusieurs l'ont quittée après y avoir passé un bon bout de temps. Comment expliquer l'attraction qu'exerce Black Star ? Où sont ses forces, ses faiblesses ? Une plongée dans l'histoire de l'agence et du photojournalisme permettra d'apporter un début de réponse à ces questions.

LE GRAND DEPART
L'AGENCE BLACK STAR ET LE MAGAZINE *LIFE*

New York, début 1936. La ville débordait d'immigrants venus d'Europe. Parmi eux se trouvaient Kurt Safranski, Ernest Mayer et Kurt Kornfeld. Quelques années plus tôt, c'étaient des professionnels de talent qui travaillaient dans des maisons d'édition ou de presse, florissantes sous la République de Weimar. Safranski était directeur de collection chez l'éditeur Ullstein, Mayer agent en illustrations et Kornfeld agent littéraire. Juifs berlinois fuyant la terreur nazie, ils se réfugièrent à New York, où ils cherchèrent à prendre pied dans la presse américaine. L'économie souffrait encore des suites du grand *krach* boursier de Wall Street de 1929. Pourtant, tous trois eurent de la chance. Ernest Mayer se souvient de ces premières années, décisives, de l'exil : «Un vaste

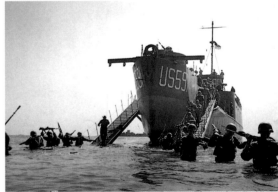

US NAVY 1944

On 15 August 1944, two months after the Allied invasion of northern France which began on D-Day, American troops landed on the French Mediterranean coast. Three days later the battle for Paris commenced.

Zwei Monate nach der alliierten Invasion in Nordfrankreich, dem D-Day, landeteten die amerikanischen Truppen am 15. August 1944 auch an der französischen Mittelmeerküste, drei Tage später begannen die Kämpfe um Paris.

Deux mois après le débarquement allié en Normandie, le jour J, les troupes américaines débarquaient également sur la Côte d'Azur, le 15 août 1944. Trois jours plus tard les combats atteignaient les abords de Paris.

years of exile: "(…) there was a wide field to work in and a big chance to develop business quickly and create something worthwhile, not just to make money." A vision still resounds in Mayer's words today. That word is photojournalism. The founders of Black Star interpreted the signs of the time correctly and in the Graybar Building in Grand Central Station built up a photojournalistic agency in the most rudimentary conditions. A black star caught Safranski's eye in the typecases of the American printers. Immediately he wanted this very star to become the trademark of the agency in American publications – just as the owl had been the publishing house Ullstein's trademark in Berlin. The name "Black Star" and the trademark were born.

Not far from the two room office in the Graybar Building the editorial development team of Time Inc. were working on a new picture magazine under the leadership of the editor Henry Luce and chief adviser Daniel Longwell. The first issue of *Life* magazine appeared in December 1936. Within a year Longwell recognized in a note to Luce that Black Star was "…our best picture agency and a solid crowd that brought good European photography to our country." This assessment is surprising at first. *Life* produced generations of picture reporters over the decades who succeeded in gaining fame and respect worldwide. However, the connection between these stars and the new magazine had to be made carefully at the beginning. And it was here that the three German agents in the Graybar Building played a central role which has been generally underestimated up until now.

Two newcomers appeared on the journalistic stage of the USA in the mid-1930s and achieved international success – Black Star and *Life*. The regional daily newspapers had dominated the trade. Photography played a subordinate role to text, as could be seen in the "grand old lady" of the American daily press, the *New York Times*. Photographers were expected to support the work of their writing colleagues and to illustrate it. But in the magazines of the day which were owned by Time Inc. a change in the conception of photography was already in evidence. In *Time,* founded as a news magazine in 1923, and in the business magazine *Fortune,* whose first number was printed in 1930, there appeared surprising pictures for the time, photojournalistic work by the American photographer Margaret Bourke-White and portrait photography by the "Invisible Cameraman" Erich Salomon. The subjects appeared to have been taken directly from life – workers in industrial plants as well as politicians in meetings. Those who saw the photos could imagine they were actually present.

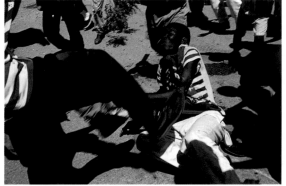

CHRISTOPHER MORRIS 1994

After the 1994 resignation of General Cédras of Haiti, Morris found himself caught in the middle of violent crowds when street fights broke out between Aristide supporters and FRAPH members.

Morris befand sich inmitten der Menschenmenge von Haitianern, als 1994 nach dem Rücktritt von General Cédras die Kämpfe zwischen Aristide-Anhängern und FRAPH-Mitgliedern ausbrachen.

En 1994, Morris se trouvait dans la foule au moment de la démission du général Cédras, lorsqu'éclatèrent les combats entre les partisans d'Aristide et les membres du FRAPH.

Diese Einschätzung überrascht zunächst. *Life* brachte über die Jahrzehnte Generationen von Fotoreportern hervor, die zu weltweitem Ruhm und Ansehen gelangten. Das Band zwischen diesen Stars und dem neuen Magazin mußte anfangs allerdings behutsam geknüpft werden. Und dabei spielten die drei deutschen Agenten im Graybar Building eine zentrale Rolle, die bisher generell unterschätzt wurde.

Zwei Neulinge betraten Mitte der 30er Jahre die publizistische Bühne der USA und hatten internationalen Erfolg – Black Star und *Life*. Die regionalen Tageszeitungen dominierten das Geschäft. Fotografie spielte z.B. in der »großen alten Dame« der amerikanischen Tagespresse, der *New York Times,* eine dem Text untergeordnete Rolle. Fotografen sollten die Arbeit ihrer schreibenden Kollegen unterstützen, sie illustrieren. In den damaligen Magazinen des *Time*-Konzerns deutete sich bereits ein Wandel in der fotografischen Auffassung an. In *Time,* als Nachrichtenmagazin bereits 1923 gegründet, und im Wirtschaftsmagazin *Fortune,* dessen erste Ausgabe 1930 erschien, tauchten in diesen Jahren überraschende Bilder auf, fotojournalistische Arbeiten der Amerikanerin Margaret Bourke-White und Porträtaufnahmen des »unsichtbaren Fotografen«, Erich Salomon. Die Motive schienen direkt aus dem Leben gegriffen zu sein – Arbeiter auf Industrieanlagen ebenso wie Politiker auf Versammlungen. Die Betrachter glaubten, direkt dabeizusein.

champ professionnel s'ouvrait, avec la possibilité de développer rapidement une affaire et de créer quelque chose qui en valait vraiment la peine – il ne s'agissait pas seulement de faire de l'argent.» Derrière ces mots de Mayer, on retrouve une vision : le photojournalisme. Les fondateurs de Black Star avaient bien interprété les signaux de l'époque et installèrent sommairement leur agence de photojournalisme dans le Graybar Building, à la gare de Grand Central. Dans les casses des linotypistes américains, Safranski remarqua une étoile noire. Aussitôt, il sentit que cette étoile devait devenir la marque de l'agence dans les publications américaines, comme la chouette était celle de l'éditeur Ullstein à Berlin. Le nom «Black Star» et son symbole étaient nés.

Non loin des deux pièces du bureau du Graybar Building, une équipe de journalistes de Time Inc. travaillait à un nouveau magazine sous la direction de l'éditeur Henry Luce et de son principal conseiller, Daniel Longwell. Le premier numéro du magazine fut publié sous le nom de *Life* en décembre 1936. Un an plus tard déjà, Longwell reconnaissait dans une note à Luce que Black Star était «… notre meilleure agence d'images et une solide équipe qui a apporté de la bonne photographie européenne à notre pays». Dans un premier temps, ce jugement peut surprendre. Au fil des décennies, *Life* a porté sur les fonts baptismaux des générations de photographes qui ont atteint une gloire et une célébrité mondiales. Au préalable pourtant, il avait fallu tisser avec patience des liens entre ces «stars» de la photographie et le magazine. Sur ce plan, les trois agents allemands du Graybar Building ont joué un rôle central qui a souvent été sous-estimé jusqu'à présent.

Au milieu des années 1930, deux nouveaux arrivants sur la scène de la presse américaine connurent un succès international : Black Star et *Life*. Jusqu'alors, les quotidiens régionaux dominaient le marché. Comme dans le cas du *New York Times* – la vieille grande dame des quotidiens américains – la photographie n'y jouait qu'un rôle secondaire par rapport au texte. Les photographes se contentaient d'illustrer le travail de leurs collègues journalistes. Dans les magazines du groupe Time Inc. d'alors, une évolution était déjà perceptible dans la manière d'approcher la photographie. Que ce soit dans *Time,* un magazine d'informations fondé en 1923, ou dans *Fortune,* dont le premier numéro parut en 1930, commencèrent à apparaître des photographies surprenantes, des clichés photojournalistiques de l'Américaine Margaret Bourke-White et des portraits dus à l'*Invisible Cameraman,* Erich Salomon. Les sujets paraissaient directement jaillir de la vie : des ouvriers sur des sites industriels, des politiciens pendant des réunions publiques. Les lecteurs croyaient y être …

A NEW WAY
OF SEEING

PHOTOJOURNALISM
IN THE WEIMAR REPUBLIC

This new way of seeing was not actually an American invention. In Germany the two great illustrated magazines of the 1920s, the *Berliner Illustrirte Zeitung (BIZ)* and the *Münchner Illustrierte Presse (MIP)*, were considerably further advanced in their use of pictures than the US media were. The idea of photojournalism was born around 1925 in the workers' illustrated magazines of the Weimar Republic and the Soviet Union. The editor-in-chief of the Munich based *MIP*, Stefan Lorant, and his fiercest Berlin rivals Kurt Korff and Kurt Safranski, appropriated the ideas of the left-wing journalistic avant-garde and through a dogged competitive struggle for readers and circulation developed the popular photographic reportage. This form of visual reporting was based on a realization which today appears obvious. Two or more pictures are placed in close proximity and unfold a visual level of meaning which considerably surpasses reporting which is dominated by text. Photographs affect the reader more directly than words, they draw him into the complex interplay between word and image. Furthermore pictures bring emotions such as melancholy and tedium, hate and grief, joy and ecstasy into a picture essay. This discovery triggered a revolution in press photography at the end of the 1920s.

German photographers such as Alfred Eisenstaedt, Martin Munkasci and Salomon filled out the ideas of the commentators with photographic substance. These names, which are today such important figures in the history of photojournalism in the Weimar Republic, are representative of those photographers of comfortable middle-class origin who were educated academically and who would have searched for a secure livelihood in industry or administration in the days of Kaiser Wilhelm. However, in the first German republic things were completely different. The lasting economic crisis prompted top-class cultural achievements. Salomon, a doctor of law, came to photography after the war through casual jobs and at the end of the 1920s ventured with the "invisible" 35 mm camera into places which had hitherto remained closed to the public "eye". A conference of heads of state in The Hague at 2.30 a.m. was as likely to be his subject as a sitting of the Reichstag. 35 mm cameras made possible the "live reporting" of events, in contexts where photography was strictly forbidden. Salomon, the "master of indiscretion", was not alone in finding a new way of seeing opened up through the camera's viewfinder. People – prominent figures as well as the unknown flowerseller – appeared in photographs of the time as both natural and spontaneous. The photographers staged nothing and gave the subjects of their curiosity no chance of posing. Eisenstaedt developed this new way of seeing into complex picture stories. In one of his exemplary reportages he enigmatically portrayed the life and activities of high society in the luxury Swiss ski resort of St. Moritz.

The names Salomon and Eisenstaedt are representative of a German school of photojournalism around 1930

DAS NEUE
SEHEN

FOTOJOURNALISMUS
IN DER WEIMARER REPUBLIK

Das neue Sehen war jedoch keine amerikanische Erfindung. In Deutschland waren die beiden großen Illustrierten der 20er Jahre, die *Berliner Illustrirte Zeitung (BIZ)* und die *Münchner Illustrierte Presse (MIP)*, wesentlich weiter in ihrer Bildsprache als die US-Medien. Die Idee des Fotojournalismus feierte ihre Geburtsstunde um 1925 in den Arbeiterillustrierten der Weimarer Republik und der Sowjetunion. Der Chefredakteur der *MIP*, Stefan Lorant, und seine härtesten Berliner Konkurrenten, Kurt Korff und Kurt Safranski, nahmen sich der Ideen der linken journalistischen Avantgarde an und entwickelten in einem verbissenen Konkurrenzkampf um Leser und Auflagenzahlen den populären Fotoessay. Diese Form der visuellen Berichterstattung beruhte auf einer heute simpel erscheinenden Erkenntnis: Zwei oder mehr Bilder werden in einen engen grafischen Kontext gestellt und entfalten eine

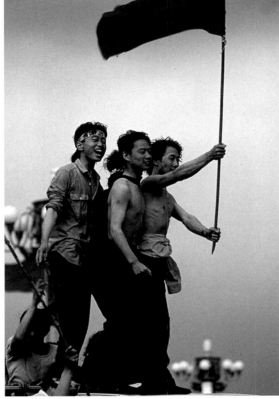

ERICA LANSNER 1989

Journalists like Lansner waited for weeks with Chinese students on the Square of Heavenly Peace (Tiananmen Square) in Beijing. Then on 4 June 1989, the Communist authorities suppressed the democratic movement with a violent use of arms.

Journalisten wie Lansner harrten wochenlang mit den chinesischen Studenten auf dem Platz des Himmlischen Friedens in Peking aus. Am 4. Juni schlugen die kommunistschen Machthaber die Demokratiebewegung mit Waffengewalt nieder.

Certains journalistes, comme Erica Lansner, restèrent pendant des semaines aux côtés des étudiants sur la place de la «Paix céleste» (Place de Tien'anmen) de Pékin. Le 4 juin, le pouvoir communiste écrasa par les armes le mouvement pour la démocratie.

UNE VISION
NOUVELLE

LE PHOTOJOURNALISME SOUS
LA REPUBLIQUE DE WEIMAR

Cette nouvelle approche de la photographie n'était pas une invention américaine. En Allemagne, les deux grands magazines des années 1920, le *Berliner Illustrirte Zeitung* (BIZ, «Journal Illustré de Berlin») et la *Münchner Illustrierte Presse* (MIP, «Presse Illustrée de Munich») étaient nettement plus avancés dans leur langage visuel que les médias américains. L'idée même du photojournalisme remonte à 1925 et apparut dans les magazines illustrés destinés aux ouvriers de la République de Weimar et de l'Union soviétique. Le rédacteur en chef de la *MIP*, Stefan Lorant, et ses plus durs concurrents berlinois, Kurt Korff et Kurt Safranski, adoptèrent les idées de l'avant-garde journalistique de gauche et se lancèrent dans un combat acharné pour les tirages et le lectorat en développant les populaires «essais photographiques». Cette forme de reportage visuel reposait sur un raisonnement qui paraît simple aujourd'hui: deux ou plusieurs images étroitement unies par un contexte graphique provoquent un impact visuel et significatif nettement plus puissant que le texte. Les photographies parlent au lecteur plus directement que les mots, elles l'incitent à entrer dans le bloc complexe formé par le texte et l'image. De plus, les clichés des essais photographiques véhiculent des émotions comme la mélancolie et l'ennui, la haine et la peine, la joie et l'extase. Cette découverte déclencha à la fin des années 1920 une révolution dans le monde de la photographie de presse.

Des photographes allemands comme Alfred Eisenstaedt, Martin Munkasci et Erich Salomon apportaient une substance visuelle aux idées des éditeurs. Aujourd'hui considérés comme de grands noms du photojournalisme sous la République de Weimar, ils ont succédé à ceux de photographes issus de la bonne bourgeoisie qui, formés à l'époque de la prospérité wilhelminienne, cherchaient surtout à s'assurer des revenus au sein de l'industrie ou de l'administration. Sous la Première République allemande, tout était devenu différent. Une crise économique durable stimule la créativité culturelle. Juriste de formation, Salomon avait fait quantité de petits boulots avant d'arriver à la photographie après la Première Guerre mondiale. Avec son appareil photo «invisible» et ses clichés en petit format, il perça à la fin des années 1920 dans un domaine jusqu'alors ignoré de l'«œil public». Une rencontre de chefs d'État à La Haye, à deux heures et demie du matin, ou les premières photos des séances du Reichstag faisaient partie des sujets qu'il affectionnait. Le petit format de ses appareils, utilisant des films de 35 mm, lui permettait de couvrir des événements qu'il était normalement strictement interdit de photographier. Salomon, le «maître de l'indiscrétion», ne fut pas le seul à explorer les nouvelles possibilités ouvertes par cette technique. D'un seul coup, chacun – des célébrités à une simple vendeuse de fleurs – apparaissait dans les photographies de l'époque sous un jour naturel et spontané. Les photographes ne faisaient plus de mise en scène, ne laissaient aucune chance de poser aux modèles qui les intéressaient. Eisenstaedt utilisa ce nouveau regard pour construire des récits visuels complexes. Dans l'un de ses

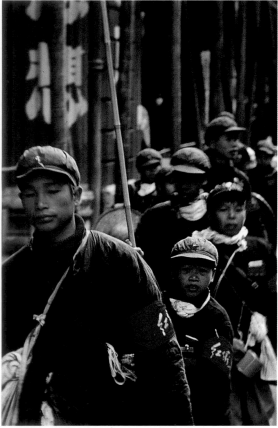

HARRY REDL 1966

Mao's Red Guards marching through Beijing. Redl was one of the few Western journalists to document the "Great Proletarian Cultural Revolution" in the years 1966 to 1968.

Die Roten Garden Maos ziehen durch Peking. Redl war einer der wenigen westlichen Fotojournalisten, die die »Große Proletarische Kulturrevolution« (1966–68) dokumentierten.

Les Gardes rouges de Mao traversent Pékin. Redl fut un des rares photojournalistes occidentals à pouvoir témoigner sur la «grande révolution culturelle prolétarienne» (1966–1968).

whose ground rules have retained their validity to this day and which shape every photojournalist's conception of common sense. Naturalness and spontaneity in the subjects portrayed are the prime ingredients of story-telling from a journalistic point of view, be it in a single picture or in a picture reportage. Formally speaking, the narrative structure of the reportage works with the three main forms of photographic perspective. These are firstly the long shot, which locates the subject in its geographical and/or social context. Secondly, there is the medium shot, which plays with the formative components of action, time and space, in order to structure all the important aspects and moments to do with a particular situation in individual pictures. Finally, there is the detailed picture which emphasizes the decisive aspects or highlights them. These principles of photographic narrative were often the subject of critical debate, given their tendency to reflect reality in a multi-dimensional fashion. However, scarcely had they been developed than this form was undermined. In 1933 the Nazis brought the media into line, turning the print media of the Weimar period into a one-dimensional propaganda machine in order to destroy every form of criticism.

visuelle Sinnebene, die wesentlich über die textdominierte Berichterstattung hinausgeht. Fotografien affizieren den Leser direkter als Worte, sie ziehen ihn in das komplexe Zusammenspiel von Schrift und Bild hinein. Darüber hinaus transportieren Bilder in einem Fotoessay Emotionen, wie Melancholie und Langeweile, Haß und Trauer, Freude und Ekstase. Diese Erkenntnis löste Ende der 20er Jahre eine Revolution in der Pressefotografie aus.

Die deutschen Fotografen, wie Alfred Eisenstaedt, Martin Munkasci und Erich Salomon, füllten die Idee der Publizisten mit fotografischer Substanz. Diese heute so großen Namen des Fotojournalismus in der Weimarer Republik stehen stellvertretend für Fotografen gutbürgerlicher Herkunft, die, akademisch ausgebildet in Zeiten wilhelminischer Prosperität, nach einem gesicherten Auskommen in Industrie oder Verwaltung gestrebt hätten. In der ersten deutschen Republik aber war alles anders. Die ökonomische Dauerkrise provozierte kulturelle Spitzenleistungen. Salomon, promovierter Jurist, fand nach Kriegsende über Gelegenheitsjobs zur Fotografie und stieß Ende der 20er Jahre mit der »unsichtbaren« Kleinbildkamera in Bereiche vor, die dem öffentlichen »Auge« bis dato verschlossen waren. Konferenzen von Staatschefs in Den Haag nachts um halb drei gehörten genauso zu seinen Sujets wie die ersten Fotos aus einer Reichstagssitzung. 35-mm-Kleinbildkameras ermöglichten die »Live-Berichterstattung« von Ereignissen, in deren Rahmen es streng verboten war zu fotografieren. Nicht nur für Salomon, den »Meister der Indiskretion«, tat sich damit die Möglichkeit eines neuen Sehens durch den Kamerasucher auf. Menschen – Prominente ebenso wie die unbekannte Blumenverkäuferin – erschienen auf Fotografien der Zeit auf einmal natürlich und spontan. Die Fotografen inszenierten nicht und ließen den Subjekten ihrer Begierde keine Chance zur Pose. Eisenstaedt entwickelte dieses neue Sehen zu komplexen Bildgeschichten. In einem seiner Parade-Essays schildert er hintergründig das Leben und Treiben der High Society im Schweizer Nobelskiort St. Moritz.

Die Namen Salomon und Eisenstaedt stehen stellvertretend für eine deutsche Schule des Fotojournalismus um 1930, deren Grundregeln bis heute ihre Gültigkeit behalten haben und die den *common sense* eines jeden Fotojournalisten bestimmen. Natürlichkeit und Spontaneität der abgebildeten Subjekte machen das journalistische Erzählen in einem Bild oder einem Fotoessay aus. Der Essay als Erzählstruktur arbeitet formal mit den drei fotografischen Hauptperspektiven: Die Totale, die das Thema in seinem geographischen und / oder sozialen Kontext verortet. Die Halbtotale, die mit den Komponenten Handlung, Zeit und Raum spielt, um alle wichtigen Aspekte und situativen Momente in Einzelbilder zu strukturieren. Die Detailaufnahme, die entscheidende Einzelheiten herausstellt oder aber auch überzeichnet. Kaum hatten sich jedoch diese Grundpfeiler des fotografischen Erzählens herausgebildet, die in ihrer Tendenz, Wirklichkeit mehrdimensional widerzuspiegeln, oft auch kritische Auseinandersetzung war, wurde diese Form ausgehöhlt. Die Gleichschaltung der Medien durch die Nazis 1933 funktionierte die Printmedien der Weimarer Zeit zu einer eindimensionalen Propagandamaschine um, die jede Form der Kritik einstampfte.

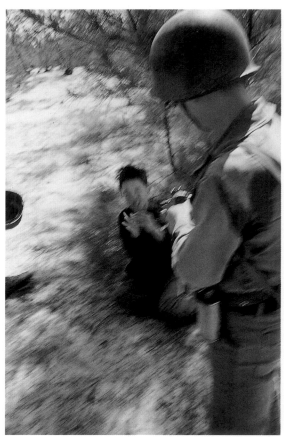

CHARLES BONNAY 1965

As an independent war reporter Charles Bonnay witnessed the execution of a Vietcong suspect by a South Vietnamese soldier.

Als unabhängiger Kriegsberichterstatter wurde Charles Bonnay Augenzeuge der Exekution eines Vietcong-Verdächtigen durch einen südvietnamesischen Soldaten.

Reporter de guerre indépendant, Charles Bonnay fut le témoin oculaire de l'exécution d'un homme soupçonné d'être un Viêt-cong par un soldat sudvietnamien.

reportages de «parade», il décrit les coulisses de la haute société dans la célèbre station de ski suisse de Saint-Moritz.

Les noms de Salomon et d'Eisenstaedt permettent à eux seuls de parler d'une école allemande du photojournalisme dans les années 1930. Ses principes, toujours d'actualité, font partie du bagage de base de chaque photojournaliste. C'est le naturel et la spontanéité des sujets qui donnent à une photo ou à une série leur pouvoir narratif. En tant que récit, le reportage se compose sur le plan formel de trois perspectives fondamentales : la perspective globale, qui situe le sujet dans son contexte géographique et / ou social, la perspective semi-globale, qui utilise les composantes d'action, de temps et d'espace pour situer tous les aspects et les moments importants par des images individuelles, et la vue de détail, qui circonscrit ou dépasse les éléments cruciaux pris séparément. Avec sa capacité à refléter la réalité sous ses aspects multiformes, mais aussi à l'affronter sur un mode critique, cette approche du récit photographique avait à peine posé ses principes de base qu'elle fut victime de la censure médiatique imposée en 1933 par le national-socialisme. La presse devint une machine de propagande unidimensionnelle qui étouffait toute forme de critique.

THE EXODUS OF THE GERMAN PRESS

A MIDWIFE FOR *LIFE* FROM BERLIN

As for so many, the only option left for the Safranskis and the Eisenstaedts was to leave the country. Those who chose the USA as their destination and gained entry to the land of opportunity found it difficult to cope with life in this somewhat unwillingly chosen adoptive country. The two American press tycoons William Randolph Hearst and Henry Luce had for years been planning magazines to be based on European photography and the creative idea of the picture essay. However, the editorial, printing and not least also the photographic know-how for this kind of magazine were lacking. It was therefore as if the two Berlin editors had been summoned to New York. Safranski was already developing a dummy magazine for Hearst in 1934 and Korff was doing the same for Luce in 1935–36. Dummies of an American picture magazine modelled on the *BIZ* were created, targeted at the general public and excellently illustrated with the work of old acquaintances from Berlin days, Martin Munkasci and Alfred Eisenstaedt.

The race for innovation in the American magazine market was closely run. Luce won the battle with time against his rival Hearst. *Life* was put into the hands of the reading public in December 1936. Hearst remained conclusively in the starting blocks when a further picture magazine, *Look,* from the Cowles publishing house, appeared two months later. *Life* became a worldwide success within a few years, with peak print runs of up to five million copies. The successful product clearly bore the signature of Korff in the design of the title, the way in which the contents were structured and the central role of the picture essay. However, this also cleared the way indirectly for Safranski as a successful agent after his failure for Hearst. Given the central role of photography in the planned magazine, he called upon the editorial staff to follow the German example of *BIZ* in the organization and payment of photographers. Korff recommended the payment of generous royalties for photography of quality – on the one hand to retain the best photographers over a period of time and on the other hand to acquire the exclusive rights for printing in the American market for a reasonable period of time. *Life* pictures and picture essays were supposed to be reserved for *Life* readers. For Korff, the cooperation between the *BIZ* and the Berlin agency Mauritius, founded by Ernest Mayer in 1929, highlighted in exemplary fashion the preeminent role of photographic agencies. Another tried and tested system was that of exclusive contracts with agencies which were designed to secure first sight of the work of first-rate photographers. And the need for quality drew Korff virtually exclusively to the hitherto unique ability of European photographers to work in a photojournalist manner. However, he was diplomatic enough to name the few American photographers whom he thought capable to the editorial staff of *Life* – all important names in

DER EXODUS DER DEUTSCHEN PRESSE

GEBURTSHILFE FÜR *LIFE* AUS BERLIN

Wie so vielen blieb den Safranskis und den Eisenstaedts nur der Exodus. Diejenigen, die die USA als Zielort wählten und die Einlaß in das Land der unbegrenzten Möglichkeiten bekamen, fanden sich nur schwer in der neuen, eher unfreiwillig gewählten Heimat zurecht. Die beiden amerikanischen Presse-Tycoons William Randolph Hearst und Henry Luce planten seit Jahren Magazine, die auf der europäischen Fotografie und der gestalterischen Idee des Fotoessays basieren sollten. Für derartige Zeitschriften fehlte jedoch das redaktionelle, grafische und nicht zuletzt auch das fotografische Knowhow. Daher kamen die beiden Berliner Herausgeber wie gerufen nach New York: Schon 1934 entwickelten Safranski für Hearst und 1935/36 Korff für Luce jeweils einen Dummy. Nach dem Vorbild der *BIZ* entstanden probeweise Nullnummern für ein amerikanisches Bildmagazin mit dem Massenpublikum als Zielgruppe – am Reißbrett und Klebetisch, bevorzugt bebildert mit den Arbeiten alter Bekannter aus Berliner Tagen – Martin Munkasci und Alfred Eisenstaedt.

Das Rennen um die Innovation des amerikanischen Magazinmarktes war knapp. Luce gewann den Wettlauf mit der Zeit gegen seinen Konkurrenten Hearst. *Life* trat im Dezember 1936 unter die Augen der Leser. Hearst dagegen blieb endgültig in den Startblöcken, als ein weiteres Bildmagazin, *Look* aus dem Verlagshaus Cowles, zwei Monate später erschien. *Life* avancierte innerhalb weniger Jahre zum Welterfolg mit Spitzenauflagen von bis zu fünf Millionen Exemplaren. Das Erfolgsprodukt trug von der Titelgestaltung über die Inhaltsstruktur bis hin zur zentralen Rolle der Fotoessays die eindeutige Handschrift Korffs. Dieser ebnete aber auch Safranski nach dessen Scheitern bei Hearst indirekt den Weg als erfolgreicher Agent. Entsprechend der zentralen Rolle der Fotografie in dem geplanten Magazin, forderte er die Redaktion auf, auch in der Organisation und Bezahlung der Fotografen dem deutschen Beispiel der *BIZ* zu folgen. Korff empfahl, großzügige Honorare für Qualitätsfotografie zu zahlen – um einerseits die besten Fotografen auch dauerhaft zu binden, andererseits, um die exklusiven Abdruckrechte für eine angemessene Sperrfrist auf dem amerikanischen Markt zu erwerben. *Life*-Fotos und -Essays sollten *Life*-Lesern als ersten vorbehalten sein. Am Beispiel der Zusammenarbeit der *BIZ* mit der Berliner Agentur Mauritius, 1929 von Ernest Mayer gegründet, verwies er auf die eminent wichtige Rolle von Bildagenturen. Ein probates Mittel seien auch Exklusivverträge mit Agenturen, um sich den ersten Blick auf die Arbeiten von Qualitätsfotografen zu sichern. Und Qualität bezog Korff fast ausschließlich auf die bis dato einzigartige Fähigkeit der europäischen Fotografen, fotojournalistisch zu arbeiten. Er war aber diplomatisch genug, der *Life*-Redaktion auch die seiner Ansicht nach wenigen fähigen amerikanischen Fotografen zu nennen – heute alles klingende Namen der Reportagefotografie: Margaret Bourke-White, Thomas McAvoy und Peter

L'EXODE DE LA PRESSE ALLEMANDE

LES BERLINOIS PARRAINENT LA NAISSANCE DE *LIFE*

Pour Safranski et Eisenstaedt comme pour tant d'autres, il ne restait plus que l'exil. Ceux qui choisirent d'émigrer aux Etats-Unis – le pays où tout est possible – eurent du mal à retrouver leurs marques. Les deux magnats de la presse américaine, William Randolph Hearst et Henry Luce, préparaient depuis longtemps des projets s'inspirant de la photographie européenne, de l'idée et de la forme de l'essai photographique. Mais ils manquaient, pour créer ce type de magazine, de l'indispensable savoir-faire journalistique, graphique et surtout photographique. Les deux éditeurs berlinois arrivaient à point nommé à New York. Dès 1934, Safranski réalisait une maquette pour Hearst. Korff en développait une pour Luce en 1935–1936. S'inspirant du *BIZ,* les numéros zéros de ces magazines illustrés conçus pour le grand public américain, nés avec force colle et ciseaux sur une table à dessin, étaient surtout illustrés par les photos de vieilles connaissances de l'époque berlinoise, Martin Munkasci et Alfred Eisenstaedt.

C'est finalement Luce qui remporta cette course à l'innovation contre Hearst. Le premier numéro de *Life* était en vente en décembre 1936. La sortie de *Look,* publié par le groupe de presse Cowles deux mois plus tard, contraignit Hearst à rester dans ses *starting-blocks*. En peu d'années, *Life* réussit une phénoménale percée mondiale avec des tirages atteignant jusqu'à 5 millions d'exemplaires. Dans tout ce qui faisait son succès – présentation des titres, structure du sommaire, mise en avant de reportages –, le magazine portait la griffe de Korff. Celui-ci facilita aussi indirectement la réussite de Safranski comme agent après son échec chez Hearst. Compte tenu de la place centrale qu'occupait la photographie dans *Life,* Korff exigea de la rédaction qu'elle suive aussi l'exemple allemand du *BIZ* en matière d'organisation et de paiement des photographes. Il lui conseilla de payer des honoraires généreux pour les photos de qualité, à la fois pour fidéliser les meilleurs photographes et pour pouvoir garder l'exclusivité des droits de reproduction pour le marché américain pendant un délai suffisant. Les meilleures photos devaient être réservées en priorité aux lecteurs de *Life.* L'exemple de la collaboration entre le *BIZ* et l'agence berlinoise Mauritius, fondée par Ernest Mayer en 1929, démontrait le rôle clé joué par les agences. Un partenariat qui pouvait être encore renforcé par des contrats de première exclusivité, permettant de voir en priorité la production des photographes de qualité. Pour Korff, la qualité passait presque exclusivement par le photojournalisme, une spécialité jusqu'alors exclusivement européenne. Il était pourtant suffisamment diplomate pour indiquer à la rédaction de *Life* quelques photographes américains de talent comme Margaret Bourke-White, Thomas McAvoy et Peter Stackpole – tous devenus des grands noms du reportage. A titre personnel, son photographe favori restait pourtant Alfred Eisenstaedt, qu'il fit

photojournalism today: Margaret Bourke-White, Thomas McAvoy and Peter Stackpole. But his personal favorite was Alfred Eisenstaedt, whom he particularly entrusted to Luce and Longwell. Korff's recommendations were accepted, and the people he had named became staff photographers. In all probability Korff would rather have seen the ratio of emigrants to Americans reversed. It was certainly a political decision on the part of the editorial staff to prefer American citizens in the allocation of jobs. Korff had to learn this bitter lesson for himself. His dream of managing the new title as editor-in-chief remained unfulfilled. Despite his influential mentor Longwell, the editorial doors of Time Inc. Buildings remained closed to him after the inspiration of the newborn *Life*.

THE FATE OF THE EMIGRANTS
BITTERNESS AND AWAKENING IN NEW YORK

The most difficult aspect of adapting to life in a new country for the emigrants was that of the language. However, there were also without doubt problems of differing mentalities. The prevailing patterns of communication and management in editorial offices were more liberal than in Germany. Adapting was especially hard for a difficult academic character like Safranski, who according to Mayer could appear quite carping, didactic and arrogant. Even Korff, who was considerably

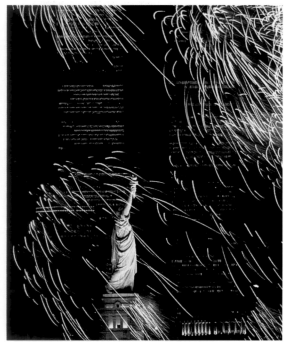

TOM SOBOLIK 1986

The centenary celebrations of the Statue of Liberty on 4 July 1986. This monumental statue at the entrance of the New York harbor symbolizes America's ideology of liberation to all arriving voyagers.

Hundertjahrfeier der Statue of Liberty am 4. Juli 1986. Am Hafeneingang plaziert verkündet sie allen ankommenden Schiffsreisenden von der amerikanischen Freiheitsideologie.

Célébration du centenaire de la Statue de la Liberté, le 4 juillet 1986. Située à l'entrée du port, elle accueille navigateurs et voyageurs au nom de l'idéologie américaine de la liberté.

Stackpole. Doch sein persönlicher Favorit hieß Alfred Eisenstaedt, den er Luce und Longwell besonders ans Herz legte. Korffs Empfehlungen wurden angenommen, die Genannten wurden Staff-Fotografen, feste Angestellte der Redaktion. Aller Wahrscheinlichkeit nach hätte es Korff lieber gesehen, daß sich das Verhältnis Emigranten/Amerikaner entgegengesetzt gestaltet hätte. Mit Sicherheit war es eine politische Entscheidung der Redaktion, Bürger des Landes bei der Vergabe fester Arbeitsplätze zu bevorzugen. Korff machte diese bittere Erfahrung selbst. Sein Traum, als Chefredakteur das neue Blatt zu leiten, ging nicht in Erfüllung. Trotz seines einflußreichen Mentors Longwell blieben für ihn die Redaktionstüren des Time Inc. Buildings nach der Inspiration des Neugeborenen *Life* verschlossen.

DAS SCHICKSAL DER EMIGRANTEN
VERBITTERUNG UND AUFBRUCH IN NEW YORK

Die größten Anpassungsschwierigkeiten bereitete den Emigranten das Sprachproblem. Ohne Zweifel gab es aber auch Mentalitätsprobleme. In den Redaktionen herrschte ein liberalerer Umgangston und Führungsstil als in Deutschland. Einem schwierigen akademischen Charakter wie Safranski, der laut Mayer leicht oberlehrerhaft und hochfahrend wirkte, fiel die Anpassung besonders schwer. Auch der wesentlich ältere Korff, der fast 30 Jahre im Verlagshaus Ullstein gearbeitet und zuletzt gemeinsam mit Safranski die Verantwortung des Herausgebers für eine Großzahl der Publikationen gehabt hatte, kämpfte mit seiner neuen Rolle im Exil. Seine Ideen und sein verlegerisches Knowhow waren begehrt, sein Wunsch, redaktionelle Verantwortung zu tragen, blieb unerfüllt. Resigniert schrieb er in seinem Entlassungsgesuch an Luce im Juli 1936: »Ich bin immer ein Glücksbringer für Verleger gewesen. Ich sage Ihnen einen großen Erfolg voraus. Sie werden das langerwartete große amerikanische Magazin schaffen.« Korff starb verbittert Anfang 1937 nach sechswöchiger Krankheit.

Wenige Wochen vor seinem Tod stellte Korff gemeinsam mit Safranski noch Überlegungen für eine gemeinsame berufliche Zukunft an – laut einer Notiz von Daniel Longwell an seinen Verleger Luce vom 5. Januar 1937: »Nun zu Korff. Vor ein paar Wochen traten die Verantwortlichen von Black Star (…) mit dem Vorschlag an mich heran, Korff zu übernehmen. Wir sollten ihm 5 000 Dollar pro Jahr zahlen, damit er in seiner jetzigen Funktion uns zur Verfügung steht. Seine Aufgabe wäre es, für sie Fotojournalisten heranzuziehen (was seine besondere Stärke ist), die dann das Gros unserer Arbeit erledigen. Da sie außer für uns auch für Werbefirmen oder andere Verlage arbeiten können, wir aber den Erstzugriff auf das Material haben, hätten wir die Möglichkeit, bei unserer Staff-Arbeit einzusparen.« Die Kooperation kam nicht mehr zustande, die Agenturidee aber hatte in einer der wichtigsten Redaktionen der Welt Fuß gefaßt. Korffs Arbeit in der Entwicklungsredaktion hatte nicht nur die Idee des Fotojournalismus in den Köpfen der Magazinmacher etabliert. Er machte ihnen auch unmißverständlich klar, daß sich der

apprécier à Luce et à Longwell. Les recommandations de Korff furent acceptées, ceux qu'il avait choisis engagés comme photographes de la rédaction. Selon toute vraisemblance, Korff aurait volontiers vu parmi eux une proportion plus importante de photographes émigrés face aux Américains d'origine. La décision de la rédaction d'engager de préférence des Américains était sans aucun doute possible l'expression d'une volonté politique. Korff en fut lui-même victime. Son rêve de devenir rédacteur en chef du nouveau magazine ne se réalisa pas. Malgré le soutien de Longwell, les portes de la Time Inc. lui demeurèrent fermées quand il eut achevé son travail de conception pour *Life*.

LE DESTIN DES EMIGRANTS
AMERTUME ET NOUVEAU DÉPART A NEW YORK

L'adaptation à la langue posait de gros problèmes aux immigrants, qui devaient aussi affronter les différences de mentalité. Un ton différent régnait dans les rédactions et elles n'étaient pas dirigées comme en Allemagne. L'adaptation était particulièrement difficile pour quelqu'un comme Safranski qui, formé à une rigueur toute académique, pouvait facilement – selon Mayer – donner l'impression d'être dogmatique et hautain. Nettement plus âgé, Korff eut également du mal à entrer dans

FRED STEIN 1947

Emigré Fred Stein came to New York in 1941; Black Star was a "piece of home" for him. He explored the metropolis in his reportages, in the example shown here Harlem.

Der Emigrant Fred Stein kam 1941 nach New York; Black Star war für ihn wie ein »Stück Heimat«. In seinen Reportagen entdeckte er die Weltstadt, hier Harlem.

Fred Stein émigra à New York en 1941 ; Black Star fut pour lui un peu de sa terre retrouvée. Ses reportages lui permirent de découvrir la métropole, ici à Harlem.

older and had worked for the publishing house Ullstein for almost 30 years and in the end had been responsible together with Safranski for editing a large number of publications, struggled with his new role in exile. His ideas and his knowledge of publishing were sought after, but his wish to assume editorial responsibilities were thwarted. Tendering his resignation to Luce, he wrote resignedly in July 1936: "I have always been a sort of mascot to publishers. I predict a big success. You really are going to create the long expected great American magazine." Korff died at the beginning of 1937, an embittered man.

A few weeks before his death, Korff – together with Safranski – was still considering how they could work together in the future. According to a note from Daniel Longwell to his publisher Luce dated 5 January 1937: "But about Korff. Some weeks ago Black Star (…) approached me on the idea that they take over Korff, that we pay him $ 5,000 a year to be at our service in the capacity he was. For them he would develop photographers (which he's best at) who would eventually take over the bulk of our work. And because they could work for advertisers and other publications as well as for us, we, having first call on this work, could get our photographic staff work more cheaply." This proposition was never realized, but the idea of an agency had gained a foothold in one of the most important editorial offices in the world. Korff's work in editorial development had not only established the idea of photojournalism in the heads of the magazine dynamos. He also made it abundantly clear to them that it would not be possible to meet the immense need for pictures on a magazine of this kind through staff photographers and the domestic market. At the same time he demonstrated ways in which they could save money on obtaining the rights for individual photographs and reportages. The principle of Black Star was in the air before any agent had even set foot in the editorial offices. Safranski, Mayer and Kornfeld simply needed to breathe life into the idea of the picture agency.

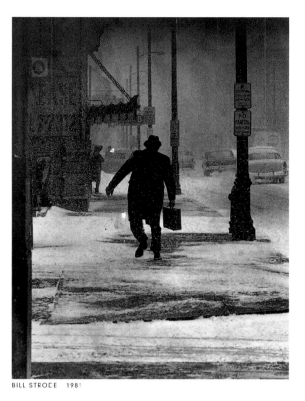

BILL STRODE 1981

The characteristic fast pace of New York is clearly evident from Strode's photo of Manhattan. New Yorkers always seem to be in a rush, regardless of the weather.

Strodes Foto zeigt den Puls Manhattans, ob es stürmt oder schneit, die New Yorker scheinen immer in Eile zu sein.

La photo de Strode montre le pouls de Manhattan : qu'il vente ou qu'il neige, les New-Yorkais semblent toujours pressés.

immense Bildbedarf eines derartigen Magazins nicht durch die Staff-Fotografen und den heimischen Markt decken ließe. Gleichzeitig zeigte er ihnen kostengünstige Wege auf, die Abdruckrechte für Einzelfotos und Essays zu erwerben. Das Prinzip »Black Star« stand im Raum, bevor irgendein Agent die Redaktion betreten hatte. Safranski, Mayer und Kornfeld brauchten das Prinzip der fotojournalistischen Agentur nur mit Leben zu erfüllen.

son nouveau rôle, lui qui avait travaillé presque 30 ans chez Ullstein, où il était responsable avec Safranski d'un grand nombre de publications. On appréciait ses idées et son expérience éditoriale, mais son désir d'exercer des responsabilités au sein d'une rédaction restait lettre morte. Dans un courrier adressé à Luce après son licenciement, en juillet 1936, il écrivait : «J'ai toujours été une sorte de mascotte pour les éditeurs. Je vous prédis un grand succès. Vous êtes vraiment en passe de créer le grand magazine américain que l'on attend depuis si longtemps.» Amer, Korff mourut peu après, au terme de six semaines de maladie, début 1937.

Quelques semaines avant sa mort, Korff avait encore fait des projets d'avenir avec Safranski. Une note datée du 5 janvier 1937 de Daniel Longwell à son éditeur, Luce, en témoigne : «Venons-en à Korff. Il y a quelques semaines, Black Star… m'a suggéré l'idée qu'ils pourraient l'embaucher et que nous pourrions lui payer une somme annuelle de 5 000 US$ pour qu'il soit à notre disposition dans les mêmes fonctions qu'auparavant. Il serait chargé par eux de former des photographes – c'est sa spécialité – capables d'assurer le gros de la production dont nous avons besoin. Comme les photographes pourraient également travailler pour la publicité et d'autres publications, nous garderions une première exclusivité sur leur travail et nous réduirions ainsi les coûts de notre équipe photographique.» Ce projet ne fut pas concrétisé, mais l'idée de l'agence avait pris pied dans l'une des plus importantes rédactions du monde. Le travail de développement de Korff n'avait pas seulement imposé le concept du photojournalisme dans l'esprit des éditeurs. Il leur avait clairement expliqué que les immenses besoins en photos d'un magazine comme *Life* ne pourraient pas être couverts uniquement par les photographes de la rédaction, ni même par le marché national. Simultanément, il leur avait indiqué une méthode pour acquérir au meilleur coût les droits de reproduction des photographies. Ainsi, le principe «Black Star» était déjà présent dans les murs de *Life* avant même qu'un agent y eût posé le pied. Il ne restait plus à Safranski, Mayer et Kornfeld qu'à animer et mettre en œuvre le principe de l'agence de photojournalisme.

THE THREE FOUNDERS
"BLACK STAR … THE BEST TEAM I HAVE EVER SEEN"

The émigré photojournalist Ralph Crane had only praise for the three founders: "Black Star was the best team I have ever seen in any outfit." Ben Chapnick, Howard's cousin and successor as President since 1 January 1990, recalls the intellectual leader of the team: "Mr. Safranski was the mastermind of the agency. He thought in larger terms and in theories that related to larger stories." His appeal to photographers was enormous. Herein lay his actual role in the agency. He was the man of ideas who lived and breathed photojournalism and could destroy the photographers just as well as build them up with his criticism of photos and ideas for essays with a few words and looks. But the American way of doing business did not suit him at all: "Of the three founders,

DIE DREI GRÜNDER
»BLACK STAR … DAS BESTE TEAM, DAS MIR JE BEGEGNET IST«

Der emigrierte Fotojournalist Ralph Crane findet nur lobende Worte für die drei Gründer: »Black Star war das beste Team, das mir in der Branche je begegnet ist.« Ben Chapnick, der Cousin Howards und sein Nachfolger als Präsident seit dem 1. Januar 1990, erinnert sich an den intellektuellen Kopf des Teams: »Mister Safranski war der Kopf der Agentur. Er besaß Weitblick und dachte in übergreifenden Zusammenhängen.« Seine Anziehungskraft auf Fotografen war enorm. Hierin lag auch seine eigentliche Funktion in der Agentur. Er war der Ideenmann, der Fotojournalismus atmete und die Fotografen mit seiner Kritik an Fotos und Essayideen mit wenigen Worten und Blicken genausogut zerstören wie aufbauen konnte. Doch der »amerikanische Stil des Geschäftes« lag ihm gar nicht: »Von den drei Gründern

LES TROIS FONDATEURS
«BLACK STAR, LA MEILLEURE EQUIPE … »

Emigré lui-même, le photojournaliste Ralph Crane n'a que des propos élogieux pour les trois fondateurs : «Dans tous les domaines, Black Star était la meilleure équipe que n'aie jamais vue», disait-il. Cousin et successeur d'Howard Chapnick à la présidence de Black Star depuis le 1er janvier 1990, Ben Chapnick se souvient de la tête pensante de l'équipe : «M. Safranski était le cerveau de l'agence. Il pensait large et ses idées débouchaient sur des reportages d'envergure.» Safranski exerçait un énorme pouvoir d'attraction sur les photographes et c'était là aussi sa véritable fonction au sein de l'agence. C'était une «boîte à idées» qui respirait littéralement le photojournalisme. D'un mot, d'un coup d'œil, ses critiques pouvaient porter un reportage au sommet ou l'anéantir. Pourtant, le style à «l'américaine»

Sobolik's photo of the streets of Prague is reminiscent of the many euphoric moments that characterized the predominantly peaceful 1989 revolutions of Eastern Europe.

Soboliks Foto aus den Straßen von Prag erinnert an viele euphorische Momente der zumeist friedlichen Revolution in Osteuropa 1989.

La photo par Sobolik des rues de Prague évoque les nombreux moments d'euphorie de la « Révolution de velours » de 1989.

he was the one who was most like a fish out of water in the United States."

But what are business partners there for if they do not relieve each other of unwelcome tasks and create the necessary freedom for each individual to develop their own strengths? Ben Chapnick saw Mayer as the driving force in business, with his experience of agencies in Berlin: "He was the glue that held the agency together. He was a good businessman and understood the practical aspects of trying to help photographers, who were known primarily as being poor businessmen, to succeed economically as well as creatively." It was Mayer's opinion that everything had to be done to lighten the financial burden for freelance photographers – whether it be in the form of guaranteed monthly payments for photographers who were under contract to Black Star or as financial management which persists to this day: "He decided that, even though the corporation was short on capital, the photographers should be reimbursed for their out-of-pocket expenses by the agency, even before the agency billed the job to the client. In this way, the photographer's capital was not impacted. Their only risk was their time, not their money."

Mayer saw in his business sense the fundamental prerequisite for running a photojournalist agency – making the work of the individual photojournalist financially safe. In a sector where from the beginning idealism played a large role it is difficult to focus on the financial basis of the work. The idea for an essay may be revolutionary or instructive, but in the first instance ways of financing it must be found. The same care which Mayer applied to the economic aspects of the business were also displayed in the development of ideas. He was captivating because of his clear intellect, insatiable thirst for knowledge, his inexhaustible reading and not least his marked journalistic intuition. Ben and Howard Chapnick both liked to recount how Mayer would come into the office on a Monday morning with a dissected copy of what had previously been a Sunday *New York Times* weighing two pounds and would present

war er derjenige, der sich in den Vereinigten Staaten am wenigsten in seinem Element fand.«

Doch wozu sind Geschäftspartner da, wenn sie sich nicht gegenseitig die ungeliebten Aufgaben abnehmen und den nötigen Freiraum zur Entfaltung der eigenen Stärken schaffen? Ben Chapnick sieht in Mayer mit seiner Berliner Agenturerfahrung den Motor des Geschäftes: »Er war das Bindeglied, das die Agentur zusammenhielt. Er war ein guter Geschäftsmann und verstand sich auf die praktischen Seiten des Gewerbes. So verhalf er Fotografen, die notorisch schlechte Geschäftsleute waren, nicht nur zu journalistischem, sondern auch zu wirtschaftlichem Erfolg.« Mayers Ansicht nach mußte alles getan werden, um die finanzielle Last der freien Fotografen zu erleichtern – sei es durch monatliche Garantiezahlungen für die Black-Star-Vertragsfotografen, sei es durch die finanzielle Regelung, die bis heute gilt: »Er entschied, daß den Fotografen auch bei Kapitalknappheit der Firma persönliche Auslagen von der Agentur zu erstatten waren, und zwar auch dann, wenn die Agentur den Auftrag dem Kunden noch nicht in Rechnung gestellt hatte. Das Geld der Fotografen lag somit nicht auf Eis. Ihr einziges Risiko war die Zeit, nicht ihr Geld.« Mayer erkannte in seinem Geschäftssinn die Grundvoraussetzung für eine fotojournalistische Agentur – die finanzielle Absicherung der Arbeit des einzelnen Fotojournalisten. In einer Branche, in der Idealismus von Anfang an groß geschrieben wurde, fällt es schwer, zunächst nach der finanziellen Grundlage der Arbeit zu fragen. Die Idee für einen Essay kann bahnbrechend und aufklärerisch sein, zunächst jedoch müssen Wege der Finanzierung gefunden werden. Die gleiche Sorgfalt, die Mayer auf die ökonomischen Aspekte verwendete, zeigte er auch bei der Entwicklung von Ideen. Er bestach mit klarem Intellekt, unstillbarem Wissensdurst, unermüdlicher Lesegier und nicht zuletzt einem ausgeprägten journalistischen Spürsinn. Ben und Howard Chapnick erzählen beide gerne, daß Mayer am Montagmorgen mit einer sezierten Ausgabe der vorher kiloschweren *New York Times* vom Sonntag das Büro betrat und einen Haufen Zeitungsschnipsel präsentierte, jeder von ihnen barg eine gute Idee.

Die Arbeitswoche begann immer mit einer redaktionellen Konferenz in der Agentur: Mayer sprudelte vor Ideen über, Safranski diskutierte sie scharfsinnig und Kornfeld traf mit seiner »Nase für Neuigkeiten« die Auswahl. Als ehemaligem Literaturagenten war Kornfeld das Gefühl für Fotografie zwar nicht in die Wiege gelegt worden, aber er verstand sich von jeher auf den Verkauf von Ideen und die Repräsentation von Autoren. Er vermochte Ehen zwischen den Redakteuren und Fotografen zu stiften. Besonders innig kümmerte er sich um die Fotografen. Der W.-Eugene-Smith-Biograph Jim Hughes drückt dies so aus: »Er schien immer die rechten Worte zu finden – und das in einem kaum verständlichen Englisch mit kehligem, deutschen Akzent, um Fotografen bei Laune zu halten.« Ein schwieriger junger Mann wie Gene Smith – er kam im Juli 1938 zu Black Star – fand schnell Zugang zu dem kleinen, kräftigen Agenten mit dem großen Herzen und nannte ihn bald »Poppa«. In unnachahmlicher Weise vermittelte Kornfeld in Redaktionen die Fähigkeiten »seiner Fotografen«, auch die nicht gerade beliebter und unbequemer Hitzköpfe wie Smith. Howard Chapnick erinnerte sich an

des affaires ne lui convenait pas : « Des trois fondateurs, c'était celui qui ressemblait le plus à un poisson hors de l'eau aux Etats-Unis… »

Mais à quoi serviraient des associés s'ils n'étaient pas là pour se soulager mutuellement des tâches qu'ils n'aiment pas, afin de mieux pouvoir épanouir leurs points forts personnels ? Pour Ben Chapnick, Mayer, avec son expérience d'agent à Berlin, était le moteur de l'affaire : « C'était le ciment qui maintenait la cohérence de l'agence. C'était un bon homme d'affaires qui comprenait bien la nécessité de soutenir les photographes – qui ne sont pas réputés pour leur sens des affaires – afin de réussir aussi bien sur le plan commercial que sur celui de la créativité. » Pour Mayer, tout devait être fait pour libérer les photographes indépendants des contraintes financières. Cette volonté prit la forme de garanties mensuelles pour les photographes sous contrat avec l'agence ou celle d'accords financiers toujours en vigueur : « Il décida que, malgré la faiblesse de ses capitaux, l'agence rembourserait les frais des photographes avant même d'avoir facturé la moindre photo. Cette méthode évitait tout impact sur les finances personnelles des photographes. Leur seul investissement, c'était le temps, pas l'argent. » Intuitivement, Mayer avait perçu que, pour bien fonctionner, une agence de photojournalisme devait garantir financièrement et individuellement le travail des photographes. Dans une activité où le mot « idéalisme » était écrit en lettres majuscules depuis l'origine, il peut paraître difficile de parler d'abord des conditions financières du travail. L'idée de reportage la plus géniale demande d'abord à être financée … Mayer consacrait la même attention aux idées qu'aux questions économiques. D'une intelligence précise, il était assoiffé de connaissances, lisait énormément et possédait de surcroît un véritable flair journalistique. Comme Howard Chapnick, Ben raconte volontiers que Mayer arrivait à l'agence le lundi matin avec une pile d'articles et d'entrefilets découpés dans la monumentale édition dominicale du

The summer of 1964 was known as the Freedom Summer of Mississippi. Three civil rights campaigners were murdered near Philadelphia and the local deputy sheriffs, Cecil Price (left) and Lawrence Rainey, were accused of the murders.

Sommer 1964 – der Freedom Summer in Mississippi. Bei Philadelphia wurden drei Bürgerrechtler ermordet. Die Deputy Sherrifs Cecil Price (l.) und Lawrence Rainey wurden dieses Mordes angeklagt.

Eté 1964 – « l'été de la liberté » dans le Mississippi. Près de Philadelphie, trois défenseurs des droits civiques furent assassinés. Cecil Price (à gauche) et Lawrence Rainey, adjoints au shérif furent accusés de ce meurtre.

them with a heap of newspaper clippings, each of them containing a good idea.

The working week always began with an editorial conference in the agency. Mayer would be bubbling over with ideas, Safranski would discuss them astutely and Kornfeld, with his "nose for news", would make the selection. As a former literary agent, Kornfeld had certainly not been born with a feel for photography, but he had always understood how to sell ideas and represent authors. He was able to establish relationships between editors and photographers. He took a sincere interest in the photographers. Jim Hughes, W. Eugene Smith's biographer expresses this as follows: "He seemed invariably to know just the right words – spoken in a nearly incomprehensible English mixed with a heavy, guttural German – to keep photographers happy." A difficult young man like Gene Smith – he joined Black Star in July 1938 – quickly established a rapport with the small, powerful agent with the big heart and was soon calling him "Poppa". Kornfeld would convey the abilities of "his photographers" in inimitable fashion to editorial departments, even if it was one of the awkward hotheads like Smith who were not exactly loved. Howard Chapnick recalled his manner with his principal client, whom he would regularly visit on a Saturday morning: "When he went to *Life,* it was always as if they were working for him. He was a very courtly, gallant gentleman and very considerate of the people up there." It can be said without exaggeration that Kornfeld was "the public face of the agency."

THE FIRST STEP
MAYER'S ENTREE TO *LIFE*

It was not Kornfeld but Mayer who made the decisive step uptown into the Rockefeller Center to Time Inc. With an enormous pile of essays by photographers including Fritz Goro and Paul Wolff, whom he had brought safely from Berlin to New York, he was preaching to the converted when he first visited the editorial development offices in January 1936. Longwell had learnt his lesson with Korff and purchased the exclusive rights to nearly all the photographs Mayer presented to him. Black Star with its tried and trusted contacts with photographers in Europe, Asia and Africa hit upon an enormous gap in the market. An agency professional like Mayer recognized the huge opportunity. A few weeks later he approached Time Inc. again and negotiated a firm contract with them. The company was to pay Black Star a considerable guaranteed sum of $ 5,000 annually for the right to print the photos which were produced on a freelance basis by Black Star photographers first, that is if they were not contracted for the work to another publishing house. Above and beyond this, *Time* paid extra to secure first sight and the right of refusal on all imported photographs. This arrangement rested upon the excellent contacts which Safranski had with Berlin. The Deutsche Verlag, the official German news agency, delivered thick parcels of photographs of the German armed forces to Black Star almost daily. The agency drew on well-nigh inexhaustible resources and inundated the editorial offices of Time Inc. with photojournalist work and exclusive material. The chief editors at *Life* were

ROBERT NICHOLS 1988

A snapshot of a miracle that took place in the skies over Hawaii. A Boeing 737 flying at an altitude of 20,000 feet had its roof ripped off but amazingly there was only one fatality.

Schnappschuß eines Wunders über Hawaii. Nachdem einer Boeing 737 in 7300 m Höhe das Dach abriß, gab es nur ein Todesopfer.

Instantané d'un miracle au-dessus de Hawaii. Un Boeing 737 arrache un toit à 7300 mètres d'altitude. Il n'y eut qu'un mort.

sein Auftreten bei seinem Hauptkunden, den er regelmäßig am Samstagmorgen besuchte: »Wenn er zu *Life* ging, schien es immer so, als würden sie für ihn arbeiten. Er war ein sehr höflicher Gentleman alter Schule und behandelte die Leute dort mit großer Zuvorkommenheit.« Ohne Übertreibung läßt sich sagen, Kornfeld war »das Aushängeschild der Agentur«.

DER ERSTE SCHRITT
MAYERS ENTREE BEI *LIFE*

Den entscheidenden Schritt uptown in das Rockefeller Center zu Time Inc. machte nicht Kornfeld, sondern Mayer. Mit einem Riesenstapel an Essays, u. a. von Fritz Goro und Paul Wolff, die er aus Berlin nach New York herübergerettet hatte, rannte er bei seinem Antrittsbesuch im Januar 1936 in der Entwicklungsredaktion offene Türen ein. Longwell hatte seine Lektion bei Korff gelernt und kaufte die exklusiven Abdruckrechte für fast alle Fotografien, die Mayer ihm präsentierte. Black Star stieß mit seinen guten und bewährten Kontakten zu Fotografen nach Europa, Asien und Afrika in eine gewaltige Marktlücke. Ein Agenturprofi wie Mayer erkannte die Riesenchance. Wenige Wochen später faßte er nach und handelte einen festen Vertrag mit Time Inc. aus. Die Verlagsgesellschaft zahlte Black Star eine beträchtliche Garantiesumme von 5000 Dollar jährlich für die Erstabdruckrechte der Fotos, die von Black-Star-Fotografen frei produziert wurden, d.h. nicht unter Auftrag eines anderen Verlages entstanden. Darüber hinaus sicherte sich der Verlag mit einer Extrasumme den ersten Blick und die Vorkaufsrechte für alle importierten Bilder. Diese Abmachung beruhte auf den hervorragenden Kontakten, die Safranski nach Berlin hatte. Der Deutsche Verlag, die offizielle deutsche Nachrichtenagentur, belieferte Black Star fast täglich mit dicken Paketen Fotos der deutschen Wehrmacht. Die Agentur schöpfte aus schier unerschöpflichen Ressourcen und überhäufte die Redaktionen der Time Inc. mit fotojournalistischen Arbeiten und exklusivem Material. Den

New York Times. Chaque coupure contenait une bonne idée de reportage…

La semaine de l'agence commençait invariablement par une conférence de rédaction. Mayer bouillonnait d'idées, Safranski les analysait tandis que Kornfeld, avec son «nez pour l'actualité», déterminait le choix final. Ancien agent littéraire, Kornfeld n'avait pas un sens inné de la photographie, mais il s'y connaissait depuis toujours lorsqu'il s'agissait de vendre une idée et de défendre les auteurs. C'était lui qui réussissait à «marier» journalistes et photographes, dont il s'occupait plus particulièrement. Biographe de W. Eugene Smith, Jim Hughes l'évoque de la façon suivante : «Il semblait toujours trouver les mots qu'il fallait – dans un mélange presque incompréhensible d'anglais et d'allemand guttural – pour contenter les photographes.» Ce petit homme corpulent au grand cœur réussit si bien à amadouer un jeune homme au caractère difficile comme Gene Smith, entré chez Black Star en juillet 1938, que celui-ci l'appela rapidement «Poppa». Kornfeld avait un extraordinaire talent pour vanter le talent de «ses» photographes – y compris celui de «têtes de bois» comme Smith – dans les rédactions des magazines. Howard Chapnick décrit ainsi sa prestation chez leur principal client, auquel il rendait toujours visite le samedi : «Quand il allait chez *Life,* il se comportait comme s'ils travaillaient pour lui. Il était très courtois, jouant au gentleman qui montrait beaucoup de considération pour tous les gens de la rédaction.» Kornfeld était la «vitrine» de l'agence.

LE PREMIER PAS
LA PERCEE DE MAYER CHEZ *LIFE*

Pourtant, ce ne fut pas Kornfeld mais Mayer qui franchit le pas décisif chez Time Inc., dans le Rockefeller Center. Lesté d'une masse de clichés – notamment de Fritz Goro et de Paul Wolff – qu'il avait réussi à transporter de Berlin jusqu'à New York, il trouva porte ouverte dès sa première visite en janvier 1936 à l'équipe qui développait le projet *Life.* Bien briefé par Korff, Longwell acheta l'exclusivité des droits de publication de la quasi-totalité des photos que Mayer lui présenta. Grâce à son excellent réseau de contacts avec les photographes en Europe, en Asie et en Afrique, Black Star se trouvait, pratiquement seule, face à un énorme marché à exploiter. Un agent professionnel comme Mayer ne s'y trompa pas. Le filon était le bon. Quelques semaines plus tard, il signa un contrat avec Time Inc. *Life* verserait à Black Star une garantie conséquente de 5000 US$ par an pour avoir les droits de première exclusivité de tous les clichés des photographes travaillant sous contrat avec l'agence. En outre, le magazine s'assurait en versant une somme supplémentaire de pouvoir voir en priorité toutes les photos importées. Cet accord n'avait été rendu possible que grâce aux contacts privilégiés de Safranski à Berlin. Le Deutscher Verlag, l'agence de presse officielle allemande, livrait presque quotidiennement à Black Star de volumineux paquets de photos de la Wehrmacht, l'armée allemande. L'agence semblait disposer de ressources presque inépuisables et submergeait toutes les rédactions de la Time Inc. de photos et de sujets exclusifs. Les responsables de *Life* n'avaient aucun mal à suivre

YOUNOSUKE NATORI 1937

Right from the beginning Black Star established a world-wide network of the most experienced photographers. From Japan, Natori supplied Black Star with the first-class photographs. This one was published by Life in 1937.

Black Star verfügte von Anfang an über ein weltweites Netz an versierten Fotojournalisten. Natori lieferte seine Bilder aus Japan an Black Star – Life druckte dieses 1937.

Dès le début, Black Star disposa d'un vaste réseau international de photojournalistes. Du Japon, Natori envoyait ses photos à l'agence; celle-ci fut publiée par Life en 1937.

WALTER BOSSHARD 1938

A Japanese soldier during sword training. Bosshard worked for Black Star from 1935 to 1939. During the Sino-Japanese war he accompanied the Japanese offensive on the mainland.

Japaner beim Schwerttraining. Bosshard arbeitete 1935–39 für Black Star. Während des chinesisch-japanischen Krieges begleitete er die Offensive der Japaner auf dem Festland.

Entraînement intensif d'un soldat japonais. Bosshard travailla pour Black Star de 1935 à 1939. Pendant la guerre sino-japonaise, il suivit l'offensive des Japonais sur le continent.

WERNER WOLFF 1950

A Kentucky folk song festival photographed by Werner Wolff. Wolff was a war photographer until 1945, he then continued his career as an exceptionally versatile photojournalist with Black Star.

Kentucky Folk Song Festival fotografiert von Werner Wolff – bis 1945 Kriegsfotograf. Er setzte er seine Karriere als äußerst vielseitiger Fotojournalist bei Black Star fort.

Photographie du festival de folk-song du Kentucky prise par Werner Wolff, reporter de guerre jusqu'en 1945. Il poursuivit sa carrière à Black Star en tant que photoreporter aux fonctions très variées.

more than eager to follow all of Korff's advice down to the smallest detail. They chose Black Star as one of their main suppliers of pictures. Life's chief picture editor at that time described Black Star's vital contribution to the magazine thus: "… we discovered we needed Black Star more than they needed us."

Whilst this statement pays tribute to the work of the founders, its bias is not justified. Black Star needed Life to the same extent. Its work for Life made up almost one-quarter of its total volume of business. Moreover, the émigré photojournalists needed the agency as a means of gaining access to the magazine which offered a competition-free stage for photojournalism in the European tradition, since the amount of work available was not great. The list of those who in the early years signed a contract with Black Star reads like a "Who's Who" of photojournalism in the following decades: Walter Bosshard, Robert Capa, Ralph Crane, Herbert Gehr, Fritz Goro, Andreas Feininger, Ernst Haas, Philippe Halsmann, Fritz Henle, Younosuke Natori, Lennart Nilsson, Walter Sanders, Fred Stein, Werner Wolff. They all embodied the new type of the photojournalist, whose creativity and working ability were urgently being sought by American magazines such as Life. The mainly Jewish emigrants possessed qualities which distinguished them from their American colleagues. Many of them had completed an academic training in subject areas other than photography and had traveled widely.

Verantwortlichen in der Life-Redaktion fiel es mehr als leicht, alle Ratschläge Korffs bis aufs i-Tüpfelchen auszuführen. Sie erwählten Black Star als einen ihrer Hauptbildlieferanten. Die damalige Bürochefin der Life-Bildredaktion beschreibt Black Stars vitale Rolle für das Magazin: »… wir merkten, daß wir Black Star mehr brauchten als sie uns.«

Zwar ehrt diese Aussage die Arbeit der Gründer, sie trifft aber in dieser Einseitigkeit nicht zu. Black Star brauchte Life in gleichem Maße. Die Life-Aufträge machten fast ein Viertel des Geschäftsvolumens aus. Zudem benötigten die emigrierten Fotojournalisten die Agentur als Türöffner zu dem Magazin, das eine konkurrenzlose Bühne für Fotojournalismus in europäischer Tradition bot, denn der Arbeitsmarkt war eng. Die Liste derer, die in den ersten Jahren einen Kontrakt bei Black Star unterzeichneten, liest sich wie ein »Who is Who« des Fotojournalismus der folgenden Jahrzehnte: Walter Bosshard, Robert Capa, Ralph Crane, Herbert Gehr, Fritz Goro, Andreas Feininger, Ernst Haas, Philippe Halsmann, Fritz Henle, Younosuke Natori, Lennart Nilsson, Walter Sanders, Fred Stein, Werner Wolff. Sie alle verkörperten den neuen Typus Fotojournalist, dessen Kreativität und Arbeitskraft amerikanische Magazine wie Life händeringend suchten. Die zumeist jüdischen Emigranten brachten Qualitäten mit, die sie gegenüber ihren amerikanischen Kollegen auszeichneten. Viele von ihnen hatten eine akademische Ausbildung in anderen

au pied de la lettre les recommandations de Korff. Ils firent de Black Star l'un de leurs principaux fournisseurs. L'ancienne responsable de la rédaction photo de Life souligne le rôle vital de Black Star pour le magazine : « Nous avons découvert que nous avions plus besoin de Black Star qu'elle de nous. »

Cette phrase rend hommage aux fondateurs de l'agence, mais elle n'est pas tout à fait exacte. En réalité, Black Star avait tout autant besoin de Life. Les commandes du magazine représentaient près du quart du chiffre d'affaires de l'agence qui accueillait nombre de photographes émigrés car ces derniers voyaient surtout une porte d'entrée pour Life, considéré sur un marché étroit comme un support sans pareil pour le photojournalisme dans la grande tradition européenne. La liste de ceux qui débutèrent leur carrière chez Black Star ressemble à un «Who's Who» de la photographie des décennies suivantes : Walter Bosshard, Robert Capa, Ralph Crane, Herbert Gehr, Fritz Goro, Andreas Feininger, Ernst Haas, Philippe Halsmann, Younosuke Natori, Lennart Nilsson, Walter Sanders, Fred Stein, Werner Wolff. Ils incarnaient tous le photojournaliste d'un nouveau type, dont la créativité et la puissance de travail correspondaient parfaitement aux magazines américains comme Life. Emigrants juifs pour la plupart, ils avaient un profil différent de celui de leurs collègues américains. Ayant pour la plupart fait des études dans d'autres domaines que la photographie, ils

They were all conversant with 35 mm cameras. Furthermore, because of their work for the large European magazines they possessed a journalistic feel for realizing picture essays.

A PIECE OF HOME
BLACK STAR'S FUNCTION FOR THE EMIGRES

For the émigré photographers, Black Star was a piece of Europe in the middle of New York. Here there were no problems with making oneself understood or with being an outsider. Agents and photographers had the common goal of getting photojournalism accepted in America as a form of visual reporting. The office doors were always wide open for all émigrés. Some, like Robert Capa, only stayed for a few weeks, whilst others, like Fritz Goro, signed contracts for 4 years. Goro, who later succeeded in becoming world famous as a scientific and medical photographer, recalls this period with mixed feelings: "It was really an incredible collection of talented people and they lost us all. And they lost us (…), well, that is a very touchy subject (…), because of how a picture agency has to be structured. (…) – all of this is very expensive (…) They were sort of forced, maybe against their will because they were nice people, to exploit us. And I felt exploited. They sort of wanted to impress the editors of this new magazine [*Life*] by having very good but very inexpensive photographers." Once he had joined Black Star in 1936, Goro received a guaranteed monthly income for his work like all other photographers. This was equally true of the period after a road accident which left him unable to work for practically a whole year. As a result, when he resumed work he was facing a mountain of debts but he made a very promising beginning with numerous contract jobs for *Life*. In 1938 Black Star sent Goro to Canada on a freelance project on a fascist organization. He achieved a journalistic coup which led to the arrest of several members once the story had been published in *Life*. Black Star billed the pictures in the routine fashion immediately after their publication in *Life*. However, Goro was subsequently of the opinion that his agents had wasted the opportunity of selling the pictures as an exclusive, for which they would have been able to demand a considerably higher royalty. This example shows the complicated relationship between agent and photographer, which is often characterized by latent mistrust. Due to his financial situation, Goro's faith in Black Star was shattered, the fundamental basis for cooperation destroyed. His success with *Life* made it possible for him in the long term to work directly for the magazine. In 1940 he left Black Star after working out his contract and in 1944 he became a staff photographer for *Life* for the next 27 years. The émigré Ralph Crane and the American W. Eugene Smith provide a completely contrary example. They number amongst the photographers who were contracted to Black Star for many years. Crane worked for the agency from 1941 to 1951 and still enthused decades later over the creative working atmosphere. Black Star helped him "… tremendously by supplying excellent ideas for picture stories and did a great job in selling them. About eighty percent of these stories

Fachrichtungen als Fotografie absolviert und hatten weite Reisen unternommen. Alle waren versiert im Umgang mit Kleinbildkameras. Zudem verfügten sie aufgrund ihrer Arbeit für die großen europäischen Magazine über journalistisches Gespür beim Umsetzen von Fotoessays.

EIN STÜCK HEIMAT
BLACK STARS FUNKTION FÜR DIE EMIGRANTEN

Black Star war für die emigrierten Fotografen ein Stück Europa mitten in New York. Hier gab es keine Verständigungsprobleme und keine Fremdelei. Agenten und Fotografen hatten das gemeinsame Ziel, Fotojournalismus als Form der visuellen Berichterstattung in Amerika durchzusetzen. Für alle Emigranten standen die Bürotüren weit offen. Einige wie Robert Capa blieben nur wenige Wochen, andere wie Fritz Goro unterschrieben Verträge für vier Jahre. Goro, der später als Wissenschafts- und Medizinfotograf zu Weltruhm gelangte, erinnert sich mit gemischten Gefühlen an diese Zeit: »Es war schon eine unglaubliche Ansammlung von Talenten, und doch haben sie uns alle verloren. Sie haben uns verloren (…), ja, das ist ein sehr heikles Thema (…), weil eine Bildagentur nun einmal so beschaffen ist. (…) – die ganze Arbeit ist sehr kostspielig (…) Daher waren sie gewissermaßen gezwungen, vielleicht gegen ihren Willen, schließlich waren es nette Leute, uns auszubeuten.

FRITZ GORO 1•39

Fritz Goro, who emigrated to New York in 1936 and worked for Black Star until 1939, specialized in scientific photography. At Hobart College, pictured here, he photographed the distillation of this top-secret mustard gas antidote.

Der Emigrant Fritz Goro, der 1936 nach New York kam und bis 1939 für Black Star arbeitete, spezialisierte sich auf die Wissenschaftsfotografie. Am Hobart College fotografierte er die Destillation eines streng geheimen Senfgas-Gegenmittels.

Fritz Goro quitta l'Allemagne pour New York en 1936 et travailla jusqu'en 1939 pour Black Star, se spécialisant dans la photographie scientifique. Il put photographier au Hobert College des expériences très confidentielles sur le gaz moutarde.

avaient beaucoup voyagé. Tous étaient familiers du petit format. Habitués à travailler avec les grands magazines européens, ils savaient aussi intégrer une dimension journalistique à leurs reportages.

UNE PETITE PATRIE
LE ROLE DE BLACK STAR POUR LES EMIGRES

Pour les photographes émigrés, Black Star était un petit morceau d'Europe en plein New York. Là, ils étaient chez eux et n'avaient pas de mal à se faire comprendre. Agents et photographes avaient le même but : imposer le photojournalisme aux Etats-Unis. Les portes de l'agence étaient grandes ouvertes à tous les émigrants. Certains, comme Robert Capa, ne restaient que quelques semaines, d'autres comme Fritz Goro signaient des contrats de quatre ans. Goro, qui allait devenir mondialement célèbre comme photographe médical et scientifique, se souvient de cette époque avec des sentiments mêlés : « Il y avait là une incroyable collection de talents et ils nous ont tous perdus. Ils nous ont perdus…, c'est un sujet sensible…, à cause de la manière dont une agence photographique devait fonctionner. Tout cela revenait très cher… D'une certaine manière, ils étaient obligés de nous exploiter – peut-être contre leur gré, parce que c'étaient des types bien. Moi, je me sentais exploité. Ils devaient impressionner les éditeurs de ce nouveau magazine, *Life,* en ayant des photographes qui étaient à la fois excellents et bon marché. » Après être entré à Black Star, en 1936, Goro reçut comme tous les autres photographes une garantie mensuelle pour son travail, une somme que l'agence continua de lui verser après l'accident de circulation qui l'empêcha de travailler pendant presque un an. Au moment où il reprit son activité, Goro se retrouva avec une montagne de dettes, mais les choses se présentaient bien : *Life* avait passé commande d'une foule de sujets. En 1938, Black Star envoya Goro au Canada pour un reportage sur une organisation fasciste. Il réussit un gros coup, puisque la publication du sujet dans *Life* entraîna l'arrestation de quelques membres de l'organisation. Après la parution, Black Star factura le reportage au tarif normal. Goro, lui, était d'avis que l'agence aurait dû exiger des honoraires plus élevés pour une histoire aussi exceptionnelle. Cet exemple illustre bien la complexité de la relation, souvent marquée par une méfiance mutuelle, entre photographes et agences. Compte tenu de sa situation financière, la confiance qu'avait Goro à l'égard de l'agence avait été ébranlée, faisant ainsi disparaître l'élément fondamental sur lequel reposait leur collaboration. Le succès de son reportage à *Life* lui permettait de travailler directement avec le magazine. Il quitta l'agence à l'expiration de son contrat, en 1940, et rejoignit *Life* en 1944. Il devait y rester pendant 27 ans. L'émigré Ralph Crane et l'Américain W. Eugene Smith illustrent un exemple contraire. Crane travailla à l'agence de 1941 à 1951 et s'enthousiasmait encore, bien des années plus tard, à propos du climat créatif qui y régnait : Black Star l'aida « remarquablement par ses excellentes idées de reportages et en effectuant un travail commercial de premier ordre. Environ 80 % des sujets

EMIL SCHULTHESS 1966

From 1964 to 1966, in the middle of the Cold War, Schulthess worked in China. His photographs led to a book, with this miner pictured on the cover.

Mitten im Kalten Krieg, 1964–66, fotografierte Schulthess in China. Seine Arbeit mündete in ein Buch, dessen Cover dieser Minenarbeiter zierte.

En pleine guerre froide, en 1964–1966, Schulthess fut reporter en Chine. Il en résulta un livre, dont la couverture était illustrée par cette photo d'un mineur.

were well sold. I am really grateful for everything they did for me. In fact that is one reason I stayed almost 10 years with them even though I had the possibility to join the *Life* staff much earlier than I did." However, even Crane succumbed to the attraction, reputation and large wallet of the *Life* editorial offices and in 1951 he joined them as a contract photographer.

THE MAGIC TRIANGLE
PHOTOGRAPHER, EDITOR AND AGENT

The experience of Goro and Crane points to differences in the relationship between photographer and agent: "For some photographers, such a relationship works; for others it doesn't." Ben Chapnick summed up this communicative aspect of the agency when he said: "The agency function, despite the change in the marketplace, is still the same. The agency acts as a conduit uniting photographer and picture editor to see that material comes into being, is published, and compensation is commensurate with the time necessary to produce the work and the exposure the material is given."

Ich fühlte mich jedenfalls ausgebeutet. Sie wollten bei den Herausgebern des neuen Magazins [*Life*] damit Eindruck machen, daß sie sehr gute und dabei sehr preiswerte Fotojournalisten hatten.« Nachdem er sich Black Star 1936 angeschlossen hatte, bekam Goro wie alle anderen Fotografen eine monatliche Garantiesumme für seine Arbeit. Dies galt auch für die Zeit nach einem Verkehrsunfall, der ihn fast ein Jahr lang arbeitsunfähig machte. Goro stand damit bei Wiederaufnahme des Berufes vor einem Schuldenberg, doch der Wiedereinstieg ließ sich vielversprechend mit zahlreichen Auftragsarbeiten für *Life* an. 1938 sandte Black Star Goro für eine freie Produktion über eine faschistische Organisation nach Kanada. Ihm gelang ein journalistischer Coup, der nach Veröffentlichung der Story in *Life* zur Verhaftung einiger Mitglieder führte. Black Star rechnete die Bilder gleich nach der Publikation in *Life* routinemäßig ab. Goro war jedoch im nachhinein der Meinung, daß die Agenten eine exklusive Geschichte verschlafen hätten, für die sie ein wesentlich höheres Honorar hätten verlangen müssen. Dieses Beispiel zeigt das komplizierte Verhältnis zwischen Agent und Fotograf, das oftmals durch latentes Mißtrauen geprägt ist. Goros Vertrauen in Black Star war aufgrund seiner finanziellen Situation erschüttert, die elementare Basis einer Zusammenarbeit vernichtet. Sein Erfolg bei *Life* ermöglichte es ihm auf lange Sicht, direkt mit dem Magazin zu arbeiten. 1940 verließ er Black Star nach Vertragserfüllung und wurde 1944 Staff-Fotograf bei *Life* für die nächsten 27 Jahre. Ein entgegengesetztes Beispiel sind der Emigrant Ralph Crane und der Amerikaner W. Eugene Smith. Sie gehörten zu den Fotografen, die über lange Jahre Kontrakte mit Black Star hatten. Crane arbeitete von 1941 bis 1951 mit der Agentur und geriet auch noch Jahrzehnte später ins Schwärmen über das kreative Arbeitsklima. Black Star half ihm »…gewaltig mit hervorragenden Ideen für Fotoreportagen und war beim Verkaufen genauso geschickt. Gut achtzig Prozent der Fotoreportagen wurden gut verkauft. Ich bin ihnen für alles, was sie für mich getan haben, wirklich dankbar. Das ist auch einer der Gründe, weshalb ich fast 10 Jahre lang bei ihnen geblieben bin, obwohl ich schon viel früher als Staff-Fotograf zu *Life* hätte gehen können, wie dann später geschehen.« Doch auch Crane erlag dem Werben, dem Renommee und dem großen Portemonnaie der *Life*-Redaktion und wurde 1951 Vertragsfotograf.

DAS MAGISCHE DREIECK
FOTOGRAF, REDAKTEUR UND AGENT

In der Retrospektive von Goro und Crane zeigt sich, daß die Beziehung zwischen Fotograf und Agent schwierig sein kann: »Für manche Fotografen funktioniert dieses Verhältnis gut, für andere nicht.« Ben Chapnick bringt diesen kommunikativen Aspekt der Agentur auf den Punkt: »Die Funktion der Bildagentur ist trotz des Wandels auf dem Markt immer noch dieselbe. Die Agentur ist das Scharnier zwischen Fotograf und Bildredakteur und sorgt dafür, daß fotojournalistische Arbeiten entstehen und veröffentlicht werden. Ferner stellt sie sicher, daß die Vergütung der angefallenen Arbeitszeit

JOHN LAUNOIS 1972

During a reportage about longevity amongst three diverse cultures, Launois became the first journalist to reach the Hunza in Pakistan.

Während seiner Reportage über »steinalte Menschen« in drei unterschiedlichen Kulturen gelang es Launois als erstem Journalisten, bis zu den Hunza in Pakistan vorzudringen.

Durant son reportage sur la longévité de trois civilisations différentes, Launois fut le premier journaliste à parvenir jusqu'aux Hunza du Pakistan.

étaient bien vendus. Je leur suis vraiment reconnaissant de tout ce qu'ils ont fait pour moi. En fait, c'est l'une des raisons pour lesquelles je suis resté dix ans avec eux, alors que j'avais la possibilité de rentrer chez *Life* bien plus tôt que je ne l'ai fait. » Pourtant, Crane céda lui aussi, en 1951, aux trompettes de la renommée et aux offres financières alléchantes de la rédaction du magazine.

LE TRIANGLE MAGIQUE
PHOTOGRAPHE, REDACTEUR ET AGENT

L'expérience de Goro et de Crane montre que la relation entre photographe et agent est souvent difficile : «Cela marche dans certains cas, dans d'autres non. » Ben Chapnick précise cet aspect relationnel avec l'agence : «Malgré l'évolution du marché, la fonction de l'agence reste la même. Elle est le lien entre le photographe et la rédaction photo qui sélectionne les sujets pour la publication. Les honoraires de l'agence sont proportionnels au temps nécessaire à produire et à présenter le travail. » Il y a plusieurs méthodes pour atteindre ces objectifs : celle d'agences comme Black Star, celle

There were and still are various ways of pursuing these goals with editorial staff. These include work offered by agencies such as Black Star; personal representatives, who only work for one or for a handful of photographers; the photographer who represents himself aside from his photographic work. Sebastão Salgado is a photographer who, for example, has gone through all of these possibilities during his meteoric career. He launched his career entirely as a self-starter from the sales point of view, was represented by the French agency Gamma from 1973, joined the photographers' cooperative Magnum four years later and since 1993 has been building up his own marketing system under the name of Amazonas Pictures. Salgado is an exceptional journalist and generalizations concerning the influence of other journalists would be going too far. Nonetheless, a trend can be discerned over the decades: it is precisely in times of economic recession, falling magazine sales and a drop in the level of commissions for the individual photographers that stars such as Salgado leave their original agencies. The agent becomes a luxury even for the journalist who still has a lot of work. In the 1990s not even Black Star was spared this trend. Photojournalists who had in the meantime become internationally renowned, such as James Balog, Donna Ferrato, Lynn Johnson and James Nachtwey, have left the agency for a wide variety of reasons. But there is no doubt that for all four their work with Black Star represented a milestone on the route to success; and current President Ben Chapnick feels no need to look back in anger: "Different stages of a photographer's career, combined with their temperament and interests, will determine which avenue they seek."

At the beginning the three founders of Black Star were simply not prepared for bitter commercial experiences or, indeed, for the personal disappointments which can go with the job. Their priority was to create a photographic home and satisfying working conditions for the photographer, whether an émigré or an American. Even Goro valued the human qualities of the founders despite all his fundamental doubts about the business side of the equation. Paradoxically, the golden era of magazine journalism, which lasted from the 1930s until the 1960s, acted as a brake on their ambitious plans. The agency had to capitulate in the face of the financial resources of *Life* and was unable to retain many great talents. Wilson Hicks, in his book "Words and Pictures", portrays the comfortable situation in which the *Life* picture editors found themselves with 36 staff photographers and nine more under contract in the mid-1950s. The opportunity for Black Star lay in the enormous appetite which magazines worldwide had for photographs, offering photojournalism a role which is inconceivable today. Picture reportages in a layout of up to eight double pages were the rule rather than the exception. *Life* employed hundreds of photographers around the world. It was at this very time that Black Star enlarged its worldwide network of freelance photographers contracted to the agency. Furthermore, Hicks points to the very close cooperation with 45 photographers who regularly contributed work to the magazine, including excellent photojournalists such as Cal Bernstein, Archie Lieberman, Ross Madden, Kosti Ruohomaa, Gordon Tenney and Werner Wolff. The healthy relationship

und der publizistischen Reichweite des veröffentlichten Bildmaterials angemessen ist.«

Um diese Ziele gegenüber den Redaktionen zu verfolgen, gab und gibt es verschiedene Wege: die Angebote von Agenturen wie Black Star; persönliche Repräsentanten, die nur für einen oder eine Handvoll Fotografen arbeiten; den Fotografen, der sich neben seiner fotografischen Arbeit selbst vertritt. Sebastão Salgado zum Beispiel hat im Verlauf seiner steilen Karriere alle diese Möglichkeiten durchgespielt. Die ersten Schritte wagte er ganz auf sich selbst gestellt, wurde ab 1973 von der französischen Agentur Gamma vertreten, schloß sich vier Jahre später der Fotografengruppe Magnum an und baute sich seit 1993 sein eigenes Vertriebssystem unter dem Namen »Amazonas Pictures« auf. Salgado ist ein Ausnahmejournalist, und Verallgemeinerungen in bezug auf das Wirken anderer Fotografen wären gewagt. Dennoch läßt sich über die Jahrzehnte beobachten, daß sich gerade in Zeiten wirtschaftlicher Rezession, sinkender Auflagenzahlen der Magazine und rückläufiger Auftragslage des einzelnen Fotografen Stars wie Salgado von ihren angestammten Agenturen verabschieden. Der Agent wird für immer noch gutbeschäftigte Journalisten zum Luxus. In den 90er Jahren machte diese Entwicklung auch vor Black Star nicht halt. Mittlerweile international renommierte Fotojournalisten wie James Balog, Donna Ferrato, Lynn Johnson und James Nachtwey haben die Agentur aus den unterschiedlichsten Motiven verlassen. Zweifellos bedeutete für alle vier die Zusammenarbeit mit Black Star einen Meilenstein auf dem Weg zum Erfolg. Der heutige Präsident Ben Chapnick kennt jedoch keinen Blick zurück im Zorn: »Fotografen entscheiden je nach Temperament, Interessenlage und dem jeweiligen Stadium ihrer Karriere, welchen Weg sie gehen wollen.«

Auf bittere geschäftliche und oft auch persönlich enttäuschende Erfahrungen waren die drei Black-Star-Gründer anfangs einfach nicht vorbereitet. Vorrangig zielten sie darauf, den Fotografen, ob Emigrant oder Amerikaner, eine fotografische Heimat und zufrieden-

J. M. RICHARDSON 1979

For three years Jim Richardson photographed life at high school in Rossville, Kansas. In 1979 his work was published as a book.

Drei Jahre fotografierte Jim Richardson das Leben an einer High School in Rossville, Kansas. Die Arbeit erschien 1979 als Buch.

Jim Richardson suivit pendant trois ans la vie d'un lycée à Rossville, Kansas. Le reportage parut sous la forme d'un livre en 1979.

d'agents personnels qui travaillent pour un seul ou quelques photographes, celle enfin du photographe seul, qui se représente lui-même en plus de son travail de réalisation. Sebastão Salgado, par exemple, a pratiqué toutes ces méthodes au cours de sa fulgurante carrière. Il vendit lui-même ses premiers travaux, puis fut représenté à partir de 1973 par l'agence française Gamma, rejoignit quatre ans plus tard l'association de photographes Magnum avant de mettre sur pied, en 1993, son propre système de distribution, Amazonas Pictures. Salgado est un photojournaliste d'exception et il serait difficile de généraliser son cas à l'ensemble des photographes. Pourtant, en observant les choses sur plusieurs décennies, on s'aperçoit que, surtout en période de récession économique, de baisse des tirages des magazines et de recul des commandes aux photographes, des stars comme Salgado se séparent de leurs agences. Pour des photographes au carnet de commande encore bien rempli, l'agence est un luxe. Black Star subit également cette évolution dans les années 1990. Des photographes réputés comme James Balog, Donna Ferrato, Lynn Johnson et James Nachtwey ont quitté l'agence pour des raisons diverses. Pour tous, leur collaboration avec Black Star a marqué une étape importante sur le chemin du succès. L'actuel président de l'agence, Ben Chapnick, observe les choses avec philosophie : «Les différentes étapes de la carrière d'un photographe, combinées à son tempérament et à ses intérêts, déterminent la voie qu'il choisit.»

Au début, les trois fondateurs de Black Star n'étaient pas préparés à affronter des déconvenues professionnelles et souvent aussi personnelles. Leur premier souci était d'offrir aux photographes, qu'ils soient émigrés ou américains, une «patrie photographique» et des conditions de travail satisfaisantes. Indépendamment de ses réserves concernant les ventes, Goro lui-même ne mettait pas en doute les qualités humaines des fondateurs. Paradoxalement, c'est l'âge d'or lui-même des magazines, des années 1930 aux années 1960, qui les empêcha d'atteindre leurs ambitions les plus hautes. Face aux énormes possibilités financières de *Life,* l'agence devait capituler et laisser partir nombre de talents. Dans son livre «Words and Pictures» («Des mots et des images»), Wilson Hicks décrit l'aisance de la rédaction photo du magazine, avec ses trente-six photographes maison et neuf photographes sous contrat dans les années 1950. La chance de Black Star était l'énorme appétit de *Life* pour les reportages photojournalistiques venus du monde entier, auxquels il accordait une place impensable aujourd'hui. Des reportages occupant jusqu'à huit doubles pages du magazine n'étaient pas l'exception mais la règle. *Life* commissionnait des centaines de photographes tout autour du globe. A cette époque, Black Star élargissait son réseau mondial de photographes indépendants liés à l'agence par contrat. Hicks évoque également, en sus des précédents, quarante-cinq photographes avec lesquels *Life* travaillait régulièrement. Parmi eux, d'excellents photojournalistes comme Cal Bernstein, Archie Lieberman, Ross Maden, Kosti Ruohomaa, Gordon Tenney et Werner Wolff. Les bons rapports entre Black Star et *Life* se poursuivirent, mais le débauchage de ses meilleurs photographes constitua toujours une épine dans le pied de l'agence. W. Eugene Smith et Crane commencèrent à travailler directement avec *Life* dans les années 1950, mais Black Star conserva les droits de diffusion

Gorbachev during his visit to Poland in 1989. More frequently than almost any other international photojournalist, Peter Turnley accompanied the architect of perestroika while he was at the top of his political career in the years 1986 to 1991.

Gorbatschow bei seinem Besuch 1989 in Polen. Peter Turnley ist wohl einer der internationalen Fotojournalisten, die den Architekten der Perestroika während seiner politischen Karriere von 1986 bis 1991 am häufigsten begleitet haben.

Gorbatchev lors de sa visite en Pologne, en 1989. Peter Turnley est sans doute l'un des journalistes internationaux qui ont le plus fréquemment accompagné l'architecte de la pérestroïka pendant sa période au pouvoir.

between Black Star and *Life* certainly lasted, although the practice of "stealing away" remained a constant thorn in the agency's flesh – W. Eugene Smith and Crane began to work directly with *Life* in the 1950s. Black Star did, however, retain the sales rights on the work which these photographers had done previously whilst under contract to the agency.

NOT A STRAIGHT-FORWARD STORY
THE PHOTOJOURNALIST AND THE EDITORS

Agents at Black Star operated throughout their lives between two fronts. The first is shaped by the everyday life of editorial departments, which has always been hectic. Picture editors fight their way through mountains of photographic material and react from behind their desks to daily events which may prove to be almost overwhelming. Picture contracts have to be monitored. The deadline is approaching. In addition hundreds of photographers submit unsolicited work during the course of the year and wish to be taken seriously with their stories and ideas. But it is precisely this work which often receives insufficient attention because even the editorial day only contains ten to twelve working hours.

For most of the time the freelance photojournalist struggles alone. If he receives an assignment he drops everything and packs his things. Over the subsequent weeks he gives his all and, if necessary, he works around the clock – and woe betide any of these hated people with a notebook and pencil who may accompany him. *Geo* author Alexander Smoltzyk writes as follows about the photojournalist, the unknown being: "Picture reporters are nice people. Except when they are working. Then they become unbearable. Then they resemble heliotropes whose mood is dictated by the presence

stellende Arbeitsbedingungen zu schaffen. Selbst Goro schätzte neben allen grundsätzlichen geschäftlichen Zweifeln die menschlichen Qualitäten der Gründer. Paradoxerweise verhinderte die goldene Zeit des Magazinjournalismus in den 30er bis 60er Jahren ihre hochgesteckten Ambitionen. Die Agentur mußte vor den finanziellen Möglichkeiten von *Life* kapitulieren und konnte viele große Talente nicht halten. Wilson Hicks schildert in seinem Buch »Words and Pictures« die komfortable Ausstattung der Bildredaktion mit 36 Staff-Fotografen und neun Vertragsfotografen Mitte der 50er Jahre. Die Chance für Black Star lag in dem enormen Bildhunger aller Magazine weltweit, die dem Fotojournalismus einen heute nicht mehr vorstellbaren Platz einräumten. Fotoessays in einem Layout von bis zu acht Doppelseiten bildeten nicht die Ausnahme, sondern die Regel. *Life* beschäftigte Hunderte von Fotografen rund um den Globus. Black Star erweiterte gerade in dieser Zeit sein weltweites Netz von freien Fotografen, die vertraglich an die Agentur gebunden waren. Hicks verweist darüberhinaus auf die sehr enge Zusammenarbeit mit 45 Fotografen, die regelmäßig für das Magazin fotografierten, unter ihnen die exzellenten Fotojournalisten wie Cal Bernstein, Archie Lieberman, Ross Madden, Kosti Ruohomaa, Gordon Tenney und Werner Wolff. Die gute Beziehung zwischen Black Star und *Life* hielt zwar an, doch die Praxis des »Wegschnappens« blieb ein ewiger Stachel im Fleisch der Agentur – W. Eugene Smith und Crane begannen in den 50er Jahren direkt mit *Life* zu arbeiten. Black Star behielt jedoch die Vertriebsrechte an den Arbeiten, die diese Fotografen vorher im Auftrag der Agentur erledigt hatten.

KEINE EINFACHE GESCHICHTE
DER FOTOJOURNALIST UND DIE REDAKTION

Agenten von Black Star haben sich zeit ihres Lebens zwischen zwei Fronten bewegt. Die eine Front ist bestimmt durch den seit jeher hektischen Redaktionsalltag. Bildredakteure kämpfen sich durch Fluten von Bildmaterial und reagieren vom Schreibtisch aus auf die sich eventuell überschlagenden Tagesereignisse. Fotoaufträge müssen überwacht werden. Die *deadline,* der Produktionstermin naht. Nebenbei präsentieren übers Jahr Hunderte von Fotografen ihre Arbeiten und möchten mit ihren Geschichten und Ideen ernst genommen werden. Doch gerade diese Arbeit kommt oft zu kurz, denn auch der Redaktionsalltag hat nur zehn bis zwölf Arbeitsstunden.

Der freie Fotojournalist kämpft die meiste Zeit allein. Bekommt er einen Auftrag, läßt er alles stehen und liegen und packt seine Sachen. Für die nächsten Wochen gibt er alles und arbeitet gegebenenfalls rund um die Uhr – und wehe einer dieser verhaßten Menschen mit Notizblock und Bleistift begleitet sie. Der *Geo*-Autor Alexander Smoltzyk schreibt über den Fotojournalisten, das unbekannte Wesen: »Fotoreporter sind nette Menschen. Außer bei der Arbeit. Dann werden sie unausstehlich. Dann ähneln sie heliotropen Pflanzen, deren Gemütszustand vom Lichteinfall geregelt wird. Zwei Lux zuwenig, und die Mundwinkel hängen welk

Robert Kennedy playing football with his children in 1967. Steve Schapiro was one of only a handful of photographers who were allowed to peep behind the public face and portray the family life of this presidential candidate. Such access was always based on a unique relationship of personal trust between photographer and photographic subject.

Robert Kennedy 1967 beim Football-Spiel mit seinen Kindern. Steve Schapiro war einer der wenigen Fotografen, der hinter die familäre Kulisse des Präsidentschaftskandidaten Kennedy blicken durfte. Dieser journalistische Zugang beruht immer auf dem Vertrauen zwischen fotografischem »Objekt« und »Subjekt«.

Robert Kennedy en 1967 jouant au football avec ses enfants. Steve Schapiro fut l'un des rares photographes admis dans l'intimité familiale du candidat à la présidence. Un tel privilège repose toujours sur une relation de confiance entre le photographe et son sujet.

des travaux qu'ils avaient effectués auparavant sur commande de l'agence.

UNE HISTOIRE COMPLIQUEE
PHOTOJOURNALISTES ET REDACTIONS

Des agents de Black Star ont passé leur vie à naviguer entre deux fronts. Le premier est le quotidien – de tout temps agité – des rédactions. Les iconographes croulent sous des masses d'images et réagissent depuis leur bureau aux événements du jour qui, éventuellement, se superposent. Il faut suivre les sujets commandés. Les délais se rapprochent. Parallèlement, des centaines de photographes viennent chaque année présenter leur travail et voudraient que leurs reportages et leurs idées soient pris en considération. Cette partie du travail est souvent celle pour laquelle les rédactions photo manquent le plus de temps. Les rédactions ne travaillent que dix à douze heures par jour…

Le photojournaliste indépendant se retrouve le plus souvent seul. S'il reçoit une commande, il laisse tout en plan pour boucler ses valises. Plusieurs semaines durant, il donne tout ce qu'il a, travaillant si besoin vingt-quatre heures sur vingt-quatre. Et il se désespère si, par malchance, l'un de ces maudits personnages avec un bloc et un crayon doit l'accompagner! Alexander Smoltzyk, de *Geo,* mentionne le photojournaliste, cet être étrange : «Les reporters-photographes sont des gens sympathiques. En dehors du travail. Là, ils deviennent insupportables. Ils ressemblent alors aux plantes héliotropes : leur état émotionnel dépend totalement de la lumière.

of light. Two lux too little and the corners of their mouths hang down limply." However, the photojournalist has to live constantly with the fear of failure, unlike the writer. Everything has to happen in the here and now, because production time is often limited. If the editor is demanding a double page spread the photographer has to deliver it.

THE STORY OF PHOTOJOURNALISM
IS IT A COMMODITY?

Photojournalism is not only a financial affair. Ideas and opinions, idealism and emotions also play their part here. Photojournalists put their all into stories which they have perhaps worked on over a period of months; the subjects of the published reportages have become a substitute for family life or even objects of hatred during the time it takes to photograph them. Whilst the editors of newspapers and magazines always protest that they value the work of the photojournalist, it is nevertheless the case that in the ivory tower of the editorial office other laws prevail. The pictures are fed into a complex personal structure. The author of the text has tapped other sources of information, the chief editor judges things in a completely different way to the copywriter and the photographer, and the designer has his own way of seeing the story as well. Facts, ideology and aesthetics produce a new "truth" which coincides with the photojournalist's story rarely, if ever.

Over the years, this explosive working atmosphere has caused crisis after crisis between editor and photojournalist. Black Star was consistently faced with a situation whereby its highly talented photographers felt that they were not understood by editorial personnel. Kornfeld negotiated for example W. Eugene Smith's first commissions for *Life*. The young Smith, who later in his career also became a Magnum photographer, very quickly developed a self-willed character and enormous self-confidence. Black Star retained him for as long as possible, but the hothead resigned more than a dozen times. The agency and Smith were long separated when, in 1954, Smith finally broke with *Life* over differing conceptions regarding his Albert Schweitzer reportage. The egomaniacal struggles of this highly gifted photographer were no longer compatible with the traditional watchwords of the Black Star agency, which were communication and compromise. Of course this does not mean that in representing the interests of the photographer there can be no direct disputes between editor and agent. Howard Chapnick reported the occasional clashes between the Black Star gentleman Kurt Kornfeld and the gruff and abrupt Wilson Hicks, who was then the picture chief at *Life:* "They would scream at each other and they would literally pound the table (…) and they would go at it, but I think *Life* realized the value of Black Star and the photographers that Black Star had." Kornfeld and Hicks had sufficient cause for arguments over the decades. Royalty and price negotiations were an eternally contentious issue. Ernest Mayer recalled the habit of *Life* editors whereby they would buy up the entire market for reports on a particular subject. This

herunter.« Doch anders als dem Schreiber sitzt dem Fotojournalisten ständig die Angst vor dem Versagen im Nacken. Alles muß hier und jetzt geschehen, denn die Produktionszeit ist oft begrenzt. Die Redaktion verlangt Doppelseiten, und der Fotograf hat sie zu liefern.

DIE EIGENE GESCHICHTE
FOTOJOURNALISMUS ALS WARE?

Fotojournalismus ist nicht nur finanzielles Geschäft, hier wird auch mit Ideen und Meinungen, Idealismus und Emotionen gehandelt. Fotojournalisten stecken all ihr Herzblut in Geschichten, sie haben im

WERNER WOLFF 1961

Werner Wolff photographed Jackie Kennedy during a meeting with Russian President Krushchev at the Vienna summit. Behind the scenes, JFK tried to persuade the Russians to take a hard military line against the newly-emerging nuclear power of China.

Werner Wolff fotografierte Jackie Kennedy beim Zusammentreffen mit dem russischen Präsidenten Chruschtschow auf dem Wiener Gipfeltreffen. Hinter den Kulissen versuchte JFK den Russen auf eine militärische Linie gegen die neue Atommacht China zu bringen.

Jackie Kennedy et le président soviétique Khrouchtchev, photographies par Werner Wolff lors du sommet de Vienne. En coulisses, J. F. Kennedy tentait d'amener les Soviétiques à une politique commune contre la nouvelle puissance atomique chinoise.

S'il manque deux lux, leur mine se flétrit d'un seul coup. » Contrairement au rédacteur, le photographe vit en permanence avec l'angoisse du ratage. Si tout ne se passe pas ici et maintenant, il est trop tard. Les délais sont souvent limités. La rédaction réclame des double-pages et le photographe doit les fournir.

UNE HISTOIRE DE PERSONNES
LE PHOTOJOURNALISME, UNE MARCHANDISE?

Le photojournalisme n'est pas seulement une affaire d'argent. On y travaille aussi avec des idées, des points de vue, de l'idéalisme et des émotions. Les photographes s'investissent totalement dans leurs sujets. Ils peuvent y avoir consacré des mois : ce qu'ils ont photographié est devenu une famille d'adoption ou un objet d'aversion. Les rédacteurs en chef des quotidiens et des magazines affirment certes apprécier le travail des photographes, mais les lois qui règnent dans les tours d'ivoire des rédactions sont bien différentes. Les photos sont ingérées par un réseau personnel complexe. L'auteur du texte a pu trouver d'autres sources, le regard que porte le rédacteur en chef sur l'état du sujet n'est pas le même que celui du journaliste ou du photographe, le directeur artistique inscrit le sujet dans sa propre vision. Les faits, le projet tel qu'il a été pensé et l'esthétique se transforment en une nouvelle «vérité», qui ne correspond qu'en théorie seulement au reportage du photographe.

Cette atmosphère de travail épuisante nerveusement a toujours provoqué des crises entre rédactions et photojournalistes. Black Star était également confrontée au problème : ses meilleurs photographes se sentaient incompris par les rédactions. Ce fut ainsi Kornfeld qui obtint les premières commandes de *Life* pour W. Eugene Smith. Encore jeune, Smith – qui rejoindra Magnum – affirma vite son caractère. Black Star s'attacha à lui aussi longtemps que possible mais, impulsif, il rompit son contrat une bonne douzaine de fois. L'agence et Smith s'étaient séparés depuis longtemps lors de sa rupture définitive avec *Life,* en 1954, à cause de divergences au sujet d'un reportage sur Albert Schweitzer. Les combats égocentriques de ce photographe de grand talent n'étaient pas compatibles avec les principes de base des agents de Black Star : communication et compromis. Une approche qui n'exclut d'ailleurs pas d'éventuels conflits directs entre les rédactions et les agents, qui représentent les intérêts des photographes. Howard Chapnick se fait l'écho des empoignades entre Kurt Kornfeld, le gentleman de Black Star, et Wilson Hicks, mauvais coucheur et ancien directeur photo de *Life :* «Ils auraient hurlé et littéralement pilonné le bureau, ils seraient allés jusqu'au bout, mais je crois que *Life* réalisait la valeur de Black Star et de ses photographes. » Au fil des années, Kornfeld et Hicks n'ont pas manqué de sujets de dispute. Les prix et leur négociation sont un éternel motif de discorde. Ernest Mayer se souvient des pratiques contestables de *Life,* qui vidait littéralement le marché en achetant tout ce qui était disponible sur un thème donné. C'était le cas chaque fois que le magazine préparait un sujet exclusif et voulait retirer aux autres

In 1954 Coco Chanel reopened her Paris couture house and introduced the Chanel suit, soon to become a fashion classic.

1954 eröffnete Coco Chanel ihren Pariser Modesalon wieder und stellte das Chanel-Kostüm vor, das zum Modeklassiker avancierte.

En 1954, Coco Chanel ouvrit sa boutique parisienne et présenta le fameux tailleur qui allait devenir un classique.

always happened whenever *Life* was planning an exclusive story and wanted to stop their American rivals from having any access to rival material. This was an embarrassing situation for an agent, because he has the moral obligation to do everything conceivable for the photojournalist to publish his stories. Psychologically, most photojournalists live from one publication to the next. The large layouts in magazines give them renewed strength to start out on new stories and earth shattering events. On the basis of his own experiences in the agency business, Ben Chapnick states that there can and must never be any taking sides with one party or the other: "From Mr. Kornfeld, I developed an understanding that a close *rapport* was necessary with both photographer and client. It was quite apparent from dealing with him that he felt that our business was service and the product that we are servicing was outstanding photography."

The rather profane sounding term "service" may not on first sight belong to the noble claims of photojournalism. However, the work by Black Star photographers collected in the present volume was created against the background of precisely this concept of business. The names Mayer, Kornfeld, Safranski and the Chapnick cousins represent the work of an agency which over the decades has constantly tried to sound out the interests of client and photographer fairly. Furthermore, the name of the agency also stands for the tradition of American photojournalism. Nobody is better placed to express this in words than Howard Chapnick: "For those who share my picture-editing philosophy, events pass the

besten Fall über Monate daran gearbeitet und die Subjekte des nun vorliegenden Essays sind für die Zeit der Arbeit zu einem Familienersatz oder auch zu Haßobjekten geworden. Zwar beteuern die Zeitungs- und Zeitschriftenredakteure immer wieder, die Arbeit des Fotojournalisten zu schätzen, doch im »Elfenbeinturm der Redaktion« herrschen andere Gesetze. Die Bilder werden in eine komplexe personelle Struktur eingespeist: Der Textautor hat weitere Informationsquellen erschlossen, der Chefredakteur beurteilt den Stand der Dinge vollkommen anders als Texter und Fotograf, und der Grafiker entwickelt seine eigene Sichtweise. Fakten, Ideologie und Ästhetik ergeben eine neue »Wahrheit«, die nur im Idealfall mit der Geschichte des Fotojournalisten übereinstimmt.

Diese brisante Arbeitsatmosphäre beschwört seit jeher immer wieder Krisen zwischen der Redaktion und dem Fotojournalisten herauf. Black Star war auch immer wieder mit dem Problem konfrontiert, daß sich seine hochtalentierten Fotografen von den Redaktionen unverstanden fühlten. Kornfeld vermittelte z.B. W. Eugene Smith die ersten Aufträge bei *Life*. Der junge Smith, im Verlauf seiner späteren Karriere auch Magnum-Fotograf, entwickelte sehr schnell einen eigenwilligen Charakter und ein ungeheures Selbstbewußtsein. Black Star hielt an ihm fest, solange es ging, doch der Hitzkopf kündigte mehr als ein Dutzend Mal die Mitarbeit auf. Noch bevor es 1954 zum endgültigen Bruch mit *Life* anläßlich verschiedener Auffassungen bezüglich seines Albert-Schweitzer-Essays kam, hatten sich die Agentur und Smith schon lange getrennt. Die egomanischen Kämpfe dieses begnadeten Fotografen waren nicht mehr mit den traditionellen Maximen der Black-Star-Agenten vereinbar, die da heißen: Kommunikation und Kompromiß. Das bedeutet keineswegs, daß es in der Vertretung der Fotografeninteressen nicht zu direkten Auseinandersetzungen zwischen Redakteur und Agent kommen kann. Howard Chapnick berichtete von gelegentlichen Zusammenstößen des Black-Star-Gentleman Kurt Kornfeld mit dem bärbeißigen und ruppigen Wilson Hicks, dem damaligen *Life*-Bildchef: »Sie schrien sich an, hauten im wahrsten Sinne des Wortes auf den Tisch (…) und kämpften mit harten Bandagen, aber bei *Life* wußte man sehr wohl den Wert der Black-Star-Agentur und ihrer Fotografen richtig einzuschätzen.« Anlässe zum Streit haben Kornfeld und Hicks über die Jahrzehnte genug gehabt. Honorar- und Preisverhandlungen sind ein ewig strittiges Thema. Ernest Mayer erinnerte sich auch an die Unsitte der *Life*-Redakteure, den Reportagemarkt zu einem bestimmten Thema leerzukaufen. Dies geschah immer dann, wenn *Life* eine exklusive Geschichte plante und das Konkurrenzmaterial für die amerikanischen Mitkonkurrenten sperren wollte. Eine fatale Situation für einen Agenten, denn er hat dem Fotojournalisten gegenüber die moralische Verpflichtung, alles Erdenkliche zu tun, um seine Geschichten zu veröffentlichen. Die meisten Fotojournalisten leben psychisch von Veröffentlichung zu Veröffentlichung. Die großen Layouts in Magazinen geben ihnen wieder die Kraft, zu neuen Geschichten und weltbewegenden Ereignissen aufzubrechen. Ben Chapnick stellt aufgrund seiner eigenen Erfahrungen im Agenturgeschäft fest, daß es niemals einseitige Parteinahme für eine der beiden Seiten geben

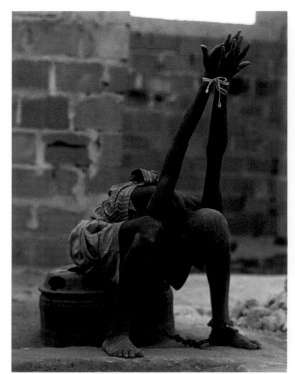

During the Angolan civil war, priests treated war-traumatized patients using rather unorthodox methods.

Angolanische Priester betreuten während des Bürgerkrieges kriegstraumatisierte Patienten mit für die Schulmedizin ungewöhnlichen Methoden.

Durant la guerre civile en Angola, des prêtres soignaient les traumatismes par des moyens inhabituels du point de vue de la médecine académique.

supports américains toute possibilité de le concurrencer. Une situation très embarrassante pour un agent, engagé moralement auprès du photographe à tout faire pour que ses reportages soient publiés. La plupart des photojournalistes vivent mentalement de publication en publication. Les double-pages des magazines leur donnent la force de produire de nouveaux sujets et de partir à la poursuite des événements qui font l'actualité. Son expérience d'agent a appris à Ben Chapnick qu'il ne pouvait se permettre de prendre parti pour l'un ou pour l'autre : « J'ai compris grâce à M. Kornfeld l'importance d'avoir des rapports étroits avec le photographe et avec le client. En le voyant négocier, il était évident que, pour lui, notre métier est un service et que le produit que nous sommes chargés de vendre est de la photographie de qualité. »

Le concept de «service» peut, à première vue, paraître trop terre à terre face aux nobles ambitions du photojournalisme. Les œuvres des photographes de Black Star réunies dans cet ouvrage ont pourtant toutes vu le jour dans ce contexte. Les noms de Mayer, Kornfeld, Safranski et des cousins Chapnick incarnent le travail d'une agence qui, pendant des dizaines d'années, a toujours cherché à trouver un terrain d'entente convenable entre clients et photographes. Une agence dont le nom symbolise la tradition du photojournalisme américain. Personne ne pourrait mieux résumer tout ceci que Howard Chapnick lui-même : «Pour ceux qui partagent ma philosophie du choix photographique, les événements dépassent l'œil du photographe et l'objectif de l'appareil. Le devoir du photographe est de distiller l'événement pour le rendre clair et compréhensible, de

photographer's eye and the camera's lens. The photographer's obligation is to distill the event and make it intelligible and understandable to the viewer in an objective way. The American aesthetic I have held through the years admires coherence, content, and composition. Underlying this theory is a need for truth and objectivity, and a belief that the photojournalist serves as an eyewitness to history."

Without question Howard Chapnick was one of the most important patrons of American photojournalists. For three decades he attracted and educated whole generations of picture reporters as photographers of the agency. His door was always open to talented people. Many Black Star photojournalists achieved great success with him, amongst them Dennis Brack, James Ellison, Charles Moore, Kosti Ruohomaa, James Sugar, Flip Schulke, the Turnley brothers David and Peter, Fred Ward and last but not least Christopher Morris, who began as a student trainee in the agency archive. It was perhaps even more true of Howard Chapnick than it was of Safranski that he lived and breathed photojournalism. Aside from his work in the agency he regularly wrote columns for the monthly magazine *Popular Photography*. Together with the photographer Ivan Massar he published three copiously illustrated books of his own conception, and with his book "Truth Needs No Ally" he left his journalistic legacy and a "textbook" for subsequent generations of photojournalists. We have him to thank for the founding of the W. Eugene Smith Foundation, which supports the work of hopeful picture journalists in memory of his friend. He influenced countless jury verdicts in international competitions with his clear sense of judgement. Howard Chapnick won people over with his intellectual strength and his charisma and worked as if obsessed on his vision – photojournalism.

kann und darf: »Ich habe mir Mister Kornfelds Auffassung zu eigen gemacht, wonach eine enge Beziehung zwischen Fotograf und Abnehmer notwendig ist. Im beruflichen Umgang mit ihm wurde klar, daß er unser Agenturgeschäft als einen Service ansah und daß unser Produkt exzellenter Fotojournalismus heißt.«

Der eher profan anmutende Begriff »Service« mag auf den ersten Blick nicht zu den hehren Ansprüche des Fotojournalismus passen. Die hier im vorliegenden Band versammelten Arbeiten der Black-Star-Fotografen sind vor dem Hintergrund genau dieser Geschäftsauffassung entstanden. Die Namen Mayer, Kornfeld, Safranski und der Chapnick-Cousins stehen für die jahrzehntelange Arbeit einer Agentur, die stets versucht hat, die Interessenlage zwischen Kunde und Fotograf in fairer Weise auszuloten. Der Name der Agentur steht darüberhinaus auch für die Tradition des amerikanischen Fotojournalismus. Keiner konnte diese besser in Worte fassen als Howard Chapnick: »Für alle, die meine Anschauung von Bildredaktion teilen, gehen Ereignisse durch das Auge des Fotografen und durch die Linse der Kamera. Der Fotograf hat die Pflicht, das Wesentliche des Ereignisses zu erfassen und es dem Betrachter nachvollziehbar und objektiv zu vermitteln. Die amerikanische Fotoästhetik, die ich in all den Jahren vertreten habe, schätzt Kohärenz, Gehalt und Komposition. Dieser Anschauung liegt ein Bedürfnis nach Wahrheit und Objektivität zugrunde und der Glaube, daß der Fotojournalist als Augenzeuge der Geschichte dient.«

Howard Chapnick gehörte zweifellos zu den bedeutendsten Förderern amerikanischer Fotojournalisten. Drei Jahrzehnte lang hat er als Präsident der Agentur ganze Generationen von Fotoreportern auf sich gezogen und erzogen. Seine Tür stand für Talente immer offen. Viele Black-Star-Fotojournalisten haben große Erfolge mit ihm gefeiert, unter ihnen Dennis Brack, James Ellison, Charles Moore, Kosti Ruohomaa, James Sugar, Flip Schulke, die Turnley-Brüder David und Peter, Fred Ward und last but not least Christopher Morris, der als Praktikant im Archiv der Agentur begann. Für Howard Chapnick gilt vielleicht noch mehr als für Safranski, daß er Fotojournalismus atmete. Neben der Arbeit in der Agentur schrieb er regelmäßig Kolumnen für das Monatsmagazin *Popular Photography*. Er veröffentlichte gemeinsam mit dem Fotografen Ivan Massar drei von ihm selbst konzipierte Bildbände und hinterließ mit seinem Buch »Truth needs no ally« seinen journalistischen Nachlaß und ein »Lehrbuch« für kommende Generationen von Fotojournalisten. Ihm ist die Gründung der W.-Eugene-Smith-Stiftung zu verdanken, die im Andenken an seinen Freund die Arbeiten hoffnungsvoller Bildjournalisten fördert. Unzählige Jury-Entscheidungen internationaler Wettbewerbe hat er mit seinem klaren Urteil beeinflußt. Howard Chapnick bestach durch seine intellektuelle Kraft wie durch sein Charisma und arbeitete wie besessen an seiner Vision – dem Fotojournalismus.

manière objective, aux yeux du lecteur. L'esthétique américaine que j'ai représentée tout au long des années admire la cohérence, le contenu et la composition. Il y a, sous cette théorie, un besoin de vérité et d'objectivité, et la conviction que le photojournaliste sert de témoin à l'histoire. »

Howard Chapnick faisait indiscutablement partie des personnalités les plus importantes ayant soutenu les photojournalistes américains. Président de l'agence pendant plusieurs décennies, il a attiré et formé des générations entières de photographes. Sa porte leur était toujours ouverte. Parmi les nombreux photojournalistes de Black Star qui ont fêté leurs grands succès en sa compagnie on retrouve Dennis Brack, James Ellison, Charles Moore, Kosti Ruohomaa, James Sugar, Flip Schulke, les frères David et Peter Turnley, Fred Ward et *last but not least* Christopher Morris, dont la carrière avait commencé aux archives de l'agence. Plus encore peut-être que pour Safranski, le photojournalisme était pour Howard Chapnick une véritable raison de vivre. A côté de son travail à l'agence, il écrivait chaque mois des articles pour le magazine *Popular Photography*. Il publia, avec le photographe Ivan Massar, trois albums qu'il avait conçus, et son livre-testament de journaliste, «Truth needs no ally» («la Vérité n'a pas besoin d'allié»), est un document précieux qui servira à des générations de jeunes photojournalistes. C'est à lui que l'on doit la création de la Fondation W. Eugene Smith qui, en souvenir de son ami, soutient le travail de photographes prometteurs. La clarté de son jugement a influencé d'innombrables décisions de jurys à travers le monde entier. Howard Chapnick, qui impressionnait tout autant par sa puissance intellectuelle que par son charisme, travailla comme un possédé pour sa vision – le photojournalisme.

STEVE WINTER 1995

An Aids research laboratory in Tuxedo, New York. Winter's reportage about Aids research on chimpanzees illustrates the intimacy which can exist between research and research object.

Winters Reportage über Aids-Forschung an Schimpansen in einem Labor in Tuxedo, New York, illustriert, welche Nähe zwischen Versuchstier und Forscher entstehen kann.

Les photos de Winter, montrant les expériences effectuées sur des chimpanzés dans un laboratoire de Tuxedo (Etat de New York) pour la recherche sur le sida, illustrent la proximité qui peut exister entre l'animal et le chercheur.

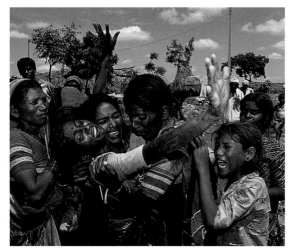

SWAPAN PAREKH 1993

Indian families in mourning. On 30 September 1993 an earthquake destroyed numerous towns and killed some 50,000 people. Parekh's photo won a World Press Award.

Indische Familien in Trauer. Am 30. September 1993 zerstörte ein Erdbeben mehrere Dörfer und tötete ca. 50000 Menschen. Parekhs Foto gewann einen World Press Award.

Familles indiennes en deuil. Le 30 septembre 1993, un tremblement de terre détruisit plusieurs villages, faisant environ 50000 victimes. Pour cette photo, Parekh reçut un World Press Award.

THE END OF AN ERA

THE CRISIS IN PHOTOJOURNALISM

In almost 60 years of agency work, Black Star has seen the best and the worst times in this business. The "high art" of journalistic story-telling in pictures entered a permanent crisis from the end of the 1960s onwards. Even the apparently symbiotic relationship between Black Star and *Life* came to an end. In 1972 the magazine ceased publication. The reason for this was primarily the magazine's appetite for the huge and spectacular with regard to budget, employees and print runs. Television, which was undergoing an explosive development in the 1960s, stole advertising revenue from *Life* with its colorful and rapid pictures and thus took away the magazine's *raison d'être*. However, other circumstances resulted in a deathblow for *Life*, as a remark made by William Owen suggests: "*Life* lost substantial advertising revenues, but it had also lost its political role. (…) *Life* played a cohering role in the creation of the American nation (…) and in asserting American power internationally, once the restraints of isolationism had been removed." Perhaps the crisis of confidence in their politicians experienced by Americans during a time of heavy defeats in Vietnam expanded into a fatal crisis of confidence in the US magazine. And finally, photojournalism has had to live with the fact that since the Second World War at the latest, it has been politically instrumentalized.

Ben Chapnick recalls the end of *Life* thus: "Very frankly, it was like any other day in the history of the agency. It had been a number of years since *Life* was an

SEBASTIAN BOLESCH 1991

German Neo-Nazis demonstrating in Halle two years after the fall of the Berlin Wall. Over the years Bolesch has been observing the radical right-wing Neo-Nazi scene in the reunited Germany. His photos, of which this Newsweek cover is an example, have been published across the globe.

Demonstrationen deutscher Neonazis in Halle, zwei Jahre nach dem Fall der Mauer. Über Jahre beobachtete Bolesch die rechtsradikale Szene im wiedervereinigten Deutschland. Seine Aufnahmen gingen um die Welt wie z.B. dieses Foto als Newsweek-Titel.

Manifestations de néo-nazis allemands à Halle, deux ans après la chute du mur. Pendant plusieurs années, Bolesch observa la scène d'extrême-droite dans l'Allemagne réunifiée. Ses photos ont fait le tour de monde, celle-ci par exemple fit la une de Newsweek.

DAS ENDE EINER ÄRA

DIE KRISE DES FOTOJOURNALISMUS

Black Star hat in fast 60 Jahren Agenturarbeit die besten und die schlechtesten Zeiten in diesem Geschäft gesehen. Die »hohe Kunst« des journalistischen Erzählens in Bildern steckt seit Ende der 60er Jahre in einer permanenten Krise. Auch die symbiotisch anmutende Beziehung zwischen Black Star und *Life* endete. 1972 stellte das Magazin sein Erscheinen ein. Grund dafür war in erster Linie die Gigantomanie des Magazins hinsichtlich Budget, Angestellten und Auflage. Das Fernsehen, das sich in den 60er Jahren geradezu explosionsartig entwickelte, stahl *Life* mit seinen bunten und schnellen Bildern die Werbeeinnahmen und damit die Existenzgrundlage. Doch noch andere Umstände versetzten *Life* den Todesstoß, wie eine Äußerung William Owens nahelegt: »*Life* mußte nicht nur substantielle Einbußen im Anzeigengeschäft hinnehmen, es verlor auch seine politische Rolle. (…) *Life* formte das Selbstverständnis der amerikanischen Nation ganz erheblich mit (…) und vertrat international den amerikanischen Machtanspruch, nachdem man sich von der Selbstbeschränkung des Isolationismus verabschiedet hatte.« Vielleicht weitete sich in einer Zeit der großen Niederlagen in Vietnam die Vertrauenskrise der Amerikaner in ihre Politiker zu einer tödlichen Vertrauenskrise in das US-Magazin aus. Schließlich muß der Fotojournalismus spätestens seit dem Zweiten Weltkrieg mit der Tatsache leben, politisch instrumentalisiert zu werden.

Ben Chapnick erinnert sich an das Ende von *Life*: »Ehrlich gesagt, für die Agentur war es ein Tag wie jeder andere. Es war schon Jahre her, daß *Life* ein Schlüsselfaktor im wirtschaftlichen Leben der Agentur war. Der Zusammenbruch des Magazins stimmte uns traurig, blieb aber ohne Auswirkungen auf die Agentur, die Fotografen und unsere damalige Arbeit.« Seit den Anfangstagen der Agentur arbeiteten die Fotografen außer für *Life* für alle wichtigen fotojournalistischen Kunden im In- und Ausland. In den USA waren dies in den 30er bis 60er Jahren die Magazine *Look, Colliers, Pageant* und *Saturday Evening Post*, daneben die fotografischen Talenten immer aufgeschlossenen Tageszeitungs-Supplemente *Parade*, *This Week Magazine* und *American Weekly*. Welch fatale Folgen die Krise des Fotojournalismus in den 60er Jahren besaß, läßt sich daran ablesen, daß keines der genannten Magazine, bis auf *Parade*, heute noch existiert. *Life* erstand zwar im Oktober 1978 als Monatsmagazin wieder auf, räumt jedoch dem traditionellen Fotojournalismus kaum noch Platz ein. Unberührt von all diesen Entwicklungen existierte seit 1888 *National Geographic*. Mit festangestellten Fotografen und einem paradiesischen Budget ausgestattet, führt diese Institution unter den internationalen Magazinen ein Inseldasein. Die strikte dokumentarische Bildauffassung in den ersten 80 Jahren des Bestehens verhinderte jedoch eine engere Zusammenarbeit mit Black Star. Mit dem Eintreten von Robert Gilka 1963 entwickelte auch *National Geographic* einen eigenen fotojournalistischen Stil. Für einige wenige Black-Star-Fotografen wie John Launois, James Sugar und Fred Ward taten sich neue Arbeitsmöglichkeiten auf.

LA FIN D'UNE ERE

LA CRISE DU PHOTOJOURNALISME

En presque 60 ans de pratique professionnelle, Black Star a vécu les meilleurs et les pires moments du métier d'agent. Depuis la fin des années 1960, le «grand art» du récit photographique est en crise permanente. Même le rapport quasisymbiotique entre Black Star et *Life* s'acheva. En 1972, le magazine suspendit sa parution. Première raison de cet échec, le gigantisme qu'avaient atteint son budget et ses effectifs. Les tirages ne suivaient pas. La télévision, qui connaissait un développement explosif dans les années 1960, priva *Life*, avec sa masse animée d'images colorées, d'une bonne part de ses rentrées publicitaires. Ce recul financier n'explique pas tout. Comme l'explique William Owens, d'autres facteurs portèrent le coup fatal au magazine : «*Life* perdit une bonne partie de ses revenus de publicité, mais il avait aussi perdu son rôle politique … Il avait joué un rôle fédérateur dans la création de la nation américaine … et en affirmant la puissance américaine sur le plan international, une fois que les contraintes de l'isolationnisme furent levées. » A cette époque de défaite des Etats-Unis au Viêtnam, la crise de confiance des Américains dans leurs dirigeants politiques se prolongea par une défiance à l'égard de *Life*, le magazine américain par excellence. Finalement, depuis la Deuxième Guerre mondiale au plus tard, le photojournalisme doit aussi s'accommoder du fait qu'il a été instrumentalisé par la politique.

Ben Chapnick se souvient de la fin de *Life* : «Franchement, c'était un jour comme n'importe quel autre à

DAVID TURNLEY 1994

This Colombian child with a false entry visa was stopped at J.F.K. airport. In a project lasting many years David Turnley pursued the suffering endured by many immigrants to the First World. In his photo reportages he captured inexplicable hatred and misanthropy.

Dieses kolumbianische Kind mit gefälschtem Visum wurde auf dem J.F.K.-Flughafen gestoppt. David Turnley verfolgte in einer langjährigen Dokumentation die Leidenswege der Einwanderer in der Ersten Welt. In seinen Reportagen fing er unbeschreiblichen Haß und Menschenverachtung ein.

Cet enfant colombien voyageant avec un faux visa fut arrêté à l'aéroport Kennedy. David Turnley a suivi pendant plusieurs années les épreuves subies par les immigrés dans les pays riches. Ses reportages sont ponctués d'images frappantes de la haine et du mépris pour autrui.

important factor in the economic life of this agency and the demise of the magazine created a sadness emotionally, but had no effect on the agency, the photographers, or the work that we were doing at that time." Since the early days of the agency its photographers had worked for the important customers with a need for photojournalism aside from *Life* at home and abroad. In the USA from the 1930s until the 1960s these were the magazines *Look, Colliers, Pageant* and the *Saturday Evening Post,* as well as the supplements of daily newspapers which were always open to photographic talent such as *Parade, This Week Magazine* and *American Weekly.* The fatal consequences of the crisis in photojournalism in the 1960s can be seen from the fact that none of the magazines named here, except *Parade,* are in existence today. Whilst *Life* reappeared as a monthly magazine in October 1978, scarcely any room was still given over to traditional photojournalism. Untouched by all of these developments, *National Geographic* has existed since 1888. Equipped with permanently employed photographers and a paradisiacal budget, this institution leads a solitary existence amongst international magazines. The strictly documentary conception of pictures during the first 80 years of its existence did however hinder a closer cooperation with Black Star. With the arrival of Robert Gilka in 1963, *National Geographic* also developed its own photojournalistic style. For a few Black Star photographers, such as John Launois, James Sugar and Fred Ward, new possibilities for work opened up.

At this time nobody had reckoned with a market which was both new and old at the same time. The news magazines *Time* and *Newsweek,* founded in 1923 and 1933, developed, in competition with television, an ever increasing appetite for pictures of events around the world. Today *U.S. News and World Report* can be classed as belonging to this American market. Furthermore, color photography began its triumphant march across the covers of these magazines, something which later continued in the inside sections. Once again Black Star recognized the signs of the times – above all Ben Chapnick, who from 1963 onwards was pushing ahead with this development of fast breaking color in cooperation with Robert V. Engle of *Newsweek,* who was at that point the new Cover Editor. With *Newsweek* and *Time* as its most important clients for photojournalism a change took place in the way in which Black Star photographers worked on photojournalistic assignments – the golden era of background stories which reflected the events of the day had become a thing of the past, henceforth reporting which focused on events predominated. A new attention to costs brought about further changes. Magazines were no longer drawing on a permanent staff of photographers. They were making use of fewer contracted photographers, who were given a minimum amount of working days during the year, and were covering any surplus requirement by using agencies. This development represented a dramatic turning point for photojournalism. In the 1990s news pictures represent the principal area of work for the photojournalist. Worldwide there are a dozen magazines which offer photojournalists a platform for picture essays – or, to use the current term, for reportage.

MARK SIMON 1993

A German Neo-Nazi musician. For years Mark Simon has been pursuing racism and xenophobia in ten countries for his international project "Extremism – victims and offenders."

Deutscher rechtsradikaler Musiker. Mark Simon verfolgt seit Jahren in seinem weltweiten Projekt »Extremismus – Opfer und Täter« die Themen Rassismus und Fremdenhaß in zehn Ländern.

Musicien allemand d'extrême-droite. Depuis des années, Mark Simon approfondit les thèmes du racisme et de la xénophobie dans dix pays, dans le cadre d'un projet international intitulé : «Extrémisme : acteurs et victimes».

Zu diesem Zeitpunkt rechnete noch niemand mit einem neuen und zugleich alten Markt. Die Nachrichtenmagazine *Time* und *Newsweek,* 1923 und 1933 gegründet, entwickelten in Konkurrenz zum Fernsehen einen immer größer werdenden Bildhunger auf die Ereignisse rund um den Erdball. Heute ist auch *U.S. News and World Report* diesem amerikanischen Markt zuzurechnen. Zudem startete die Farbfotografie ihren Siegeszug auf den Umschlägen dieser Magazine, der sich später im Innenteil fortsetzte. Wieder einmal erkannte Black Star die Zeichen der Zeit – allen voran Ben Chapnick, der gemeinsam ab 1963 mit dem damaligen neuen *Newsweek*-Bildchef Robert V. Engle die Entwicklung aktueller Farbbilder vorantrieb. Mit *Newsweek* und *Time* als wichtigen fotojournalistischen Kunden fand ein Wechsel in der fotojournalistischen Arbeit statt – die große Zeit der die Tagesereignisse reflektierenden Hintergrundgeschichten war abgelaufen, fortan dominierte die ereignisorientierte Berichterstattung. Ein neues Kostenbewußtsein brachte weitere Veränderungen. Die Magazine bauten nicht mehr auf einen Stamm festangestellter Fotografen. Sie bedienten sich einiger weniger Vertragsfotografen, denen ein Mindestmaß an Arbeitstagen im Jahr gewährt wurde, und deckten den weiteren Bedarf durch Agenturen. Diese Entwicklung stellte für den Fotojournalismus einen dramatischen Einschnitt dar. In den 90er Jahren sind die Nachrichtenbilder das Hauptarbeitsgebiet des Fotojournalismus. Weltweit gibt es hingegen nur ein Dutzend Magazine, die Fotojournalisten eine Bühne für fotoessayistische Arbeiten oder – um den heute gängigen Begriff zu benutzen – Reportagen bieten.

l'agence. L'époque où *Life* avait été un facteur économique fondamental pour l'agence remontait à bien longtemps. La disparition du magazine a provoqué une certaine tristesse, mais elle n'a pas eu d'effet sur l'agence, sur les photographes ou sur les travaux qui étaient en cours à ce moment-là. » Depuis les débuts de l'agence en effet, ses photographes ne travaillaient pas uniquement pour *Life* mais aussi pour tous les grands magazines américains et étrangers. De 1930 aux années 1960, on peut citer aux Etats-Unis seulement les magazines *Look, Colliers, Pageant* et le *Saturday Evening Post,* ainsi que nombre de suppléments de quotidiens sans cesse plus ouverts aux talents photographiques, comme *Parade, This Week Magazine* et *American Weekly.* A l'énumération de ces titres, on peut juger de la profondeur de la crise qui ébranla la presse dans les années 1960 : aucun d'eux, sauf *Parade,* n'existe plus aujourd'hui ! *Life,* qui reparut sous forme de mensuel en octobre 1978, n'accorde presque plus de place au photojournalisme traditionnel. La revue *National Geographic,* qui existe depuis 1888, a réussi à traverser toutes ces péripéties. Avec ses photographes salariés et ses budgets mirobolants, cette institution mène une existence solitaire parmi les magazines internationaux. La définition visuelle de la revue, très documentaire, empêcha pendant ses quatre-vingt premières années d'existence une collaboration étroite avec Black Star. L'arrivée de Robert Gilka, en 1963, marqua le développement d'un nouveau style photojournalistique au *National Geographic.* Pour quelques photographes de l'agence, comme John Launois, James Sugar et Fred Ward, de nouvelles possibilités de travail s'ouvrirent.

A ce moment, personne ne comptait encore sur un marché à la fois neuf et ancien. *Time* et *Newsweek,* des magazines d'actualité fondés respectivement en 1923 et 1933, décidèrent – en réaction face à la télévision – de renforcer la présence des photos dans leurs colonnes. C'était aussi l'époque où la couleur commençait son offensive victorieuse sur leurs couvertures, avant de se poursuivre dans les pages intérieures. Une fois de plus, Black Star sentit venir le vent. Ben Chapnick surtout, qui poussa cette évolution dès 1963 avec le nouveau rédacteur en chef du *Newsweek* d'alors, Robert V. Engle. Avec *Newsweek* et *Time* comme clients importants pour ses reportages, le travail photojournalistique de l'agence évolua. La grande époque des événements quotidiens chargés de refléter des sujets plus vastes était révolue au profit de l'actualité. Une nouvelle prise de conscience des coûts apporta d'autres modifications. Les magazines ne tenaient plus à disposer d'une équipe de photographes à demeure, préférant faire appel à quelques photographes sous contrat auxquels ils garantissaient un minimum de jours de travail annuels et complétant leurs besoins par l'intermédiaire des agences. Cette évolution correspond à une fracture majeure pour le photojournalisme. Dans les années 1990, l'essentiel du travail est lié à l'actualité. Dans le monde entier, une douzaine de magazines seulement offrent une tribune aux photojournalistes pour leurs essais photographiques, leurs « reportages » selon la terminologie actuelle.

THE HIGH POINT OF PHOTO-JOURNALISM ...

AND THE LOW POINTS OF THE MARKET

Although it may appear paradoxical, the fewer royalties that can be paid and the less room magazines have to put at the disposal of photojournalistic work, the more young men and women try their hand at this profession and at the high art of reportage. The myth of the picture reporter, as embodied in figures like Robert Capa and W. Eugene Smith, is still potent at the end of the 20th century. Historical accounts, universities, publishing houses, photo galleries and agencies fuel this myth and thrive on it, as does this reportage. It appears to be a typical phenomenon during a crisis, that in a time when journalism is in decline original photography and photojournalism are the ubiquitous subject of praise.

Black Star would no longer exist had the management doggedly held fast to the concept of a purely photojournalist contractual agency. The current President Ben Chapnick, who began in the agency as a messenger boy in the 1950s while he was still studying, makes an open secret of "corporate photography". Immediately after his military service in May 1960, he received an offer from Mayer and seized the chance: "I took my coat off and started." His sphere of activity was not exactly defined; photojournalism was still in full bloom and the agency had excellent people at its disposal. The new starter made a virtue out of necessity. After he had achieved some quite considerable successes in the realm of magazines – his cooperation with *Newsweek* – he built up a business sector which, whilst it had certainly, from the beginning, been in existence with industrial clients such as Exxon's magazine *Lamp,* was still in a rather underdeveloped form. This sector involved the work of photojournalists for large American companies and their publications. Ben Chapnick developed market strategies and fought difficult battles with art directors, convincing them of the possibilities of 35 mm photography. Finally he defeated industry with its own weapons – with economic arguments. The photojournalist was quicker and more flexible with his equipment than he was with a massive large-format camera; the agent could group together several commissions for a photographer overseas and thus save on air fares. Chapnick won over not only art directors with his idea but also the bookkeepers. Since then, the word in the winter months is always "It's annual report season."

The idea which idealistic critics of the photojournalistic business have always described as a sell-out was the saving of Black Star. Ben Chapnick assesses his own role today very realistically: "It is quite apparent to me that without the corporate business and its expansion since 1960, Black Star would either not have existed until this date or would have existed as a much smaller entity if we were able to survive. Corporate work has enabled the photographers to stay in business, and to continue to do their journalistic work even when that journalistic work no longer brings back the kind of income it used to. It is very rare for a photographer today to be able to live,

DAS HOHE LIED DES FOTO-JOURNALISMUS ...

UND DIE NIEDERUNGEN DES MARKTES

So paradox es scheinen mag, je weniger Honorare gezahlt werden können und je weniger Raum die Magazine fotojournalistischen Arbeiten zur Verfügung stellen, desto mehr junge Männer und Frauen versuchen sich in diesem Metier und in der hohen Kunst der Reportage. Der Mythos der Fotoreporter wie Robert Capa und W. Eugene Smith wirkt auch im ausgehenden 20. Jahrhundert. Geschichtsschreibung, Universitäten, Verlage, Fotogalerien und Agenturen betreiben diese Mythenbildung und leben davon. Auch dieser Essay. Es scheint ein geradezu typisches Krisenphänomen, daß in der Zeit des journalistischen Niedergangs Autorenfotografie und Fotojournalismus allerorten gepriesen werden.

Black Star würde nicht mehr existieren, hätten die Verantwortlichen stur an dem Konzept der rein fotojournalistischen Auftragsagentur festgehalten. Der heutige Präsident Ben Chapnick, der in den 50er Jahren neben seinem Studium als Laufbursche in der Agentur begann, hütet ein offenes Geheimnis: »Industriefotografie«. Direkt nach seinem Militärdienst im Mai 1960 bekam er ein Angebot Mayers und ergriff die Chance:

JOSEPH RODRIGUEZ 1990

Rodriguez photographed the life of Hispanic immigrants in East Harlem. It appeared as cover story in a 1990 issue of National Geographic.

Rodriguez fotografierte das Leben hispanischer Einwanderer in East Harlem. Die Reportage erschien 1990 als Titelgeschichte in National Geographic.

Rodriguez a fait un reportage sur la vie des immigrés hispaniques à East Harlem. La série parut en 1990 dans le National Geographic.

LES SIRENES DU PHOTO-JOURNALISME...

ET LES ALEAS DU MARCHE

Cela peut paraître paradoxal, mais plus les honoraires payés pour les productions photojournalistiques sont bas, plus la place qui leur est réservée dans les magazines diminue, plus il y a de jeunes gens qui se lancent dans le métier et dans l'art difficile du reportage. En cette fin de 20ᵉ siècle, le mythe de photoreporters comme Robert Capa et W. Eugene Smith continue malgré tout de fasciner. Les historiens, les universités, les éditeurs, les galeries de photo, les agences, tous ceux qui vivent de cette mythification du photographe contribuent à l'encourager – tout comme ce livre. Un phénomène sans doute caractéristique d'une crise, qui privilégie universellement la photographie d'auteur et le photojournalisme alors que le journalisme est en plein déclin.

Si ses responsables s'en étaient strictement tenu à son rôle d'agence photojournalistique, Black Star n'existerait plus à l'heure qu'il est. Son président actuel, Ben Chapnick, commença à travailler comme coursier à l'agence dans les années 1950, parallèlement à ses études, et développa le marché de la «photo industrielle». Juste après son retour du service militaire, en mai 1960, il reçut une offre de Mayer et saisit sa chance : « J'ai pris mon manteau et je suis parti. » Ses fonctions n'étaient pas vraiment définies, mais le photojournalisme était encore en plein essor et l'agence disposait de collaborateurs de grande valeur. Nécessité faisant loi, le jeune débutant accumula les succès. Après sa réussite avec les magazines – sa collaboration avec *Newsweek* –, il développa rapidement une clientèle parmi les grandes entreprises américaines. *Lamp,* le magazine de l'industriel Exxon était certes client de l'agence depuis ses débuts, mais un marché nouveau s'ouvrait pour les photographes. Ben Chapnick mit sur pied des stratégies de marché et affronta les directeurs artistiques au sujet des possibilités de la photographie en petit format. Finalement, il battit l'industrie en utilisant ses propres armes : des arguments économiques. Avec son équipement léger, le photojournaliste était plus rapide et plus souple qu'avec un gros appareil grand format, l'agent pouvait charger un photographe de plusieurs commandes et économisait ainsi sur les frais de transport, surtout outre-mer. Chapnick réussit à convaincre les directeurs artistiques, mais aussi les comptables. Depuis lors, on entend dire à l'agence, pendant les mois d'hiver : «C'est l'époque du rapport annuel. »

Cette idée, que les puristes du photojournalisme ont toujours qualifiée de «braderie», a sauvé Black Star. Ben Chapnick s'exprime de manière très réaliste sur son rôle: «Pour moi, il est évident que sans nos clients industriels et le développement de ce secteur depuis les années 1960, Black Star aurait disparu ou aurait survécu sous forme d'une entité beaucoup plus petite. Les commandes industrielles ont permis aux photographes de rester dans le métier et de poursuivre leur travail journalistique à une époque où celui-ci ne rapporte plus les revenus auxquels ils étaient habitués auparavant. Il est très rare aujourd'hui qu'un photographe puisse survivre, vivre et bien s'en

A feather and an apple in a state of free fall in a vacuum. Sugar designed this technically challenging photograph as lead picture for his National Geographic story about gravity demonstrating: "Newton was right."

Feder und Apfel im freien Fall im Vakuum. Sugar konzipierte dieses technisch aufwendige Bild als Aufmacher für seine National-Geographic-Story über Schwerkraft und zeigte: »Newton hatte recht.«

Plume et pomme en chute libre dans le vide. Cette photo techniquement difficile à réaliser ouvrait le reportage de Sugar sur la pesanteur, dans le National Geographic. Commentaire : « Newton avait raison. »

survive, and do well only by doing journalistic work. Photographers like Chris Morris are the absolute exception. In that sense, Black Star has learned to cope with the existing marketplace, to find out where our photojournalistic capabilities will work and to bring these capabilities into new ways of representing the photographer." This statement sounds like a line drawn under the agency's history at a time when digital cameras and the digital treatment and transmission of pictures is undermining the sector anew.

The historical perspective shows that Black Star has mastered all challenges hitherto and also continues to work tirelessly towards the solution of new photographic problems. The fighting spirit of the founders animates the new offices in Manhattan. In this sense a footnote in the history of the agency takes on meaning. Kornfeld often used to bark the words "Du grosser Dummesel" – which translate approximately as "You stupid ass" – at Ben when he was an errand boy in the 1950s. Chapnick frequently allows these three German words to cross his lips with a typical New York accent and a complacent smile. And the visitor to his office, so endearingly addressed, will have had a brief encounter with the spirit of the founders, which for a moment has sparkled in a very real fashion on 27th Street on the fourth and fifth floors.

Hendrik Neubauer

»Ich zog meine Uniform aus und fing sofort an«. Sein Aufgabenfeld war nicht genau definiert, der Fotojournalismus stand noch in voller Blüte, und die Agentur verfügte über hochkarätige Leute. Aus der Not entwickelte der Berufseinsteiger eine Tugend. Nach durchaus achtbaren Erfolgen im Magazinbereich – seine Zusammenarbeit mit *Newsweek* – baute er einen Geschäftsbereich aus, der zwar seit Anbeginn mit Industriekunden wie Exxons Magazin *Lamp* vorhanden war, jedoch lediglich in unterentwickelter Form – die Arbeit von Fotojournalisten für große amerikanische Firmen und deren Publikationen. Ben Chapnick entwickelte Marktstrategien und führte harte Überzeugungskämpfe mit Art-Direktoren über die Möglichkeiten der Kleinbildfotografie. Schließlich schlug er die Industrie mit ihren eigenen Waffen – mit ökonomischen Argumenten. Der Fotojournalist war mit seinem Equipment schneller und flexibler als mit einer massiven Großbildkamera, der Agent bündelte mehrere Aufträge für einen Fotografen in Übersee und sparte Flugkosten. Chapnick gewann nicht nur die Art-Direktoren für seine Idee, sondern auch die Buchhalter. Seitdem heißt es in den Wintermonaten immer wieder »Die Zeit der Geschäftsberichte bricht an.«

Die Idee, die idealistische Kritiker des fotojournalistischen Geschäfts immer wieder als Ausverkauf bezeichnet haben, rettete Black Star das Leben. Ben Chapnick beurteilt heute seine eigene Rolle sehr realistisch: »Für mich ist klar, daß Black Star ohne die Industriekunden und die Expansion dieses Geschäftsbereichs seit 1960 heute gar nicht mehr existieren würde oder doch in so geschrumpfter Form, daß wir nicht mehr überlebensfähig wären. Dank der Arbeit für die Industrie können Fotografen weiterhin ihr Gewerbe ausüben und ihrer journalistischen Arbeit nachgehen, auch wenn der Journalismus nicht mehr die Einnahmen bringt wie früher. Heutzutage ist es sehr selten, daß ein Fotograf allein von journalistischer Arbeit leben oder auch nur ein Auskommen finden kann. Fotografen wie Chris Morris sind die großen Ausnahmen. Wir von Black Star haben gelernt, uns auf dem heutigen Markt zu behaupten, neue Anwendungen für unsere fotojournalistische Kompetenz zu finden und diese Kompetenz auch in neuen Formen darzustellen.« Diese Aussage wirkt wie ein Schlußwort in einer Zeit, in der digitale Kameras und die digitale Bildbearbeitung und -übertragung die Branche erneut verunsichern.

Der historische Rückblick zeigt, daß Black Star alle bisherigen Herausforderungen gemeistert hat und auch weiterhin unermüdlich an der Lösung der neuen fotografischen Probleme arbeitet. Der Kampfgeist der Gründer beseelt die neuen Büroräume in Manhattan. In diesem Sinne bekommt eine Fußnote in der Geschichte der Agentur Bedeutung. Kornfeld herrschte den Laufburschen Ben in den 50er Jahren oftmals an: »Du großer Dummesel.« Chapnick läßt diese drei deutschen Worte des öfteren, mit dem typischen New Yorker Akzent und einem süffisanten Lächeln, über seine Lippen kommen. Was der so liebenswürdig gescholtene Besucher in seinem Büro bisher wohl nicht bemerkte, war der Geist der Gründer, der für einen kurzen Moment ganz konkret an der 27th Street im vierten und fünften Stock aufblitzte.

Hendrik Neubauer

In reportages such as "Universe", photojournalist and industrial photographer Sugar made the invisible visible.

Sugar, sowohl Fotojournalist als auch Industriefotograf, machte in Reportagen wie »Universe«, Unsichtbares sichtbar.

Avec les reportages comme « Univers », le photojournaliste et photographe d'industrie, Sugar, a rendu visible l'invisible.

sortir en travaillant uniquement pour la presse. Des photographes comme Chris Morris sont des exceptions. Dans ce sens, Black Star a appris à travailler avec le marché existant, à déterminer dans quelles directions nous pouvions engager les moyens photojournalistiques dont nous disposons et à imaginer de nouvelles façons de représenter les photographes.» Alors que les appareils photo numériques, avec la possibilité de transmettre et de retravailler numériquement les clichés, sont en train de plonger la profession dans de nouvelles incertitudes, ces mots résonnent comme une conclusion.

Un regard en arrière montre que Black Star a réussi à surmonter jusqu'à présent tous les défis et à poursuivre inlassablement son travail pour résoudre les nouveaux problèmes de la photographie. L'esprit conquérant des fondateurs a suivi l'agence dans ses nouveaux bureaux de Manhattan. Dans ce contexte, une petite histoire anecdotique prend tout son sens pour le destin de l'agence. Dans les années 1950, Kornfeld s'en prenait souvent à Ben Chapnick en lui criant : « Du grosser Dummesel ! » (« Toi, le grand dadais ! »). Chapnick, lui aussi, laisse souvent échapper ces trois mots allemands, prononcés avec un accent new-yorkais typique. Le visiteur qui se trouve dans son bureau et qui est gentiment apostrophé de la sorte se rend compte brusquement d'une chose : l'esprit des fondateurs souffle toujours aux 4ᵉ et 5ᵉ étages des bureaux de la 27ᵉ Rue et c'est lui qui vient ainsi de se manifester dans un bref éclair de malice.

Hendrik Neubauer

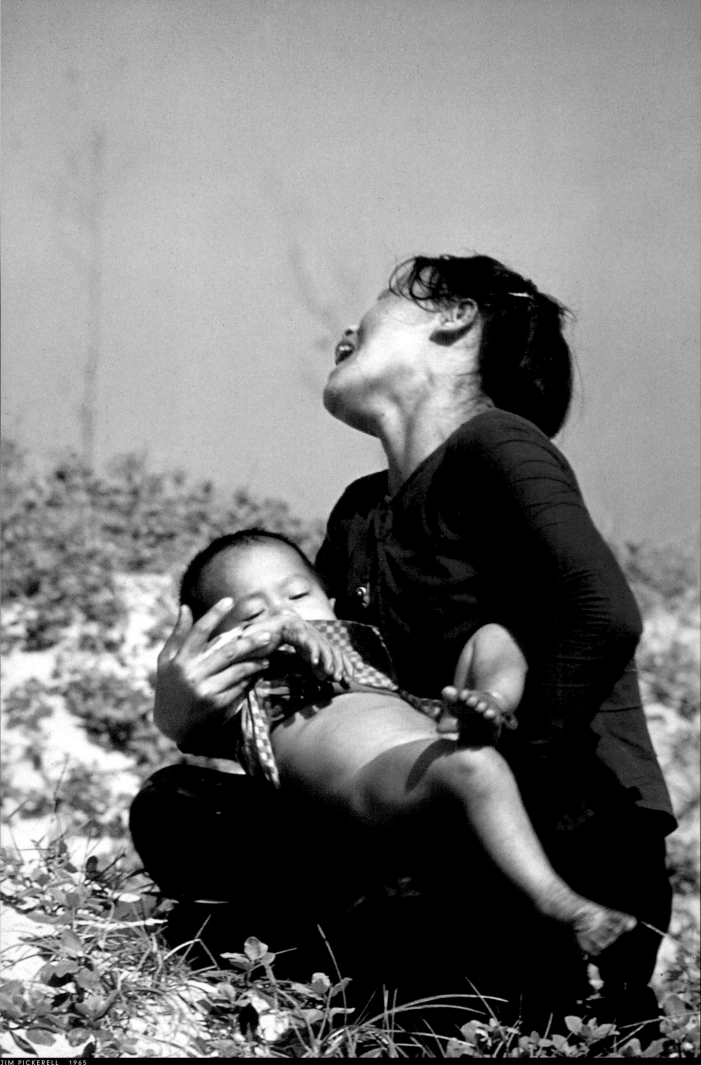

War and Crisis
Krieg und Krise
Guerres et conflits

The Vietnam War 1965. Black Star photographer Jim Pickerell described this photograph as his Pietà take.

Vietnamkrieg 1965. Der Black-Star-Fotograf Jim Pickerell nannte diese Aufnahme sein persönliches Pietà-Bild.

La guerre au Viêtnam, 1965. Jim Pickerell, de l'agence Black Star, disait de cette photo qu'elle était sa Pietà.

If your pictures aren't good enough, you're not close
enough." Robert Capa's statement became the
mantra of every war journalist after he tragically
stepped on a mine in Indochina in 1954. These words
are equally valid for every reporter who wishes to
chronicle crises, poverty and suffering in pictures.
Colleagues who use a typewriter are able to write from
behind their desks or at a safe distance by using their
imagination to good effect, but the photographer is
always in the thick of the battle.

What kind of people go to war and crisis locations
with a camera? Howard Chapnick knew these "trench-
coat warriors" from long experience: "It's not for the
faint-hearted or those unwilling to risk personal
danger. Reporting what happens in the world puts
photographers on the edge of constant disaster." Not
only is it the adrenaline rush which drives them, but
also an eternal fascination with people in extreme
situations. Of course, the wish to become famous by
taking the ultimate shot also plays an important part.

To the question "Why were you there?" generations
of photographers have given the same answer: "To
expose injustice and to inform people about inhuman
crimes, in order to give a voice to those who do not
have one or who have died in the turmoil of war."

When a photojournalist finds himself in a crisis
zone he will often have to submit to censorship. The
camera became a propaganda weapon in the Second
World War. Neither Allied nor Axis newspapers and
magazines were allowed to show the dead. This World
War first became accessible in its brutality and
inhuman excesses in photographs which were
published much later in magazines, illustrated books
and history books.

Censorship also prevailed in the 1990s, as the
example of the Gulf War shows. The clinically clean
war was shown live on CNN, accompanied by
magazine publications, which portrayed heroic
American GIs flying precision bombers or playing
football on the Saudi Arabian sand.

Wenn deine Bilder nicht gut genug sind, bist du
nicht nah genug dran.« Dieser Satz Robert Capas
wurde nach seinem tragischen Fehltritt auf eine Mine
1954 in Indochina zum Mantra eines jeden Kriegsjour-
nalisten. Er gilt genauso für jeden Reporter, der in Bil-
dern über Krisen, Armut und Elend erzählen will. Die
schreibenden Kollegen können mit entsprechender
Phantasie aus sicherer Entfernung oder vom Redak-
tionsschreibtisch aus berichten, der Fotograf aber steht
immer im Gefechtslärm.

Was für Menschen ziehen mit der Kamera in
Kriegs- und Krisengebiete? Howard Chapnick kannte
die »Trenchcoat-warriors« aus langer Erfahrung: »Das
ist nichts für Zaghafte und Leute, die nicht bereit sind,
sich selbst in Gefahr zu bringen. Um zu berichten, was
in der Welt geschieht, bewegt sich der Fotograf perma-
nent am Rande der Katastrophe.« Reporter treibt der
Nervenkitzel und die unendliche Neugier auf Men-
schen in Extremsituationen. Und nicht zuletzt ist es
der Wunsch, mit dem ultimativen Schuß berühmt zu
werden.

Auf die Frage nach dem »Warum seid ihr dort
gewesen?«, antworten Generationen von Fotografen
gleich: »Um Ungerechtigkeit aufzudecken und über
unmenschliche Verbrechen aufzuklären, um denen
eine Stimme zu verleihen, die keine Lobby haben oder
in den kriegerischen Wirren umgekommen sind.«

Begibt sich der Fotojournalist in Krisengebiete,
dann unterwirft er sich auch meist der Zensur. Endgül-
tig zur Propagandawaffe wurde die Kamera im Zweiten
Weltkrieg. Ob alliierte oder nationalsozialistische Zei-
tungen und Magazine – sie waren nur ein Zerrbild der
kriegerischen Wirklichkeit. Dieser Weltkrieg erschloß
sich in seiner Brutalität und den Auswüchsen der
Unmenschlichkeit erst aus viel späteren Veröffent-
lichungen in Magazinen, Bildbänden und Geschichts-
büchern.

Auch in den 90er Jahren herrscht Zensur, wie das
Beispiel Golfkrieg zeigt: Der klinisch reine Krieg live
auf CNN, begleitet von Magazinveröffentlichungen,

Si vos photos ne sont pas bonnes, c'est que vous
n'êtes pas assez près. » Après la mort de Robert
Capa – tué par une mine en Indochine, en 1954 – cette
phrase devint une sorte de mantra pour tous les
reporters de guerre. Elle est aussi valable pour tous les
journalistes qui veulent rendre compte par l'image des
conflits, de la pauvreté et de la misère. Avec un peu de
fantaisie, les collègues rédacteurs peuvent toujours
raconter les choses à bonne distance ou derrière leur
bureau. Le photographe, lui, est toujours au milieu du
fracas des combats.

Comment sont-ils, ceux qui partent avec leur
appareil photo dans les zones de guerre et de conflits ?
Howard Chapnick connaissait les « soldats en imper »
depuis longtemps : « Ce n'est pas un truc pour les gens
sensibles ou ceux qui ne sont pas prêts à courir des
risques personnels. Faire des reportages sur ce qui se
passe dans le monde place en permanence les photo-
graphes au bord du désastre. » Ce qui démange les
reporters, c'est la curiosité à l'égard des gens qui se trou-
vent dans des situations extrêmes. Bien sûr, le mythe de
« la » photo, celle qui rend célèbre, les pousse aussi.

A la question : « Pourquoi êtes-vous allés là-bas ? »,
des générations de photographes ont apporté la même
réponse : « Pour mettre au jour les injustices et révéler
des crimes inhumains. Pour donner une voix à ceux
qui n'ont pas de lobby derrière eux ou qui sont morts
dans des conflits. »

Lorsqu'un photographe se rend dans une zone de
guerre, il est aussi soumis le plus souvent à une
censure. L'appareil photo est définitivement devenu
une arme de propagande pendant la Deuxième Guerre
mondiale. D'un côté comme de l'autre, la presse se
voyait interdire de montrer les morts. La brutalité de
cette guerre et ses aspects les plus inhumains n'ont été
révélés que bien plus tard par les clichés publiés par les
magazines, les livres de photographies et d'histoire.

Comme le montre l'exemple de la guerre du Golfe,
la censure existe aussi dans les années 1990. CNN avec
la guerre « en direct » et la presse n'ont montré que les

This retrogressive control is easily explained. Photographs of the Vietnam War possessed an explosive political power as the American authorities, in line with the liberal atmosphere of the time, did not impose restrictions on journalists. Whilst their photographs did not end the war, they forced the American people to reflect on the role of the USA as a global policeman.

From the very beginning, news photography was a specialist area for Black Star photographers. Names such as Walter Bosshard, Robert Ellison, Charles Moore, Christopher Morris, Younosuke Natori and the Turnleys are representative of this tradition. Not all of them created anti-war icons as David Turnley did with his picture of weeping Gulf War soldiers in a helicopter. Yet, in dramatic situations, all of them have displayed that instinctive gut feeling for action, time and space. The moment which emerges from the turmoil triggers our dismay – however emotive such an explanation may sound.

The contemporary war photography that has appeared in print suggests that the work of American photojournalists has become static and lacking in imagination. The theaters of war may change but the pictures remain the same, the action is documented clinically and in a quite calculated fashion. The reportages by Christopher Morris on Chechnya and David Turnley on Bosnia are by contrast carried out in the good old photojournalistic tradition – reflective and looking out over the mountains of corpses. The will and ability of journalists is there to go into the depths and to investigate thoroughly the insane surface of war and crisis. Yet editorial offices continue to shout for shocking and sensational pictures.

die heroische, amerikanische GIs in Präzisionsbombern oder footballspielend im saudiarabischen Sand vorgaukelten.

Dieser politische Rollback ist einfach zu erklären. Die Bilder des Vietnamkriegs konnten politische Sprengkraft entfalten, da die amerikanischen Behörden, aus dem libertären Zeitgeist heraus, die Arbeitsmöglichkeiten für Journalisten nicht beschränkten. Die Fotografien beendeten zwar nicht den Krieg, sie zwangen aber das amerikanische Volk über die Rolle der USA als Weltpolizei nachzudenken.

Die Pressefotografie war seit Anbeginn eine Domäne der Black-Star-Fotografen. Namen wie Walter Bosshard, Robert Ellison, Charles Moore, Christopher Morris, Younosuke Natori und die Turnleys stehen für diese Tradition. Nicht jeder von ihnen schuf Ikonen gegen den Krieg wie David Turnley mit seinem Bild der weinenden Soldaten im Hubschrauber während des Golfkriegs. Sie alle aber haben in dramatischen Situationen den »richtigen Riecher« für Handlung, Zeit und Raum gehabt. Der aus den Wirren herausgeschälte Augenblick entscheidet über unsere Betroffenheit – so pathetisch diese Erklärung auch klingen mag.

Die veröffentlichte zeitgenössische Kriegsfotografie legt den Schluß nahe, die Arbeiten amerikanischer Fotojournalisten seien statisch und einfallslos geworden. Die Schauplätze jedes Krieges mögen wechseln, aber die Bilder bleiben die gleichen, klinisch und völlig ausrechenbar wird das Geschehen dokumentiert. Die Essays von Christopher Morris über Tschetschenien und David Turnley über Bosnien sind hingegen in guter alter fotojournalistischer Tradition gearbeitet – reflektierend und über die Berge von Opfern hinausschauend. Der Wille und die Fähigkeit der Journalisten sind da, in die Tiefe zu gehen und die Oberfläche des Wahnsinns von Krieg und Krise zu durchleuchten. Die Redaktionen schreien jedoch nach reißerischen Bildern.

héroïques GIs américains dans des bombardiers à la précision chirurgicale ou en train de jouer au football dans les déserts d'Arabie Saoudite.

Ce retournement politique est facile à expliquer. Les photos de la guerre du Viêtnam déployaient une énorme charge politique parce que les autorités américaines – conformément à l'esprit libertaire de l'époque – n'avaient pas restreint le champ d'action des journalistes. Si les photos ne mirent pas fin à la guerre, elles incitèrent le peuple américain à reconsidérer le rôle des Etats-Unis en tant que gendarme du monde.

Dès le début la photographie d'actualité a été le territoire de prédilection des photographes de Black Star. Les noms de Walter Bosshard, Robert Ellison, Charles Moore, Christopher Morris, Younosuke Natori et celui des frères Turnley illustrent bien cette tradition. Ils n'ont pas tous réalisé des clichés mythiques, des icônes, comme David Turnley avec sa photo des soldats pleurant dans un hélicoptère pendant la guerre du Golfe, mais ils ont tous su « se placer » dans l'action, le temps et l'espace dans les situations dramatiques où ils se sont trouvés. Même si cela paraît excessif, c'est l'instant précis qu'ils découpent au cœur du tumulte qui décide dans quelle mesure nous nous sentirons concernés.

Les photographies de guerre publiées actuellement pourraient laisser penser que les travaux des photographes américains sont devenus statiques et ternes. Les lieux des conflits changent, mais les images restent les mêmes, froidement cliniques et totalement prévisibles. Les reportages de Christopher Morris en Tchétchénie et de David Turnley en Bosnie sont quant à eux réalisés dans la grande tradition photojournalistique – avec du recul et en regardant au-delà des accumulations de victimes.

Les journalistes ont la volonté et la capacité de s'immerger au plus profond, d'aller au-delà des apparences pour révéler la folie de la guerre et des conflits. Mais les rédactions réclament à grands cris des images choc.

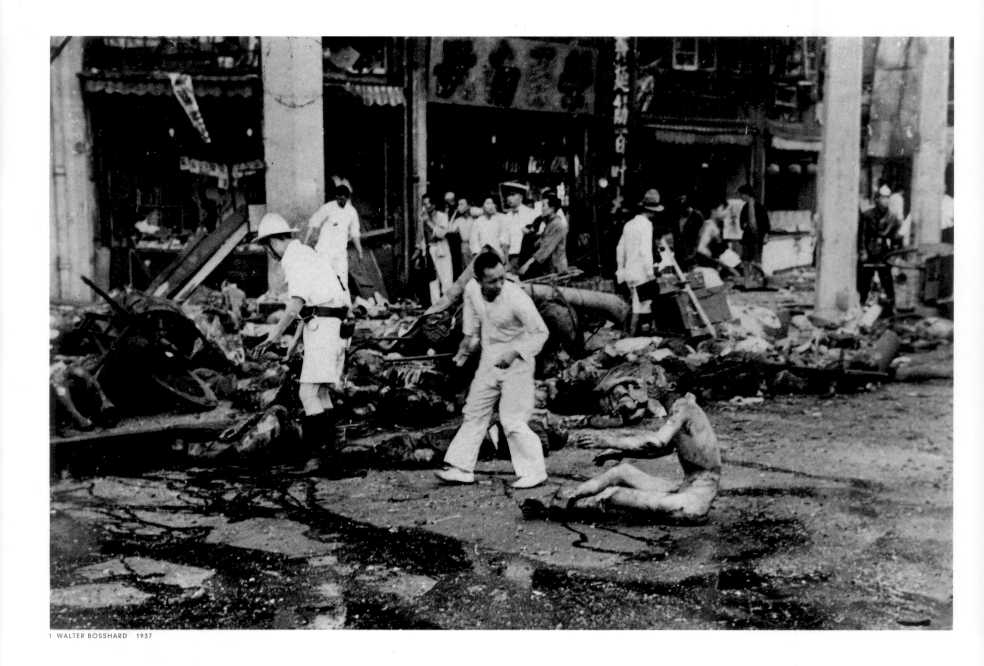

1 WALTER BOSSHARD 1937

THE SINO-JAPANESE WAR
1937–1945

Japanese expansion on the Chinese mainland sought to exploit the domestic political vacuum that had arisen due to the civil war between the Nationalist Chinese and the Communists. (1) The Japanese air raid on the amusement park in the international city of Shanghai on 14 August 1937 gave the conflict an international dimension since American and British nationals also died in these attacks. (2) Japanese prisoner of war camp in occupied China. The Japanese photographer Younosuke Natori wrote of this picture: "The most intelligent prisoners are being carefully instructed and will become policemen in Chinese cities..." (3) Execution of Chinese prisoners at daybreak in front of the walls of Nanking. During the Japanese general mobilization in 1938 troops advanced even further into Southwest China.

DER CHINESISCH-JAPANISCHE
KRIEG 1937–1945

Die japanische Expansion auf dem chinesischen Festland versuchte das innenpolitische Vakuum, das durch den Bürgerkrieg zwischen Nationalchinesen und Kommunisten entstanden war, auszunutzen. (1) Der japanische Luftangriff auf den Vergnügungspark der internationalen Stadt Schanghai am 14. August 1937 gab dem Konflikt eine internationale Dimension, da auch Amerikaner und Briten bei diesen Angriffen umkamen. (2) Japanisches Kriegsgefangenenlager im besetzten Gebiet Chinas. Der japanische Fotograf Younosuke Natori schrieb zu seinem Bild: »Die intelligentesten Gefangenen werden gewissenhaft ausgebildet und werden Polizeibeamte in chinesischen Städten ...« (3) Erschießung chinesischer Gefangener im Morgengrauen vor den Mauern Nankings. Im Rahmen der japanischen Generalmobilmachung 1938 rücken die Truppen immer weiter in den Südwesten Chinas vor.

LA GUERRE SINO-JAPONAISE
1937–1945

L'expansion japonaise sur les territoires chinois correspondait à une tentative d'exploiter la situation de politique intérieure réduite à néant par la guerre civile entre les nationalistes et les communistes chinois. (1) L'attaque aérienne japonaise sur le parc d'attractions de la ville internationale de Shanghai, le 14 août 1937, fit des victimes parmi les Américains et les Britanniques et donna au conflit une dimension internationale. (2) Camp japonais de prisonniers, dans la région occupée en Chine. Le Japonais Younosuke Natori commenta ainsi sa photo : « Les prisonniers les plus intelligents sont soigneusement formés et deviendront policiers dans les villes chinoises… » (3) Exécution de prisonniers chinois à l'aube, devant les murs de Nankin. Suite à la mobilisation de 1938, les troupes japonaises avancent dans le sud-ouest de la Chine.

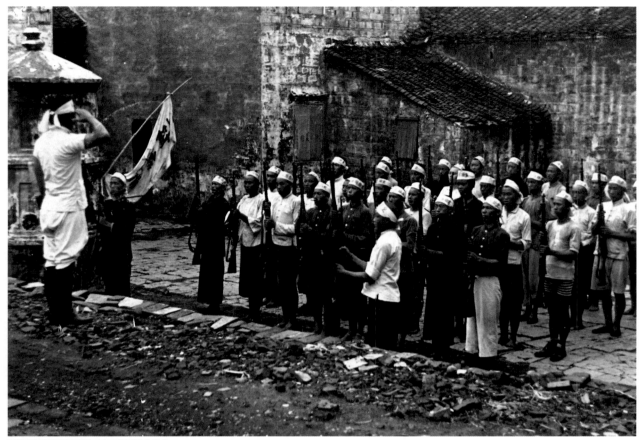

2 YOUNOSUKE NATORI UNDATED/O.D./S.D.

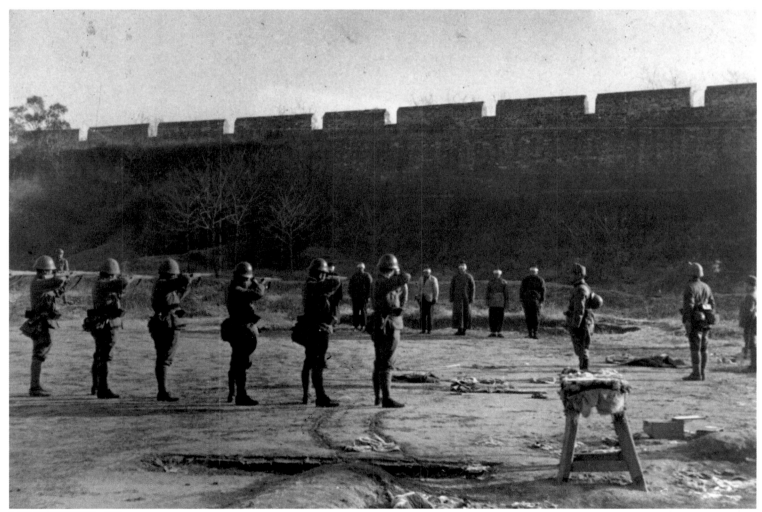

3 YOUNOSUKE NATORI 1938

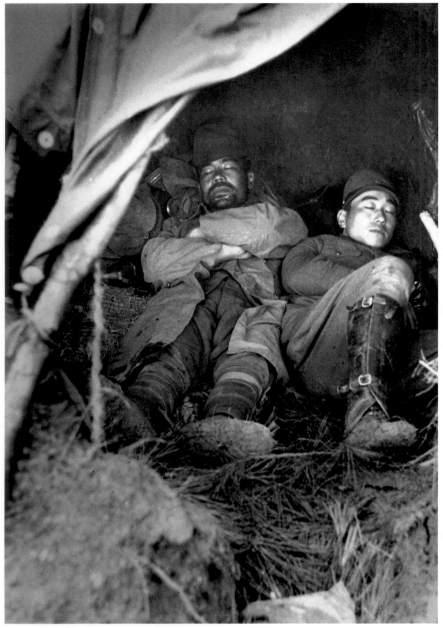

1 YOUNOSUKE NATORI 1938

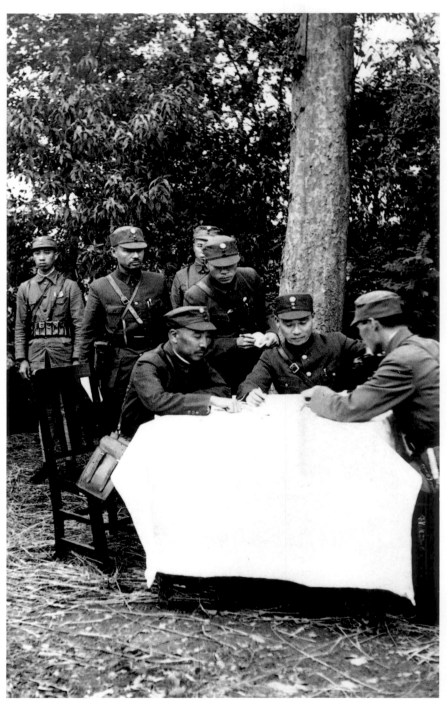

2 PIERRE VERGER 1937

(1) The American magazine Life of 14 November 1938 wrote of this picture: "The (Japanese) officer who got shot (right) slept beside a private – an unheard of intimacy in any Western army. In the morning, photographer Natori followed him into battle." (2) Meeting of Nationalist Chinese generals behind the lines near Shanghai in 1937. After the domestic political turmoil of the years 1927 to 1936 between the Communists and the Nationalist Chinese, Chiang Kai-shek was made commander-in-chief in the struggle against Japan.

(1) Das amerikanische Magazin Life vom 14. November 1938 schrieb zu diesem Bild: »Der (japanische) Offizier, der angeschossen wurde (r.), schlief neben einem Gefreiten – eine unvorstellbare Vertraulichkeit in einer westlichen Armee. Am Morgen folgte ihm der Fotograf Natori in die Schlacht.« (2) Beratung nationalchinesischer Generäle hinter den Linien bei Schanghai 1937. Nach den innenpolitischen Wirren von 1927 bis 1936 zwischen Kommunisten und Nationalchinesen wurde Tschiang Kai-schek zum Oberbefehlshaber im Kampf gegen Japan ernannt.

(1) Le magazine américain Life du 14 novembre 1938 donne à cette image le commentaire suivant : « L'officier (japonais) blessé (à droite) dort à côté d'un soldat de première classe – intimité impensable dans une armée occidentale. Au matin, le photographe Natori le suivra dans la bataille. » (2) Conseil des généraux nationalistes chinois derrière les lignes de Shanghai, en 1937. Après les troubles de politique intérieure, de 1927 à 1936, entre communistes et nationalistes, Chiang Kai-shek fut désigné comme commandant en chef dans la guerre contre le Japon.

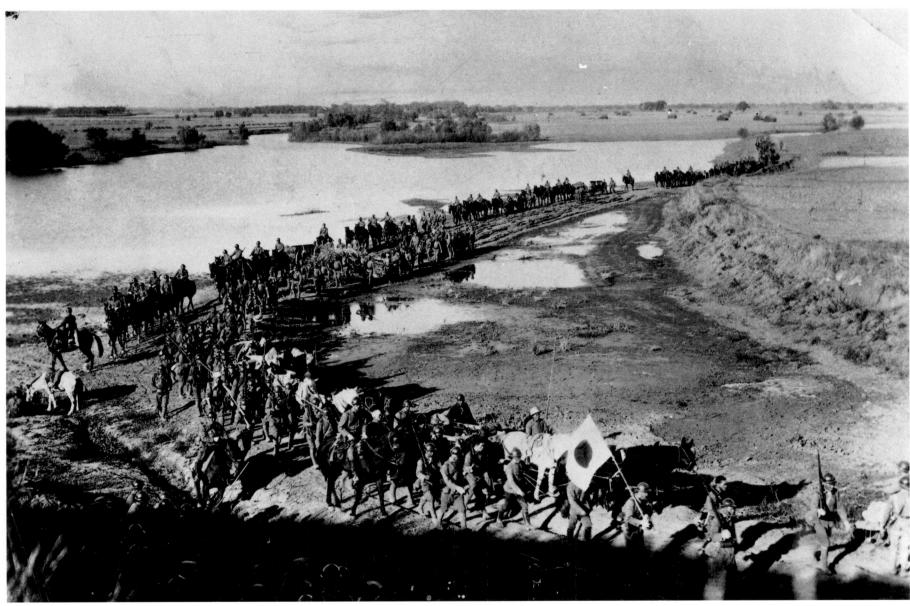

3 N.N. 1937

(3) Japanese troop manoeuvre through its satellite state Manchukuo on the Chinese mainland. The founding of this state in 1932 was the beginning of the Japanese policy of expansion which finally collapsed in 1945.

(3) Japanische Truppenbewegung durch ihren Satellitenstaat Mandschukuo auf dem chinesischen Festland. Die Gründung dieses Staates 1932 war der Beginn und die Ausgangsbasis der 1945 letztendlich gescheiterten japanischer Expansionspolitik.

(3) Mouvement de troupes japonaises dans leur Etat fantoche du Mandchukuo sur le territoire chinois, dont la création en 1932 avait inauguré l'expansionnisme japonais qui devait aboutir à un échec en 1945.

1 GEORGES REISNER UNDATED/O.D./S.D.

2 GEORGES REISNER UNDATED/O.D./S.D.

THE SPANISH CIVIL WAR
1936–1939

Since 1923 Spain had been hovering on the edge of a civil war. (1, 2) International Brigades fought on the side of the Republican soldiers, recruiting from socialists and communists all over the world.

DER SPANISCHE BÜRGERKRIEG
1936–1939

Spanien schwebte seit 1923 am Rande eines Bürgerkrieges. (1, 2) Auf Seiten der republikanischen Soldaten kämpften internationale Brigaden, die sich aus Sozialisten und Kommunisten aus aller Welt rekrutierten.

LA GUERRE CIVILE EN ESPAGNE
1936–1939

L'Espagne était au bord de la guerre civile depuis 1923. (1, 2) Aux côtés des soldats républicains combattaient des brigades internationales composées de socialistes et de communistes venus du monde entier.

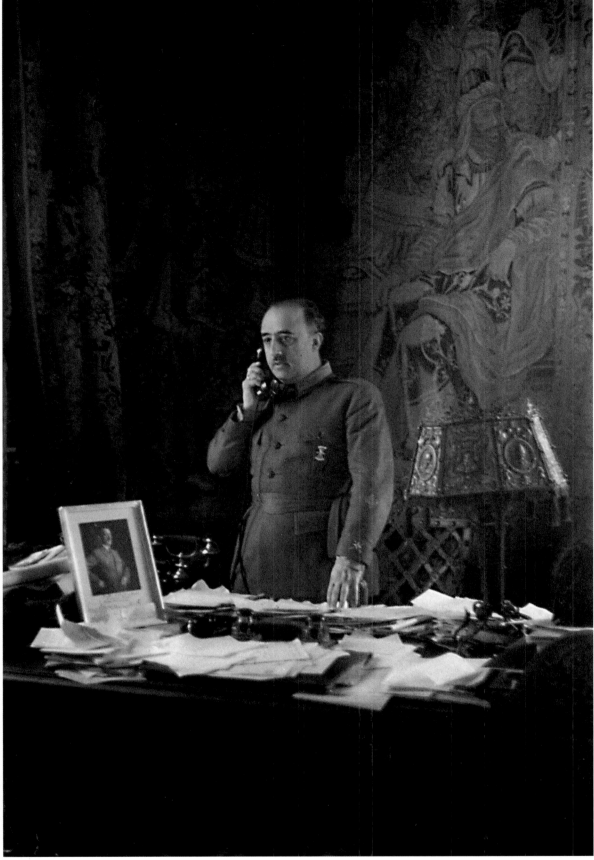

3 N.N. 1937

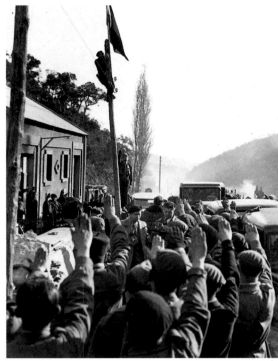

(3) General Franco, seen here in his study in Cáceres in 1937, carried out a putsch in July 1936 with the support of the military against the newly elected government of the Popular Front. (4) The factions in the civil war were certain of international support – the fascist troops under Franco's command were reinforced by German and Italian units.

(3) General Franco, hier in seinem Arbeitszimmer in Cáceres 1937, putschte im Juli 1936 mit der Unterstützung des Militärs gegen die neu gewählte Volksfrontregierung. (4) Die Bürger-kriegsparteien waren sich internationaler Unterstützung gewiß – die von Franco befehligten faschistischen Truppen wurden durch deutsche und italienische Verbände verstärkt.

(3) Le général Franco – ici dans son bureau à Cáceres en 1937 – opéra un putsch en juillet 1936, appuyé par l'armée, contre le gouvernement de front populaire récemment élu. (4) Les partis en guerre bénéficiaient de soutiens internatio-naux : Franco et ses troupes fascistes avaient passé des pactes avec l'Italie et l'Allemagne.

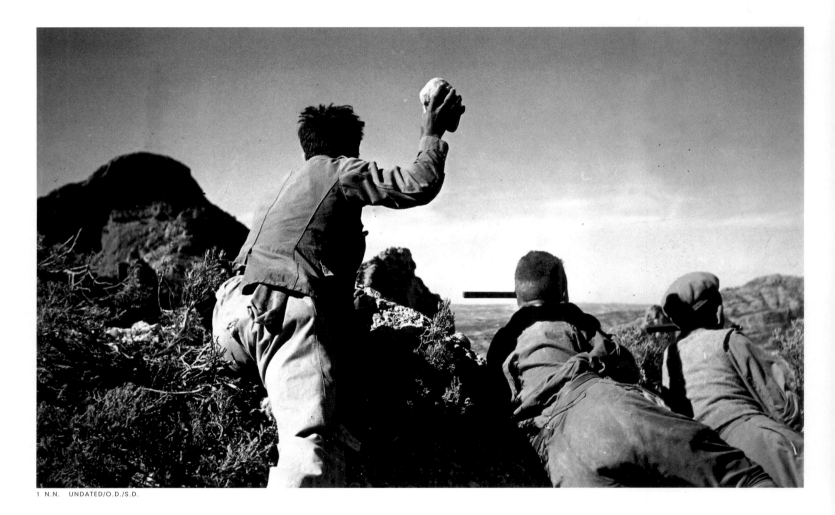

1 N.N. UNDATED/O.D./S.D.

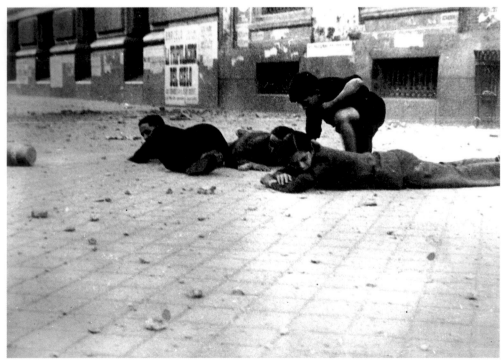

2 MAYO 1939

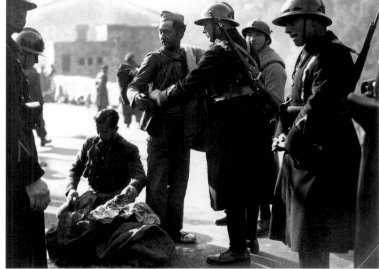

3 N.N. UNDATED/O.D./S.D.

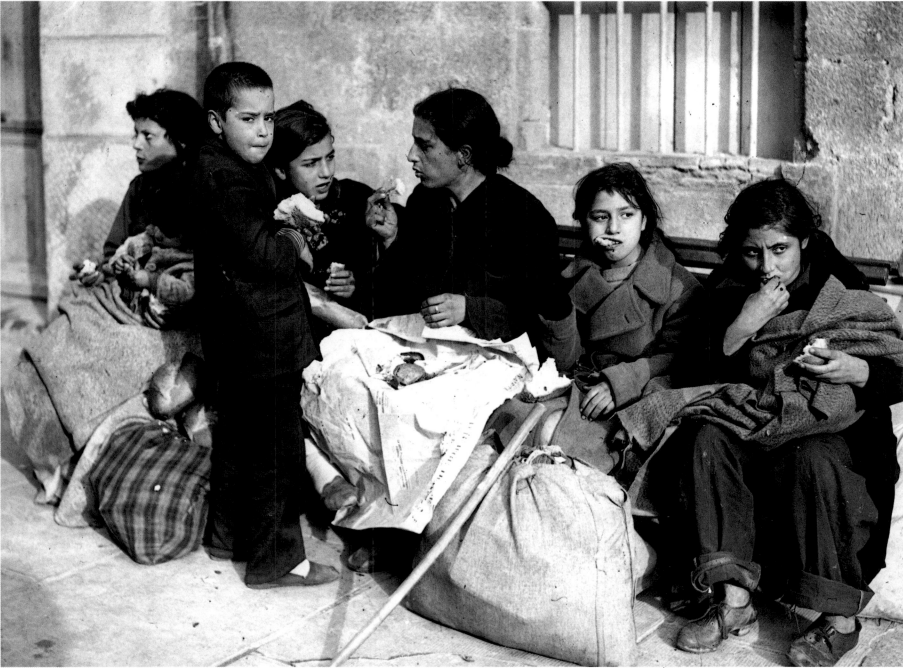

4 N.N. UNDATED/O.D./S.D.

(1) Black Star described the contents of this picture with the words: "A Francoist machine-gun patrol in the mountains." The Deutsche Verlag in Berlin sent this agency picture to New York with the propagandistic description: "... the legionaries have a sense of humor, and one of them is demonstrating how he would send the enemy, who was supposed to climb up the rock, back down it by throwing a stone." (2) 1939 – the battle for Madrid. After Barcelona capitulated to Franco's troops in January, the capital fell in March. (3) Border crossing at Le Perthus. Picture of defeat – Republican militiamen flee before the fascists. (4) The Civil War claimed around 600,000 human lives and forced countless Spaniards to flee to France.

(1) Black Star beschrieb den Bildinhalt mit den Worten: »Eine francistische MG-Patrouille im Gebirge.« Der Deutsche Verlag in Berlin lieferte dieses Agenturbild mit der Propaganda-zeile nach New York: »... die Legionäre haben Witz, und einer demonstriert, wie er mit einem Steinwurf den Gegner, der diesen Felsen heraufklettern sollte, hinunterjagen würde.« (2) 1939 – der Kampf um Madrid. Nachdem im Januar Barcelona vor Francos Truppen kapitulierte, fiel die Hauptstadt im März. (3) Grenzübergang Le Perthus. Bilder der Niederlage – Republikanische Milizionäre fliehen vor den Faschisten. (4) Der Bürgerkrieg kostete an die 600 000 Menschenleben und zwang unzählige Spanier zur Flucht nach Frankreich.

(1) Cette image était ainsi légendée par Black Star : « Patrouille de mitrailleurs franquistes dans la montagne ». Le Deutsche Verlag de Berlin transmit la photo d'agence à New York avec ce commentaire de propagande : « ... Les légionnaires ne manquent pas d'humour et l'un d'eux indique ici comment il ferait fuir d'un jet de pierre le premier des adversaires qui tenterait d'escalader ces rochers. » (2) 1939 – la bataille de Madrid. Après Barcelone en janvier, la capitale tomba en mars devant les troupes franquistes. (3) Passage de frontière au Perthus. Image de la défaite – les miliciens républicains fuyant devant les fascistes. (4) La guerre civile coûta la vie à 600 000 personnes et obligea de nombreux Espagnols à fuir en France.

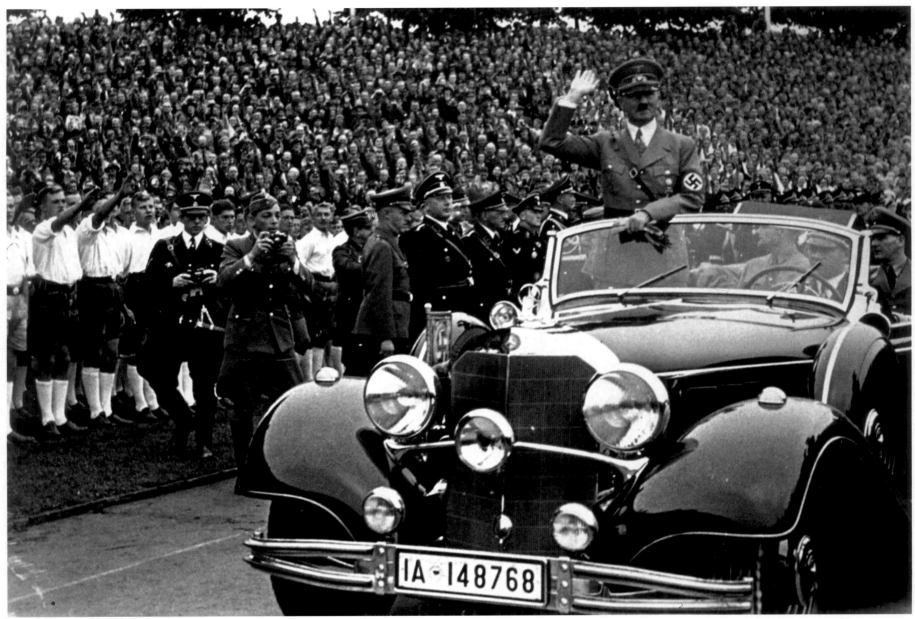

1 DEUTSCHER VERLAG 1938

THE FASCINATION OF THE THIRD REICH

In the National Socialists' (Nazis') irrational conception of the world there were two central concepts, namely the "Volk" or the "National Community", and the "Führer", Adolf Hitler, who took on the role of savior and redeemer. (2) A favored political platform used to orchestrate the pseudo-socialist "National Community" was the annual Nuremberg Nazi Party Rally. (1) The prominent actor of these events was undeniably the "Führer", Hitler.

The propaganda machine of Nazism continually produced new ideological images, which also included material to be exported abroad. Deutscher Verlag in Berlin regularly supplied Black Star with photographs from the Third Reich. These pictures spread both fear and incomprehension amongst readers of American magazines and newspapers.

DER SCHÖNE SCHEIN DES DRITTEN REICHES

Im irrationalen Weltbild des Nationalsozialismus herrschten die beiden Leitbegriffe »Volk« bzw. »Volksgemeinschaft« und der als Erlöser und Retter auftretende »Führer«. (2) Die politische Inszenierung der pseudo-sozialistischen Volksgemeinschaft hatte ihre bevorzugte Bühne auf dem Reichsparteitag in Nürnberg. (1) Der Hauptdarsteller dieser Veranstaltung war jedoch der »Führer« Adolf Hitler.

Der Propaganda-Apparat der Nationalsozialisten produzierte ständig neue ideologische Trugbilder, auch um sie ins Ausland zu liefern. Der Deutsche Verlag in Berlin belieferte Black Star regelmäßig mit Fotografien aus dem Dritten Reich. Bei den Lesern der amerikanischen Magazine und Zeitungen verbreiteten diese Aufnahmen Angst und Unverständnis zugleich.

LES FEUX DU TROISIEME REICH

Les maîtres-mots de l'irrationalisme national-socialiste étaient la « Volksgemeinschaft », une conception fusionnelle du peuple, et le « Führer », qui se présentait comme un sauveur et un libérateur providentiel. (2) La mise en scène politique de la « communauté populaire », d'inspiration pseudo-socialiste, trouva son expression la plus aboutie à la fête du parti nazi à Nuremberg. (1) L'acteur principal de cette manifestation était pourtant bien le « Führer », Adolf Hitler.

L'appareil de propagande nazi produisait à profusion des images à contenu idéologique, destinées à circuler aussi à l'étranger. Le Deutscher Verlag de Berlin envoyait régulièrement à Black Star des photos du IIIe Reich qui suscitaient la peur et l'incompréhension chez les lecteurs de la presse américaine.

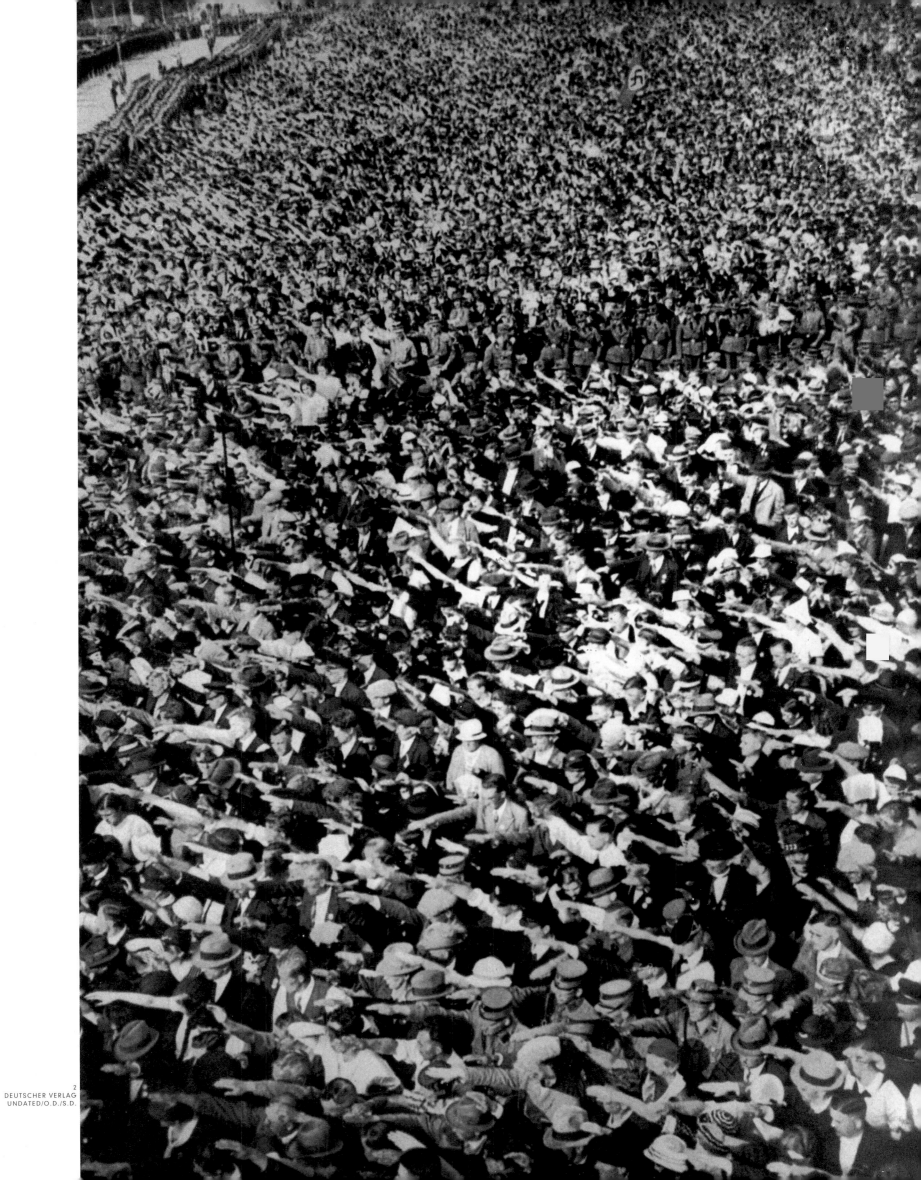

1 ROMAN VISHNIAC 1938

Vishniac took his most famous photographs in the Warsaw Ghetto in 1938. (1) Pogroms against Jews were the order of the day. A man has hidden himself from the Endecy, the feared members of the Polish National Democratic Party, behind an iron door. (2) The poverty was unimaginable, people had to subsist on 200 calories a day.

Vishniac machte seine bekanntesten Aufnahmen 1938 im Warschauer Ghetto. (1) Pogrome gegen Juden waren an der Tagesordnung. Ein Mann hat sich vor den Endecy, den gefürchteten Mitgliedern der Nationaldemokratischen Partei Polens, hinter einer Eisentür versteckt. (2) Die Armut war unvorstellbar, die Menschen mußten sich von 200 Kalorien am Tag ernähren.

C'est dans le ghetto de Varsovie, en 1938, que Vishniac fit ses photos les plus connues. (1) Les pogromes contre les Juifs étaient chose quotidienne. Un homme se cache derrière une porte de fer, devant les Endecy, les effrayants membres du parti « national-démocratique » polonais. (2) La pauvreté était indescriptible, les hommes devaient se contenter de 200 calories par jour.

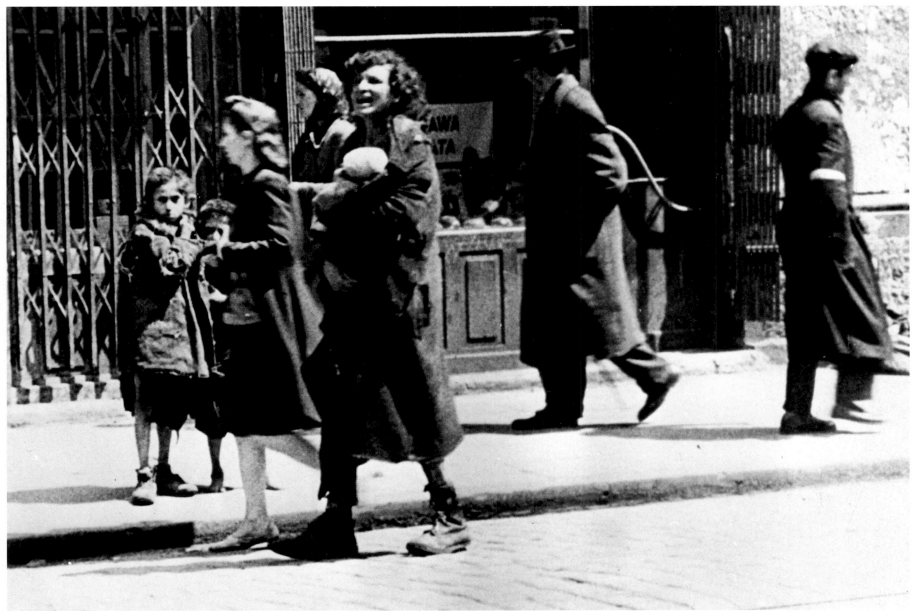

2 ROMAN VISHNIAC 1938

VANISHING WORLD

Between 1933 and 1939 Roman Vishniac (b. 1897 in St Petersburg) travelled into the old ghettos in Poland and the small *schtetls* between the Baltic Sea and the Carpathian Mountains. "Why did I do it? That somebody recorded images with a hidden camera from the life of a people that did not want to be photographed at all may appear surprising to you. Was it an act of madness to travel around in countries in which I was in mortal danger every single day? (...) It had to be done. I felt that the racial mania of the National Socialists would soon cover the world in a darkness in which nobody would feel moved to record the life of their fellow believers, a life which was full of suffering. (...) I knew that it was my task to do something so that this vanishing world did not sink completely into oblivion."

VERSCHWUNDENE WELT

Roman Vishniac (geb. 1897 in St. Petersburg) reiste zwischen 1933 und 1939 in die alten Ghettos in Polen und die kleinen *Schtetl* zwischen der Ostsee und den Karpaten. »Warum ich es getan habe? Daß jemand mit versteckter Kamera Bilder aus dem Leben eines Volkes aufgezeichnet hat, das gar nicht fotografiert werden wollte, mag Ihnen verwunderlich erscheinen. War es eine Verrücktheit, in Ländern herumzureisen, in denen ich tagtäglich in Lebensgefahr geriet? (...) Es mußte getan werden. Ich ahnte, daß der nazistische Rassenwahn die Welt bald in Dunkelheit hüllen würde, in der sich niemand bewogen fühlte, das leidvolle Leben seiner Glaubensbrüder aufzuzeichnen. (...) Ich wußte, daß es meine Aufgabe war, etwas dafür zu tun, daß diese verschwundene Welt nicht ganz der Vergessenheit anheimfallen würde.«

UN MONDE DISPARU

Roman Vishniac (né en 1897 à St-Pétersbourg) parcourut de 1933 à 1939 les ghettos polonais et les *schtetls* qui existaient encore entre la mer Baltique et les Carpates. « Pourquoi j'ai fait cela ? Que quelqu'un ait pris, à l'aide d'un appareil-photo caché, des images d'un peuple qui ne souhaitait pas être photographié, cela peut vous sembler étrange. Etait-ce une folie de voyager dans des pays où je mettais quotidiennement ma vie en danger ? (...) Cela devait être fait. Je me doutais que la frénésie raciste des nazis allait bientôt plonger le monde dans une obscurité où plus personne ne serait en mesure de témoigner par des images des souffrances de ses correligionnaires. (...) Je savais qu'il était de mon devoir de faire quelque chose pour que ce monde disparu ne soit pas tout à fait la proie de l'oubli. »

1 ROMAN VISHNIAC 1938

(2) The death rate in the Warsaw ghetto grew daily. As there were not enough coffins, the dead were taken away on open-frame wooden handcarts. (1) This photograph of the Vienna ghetto dates from 1938. An old man is softening stale bread. After the annexation of Austria by Germany the situation also worsened for Jews here.

(2) Die Todesrate im Warschauer Ghetto wuchs täglich. Da es nicht genügend Särge gab, wurden die Toten auf Leiter-wagen fortgeschafft. (1) Dieses Foto stammt aus dem Ghetto in Wien, 1938. Ein alter Mann weicht altes Brot auf. Nach dem Anschluß Österreichs an Deutschland verschärfte sich die Situation für Juden auch hier.

(2) Le nombre des morts dans le ghetto de Varsovie aug-mentait chaque jour. Comme il n'y avait pas suffisamment de cercueils, les morts étaient emportés sur des charettes à ridelles. (1) Le ghetto de Vienne, 1938. Un vieil homme passe du pain rassis sous l'eau pour l'amollir. Après l'annexion de l'Autriche à l'Allemagne, la situation des Juifs s'aggrava, là aussi.

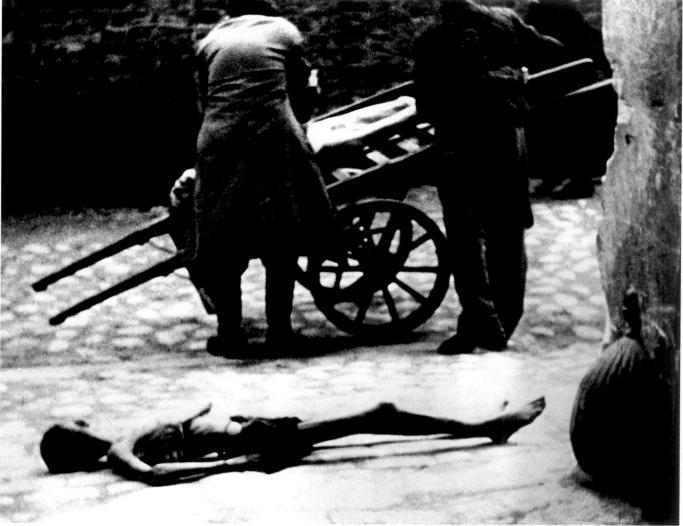

2 ROMAN VISHNIAC 1938

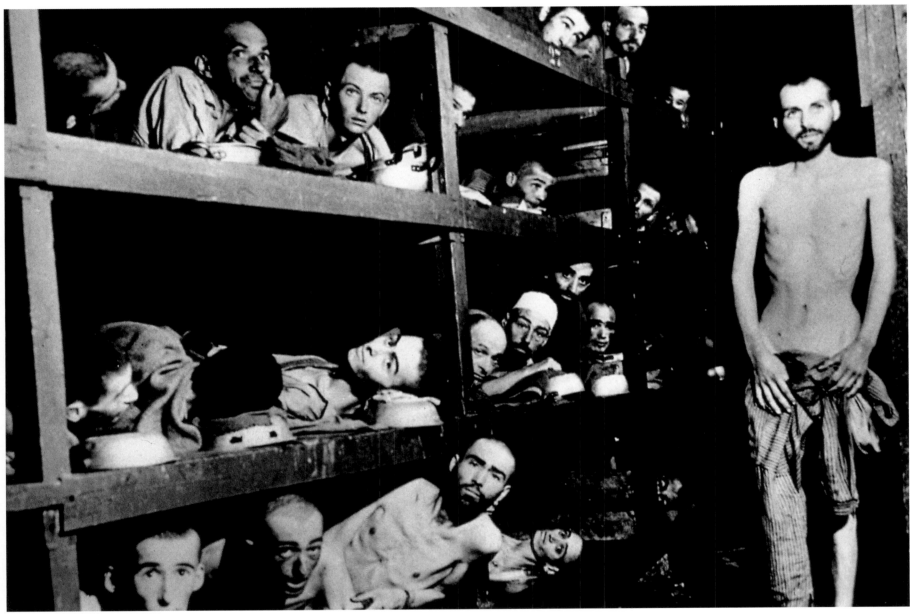

3 N.N. 1945

THE HOLOCAUST

The National Socialists turned their racial mania into a systematic plan at the Wannsee Conference in January 1942. They murdered over 6 million Jews from all over Europe in concentration camps. The Allied liberators were confronted by a human abyss in Dachau. According to American war reporters the survivors mostly answered the question "What now?" with only one word: "Palestine" (3).

DER HOLOCAUST

Auf der Wannseekonferenz im Januar 1942 formten die Nationalsozialisten ihren Rassenwahn zu einem systematischen Plan. In den Konzentrationslagern ermordeten sie über 6 Millionen Juden aus ganz Europa. Auch in Dachau tat sich den alliierten Befreiern ein menschlicher Abgrund auf. Amerikanischen Kriegsberichterstattern zufolge antworteten die Überlebenden auf die Frage: »Was nun?« meist nur mit einem Wort: »Palästina« (3).

LE GENOCIDE

C'est à la conférence de Wannsee, en janvier 1942, que le racisme délirant des nazis prit la forme d'une extermination systématique. Dans les camps de concentration, ils assassinèrent plus de 6 millions de Juifs venus de toute l'Europe. A Dachau, à la fin de la guerre, les libérateurs américains crurent voir s'ouvrir un abîme. A la question « et maintenant ? » posée par les correspondants de guerre américains, les survivants répondaient : « En Palestine » (3).

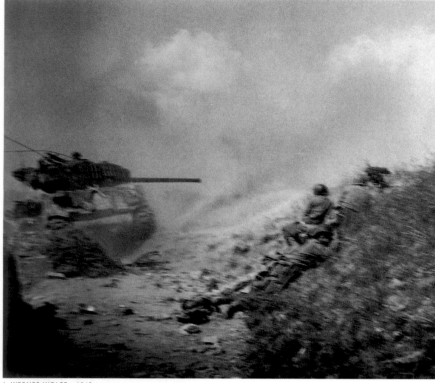

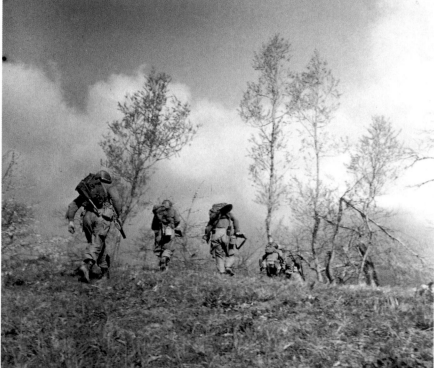

1 WERNER WOLFF 1945

2 WERNER WOLFF 1945

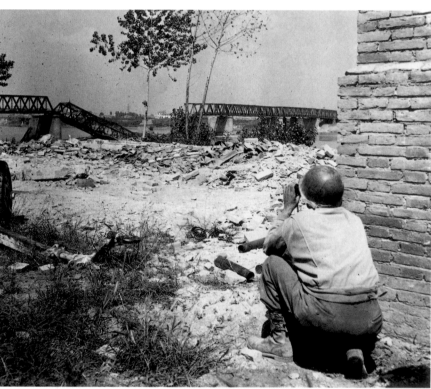

3 WERNER WOLFF 1945

4 WERNER WOLFF 1945

THE ADVANCE OF THE 88TH DIVISION THROUGH ITALY

The Apennine Front, winter 1944–45. (Previous double page) The 5th Army during its advance on Bologna enters a city which had been totally destroyed, showing the evidence of the determined resistance and heavy losses of the German Army. (5) The mud in the Apennines in winter 1944 slowed down the Allied advance considerably. (1–4) Units of the 88th Division during the battle around the Po Bridge between Rovere and East Liguria in spring 1945.

DER VORMARSCH DER 88. DIVISION DURCH ITALIEN

Apenninfront, Winter 1944/45. (Vorhergehende Doppelseite) Die 5. Armee zieht auf dem Vormarsch nach Bologna in eine total zerstörte Stadt ein, die von dem heftigen und verlustreichen Widerstand der deutschen Wehrmacht zeugt. (5) Der Schlamm in den Apenninen im Winter 1944 behinderte den Vormarsch der Alliierten erheblich. (1–4) Einheiten der 88. Division während der Schlacht um die Po-Brücke zwischen Rovere und Ostligurien im Frühjahr 1945.

LA MARCHE DE LA 88ᴱ DIVISION A TRAVERS L'ITALIE

Front des Apennins, hiver 1944/1945. (Double page précédente) La 5ᵉ armée entre dans Bologne. Les ruines témoignent de la résistance acharnée de la ville et des lourdes pertes dans la Wehrmacht. (5) La boue des monts apennins, au cours de l'hiver 1944, entrava considérablement l'avancée des Alliés. (1–4) Printemps 45 : unités de la 88ᵉ division dans la bataille du Pô, entre Rovere et l'est de la Ligurie.

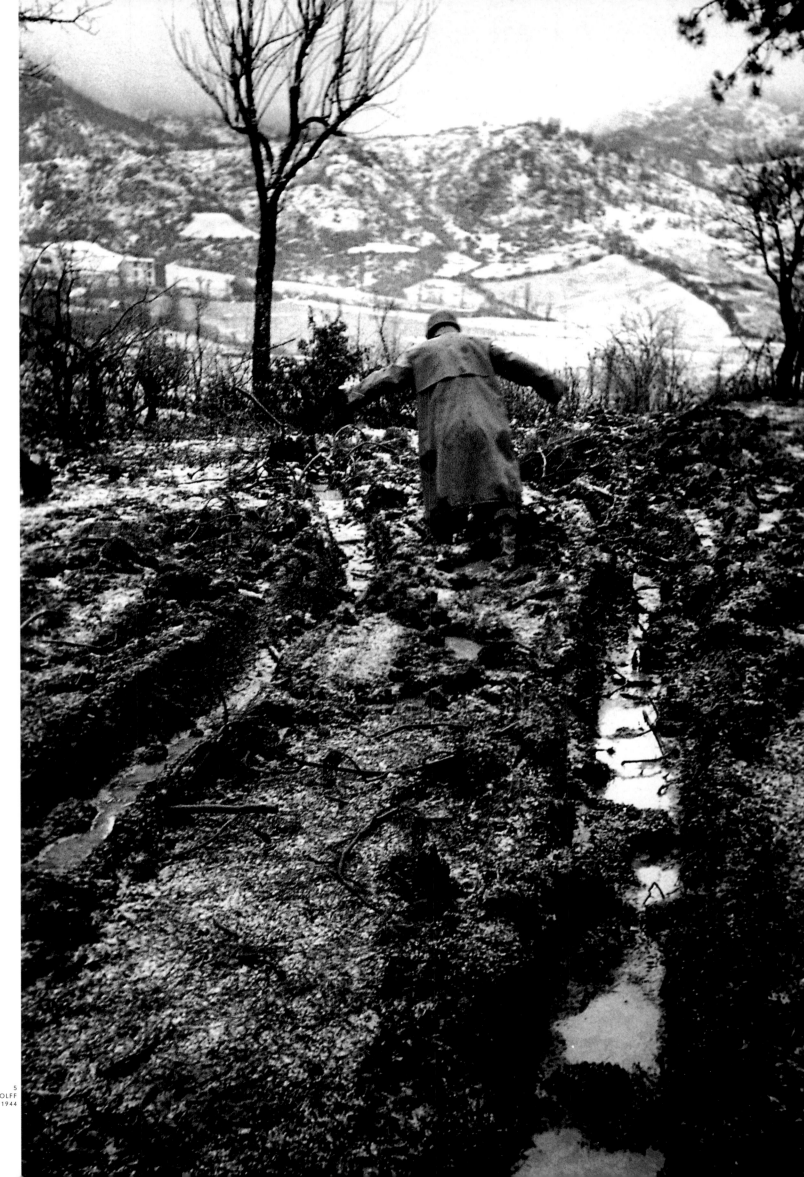

5
WERNER WOLFF
1944

The German émigré Werner Wolff (b. 1916 in Mannheim) started taking photographs when he was very young. In 1936 he fled to New York and quickly found work in the laboratory of the Black Star rival Pix. Here he developed the work of Alfred Eisenstaedt amongst others. After founding his own agency and taking on assignments for *Life* he was declared an enemy alien at the outbreak of war – his camera and his shortwave radio were confiscated. After the USA entered the war, Wolff was nonetheless drafted and was naturalized shortly afterwards. The exile fought in Algeria as a combat soldier in long distance reconnaissance, known as a pigeoneer, and after the invasion of 1943 in Italy against his former countrymen. As chance would have it, the Army magazine *Yank* was looking for a photographer in Italy and Wolff was at hand. "I was constantly on the move, shooting all kinds of stories for the Mediterranean edition." His photo essay shown here tells the story of the advance of the 88th Division during the period from autumn 1944 to spring 1945. For the first time his work is published here in a coherent spread.

Der Emigrant Werner Wolff (geb. 1916 in Mannheim) fotografierte seit frühester Jugend. 1936 floh er nach New York und fand schnell Arbeit im Labor der Black-Star-Konkurrenz Pix. Hier entwickelte er u.a. die Arbeit von Alfred Eisenstaedt. Nach Gründung einer eigenen Agentur und Arbeiten für *Life* wurde er bei Kriegsausbruch zum »feindlichen Ausländer« erklärt – seine Kamera und sein Kurzwellenradio wurden konfisziert. Nach Kriegseintritt der USA bekam Wolff jedoch seine Einberufung und wurde kurz danach eingebürgert. Der Heimatlose kämpfte als Aufkärungssoldat, als *pigeoneer,* in Algerien und nach der Invasion 1943 in Italien gegen seine ehemaligen Landsleute. Der Zufall wollte es, daß das Armee-Magazin *Yank* einen Fotografen in Italien suchte und Wolff zur Stelle war. »Ich war ständig in Bewegung, fotografierte alle Arten von Geschichten für die Mittelmeer-Ausgabe.« Sein hier gezeigter Fotoessay erzählt die Geschichte des Vormarsches der 88. Division in der Zeit vom Herbst 1944 bis Frühjahr 1945. Seine Arbeit wird hier erstmals zusammenhängend publiziert.

L'Allemand Werner Wolff (né en 1916 à Mannheim) s'adonnait à la photographie depuis son plus jeune âge. En 1936, il émigra à New York et trouva bientôt du travail dans le laboratoire de développement d'un concurrent de Black Star, Pix. C'est là qu'il effectua les tirages des travaux d'Alfred Eisenstaedt. Ayant ouvert sa propre agence et travaillé pour *Life,* il fut désigné comme « ennemi étranger » à la déclaration de la guerre. Son appareil-photo et sa radio à ondes courtes furent confisqués. Quand les Etats-Unis s'engagèrent dans la guerre, Wolff fut enrôlé dans l'armée et obtint peu après la citoyenneté américaine. Il combattit comme soldat de reconnaissance en Algérie et après l'invasion de 1943, en Italie, contre ses anciens compatriotes. Le hasard fit que le magazine de l'armée, *Yank,* eut besoin d'un photographe en Italie au moment où Wolff s'y trouvait. « J'étais toujours en mouvement, je faisais toutes sortes de sujets pour l'édition méditerranéenne. » Le reportage présenté ici rapporte l'avancée de la 88ᵉ division, de l'automne 1944 au printemps 1945. Ce travail est publié ici pour la première fois dans un contexte cohérent.

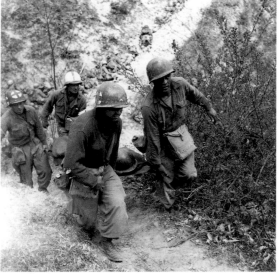

1 WERNER WOLFF 1945

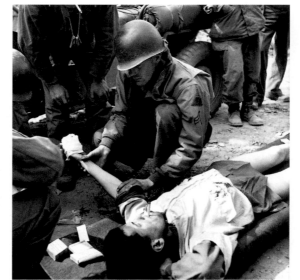

2 WERNER WOLFF 1945

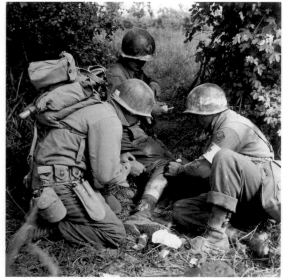

3 WERNER WOLFF 1945

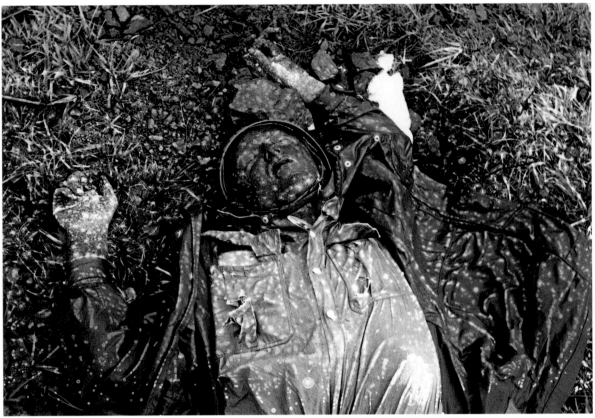

4 WERNER WOLFF 1944

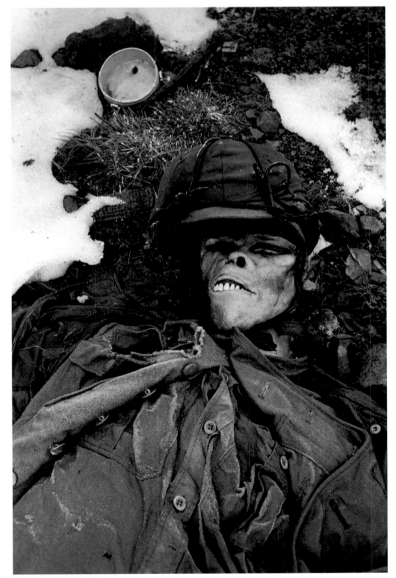

5 WERNER WOLFF 1944

(1–3) Wounded soldiers during the battle in the Po delta in 1945. (4, 5) Winter 1944. Dead German soldiers in the forests of the Apennines.

(1–3) Verwundete Soldaten während der Schlacht im Po-Delta, 1945. (4, 5) Winter 1944. Tote deutsche Soldaten in den Wäldern des Apennin.

(1–3) Soldats blessés dans la bataille du delta du Pô, en 1945. (4, 5) Hiver 1944. Soldats allemands morts dans les forêts apennines.

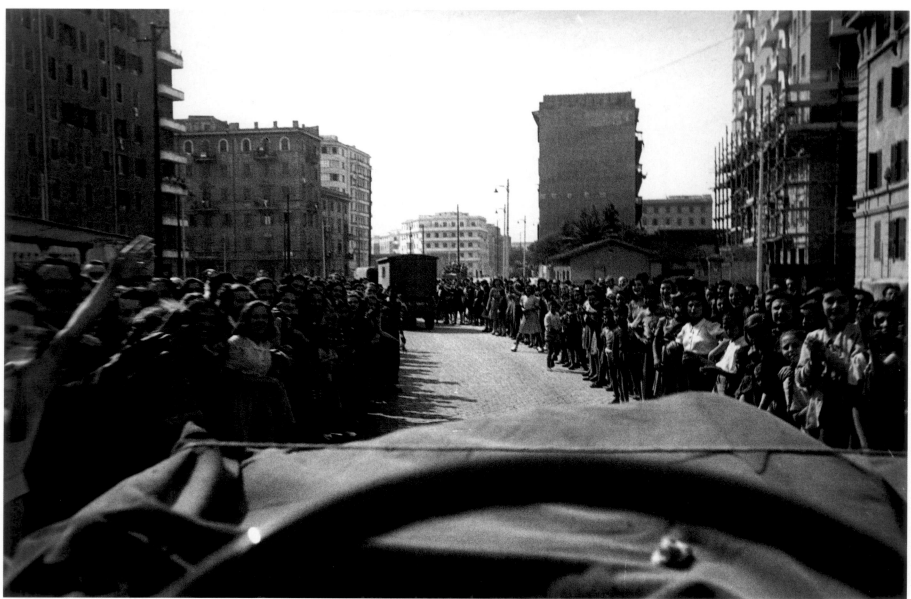

1 WERNER WOLFF 1945

April 1945. Following the successful Allied offensive, the battle which went on for months in the Apennines and around Bologna finally came to an end. On 2 May the German Army capitulated in Italy. (1) American soldiers entering Bologna. (4) 1945. Victors and vanquished. The 88th Division advances, German troops on their way into captivity. (2, 3) Spring 1945. German soldiers are taken captive in Northern Italy. (5) Female members of the Wehrmacht and members of the SS in a PoW camp near Florence.

April 1945. Nach der erfolgreichen alliierten Offensive war die monatelange Schlacht im Apennin und um Bologna endlich beendet. Am 2. Mai kapitulierte die deutsche Wehrmacht in Italien. (1) Hier der Einmarsch der Amerikaner in Bologna. (4) 1945. Sieger und Besiegte. Die 88. Division auf dem Vormarsch, deutsche Truppen auf dem Weg in die Kriegsgefangenschaft. (2, 3) Frühjahr 1945. Gefangennahme deutscher Soldaten in Norditalien. (5) Weibliche Wehrmachtsangehörige und SS-Mitglieder in einem Lager nahe Florenz.

Avril 1945. Après le succès de l'offensive alliée, la bataille, qui a duré des mois entiers dans les Apennins et autour de Bologne, est enfin terminée. Le 2 mai, l'armée allemande capitule en Italie. (1) L'entrée des Américains à Bologne. (4) 1945. Vainqueurs et vaincus. La 88ᵉ division en marche, emmenant des soldats allemands comme prisonniers de guerre. (2, 3) Printemps 1945. Soldats capturés en Italie du Nord. (5) Membres féminins de l'armée allemande et membres des SS dans un camp près de Florence.

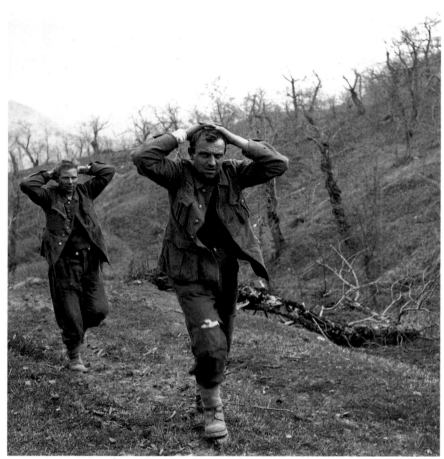

2 WERNER WOLFF 1945

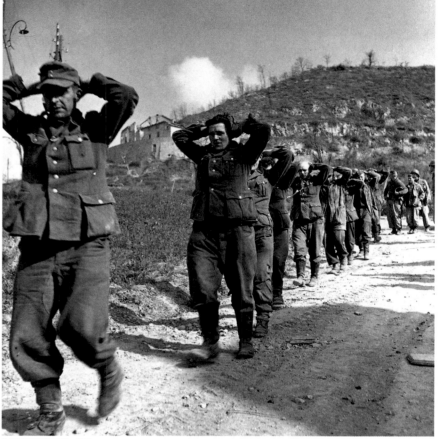

3 WERNER WOLFF 1945

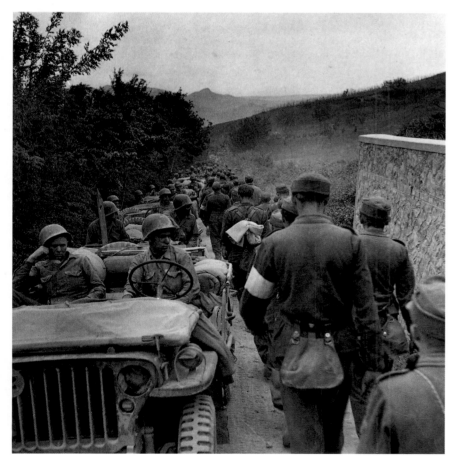

4 WERNER WOLFF 1945

5 WERNER WOLFF 1945

1 WERNER WOLFF 1945

2 WERNER WOLFF 1945

3 WERNER WOLFF 1945

4 WERNER WOLFF 1945

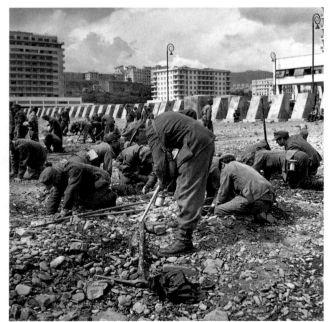

5 WERNER WOLFF 1945

6 WERNER WOLFF 1945

(1, 3, 4, 6) June 1945. The 5th Army internment camp in Ghedi with 70,000 prisoners. The camp had a completely self-sufficient infrastructure. (2) German women soldiers in a camp near Florence. (5) German prisoners recover mines in the harbor at Genoa. (7) May 1945. Following the defeat of fascism the hunt for collaborators began across the whole of Europe. Three Italian women, who had supposedly collaborated with the Germans and whose heads have been shaven as a punishment, "run the gauntlet" in Bologna. (8) Woman mourning at the Ardeatine Caves. It was here that the German Waffen-SS shot 335 Italian men, women and children in revenge for a fatal attack on 35 German policemen in Rome.

(1, 3, 4, 6) Juni 1945. Internierungslager der 5. US-Armee in Ghedi mit 70 000 Gefangenen. Die Lager hatten eine vollkommen eigene Infrastruktur. (2). Weibliche Angehörige der Wehrmacht in einem Lager nahe Florenz. (5) Deutsche Gefangene bergen Minen im Hafen von Genua. (7) Mai 1945. Mit der Niederlage des Faschismus beginnt in ganz Europa die Jagd auf Kollaborateure. Drei Italienerinnen, die mit den Deutschen kollaboriert haben sollen und denen zur Strafe die Köpfe geschoren wurden, bei einem Spießrutenlauf in Bologna. (8) Trauernde Frau in den Ardeatinischen Höhlen. Hier erschoß die deutsche Waffen-SS 335 italienische Männer, Frauen und Kinder als Vergeltung für ein tödliches Attentat auf 35 deutsche Polizisten in Rom.

(1, 3, 4, 6) Juin 1945. Camp d'internement de la 5e armée américaine à Ghedi, avec 70 000 prisonniers. Les camps avaient une infrastructure entièrement autonome. (2) Membres féminins de l'armée allemande dans un camp près de Florence. (5) Des prisonniers allemands déminent le port de Gênes. (7) Mai 1945. Avec la défaite du fascisme commence dans toute l'Europe la chasse aux collaborateurs. A Bologne, trois Italiennes censées avoir collaboré avec les Allemands ont la tête rasée en guise de punition et doivent passer ici entre deux haies de curieux. (8) Femme en deuil dans les Fosses ardéatines, où les Waffen-SS ont exécuté 335 hommes, femmes et enfants italiens, en représailles d'un attentat mortel contre 35 policiers allemands à Rome.

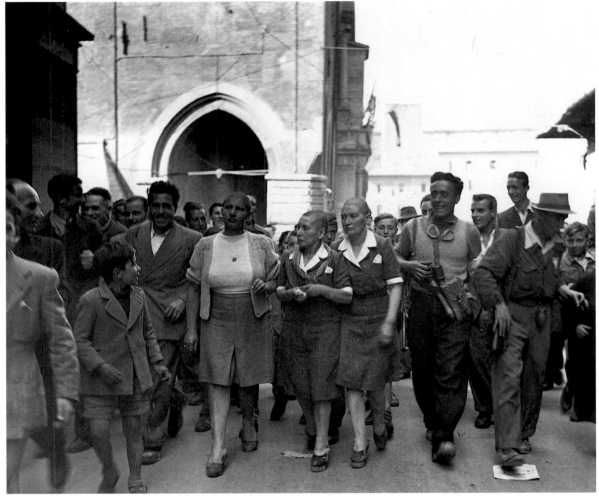

7 WERNER WOLFF 1945

8 WERNER WOLFF 1945

1 WERNER WOLFF 1945

(1) Two war veterans observe the entry of the US 5th Army into Innsbruck. (2) A member of the partisan group responsible for the shooting of Mussolini as he attempted to escape into Switzerland, near Lake Como.

(1) Zwei Kriegsveteranen beobachten den Aufmarsch der 5. US-Armee in Innsbruck. (2) Ein Angehöriger der Partisanengruppe, die Mussolini bei seinem Fluchtversuch in die Schweiz erschoß, in der Nähe des Comer Sees.

2 WERNER WOLFF 1945

(1) Deux vétérans de guerre observent l'avancée de la
5e armée américaine à Innsbruck. (2) Un membre du groupe
de partisans qui fusilla Mussolini près du lac de Côme lors de
sa tentative de fuite en Suisse.

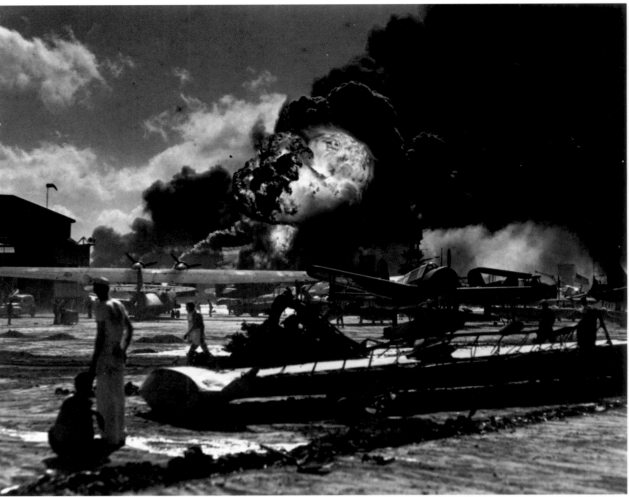

1 U.S. NAVY 7.12.1941

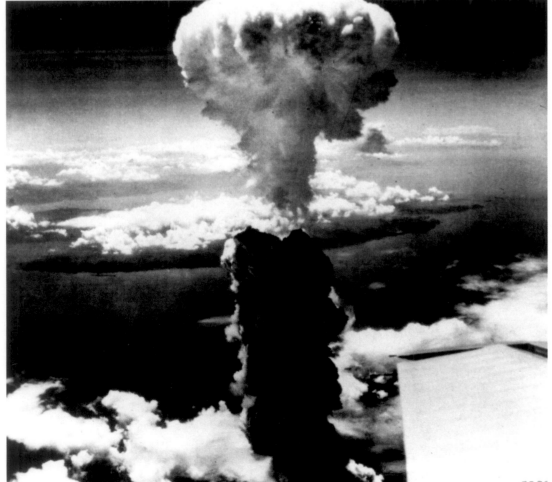

2 U.S. AIR FORCE 9.8.1945

THE SECOND WORLD WAR

(1) Pearl Harbor. This photo of the destruction of the American Pacific Fleet by Japanese bombers shocked a whole nation. The USA declared war. (2) Nagasaki. The end of the war in Asia. The age of the atomic bomb in the media begins with the pictures from Hiroshima and Nagasaki. (3) The Western Front in spring 1945. British soldiers fighting German soldiers in Arnhem. In the background the burning city center which had been set alight by the German Army.

DER ZWEITE WELTKRIEG

(1) Pearl Harbor. Dieses Foto von der Zerstörung der amerikanischen Pazifik-Flotte durch japanische Bomber schockte eine ganze Nation. Die USA erklären ihren Kriegseintritt. (2) Nagasaki. Kriegsende in Asien. Das Zeitalter der Atombombe beginnt in der Öffentlichkeit mit den Bildern aus Hiroshima und Nagasaki. (3) Die Westfront im Frühjahr 1945. Britische Soldaten im Kampf mit deutschen Soldaten in Arnheim. Im Hintergrund das brennende Stadtzentrum, das von der deutschen Wehrmacht in Brand gesetzt wurde.

LA DEUXIEME GUERRE MONDIALE

(1) Pearl Harbor. Toute l'Amérique fut ébranlée par cette image de la destruction de sa flotte du Pacifique par les bombardiers japonais. Les Etats-Unis entrèrent en guerre. (2) Nagasaki. Fin de la guerre en Asie. L'ère atomique commence officiellement avec les images de Hiroshima et Nagasaki. (3) Le front de l'Ouest au printemps 1945. Soldats britanniques en lutte contre des soldats allemands à Arnhem. A l'arrière-plan, le centre de la ville mis en flammes par l'armée allemande.

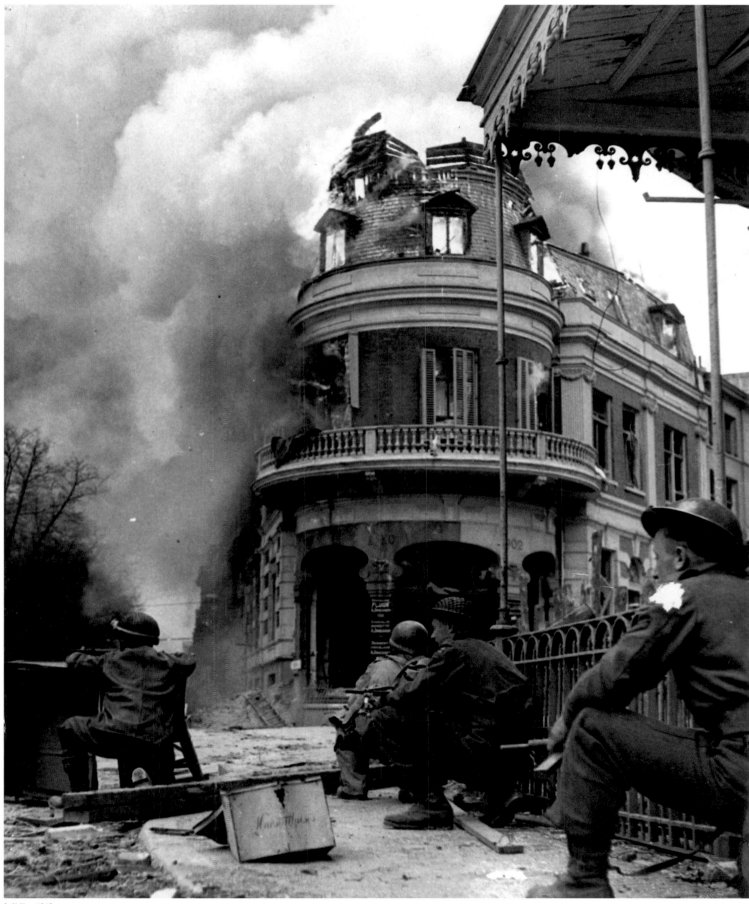

3 N.N. 1945

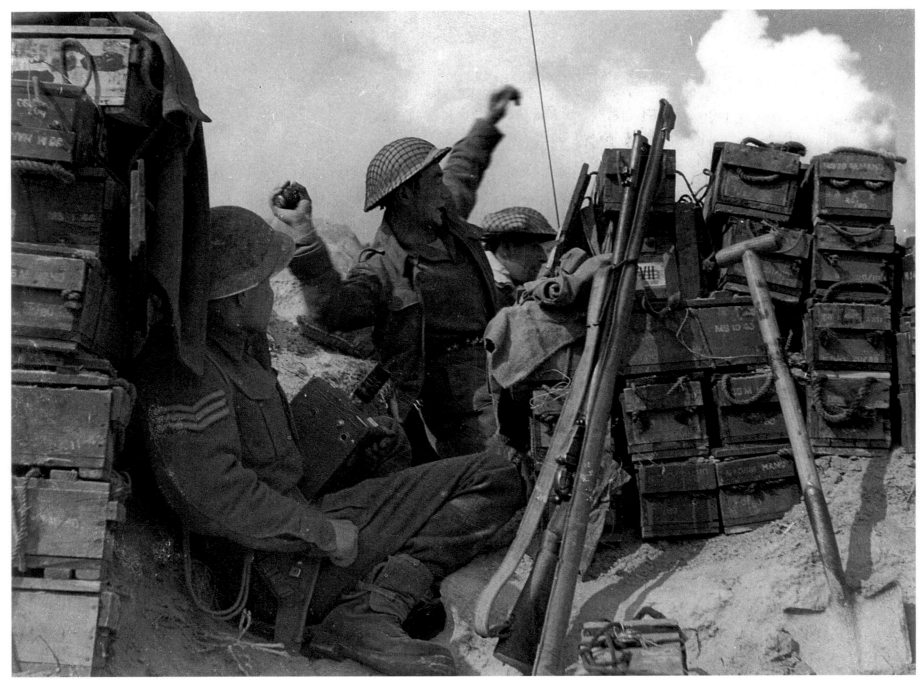

1 N.N. 1945

(1) British infantrymen led the final assault on a German Army bridgehead on the Northern Italian river Senio. (3) Allied soldiers and French resistance fighters pushed the German Army further and further back. After the first exchanges of fire between French resistance fighters and German occupying troops Paris was liberated on 19 August 1944 with hardly any struggle or destruction. (2) The Netherlands suffered under occupation until the unconditional surrender of the Germans on 8 May 1945. Only then did German Army soldiers give themselves up, as here in Utrecht.

(1) Britische Infanteristen führten die letzten Kämpfe gegen einen Brückenkopf der deutschen Wehrmacht am norditalienischen Fluß Senio. (3) Alliierte Soldaten und französische Widerstandskämpfer drängten die deutsche Wehrmacht immer weiter zurück. Nach ersten Schießereien zwischen Résistance-Kämpfern und Besatzungssoldaten wurde Paris am 19. August 1944 mehr oder weniger kampflos und ohne Zerstörungen befreit. (2) Die Niederlande litten bis zur bedingungslosen Kapitulation der Deutschen am 8. Mai 1945 unter der Besatzung. Erst dann ergaben sich die Wehrmachtsoldaten, wie hier in Utrecht.

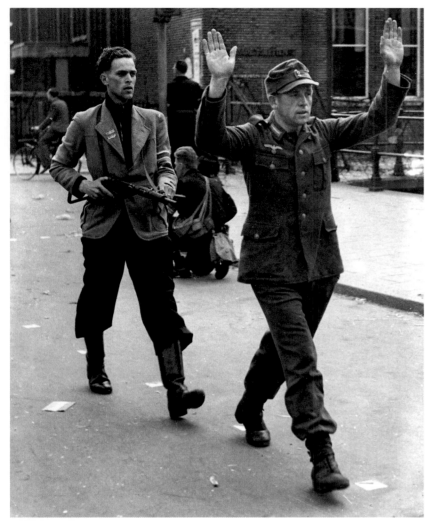

2 N.N. 1945

(1) Les soldats de l'infanterie britannique mènent les derniers combats contre une tête de pont de l'armée allemande sur le fleuve Senio, en Italie du Nord. (3) Les soldats alliés et les combattants de la Résistance française repoussent l'armée allemande de plus en plus loin. Le 19 août 1944, Paris est libéré presque sans combats et sans dégâts aux premiers échanges de tirs entre résistants et soldats d'occupation.
(2) Les Pays-Bas eurent à subir l'occupation jusqu'à la reddition sans conditions de l'Allemagne, le 8 mai 1945. Alors seulement, les soldats allemands rendirent les armes, comme ici à Utrecht.

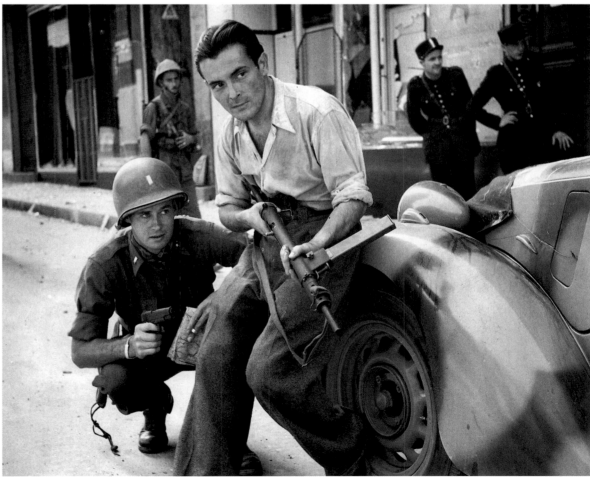

3 N.N. 1944

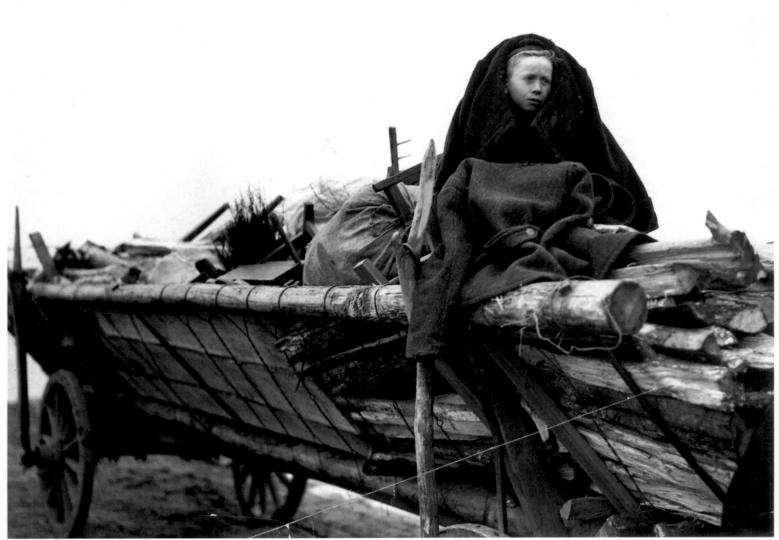

1 JOHN FELIX VACHON 1939

2 N.N. 1940

(1) On 1 September 1939 German troops marched into Poland. Large numbers of Polish civilians fled before the occupying forces to East Prussia. (2) The battle for Norway. German bombardment of the Norwegian port and ore transhipment site of Narvik in April 1940. (3) The battle in the skies over England also affected the population of the countryside. The children of English hop-pickers watch the sky from a protective ditch in the middle of a field. Their parents would only retreat to the ditch at the last minute so that they could continue working for as long as possible.

(1) Am 1. September 1939 marschierten die deutschen Truppen in Polen ein. Große Teile der polnischen Zivilisten flohen vor den Besatzern nach Ostpreußen. (2) Der Kampf um Norwegen. Deutsches Bombardement auf den norwegischen Hafen und Erzumschlagplatz Narvik im April 1940. (3) Der Luftkrieg um England traf auch die Landbevölkerung. Die Kinder englischer Hopfen-Pflücker beobachten den Luftraum aus einem Schutzgraben mitten auf einem Feld, in den sich ihre Eltern immer erst in letzter Minute vor den Angriffen zurückzogen, um so lange wie möglich pflücken zu können.

(1) Le 1er septembre 1939, les troupes allemandes entrent en Pologne. De grandes parties de la population polonaise fuient vers la Prusse orientale. (2) La guerre en Norvège, avril 1940 : les Allemands bombardent Narvik, port norvégien et centre d'exportation de minerais. (3) La guerre aérienne qui se livrait au-dessus de l'Angleterre atteignit également la population rurale. Des enfants des cueilleurs de houblon anglais observent l'espace aérien depuis une tranchée au milieu d'un champ. Les parents ne s'y réfugiaient qu'à la dernière minute avant l'attaque, afin de poursuivre leur cueillette aussi longtemps que possible.

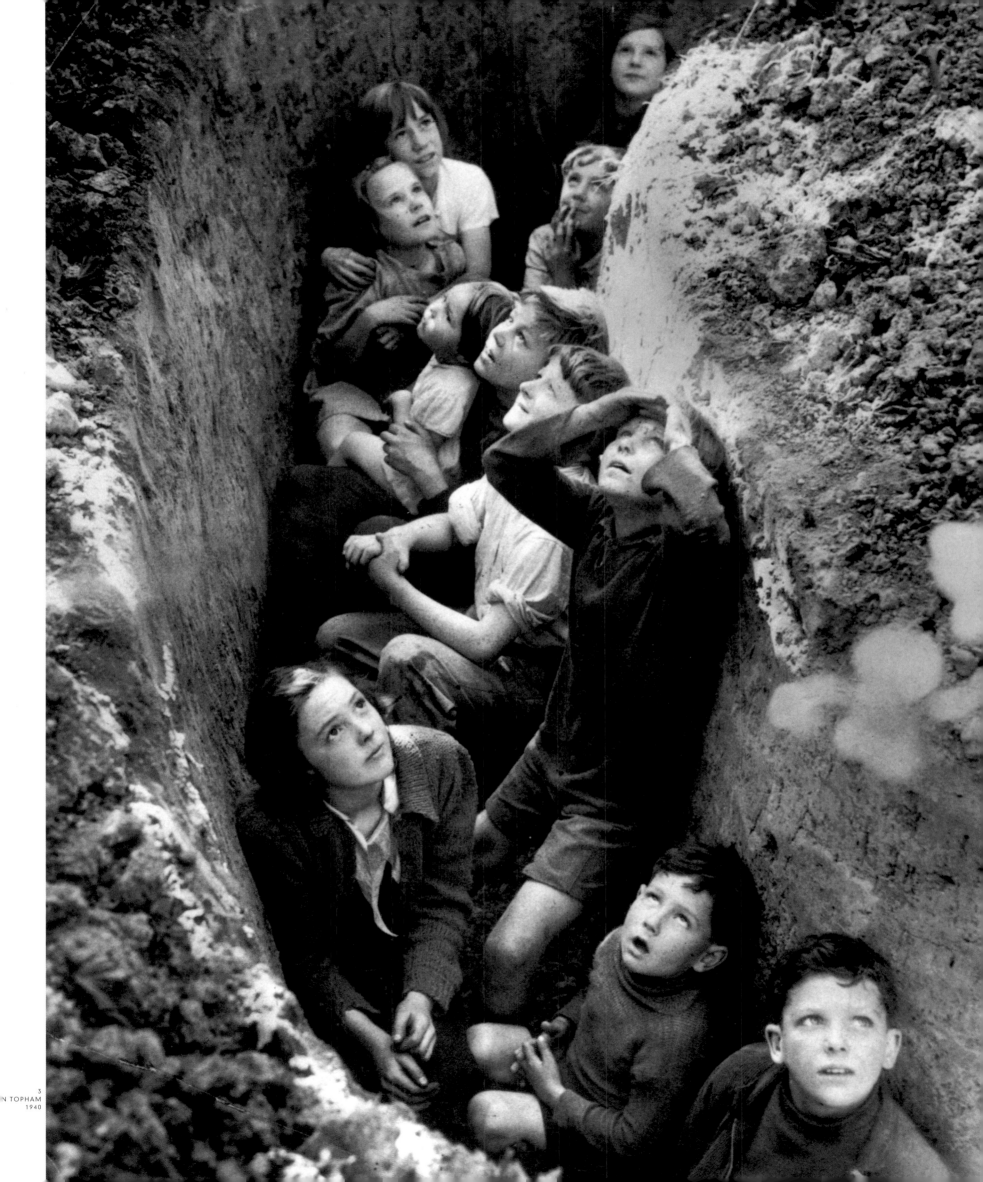

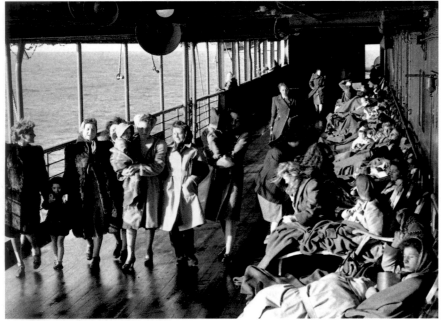

1 SAIDMAN 1945

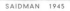

2 N.N. 1946

(1) For the duration of the conflict the route across the Atlantic offered the only way out of a Europe at war. British women and children who want to visit their husbands in the USA on board the steamer Argentina. (3) On the American home front many things from normal everyday life were lacking, for example silk and nylon stockings. (2) May 1946. Two pillars of the British war effort against Hitler pay their mutual respects – ex-Prime Minister Winston Churchill and the Guard of Honour of Civil Defence and the Home Guard.

(1) Der Seeweg über den Atlantik bot während des gesamten Krieges den einzigen Ausweg aus dem umkämpften Europa. Britische Frauen und Kinder, die ihre Männer in den USA besuchen wollen, auf dem Dampfer Argentina. (3) An der amerikanischen Heimatfront fehlten auf einmal viele Dinge des sonstigen Alltags, wie z.B. hier Seiden- und Nylonstrümpfe. (2) Mai 1946. Zwei Säulen des britischen Widerstands gegen Hitler geben sich gegenseitig die Ehre – Winston Churchill, Premierminister a.D., und die Guard of Honour of Civil Defence und die Home Guard.

(1) La traversée de l'Atlantique resta durant toute la guerre la seule issue permettant d'échapper aux combats qui embrasaient l'Europe entière. Femmes britanniques avec leurs enfants, en route pour rejoindre leurs époux aux Etats-Unis, sur le vapeur Argentina. (3) En Amérique, il y avait pénurie ; des choses du quotidien manquaient soudain, comme par exemple des bas en soie ou en nylon. (2) Mai 1946. Deux piliers de la résistance britannique contre Hitler : Winston Churchill, ancien premier ministre, et la Guard of Honour of Civil Defence et la Home Guard.

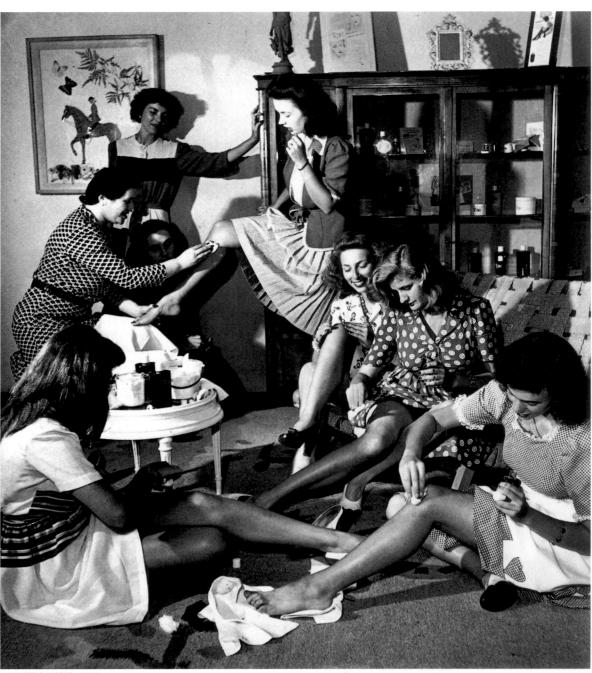

3 WALTER SANDERS 1942

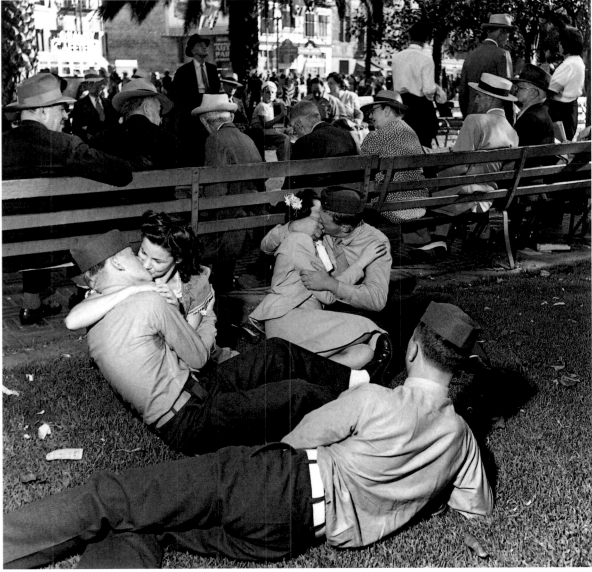

4 RALPH CRANE 1945

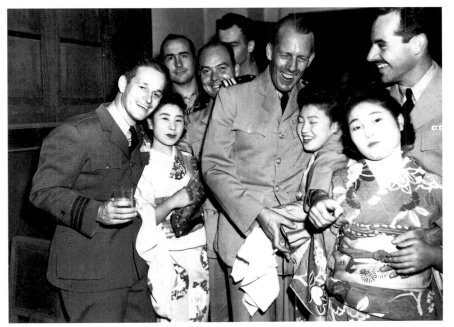

5 N.N. 1945

(4) Celebrating on the day of the American victory – V-Day in Los Angeles. (5) The occupiers and the vanquished – American soldiers of occupation in Japan.

(4) Der Tag der amerikanischen Siegesfeier – V-Day in Los Angeles. (5) Besatzer und Besiegte – amerikanische Besatzungssoldaten in Japan.

(4) La fête de la victoire en Amérique; V-Day à Los Angeles. (5) Occupants et vaincus. Soldats d'occupation américaine au Japon.

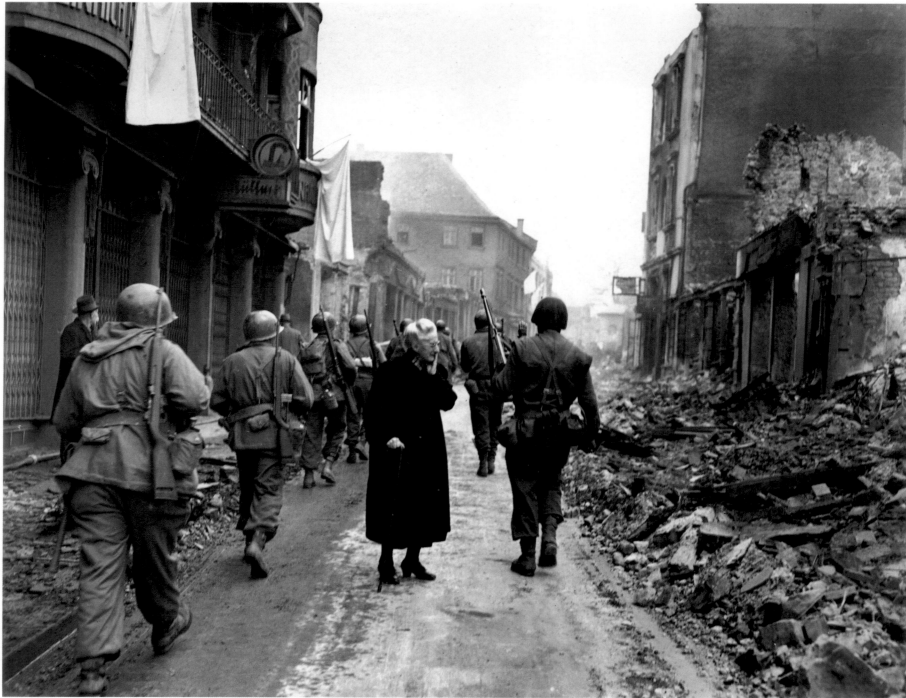

(1) Germany shortly before the final collapse. Up until the
end of March 1945 the front ran along the Rhine.

(1) Deutschland kurz vor dem endgültigen Zusammenbruch.
Bis Ende März 1945 verlief die Front entlang des Rheins.

(1) L'Allemagne, peu avant l'effondrement final. Jusqu'à la
fin mars 1945, le front se déroula le long du Rhin.

(2) Documentary film footage from concentration camps was shown to the Germans in internment camps. (3) German war criminals on trial in Nuremberg. Black Star sold this photograph under the title "The greatest trial in history opens."

(2) In den Internierungslagern wurden den Deutschen dokumentarische Filmszenen aus Konzentrationslagern gezeigt. (3) Die deutschen Kriegsverbrecher in Nürnberg vor Gericht. Black Star verkaufte dieses Bild unter der Überschrift: »Der größte Prozeß der Geschichte eröffnet.«

(2) Dans les camps d'internement, on montrait aux Allemands des films tournés dans les camps de concentration. (3) Les criminels de guerre allemands devant le tribunal de Nuremberg. Black Star vendit cette photo sous le titre : « Ouverture du plus grand procès de l'histoire ».

2 JACK GOULD 1945

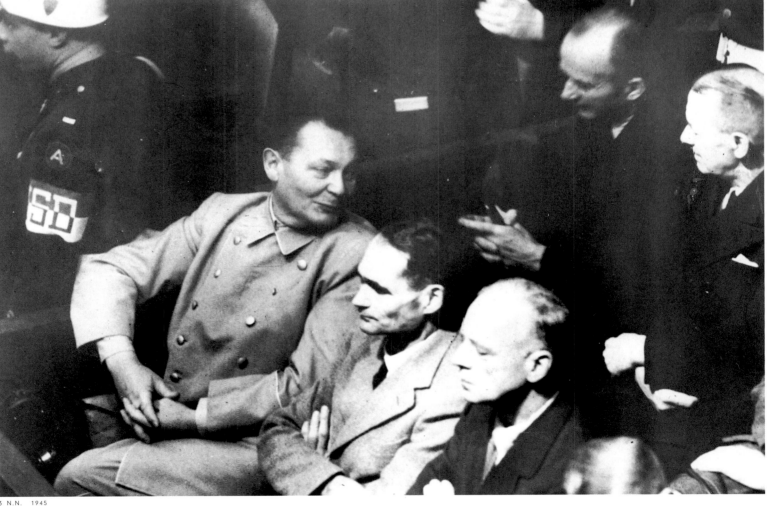

3 N.N. 1945

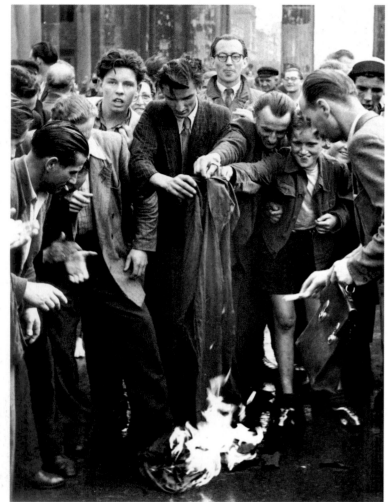

1 KURT BREKER 1953

PEOPLE'S UPRISING IN THE GDR

(2) The strike launched by East Berlin's construction workers against sharp increases in workquotas turned into a general uprising against the SED government and rapidly spread across the whole of the Republic. On the morning of 17 June 1953 some 10,000 demonstrators gathered in front of the House of Ministries on Potsdamer Platz and at 1.30 pm a state of emergency was declared in East Berlin. (1) Demonstrating East Berliners burn the Russian flag which two young men had taken from the Brandenburg Gate (in the background).

VOLKSAUFSTAND IN DER DDR

(2) Der Streik der Ost-Berliner Bauarbeiter gegen die Erhöhung der Arbeitsnormen weitete sich schnell zu einem republikweiten Aufstand gegen die SED-Regierung aus. Hier am Potsdamer Platz fanden sich am Vormittag des 17. Juni 1953 10 000 Demonstranten vor dem Haus der Ministerien ein. Um 13.30 Uhr wurde der Ausnahmezustand über den Osten der Stadt verhängt. (1) Ost-Berliner Demonstranten verbrannten die russische Fahne, die zuvor von zwei jungen Männern vom Brandenburger Tor (im Hintergrund) geholt worden war.

SOULEVEMENT POPULAIRE EN RDA

(2) La grève des ouvriers du bâtiment, à Berlin-Est, pour protester contre le durcissement des normes de travail, prit rapidement les dimensions d'un soulèvement dans toute la République démocratique, contre le gouvernement du S.E.D. (Parti socialiste unifié). Sur la Potsdamer Platz, 10 000 manifestants se trouvaient dès le matin du 17 juin 1953 devant le bâtiment des ministères. A 13h30, l'état d'urgence était décrété dans toute la ville. (1) Des manifestants de Berlin-Est brûlent le drapeau soviétique, précédemment amené de la porte de Brandebourg (à l'arrière-plan) par deux jeunes gens.

2
PETER CÜRLIS
1953

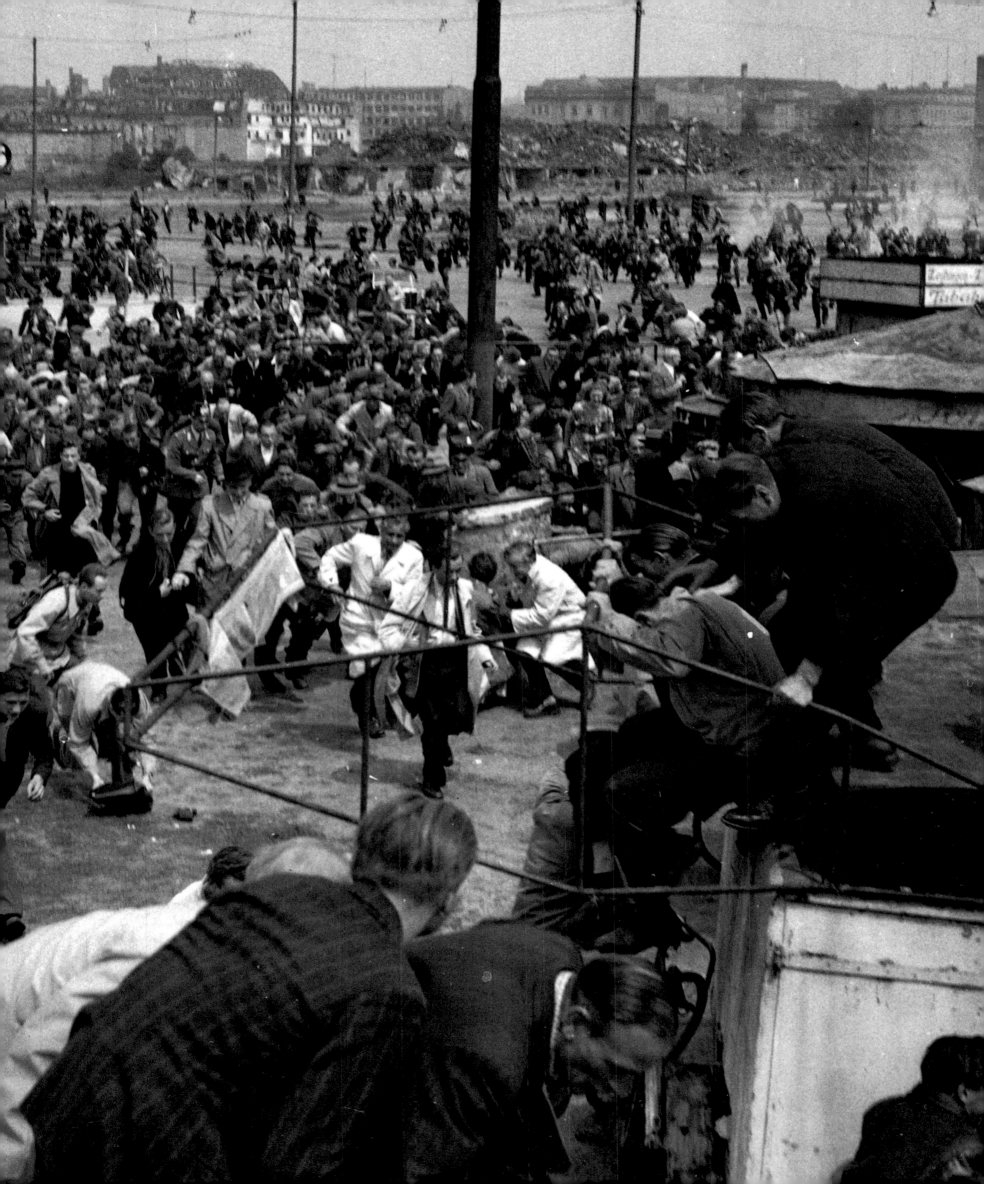

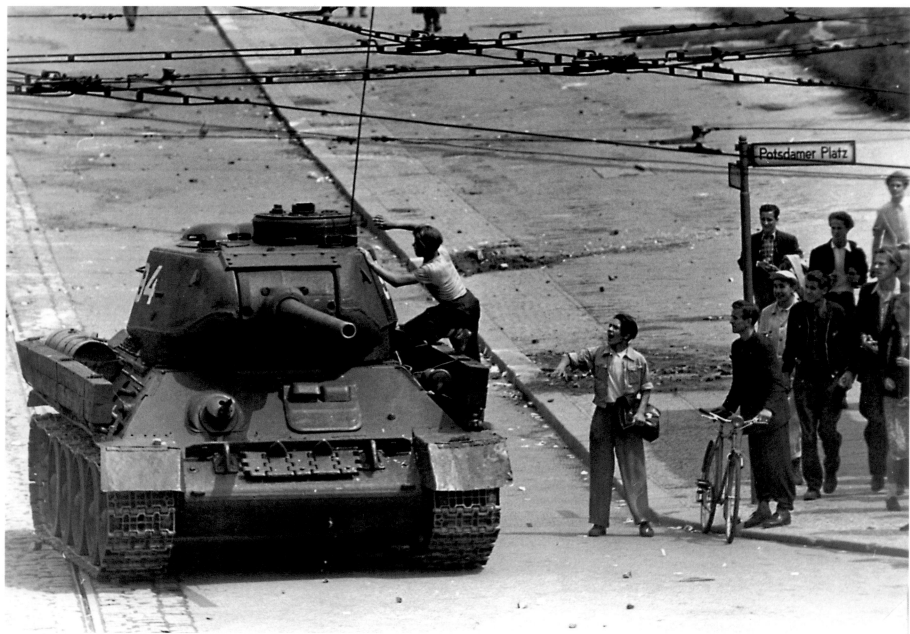

1 PETER CÜRLIS 1953

(1) Demonstrators on Potsdamer Platz succeeded in damaging several Russian tanks by sabotaging tank tracks and gun barrels. It took two days to put down the uprising.

(1) Auf dem Potsdamer Platz gelang es Demonstranten, einige russische Panzer zu beschädigen sowie Laufketten und Geschützrohre zu blockieren. Erst zwei Tage später konnte der Aufstand niedergeschlagen werden.

(1) Sur la place de Potsdam, les manifestants réussirent à endommager quelques chars russes et à bloquer chenilles et canons. Il fallut deux jours aux autorités pour réprimer le soulèvement.

ANTI-COMMUNISM IN THE USA

In the wake of the Cold War anti-Communist prejudices which were widespread in America swelled to become an all-encompassing wave of persecution called McCarthyism. (2) Joseph McCarthy (right) chaired the House Committee on Un-American Activities from 1950 to 1954. After President Eisenhower had exempted members of the army from hearings before the Committee in May 1954, McCarthy suffered his final defeat in the hearings with the army's legal adviser Joseph Welch (left). Shortly afterwards, he was reprimanded by the Senate and stripped of his power. (3) "Stop Stalin" – the liberal participants of the World Peace Conference were meeting behind the doors of the Waldorf Astoria. In front of the hotel radical anti-Communists knelt in prayer against "Communist aspirations to world domination."

ANTIKOMMUNISMUS IN DEN USA

Im Zuge des Kalten Krieges weiteten sich die weitverbreiteten antikommunistischen Vorurteile in Amerika zu einer umfassenden Verfolgungswelle aus, McCarthyism genannt. (2) Joseph McCarthy (rechts) leitete von 1950 bis 1954 den Senatsausschuß für unamerikanische Aktivitäten. Nachdem Präsident Eisenhower im Mai 1954 Armeeangehörige von Anhörungen vor dem Ausschuß freigestellt hatte, erlitt McCarthy seine endgültige Niederlage in den Hearings mit dem Rechtsberater des Heeres, Joseph Welch (links). Kurz danach wurde er vom Senat gerügt und entmachtet. (3) »Stop Stalin« – hinter den Türen des Waldorf Astoria tagten die liberalen Teilnehmer der World Peace Conference. Vor dem Hotel knieten radikale Antikommunisten im Gebet gegen den »kommunistischen Weltherrschaftsanspruch«.

ANTI-COMMUNISME AUX ETATS-UNIS

Dans le sillage de la guerre froide, les préjugés anti-communistes engendrèrent en Amérique une vague de persécutions généralisées, qui prit le nom de maccarthysme. (2) Joseph McCarthy (à droite) dirigea de 1950 à 1954 la commission du Sénat contre les activités antiaméricaines. Le président Eisenhower ayant refusé que la commission procède à l'audition de militaires, McCarthy subit son ultime défaite lors des audiences du conseiller juridique de l'armée, Joseph Welch (à gauche). Peu après, il reçut le blâme du Sénat et fut destitué. (3) « Stop Stalin » – derrière les portes de l'hôtel Waldorf Astoria avait lieu la séance des libéraux à la Conférence mondiale pour la paix. Devant l'hôtel, des anti-communistes radicaux s'agenouillent pour prier contre « l'aspiration communiste à dominer le monde ».

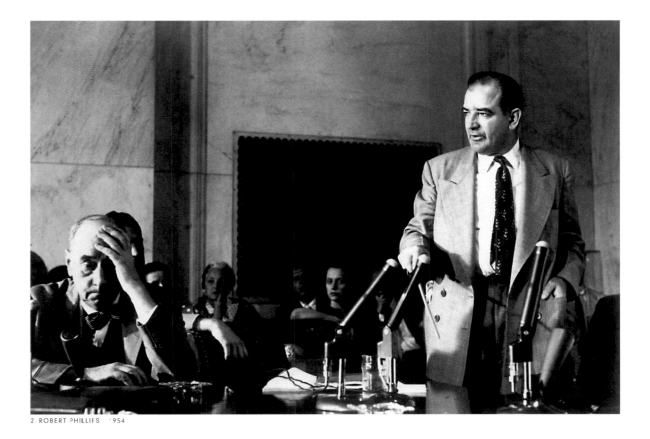

2 ROBERT PHILLIPS 1954

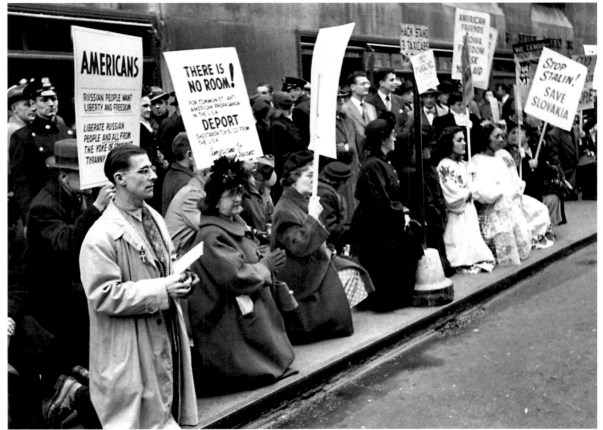

3 JOE COVELLO 1949

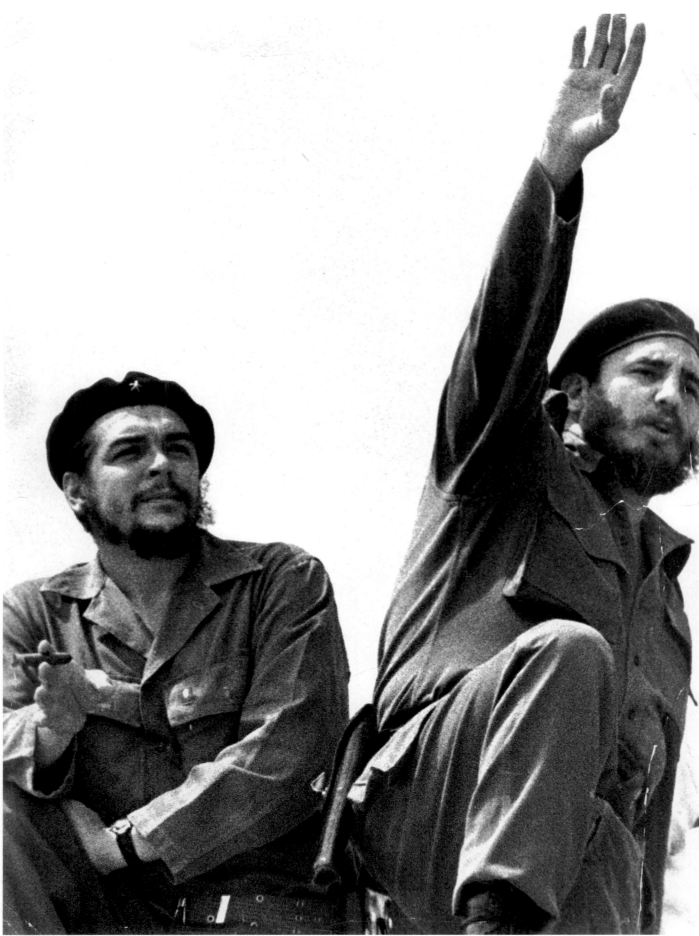

1 OSVALDO SALAS 1959

CASTRO'S CUBA, CUBA'S FIDEL

(1) Ernesto "Che" Guevara (left) and Fidel Castro were key figures in the long drawn out battle for democracy mounted by Cuban guerrillas against the dictatorship of President Fulgencio Batista. The dictator fled Havana on 1 January 1959 and left the island after large numbers of the population had joined the general strike called by Castro the day before. After a short time Guevara turned his back on politics in order to coordinate the guerrilla struggle in Latin America. Castro subsequently established himself as a statesman.

CASTROS KUBA, KUBAS FIDEL

(1) Ernesto »Che« Guevara (links) und Fidel Castro waren die Leitfiguren im jahrelangen Kampf der kubanischen Guerilla für Demokratie gegen die Diktatur des Präsidenten Fulgencio Batista. Der Diktator floh am 1. Januar 1959 aus Havanna und verließ die Insel, nachdem sich weite Kreise der Bevölkerung dem von Castro ausgerufenen Generalstreik am Vortag angeschlossen hatten. Guevara kehrte nach kurzer Zeit der Politik wieder den Rücken zu, um als Anführer den Partisanenkampf in Lateinamerika zu forcieren, Castro etablierte sich in der Folgezeit als Staatsmann.

LE CUBA DE CASTRO, LE FIDEL DE CUBA

(1) Ernesto « Che » Guevara (à gauche) et Fidel Castro furent les figures dirigeantes de la longue guérilla cubaine pour la démocratie, contre la dictature du président Fulgencio Batista. Le 1ᵉʳ janvier 1959, ce dernier s'enfuit de La Havane et quitta l'île, après qu'une grande partie de la population eut suivi le mot d'ordre de grève générale lancé par Castro le matin même. Peu après, Guevara abandonnait le pouvoir pour prendre la tête de la résistance en Amérique latine, tandis que Castro prenait la direction de l'île.

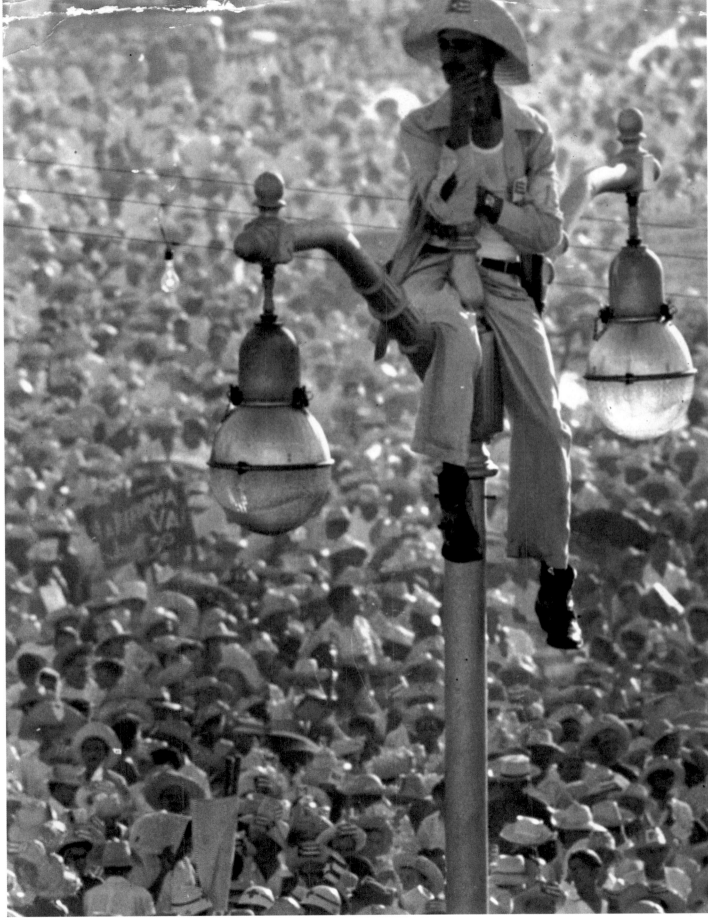

(2) A crowd of people listening to a speech by Castro following his take-over. The journalist Claude Julien, a Castro sympathiser, judged the Cuban revolution as follows: "Fidel Castro's victory was not a real military victory. It was primarily a moral victory of the people."

(2) Menschenmenge bei einer Rede Castros nach der Macht-übernahme. Der Journalist Claude Julien, ein Castro-Sympathisant, beurteilte die kubanische Revo-lution: »Der Sieg Fidel Castros war kein wirklich militärischer Sieg. Er war in erster Linie ein moralischer Sieg des Volkes.«

(2) La foule écoutant un discours de Castro après la prise de pouvoir. Le journaliste Claude Julien, un sympathisant de Castro, jugeait ainsi la révolution cubaine : « La victoire de Fidel Castro n'a pas vraiment été une victoire militaire. Ce fut avant tout une victoire morale du peuple. »

2 KORDA 1959

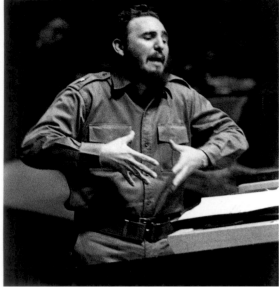

1 WERNER WOLFF 1960

2 LEE LOCKWOOD 1960

3 LEE LOCKWOOD 1964

Lee Lockwood was one of the first journalists to arrive on the island the night before the revolution (2–6). His career as a photojournalist began in Cuba and thanks to his excellent contacts he returned here regularly. (2) The máximo líder celebrated Independence Day 1960 in Las Mercedes with his press officer René Vallejo and the head of the Revolutionary Army, Juan Almeida. (3) Castro, seen here in a cement factory in 1964, would often appear unannounced in the workplace in order to talk directly with the working population. (1) Werner Wolff photographed Castro's first international appearance before the UN General Assembly in New York, 1960. This was the year when Cuba's domestic policy entered its socialist phase. No other statesman was as hated as Castro in the USA because he resisted the temptations of the American way of life so completely.

Lee Lockwood traf als einer der ersten Journalisten am Vorabend der Revolution auf der Insel ein (2–6). Seine Karriere als Bildjournalist begann auf Kuba, und er kehrte aufgrund seiner guten Kontakte immer wieder hierher zurück. (2) Der máximo líder feierte den Unabhängigkeitstag mit seinem Presseoffizier René Vallejo und dem Chef der Revolutionsarmee Juan Almeida in Las Mercedes, 1960. (3) Castro, hier 1964 in einer Zementfabrik, tauchte oft unangemeldet an Arbeitsplätzen auf, um Gespräche mit der arbeitenden Bevölkerung zu führen. (1) Werner Wolff fotografierte den ersten internationalen Auftritt Castros vor der UN-Vollversammlung in New York 1960. Kubas Innenpolitik trat in diesem Jahr in die sozialistische Phase ein. Kein anderer Staatsmann war in den USA so verhaßt wie Castro, weil er den Verlockungen des American way of life so souverän widerstand.

Lee Lockwood fut l'un des premiers journalistes à débarquer sur l'île à la veille de la révolution (2–6). Sa carrière comme photoreporter débuta à Cuba, où ses contacts le firent revenir régulièrement. (2) Le máximo líder célèbre le jour de l'indépendance à Las Mercedes, en compagnie de son officier de presse, René Vallejo, et du chef de l'armée révolutionnaire, Juan Almeida, en 1960. (3) Castro, ici en 1964 dans une cimenterie, surgissait souvent sans prévenir sur des lieux de travail pour discuter avec la population ouvrière. (1) Werner Wolff a photographié la première apparition internationale de Castro, devant l'assemblée plénière de l'ONU à New York, en 1960. La politique intérieure de Cuba entra cette année-là dans sa phase socialiste. Fidel Castro était l'homme politique le plus haï aux Etats-Unis, à cause de sa souveraine indifférence aux séductions de l'American way of life.

4 LEE LOCKWOOD 1959

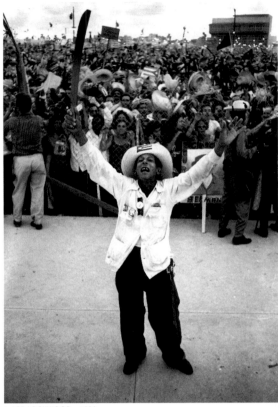

5 LEE LOCKWOOD 1959

6 LEE LOCKWOOD 1959

(4) Liberated political prisoners of the Batista regime celebrate Castro's victory on 1 January 1959 in Havana. Some of them are still wearing parts of their prison uniforms, the weapons come from the central prison El Principe.
(5, 6) 26 July 1959, Havana. Castro declared this day the Independence Day of the "new" Cuba. He had founded the Movement of 26th July in 1956.

(4) Befreite politische Gefangene des Batista-Regimes feierten den Sieg Castros am 1. Januar 1959 in Havanna. Einige von ihnen tragen noch Teile der Gefängnisuniform, die Waffen stammen aus dem Zentralgefängnis El Principe.
(5, 6) 26. Juli 1959, Havanna. Dieser Tag wurde von Castro zum Unabhängigkeitstag des »neuen« Kubas erklärt. 1956 hatte er die Bewegung des 26. Juli gegründet.

(4) 1er janvier 1959 à La Havane, des prisonniers politiques de Batista, libérés, fêtent la victoire de Castro. Quelques-uns d'entre eux portent encore des morceaux de l'uniforme des prisonniers, les armes viennent de la prison centrale d'El Principe. (5, 6) 26 juillet 1959, La Havane. Cette journée fut déclarée par Castro, jour de l'indépendance du « nouveau » Cuba. En 1956, il avait fondé le Mouvement du 26 juillet.

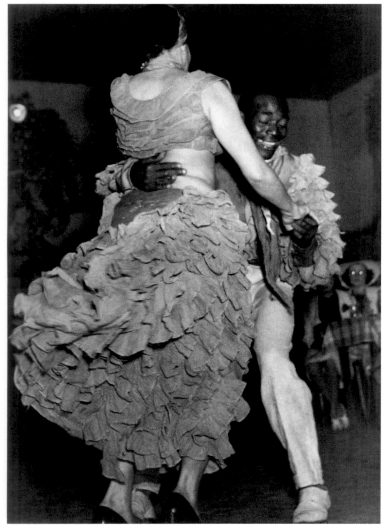

1 VICTOR DE PALMA UNDATED/O.D./S.D.

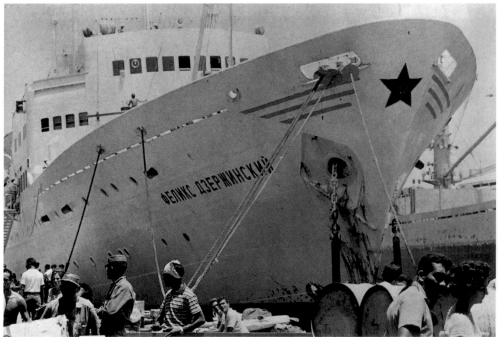

2 LEE LOCKWOOD 1965

3 LEE LOCKWOOD 1965

WAR AND CRISIS

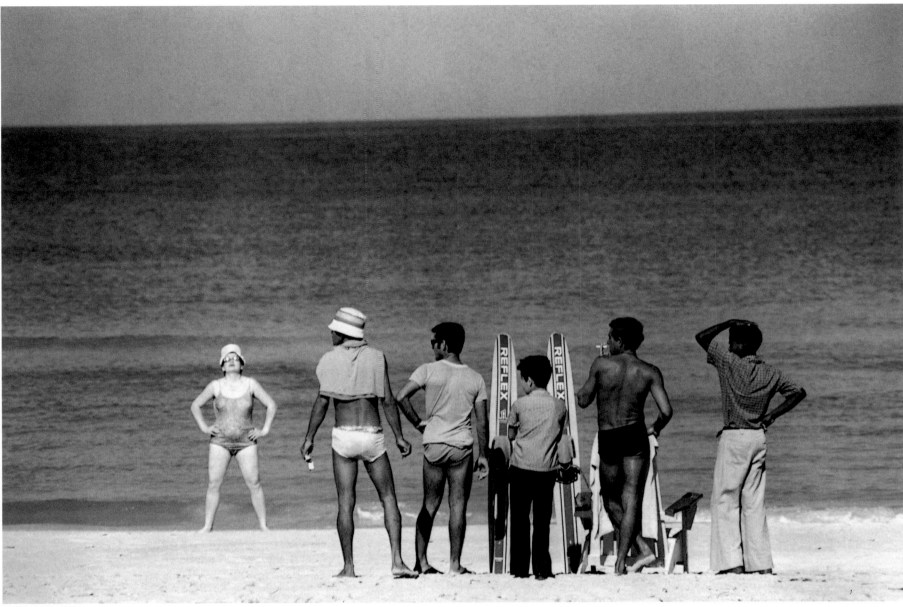

4 FRED WARD 1978

(1) The Caribbean version of communism – the rumba dance as an expression of Cuban joie de vivre. (3) An exclusive photograph for Life magazine by Lee Lockwood – Fidel Castro in a pizzeria with Swiss Ambassador Stadelhofer in October 1965 discussing the flood of Cuban immigrants into the USA. Since the invasion of the Bay of Pigs in 1961 and the Cuban Missile Crisis of 1962 there were no longer any diplomatic relations between Cuba and the USA – the Swiss Embassy looked after American interests on the island. (2) A Soviet ship in Havana, 1965. Cuba's change of direction towards Soviet Communism was complete by 1962. Due to the US trade embargo, the entire economy of the island state was built on support from the Soviet Union. (4) 1978. American tourists and Cubans alike are amused by the Russian style of sunbathing.

(1) Die karibische Variante des Kommunismus – der Rumba-Tanz als Ausdruck kubanischer Lebensfreude. (3) Ein Exklusiv-Foto für das Life-Magazin von Lee Lockwood – Fidel Castro in einer Pizzeria im Gespräch mit dem Schweizer Botschafter Stadelhofer im Oktober 1965 über die kubanische Immigrantenflut in die USA. Seit der Invasion in der Schweinebucht 1961 und der Raketenkrise 1962 existierten keine diplomatischen Beziehungen mehr zwischen Kuba und den USA – die Schweizer Botschaft nahm die amerikanischen Interessen auf der Insel wahr. (2) Ein sowjetisches Schiff in Havanna, 1965. Kubas Hinwendung zum Sowjet-Kommunismus war bis 1962 vollzogen. Die gesamte Wirtschaft des Inselstaates baute seit dem Handelsembargo der USA auf Unterstützung aus der Sowjetunion. (4) 1978. Amerikanische Touristen amüsieren sich gemeinsam mit Kubanern über die russische Art des Sonnenbadens

(1) Le communisme aux Caraïbes … et la rumba, expression de la joie de vivre cubaine. (3) Une photo exclusive de Lee Lockwood pour Life : Dans une pizzeria en octobre 1965, Fidel Castro en conversation avec Stadelhofer, l'ambassadeur helvétique, au sujet du flux d'immigration cubaine aux Etats-Unis. Depuis l'invasion de la baie des Cochons en 1961 et la crise des fusées en 1962, les relations diplomatiques entre Cuba et les USA étaient rompues et l'ambassade helvétique défendait les intérêts américains dans l'île. (2) Un bateau soviétique à La Havane, en 1965. Depuis 1962, Cuba avait définitivement adopté le communisme soviétique. L'ensemble de l'économie de l'Etat insulaire était basé, depuis l'embargo commercial américain, sur le soutien de l'Union soviétique. (4) 1978. Des touristes américains et des Cubains se divertissent ensemble en prenant un bain de soleil à la mode russe.

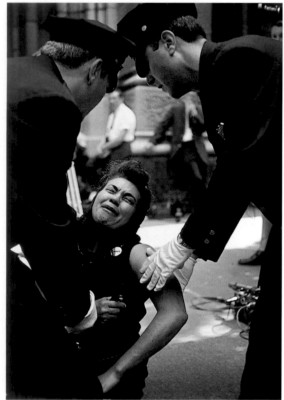

1 N.N. 1963

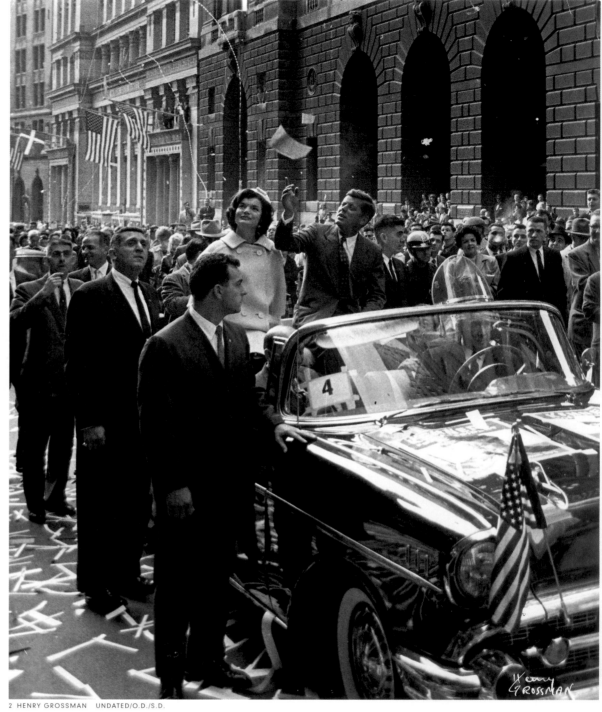

2 HENRY GROSSMAN UNDATED/O.D./S.D.

3 STEVE SCHAPIRO 1965

4 N.N. 1968

THE KENNEDY MYTH

The name Kennedy is inseparable from American history.
(2) John F. Kennedy, seen here with his wife Jacqueline in
New York, became the youngest-ever president of the USA
on 9 November 1960. JFK succeeded in creating a mood of
political awakening in the country. That mood was abruptly
destroyed by his assassination in Dallas on 22 November
1963. (1) The news of the assassination caused mourners to
collapse in the street. (3) Following the murder of his brother,
Robert Kennedy came increasingly into conflict with
presidential successor Lyndon B. Johnson and resigned his
Cabinet office in 1964. As a senator he campaigned against
the Vietnam War and travelled widely abroad. He is shown
here in Peru in 1965. (4) In 1968 he announced his return to
the main political stage by declaring himself a candidate for
the Democratic presidential nomination, and is shown here
during the election campaign on 2nd Avenue in Manhattan.
On 6 June 1968 he also became the victim of an
assassination. In the pictures of the Kennedy brothers the
myth of "another" America in the 1960s lives on.

DER KENNEDY-MYTHOS

Der Name Kennedy ist aus der amerikanischen Geschichte
nicht mehr wegzudenken. (2) John F. Kennedy, hier mit
Ehefrau Jacqueline in New York, wurde am 9. November
1960 zum bisher jüngsten Präsidenten der USA gewählt. JFK
gelang es , eine politische Aufbruchstimmung im Land zu
erzeugen, die durch das Attentat am 22. November 1963 in
Dallas abrupt zerstört wurde. (1) Die Nachricht vom Attentat
ließ Trauernde auf der Straße zusammenbrechen. (3) Nach
der Ermordung seines Bruders geriet Robert Kennedy in
Konflikt mit dessen Nachfolger Lyndon B. Johnson und nahm
1964 seinen Abschied als Justizminister. Als Senator agitierte
er gegen den Vietnamkrieg und unternahm Auslandsreisen,
hier 1965 nach Peru. (4) 1968 meldete er sich als Präsident-
schaftskandidat der Demokraten in der großen Politik zurück,
hier im Wahlkampf auf der 2nd Avenue in Manhattan. Am
6. Juni 1968 wurde auch er Opfer eines Attentats. In den
Bildern der Kennedy-Brüder lebt der Mythos eines »anderen«
Amerika in der 60er Jahren fort.

LE MYTHE KENNEDY

Le nom de Kennedy est intimement lié à l'histoire des Etats-
Unis. (2) Elu le 9 novembre 1960, John F. Kennedy, ici avec
son épouse Jacqueline à New York, était le plus jeune prési-
dent des Etats-Unis jusqu'alors. JFK parvint à donner au pays
une nouvelle impulsion politique, qui fut brisée abruptement
par l'attentat de Dallas, le 22 novembre 1963. (1) La nouvelle
de l'attentat provoqua des crises de nerfs en pleine rue.
(3) Après le meurtre de son frère, Robert Kennedy entra en
conflit avec le successeur de ce dernier, Lyndon B. Johnson,
et rendit en 1964 son portefeuille de ministre. Il fit campagne
en tant que sénateur contre la guerre du Viêtnam et
voyagea à l'étranger. Ici, en 1965, au Pérou. (4) En 1968, il
refit surface comme candidat démocrate à la présidence ;
ici, en campagne à Manhattan, sur la 2ᵉ Avenue. Le 6 juin
1968, il fut à son tour victime d'un attentat. Les frères
Kennedy ont incarné le mythe d'une « autre » Amérique, dont
l'image a survécu aux années 60.

1 ARTHUR RICKERBY 1962

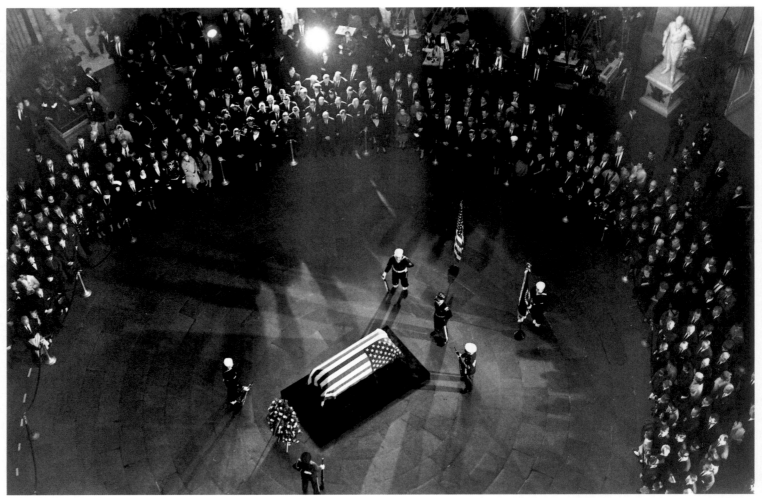

2 FLIP SCHULKE 1963

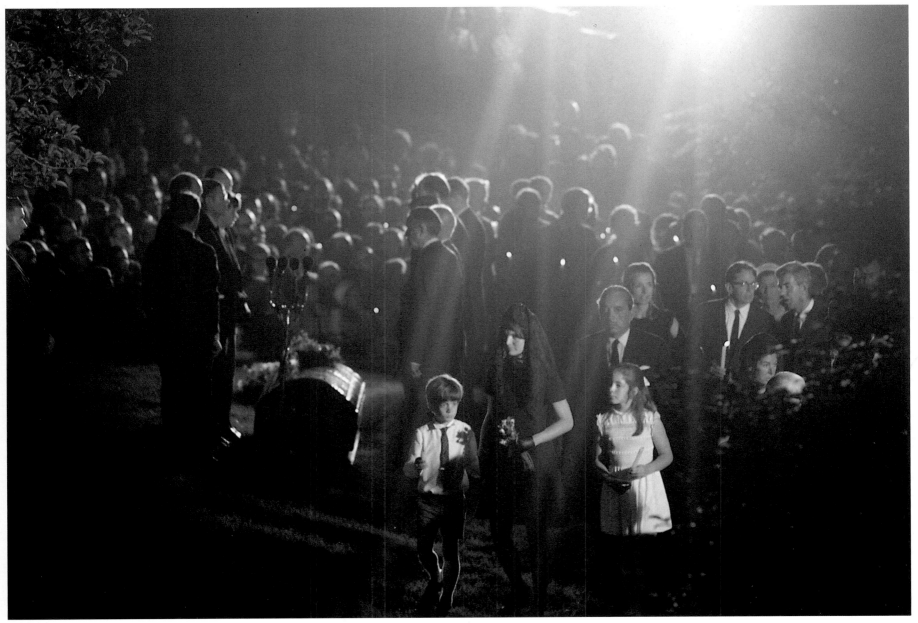

3 DENNIS BRACK 1963

The Kennedy mystique has survived all kinds of revelations and revisionist attacks. The central figure in the creation of this myth was JFK. (1) The words with which he introduced Robert to the office of Attorney General aptly illustrate the family's collective drive for power: "Why shouldn't he gather a bit of legal experience before he enters big business?" (2) The funeral ceremony for JFK in Washington was a world event. In only a very brief period of office JFK generated an unprecedented sense of anticipation with slogans such as "We will get America moving again." In the years since then Kennedy's unfulfilled promise has been turned into a legend by politicians and the media. The exact circumstances of his assassination remain unclear. (3) Kennedy's widow Jacqueline with their children John and Caroline.

Der Kennedy-Mythos überstand alle Enthüllungen und revisionistischen Angriffe. Zentrale Figur der Mythenbildung war JFK. (1) Den Familienwillen zur Macht zeigten die Worte, mit denen er Robert in das Ministeramt einführte: »Warum sollte er nicht ein paar juristische Erfahrungen sammeln, ehe er selbst ins große Geschäft einsteigt?« (2) Die Trauerfeier für JFK in Washington war ein Weltmedienereignis. Nach der kurzen Amtszeit, in der JFK mit Slogans wie: »We will get America moving again« (»Wir setzen Amerika wieder in Gang«) eine bis dato beispiellose Aufbruchstimmung erzeugt hatte, strickten die Politiker und Medien an der Legende von Kennedys unerfülltem Versprechen. Die exakten Umstände des Mordes hingegen blieben unaufgeklärt. (3) Seine Witwe Jacqueline mit ihren Kindern John und Caroline.

Le mythe Kennedy a survécu à toutes les démystifications et à tous les révisionnismes. La figure centrale de ce mythe fut JFK. (1) L'ambition familiale était manifeste dans les paroles par lesquelles il fit entrer son frère Robert dans la fonction ministérielle : « Pourquoi ne rassemblerait-il pas quelques connaissances juridiques avant de passer aux choses sérieuses ? » (2) La cérémonie de deuil, à Washington, après l'assassinat de JFK, fut un événement médiatique mondial. Ce court mandat avait été illustré par des slogans tels que « We will get America moving again » (« Nous remettrons l'Amérique en marche ») et par une activité économique sans exemple jusqu'alors. Les hommes politiques et les médias eurent alors beau jeu de tisser la légende des promesses non tenues de Kennedy. Quant aux circonstances précises du meurtre, elles ne furent jamais éclaircies. (3) Sa veuve, Jackie Kennedy, et leurs enfants, John et Caroline.

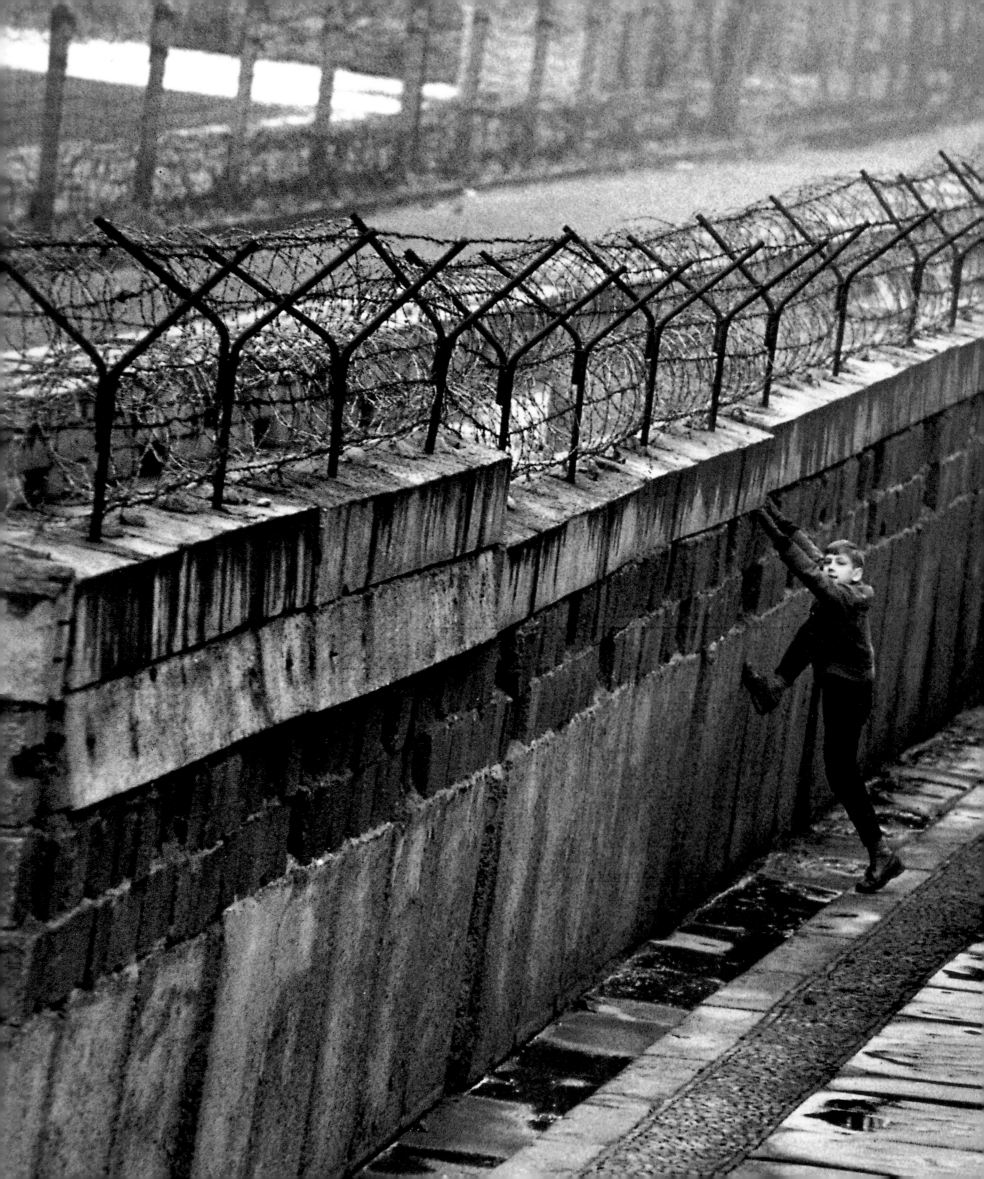

2 FLIP SCHULKE 1961

THE BERLIN WALL

The construction of the Berlin Wall on 13 August 1961 created the symbol of a divided Europe during the Cold War. Black Star photographers provided variations on the theme "The view of the East from the free West".

DIE BERLINER MAUER

Die Errichtung der Berliner Mauer am 13. August 1961 schuf das Symbol für das geteilte Europa im Kalten Krieg. Die Black-Star-Fotografen variierten das Thema »Der Blick vom freien Westen nach drüben«.

LE MUR DE BERLIN

L'édification du mur de Berlin, le 13 août 1961, symbolisa l'Europe divisée par la guerre froide. Variations, par les photographes de Black Star, sur le thème « Regard depuis l'Ouest libre vers l'autre côté ».

1
DOMINIQUE
BERETTY
1961

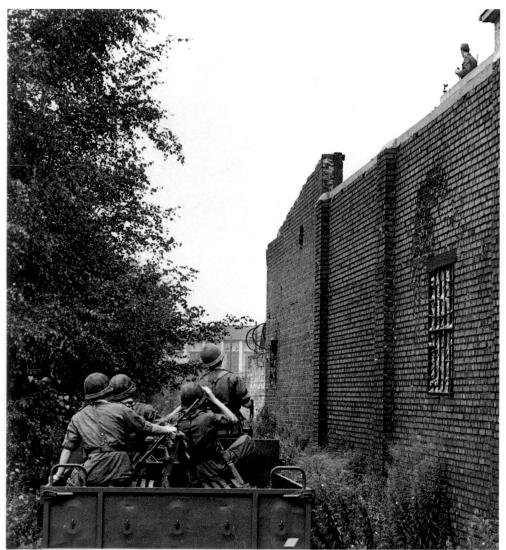

1 DOMINIQUE BERETTY 1961

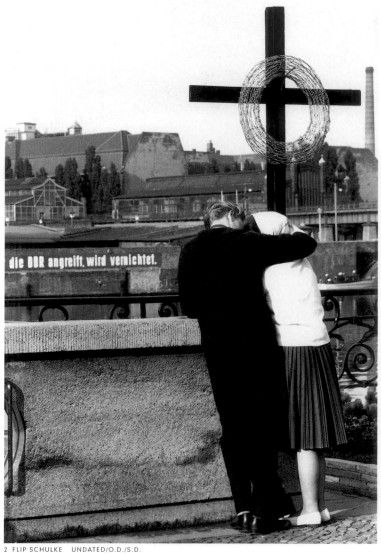

2 FLIP SCHULKE UNDATED/O.D./S.D.

(1) For 28 years, GDR border troops and Allied soldiers faced each other along the Berlin Wall until it crumbled on 9 November 1989. (2) The human tragedy of the division of Germany is reflected in Schulke's picture of a couple in mourning at the Wall against a background of the threatening words "Those who attack the GDR will be destroyed."

(1) 28 Jahre lang standen sich an der Berliner Mauer Grenztruppen der DDR und alliierte Soldaten gegenüber, bis am 9. November 1989 die Mauer fiel. (2) Die menschliche Tragödie der Teilung Deutschlands spiegelt sich in Schulkes Bild vom trauernden Paar an der Mauer vor dem Hintergrund der drohenden Parole: »Wer die DDR angreift, wird vernichtet.«

(1) Pendant 28 ans se firent face les troupes est-allemandes et les soldats alliés, séparés par le mur de Berlin jusqu'à la chute de celui-ci, le 9 novembre 1989. (2) La photographie de Schulke reflète la tragédie humaine de la division de l'Allemagne à travers ce couple désolé devant le mur, sur fond de menace : « Quiconque s'attaque à la RDA sera anéanti. »

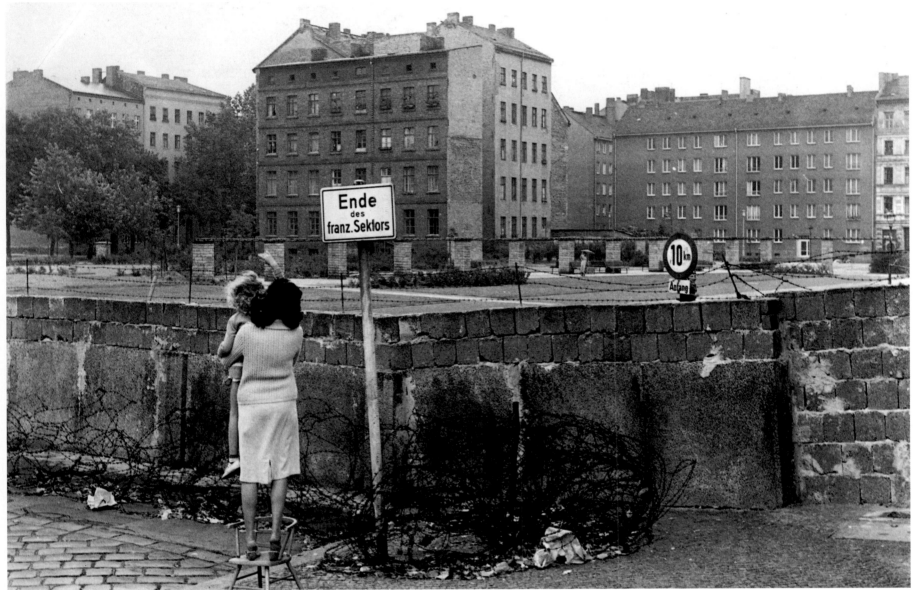

3 BUNDESPRESSEAMT 1961

(3) The agency also sold a photograph from the West German Press Office of a mother with her child waving to her relatives on the otherside of the Wall. The official caption in English, French and Italian speaks volumes about the outrage and the blind anger felt over the division of Germany: "The USSR together with the illegal dictators of the Soviet-occupied zone of Germany violated the [existing] agreements. (...) The East Berliners are now guarded as in a concentration camp."

(3) Die Agentur vertrieb auch ein Bild des Presseamts der BRD: Mutter mit Kind winkt ihren Verwandten hinter der Mauer zu. Die offizielle Bildlegende in englisch, französisch und italienisch spricht Bände der damaligen Empörung und der blinden Wut über die Teilung Deutschlands: »Die UdSSR verletzte gemeinsam mit den illegalen Diktatoren der sowjetisch besetzten Zone in Deutschland die [bestehenden] Abkommen. (...) Die Ost-Berliner sind nun bewacht wie in einem Konzentrationslager.«

(3) L'agence diffusa également une image issue de l'Office de presse de la RFA : une femme avec son enfant fait signe à des parents, de l'autre côté du mur. La légende officielle de la photo, en anglais, français et italien, en dit long sur la colère éprouvée alors au sujet de la partition de l'Allemagne : « Ces accords ont été violés par l'U.R.S.S. avec l'aide des dictateurs illégaux de la zone soviétique de l'Allemagne. (...) Les habitants de Berlin-Ouest sont maintenant surveillés comme dans un camp de concentration. »

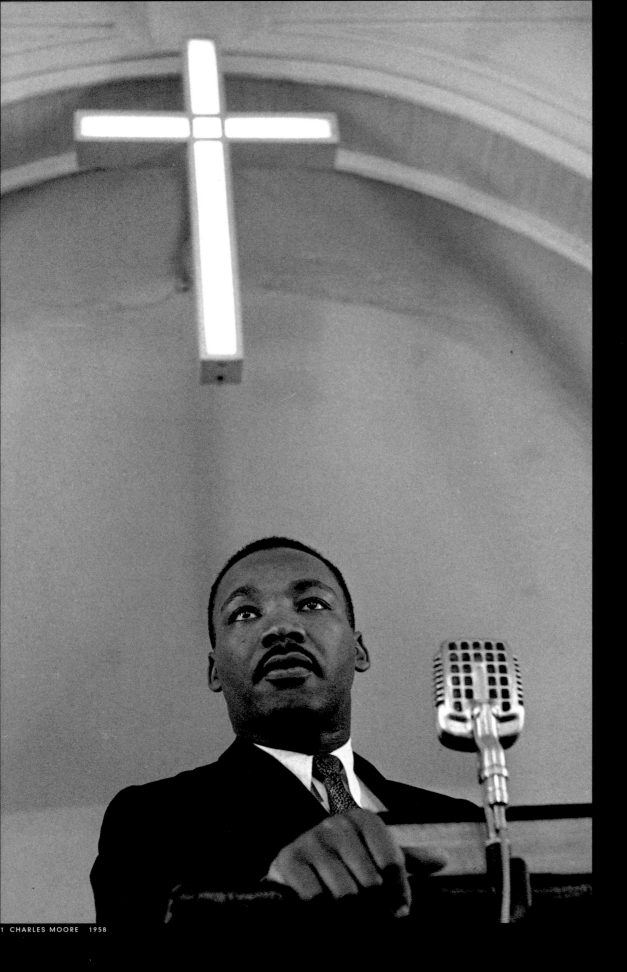

1 CHARLES MOORE 1958

The civil rights movement in the South was based on the principle of non-violent resistance and civil disobedience. (1) Martin Luther King giving a speech before a meeting of the Montgomery Improvement Association which was founded in 1955 to organize the bus boycott. The one-year boycott was successful, and racial segregation on buses was abolished.

Die Bürgerrechtsbewegung im Süden basierte auf dem Prinzip des gewaltlosen Widerstands und des zivilen Ungehorsams. (1) Martin Luther King in einer Rede vor einer Versammlung der Montgomery Improvement Association, die 1955 gegründet wurde, um den Bus-Boykott zu organisieren. Der einjährige Boykott war erfolgreich, die Rassentrennung in den Bussen wurde aufgehoben.

Le mouvement des droits civiques, dans le Sud, se fondait sur le principe de la résistance passive et de la désobéissance civile. (1) Martin Luther King pendant un discours devant une assemblée de la Montgomery Improvement Association, fondée en 1955 pour organiser le boycott des bus. Ce boycott d'un an eut pour conséquence la levée de la discrimination raciale dans les bus.

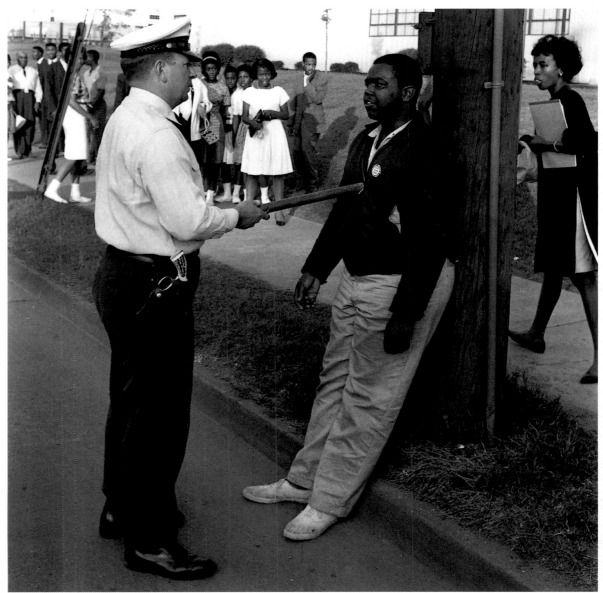

(2) A young demonstrator in Birmingham. King came here in January 1963 to break down the pronounced racism in the city by peaceful means. King and his assistants trained young people in non-violent protest.

(2) Ein jugendlicher Demonstrant in Birmingham. King ging im Januar 1963 hierher, um den ausgeprägten Rassismus dieser Stadt mit friedlichen Mitteln aufzubrechen. King und seine Helfer trainierten Jugendliche im gewaltlosen Protest.

(2) Un jeune manifestant à Birmingham, où King s'était rendu en 1963 pour briser le racisme prononcé de la ville. King et ses partisans initièrent des jeunes à la protestation non-violente.

2 CHARLES MOORE UNDATED/O.D./S.D.

POWERFUL DAYS

Charles Moore (b. 1931 in Hackleburg, Alabama) grew up with racial segregation. He was raised in a tolerant Baptist household in the American south. After studying photography in California he returned to the state capital of Alabama in 1957 as a photographer on a daily newspaper and from 1962 he worked as a freelancer for Black Star.

Since the bus boycott of 1955 the capital Montgomery had been the main battleground for the black population against racial segregation and for their civil rights. Martin Luther King began his career as a civil rights campaigner here. The photographer recalls: "Suddenly I found myself involved with blacks in a different way." White journalists such as Moore were "nigger lovers" in the eyes of rednecks. Moore's photographs from the years 1957 to 1965, published in his book "Powerful Days" in 1991, are a unique document of the civil rights movement. They side with the blacks and unmask irrational white aggression.

STARKE TAGE

Charles Moore (geb. 1931 in Hackleburg, Alabama) wuchs in einem toleranten Baptistenhaushalt mit der Rassentrennung in Amerikas Süden auf. Nach dem Studium der Fotografie in Kalifornien kehrte er 1957 als Tageszeitungsfotograf in die Hauptstadt Alabamas zurück, ab 1962 arbeitete er freiberuflich für Black Star.

Die Hauptstadt Montgomery war seit dem Bus-Boykott 1955 der Hauptkampfplatz der schwarzen Bevölkerung gegen die Rassentrennung und für ihre Bürgerrechte. Hier begann Martin Luther Kings Karriere als Bürgerrechtler. Der Fotograf erinnert sich: »Plötzlich fand ich mich selbst auf eine andere Weise involviert mit den Schwarzen.« Weiße Journalisten wie Moore waren in den Augen der Rednecks *nigger lovers*. Moores Aufnahmen aus den Jahren 1957 bis 1965, 1991 in seinem Buch »Powerful Days« veröffentlicht, sind ein einzigartiges Dokument der Bürgerrechts-bewegung. Sie nehmen Partei für die Sache der Schwarzen und entlarven die irrationale weiße Aggression.

LES JOURS PUISSANTS

Charles Moore (né en 1931 à Hackleburg, Alabama) grandit dans une famille de baptistes tolérants alors que la ségrégation raciale faisait des ravages dans le sud des Etats-Unis. Après des études de photo-graphie en Californie, il rentra à Montgomery en 1957 comme photographe pour un quotidien et travailla dès 1962 pour Black Star. Depuis le boycott des bus de 1955, la capitale de l'Alabama était le foyer de la lutte de la population noire contre la discrimination et pour l'obtention des droits civiques. C'est ici que partit le mouvement des droits civiques de Martin Luther King. Le photographe se souvient : « Soudain, je me trouvai engagé d'une manière nouvelle aux côtés des noirs. » Les paysans racistes du Sud, les rednecks, traitaient les journalistes blancs comme Moore de *nigger lovers*. Les photos de Moore qui vont de 1957 à 1965, publiées en 1991 dans son livre « Powerful Days », sont des documents uniques sur le mouvement des droits civiques. Elles prennent parti pour la cause des noirs et démasquent l'agressivité irrationnelle des blancs.

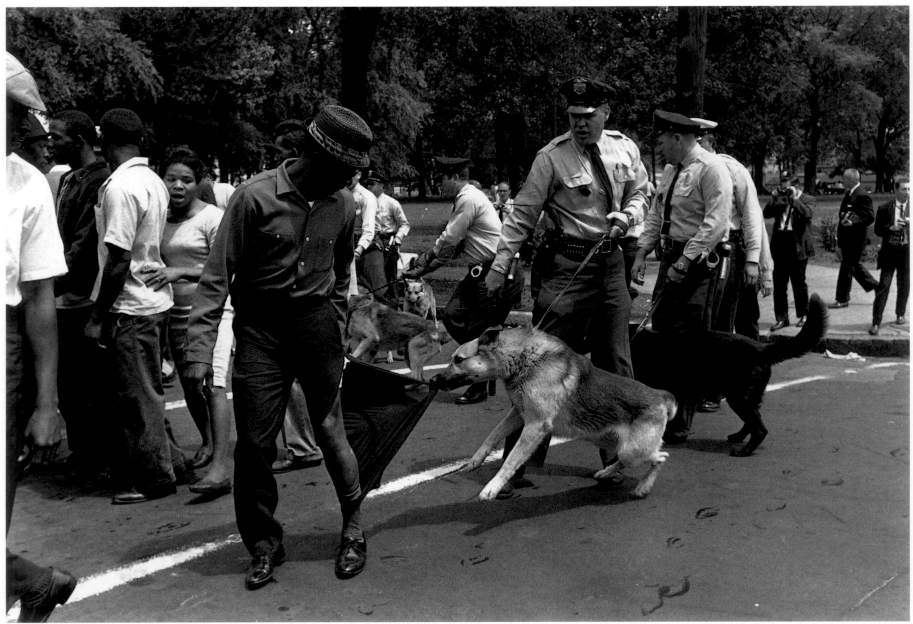

1 CHARLES MOORE 1963

Birmingham 1963 – police violence escalates. (4) Demonstrators abuse a policeman in the city center. The police authorities sent in police dogs (1) and fire hoses (3) in the struggle against the civil rights campaigners – Moore remembers: "I knew that those high-pressure hoses hurt people (...) But the sight of snarling dogs revolted me." These photographs went around the world, Life publishing them in a large layout. (2) One of the most famous photographs, taken in Montgomery 1960. In reaction to a non-violent sit-in in the city cafeteria against racial segregation in restaurants, two white men attack two black women in the street days later while they are shopping.

Birmingham 1963 – die Polizeigewalt eskaliert. (4) Demonstranten beschimpfen einen Polizisten in der Stadtmitte. Die Polizeiführung setzte Polizeihunde (1) und Feuerwehrspritzen (3) im Kampf gegen die Bürgerrechtler ein – Moore erinnert sich: »Ich wußte, daß die Hochdruckspritzen Leute verletzen (…), aber der Anblick der knurrenden Hunde war empörend für mich.« Diese Fotos gingen um die Welt, Life zeigte sie in einem großen Layout. (2) Eines der berühmtesten Fotos. Montgomery 1960. Als Reaktion auf ein gewaltloses sit-in in der städtischen Cafeteria gegen Rassentrennung in Restaurants überfallen Tage später zwei weiße Männer zwei schwarze Frauen beim Shopping auf offener Straße.

Birmingham 1963 – escalade de la violence policière. (4) Des manifestants invectivent un policier dans le centre de la ville. Le commandement de la police recourt aux chiens (1) et aux lances à incendie (3) contre les défenseurs des droits civiques. Moore se souvient : « Je savais que les jets d'eau à haute pression blessaient les gens (…) Mais la vision de ces chiens qui grondaient me révoltait. » Ces photos firent le tour du monde. Life les publia en grand format. (2) L'une des photos les plus célèbres. Montgomery, 1960. Quelques jours après un sit-in non-violent à la cafétéria municipale contre la discrimination raciale dans les restaurants, deux policiers blancs maltraitent en pleine rue deux femmes noires en train de faire leurs courses.

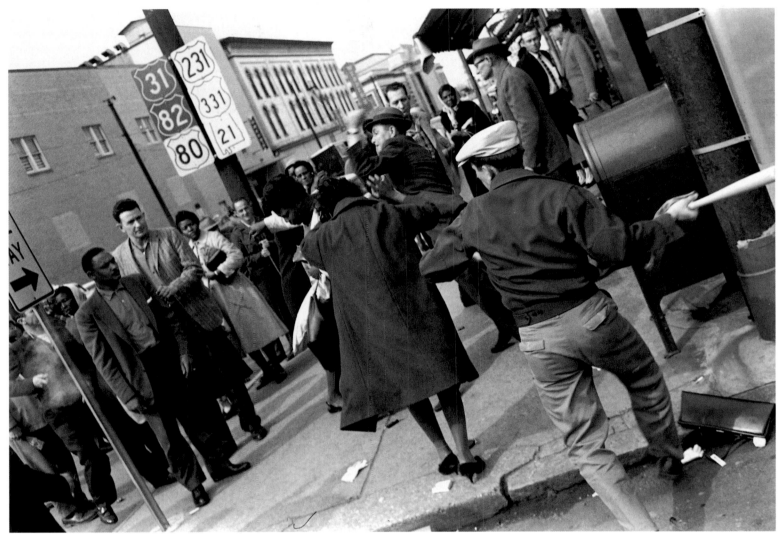

2 CHARLES MOORE 1960

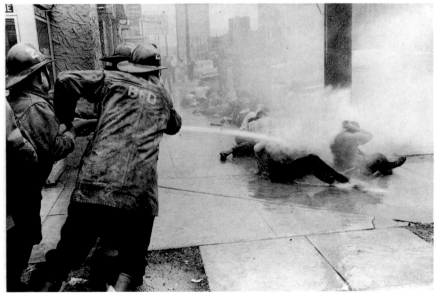

3 CHARLES MOORE 1963

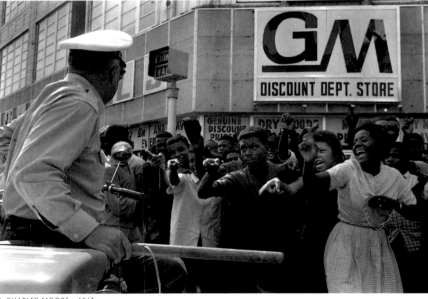

4 CHARLES MOORE 1963

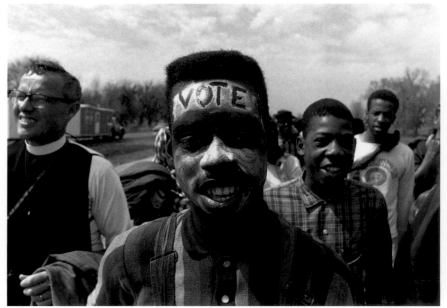

2 CHARLES MOORE 1965

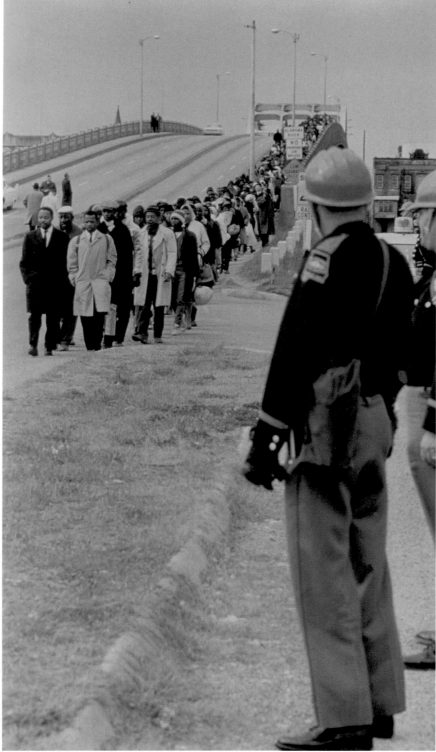

1 CHARLES MOORE 1965

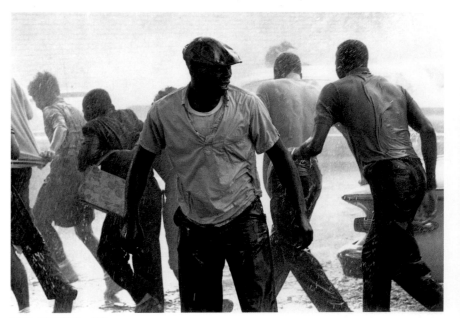

3 CHARLES MOORE 1963

Aspects of police violence. (3) Birmingham in April 1963. The struggle for civil rights explodes. (1) The Selma march on "Bloody Sunday," 7 March 1965. Protesting for their right to vote, demonstrators tried to march from the "white city" of Selma to Montgomery. At the foot of the Edmund Pettus Bridge they were forcefully driven back by state police. (2) On March 21 the march from Selma to Montgomery was successful with the support of a Federal Court. 25,000 people join in.

Stationen polizeilicher Gewalt. (3) Birmingham, April 1963. Der Bürgerrechtskampf explodiert. (1) Der Selma-Marsch am »Blutsonntag«, dem 7. März 1965. Im Kampf für ihre Wahlrechte versuchten Demonstranten, aus der »weißen Stadt« Selma nach Montgomery zu marschieren. Am Fuß der Edmund-Pettus-Brücke wurden sie von der Staatspolizei gewaltsam zurückgeschlagen. (2) Am 21. März gelingt der Marsch von Selma nach Montgomery mit Unterstützung eines Bundesgerichtes. 25 000 Menschen schließen sich an.

Etapes de la violence policière. (3) Birmingham, avril 1963. Explosions de violence dans la lutte pour les droits civiques. (1) Le « dimanche sanglant », 7 mars 1965. Dans le cadre de la revendication du droit de vote, des manifestants de la ville « blanche » de Selma organisent une marche vers Montgomery. Au pied du pont Edmund Pettus, ils sont violemment refoulés par la police d'Etat. (2) Le 21 mars, la marche aboutit de Selma à Montgomery, sous la protection de la justice fédérale. 25 000 personnes rejoignent le mouvement.

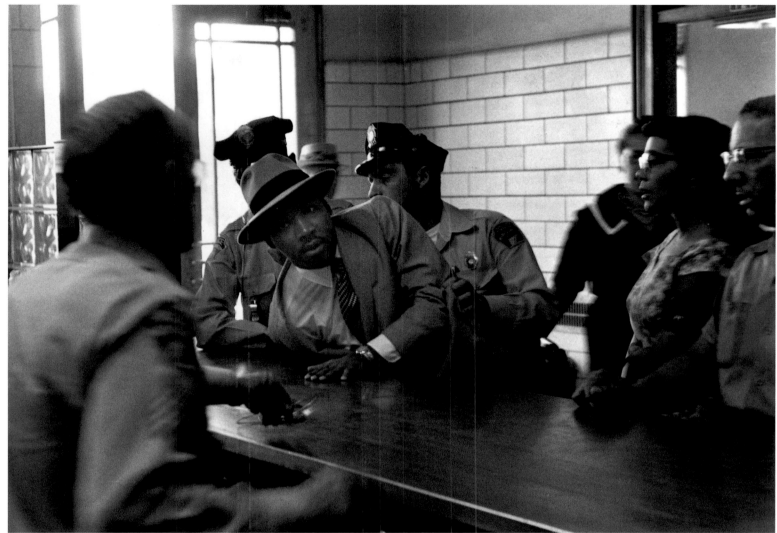

4 CHARLES MOORE 1958

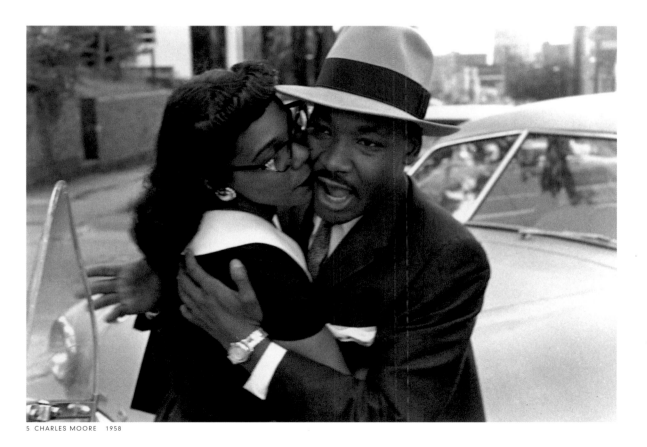

5 CHARLES MOORE 1958

Montgomery 1958. (4) King is arrested in front of his wife Coretta (right) for "loafing around in court". (5) Supporters of non-violence: King and his wife. This early picture evokes the subsequent successes, the legal recognition of black civil rights in 1964 and 1965, but also to the violent end of the leader of the movement, his assassination in Memphis in 1968.

Montgomery 1958. (4) King wird vor den Augen seiner Frau Coretta (rechts) wegen »Herumlungerns im Gericht« verhaftet. (5) Protagonisten der Gewaltlosigkeit: Das Ehepaar King. Dieses frühe Bild verweist auf die späteren Erfolge, die gerichtliche Anerkennung der schwarzen Bürgerrechte 1964 und 1965, aber auch auf das gewaltsame Ende des Führers der Bewegung, das Attentat in Memphis 1968.

Montgomery, 1958. (4) King est arrêté sous les yeux de sa femme, Coretta (à droite), au motif qu'il «traîne au Tribunal». (5) Protagonistes de la non-violence : Le couple King. Cette première image évoque les succès tardifs, la reconnaissance légale des droits civiques des noirs en 1964 et 1965, mais aussi la fin violente du leader du mouvement dans l'attentat de Memphis, en 1968.

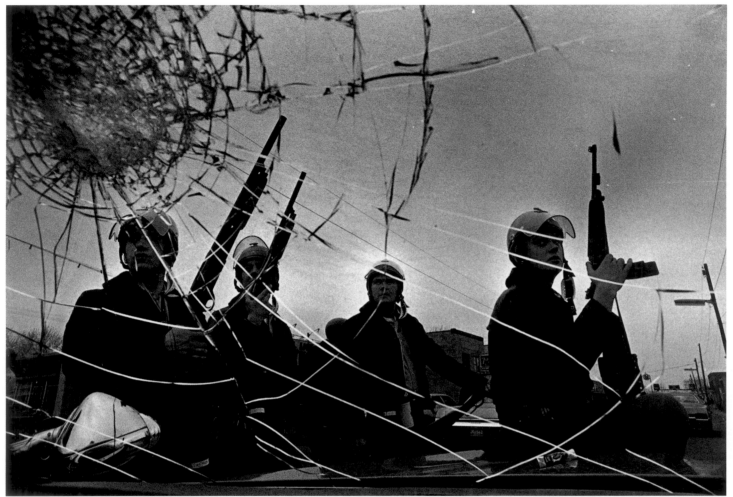

1 JOHN COLLIN 1967

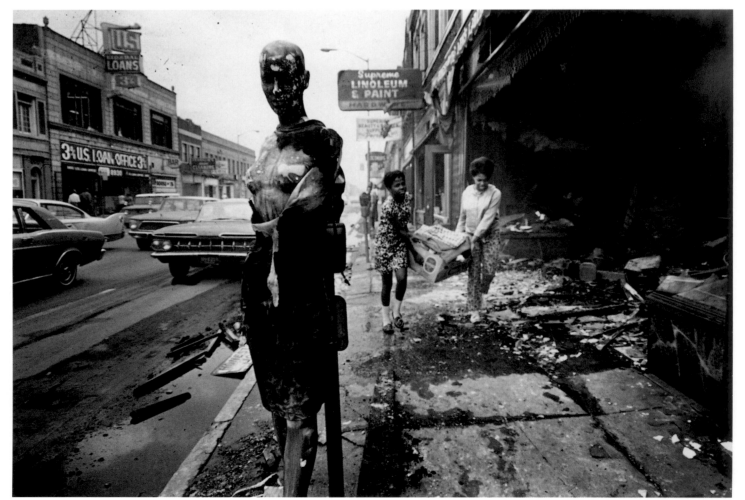

2 DENNIS BRACK 1967

BLACK POWER

The mid-1960s. In the black ghettos in the North of the USA Stokely Carmichael and Malcolm X declared war on the white section of the nation. The Black Muslims and the Black Panthers overturned King's model of non-violence: "Revolution is never based on asking somebody for an integrated cup of coffee." Their goal was the independence of the "Black Nation" from the "White Nation". Their demands did not go unnoticed, as repeated severe racial unrest occured in many cities of the North. The same was also true of Detroit in July 1967: (2) Riots which lasted for days shook the city. Businesses were looted, public buildings went up in flames. (1) Aside from the police and the National Guard, paratroopers were deployed to put down the uprising. (3) 37 people died and countless numbers were injured.

BLACK POWER

Mitte der 60er Jahre. In den schwarzen Ghettos im Norden der USA sagten Stokely Carmichael und Malcolm X dem weißen Teil der Nation den gewalttätigen Kampf an. Die Black Muslims und die Black Panthers verwarfen Kings Modell der Gewaltlosigkeit: »Revolution basiert niemals darauf, daß man jemanden um eine integrierte Tasse Kaffee bittet.« Ihr Ziel war eine Abspaltung der Black Nation von der White Nation. Ihre Forderungen blieben nicht ohne Folgen, ab 1965 kam es in vielen Städten des Nordens immer wieder zu schweren Rassenunruhen. So auch in Detroit im Juli 1967: (2) Tagelange Krawalle erschütterten die Stadt. Geschäfte wurden geplündert, öffentliche Gebäude gingen in Flammen auf. (1) Neben Polizei und Nationalgarde wurden Fallschirm-jäger eingesetzt, um den Aufstand rigoros niederzuschlagen. (3) 37 Menschen starben, unzählige wurden verletzt.

BLACK POWER

Au milieu des années 60, dans les ghettos noirs du nord des Etats-Unis, Stokely Carmichael et Malcolm X lancent un défi à la population blanche du pays et choisissent la lutte violente. Les Black Muslims et les Black Panthers rejettent le modèle non-violent de King : « On ne fait pas la révolution en demandant une tasse de café intégrée. » Leur objectif est la scission entre nation noire et nation blanche. Leurs exigences ne resteront d'ailleurs pas sans conséquences, et à partir de 1965, dans de nombreuses villes du Nord, les troubles sont de plus en plus fréquents. Ainsi en juillet 1967, (2) la ville de Detroit est secouée par des émeutes des jours durant. Des magasins sont pillés, des immeubles publics brûlent. (1) Outre la police et la garde nationale, on mobilise des parachutistes pour écraser le soulèvement. (3) Le bilan est de 37 morts et d'innombrables blessés.

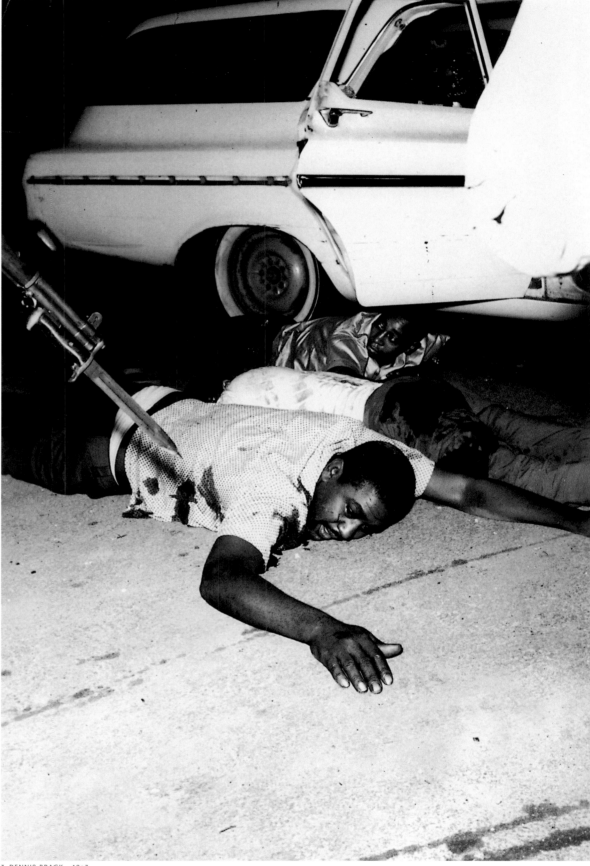

3 DENNIS BRACK 1967

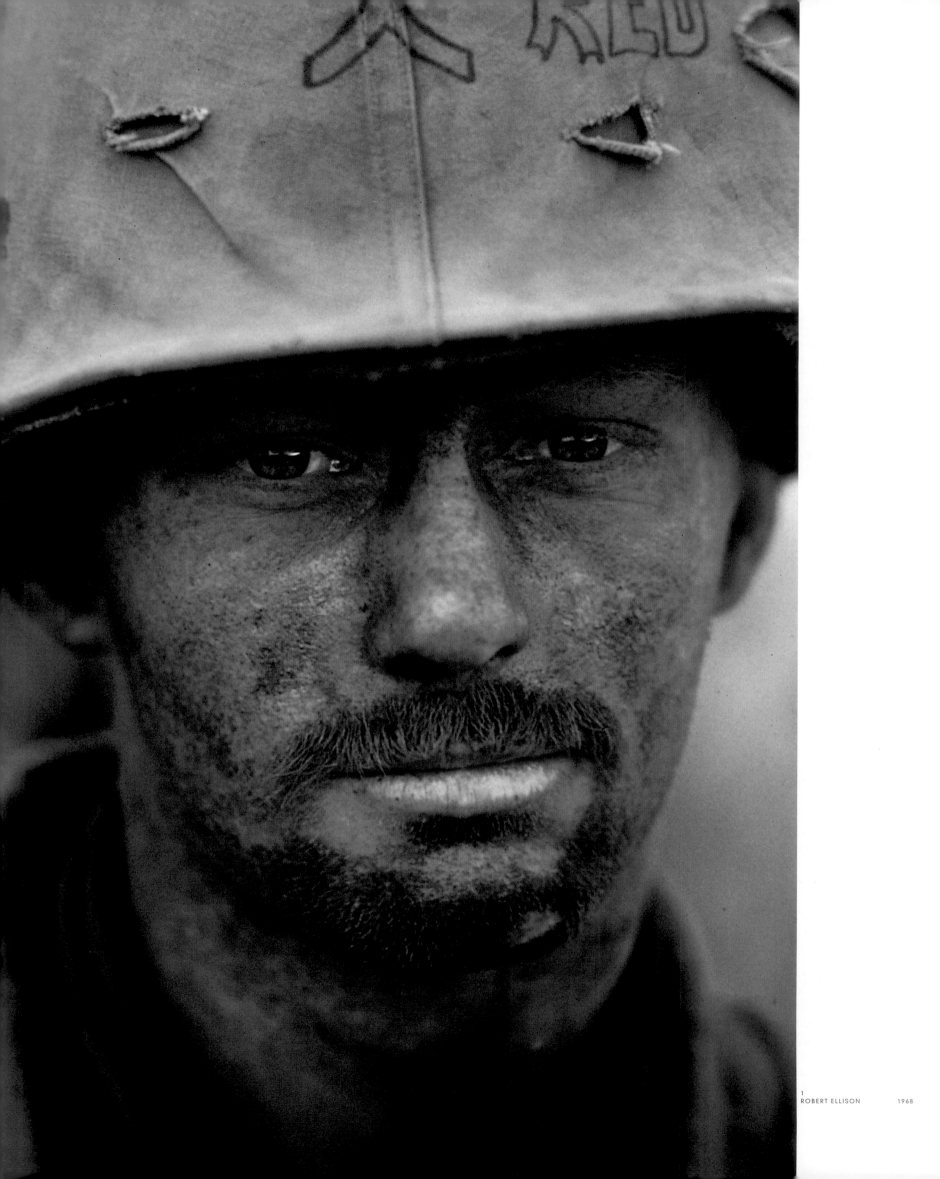

1
ROBERT ELLISON 1968

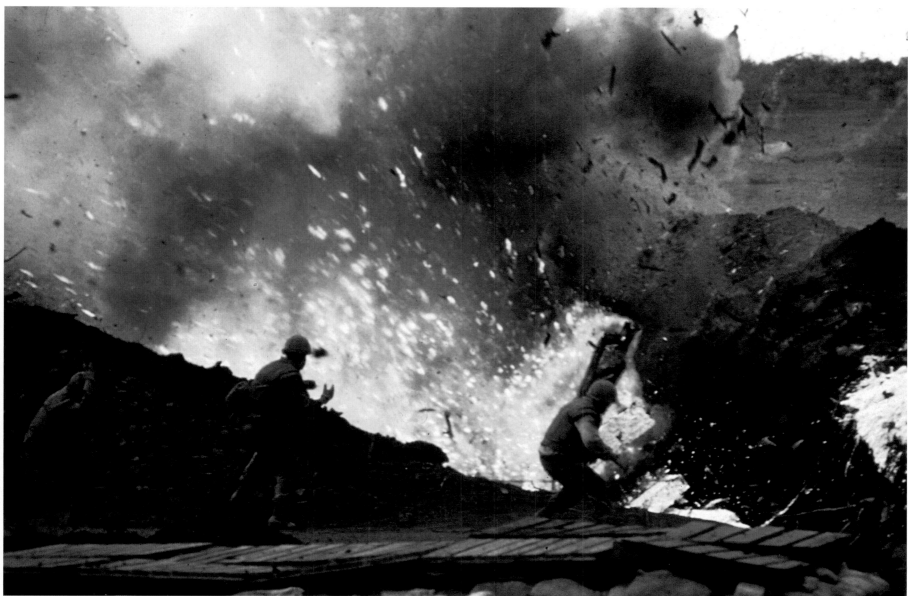

2 ROBERT ELLISON 1968

THE VIETNAM WAR

Robert Ellison (b. 1944, d. 1968) is the only Black Star photographer who has ever died on a journalistic assignment in a combat zone. His series of photographs from Khe Sanh in South Vietnam, taken during the North Vietnamese Tet Offensive in January and February 1968, is one of the most impressive documents of modern war photography. (2) An enemy projectile hitting the munitions depot of a position held by American Marines. (1) "Short pause from the battle."

Two weeks after these photographs were taken Ellison and the crew of a C-47 were shot down by the Vietcong as they tried to return to Khe Sanh. After nearly forty days the US Army succeeded in repelling the Tet Offensive. In the United States indignation about the "madness of Vietnam" turned into storms of protest. As a result of this President Johnson announced an end to bombardments and a reduction in troops.

DER VIETNAMKRIEG

Robert Ellison (geb. 1944, gest. 1968) ist bisher der einzige Black-Star-Fotograf, der während journalistischer Arbeit in Kampfgebieten umgekommen ist. Seine Bildserie aus Khe Sanh in Südvietnam, entstanden während der nordvietnamesischen Tet-Offensive im Januar und Februar 1968, gehört zu den beeindruckendsten Dokumenten der modernen Kriegsfotografie. (2) Ein feindliches Geschoß traf ein Munitionsdepot einer Stellung der amerikanischen Marines. (1) »Kurze Kampfpause«.

Zwei Wochen nach dem Entstehen dieser Bilder wurden Ellison und die Besatzung einer C-47 bei dem Versuch, nach Khe Sanh zurückzukehren, vom Vietcong abgeschossen. Nach fast vierzig Tagen gelang es der US-Army, die Tet-Offensive zurückzuschlagen. In den Vereinigten Staaten steigerte sich die Entrüstung gegen die *madness of Vietnam* zu Proteststürmen. Präsident Johnson kündigte daraufhin die Einstellung von Bombardements und eine Truppenreduzierung an.

LA GUERRE DU VIETNAM

Robert Ellison (né en 1944, décédé en 1968) est à ce jour le seul photographe de Black Star à avoir disparu au cours de son travail de reporter dans des régions en guerre. La série qu'il a faite à Khe Sanh, au Viêtnam du Sud, pendant l'offensive du Têt en janvier–février 1968, fait partie des documents les plus impressionnants de la photographie de guerre moderne. (2) Un tir ennemi atteint un dépôt de munitions sur une position de marines américains. (1) « Courte pause dans les combats ».

Deux semaines après avoir pris ces photos, le C-47, où Ellison et l'équipage tentaient de rentrer à Khe Sanh, fut abattu par le Viêt-công. Au bout de presque 40 jours, l'armée américaine réussit à repousser l'offensive. Aux Etats-Unis, l'indignation montant au sujet du désastre vietnamien, les manifestations faisaient rage. En conséquence, le président Johnson annonça l'arrêt des bombardements et une réduction des troupes.

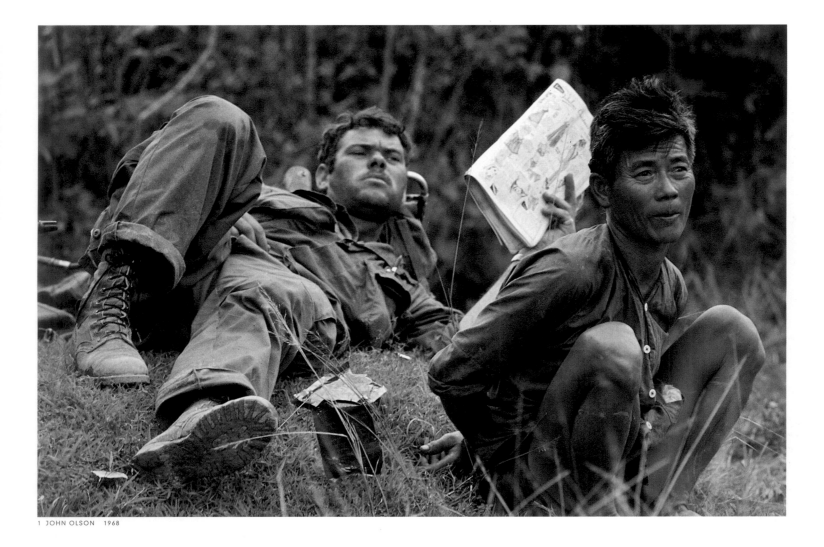

1 JOHN OLSON 1968

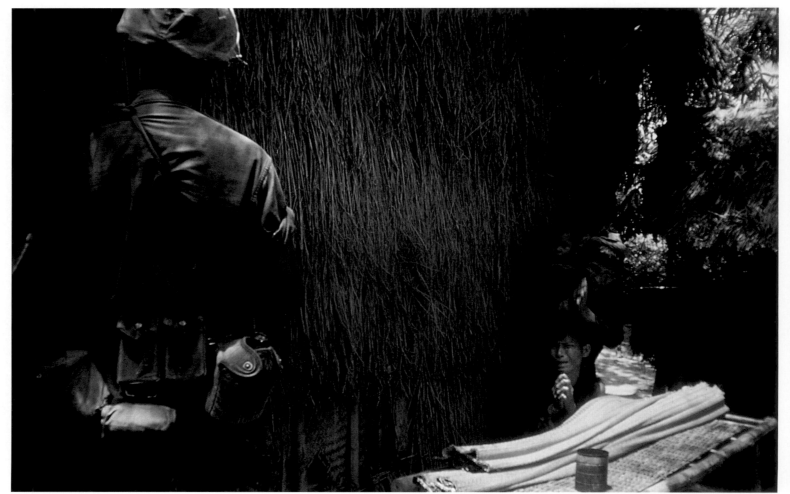

2 JIM PICKERELL 1965

WAR AND CRISIS

The US military support of South Vietnam against the Communists from the North has its roots in the mid-1950s. When the South Vietnamese troops faced their final defeat in 1965, American soldiers openly joined in the fighting. (2, 3) The 101st Airborne Division searching for Vietcong in a village near An Khe. This war was shaped by the guerrilla warfare of the Vietcong, who repeatedly infiltrated the South of the country via the Ho Chi Minh Trail and through tunnel systems. After a few months the American supreme commander General Westmoreland changed the original strategy of "clear and hold" to "search and destroy". (1) Vietcong soldiers in captivity in the Que-son Valley. In the dense jungle the Americans had great difficulty tracking their invisible adversaries down.

Die US-militärische Unterstützung Südvietnams gegen die Kommunisten aus dem Norden reicht bis in die Mitte der 50er Jahre zurück. 1965 drohte den südvietnamesischen Truppen die endgültige Niederlage, woraufhin amerikanische Soldaten offen in die Kämpfe eingriffen. (2, 3) Die 101. Luftlandedivision auf der Suche nach Vietcong in einem Dorf bei An Khe. Dieser Krieg war bestimmt vom Partisanenkampf der Vietcong, die über den Ho-Tschi-Minh-Pfad und Tunnelsysteme immer wieder in den Süden des Landes vordrangen. Der amerikanische Oberbefehlshaber Westmoreland änderte nach wenigen Monaten die ursprüngliche Strategie des »Säubern und Besetzen« in »Aufspüren und Vernichten«. (1) Vietcong-Kämpfer in Gefangenschaft im Que-son-Tal. Im Dschungelkampf blieb der amerikanische Gegner jedoch meist unsichtbar.

Le soutien militaire des Etats-Unis au Viêtnam du Sud contre les communistes au Nord remonte au milieu des années 50. En 1965, les troupes sud-vietnamiennes étant menacées de défaite, les soldats américains intervinrent ouvertement. (2, 3) La 101ᵉ division de parachutistes traquant les Viêt-công dans un village près d'An Khe. Cette guerre était issue de la lutte des partisans du Viêt-công, qui avançaient dans le sud du pays par la route de Ho Chi Minh et le système de tunnels. Le commandant en chef des troupes américaines, Westmoreland, modifia au bout de quelques mois sa stratégie, « nettoyage et occupation », qui devint « rechercher et détruire ». (1) Combattants du Viêt-công faits prisonniers dans la vallée de Que-son ; dans la jungle, les adversaires des Américains restaient invisibles la plupart du temps.

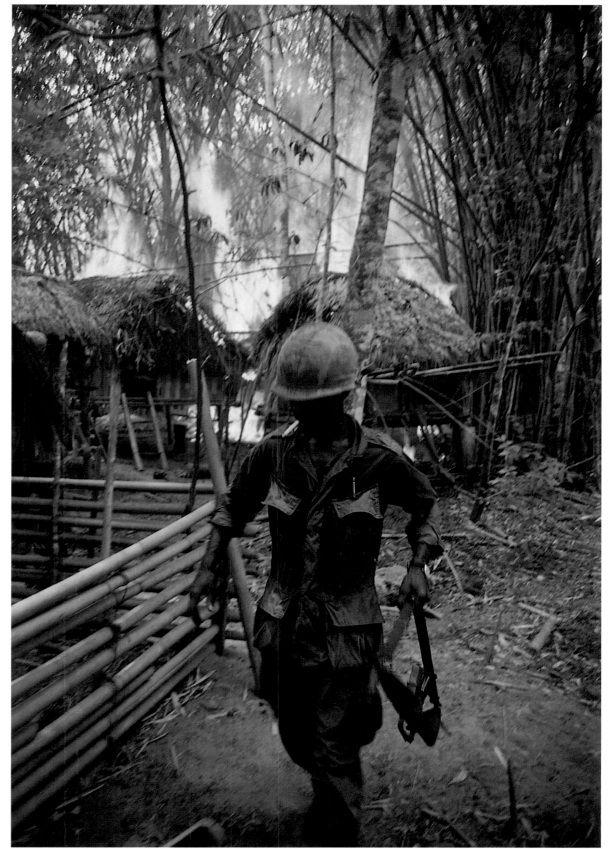

3 JIM PICKERELL 1965

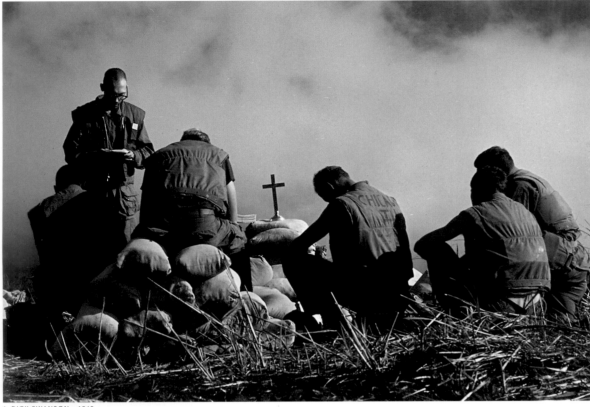

(2) Between 1965 and 1972, 3.4 million US soldiers were ordered to Vietnam, approximately a million of them saw front-line service. Over 47,000 GIs fell in battle and over 300,000 were wounded. (1) The Sunday sermon. An oasis of calm in the daily madness of war.

(2) Zwischen 1965 und 1972 wurden 3,4 Millionen US-Soldaten nach Vietnam beordert, etwa eine Million von ihnen kamen zum Fronteinsatz. Über 47 000 GIs fielen im Kampf, über 300 000 wurden verwundet. (1) Die sonntägliche Feldpredigt. Ein Ort der Muße im alltäglichen Wahnsinn des Krieges.

(2) Entre 1965 et 1972, 3,4 millions de soldats américains furent envoyés au Viêtnam, environ un million d'entre eux se battirent sur le front. Plus de 47 000 GIs moururent au combat et plus de 300 000 furent blessés. (1) Le prêche du dimanche matin. Un moment de répit dans la folie quotidienne de la guerre.

1 DICK SWANSON 1969

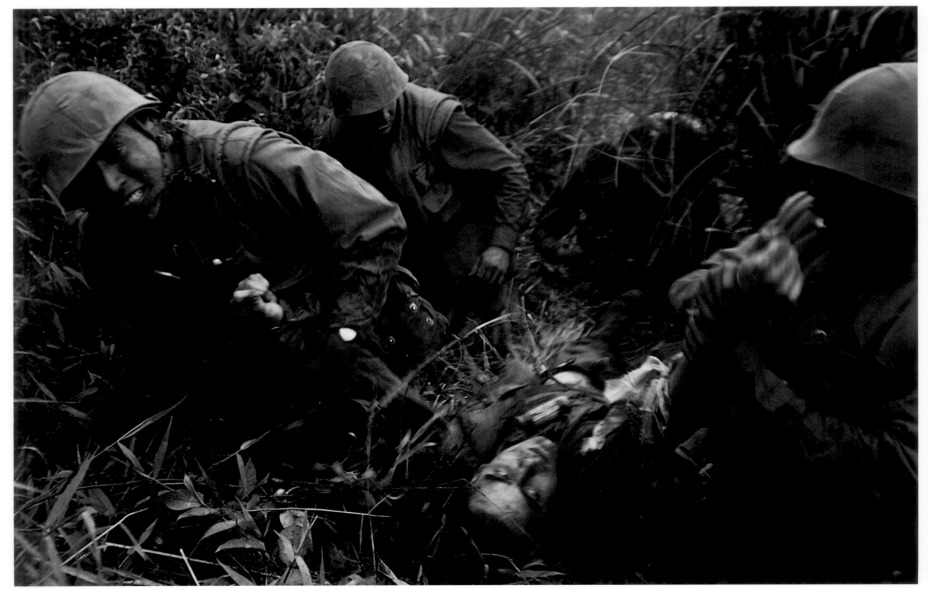

2 ROBERT ELLISON 1968

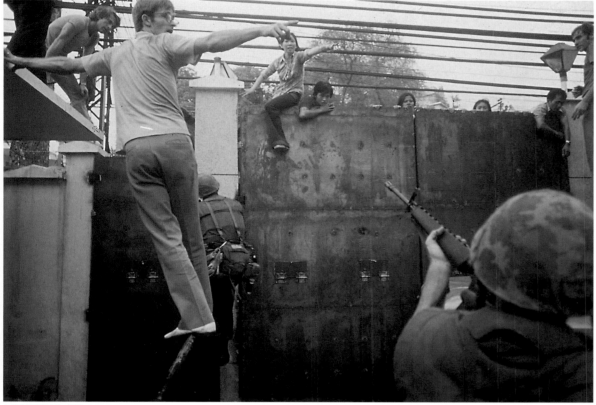

(4) Saigon. The Americans changed the appearance of the city. "And at the same time the capital turned into an enormous brothel," reported Jim Pickerell. (3, 5) 30 April 1975. Saigon on the day of surrender. South Vietnamese tried to storm the American Embassy. GIs were gradually withdrawn. Despite international negotiations and the 1973 ceasefire, it was only now with the victory of the North that the war came to an end.

(4) Saigon. Die Amerikaner veränderten das Stadtbild. »Und zugleich verwandelte sich die Hauptstadt in ein riesiges Bordell«, berichtete Jim Pickerell. (3, 5) 30. April 1975. Saigon am Tag der Kapitulation. Südvietnamesen versuchten die amerikanische Botschaft zu stürmen. GIs wurden nach und nach abgezogen. Trotz internationaler Verhandlungen, trotz des Waffenstillstandes von 1973 – erst jetzt endete der Krieg mit dem Sieg des Nordens.

(4) Saigon. Les Américains transformèrent la ville. « En même temps, la capitale se changeait en un gigantesque bordel », raconte Jim Pickerell. (3, 5) 30 avril 1975. Saigon, le jour de la capitulation. Des Sud-viêtnamiens tentèrent de prendre d'assaut l'ambassade américaine. Peu à peu, les GIs furent rappelés. Malgré les négociations internationales et le cessez-le-feu de 1973, la guerre avait continué jusqu'à la victoire du Nord.

3 NIK WHEELER 1975

4 JIM PICKERELL 1967

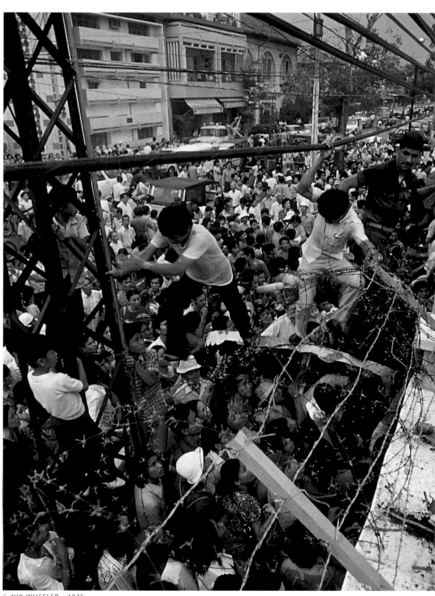

5 NIK WHEELER 1975

1968 – THE YEAR OF PROTEST

(1, 2) Following the closure of a faculty at the Sorbonne on 3 May 1968 there was a demonstration by 400 students on campus. They were demanding reforms. The police responded by taking unnecessarily vigorous action against the demonstrators. Street battles in Paris lasting for days ensued. The chaos in France spread through solidarity strikes by the trade unions and the occupation of factories.

1968 – DAS JAHR DES PROTESTES

(1, 2) In Paris kam es am 3. Mai 1968 nach Schließung einer Fakultät der Sorbonne auf dem Campus zu einer Demonstration von 400 Studenten. Sie forderten Reformen. Die Polizei ging mit Polizeistaatsmethoden gegen die Demonstranten vor. Danach gab es in Paris tagelange Straßenschlachten. Das Chaos in Frankreich weitete sich durch Solidaritätsstreiks der Gewerkschaften und Fabrikbesetzungen aus.

1968 – L'ANNÉE DE LA CONTESTATION

(1, 2) A Paris, le 3 mai 1968, la fermeture de la Sorbonne donna immédiatement lieu à une manifestation de 400 étudiants qui exigeaient des réformes. L'appel aux forces de l'ordre contre les manifestants provoqua des batailles de rues qui durèrent plusieurs jours. Les grèves de soutien et les occupations d'usines donnèrent au mouvement une ampleur nationale.

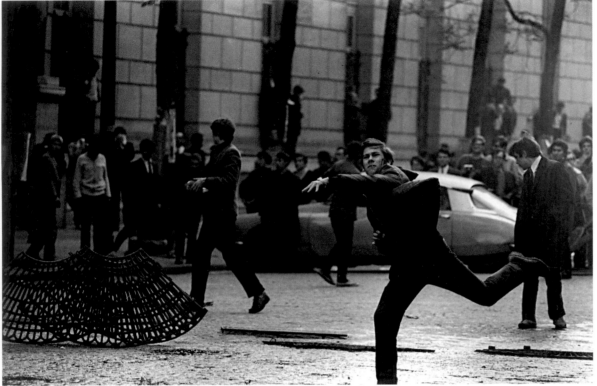

1 PETER ROSENBERG 1968

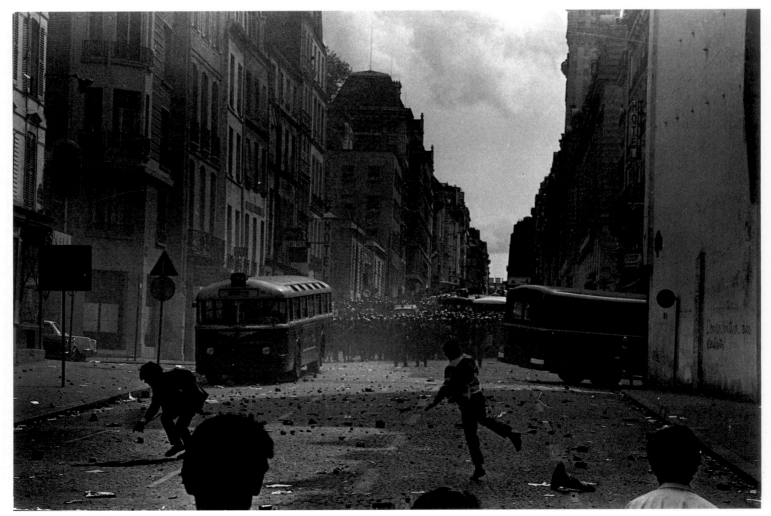

2 PETER ROSENBERG 1968

The student movement in America was founded on a complete rejection of society. (4) Jerry Rubin, shown here during a Black Panther demonstration at Yale University, was one of the leaders of the Youth International Party. The "Yippies" saw themselves as practitioners of psychological guerrilla warfare against the establishment.

Die Studenterbewegung in Amerika gründete sich auf der totalen Ablehnung der Gesellschaft. (4) Jerry Rubin, hier auf einer Black-Panther-Demonstration an der Yale-Universität, war einer der Köpfe der Youth International Party. Die »Yippies« verstanden sich als psychologische Guerillakrieger gegen das Establishment.

En Amérique, le mouvement étudiant se basait sur un rejet de la société. (4) Jerry Rubin, ici à une manifestation des Black Panthers à l'Université de Yale, fut l'une des têtes dirigeantes du Parti de la jeunesse internationale. Les « yippies » se voyaient comme des guérilleros menant un combat psychologique contre l'establishment.

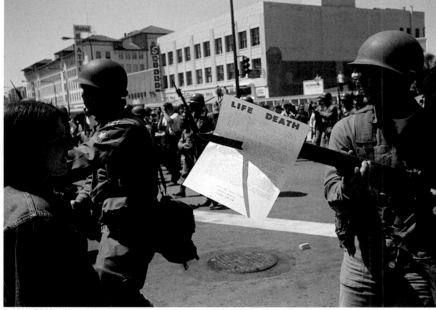

3 ALAN COPELAND 1969

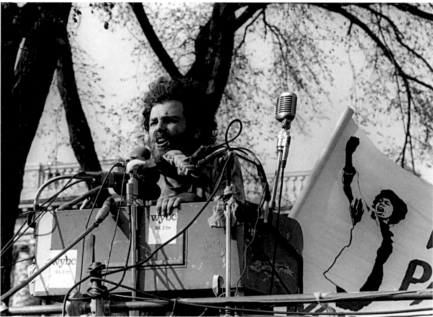

4 DENNIS BRACK 1970

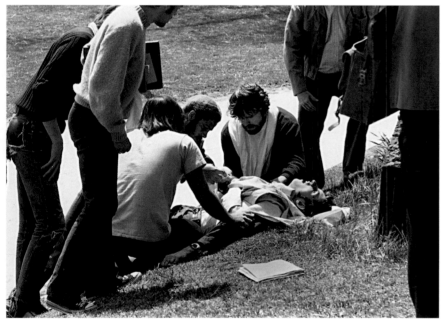

5 HOWARD RUFFNER 1970

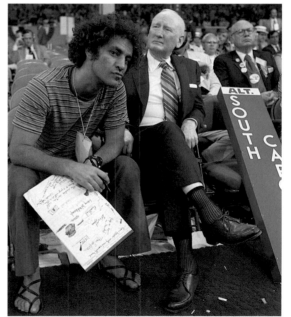

6 MICHAEL ABRAMSON 1968

(6) The Yippie Abbie Hoffman at the Democratic Party Conference in Chicago in 1968. With the battlecry "Every man a revolution" Hoffman, the guerrilla of fun, destroyed the established politicians in election year. (3) Anti-Vietnam demonstration in Berkeley in 1969. After Chicago the violence escalated. (5) At Kent State University (Ohio) the National Guard shot dead four students in May 1970.

(6) Der Yippie Abbie Hoffman auf dem Parteikonvent der Demokraten 1968 in Chicago. Mit dem Schlachtruf »Every man a revolution« verstörte Spaßguerillero Hoffman die etablierten Politiker im Wahljahr. (3) Anti-Vietnam-Demo in Berkeley 1969. Nach Chicago eskalierte die Gewalt. (5) An der Kent State University (Ohio) erschoß die Nationalgarde im Mai 1970 vier Studenten.

(6) Le yippie Abbie Hoffman à la convention des démocrates en 1968, à Chicago. Avec son slogan « Every man a revolution » (« Tout homme est une révolution »), Abbie Hoffman, le combattant pour rire, mit la pagaille dans le monde politique traditionnel, en pleine année électorale. (3) Manifestation contre la guerre au Viêtnam, à Berkeley en 1969. Après Chicago, la violence ne cessa d'augmenter. (5) A l'université de Kent (Ohio), en mai 1970, la garde nationale tirait sur quatre étudiants.

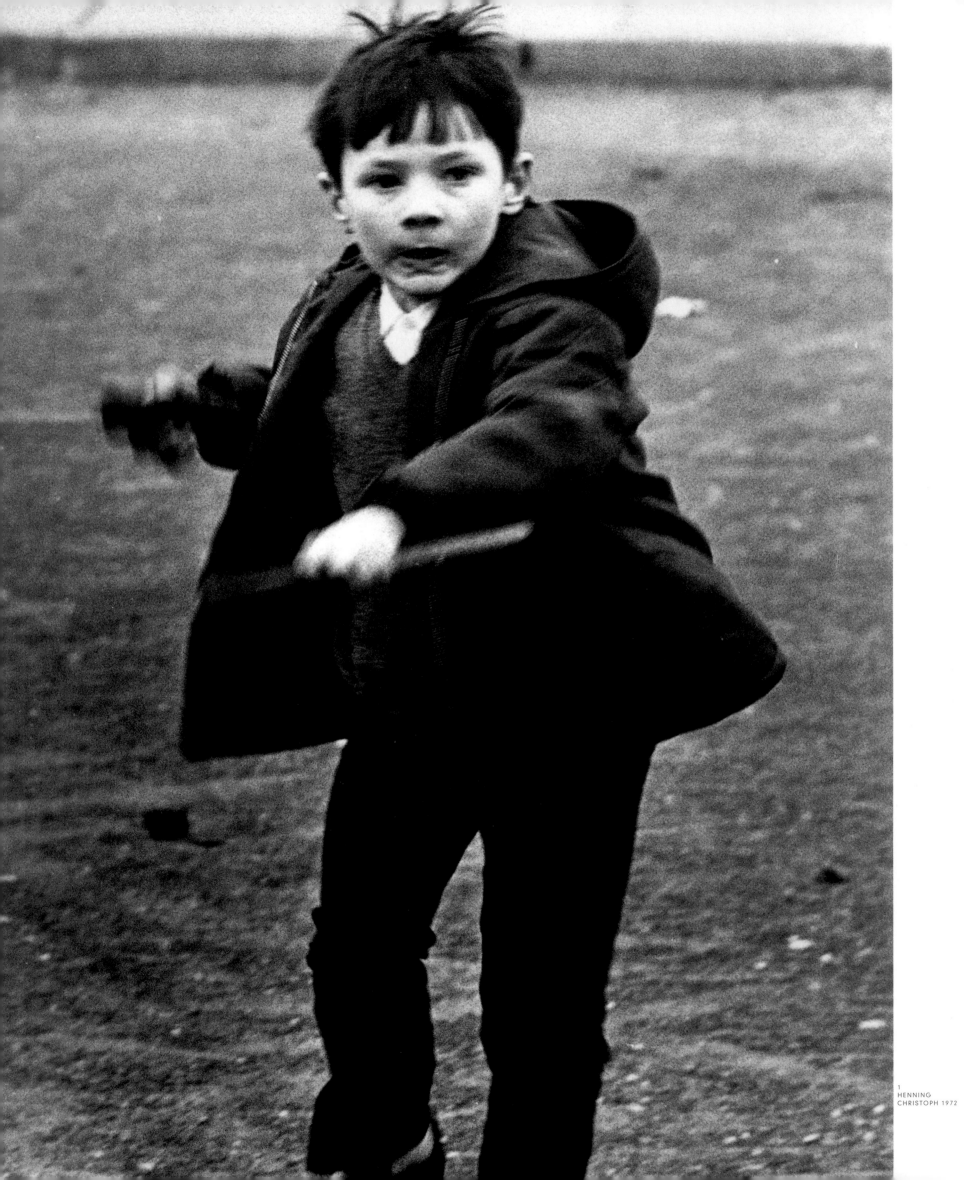

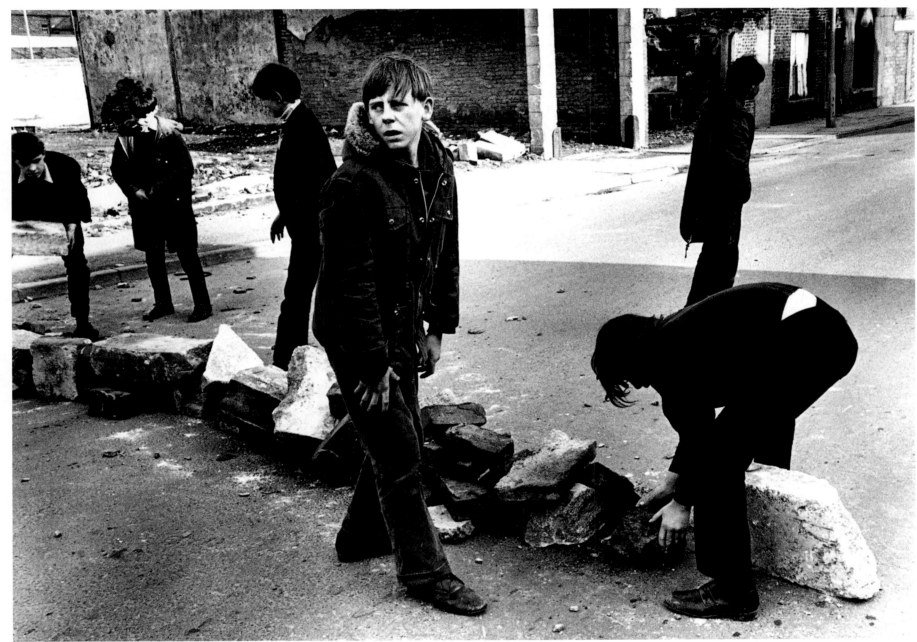

2 HENNING CHRISTOPH 1972

IRELAND, OH IRELAND

The key pictures from the report "Children and Violence in the Bogside, Londonderry". (1) Peter Carr throwing stones at British soldiers, February 1972. Henning Christoph followed the life of this boy from a Catholic working class family of eight, who was nine years old at the time this photograph was taken, for four years. (2) Children building a barricade at the corner of William Street and Rossville Street in the city center. This was a daily occurrence. They would entice the army from its positions to throw stones and milk bottles at the troops, who replied with teargas and rubber bullets.

IRLAND – IRRLAND?

Die Schlüsselbilder der Reportage »Kinder und Gewalt in der Bogside, Londonderry«. (1) Peter Carr beim Steinwurf gegen britische Soldaten, Februar 1972. Henning Christoph verfolgte die Entwicklung des damals Neunjährigen aus einer achtköpfigen katholischen Arbeiterfamilie über vier Jahre. (2) Kinder beim täglichen Barrikadenbau an der Ecke William Street und Rossville Street in der Innenstadt. Sie lockten die Armee aus ihren Stellungen, um sie dann mit Steinen und Milchflaschen zu bewerfen. Die Soldaten antworteten mit Tränengas und Gummigeschossen.

L'IRLANDE A FEU ET A SANG

Les images-clé du reportage « Les enfants et la violence dans le Bogside, Londonderry ». (1) Peter Carr lançant des pierres contre les soldats britanniques, février 1972. Henning Christoph suivit pendant quatre ans le développement du gamin, qui avait alors neuf ans, dans une famille d'ouvriers catholiques de huit enfants. (2) Des enfants refaisaient tous les jours les barricades à l'angle des rues William et Rossville, dans le centre de la ville. Ils attiraient les militaires hors de leurs positions pour leur lancer des pierres et des bouteilles de lait. Les soldats ripostaient avec du gaz lacrymogène et des balles en caoutchouc.

The American Henning Christoph (b. 1944 in Grimma, Germany) studied ethnology and journalism in Washington, D.C., and was actively engaged in the student movement. To avoid the draft for Vietnam he emigrated to Germany and studied photography in Essen. His international journalistic break-through came in 1969 with his first report from Northern Ireland on the outbreak of the troubles. Christoph recalls: "It was here that I experienced my personal Vietnam. I sided with the Catholics in this British colony who were rebelling against the oppression by the Protestants which they had experienced for centuries. I wanted to support their struggle with my photographs although that struggle also frequently put my life in danger through close contact with the IRA." Almost ten years of reporting from this crisis zone in Western Europe are collected in his book "Ireland, oh Ireland," which was published in 1978. Christoph continues: "My way of thinking about politics was in black and white and this allowed me to work in stark contrasts. It was fine then, but today one looks at this continuing conflict in a rather more complex way."

Der Amerikaner Henning Christoph (geb. 1944 in Grimma, Deutschland) studierte in Washington Ethnologie und Publizistik und engagierte sich aktiv in der Studentenbewegung. Um der Einberufung nach Vietnam zu entgehen, emigrierte er nach Deutschland und studierte Fotografie in Essen. Sein internationaler journalistischer Durchbruch gelang ihm 1969 mit seiner ersten Reportage aus Nordirland über den Ausbruch des Bürgerkrieges. Christoph blickt zurück: »Hier erlebte ich mein persönliches Vietnam. Ich nahm Partei für die Katholiken in dieser britischen Kolonie, die sich gegen die jahrhundertelange Unterdrückung durch die Protestanten auflehnten. Mit meinen Fotos wollte ich ihren Kampf, der auch mich selbst durch enge Kontakte zur IRA oft in Lebensgefahr brachte, unterstützen.« Fast zehn Jahre Berichterstattung aus dieser Krisenregion im Westen Europas finden sich in seinem 1978 veröffentlichten Buch »Irland – Irrland?«: »Mein politisches Schwarz-Weiß-Denken ließ mich in starken Kontrasten arbeiten. Das war gut so, doch heute sieht man den immer noch andauernden Konflikt wesentlich differenzierter.«

L'Américain Henning Christoph (né en 1944 à Grimma, Allemagne) étudia à Washington D.C. l'ethnologie et le journalisme et prit part activement au mouvement étudiant. Il émigra en Allemagne afin d'éviter d'être incorporé pour le Viêtnam et étudia la photo à Essen. La reconnaissance journalistique inter-nationale vint en 1969 avec son premier reportage en Irlande du Nord, sur le déclenchement de la guerre civile. Christoph se rappelle : « C'est là que j'ai vécu mon Viêtnam. J'ai pris parti pour les catholiques qui, dans cette colonie britannique, se soulevaient contre l'oppression protestante séculaire. Avec mes photos, je voulais les soutenir dans leur lutte, ce qui m'amena plusieurs fois à mettre ma propre vie en danger, à cause de mes contacts étroits avec l'IRA. » Le livre « L'Irlande à Feu et à Sang », publié en 1978 contient près de dix ans de reportages. « Ma pensée politique, plutôt différenciée, me faisait travailler un noir et blanc très contrasté. Ça m'allait bien, mais aujourd'hui, cet interminable conflit est considéré de manière beaucoup plus nuancée. »

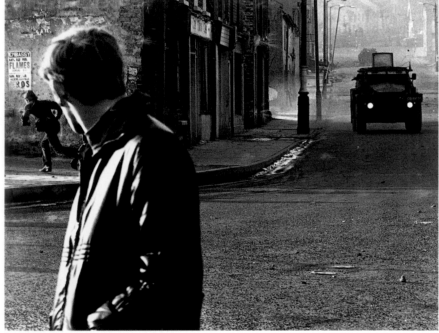

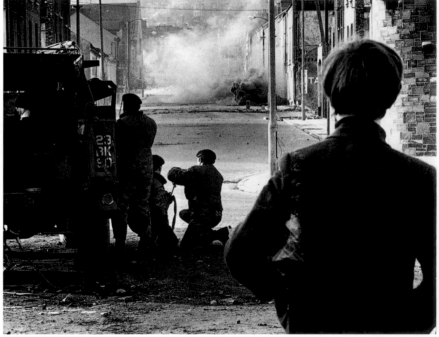

1 HENNING CHRISTOPH 1972

2 HENNING CHRISTOPH 1972

The political and social oppression of the Roman Catholic minority exploded into street battles from January 1969. (1, 2) The British Army in the Bogside, the Roman Catholic working class district of Londonderry. From 14 August 1969 onwards Northern Ireland was systematically put under "siege". On "Bloody Sunday", 30 January 1972, 13 demonstrators died from British bullets. The Catholics became increasingly radical. In March 1972 the British Government dissolved the self-governing parliament.

Die politisch-soziale Unterdrückung der katholischen Minderheit explodierte ab Januar 1969 in Straßenschlachten. (1, 2) Die britische Armee in der Bogside, dem katholischen Arbeiterviertel Londonderrys. Ab dem 14. August 1969 be-gann die systematische »Belagerung Nordirlands«. Am Bloody Sunday, dem 30. Januar 1972, starben 13 Demon-stranten durch britische Kugeln. Die Radikalisierung der Katholiken schritt voran. Im März 1972 löste die britische Regierung das selbstverwaltete Parlament auf.

L'oppression politique et sociale de la minorité catholique conduisit à partir de janvier 1969 à des batailles de rue. (1, 2) L'armée britannique dans le Bogside, le quartier catholique ouvrier de Londonderry. A partir du 14 août 1969, le « siège de l'Irlande du Nord » devint systématique. Le « dimanche sanglant » du 30 janvier 1972, 13 manifestants furent tués par des balles britanniques. Le mouvement catholique se radicalisa. En mars 1972, le gouvernement britannique prononça la dissolution du parlement d'auto-nomie.

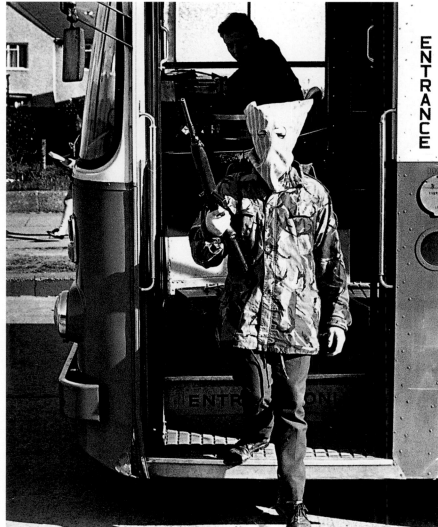

3 HENNING CHRISTOPH 1972

4 HENNING CHRISTOPH 1972

5 HENNING CHRISTOPH 1972

(3) June 1972. "Free Derry". The Irish Republican Army (IRA) controlled the entire infrastructure of Catholic areas of the city for years. This illegal "liberation army", founded in 1919, pursues today the political unification of Ireland. (5) Since the 1970s the IRA has launched terrorist attacks and bombings on buildings, policemen, soldiers and politicians. (4) The Protestant rabble-rousers Ian Paisley and J. McClelland. "Fight the Catholics and you will be saved" was one of their election slogans.

(3) Juni 1972. Free Derry. Die Irisch-Republikanische Armee (IRA) kontrollierte über Jahre die gesamte Infrastruktur katholischer Stadtteile. Diese illegale »Befreiungs-armee«, 1919 gegründet, verfolgt bis heute die politische Einheit Irlands. (5) Seit den 70er Jahren kämpft die IRA durch gezielte Terror- und Bombenanschläge auf Gebäu-de, Polizisten, Soldaten und Politiker im Untergrund. (4) Die protestantischen Scharf-macher Ian Paisley und J. McClelland. Einer ihrer Wahlsprüche lautete: »Bekämpft die Katholiken, und ihr werdet gerettet.«

(3) Juin 1972. Free Derry (« Libérez le Derry »). L'armée républicaine d'Irlande (IRA) contrôla pendant des années l'infrastructure des quartiers catholiques. L'objectif de cette « armée de libération » illégale, fondée en 1919, est toujours l'unité politique de l'Irlande. (5) Depuis les années 70, l'IRA se bat clandestinement, au moyen d'actes terroristes dirigés contre la police, l'armée, des personnalités politiques ou des immeubles précis. (4) Les provocateurs protestants Ian Paisley et J. McClelland. L'un de leurs slogans électoraux : « Combattez les catholiques et vous serez sauvés. »

Michael Coyne (b. 1945 in Daventry, England) worked for eight years in the Iranian theocracy established by Ayatollah Khomeini in 1979. "In 1984 I arrived in a country which stifled me with larger-than-life pictures of the Ayatollah and his religious messages wherever I went. The mullahs wanted to strengthen Islam in all areas of society after what they perceived as the godless dictatorship of the Shah which had lasted for decades." Western journalists were extremely unwelcome: "When I was standing on a platform with President Rafsanjani at Friday night prayers in front of 30,000 people who were praying, shouting and shaking their fists, he denounced foreign correspondents for painting a false picture of Iran. Whilst I was retreating from this experience with trembling knees one of those present approached me. He asked me (…) to get him a visa for Australia. Life is full of contradictions, even in the middle of a revolution!" Coyne was always searching for these contradictions in his reports from Iran, for example, the Revolutionary Celebrations 1986 (1, 2).

Michael Coyne (geb. 1945 in Daventry, England) arbeitete über acht Jahre im iranischen Gottes-staat, der 1979 durch Ayatollah Khomeini errichtet wurde. »Ich betrat 1984 einen Staat, der mich, wohin ich auch kam, mit überlebensgroßen Bildern des Ayatollah und seinen religiösen Botschaften erschlug. Die Mullahs wollten nach der jahrzehntelangen, in ihren Augen gottlosen Diktatur des Schahs den Islam in allen Gesellschaftsbereichen wieder festigen.« West-liche Journalisten waren äußerst unwillkommen: »Als ich während eines Freitagsgebets in Teheran mit Präsi-dent Rafsandschani auf einer Plattform vor 30 000 schreienden und faustschwingenden Betenden stand, denunzierte er ausländische Korrespondenten, ein falsches Bild des Iran zu zeigen. Während ich mich mit wackelnden Knien von diesem Ereignis entfernte, näherte sich mir ein Mitglied der Gemeinde. Er bat mich, (…) ihm ein Visum für Australien zu beschaffen. Das Leben ist voller Widersprüche, auch inmitten einer Revolution!« Coyne begab sich in seinen Reportagen aus dem Iran immer wieder auf die Suche nach diesen Widersprüchen. Hier die Revolutionsfeier 1986 (1, 2).

Michael Coyne (né en 1945 à Daventry en Angle-terre) travailla plus de huit ans dans l'Etat reli-gieux iranien édifié en 1979 par l'ayatollah Khomeiny. « J'entrai en 1984 dans un Etat qui, où que j'aille, m'assommait de portraits plus grands que nature de l'ayatollah et de ses émissaires religieux. Après plusieurs décennies de la dictature du Shah impie à leurs yeux, les mollahs voulaient réimplanter l'islam dans tous les domaines de la société. » Les journalistes occidentaux étaient particulièrement indésirables : « A la prière du vendredi, alors que je me tenais sur une plate-forme avec le président Rafsandjani, devant 30 000 fidèles criant et agitant le poing, il accusa les correspondants étrangers de montrer une fausse image de l'Iran. Tandis que je m'éloignais de cette scène, les genoux tremblants, un membre de la communauté s'approcha de moi. Il me demanda (…) de lui fournir un visa pour l'Australie. La vie est pleine de contradic-tions, même en pleine révolution ! » Dans ses repor-tages sur l'Iran, ici la fête de la Révolution, 1986 (1, 2), c'est toujours ces contradictions que Coyne cherche à saisir.

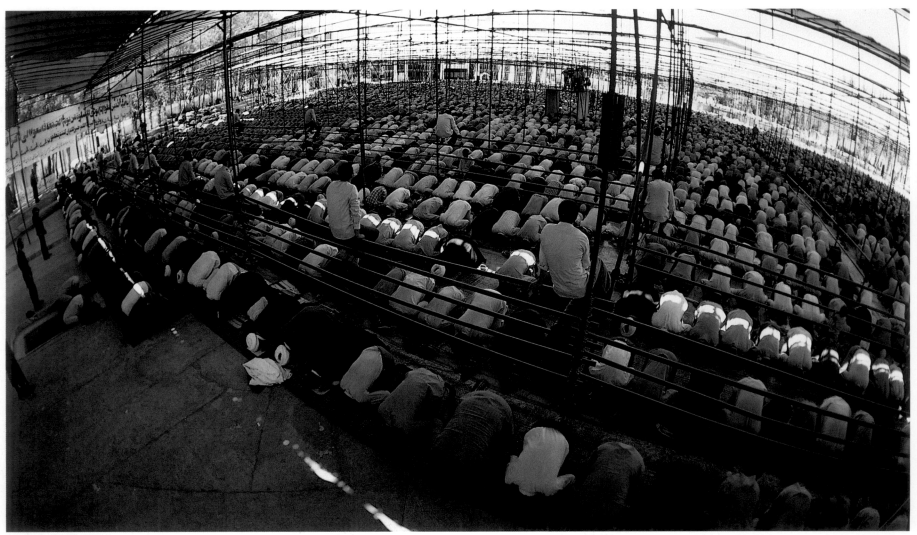

1 MICHAEL COYNE 1986

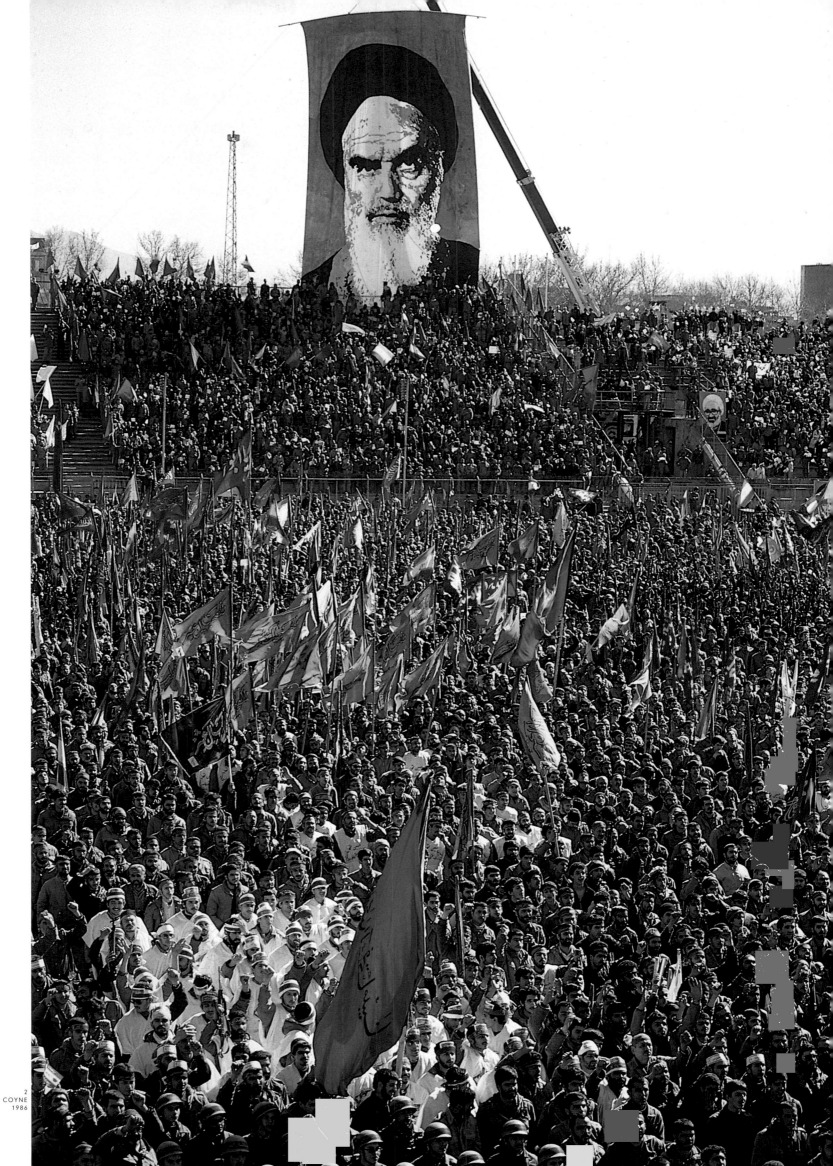

MICHAEL COYNE
1986

2 DAVID TURNLEY 1986

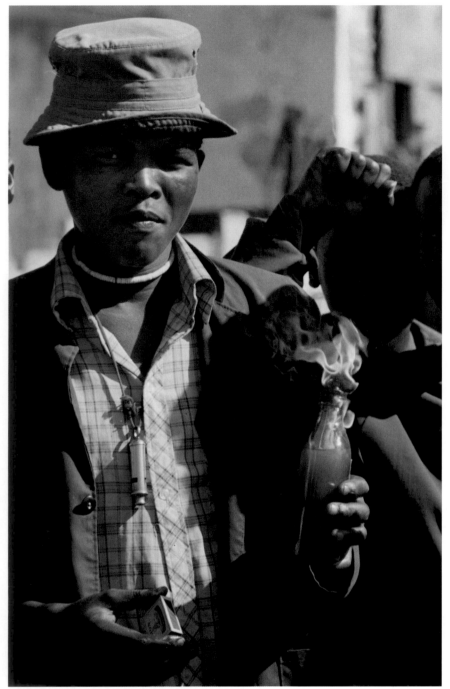

1 DAVID TURNLEY 1985–87

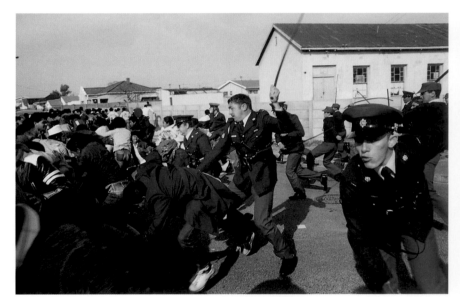

3 DAVID TURNLEY 1985–87

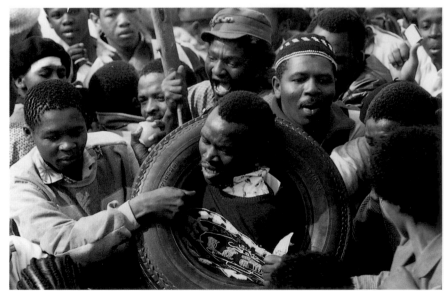

4 DAVID TURNLEY 1985–87

(1) A township near Cape Town. (2) A farmer and a 14-year-old domestic servant in the Orange Free State. (3) Disturbances in Cape Town. (4) A police informant with a "necklace". His imminent execution was however prevented by clergymen. (5) A Xhosa woman in the hills of the Transkei.

(1) Township bei Kapstadt. (2) Farmer und 14-jähriges Hausmädchen im Oranje-Freistaat. (3) Tumulte in Kapstadt. (4) Polizeiinformant mit »Halskette«, der von Geistlichen vor der Exekution gerettet wurde. (5) Xhosa-Frau in den Bergen der Transkei.

(1) Township à Capetown. (2) Fermier et domestique de 14 ans à l'Etat libre d'Orange. (3) Tumulte à Capetown. (4) L'homme au « collier » est un indicateur, sauvé par des religieux d'une exécution. (5) Femme xhosa dans les monts du Transkei.

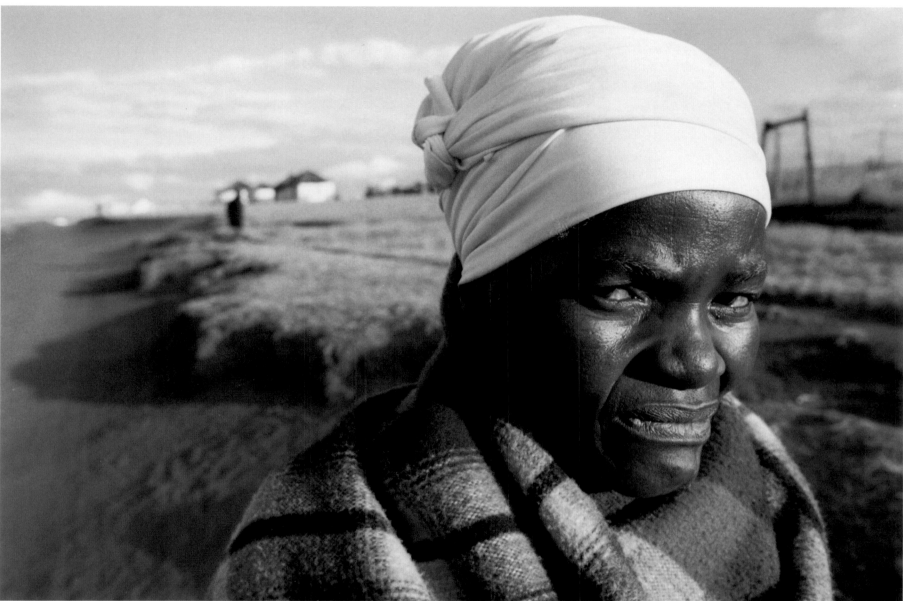

5 DAVID TURNLEY 1985–87

APARTHEID
IN SOUTH AFRICA

After studying French literature David Turnley (b. 1955 in Indiana) pursued a journalistic career. Since 1980 he has worked for the daily newspaper *Detroit Free Press* as an international photojournalist. With the help of the *Detroit Free Press* and with Black Star as an additional partner his planned project "South Africans under Apartheid" turned into the decisive color documentation of South African life between 1985 and 1987. *National Geographic* and other magazines worldwide printed his work. As well as international prizes, a book and an exhibition honored Turnley's portrait of a divided nation with the title "Why are they weeping?" In November 1987 the photographer was refused an extension to both his residence and work permits, but following Mandela's release in 1990 he has pursued this subject further.

DIE APARTHEID
IN SÜDAFRIKA

David Turnley (geb. 1955 in Indiana) wechselte nach dem Studium der französischen Literatur das Fach. Seit 1980 arbeitet er für die Tageszeitung *Detroit Free Press* als internationaler Fotoreporter. Mit Hilfe von *Detroit Free Press* und Black Star als zusätzlichem Partner entwickelte sich sein geplantes Projekt »South Africans under Apartheid« zu der entscheidenden Farbdokumentation des südafrikanischen Lebens zwischen 1985 und 1987. *National Geographic* und andere Magazine druckten weltweit seine Arbeit. Neben internationalen Preisen würdigten ein Buch und eine Ausstellung Turnleys Porträt einer gespaltenen Nation unter dem Titel »Why are they weeping?« Im November 1987 wurde dem Fotografen die weitere Aufenthalts- und Arbeitserlaubnis verweigert; seit der Freilassung Mandelas 1990 verfolgt er dieses Thema jedoch weiter.

L'APARTHEID
EN AFRIQUE DU SUD

David Turnley (né en 1955 dans l'Indiana) changea son fusil d'épaule après avoir étudié la littérature française. Depuis 1980, il travaille pour le *Detroit Free Press,* comme photoreporter international. Soutenu par le *Detroit Free Press* et Black Star, son projet envisagé « South Africans under Apartheid » constitue désormais le fond documentaire en couleurs le plus important sur la vie en Afrique du Sud entre 1985 et 1987. Le *National Geographic* et d'autres magazines dans le monde entier publièrent ses travaux. Ce portrait d'une nation divisée fut récompensé par des prix internationaux et fit l'objet d'un livre et d'une exposition sous le titre « Pourquoi pleurent-ils ? ». En novembre 1987, le photographe se vit refuser la prolongation de son autorisation de séjour et de travail. Depuis la libération de Mandela en 1990, il a pu reprendre ses travaux sur ce thème.

1 DAVID TURNLEY 1992

(2) The everyday face of Apartheid in the 1980s. A white high school student waiting at a suburban train station in Cape Town while black women are walking past him to the "non-white" section of the platform. (1) Protagonists of the "new South Africa" in the 1990s. (3) Nelson Mandela, who was released after 27 years in prison in 1990, took over the office of President from F. W. de Klerk on 9 May 1994; in the foreground de Klerk's wife. The first free elections which commenced on 26 April 1994 ended in a victory for the ANC.

(2) Der Alltag der Apartheid in den 80er Jahren. Ein weißer High-School-Student auf einem Vorortbahnhof in Kapstadt. Die schwarzen Frauen gingen auf den »nichtweißen« Teil des Bahnsteigs. (1) Protagonisten des Neuen Südafrika in den 90er Jahren. (3) Nelson Mandela, nach 27 Jahren Haft 1990 freigelassen, übernahm am 9. Mai 1994 das Amt des Präsidenten Frederik W. de Klerk, im Vordergrund dessen Gattin. Am 26. April 1994 begannen die ersten freien Wahlen, die den ANC als Wahlsieger bestätigten und das endgültige Ende der Apartheid besiegelten.

(2) L'apartheid au quotidien, dans les années 80. Un lycéen blanc dans une gare de la banlieue de Capetown. Les femmes vont vers la partie du quai réservée aux « non-blancs ». (1) Protagonistes de la « nouvelle » Afrique du Sud dans les années 90. (3) Nelson Mandela, libéré au bout de 27 ans de prison, devint président le 9 mai 1994, succédant à Frederik de Klerk, dont l'épouse est ici au premier plan. Le 26 avril 1994 commencèrent les premières élections libres, qui virent la victoire de l'ANC.

2 DAVID TURNLEY 1985–87

1 CHRISTOPHER MORRIS 1988

THE US INVASION OF PANAMA

Christopher Morris (b. 1958 in Florida) studied photography in Fort Lauderdale and received a scholarship from the ICP in New York in 1980. Originally attracted to artistic photography, a temporary job in the Black Star archives triggered an interest in photojournalism. Since becoming a Black Star staff photographer in 1985, Morris is always to be found amongst the crowds in crisis areas across the world. Since 1990 he has moreover worked as a contract photographer for *Time* magazine. For his photographs of the American invasion of Panama, Morris won his first international prize as a daily news photographer.

DIE US-INVASION IN PANAMA

Christopher Morris (geb. 1958 in Florida) studierte Fotografie in Fort Lauderdale und bekam 1980 ein Stipendium des ICP in New York. Zunächst an künstlerischer Fotografie interessiert, begeisterte ihn die Aushilfsarbeit im Black-Star-Archiv für den Fotojournalismus. Ab 1985 ist Morris als Black-Star-Staff-Fotograf an allen Krisenherden der Welt zu finden. Seit 1990 arbeitet er zudem als Vertragsfotograf für das Magazin *Time*. Mit den Bildern der amerikanischen Invasion in Panama gewann Morris seinen ersten internationalen Preis als *Spot-News*-Fotograf.

L'INVASION DU PANAMA PAR LES ETATS-UNIS

Christopher Morris (né en 1958 en Floride) étudia la photo à Fort Lauderdale et reçut en 1980 une bourse de l'ICP à New York. D'abord intéressé par la photographie d'art, il commença à se passionner pour le photojournalisme à l'occasion d'un stage dans les archives de Black Star. Dès 1985, Morris est envoyé par Black Star sur les foyers de crise du monde entier. Depuis 1990, il travaille également sous contrat pour *Time* magazine. Morris reçut son premier prix international pour ces images de l'invasion américaine au Panamá en tant que photographe de revue de presse.

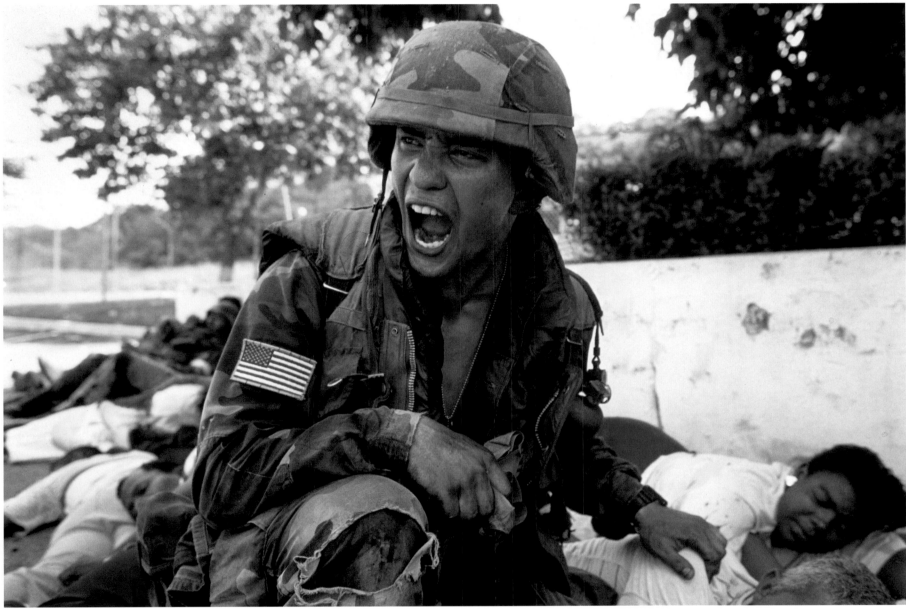

2 CHRISTOPHER MORRIS 1989

US foreign policy in the 1980s rested on a show of strength through short-term military interventions – in Panama too. Since 1985 General Manuel Noriega had been in power behind the facade of a democracy. After he had the elections annulled in March 1989, the dictator increasingly became a destabilizing influence in the Panama Canal region. (1) The first military revolt against Noriega, which had also been joined by members of the civilian opposition, failed in 1988. (2) On 20 December 1989 26,000 US soldiers marched into Panama. In unexpectedly heavy fighting there were approximately 1,500 casualties and one district was levelled by an earthquake. Noriega was arrested and accused of drug trafficking in the USA.

Die US-Außenpolitik setzte in den 80er Jahren auf die Demonstration von Stärke mittels kurzfristiger militärischer Interventioner – auch in Panama. Hier regierte seit 1985 General Manuel Noriega hinter den scheinparlamentarischen Kulissen. Nachdem er im März 1989 die Wahlen annullieren ließ, wurde der Diktator immer mehr zu einem Unsicherheitsfaktor in der Panamakanalzone. (1) 1988 scheiterte die erste Militärrevolte gegen Noriega, der sich auch zivile Oppositionelle anschlossen. (2) Am 20. Dezember 1989 marschierten 26 000 US-Soldaten in Panama ein. Bei unerwartet schweren Kämpfen starben ca. 1500 Menschen, und ein Stadtviertel wurde dem Erdbocen gleichgemacht. Noriega wurde verhaftet und in den USA wegen Drogenhandels angeklagt.

Dans les années 80, la politique extérieure américaine se spécialisa dans les démonstrations de force, avec des interventions-éclair de l'armée – dont le Panamá est un bon exemple. Le général Manuel Noriega régnait en maître depuis 1985, derrière une façade parlementaire. Après qu'il eut fait annuler les résultats électoraux de mars 1989, le dictateur apparut de plus en plus comme un facteur d'insécurité dans la région du canal de Panamá. (1) 1988, échec de la première révolte militaire contre Noriega, à laquelle se sont associés des opposants civils. (2) Le 20 décembre 1989, 26 000 soldats américains entrent au Panamá. Les combats surprirent par leur violence et firent 1 500 morts. Un quartier fut totalement rasé. Noriega fut arrêté et mis en accusation aux Etats-Unis pour trafic de drogue.

BEIJING SPRING

China in spring 1989. The Turnley twins David and Peter recall in their photoessay "Beijing Spring" those euphoric and shocking moments which were the subject of worldwide public scrutiny on Tiananmen Square in the middle of the capital Beijing. The peaceful protest of the students and their demands for democracy were answered by the political leadership on 20 May with the declaration of martial law. The tanks crushed the "counter-revolutionary uprising", opening fire in the early morning of 4 June. Peter had arrived in the middle of April, David four weeks later.

The Turnleys and their colleagues became the international mouthpiece of the protest for a few weeks. Completely involved in the movement, they worked around the clock. Their cameras were destroyed and confiscated and they lived under a threat made by the Chinese authorities that they would open fire on photographers. Their collective work was published in 1989 as a book with the title "Beijing Spring."

PEKINGER FRÜHLING

China im Frühjahr 1989. Die Turnley-Zwillinge David und Peter erinnern mit ihrem Fotoessay »Beijing Spring« an die euphorischen und die schockierenden Momente, die sich mitten in der Hauptstadt Peking auf dem Tienanmen-Platz der Weltöffentlichkeit darboten. Den friedlichen Protest der Studenten und ihre Forderungen nach Demokratie beantwortete die politische Führung am 20. Mai mit der Ausrufung des Kriegsrechts. Die Panzer walzten und schossen am frühen Morgen des 4. Juni den »konterrevolutionären Aufstand« nieder. Peter traf Mitte April ein, David vier Wochen später.

Die Turnleys und ihre Kollegen wurden für wenige Wochen zum internationalen Sprachrohr des Protestes. Als Teil der Bewegung arbeiteten sie rund um die Uhr. Ihre Kameras wurden zerstört und konfisziert, und sie lebten mit der offenen Drohung der chinesischen Autoritäten, auf Fotografen das Feuer zu eröffnen. Noch 1989 wurde die gemeinsame Arbeit als Buch mit dem Titel »Beijing Spring« publiziert.

LE PRINTEMPS DE PEKIN

Printemps 1989, la Chine. Les jumeaux Turnley, David et Peter, rappellent avec leur série intitulée « Printemps de Pékin », les moments d'abord euphoriques puis bouleversants qui se déroulèrent en plein centre de la capitale chinoise, place Tian'anmen, sous les yeux du monde entier. La contestation pacifique des étudiants et leur aspiration à la démocratie fut violemment réprimée par le pouvoir qui proclama l'état de guerre le 20 mai. Les chars entrèrent et écrasèrent le « soulèvement contre-révolutionnaire » à l'aube du 4 juin. Peter arriva à la mi-avril, David quelques semaines plus tard.

Les Turnley et leurs collègues se firent les portevoix de la contestation auprès de la communauté internationale. Entièrement engagés dans le mouvement, ils travaillèrent parfois 24 heures sur 24. Leurs appareils étaient confisqués, détruits et ils vivaient sous la menace explicite des autorités chinoises d'ouvrir le feu sur les photographes. Avant la fin de l'année 1989, leur travaux furent publiés ensemble sous le titre « Beijing Spring ».

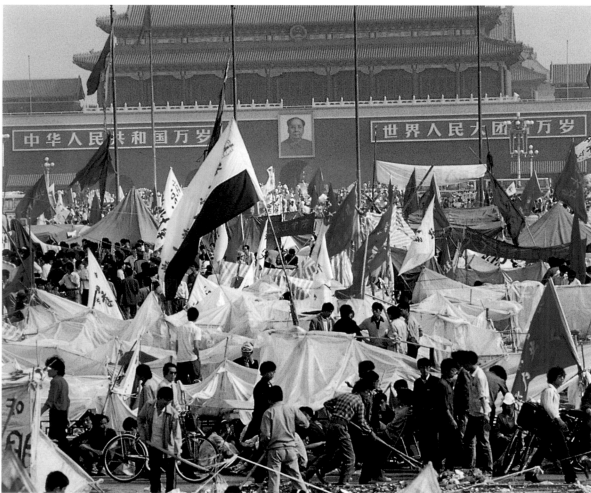

1 DAVID TURNLEY 1989

(1) Thousands of students occupied Tiananmen Square for weeks. Their protest turned into a mass movement. (3) Days later. Life returns to normal on the devastated Changan boulevard. In the following months however the authorities instigated a "purge" and mass arrests ensued.

(1) Wochenlang besetzten tausende Studenten den Tienanmen-Platz. Ihr Protest geriet zu einer Massenbewegung. (3) Tage später. Der Alltag kehrte auf den verwüsteten Boulevard Changan zurück. In den folgenden Monaten setzte jedoch eine »Säuberungswelle« mit Massenverhaftungen ein.

(1) Durant des semaines, des milliers d'étudiants occupent la place Tien'anmen. Leurs protestations tournent au mouvement de masse. (3) Plusieurs jours plus tard. La vie quotidienne est revenu sur le boulevard Changan dévasté. Les mois qui suivent, une « vague d'épuration » donnera lieu à des arrestations en masse.

(2) In the middle of this symbolic square of Chinese Communism the students erected "The Goddess of Freedom". The statue was a mixture of elements of Chinese martyr figures and New York's Statue of Liberty. (4) The bloodbath in the early hours of the morning of 4 June. Estimates of the number of dead vary between 300 and 3,600.

(2) Mitten auf dem symbolträchtigen Platz des chinesischen Kommunismus errichteten die Studenten »Die Göttin der Freiheit«. Die Statue vermischte Elemente chinesischer Märtyrer-gestalten mit der New Yorker Freiheitsstatue. (4) Das Blutbad in den frühen Morgenstunden des 4. Juni. Die Angaben über die Zahl der Toten schwanken zwischen 300 und 3 600.

(2) En plein milieu de la place qui symbolise le communisme chinois, les étudiants ont érigé la « déesse de la liberté ». La statue associe des figures de martyrs chinois et la statue de la liberté de New York. (4) Le bain de sang, au matin du 4 juin. Les données concernant le nombre des morts varient de 300 à 3 600.

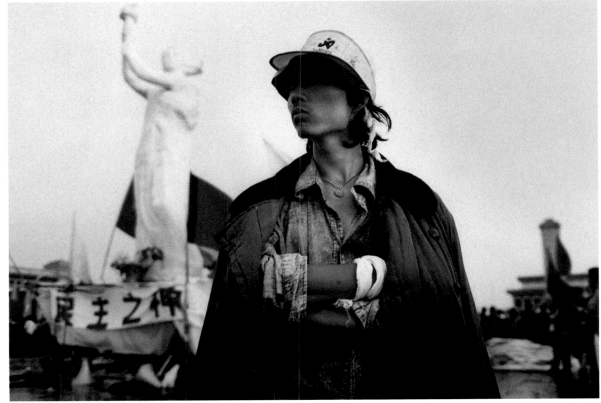

2 DAVID TURNLEY 1989

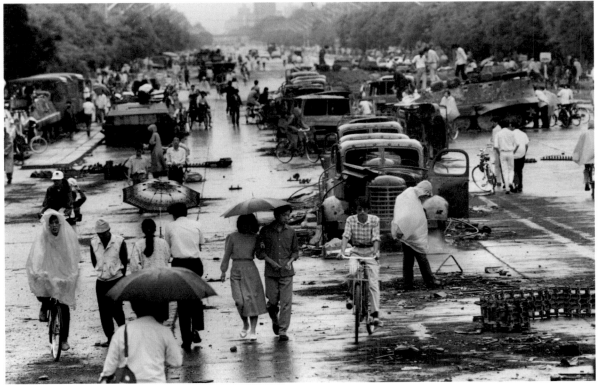

3 DAVID TURNLEY 1989

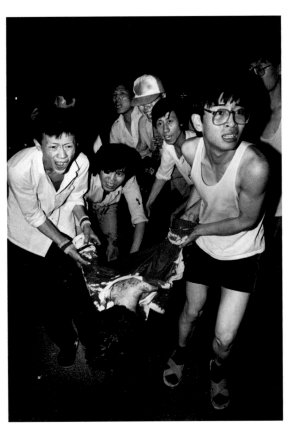

4 DAVID TURNLEY 1989

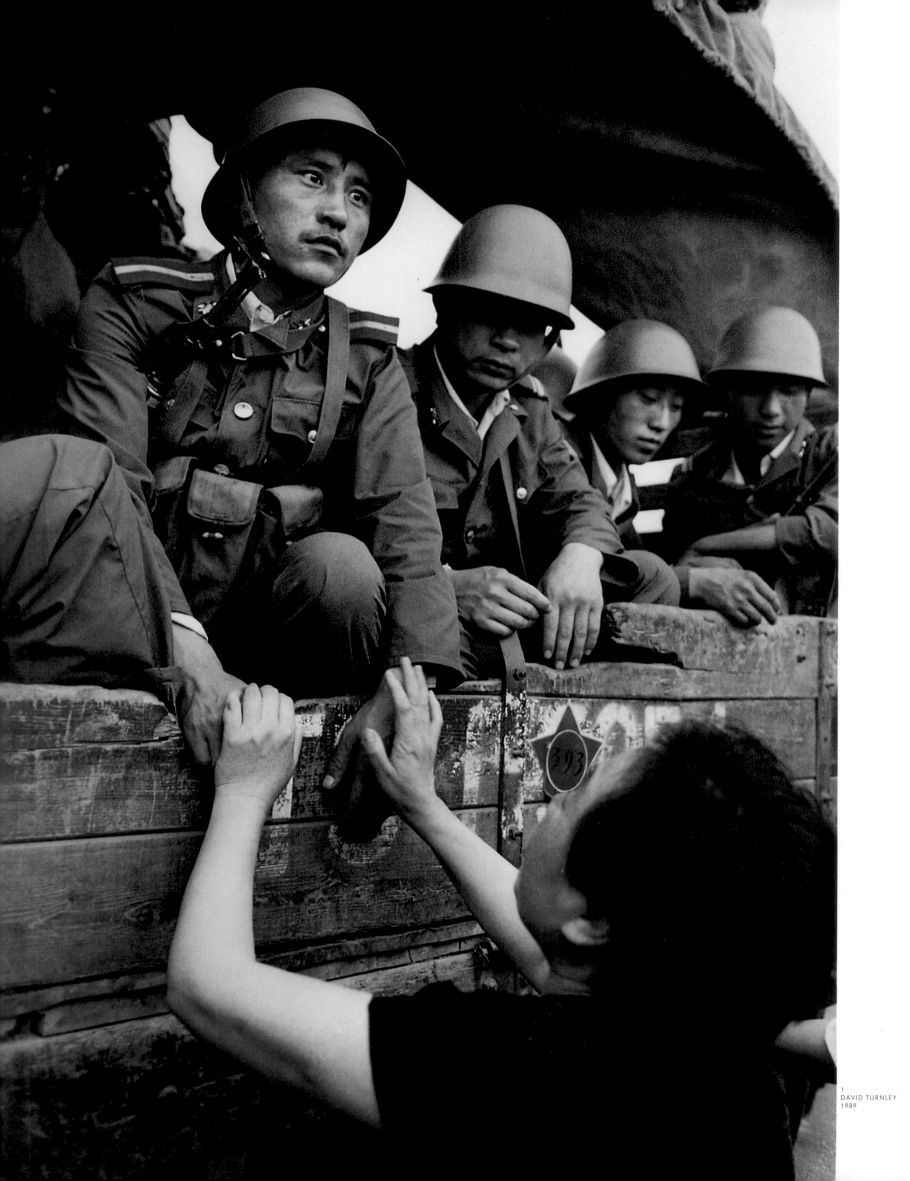

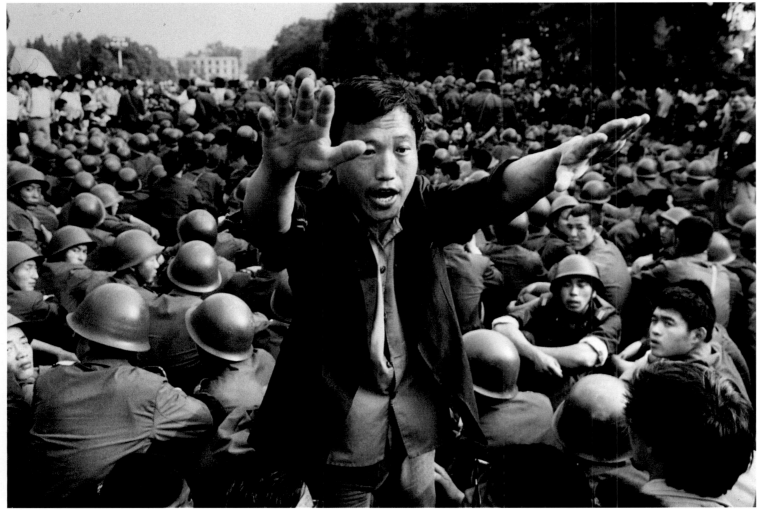

2 DAVID TURNLEY 1989

(3) In mid-May troops advancing from the provinces were held up by students at Beijing's city limits. (1, 2) 3 June on Tiananmen Square. Rumors became rife that the soldiers were going to clear the square by using armed force.

(3) Mitte Mai werden anrückende Provinztruppen an der Stadtgrenze Pekings durch Studenten aufgehalten. (1, 2) 3. Juni auf dem Tienanmen-Platz. Gerüchte wurden laut, daß die Soldaten den Platz mit Waffengewalt räumen werden.

(3) A la mi-mai, les troupes de campagne qui approchent de Pékin sont arrêtées par des étudiants. (1, 2) Le 3 juin sur la place Tian'anmen. La rumeur va croissant que des soldats vont évacuer la place par les armes.

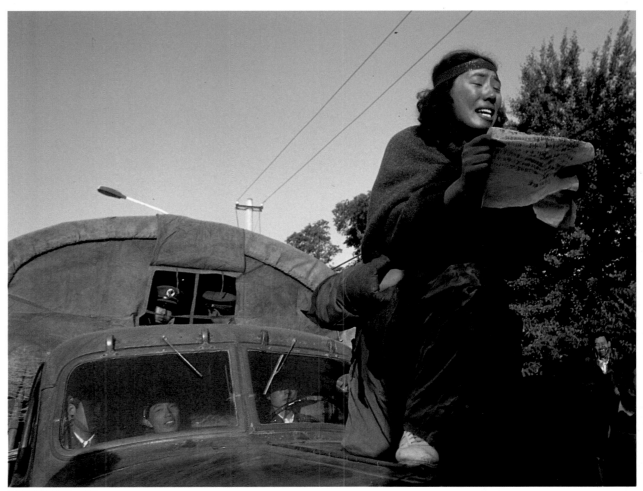

3 PETER TURNLEY 1989

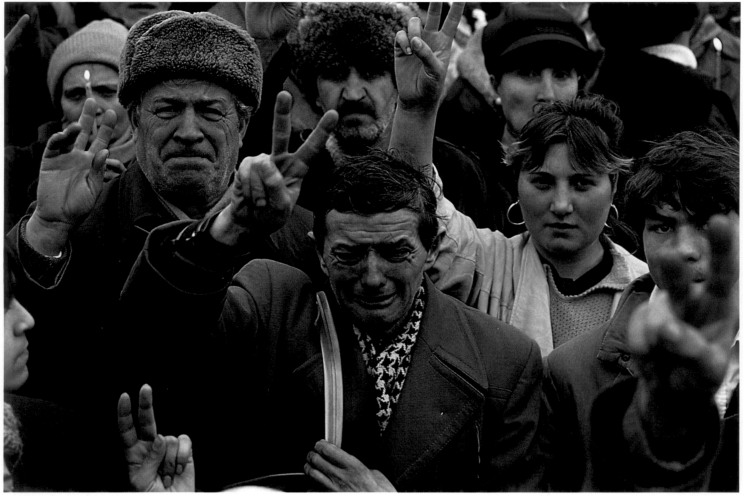

1 PETER TURNLEY 1989

1989. The last days of the Ceauşescu regime in Romania. (3) On 22 December 1989 riots broke out in Bucharest. The dictator fled the city.
(2) A revolutionary watches Ceauşescu's execution on a television in what used to be the dictator's study in the presidential palace.
(1) Crowds of people in Bucharest pay their last respects to those who died during the revolution.

1989. Die letzten Tage des Ceauşescu-Regimes in Rumänien. (3) Am 22. Dezember brachen in Bukarest Straßenkämpfe aus. Der Diktator floh aus der Stadt. (2) Im ehemaligen Präsidenten-palast. Ein Revolutionär schaut sich im Fernsehen im Arbeitszimmer Ceauşescus dessen Hinrichtung an. (1) Die Menschenmenge in Bukarest gibt den Toten der Revolution das letzte Geleit.

1989, les derniers jours du régime Ceauşescu en Roumanie. (3) Le 22 décembre, des combats de rue éclatent à Bucarest. Le dictateur quitte la ville en hâte. (2) Dans l'ancien palais présidentiel, l'un des insurgés suit l'exécution de Ceauşescu à la télévision, depuis le bureau de ce dernier.
(1) A Bucarest, la foule rend les derniers honneurs aux morts de la révolution.

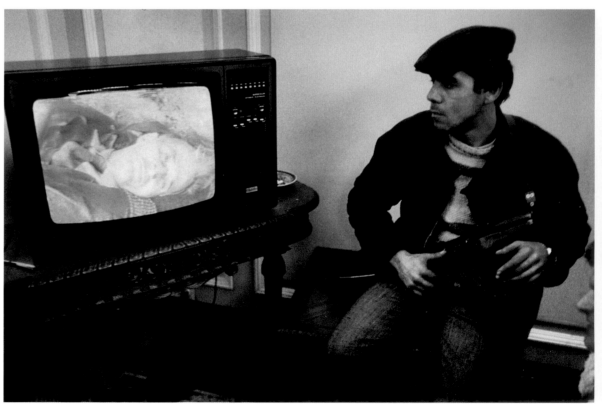

2 DAVID TURNLEY 1989

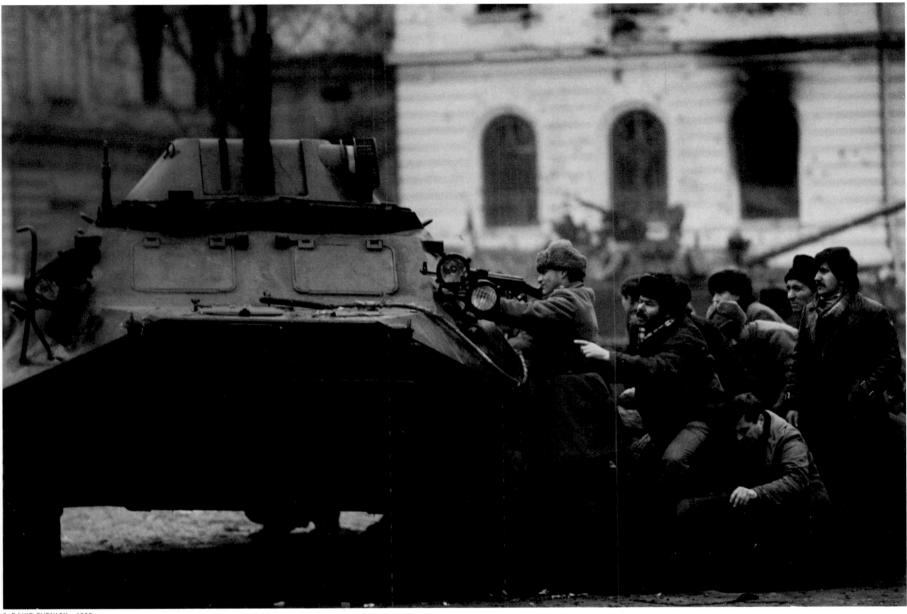

3 DAVID TURNLEY 1989

MOMENTS OF THE REVOLUTION

At the end of 1989 David and Peter Turnley photographed the quiet and dramatic "moments of the revolution" in large parts of Eastern Europe. Their work, which was published in a book in 1990, is reminiscent of the euphoria which inspired millions of people during the fall of communism in East Germany, Czechoslovakia, Romania, Bulgaria, Poland and Hungary. A few years later this euphoria was long forgotten in the face of subsequent economic crises.

MOMENTE DER REVOLUTION

David und Peter Turnley fotografierten Ende 1989 die stillen und dramatischen Momente der Revolution in großen Teilen Osteuropas. Ihre Arbeit, 1990 als Buch veröffentlicht, erinnert an die Euphorie, die Millionen Menschen während des Fall des Kommunismus in der DDR und ČSSR, Rumänien und Bulgarien, Polen und Ungarn beseelte und die wenige Jahre später angesichts der nachfolgenden wirtschaftlichen Krisen wieder in Vergessenheit geriet.

MOMENTS DE LA RÉVOLUTION

En 1989, David et Peter Turnley photographièrent le calme et la tempête qui rythmèrent les bouleversements en l'Europe de l'Est durant la chute du communisme. Publiés en 1990, leurs travaux évoquent l'euphorie qui s'empara de millions de personnes en Allemagne de l'Est, Tchécoslovaquie, Roumanie, Bulgarie, Pologne ou encore Hongrie. Les années qui suivirent, l'euphorie se dissipa face aux difficultés économiques.

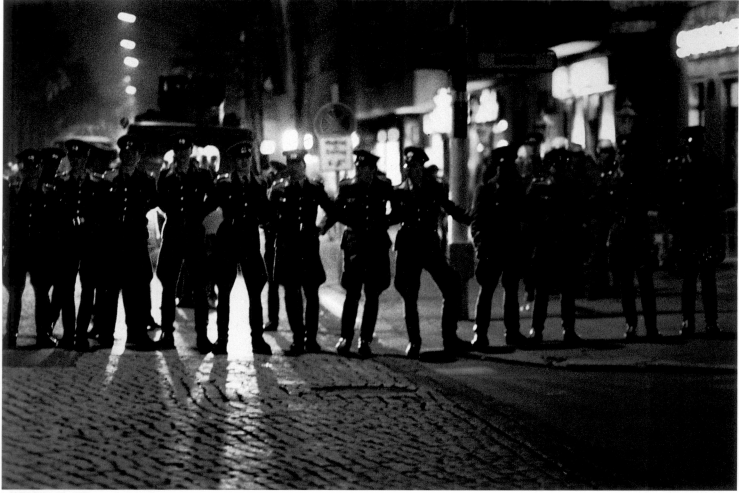

1 PETER TURNLEY 1989

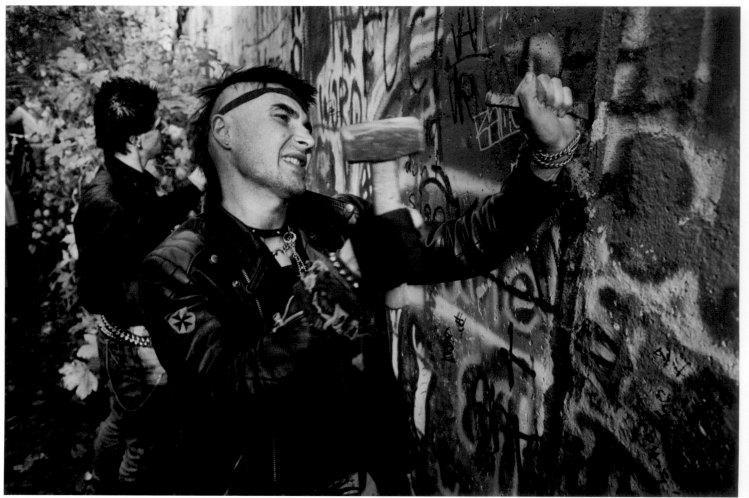

2 DAVID TURNLEY 1989

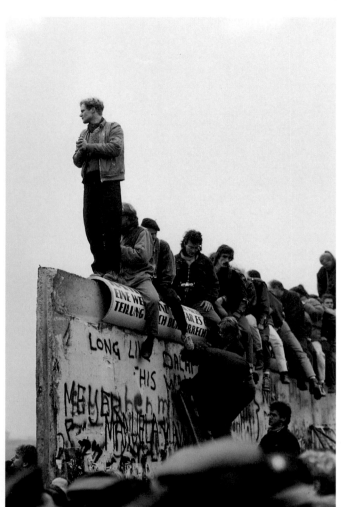

(1) Members of the "People's Police" in the East German capital of East Berlin on 7 October 1989. This was the eve of celebrations commemorating the founding of the German Democratic Republic 40 years earlier. Since the summer, peaceful protests in this land of laborers and farmers had grown steadily. An increasing number of people fled to the West via Prague and Budapest. (3) On 9 November 1989 at 6:57 pm the East German Information Secretary, Schabowski, appeared at an international press conference and announced the opening of the borders – with immediate effect. In the course of the same night tens of thousands of East Germans flocked to West Berlin. (2) "Wall peckers" on the West and East side of the wall doing their share to break down the "anti-fascist barrier", as the border with the West was called in the official jargon of the GDR. (4) At the end of the month demonstrations also swept to Prague – where the 1968 "Prague Spring" had been so brutally suppressed by Soviet tanks.

(1) Volkspolizisten in der Hauptstadt Ost-Berlin am Vorabend des 40. Jahrestages der DDR, dem 7. Oktober 1989. Seit dem Sommer wuchs der friedliche Protest im Arbeiter- und Bauernstaat von Tag zu Tag. Immer mehr Menschen flohen über Prag und Budapest. (3) Am 9. November 1989, um 18.57 Uhr, trat der Informationssekretär Schabowski vor eine internationale Pressekonferenz und verkündete die Öffnung der Grenzen – ab sofort. Noch in der Nacht strömten Zehntausende DDR-Bürger nach West-Berlin. (2) »Mauerspechte« in Ost und West machen sich an den Abbau des »antifaschistischen Schutzwalles«, wie die Westgrenze im DDR-Jargon hieß. (4) Ende des Monats greifen die Demonstrationen auch nach Prag über – dort, wo 1968 der »Prager Frühling« von sowjetischen Panzern niedergewalzt wurde.

(1) La police populaire à Berlin-Est, à la veille du 40ᵉ anniversaire de la RDA, le 7 octobre 1989. Depuis l'été, les revendications pacifiques ne cessaient de croître dans l'Etat des travailleurs et des agriculteurs. De plus en plus de gens fuyaient le pays en passant par Prague ou Budapest. (3) Le 9 novembre 1989, à 18 heures 57, le secrétaire de l'information Schabowski annonça, dans une conférence de presse internationale, l'ouverture des frontières, avec effet immédiat. La nuit même, des dizaines de milliers de Berlinois passaient de l'est à l'ouest de la ville. (2) Des deux côtés, des «pics-du-mur» entreprirent de démolir le «mur de protection anti-fasciste», selon le jargon est-allemand. (4) Dès la fin du mois, les manifestations gagnèrent Prague – où en 1968 les chars russes avaient réprimé le « Printemps de Prague. »

3 DAVID TURNLEY 1989

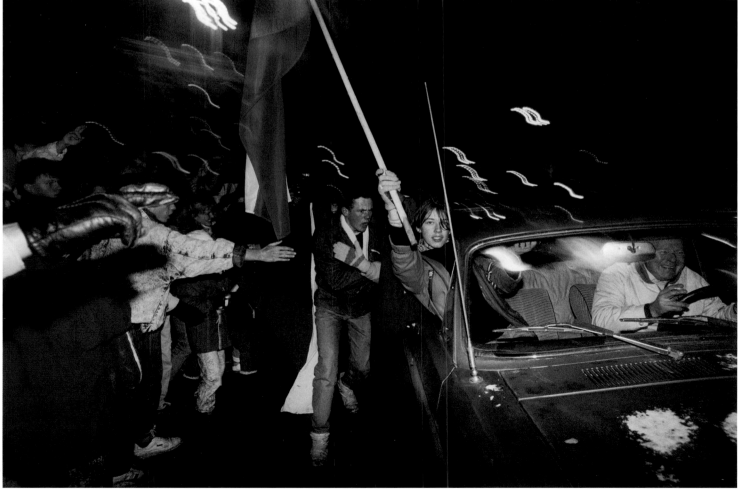

4 DAVID TURNLEY 1989

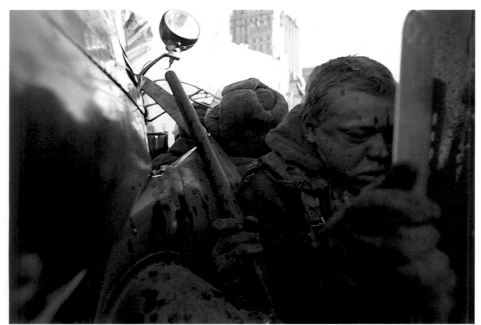

1 MALCOLM LINTON 1993

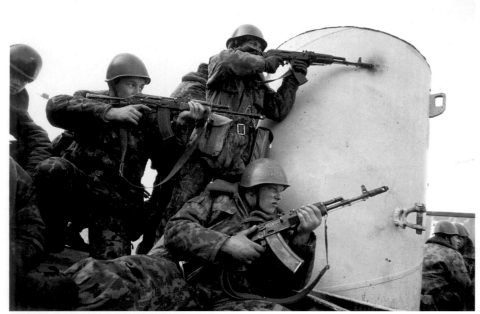

2 CHRISTOPHER MORRIS 1993

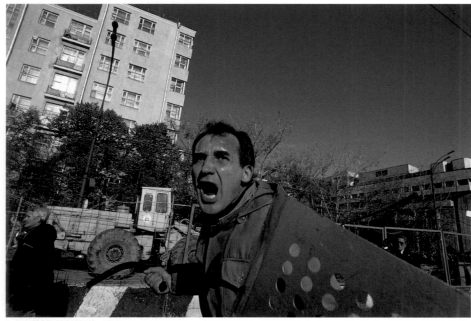

3 CHRISTOPHER MORRIS 1993

THE COUP IN MOSCOW

In 1993 President Boris Yeltsin had to defend his reforms against fierce communist opposition in Russia. After Yeltsin's threats to dissolve parliament, a coup was orchestrated under the leadership of Alexander Ruzkoi at the end of September. (3) Moscow on 3 October. A drunkard with the gun shield and rubber truncheon of a policeman. During an anti-Yeltsin demonstration the crowds broke through police barriers in front of the White House, the seat of the Russian parliament, which was occupied by the rebels. (1) Violent rioting around the White House. This member of the militia was caught between two vehicles. (2) Once again in a repeat of Yeltsin's coup against Gorbachev, the elite troops of the army sided with him. On 4 October these troops intervened and attacked the rebels in the White House from the rooftop of a nearby building, successfully suppressing the coup. (5) Curious onlookers gathering around civilian fatalities. (4) The funeral of one of the almost 200 victims of the coup.

DER MOSKAU-COUP

In Rußland kämpfte Präsident Boris Jelzin 1993 gegen die starke kommunistische Opposition für seine Reformpolitik. Nach Jelzins Drohung, das Parlament aufzulösen, kam es Ende September unter der Führung von Alexander Ruzkoi zum Putsch. (3) Moskau am 3. Oktober. Ein Betrunkener mit dem Schutzschild und dem Gummiknüppel eines Polizisten. Während einer Anti-Jelzin-Demonstration durchbrach die Menge die Polizeisperren vor dem Weißen Haus, dem russischen Parlament, das die Putschisten besetzten. (1) Schwere Straßenkämpfe um das Weiße Haus. Dieses Miliz-Mitglied wurde zwischen zwei Fahrzeugen einge-klemmt. (2) Am 4. Oktober. Elitetruppen der Armee griffen, wie bereits im August 1991 beim Putsch gegen Gorbatschow, auf seiten Jelzins ein und beschossen von einem nahegele-genen Dach die Putschisten im Weißen Haus. Dieser Einsatz schlug den Putsch nieder. (5) Schaulustige versammeln sich um tote Zivilisten. (4) Beerdigung eines der fast 200 Opfer des Putsches.

LE COUP D'ETAT A MOSCOU

En Russie, en 1993, le président Boris Eltsine eut à défendre sa politique de réformes face à une forte opposition communiste. Faisant suite à sa menace de dissoudre le Parlement, un putsch dirigé par Alexander Routskoï eut lieu en septembre. (3) Moscou, 3 octobre. Un homme ivre, armé d'un bouclier et d'une matraque pris à un policier. Au cours d'une manifestation contre Eltsine, la foule avait percé le cordon de policiers qui protégeait la Maison blanche (le parlement russe) occupée par les putschistes. (1) Violentes batailles de rues aux abords de la Maison blanche. Ce membre de la milice a été pris entre deux véhicules. (2) 4 octobre. Comme pendant le putsch de 1991 contre Gorbatchev, les troupes d'élite de l'armée prennent le parti d'Eltsine et tirent depuis les toits sur les putschistes qui sont dans la Maison blanche. Cet assaut réduira à néant la tentative de coup d'Etat. (5) Des badauds se rassemblent autour de victimes civiles. (4) Inhumation de l'un des 200 morts environ du coup d'Etat.

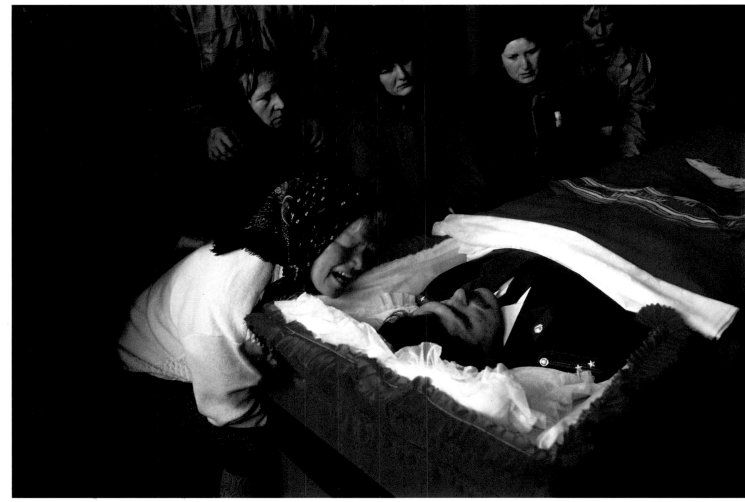

4 CHRISTOPHER MORRIS 1993

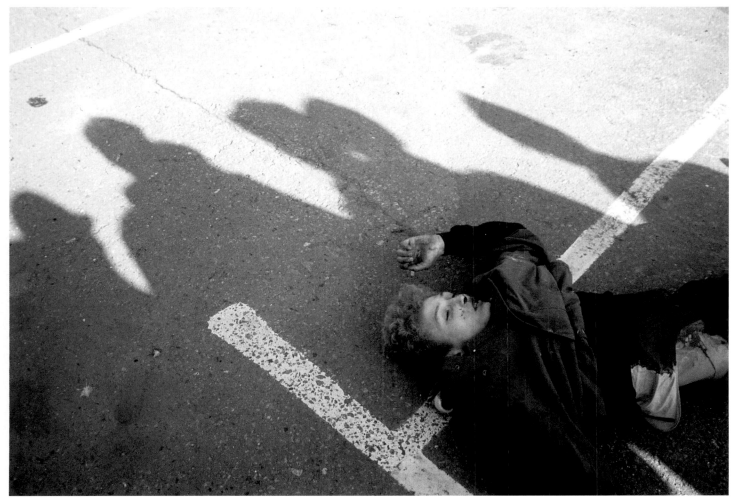

5 CHRISTOPHER MORRIS 1993

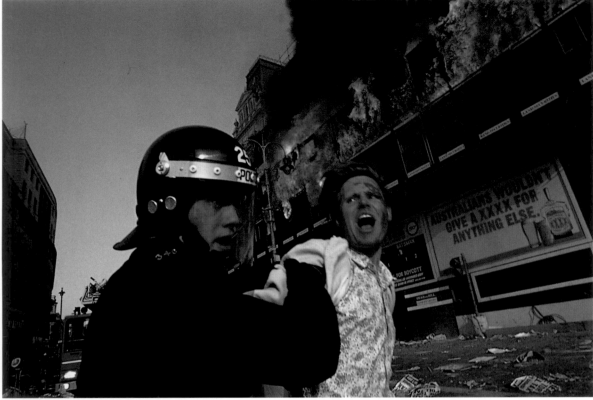

1 CHRISTOPHER MORRIS 1990

POLL TAX – RIOTS IN LONDON

(1) At the climax of nationwide protests against the antisocial "poll tax" which was due to replace local property rates and taxes on 1 April 1990, 475 people were injured and 300 arrested in what turned into a riot. (2) Almost 200,000 Britons protested in the capital on 31 March.

KOPFSTEUER – TUMULTE IN LONDON

(1) 475 Verletzte und 300 Verhaftungen waren der Höhepunkt landesweiter Demonstrationen gegen die unsoziale Kopfsteuer, die am 1. April 1990 die kommunale Steuer auf Haus- und Grundbesitz ersetzen sollte. (2) Etwa 200 000 Briten protestierten in der Hauptstadt am 31. März.

LONDRES : MANIFESTATIONS CONTRE « L'IMPOT PAR TETE »

(1) 475 blessés et 300 arrestations au plus fort des manifestations qui se déroulèrent dans tout le pays contre cet « impôt par tête », d'esprit assez peu social, qui devait remplacer à partir du 1ᵉʳ avril 1990 l'impôt communal local. (2) Près de 200 000 Britanniques manifestèrent dans la capitale le 31 mars.

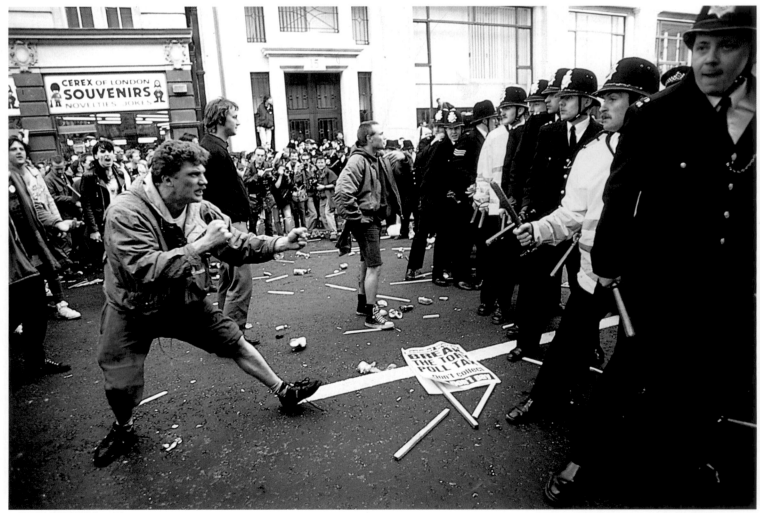

2 CHRISTOPHER MORRIS 1990

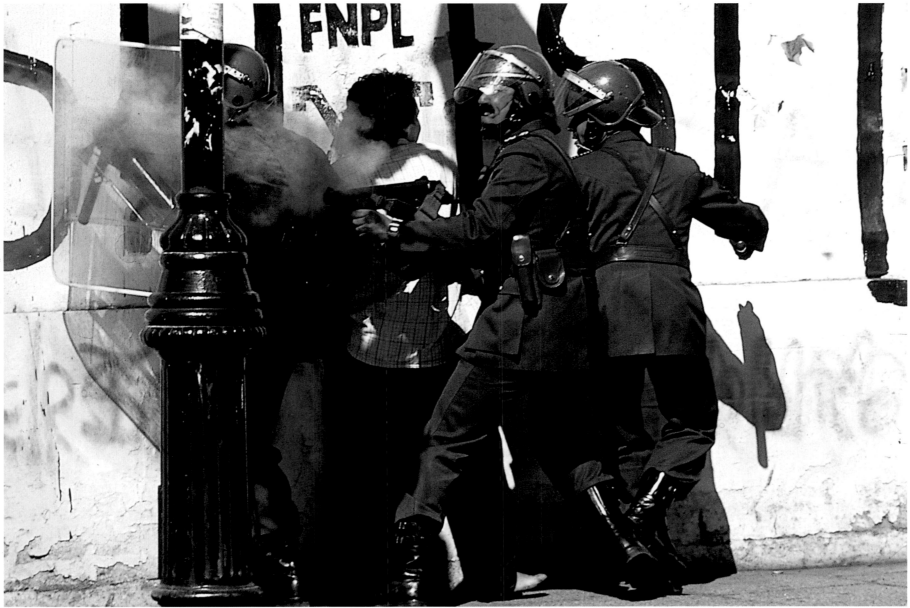

3 CHRISTOPHER MORRIS 1988

PLEBISCITE IN CHILE

Santiago de Chile in October 1988. (3) After a plebiscite in which Chileans voted for an end to the 15-year-long dictatorship of General Pinochet, riots broke out. Christopher Morris also became the target of fanatic Pinochet supporters. Only the courageous interference of his colleague, Wesley Boxce, saved him from the violence of the thugs. In 1989 Pinochet stepped down reluctantly.

PLEBISZIT IN CHILE

Santiago de Chile im Oktober 1988. (3) Nach dem Plebiszit, in dem sich die Chilenen für das Ende der 15jährigen Diktatur General Pinochets aussprachen, kam es zu Straßenkämpfen. Auch Christopher Morris wurde zum Ziel fanatischer Pinochet-Anhänger. Nur das beherzte Eingreifen seines Kollegen Wesley Boxce konnte ihn aus der Gewalt der Schläger befreien. Pinochet trat 1989 nur unwillig zurück.

PLEBISCITE CHILIEN

Santiago de Chili, octobre 1988. (3) Des combats de rues suivirent le plébiscite massif des Chiliens pour la fin de la dictature de 15 ans du général Pinochet. Christopher Morris fut pris pour cible par les partisans fanatiques du dictateur. Il fallut la courageuse intervention de son collègue Wesley Boxce pour le soustraire à leurs coups. Pinochet finit par se retirer en 1989, bien malgré lui.

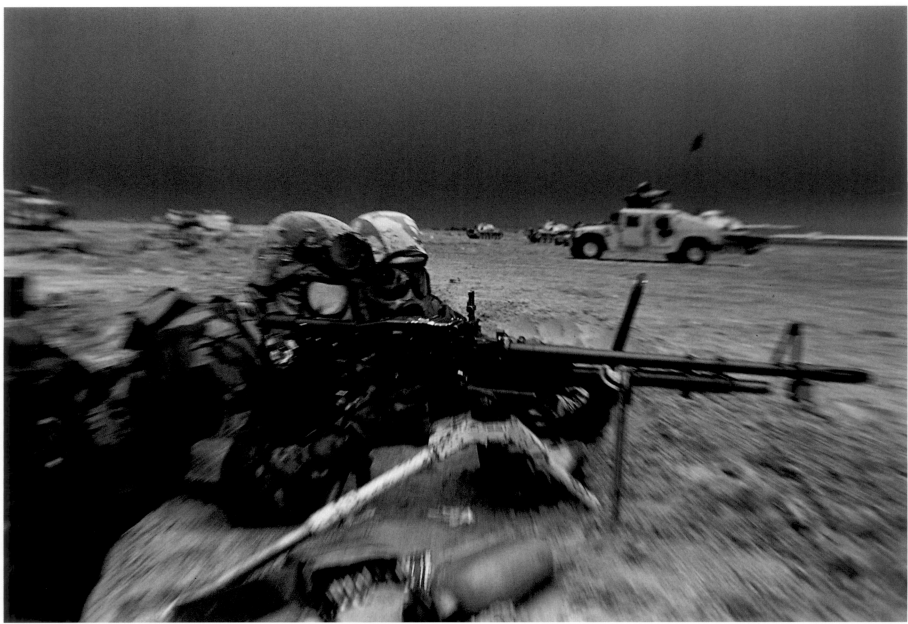

1 CHRISTOPHER MORRIS 1991

(1) US Marines during the liberation of Kuwait on 26 February 1991. On 2 August 1990 Saddam Hussein invaded Kuwait in order to bring Kuwaiti oil reserves under Iraqi control. This blatantly aggressive act by Hussein, the previously "disliked" coalition partner, was quickly countered by America who stationed the first GIs in Saudi Arabia six days later. On 17 January 1991 Operation Desert Storm was launched. The USA, the United Kingdom and France embarked on a strategy of aerial warfare. The heavy bombardment lasted for weeks. A land offensive was set in motion on 24 February.

(1) US-Marines bei der Befreiung Kuwaits am 26. Februar 1991. Am 2. August 1990 hatte Saddam Hussein Kuwait überfallen, um dessen Ölquellen unter irakische Kontrolle zu bringen. Diesen Vorstoß Husseins, bis dahin ungeliebter Koalitionspartner, konterten die USA sechs Tage später mit der Stationierung der ersten GIs in Saudi-Arabien. Am 17. Januar 1991 begann die Operation Wüstensturm. USA, England und Frankreich starteten einen Luftkrieg mit wochenlangen Bombardements. Am 24. Februar setzte die Landoffensive ein.

(1) Marines US durant les combats pour la libération du Koweit, le 26 février 1991. Le 2 août 1990, Saddam Hussein avait envahi le Koweit, dont les puits de pétrole l'intéressaient. Hussein était jusqu'alors peu aimé, mais partenaire des Etats-Unis. A ce débordement, les Américains répondirent six jours plus tard avec un premier stationnement de GIs en Arabie Saoudite. Le 17 janvier 1991 commençait l'opération Tempête du désert. Les Etats-Unis, la Grande-Bretagne et la France entreprenaient une guerre aérienne, faite de bombardements intensifs qui durèrent des semaines. Le 24 février débutait l'offensive terrestre.

(2) American soldiers of the USS Stark killed by an Iranian missile attack in June 1987. To ensure continued American access to the oil reserves of the Persian Gulf during the war between Iran and Iraq (1980–88), US ships and Marines maintained a constant and visible presence in the region.

(2) Nach iranischem Raketenangriff getötete Soldaten der USS Stark im Juni 1987. Um den amerikanischen Zugang zu den Erdölvorräten am Persischen Golf auch während des Iran-Irak-Krieges (1980–88) zu sichern, zeigte die US-Marine ständige Präsenz in der Region.

(2) Soldats de l'USS Stark tués par un tir de missiles iraniens, juin 1987. La marine américaine était restée présente dans la région afin de garantir un accès américain aux réserves pétrolières du Golfe persique pendant toute la durée de la guerre Irak-Iran (1980–1988).

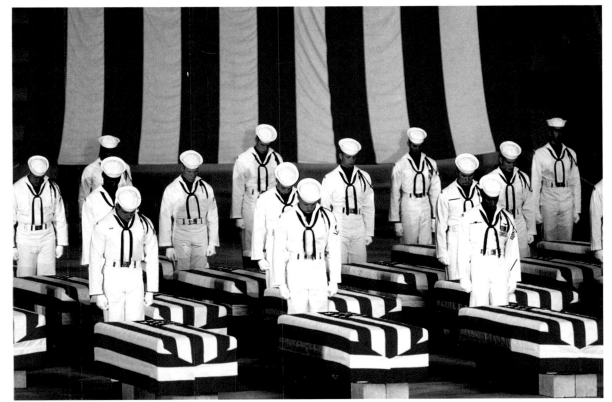

2 CHRISTOPHER MORRIS 1987

THE GULF WAR

During the "media war" in the Persian Gulf Christopher Morris spent six weeks with the Marines for *Time*. However, it was only towards the end of the war that the Marines engaged in combat: "This pole position would have been the best opportunity for photos of this type… The only problem was that the Iraqis did not want to fight, they could not wait to surrender." It was this photographic misfortune which possibly prompted Morris to do something which went against his professional instincts: "As a journalist you rely on your instincts, knowing how far and how hard to push. Competitiveness caused me to stop listening to my instincts for self-preservation." Along with Todd Buchanan he set out from Kuwait to Basra in southern Iraq to photograph the Shiites, who were at that point in time rebelling against Saddam. After warnings at various checkpoints, they were already on their way back when a convoy of colleagues sped past them in the direction of Basra. Morris immediately turned around. Later on the whole convoy was captured and commandeered. At first there was no sign of life, but after six days the 40 journalists were handed over to the Red Cross in Baghdad.

DER GOLFKRIEG

Christopher Morris verbrachte für *Time* im »Medienkrieg« sechs Wochen mit den Marines, die jedoch erst gegen Kriegsende eingriffen: »Diese Zielposition wäre die beste Möglichkeit für Fotos dieser Art gewesen… Das einzige Problem war, daß die Iraker nicht kämpfen wollten; sie konnten es nicht erwarten, sich zu ergeben.« Vielleicht machte Morris aus dieser fotografischen Misere heraus einen Vorstoß, der eigentlich seinem Berufscredo widerspricht: »Als Journalist verläßt man sich auf seine Instinkte, man weiß, wie weit und wie sehr man Druck ausüben kann. Konkurrenzgeist war es, warum ich nicht mehr auf meine Selbsterhaltungs-Instinkte hörte.« Gemeinsam mit Todd Buchanan startete er von Kuwait aus ins südirakische Basra, um die seit dem 1. März gegen Saddam rebellierenden Schiiten zu fotografieren. Nach Warnungen an Checkpoints befanden sie sich schon wieder auf dem Rückweg, als ein Konvoi von Kollegen an ihnen vorbei in Richtung Basra raste. Sofort drehte Morris um. Später wurde der gesamte Konvoi okkupiert und requiriert. Zunächst gab es keine Lebenszeichen der 40 Journalisten, nach sechs Tagen jedoch wurden sie dem Roten Kreuz in Bagdad übergeben.

LA GUERRE DU GOLFE

Christopher Morris fut pendant six semaines correspondant du magazine *Time* dans la première « guerre médiatique », accompagnant les marines qui n'étaient intervenus que vers la fin de la guerre : « J'étais au premier rang, l'occasion rêvée pour des photos de ce type… Le problème, c'était que les Irakiens n'avaient pas envie de se battre, ils n'attendaient que le moment de se rendre. » Peut-être cette absence de matériau visuel a-t-il poussé Morris à transgresser son crédo habituel : « Un journaliste doit se fier à son instinct pour savoir jusqu'où aller et où s'arrêter. Par pur esprit de compétition, j'ai ignoré tout instinct de conservation. » Avec Todd Buchanan, il quitte le Koweit pour Bassora, dans le Sud irakien, pour photographier la révolte des Chiites contre Saddam Hussein, qui avait éclaté le 1er mars. Après quelques avertissements aux différents points de contrôle, ils rebroussaient chemin quand il croisèrent un convoi de collègues filant vers Bassora. Aussitôt, Morris fit demi-tour et se joignit à eux. Le convoi fut arrêté et réquisitionné. On resta d'abord sans nouvelles des 40 journalistes. Au bout de six jours, ils furent remis à la Croix-Rouge, à Bagdad.

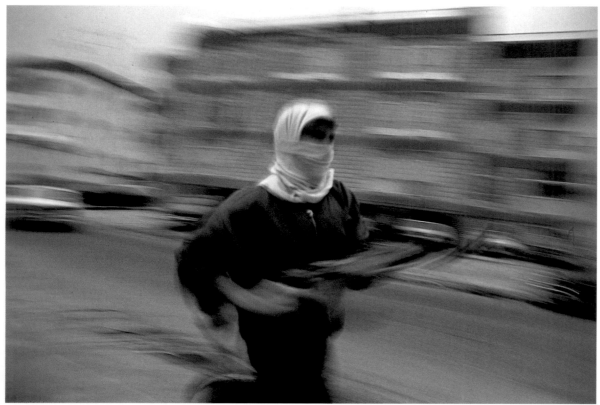

(1) A Kuwaiti on the hunt for pro-Iraqi collaborators. Two days after the Allies land offensive had started, Saddam Hussein ordered the withdrawal of his troops. The Allies ceased firing. In March Shiite revolts against the Iraqi dictator spread to Kurdistan. Saddam's troops remained loyal and suppressed the revolts in the region. (2) The euphoria of victory in Kuwait could not conceal the fact that the war had cost the lives of some 100,000 people and that the region was severely damaged. The retreating Iraqis had also set fire to Kuwaiti oil reserves, setting off fears of major oil pollution.

(1) Kuwaiti auf der Suche nach pro-irakischen Kollaborateuren. Nach Beginn der alliierten Landoffensive befahl Hussein innerhalb von zwei Tagen den Truppenabzug. Die Alliierten stellten das Feuer ein. Im März breitete sich die schiitische Revolte gegen den irakischen Diktator bis nach Kurdistan aus. Husseins Armee blieb loyal und schlug den Aufstand landesweit nieder. (2) Der Siegestaumel in Kuwait täuschte nicht über ca. 100 000 Tote und die Zerstörung der Region hinweg. Zudem hatten Iraki kuwaitische Ölquellen in Brand gesetzt, und es drohte eine Ölpest.

(1) Koweitien à la recherche de collaborateurs pro-irakiens. Deux jours après le début de l'offensive terrestre alliée, Hussein ordonna le retrait des troupes. Les Alliés ouvrirent le feu. En mars, la révolte des Chiites contre le dictateur irakien s'étendit jusqu'au Kurdistan. L'armée de Husein lui resta fidèle et réprima le soulèvement dans tout le pays. (2) Les manifestations de victoire, au Koweit, ne trompèrent personne : la guerre avait fait environ 100 000 morts et dévasté la région. De surcroît, les Irakiens avaient mis le feu à des puits de pétrole koweitiens et on redoutait une pollution massive.

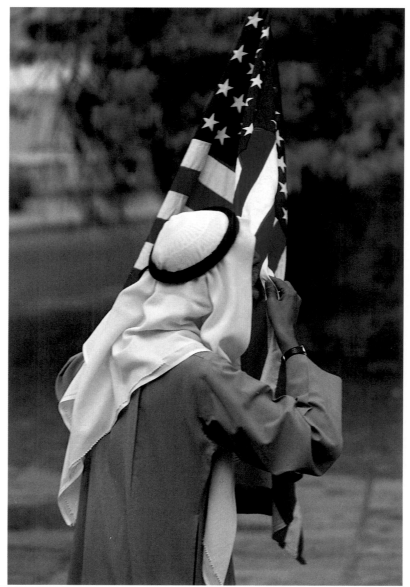

KURDISH REFUGEES

Kurds living in Turkey, Iran and Iraq have so far been denied all rights of autonomy. (1) Iraqi Kurds joined in the March 1991 revolts against Saddam Hussein. After the arrival of the Iraqi army however, the world community idly watched as the Iraqis attacked the Kurds, using helicopters and napalm. Most Iraqi Kurds tried to escape these fierce attacks by fleeing to Turkey and Iran. (2) A mother and her baby who had been on the road for ten days without any food. In May, under UN protection, most of the refugees returned home.

KURDISCHE FLÜCHTLINGE

Kurden, egal ob in der Türkei, im Iran oder Irak lebend, wurde in der Neuzeit bisher jegliches Recht auf Autonomie abgesprochen. (1) Irakische Kurden schlossen sich dem Aufstand gegen Saddam Hussein im März 1991 an. Nach Eintreffen der Armee versuchten die Kurden vor den Irakern, die Hubschrauber und Napalm einsetzten und deren Treiben die Weltöffentlichkeit zunächst tatenlos zusah, in die Türkei oder den Iran zu fliehen. (2) Mutter mit Baby nach zehn Tagen Marsch ohne Nahrung. Im Mai kehrten die meisten Flüchtlinge unter UN-Schutz in ihre Heimat zurück.

REFUGIES KURDES

En Turquie, en Iran ou en Irak, les Kurdes n'ont jamais réussi jusqu'ici à obtenir l'autonomie. (1) En mars 1991, les Kurdes d'Irak s'associèrent au soulèvement contre Saddam Hussein. Après l'intervention de l'armée irakienne – hélicoptères et napalm – sous le regard du monde entier qui observait sans rien faire, les Kurdes tentèrent de fuir en Turquie ou en Iran. (2) Une mère avec son enfant après dix jours de marche sans nourriture. En mai, la plupart des réfugiés rentrèrent chez eux sous la protection de l'ONU.

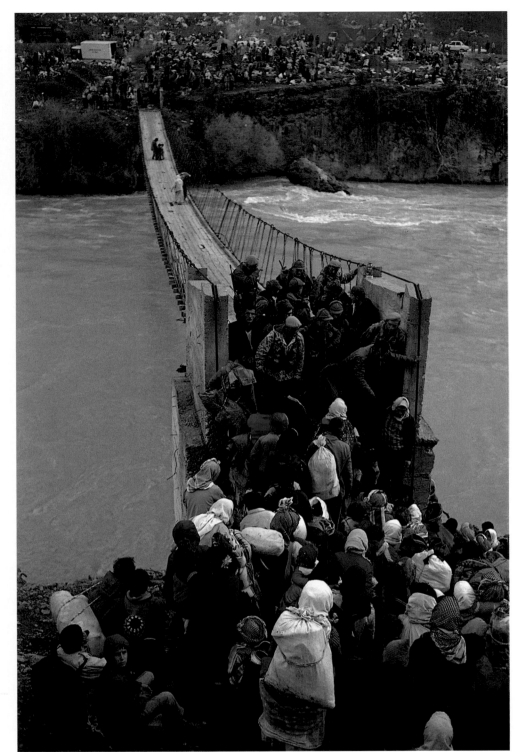

1 KLAUS REISINGER 1991

2 KLAUS REISINGER 1991

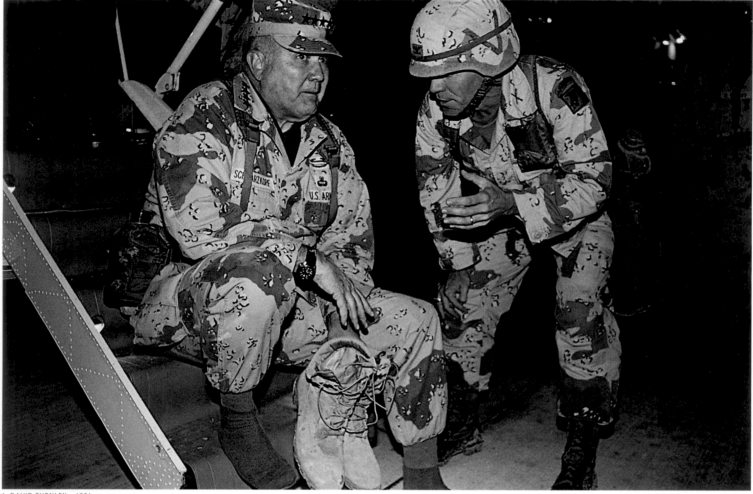

1 DAVID TURNLEY 1991

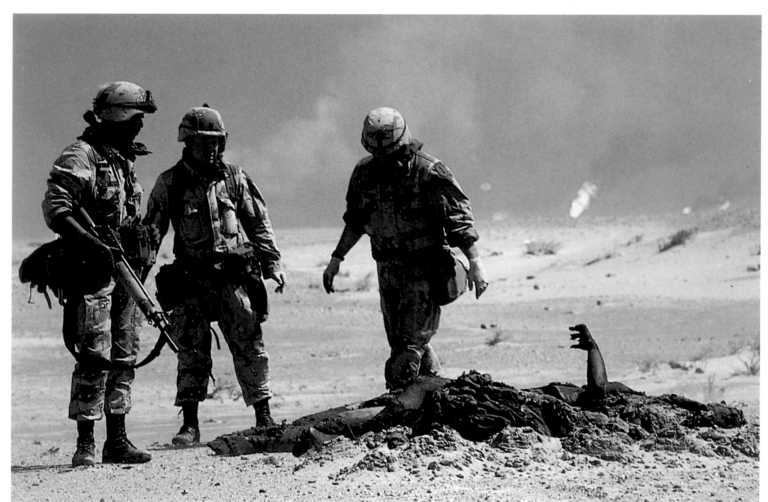

2 PETER TURNLEY 1991

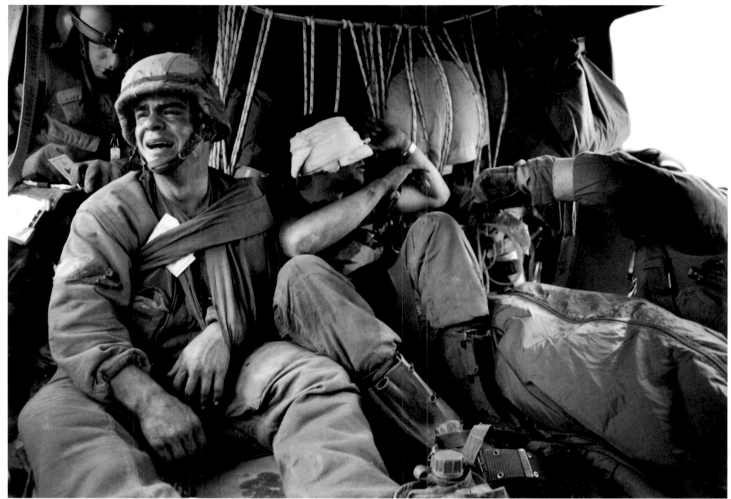

3 DAVID TURNLEY 1991

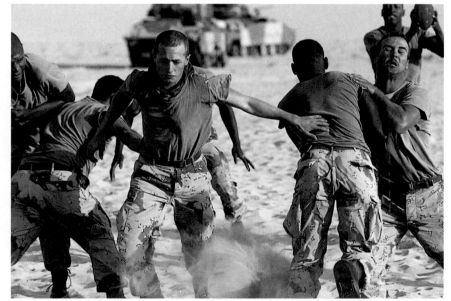

4 DAVID TURNLEY 1991

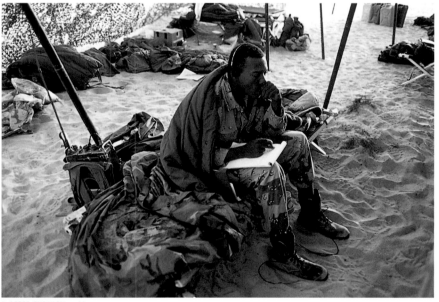

5 PETER TURNLEY 1991

During the Gulf War censorship strictly limited and directed journalists. (1–5) Black Star photographers, like the Turnley brothers, concentrated on personal and emotionally charged shots of the desert fighters. (1) The exhausted "war hero" General Schwarzkopf and (3) the GI mourning for his friend in the body bag next to him. (2) The reality of the war remained largely undocumented. Here Peter managed to take a shot of GIs with a dead Iraqi before press access to the scene was denied.

Die Arbeit der Journalisten im Golfkrieg wurde durch eine Zensurinstanz vor Ort strengstens beobachtet und dirigiert. (1–5) Die Black-Star-Fotografen wie hier die Turnley-Brüder konzentrierten sich auch auf die persönliche, emotional aufgeladene Situation der Wüstenkrieger. (1) Der müde »Kriegsheld« General Schwarzkopf und (3) der GI, der um den Freund im Leichensack trauert. (2) Die Realität der Kampfhandlungen blieb weitgehend undokumentiert. Hier gelang es Peter, die GIs angesichts eines toten Irakers zu fotografieren, bevor der Zugang verboten wurde.

Le travail des journalistes pendant la guerre du Golfe fut sévèrement contrôlé et orienté par un organe de censure sur les lieux mêmes. (1–5) Dans ces conditions les photographes de Black Star, comme les frères Turnley, s'intéressèrent de près à la situation personnelle, très chargée émotionnelle-ment, des guerriers du désert. (1) Le général Schwarzkopf en héros fatigué, ou (3) un GI veillant son ami mort gisant dans un sac à côté de lui. (2) La réalité des combats resta largement invisible. Peter réussit néanmoins à photographier des GIs devant un Irakien mort, avant l'interdiction de l'accès aux photographes.

1 PETER TURNLEY 1988

By the end of the 1980s conflict in Africa was concen-
trated in its southern regions and in the Horn of Africa.
(1) New arrivals from Mozambique in the refugee camp
at Nsanje in Malawi. These refugees were fleeing the
terror of Renamo, one of the opposing parties in the civil
war. (2) Ethiopians at the Tug Wajale Camp in Somalia. A
civil war raged in their country from 1974 onwards,
particularly in the provinces of Eritrea, Oroma and Tigray.

Ende der 80er Jahre lagen die afrikanischen Konflikt-
zentren vor allem im Süden und am Horn von Afrika.
(1) Neuankömmlinge aus Mozambique in einem Flücht-
lingscamp bei Nsanje in Malawi. Sie flohen vor dem
Terror der Bürgerkriegspartei Renamo. (2) Äthiopier im
Tug-Wajale-Camp in Somalia. In ihrer Heimat tobte seit
1974 der Bürgerkrieg in den Provinzen Eritrea, Oroma und
Tigray.

A la fin des années 80, les foyers de conflits se situaient
essentiellement au Sud et dans la corne de l'Afrique.
(1) Dans un camp de réfugiés près de Nsanje, au Malawi,
nouveaux arrivants en provenance du Mozambique,
fuyant la terreur exercée par le parti de la guerre civile,
le Renamo. (2) Ethiopiens au camp Tug Wajale, en
Somalie. La guerre civile ravageait leur pays depuis 1974
dans les provinces d'Erithrée, d'Oroma et du Tigré.

THE WORLD'S HOMELESS

A professional photographer for almost 20 years, Peter Turnley (b. 1955 in Indiana) has, since the 1980s, become one of the most distinguished news photojournalists in the world. From his Paris base, he works on a contractual basis for the American news magazine *Newsweek*. Howard Chapnick, both his fiercest critic and mentor, encouraged the photographer in 1988 to develop a long-term project to counterbalance the immediate nature of news shots. With the support of *Newsweek* Turnley started photographing "The World's Homeless." He documented the life of war and disaster victims in six countries on four continents. From time to time he continues to develop the project further. From these experiences Turnley draws the conclusion that "there is a spirit of survival and a very quiet dignity, even in the face of almost total loss."

DIE HEIMATLOSEN DER WELT

Peter Turnley (geb. 1955 in Indiana) fotografiert seit fast 20 Jahren und zählt seit den 80er Jahren zu den profiliertesten News-Fotojournalisten weltweit. Von Paris aus arbeitet er als Vertragsfotograf für das amerikanische Nachrichtenmagazin *Newsweek*. Howard Chapnick, sein schärfster Kritiker und Mentor zugleich, ermunterte den Fotografen 1988 dazu, ein Langzeitprojekt zu entwickeln, um den schnellen Nachrichtenbildern eine große Arbeit entgegenzusetzen. Turnley fotografierte daraufhin mit Unterstützung von *Newsweek* »The World's Homeless«. Er dokumentierte das Leben von Katastrophen- und Kriegsopfern in sechs Ländern auf vier Kontinenten. Von Zeit zu Zeit verfolgt er dieses Projekt weiter. Peter Turnley zieht sein persönliches Fazit: »Selbst in den Gesichtern derer, die nahezu alles verloren haben, sieht man den Überlebenswillen und ihre ruhige Würde.«

SANS-ABRIS DU MONDE ENTIER

Peter Turnley (né en 1955 dans l'Indiana) exerce le métier de photographe depuis près de 20 ans et il est aujourd'hui l'un des photoreporters les plus célèbres. Basé à Paris, il est sous contrat avec le magazine américain d'information *Newsweek*. Howard Chapnick, son mentor et son plus sévère critique, encouragea le photographe en 1988 à élaborer un projet de longue durée, pour avoir quelque chose à opposer à la rapidité des images d'information. Soutenu par *Newsweek*, Turnley commença alors une série intitulée « Sans-abris du monde entier ». Il rapporta des témoignages sur la vie des victimes des catastrophes et des guerres dans six pays et quatre continents. De temps en temps, il reprend ce projet. Bilan de Peter Turnley sur cette expérience : « Il y a un esprit de survie et une dignité très tranquille, même quand on a presque tout perdu. »

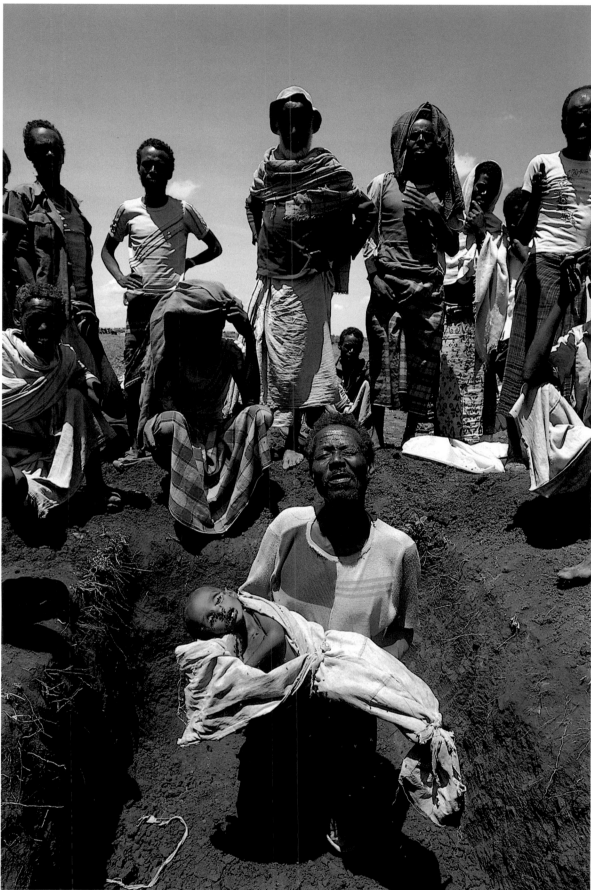

2 PETER TURNLEY 1988

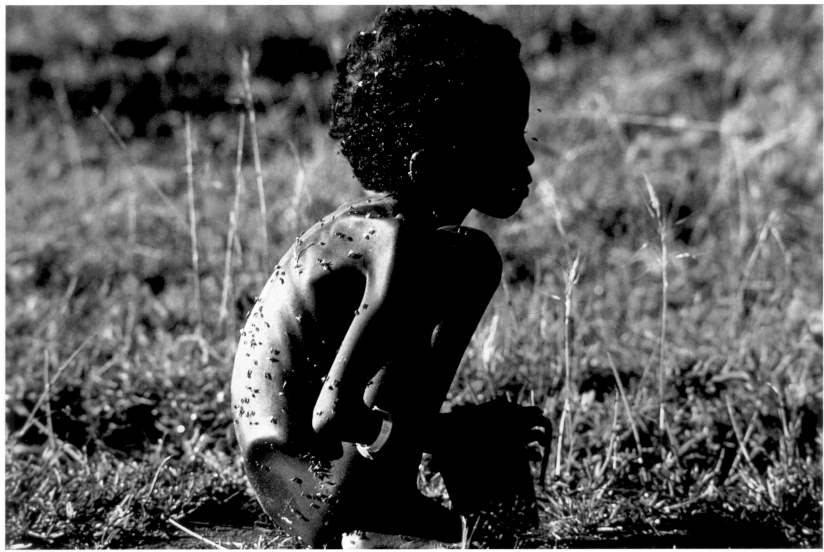

1 PETER TURNLEY 1988

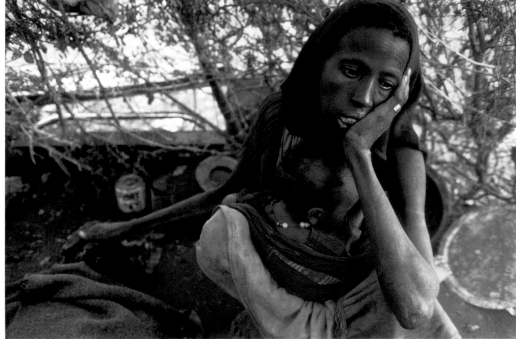

2 PETER TURNLEY 1988

More than three quarters of all refugees in the world are women and children. (1, 2) Ethiopians at the Tug Wajale Camp in Somalia.

Mehr als drei Viertel der Flüchtlinge in aller Welt sind Frauen und Kinder. (1, 2) Äthiopier im Tug-Wajale-Camp in Somalia.

Plus des trois quarts des réfugiés du monde entier sont des femmes et des enfants. (1, 2) Ethiopiens au camp de Tug Wajale, en Somalie.

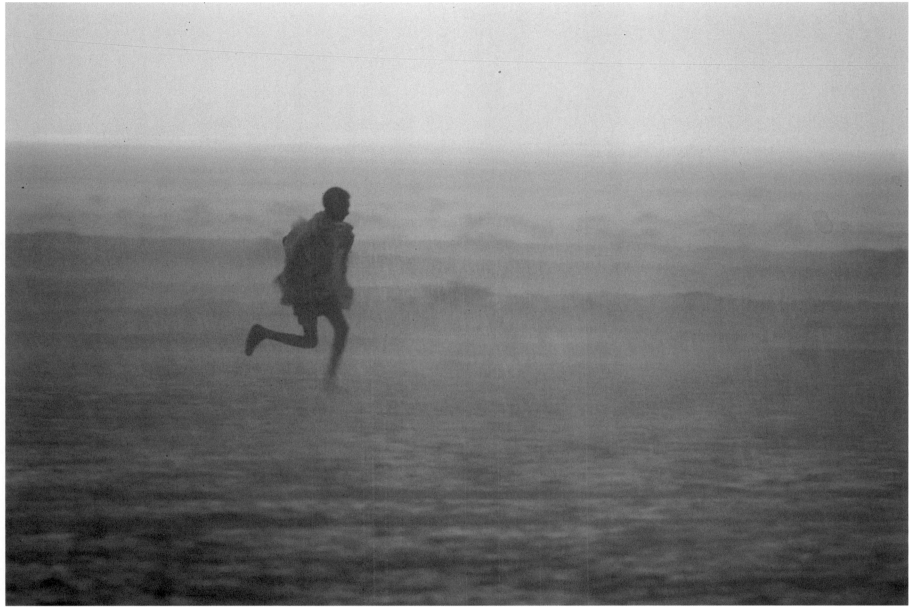

3 PETER TURNLEY 1988

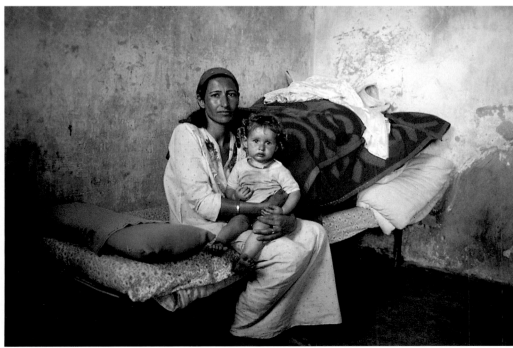

4 PETER TURNLEY 1988

(3) A refugee looking for food around the Tug Wajale Camp during a rain storm. (4) The Palestinian camp Rafiah situated in the Gaza Strip.

(3) Flüchtling auf Nahrungssuche außerhalb des Tug-Wajale-Camps im Regensturm. (4) Palästinenser-Lager Rafiah im Gaza-Streifen.

(3) Réfugié cherchant de la nourriture hors du camp de Tug Wajale, sous l'orage. (4) Le camp palestinien de Rafiah, dans la bande de Gaza.

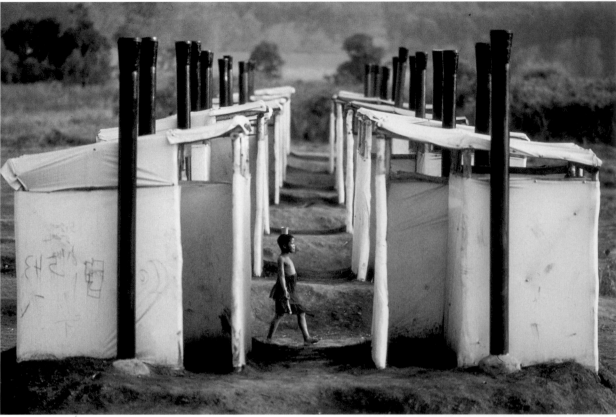

1 PETER TURNLEY 1988

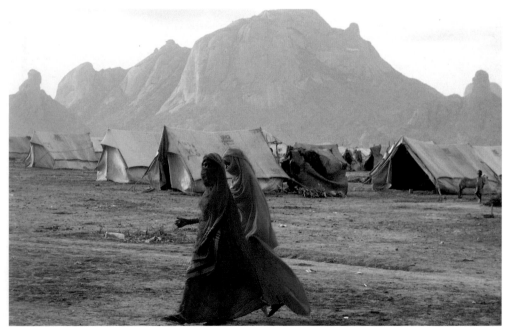

2 PETER TURNLEY 1988

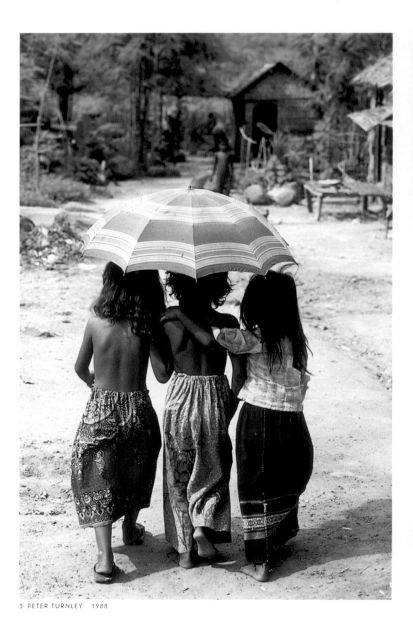

International aid organizations continually set up tent villages and organize food and water supplies. (1) A Mozambican woman among camp toilets in Malawi. (2) Refugees from Eritrea in the Wad Sharif camp in East Sudan. (3) Children living in a Cambodian refugee camp in Thailand.

Internationale Hilfsorganisationen errichten immer wieder Zeltstädte und organisieren Lebensmittel- und Wasserversorgung. (1) Frau aus Mozambique zwischen den Lagerlatrinen in Malawi. (2) Flüchtlinge aus Eritrea im Lager Wad Sharif im Ost-Sudan. (3) Lagerleben kambodschanischer Kinder in Thailand.

Les organisctions internationales d'aide humanitaire érigent des villages de tentes et organisent l'approvisionnement en eau et en nourriture. (1) Une Mozambicaine entre les rangées de atrines du camp au Malawi. (2) Réfugiés d'Erithrée au camp de Wad Sharif, dans l'Est du Soudan. (3) La vie des enfants cambodgiens dans les camps en Thaïlande.

3 PETER TURNLEY 1988

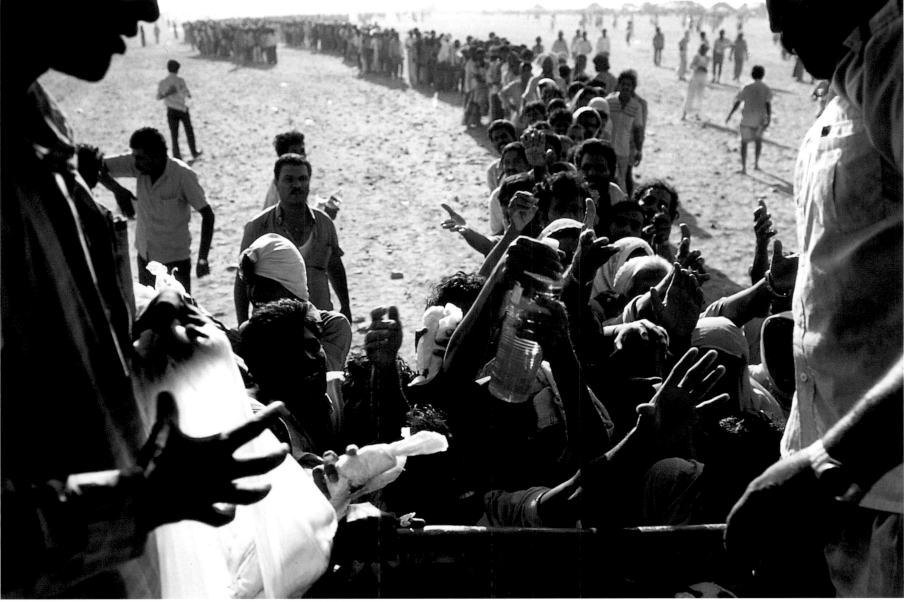

4 PETER TURNLEY 1992

(4) Food is handed out to Kurds on the border between Jordan and Iraq. According to a UN report, 45 million people were refugees in the 1990s.

(4) Hilfsmittelverteilung an Kurden an der Grenze zwischen Jordanien und Irak. Laut einem UN-Bericht waren Mitte der 90er Jahre 45 Millionen Menschen auf der Flucht.

(4) Distribution de matériel aux Kurdes à la frontière jordano-irakienne. D'après un rapport de l'ONU, 45 millions de personnes étaient en fuite au milieu des années 90.

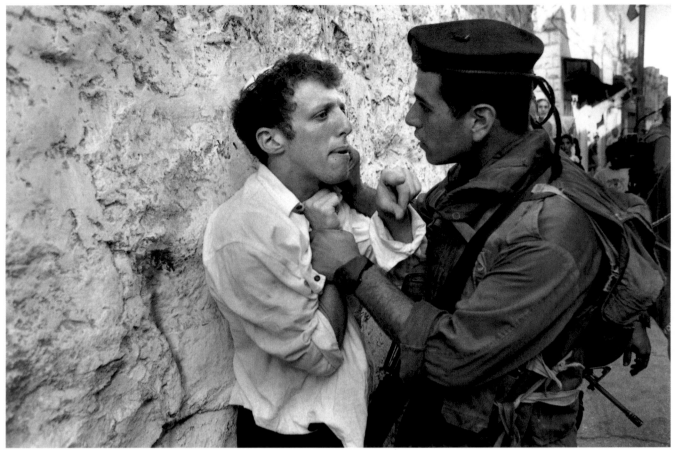

1 DAVID TURNLEY 1995

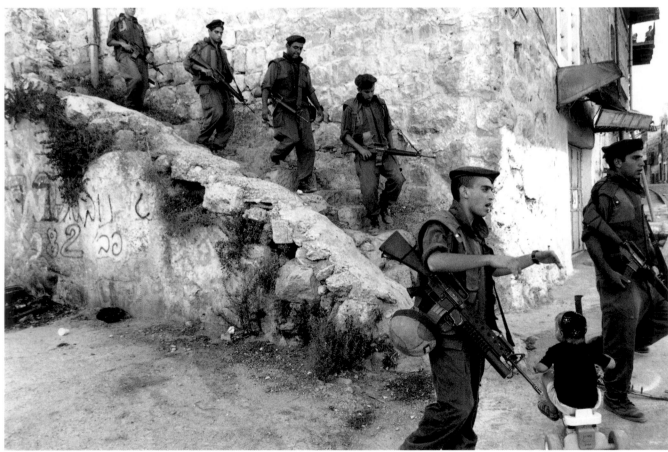

2 DAVID TURNLEY 1995

In 1995 there were days when Hebron was as explosive as a powder keg. (1) A settler is arrested. On this particular Jewish Sabbath, settlers from the whole of the West Bank came to Hebron to demonstrate solidarity with their 400 fellow Jews who live in the old part of the city. (2) A boy on a tricycle in front of his parents' house is not at all impressed by a patrol of Israeli soldiers. These patrols have become an integral part of everyday life in the city.

Hebron glich 1995 an manchen Tagen einem Pulverfaß. (1) Verhaftung eines Siedlers. An jedem jüdischen Sabbat kamen Siedler aus der gesamten Westbank, um ihre Solidarität mit 400 Glaubensgenossen, die in der Altstadt von Hebron wohnen, zu bekunden. (2) Der Junge auf dem Dreirad vor dem Haus seiner Eltern zeigt sich wenig beeindruckt von der Patrouille israelischer Soldaten, die zum alltäglichen Stadtbild gehört.

En 1995, Hébron ressemblait, certains jours, à un baril de poudre. (1) Arrestation d'un colon. Chaque vendredi, pour le Sabbat, des colons arrivaient de toute la Cisjordanie occupée pour manifester leur solidarité avec leur 400 coreligionnaires qui vivaient à Hébron. (2) Devant la maison de ses parents, ce gamin à tricycle n'est pas impressionné par les soldats israéliens en patrouille : leur présence fait partie du quotidien.

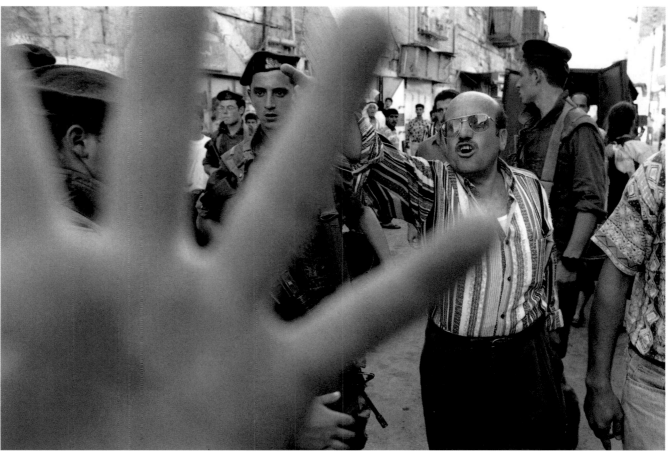

3 DAVID TURNLEY 1995

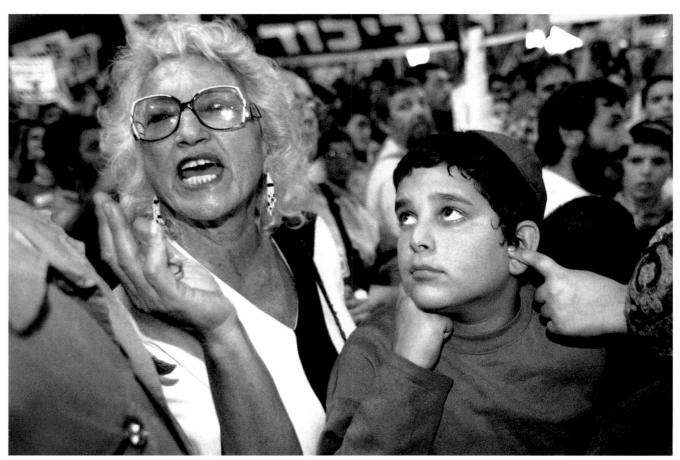

4 DAVID TURNLEY 1995

(3) The weekly display of power by partially armed Zionists was disturbed by two Christian women who were subsequently pushed to the ground. This resulted in Palestinians streaming out into the streets and further disturbances. It ended with a number of warning shots and the arrest of two settlers. (4) Jewish settlers and their children demonstrating in Jerusalem. They are demanding the retention of the status quo for settlers on the West Bank. Even in 1995 these rights seemed seriously at risk.

(3) Nachdem an diesem Tag die wöchentliche Machtdemonstration z.T. bewaffneter Zionisten von zwei christlichen Frauen gestört wurde und diese zu Boden gestoßen wurden, strömten Palästinenser in die Straßen. Es kam zu Tumulten, begleitet von Warnschüssen, die in der Verhaftung zweier Siedler endeten. (4) Jüdische Siedler demonstrierten gemeinsam mit ihren Kindern in Jerusalem. Sie kämpften für den status quo der Siedler auf der Westbank, der sich aber bereits 1995 aufzulösen drohte.

(3) Ce jour-là, après que la manifestation de force hebdomadaire des colons armés eut été dérangée par deux femmes chrétiennes qui furent jetées au sol, les Palestiniens affluèrent dans les rues. Il y eut des émeutes et des tirs de semonce, et deux colons furent finalement arrêtés.(4) Des colons juifs manifestent avec leurs enfants à Jérusalem. Ils réclament des assurances que la colonisation, en Cisjordanie, ne sera pas remise en question en 1995.

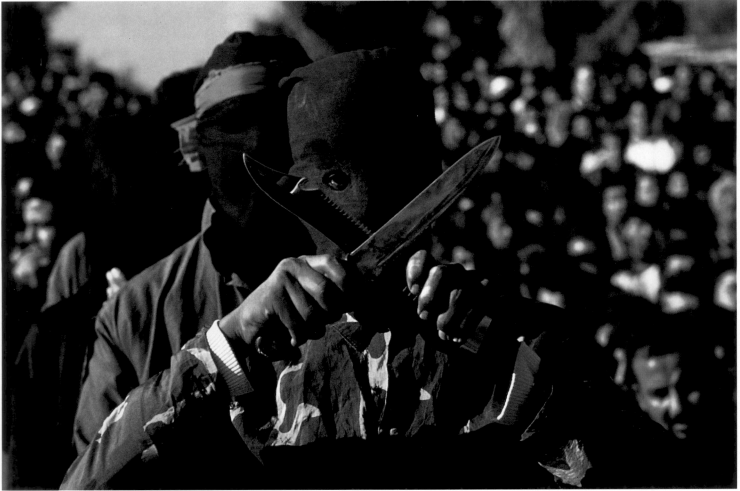

1 PETER TURNLEY 1993

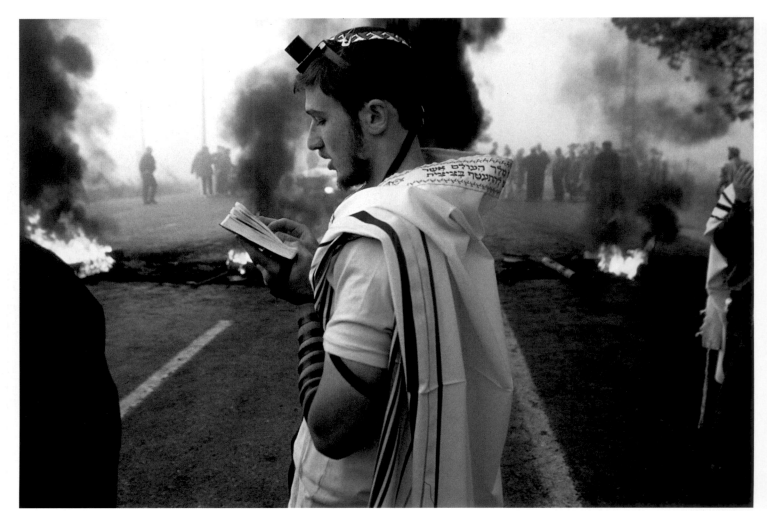

2 PETER TURNLEY 1993

THE GAZA-JERICHO PEACE AGREEMENT

There was yet again a threat to peace when the Hebron massacre of 25 February 1994 jeopardized the final ratification of the treaty. Radicals on both sides tried to thwart the peace efforts. They are: (1) Hamas in the Gaza Strip on the Palestinian side and (2) orthodox West Bank settlers on the Jewish side. (3) The Wailing Wall has also become a target for stone-throwers. (4) Despite all the opposition, the treaty was finally ratified on 4 May 1994. Arafat moved to Gaza in July.

GAZA-JERICHO-ABKOMMEN

Das Hebron-Massaker am 25. Februar 1994 gefährdete noch einmal die endgültige Ratifizierung des Vertrags. Radikale beider Konfliktparteien versuchten den Friedensprozeß zu vereiteln: (1) Hamas in Gaza auf palästinensischer und (2) orthodoxe Westbank-Siedler auf jüdischer Seite. (3) Auch die Klagemauer war Ziel von Steinwürfen. (4) Trotz allen Widerstands wurde am 4. Mai 1994 der Vertrag geschlossen, Arafat zog im Juli in Gaza ein.

L'ACCORD GAZA-JÉRICHO

Le massacre de Hébron, le 25 février 1994, menaçait la ratification du texte. Des deux côtés, des opposants radicaux tentaient de faire échouer le processus de paix : (1) le Hamas à Gaza, du côté palestinien, et (2) les colons religieux des territoires occupés du côté israélien. (3) Le mur des Lamentations fut lui aussi la cible des pierres. (4) Malgré les résistances, l'accord fut signé le 4 mai 1994. En juillet, Arafat s'installait à Gaza.

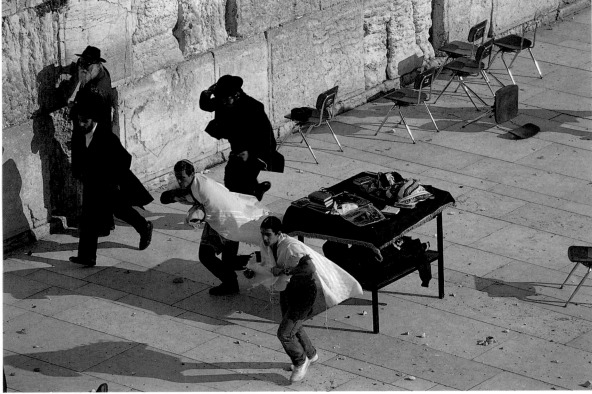

3 ERICA LANSNER 1994

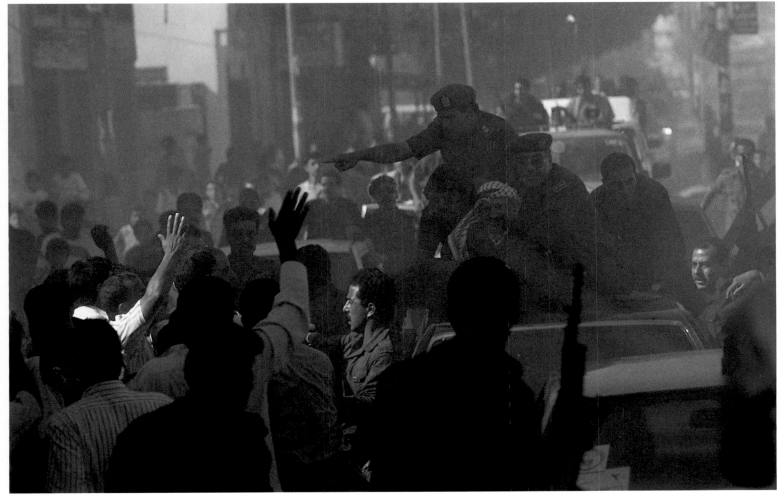

4 PETER TURNLEY 1994

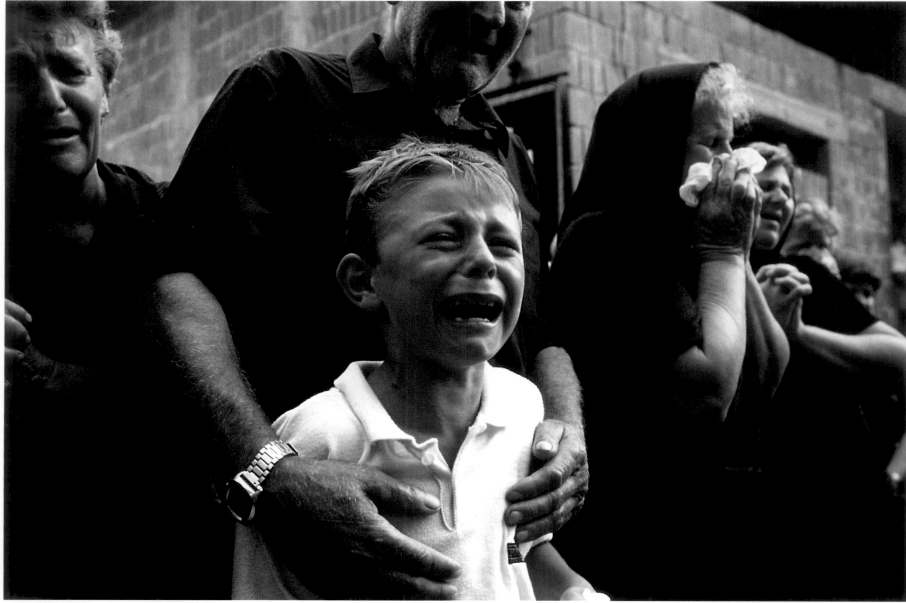

1 CHRISTOPHER MORRIS 1991

(1) The funeral of a Croatian policeman who was killed in an ambush attack. The boy in the foreground is his son.

(1) Begräbnis eines kroatischen Polizisten, der aus dem Hinterhalt getötet worden war. Der Junge im Vordergrund ist sein Sohn.

(1) Enterrement d'un policier croate, tué dans une embuscade. Au premier plan, son fils.

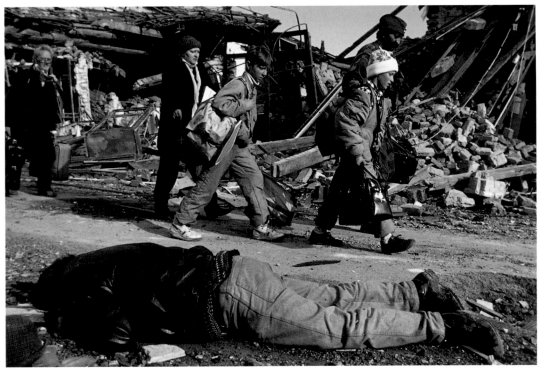

Vukovar, Croatia in 1991. Of the original 81,000 inhabitants only 5,000 remained. (2) After Vukovar had been overrun by the Serbian army, the inhabitants fled the city – passing maimed corpses along the roadside.

Vukovar in Kroatien im November 1991. Von ursprünglich 81 000 Einwohnern waren nur noch 5 000 zurückgeblieben. (2) Nachdem Vukovar von der serbischen Armee überrannt worden war, flohen die Bewohner der Stadt, vorbei an den Leichen am Straßenrand.

Vukovar, Croatie, novembre 1991. Sur les 81 000 habitants qui y vivaient, 5 000 étaient restés dans la ville. (2) Après la prise de Vukovar par l'armée serbe, les habitants s'enfuient de la ville, longeant les cadavres amoncelés au bord de la rue.

2 CHRISTOPHER MORRIS 1991

A LIVING HELL

Throughout the period between 1991–1995 Christopher Morris observed the civil war in the former Yugoslavia directly at the front line. Of the first six months, during which he mainly worked in Croatia, he subsequently recalled: "I first flew to Belgrade in July 1991 soon after Slovenia and Croatia had declared their independence. I went back and forth between Yugoslavia and New York six times, I would put in a week, then take a week or two off to try to get my nerve back. Even though I've covered many other conflicts, I was unprepared for the hatred between the Croats and the Serbs, which is deeply rooted in their history and intensified during World War II when the Croats sided with the Fascists." For Morris this human inferno once again confirmed previous personal experiences: "For three days after you've been in a combat zone, you're incredibly sensitive to everything - when you eat, when you drink, when you see a friend you hug and kiss him. The allure of the front line keeps drawing you back. It gives you a feeling you can almost taste - a deep gratitude for life." At the time of this particular interview, the war had just broken out, but Morris was already well respected and had won numerous prizes for his photographic efforts. He followed the rest of the war until 1995 with great commitment and direct personal involvement, but in 1997 he admitted in hindsight: "I burned out after the first two years of war. What else can I say:..?" The selection of Vukovar photographs representing his work during this period speak for themselves.

HÖLLE AUF ERDEN

Christopher Morris war von 1991–1995 immer wieder beobachtender Teilnehmer des Bürgerkriegs in Ex-Jugoslawien. Über die ersten sechs Monate, in denen er vor allem in Kroatien arbeitete, berichtete er: »Ich flog das erste Mal im Juli 1991 nach Belgrad, kurz nachdem Slowenien und Kroatien ihre Unabhängigkeit erklärt hatten Ich flog sechsmal zwischen Jugoslawien und New York hin und her; nach einer Woche Arbeit brauchte ich ein oder zwei Wochen Pause, um meine Nerven zu regenerieren. Obwohl ich über viele andere Konflikte berichtet habe, war ich nicht auf den Haß zwischen Kroaten und Serben vorbereitet, der tief in ihrer Geschichte wurzelt und der während des Zweiten Weltkriegs verstärkt wurde, als die Kroaten an der Seite der Faschisten kämpften.« Für Morris bestätigte sich in diesem menschlichen Inferno wieder einmal seine Erkenntnis: »Drei Tage, nachdem du in einem Kampfgebiet warst, bist du unglaublich empfindlich gegen alles – wenn du ißt, wenn du trinkst, wenn du einen Freund siehst, umarmst und küßt du ihn. Der Reiz der Front zieht dich immer wieder zurück. Er gibt dir ein Gefühl, das du fast schmecken kannst – eine tiefe Dankbarkeit für das Leben.« Zum Zeitpunkt dieses Interviews hatte der Krieg erst begonnen, Morris hatte aber bereits unzählige Preise für diese Arbeit erhalten. Den weiteren Kriegsverlauf bis 1995 verfolgte er engagiert, jedoch gestand er in einem Rückblick 1997 auf die Zeit: »Nach den ersten zwei Kriegsjahren war ich ausgebrannt. Was soll ich noch sagen…?« Stellvertretend für seine Arbeiten sprechen hier die Vukovar-Bilder.

UN ENFER SUR TERRE

De 1991 à 1995, Christopher Morris fut un observateur engagé de la guerre en ex-Yougoslavie. Des six premiers mois, passés surtout en Croatie, il raconte : « Je me suis d'abord enfui à Belgrade en juillet 1991, peu après que la Slovénie et la Croatie eurent déclaré leur indépendance. J'ai fait six allers-retours entre New York et la Yougoslavie. Je restais une semaine, puis il me fallait une semaine ou deux de congé pour retrouver mon calme. J'avais couvert pas mal d'autres guerres, mais je n'étais pas préparé à cette haine entre Croates et Serbes, une haine profondément enracinée dans leur histoire et intensifiée pendant la Deuxième Guerre mondiale, à cause de l'engagement croate du côté fasciste. » Cet enfer confirme ses expériences passées : « Quand on arrive dans une région en guerre, les trois premiers jours, on est incroyablement sensible à tout : manger, boire, voir un ami, l'embrasser. C'est cela qui vous fait irrésistiblement revenir sur les lignes de front. Cela vous donne un sentiment presque palpable, une profonde gratitude envers la vie. » A l'époque de cette interview, la guerre venait de commencer mais Morris avait déjà reçu d'innombrables prix pour ses travaux. Il suivit la guerre jusqu'en 1995, mais avouait en 1997 dans un entretien : « Deux ans après le début de la guerre, j'avais brûlé mes réserves. Que dire d'autre… » Ces images de Vukovar parlent pour lui.

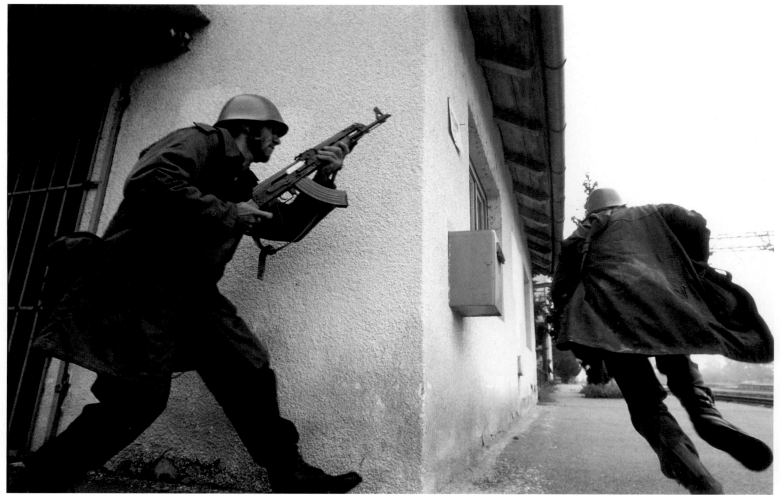

1 CHRISTOPHER MORRIS 1991

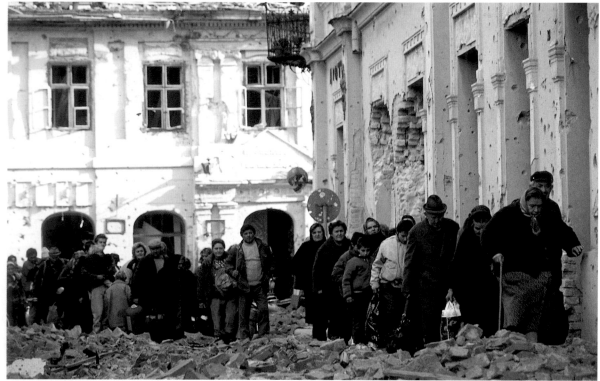

2 CHRISTOPHER MORRIS 1991

Time published Morris's reportage under the title
"A Living Hell." The opening words were: "These
look like scenes from World War II, yet they are
occurring in the center of Europe." (1) In the fall of
1991 Vukovar was besieged for three months. At
this time Morris accompanied Croatian soldiers
until they were only 50 yards away from the front
line with the Serbs. (2) In November he returned
to the destroyed city, but this time it was along
with the occupying invaders. The inhabitants
came crawling out of their emergency bunkers.

Das Magazin Time veröffentlichte Morris' Repor-
tage unter dem Titel »A Living Hell« und begann
mit den Worten: »Diese Szenen ähneln denen des
Zweiten Weltkriegs, nur daß sie sich nun in der
Mitte Europas ereignen« (1) Vukovar wurde im
Herbst drei Monate lang belagert. Zu dieser Zeit
begleitete Morris die kroatischen Soldaten bis auf
50 Meter an die Front zu den Serben. (2) Im
November kehrte er mit den Angreifern in die
zerstörte Stadt zurück. Die Bewohner stiegen aus
ihren Notbunkern.

Le reportage de Morris fut publié par le magazine
Time sous le titre « A Living Hell », et introduit par
ces mots : « Ces images ressemblent à celles de
la Deuxième Guerre mondiale, et pourtant cela
se passe au centre de l'Europe… » (1) Vukovar
fut assiégée à l'automne, durant trois mois. A
cette époque, Morris accompagna les soldats
croates jusqu'à 50 mètres des lignes serbes.
(2) En novembre, il revint avec les attaquants
dans la ville détruite. Les habitants sortaient de
leurs abris.

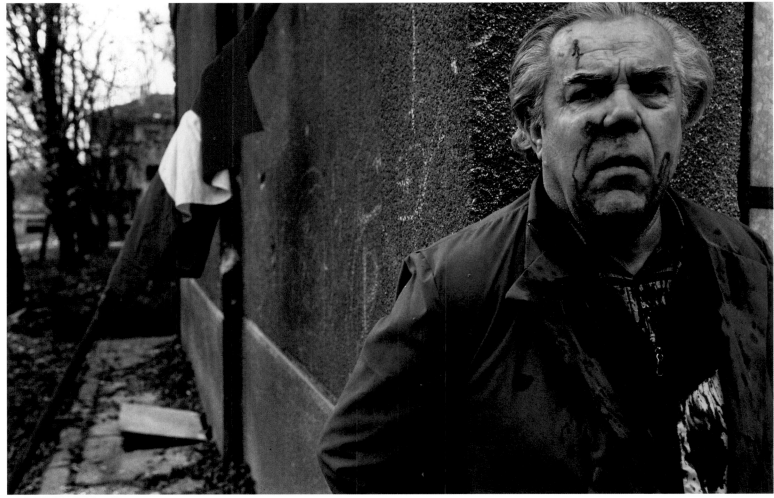

3 CHRISTOPHER MORRIS 1991

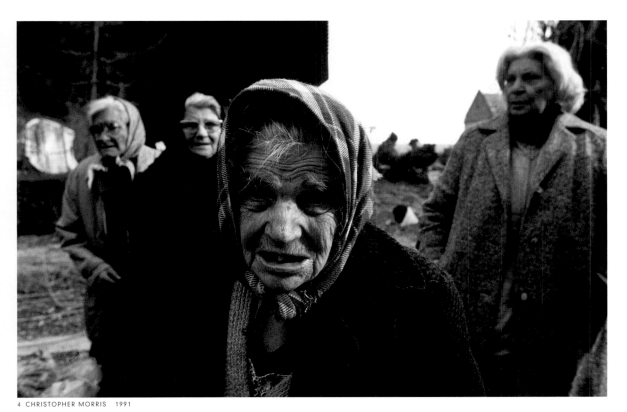

4 CHRISTOPHER MORRIS 1991

(3) A wounded civilian in Vukovar surrendering to the victors. (2) An old woman waiting at a road block for her documents in order to leave the city. This "changing of sides" aroused conflicting feelings in Morris: "Oddly, when I was with the Croats, I found myself siding with the Serbs and when I was with the Serbs vice-versa, just because I could see the senselessness of each side's hatred."

(3) Ein verwundeter Zivilist in Vukovar ergibt sich den Siegern. (4) Eine alte Frau wartet an einer Straßensperre auf ihre Papiere, um die Stadt zu verlassen. Der Seitenwechsel von den Kroaten zu den Serben löste bei Morris sehr gemischte Gefühle aus: »Merkwürdigerweise, als ich bei den Kroaten war, fing ich an, für die Serben Partei zu ergreifen, und als ich bei den Serben war, war es genau umgekehrt, nur weil ich die Sinnlosigkeit des Hasses auf beiden Seiten sehen konnte.«

(3) Un civil blessé de Vukovar se rend aux occupants. (4) Une vieille femme attend ses papiers à un barrage pour quitter la ville. Le passage d'un bord à l'autre, des Croates aux Serbes, provoqua chez Morris des sentiments mêlés : « Bizarrement, quand j'étais avec les Croates, je prenais la défense des Serbes et le contraire quand j'étais avec les Serbes, simplement parce que je voyais l'absurdité de leur haine réciproque. »

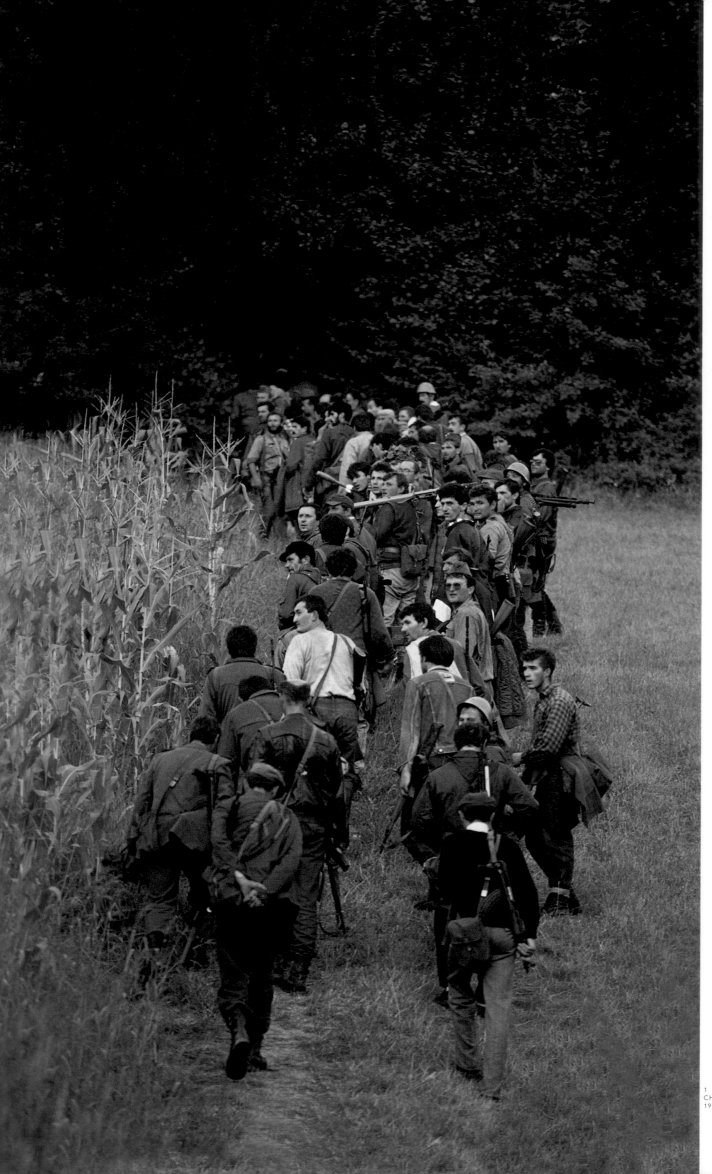

(1) Serbian guerrillas in the Okučani mountains preparing themselves for action. (2) A soldier of the Serbian army posing in front of a dead Croat. (3) A Croatian guard looking at the corpse of a Serbian soldier. Morris effectively summed up the crazy absurdity of a war characterized by such a futile pattern of arbitrary attacks and revengeful retaliations: "This was a war in which it was extremely easy to get access to the front lines, and there were virtually no regulations prohibiting journalists who flocked there from nearby Europe. I soon came to realize the situation in Yugoslavia was more dangerous than anything I'd ever gotten myself into. You could always find trouble. We saw executions in which Serbian irregulars or militia lined Croats up and shot them right in front of us. And I saw a lot of innocent victims – women and children and other civilians. Journalists were also killed. One of my friends, Paul Jenks, was killed by a sniper during a cease-fire in January 1992."

(1) Serbische Guerillas in den Bergen Okuča-nis präparieren sich für den Einsatz. (2) Ein Soldat der serbischen Bundesarmee posiert vor einem toten Kroaten. (3) Ein kroatischer Wachmann blickt auf einen erschlagenen serbischen Soldaten. Morris faßt diesen Wahnsinn von kriegerischer Aktion und Reaktion zusammen: »In diesem Krieg war es extrem leicht, Zugang zu den Frontlinien zu bekommen. (...) Mir wurde schnell bewußt, daß die Situation in Jugoslawien gefährlicher war, als alles, was ich bis dahin gekannt hatte. Wir sahen Exekutionen, in denen serbische Irreguläre und Militärs Kroaten in einer Reihe aufstellten und sie direkt vor unseren Augen erschossen. Und ich sah viele unschuldige Opfer – Frauen, Kinder und andere Zivilisten. Journalisten wurden auch umgebracht. Einer meiner Freunde, Paul Jenks, wurde von einem Heckenschützen während einer Waffenruhe im Januar 1992 getötet.«

(1) Dans les monts d'Okučani, des miliciens serbes avant l'assaut. (2) Un soldat de l'armée fédérale serbe pose devant un mort croate. (3) Un garde croate regarde un soldat serbe abattu. Morris résuma ainsi la folie guerrière qui régnait alors : « Dans cette guerre, l'accès au front était très facile (...) J'ai vite réalisé que la situation en Yougoslavie était plus dangereuse que tout ce que j'avais connu. Nous avons vu des exécutions où les irréguliers ou les miliciens serbes alignaient des Croates et les fusillaient devant nous. Et j'ai vu beaucoup de victimes innocentes – femmes, enfants et autres civils. Des journalistes aussi furent tués. L'un de mes amis, Paul Jenks, a été tué par un tireur embusqué pendant un cessez-le-feu en janvier 1992. »

1
CHRISTOPHER MORRIS
1991

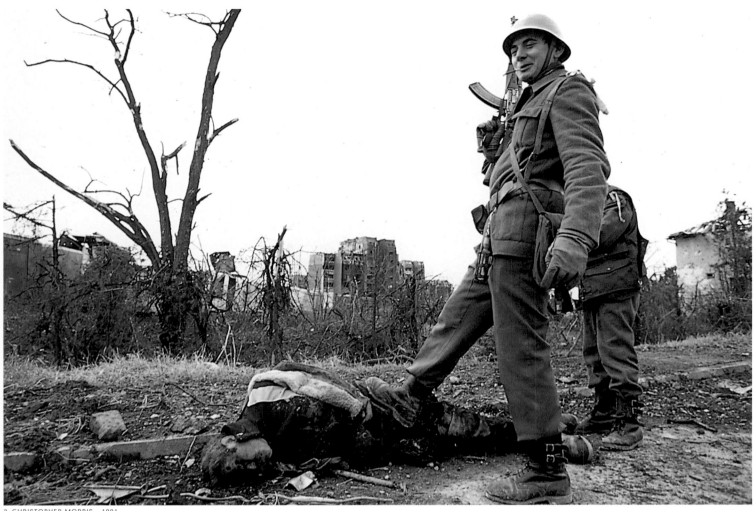

2 CHRISTOPHER MORRIS 1991

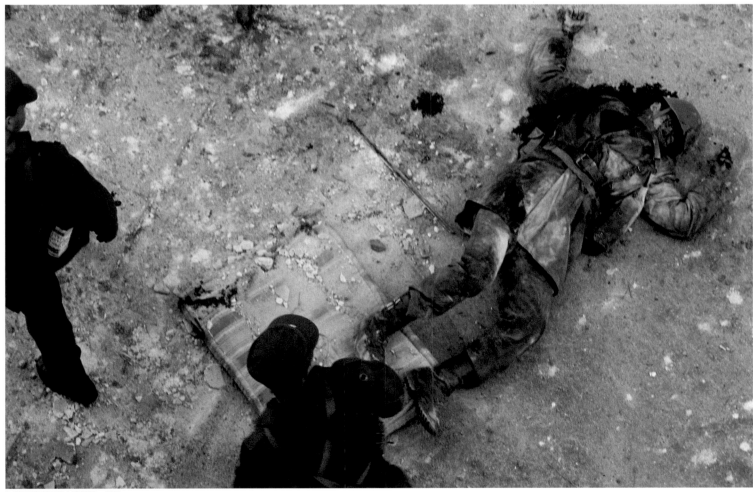

3 CHRISTOPHER MORRIS 1991

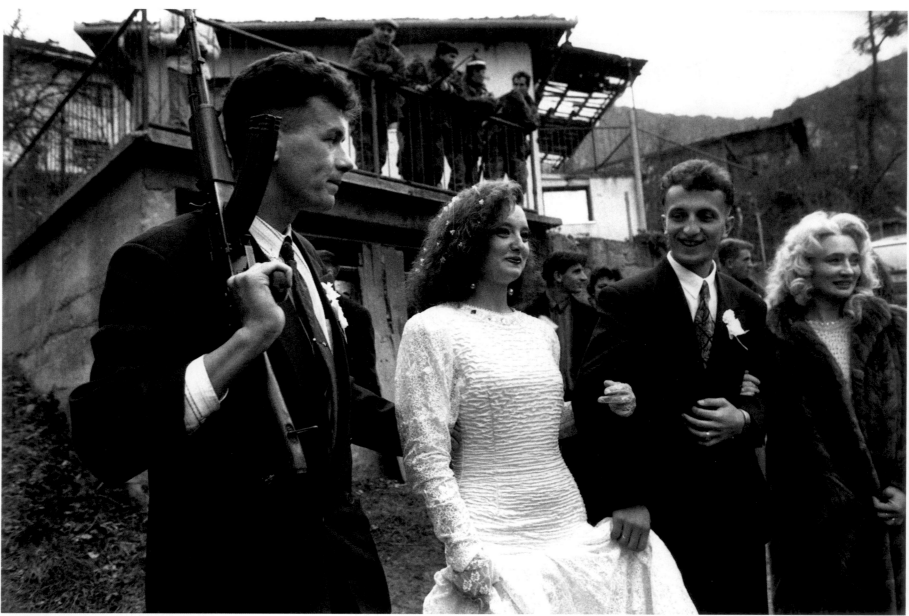

1 DAVID TURNLEY 1995

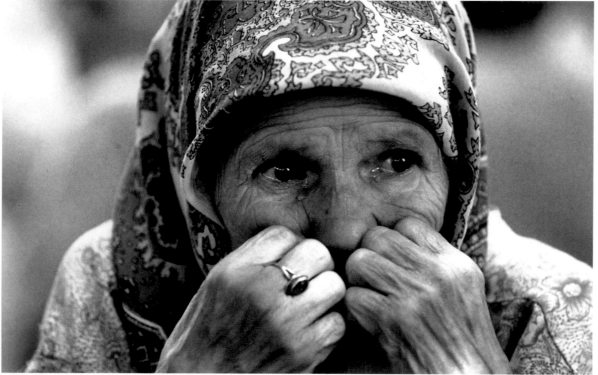

2 DAVID TURNLEY 1995

(1) Shots are fired in celebration at a Muslim wedding in the mountains of Sarajevo. (2) A woman from the enclave of Srebenica who fled to an emergency lodging in Banovici after the Serbian massacre in July. (3) In August 1995 the Croatian offensive against the Serbian occupation of Krajina was launched. Some 100,000 Serbs fled the city. (4) The destruction of the divided city of Mostar. Croats and Muslims lived strictly separated. (5) Sarajevo. An old man at the gravestone of his son, which is covered in gun-shot holes.

(1) Salutschüsse für eine muslimische Hochzeit in den Bergen Sarajevos. (2) Eine Frau aus der Enklave Srebenica floh nach dem serbischen Massaker im Juli in eine Notunterkunft in Banovici. (3) Im August startete die kroatische Offensive gegen die serbisch besetzte Krajina. 100 000 Serben traten die Flucht an. (4) Die Zerstörung in der geteilten Stadt Mostar. Kroaten und Muslime lebten streng getrennt. (5) Sarajevo. Ein alter Mann am zerschossenen Grabmal seines Sohnes.

(1) Tirs de joie pour un mariage musulman dans les montagnes près de Sarajevo. (2) Une femme de l'enclave de Srebrenica, ayant fui après les massacres commis par les Serbes en juillet, trouve refuge à Banovici. (3) En août, début de l'offensive croate en Krajina, occupée par les Serbes. 100 000 Serbes doivent fuir. (4) Destruction de la ville divisée de Mostar, où Croates et Musulmans vivaient séparés. (5) Sarajevo. Un vieil homme sur la tombe criblée de tirs de son fils.

BOSNIA 1995

After the Dayton peace accord had been signed, David Turnley traveled for a month through Bosnia-Herzegovina in December 1995. This was the main battlefield during the 4-year-long war in which 250,000 Muslims and Bosnian Croats lost their lives. Despite all the fighting, the Serbs and Croats failed to achieve their respective hegemonic goals. The Dayton treaty was the stronghold of the weaker third party, Bosnia-Herzegovina. Turnley's reportage demonstrates the difficulties of transition which lay ahead for the peoples of Bosnia-Herzegovina in their attempts to achieve unity and self-government.

BOSNIEN 1995

David Turnley reiste im Dezember 1995 nach dem Friedensabkommen von Dayton einen Monat durch Bosnien-Herzegowina. In fast vier Jahren Krieg waren hier die Hauptkriegsschauplätze – 250 000 Moslems und bosnische Kroaten sollen in den Kämpfen umgekommen sein. Dennoch gelang es den Serben und Kroaten nicht, ihre jeweiligen Hegemonieansprüche durchzusetzen. Dayton war die territoriale Behauptung der schwachen dritten Partei Bosnien-Herzegowina. Turnleys Essay zeigte jedoch, wie schwer der Übergang zu einer Gemeinschaft der verschiedenen Ethnien in Bosnien-Herzegowina werden würde.

BOSNIE 1995

En décembre 1995, après les accords de paix de Dayton, David Turnley voyagea pendant un mois à travers la Bosnie-Herzégovine, où cette guerre de près de quatre ans avait fait le plus de ravages. 250 000 Bosniaques avaient trouvé la mort, sans que les Serbes ni les Croates ne parviennent à imposer leur hégémonie. Dayton affirma le droit à l'existence territoriale de la Bosnie-Herzégovine. Le reportage de Turnley montre combien il était difficile dans ce pays de créer une communauté d'ethnies différentes.

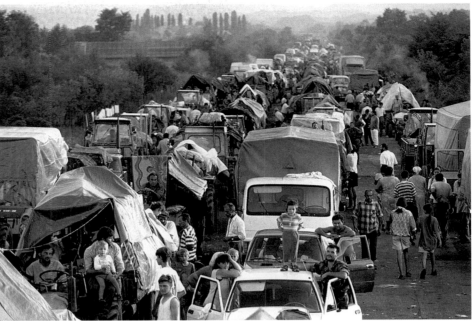

3 DAVID TURNLEY 1995

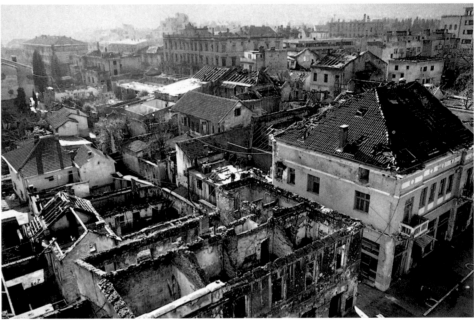

4 DAVID TURNLEY 1995

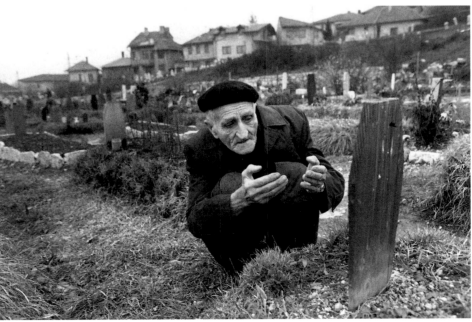

5 DAVID TURNLEY 1995

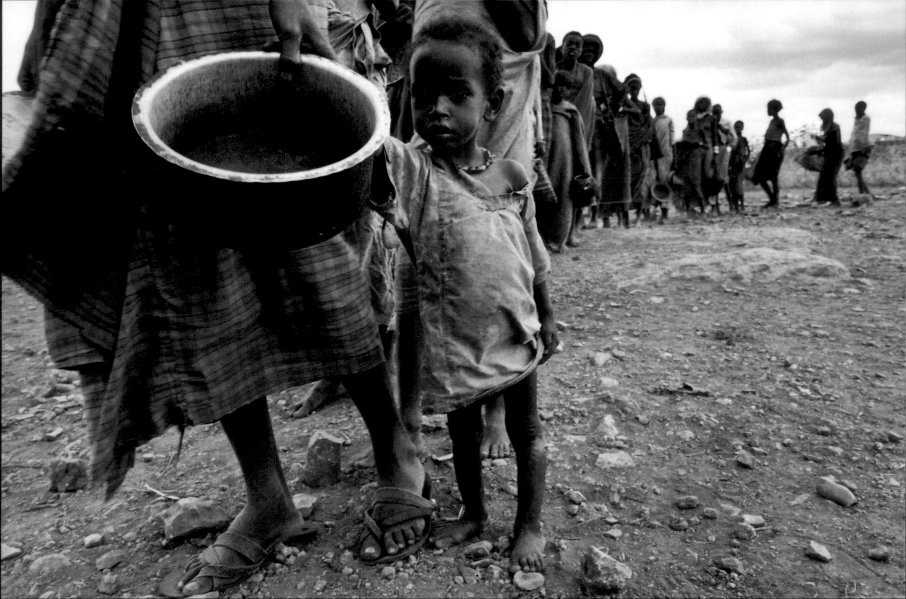

1 DAVID TURNLEY 1992

LAND OF CHAOS

In 1992 David Turnley traveled to Baidoa. His overall impression was: "Somalia is a country in a complete state of anarchy, and as such everything that has value, including food, has been looted by gangs armed to the teeth, all subclans of the bigger two warring sides in the civil war. This leaves thousands of people without food. Although the manifestation of this chaos has been a famine on perhaps a more dramatic scale than in Ethiopia, the root causes are different – this famine is not the result of a drought, there is plenty of food in the hands of essentially feudal lords who are looting the relief efforts, and the food is sold on markets for prices that cannot be afforded by the masses. It is important to note the distinction that the humanitarian relief which is being sent to Somalia may be easing the conscience of the Western World, but supplies are not reaching the people that need them. (…) The death reaches Holocaust proportions."

LAND IM CHAOS

David Turnley reiste 1992 nach Baidoa und schilderte seinen Gesamteindruck: »Somalia ist ein Land, das sich in einem totalen Zustand der Anarchie befindet, und daher wird alles, was Wert hat, Nahrung inbegriffen, von bis an die Zähne bewaffneten Teilclans der beiden größeren kriegführenden Parteien geplündert; tausende Menschen bleiben deshalb ohne Nahrung. Auch wenn die Folge dieses Chaos eine Hungersnot vielleicht dramatischeren Ausmaßes als in Äthiopien ist, so sind die eigentlichen Ursachen doch andere – diese Hungersnot ist ist nicht das Ergebnis einer Dürre; es gibt reichlich Nahrung in den Händen einiger Feudalherren, die die Hilfslieferungen plündern und die Lebensmittel auf den Märkten zu Preisen verkaufen, die sich die Massen nicht leisten können. Diesen Unterschied zu bemerken ist ebenso wichtig wie humanitäre Hilfe nach Somalia zu schicken – die vielleicht das Gewissen der westlichen Welt erleichtert, die bedürftigen Menschen aber nicht erreicht. (…) Der Tod erreicht Holocaust-Proportionen.«

PAYS EN CRISE

En 1992, David Turnley s'est rendu à Baidoa et a décrit ainsi son impression: « La Somalie est en état de complète anarchie. Dans ces conditions, tout ce qui a de la valeur, y compris la nourriture, est la proie de gangs armés jusqu'aux dents, eux-mêmes aux ordres respectifs des deux camps de la guerre civile, laissant des milliers de gens sans nourriture. L'une des conséquences de ce chaos a été une famine peut-être plus terrible encore que celle de l'Ethiopie, mais les vraies causes sont ailleurs; cette famine n'est pas le résultat d'une sécheresse, la nourriture est là, mais elle est aux mains de seigneurs féodaux qui rackettent l'approvisionnement et le mettent sur le marché à des prix inabordables pour le peuple. Il est important de comprendre cela, l'aide humanitaire qui est envoyée en Somalie soulage peut-être la conscience du monde occidental, mais la nourriture ne parvient pas aux gens à qui elle est destinée. (...) La mortalité atteint les proportions d'un génocide. »

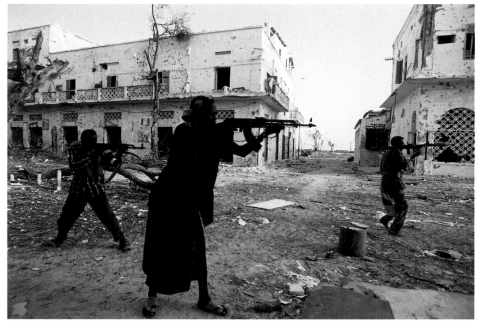

3 CHRISTOPHER MORRIS 1992

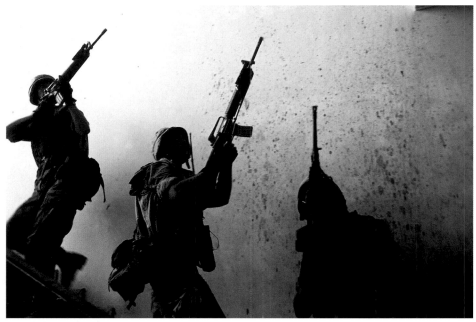

2 CHRISTOPHER MORRIS 1992

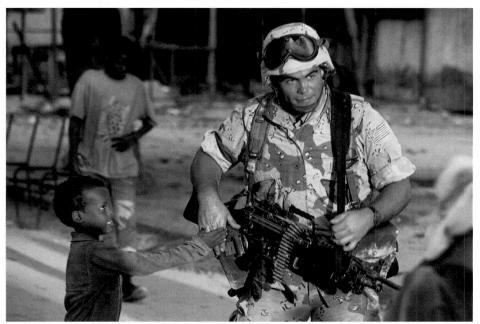

1 CHRISTOPHER MORRIS 1992

Christopher Morris was one of the first photographers to experience and expose the warring clans of Somalia. (1) The two rival parties in the civil war: Soldiers of President Ali Mahdi fighting in February 1992 against the troops of General Aidid in the capital Mogadishu. (2) Under the leadership of US military forces, a UN peace operation was launched at the end of 1992. Here GIs are searching for weapon caches and marksmen in Mogadisho. (3) Mission "New Hope" initially met with little resistance, but in June 1993 the situation intensified and in 1994 the UN troops retreated.

Christopher Morris begab sich als einer der ersten Fotografen in die Kämpfe des somalischen Clanwesens. (1) Die beiden Bürgerkriegsparteien: Soldaten des Präsidenten Ali Mahdi kämpften im Februar 1992 mit den Truppen des General Aidid in der Hauptstadt Mogadischu. (2) Unter Führung des US-Militärs begann Ende 1992 eine Friedensoperation der UN. Hier suchten GIs nach Waffenlagern und Scharfschützen in Mogadischu. (3) Die Mission »Neue Hoffnung« traf zunächst auf wenig Widerstand, im Juni 1993 spitzte sich die Lage jedoch zu, 1994 zogen die UN-Truppen ab.

Christopher Morris fut l'un des premiers photographes à se rendre sur les lieux des combats entre les clans en Somalie. (1) Les deux camps de la guerre civile : des soldats du président Ali Mahdi luttèrent en février 1992 contre les troupes du général Aïdid dans la capitale, Mogadishu. (2) Sous la conduite de l'armée américaine, une opération de paix de l'ONU commença fin 1992. GIs à la recherche de caches d'armes et de tireurs d'élite, à Mogadishu. (3) La mission « Nouvel espoir » rencontra peu de résistance au début, mais la situation devint critique en juin 1993 et les troupes de l'ONU se retirèrent en 1994.

1 KLAUS REISINGER 1992

POST-SOVIET CONFLICTS

After conflict had smoldered intermittently since 1987, war between Armenia and Azerbaijan finally broke out in and around the Armenian enclave of Nagorny Karabagh in 1991. Since then pogroms have been regularly launched against the respective minorities of both countries. (1, 2) Victims of an Armenian pogrom in Khojaly.

POST-SOWJETISCHE KONFLIKTE

Seit 1987 schwelte der Konflikt, 1991 begann der Krieg zwischen Armenien und Aserbaidschan in und um die armenische Enklave Nagornij Karabach. Seitdem gab es auf beiden Seiten immer wieder Pogrome gegen die jeweiligen Minderheiten. (1, 2) Opfer eines armenischen Pogroms in Khojaly.

CONFLITS POST-SOVIETIQUES

Le conflit ne cessait de croître depuis 1987 et en 1991, la guerre entre l'Arménie et l'Azerbaïdjan éclata dans l'enclave arménienne du Nagorny Karabakh et autour. Des deux côtés les minorités respectives subissaient des pogromes. (1, 2) Victime d'un pogrome arménien à Khojaly.

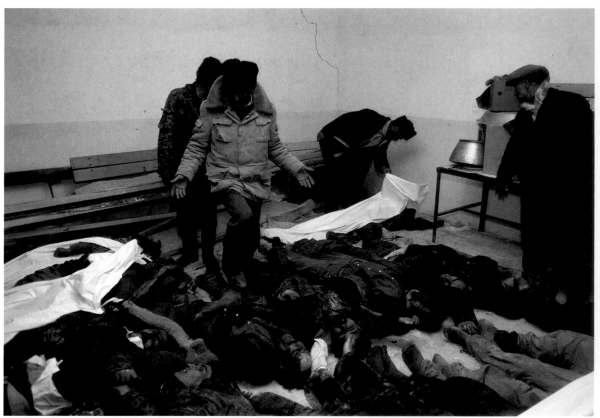

2 KLAUS REISINGER 1992

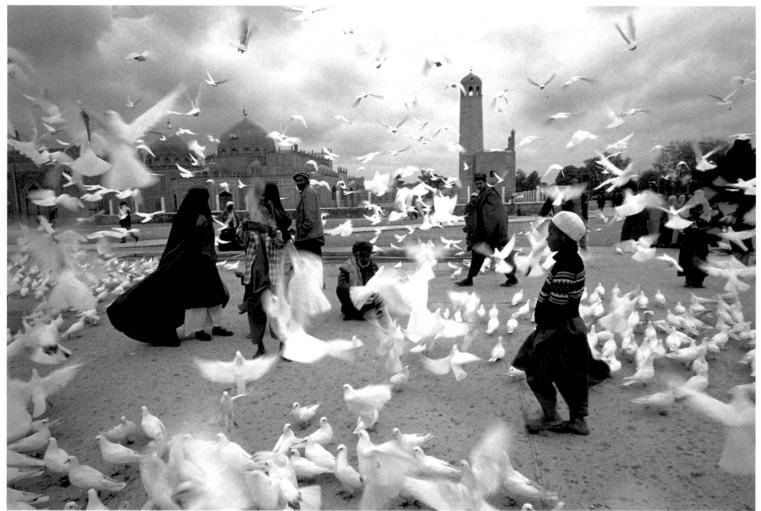

3 KLAUS REISINGER 1992

Afghanistan has been plagued by war since 1979. Although the common enemy of the Mujahedin, the Soviet army, left the central Asian country in 1989, Islamic rebel factions continue to fight amongst themselves. (4) A member of the Mujahedin leads a man convicted of theft according to the Shariah (Islamic Law) through the streets of Kabul. Since the withdrawal of the Communist government in 1992, Islam has increasingly dominated even the capital. (3) The Blue Mosque of Mazar I Sharif.

In Afghanistan herrscht seit 1979 Krieg. Nachdem der gemeinsame Feind der Mudschaheddin, die Sowjetarmee, 1989 das zentralasiatische Land verlassen hatte, zerstritten sich die moslemischen Rebellengruppen. (4) Ein Mudschaheddin führt einen nach der Scharia verurteilten Dieb durch die Straßen Kabuls. Nach dem Rücktritt der kommunistischen Regierung 1992 gewann der Islam auch in der Hauptstadt immer mehr an Macht. (3) Die Blaue Moschee in Mazar I Sharif.

La guerre fait rage en Afghanistan depuis 1979. Une fois que l'ennemi commun des Mudjahiddines, l'armée soviétique, eut quitté ce pays d'Asie centrale en 1989, les groupes rebelles musulmans entrèrent en conflit les uns avec les autres. (4) Un Mudjahiddine conduit un voleur, jugé selon la loi coranique, à travers les rues de Kaboul. Depuis le retrait du gouvernement communiste en 1992, l'islam est de plus en plus puissant, même dans la capitale. (3) La Mosquée bleue à Mazar I Sharif.

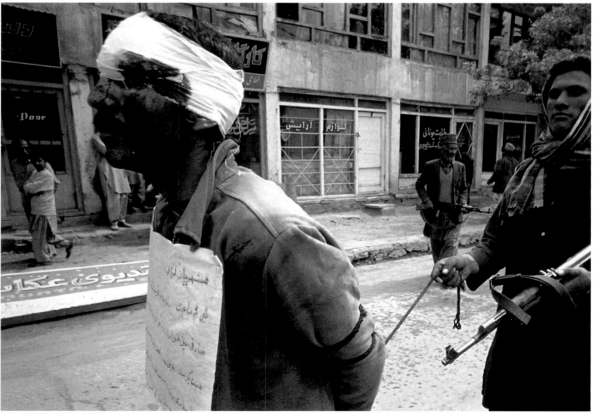

4 KLAUS REISINGER 1992

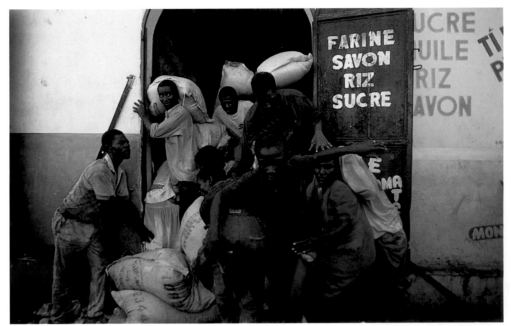

1 CHRISTOPHER MORRIS 1994

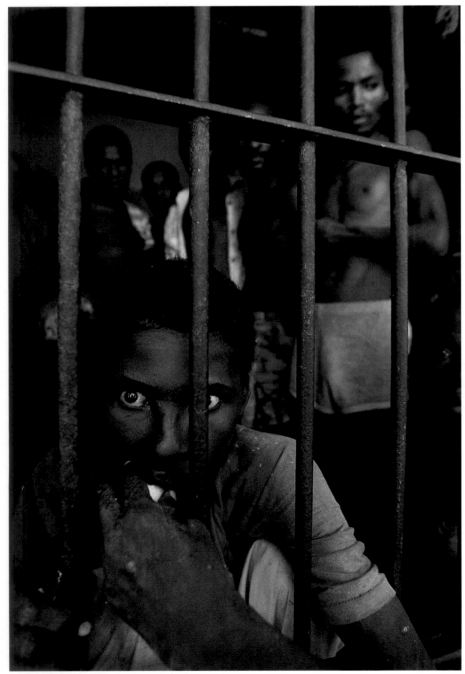

2 KLAUS REISINGER 1994

3 KLAUS REISINGER 1994

WAR AND CRISIS

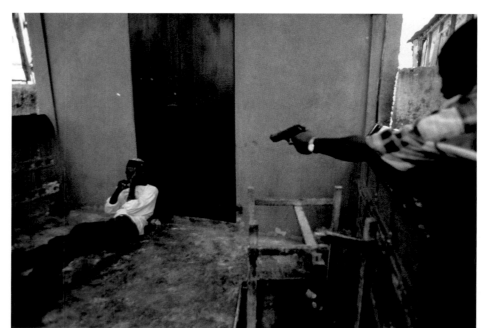

4 CHRISTOPHER MORRIS 1994

HAITI – ISLAND OF TERROR

1991, after 186 years of dictatorship, Haiti's new democracy only lasted 9 months before the elected president, Jean-Baptiste Aristide, was overthrown in a military coup. An international agreement with the military junta was supposed to guarantee Aristide's reinstatement. However, through a regime of terror, General Cédras managed to delay Aristide's return until October 1994. (4, 6) Aristide supporters were publicly executed in the streets.
(5) Generally, the chaos raging in the country made funeral services impossible. (2) Prisons were full to the brim with opponents of the military regime. (1) For Haitians, in order to survive, there were only two stark choices: open resistance - like this looting - or an attempt to flee the country. Only with direct USA involvement, particularly the stationing of 15,000 soldiers in the country, did General Cédras finally surrender.
(3) On 15 October 1994 the populace welcomed Aristide back home to Port au Prince from the USA.

HAITI – INSEL DES TERRORS

Nach 186 Jahren Diktatur währte die Demokratie auf Haiti 1991 nur neun Monate, bis Militärs den gewählten Präsidenten Jean-Baptiste Aristide stürzten. Ein internationales Abkommen mit der Junta sollte dessen Wiedereinsetzung 1993 garantieren. Doch dem Terrorregime unter General Cédras gelang es, die Rückkehr bis zum Oktober 1994 herauszuzögern. (4, 6) Aristide-Anhänger wurden auf offener Straße exekutiert. (5) Das Chaos verhinderte in der Regel Beerdigungszeremonien. (2) Gefängnisse waren überfüllt mit Regimegegnern. (1) Widerstand wie hier bei einer Plünderung oder Fluchtversuche, waren für viele Haitianer die einzigen Alternativen zum Überleben. Erst als die USA mit der Stationierung von 15 000 Soldaten begannen, gab Cédras auf. (3) Menschen in Port au Prince begrüßten Aristide am 15. Oktober 1994.

HAITI – ILE DE LA TERREUR

Après 186 ans de dictature, la démocratie ne parvint à se maintenir en Haïti en 1991 que 9 mois, jusqu'au renversement du président Jean-Baptiste Aristide par des militaires. Un accord international avec la junte devait garantir le retour du président au pouvoir, mais le régime de terreur du général Cédras réussit jusqu'en octobre 1994 à le dissuader de revenir. (4, 6) Des partisans d'Aristide sont exécutés en pleine rue. (5) Le chaos qui régnait empêchait généralement les cérémonies d'enterrement. (2) Les prisons étaient remplies d'opposants au régime. (1) La survie impliquait comme seules alternatives la résistance, comme ici contre un pillage, ou la fuite. Il fallut l'intervention des Etats-Unis, avec 15 000 soldats stationnés, pour que Cédras abandonne. (3) Aristide fut acclamé par la foule à Port-au-Prince, le 15 octobre 1994.

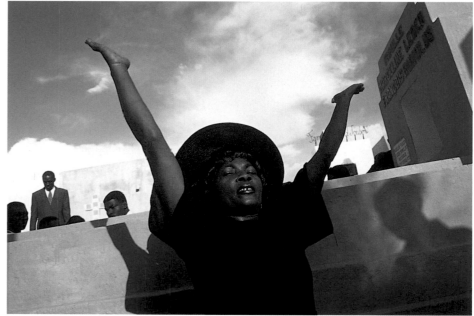

5 PETER TURNLEY 1994

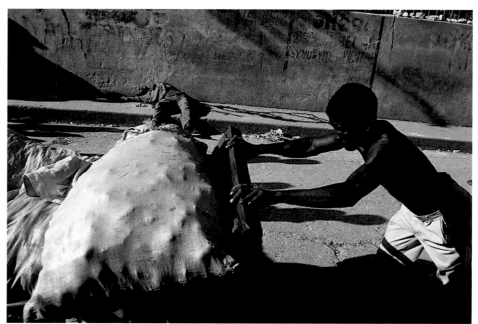

6 PETER TURNLEY 1994

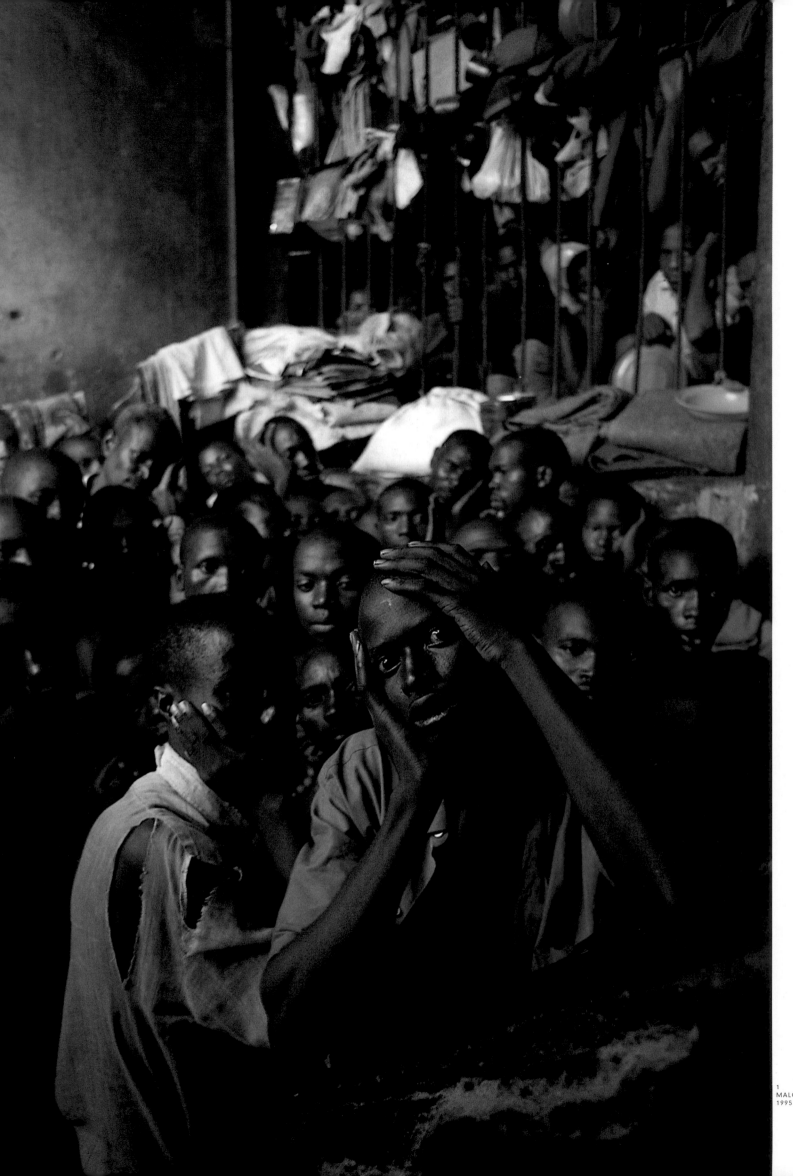

1
MALCOLM LINTON
1995

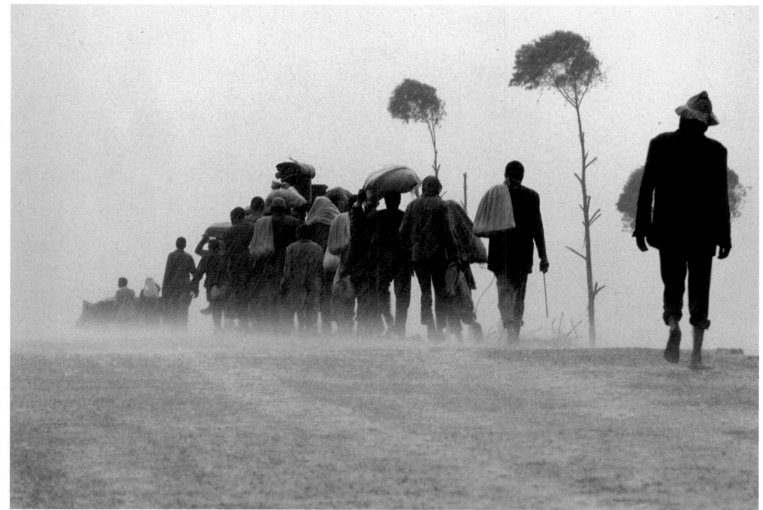

2 KLAUS REISINGER 1994

In 1960 the long predominance of the Tutsi minority in Rwanda came to an end when a Hutu government was elected. Since then, Tutsis in exile have persistently spread unrest in Rwanda. (2) In 1990 a civil war broke out which resulted in hundreds of thousands of people dying or fleeing their homes and country. (1) The murder of the Hutu president in 1994 provided the catalyst for a full-scale genocide of the Tutsis. The Tutsis had formed the government since July and were launching a war of revenge. In 1995, they imprisoned some 6,000 Hutus in a jail designed to hold 1,000 prisoners. (3) A mass grave in Zaire. International aid organizations were powerless in the face of cholera and malnutrition in refugee camps numbering up to half a million people.

1960 beendete eine gewählte Hutu-Regierung die lange Vorherr-schaft der Tutsi-Minderheit. Seitdem wurde der Konflikt immer wieder von Exil-Tutsi nach Ruanda hineingetragen. (2) 1990 brach der Bürgerkrieg offen aus und forderte seitdem Hunderttausende Todesopfer und Flüchtlinge. (1) Der Ermordung des Hutu-Präsidenten 1994 folgte ein Genozid an den Tutsi, die sich revanchierten und seit Juli die Regierung bildeten. Sie inhaftierten 1995 etwa 6 000 Hutus in einem Gebäude für 1000 Häftlinge. (3) Ein Massengrab in Zaire. Auch Hilfsorganisationen waren hilflos gegen Cholera und Unterernährung in Lagern mit bis zu einer halben Million Menschen.

En 1960, un gouvernement hutu élu mit fin à la longue hégémonie de la minorité tutsie. Depuis, le conflit ne cessa d'être rallumé par des exilés tutsis au Rwanda. (2) En 1990, la guerre civile éclata ouverte-ment et n'a cessé, depuis, de faire des centaines de milliers de victimes et de réfugiés. (1) L'assassinat du président hutu, en 1994, fut suivi d'un génocide sur la population tutsie, laquelle se vengea par la suite et reprit le pouvoir en juillet. En 1995, des Tutsis enfermèrent 6 000 Hutus dans un bâtiment qui pouvait en contenir 1000. (3) Charnier au Zaïre. Les organisations d'aide humanitaire furent impuissantes à lutter contre le choléra et la faim qui régnaient dans des camps contenant jusqu'à un demi-million de personnes.

3 DAVID TURNLEY 1994

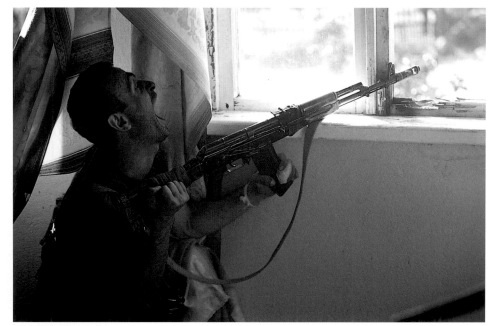

1 MALCOLM LINTON 1993

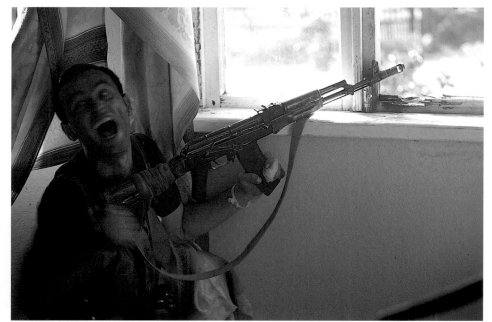

2 MALCOLM LINTON 1993

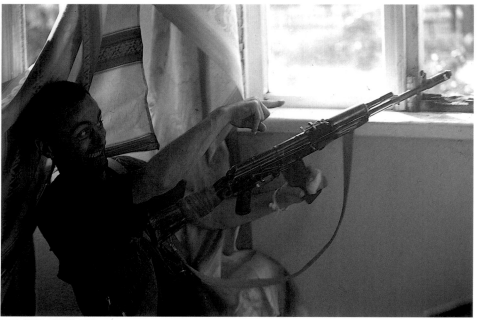

3 MALCOLM LINTON 1993

GEORGIA

(1–3) A Georgian soldier who had shot dead an Abkhazian marksman. The Georgians lost their battle to retain their ruling authority and the territorial integrity of Georgia against the separatist ethnic Abkhazian and Ossetia minorities.

GEORGIEN

(1–3) Ein georgischer Soldat, der einen abchasischen Scharfschützen erschoß. Die Georgier scheiterten im Kampf um ihre nationale Vorherrschaft und gegen die Autonomie der ethnischen Minderheiten der Abchasier und Osseten.

GEORGIE

(1–3) Ce soldat géorgien vient d'abattre un tireur abkhase. Les Géorgiens échouèrent dans leur combat pour l'indépendance et contre l'autonomie des minorités abkhaze et ossète.

INDEPENDENCE FOR CHECHNYA

(4–9) In his essay, Christopher Morris describes the misery of war in the Chechen capital, Grozny. This Caucasian republic, particularly rich in mineral oil, cut itself loose from the Soviet Union in an 18-month-long war. Chechnya subsequently won the struggle for independence – but at a very high cost. At the end of the war Grozny was one big battlefield.

UNABHÄNGIGKEIT IN TSCHETSCHENIEN

(4–9) Christopher Morris beschrieb 1995 in seinem Essay das Kriegsgrauen in der tschetschenischen Hauptstadt Grosny. Die mit Erdölreichtum gesegnete Kaukasus-Republik sagte sich von Rußland in einem 18monatigen Unabhängigkeits-krieg los und gewann zu einem hohen Preis. Grosny glich bei Kriegsende einem Schlachtfeld.

INDEPENDANCE EN TCHETCHENIE

(4–9) En 1995, Christopher Morris décrivit dans un reportage l'horreur de la guerre à Grozny, la capitale tchétchène. La république caucasienne, riche en pétrole, obtint son indépendance au prix d'une guerre de 18 mois contre la Russie. A l'issue de cette guerre, Grozny n'était plus qu'un champ de ruines.

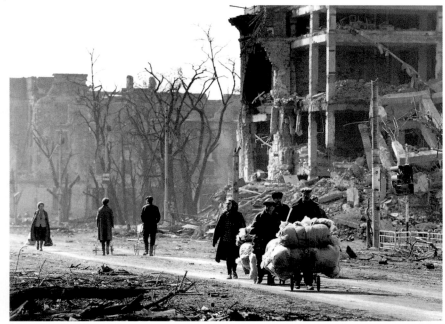

4 CHRISTOPHER MORRIS 1995

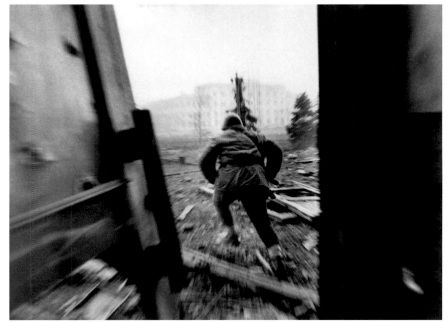

5 CHRISTOPHER MORRIS 1995

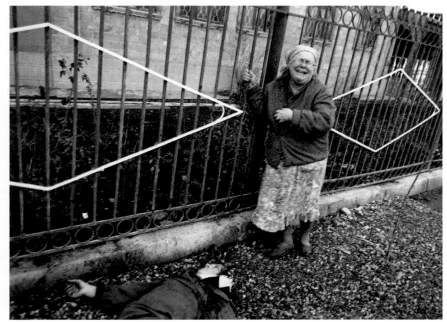

6 CHRISTOPHER MORRIS 1995

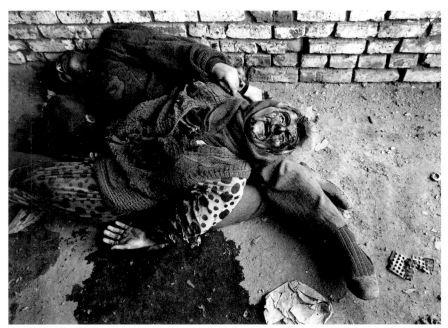

7 CHRISTOPHER MORRIS 1995

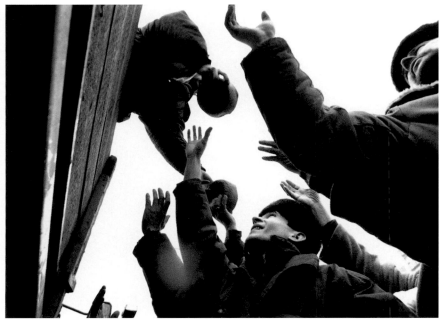

8 CHRISTOPHER MORRIS 1995

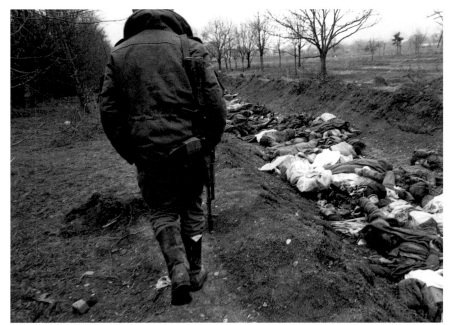

9 CHRISTOPHER MORRIS 1995

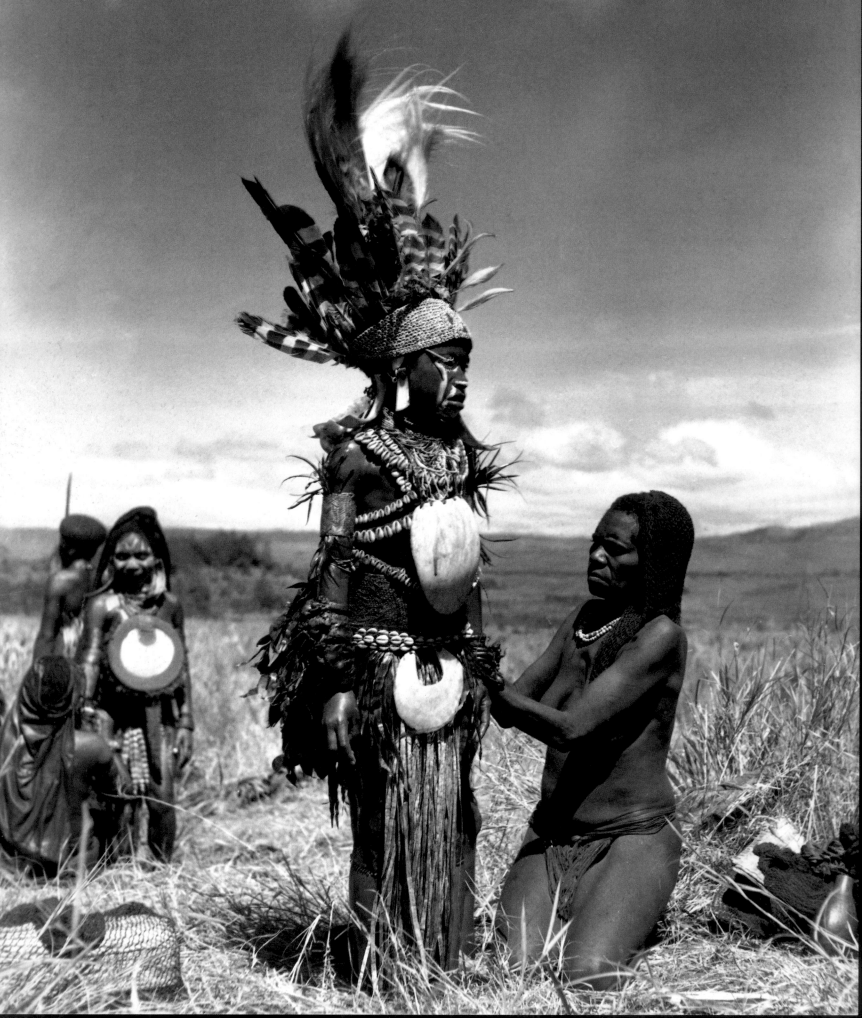

Hunters and Gatherers
Jäger und Sammler
Chasseurs et cueilleurs

Highlands in eastern New Guinea. A mother meticulously prepares her son for the traditional Sing-Sing. At these dancing festivals the tribes struggled for regional esteem. Alien cultures have always been a matter of interest for periodicals and illustrated magazines. However, the way in which exotic hunter-gatherer cultures are seen changed over the course of the 20th century. While early photographers with their plate cameras "shot" their human subjects like big game, photojournalists developed the perspective of "participatory observation".

Hochland in Ost-Neuguinea. Eine Mutter bereitet mit Akribie ihren Sohn auf das traditionelle Sing-Sing vor. Auf diesen Tanz-Festen rangen die Stämme um regionales Ansehen. Fremde Kulturen sind seit jeher ein Thema der Illustrierten und Magazine. Der Blick auf exotische Jäger- und Sammler-Kulturen veränderte sich jedoch im 20. Jahrhundert. Während die frühen Fotografen mit ihren Plattenkameras ihre menschlichen Motive wie Freiwild abschossen, entwickelten die Fotojournalisten die Perspektive der »teilnehmenden Beobachtung«.

Massif montagneux à l'est de la Nouvelle-Guinée. Une mère prépare méticuleusement son fils aux fêtes traditionnelles du Sing-Sing, au cours desquelles les tribus se disputent le prestige régional. Les civilisations étrangères ont, de tous temps, été un sujet intéressant pour les illustrés et les magazines. Mais la façon de voir les civilisations exotiques de chasseurs et de cueilleurs s'est modifiée au XXᵉ siècle. Contrairement aux premiers photographes qui, avec leurs appareils photo à plaques, «tiraient» leurs motifs humains comme du gibier, les reporters-photographes ont développé la perspective de l'«observateur participant».

Hunters and Gatherers
Jäger und Sammler
Chasseurs et cueilleurs

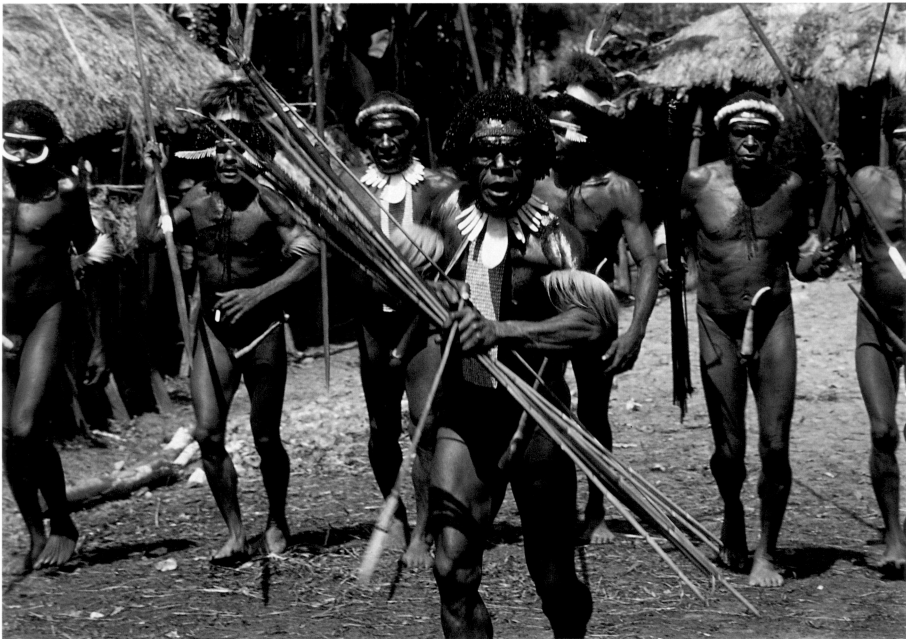

1 RICHARD FALCO 1992

(1) The formerly warlike people only bring the insignia of war, such as the spear, the arrow and the bow out of the men's house for festivals. They have also given up headhunting and cannibalism. (2) The men's house is the spiritual center. It is here that the Dani preserve one of the few mummies in the valley which exercise a protective role for this animistic community. Special people in the life of the community who have died are mummified by being dried in a squatting position over a fire in a process that lasts for months.

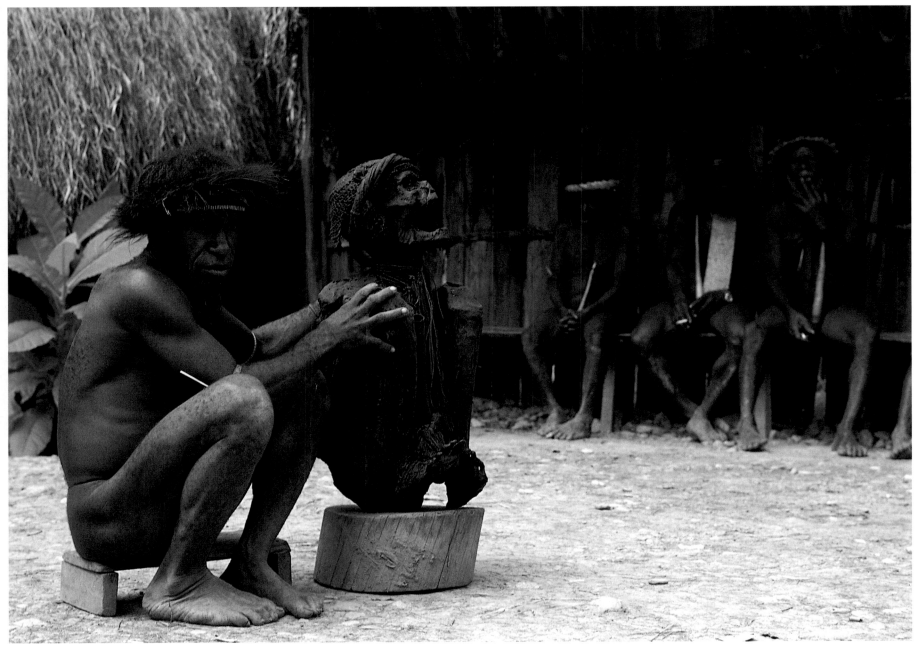

2 RICHARD FALCO 1992

(1) Das ehemals kriegerische Volk holt die Insignien des Krieges wie Speer, Pfeil und Bogen nur noch zu Festen aus dem Männerhaus. Auch die Kopfjagd und den Kannibalismus haben sie aufgegeben. (2) Das Männerhaus ist das spirituelle Zentrum. Hier bewahren die Dani eine der seltenen Mumien des Tals auf, die eine Schutzfunktion für die animistische Glaubensgemeinschaft ausüben. Besondere verstorbene Persönlichkeiten der Gemeinschaft werden in Hockstellung in einem monatelangen Prozeß über einem Feuer ausgetrocknet und mumifiziert.

(1) Les symboles guerriers, lances, flèches et arcs, ne sortent aujourd'hui de la Maison des hommes que pour les fêtes. Comme la guerre, la chasse aux têtes et le cannibalisme ont été abandonnés par ce peuple. (2) La Maison des hommes est le centre spirituel. Ici, les Dani conservent l'une des rares momies de la vallée, qui a une fonction protectrice dans cette communauté religieuse animiste. A leur mort, les corps des grandes personnalités de la communauté sont mis à sécher en position accroupie au-dessus d'un feu et momifiés grâce à un processus qui dure plusieurs mois.

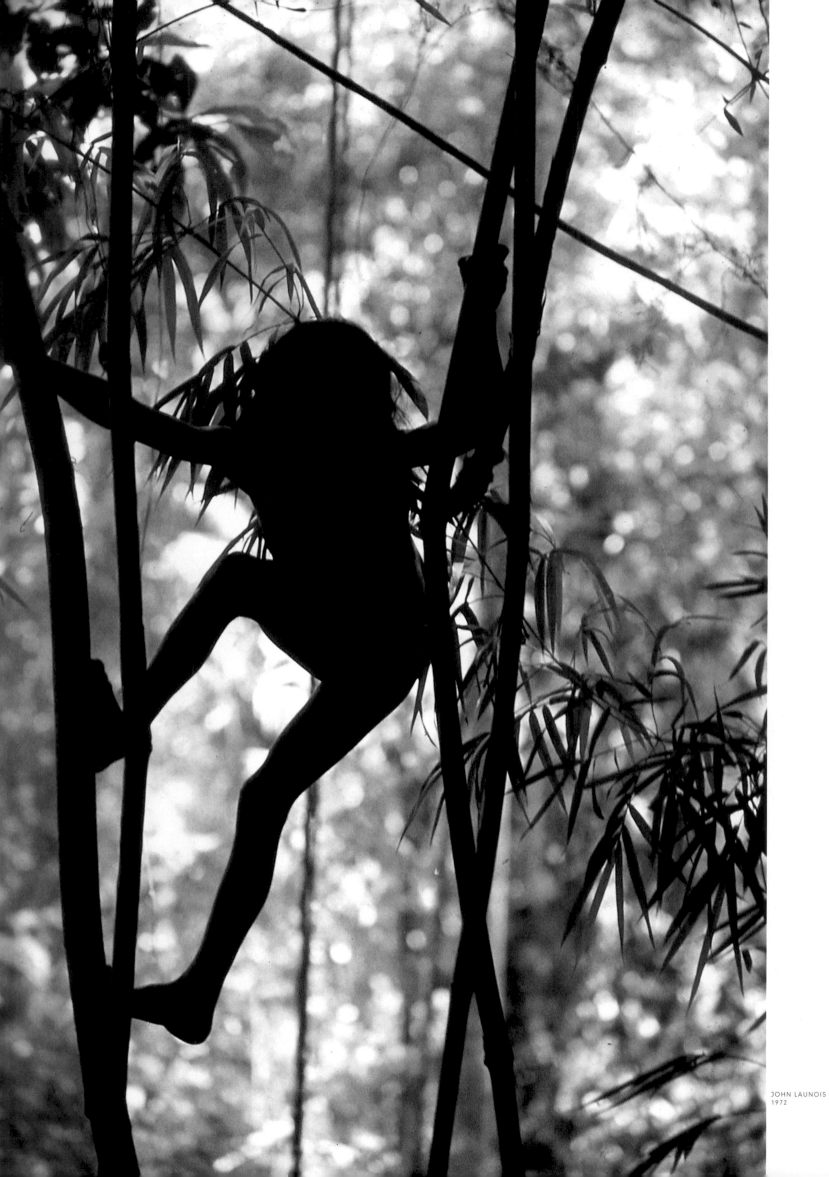

JOHN LAUNOIS
1972

THE TASADAY TRIBE
IN MINDANAO

John Launois (b. 1928 in France) worked as an assistant to the Black Star photographer Joe Pazen in Paris in 1947. After stops in California and Japan he began collaborating with Black Star in 1955. Launois returned to Japan and his first reportages from Asia for *Life* became milestones in his career. In 1971 a brief newspaper report electrified Launois: "Lost Tribe found!" In March 1972 he accompanied an expedition to the "lost" Tasaday on the Philippine island of Mindanao: "Our helicopter could not land in the unbroken rain forest. So from our chopper, we jumped onto a 75 foot high treetop platform built by our ground crew. There in primeval Eden, we found a tribe of 24 people living in naked innocence. The Tasadays were food gatherers. They slept in caves around a huge fire to warm themselves and keep wild animals away. I had gone to the Stone Age, awed by the gentle nature of the people I encountered." *National Geographic* printed Launois' photo-reportage in a cover story in 1972. The "Stone Age idyll" of the Tasaday region, which was turned into a protected reservation by President Marcos, came to an end after his downfall. Loggers invaded the reservation in 1978.

DIE TASADAY
AUF MINDANAO

John Launois (geb. 1928 in Frankreich) arbeitete 1947 in Paris als Assistent des Black-Star-Fotografen Joe Pazen. Nach den Stationen Kalifornien und Japan begann 1955 die Zusammenarbeit mit Black Star. Launois ging zurück nach Japan und setzte mit seinen ersten Reportagen aus Asien für *Life* Meilensteine seiner Karriere. 1971 elektrisierte Launois eine kurze Zeitungsmeldung: »Lost Tribe found!« Im März 1972 begleitete er eine Expedition zu den »verlorenen« Tasaday auf der philippinischen Insel Mindanao: »Unser Hubschrauber konnte in dem dichten Regenwald nicht landen. So sprangen wir aus dem Chopper auf eine 23 Meter hohe Baumplattform, die von unserer Boden-Crew gebaut worden war. Dort im ursprünglichen Eden fanden wir einen Stamm von 24 Menschen, die in nackter Unschuld lebten. Die Tasaday waren Sammler. Sie schliefen in Höhlen um ein großes Feuer herum, um sich zu wärmen und wilde Tiere fernzuhalten. Ich war in die Steinzeit gereist, ehrfurchtsvoll ergriffen von der sanften Natur der Menschen, die ich traf.« *National Geographic* druckte 1972 Launois' Fotoreportage in einer Titelgeschichte. Die »steinzeitliche Idylle« endete mit dem Sturz des Präsidenten Marcos, der zuvor das Gebiet der Tasaday in einem Reservat schützen ließ. 1978 fielen die Holzfäller in das Reservat ein.

LA TRIBU DES TASADAY
DE MINDANAO

John Launois (né en 1928 en France) travailla à Paris en 1947 comme assistant de Joe Pazen, photographe pour Black Star. Après des séjours en Californie et au Japon, c'est en 1955 que commença sa collaboration avec Black Star. Launois retourna au Japon et débuta brillamment avec ses premiers reportages d'Asie pour *Life*. En 1971, un court article de journal électrisa Launois : « Lost Tribe found ! » En mars 1972, il accompagna une expédition à la recherche des Tasaday « perdus » de l'île philippine de Mindanao : « Notre hélicoptère ne pouvait pas se poser dans l'épaisse forêt équatoriale. Nous avons donc sauté de l'hélico sur une plate-forme de 23 mètres de haut, réalisée avec des troncs d'arbres par notre équipe au sol. C'est dans cet Eden originel que nous avons découvert une tribu de 24 personnes, qui vivaient couvertes de leur seule innocence. Les Tasaday étaient des cueilleurs. Ils dormaient dans des grottes autour d'un grand feu, pour se réchauffer et tenir les bêtes sauvages à distance. J'étais revenu à l'âge de pierre et saisi de respect pour la douceur naturelle des hommes que je rencontrais. » En 1972, le *National Geographic* publie le reportage de Launois avec un article en première page. L'« idylle néolithique » prend fin à la chute du président Marcos, qui avait fait de la région des Tasaday une réserve. En 1978, les bûcherons l'envahirent.

The central mountain in the southern rain forest of Mindanao gave the Tasaday their name. After a hunter from a neighboring tribe discovered the Tasaday in 1967 the Private Association for National Minorities undertook a research expedition to investigate the tribe four years later. It was only in exceptional cases that journalists gained access to the area.

Der zentrale Berg im südlichen Regenwald Mindanaos gab den Tasaday ihren Namen. Nachdem ein Jäger eines benachbarten Stammes 1967 die Tasaday endeckte, nahm sich vier Jahre später die Private Gesellschaft für Nationale Minderheiten dessen Erforschung an. Journalisten erhielten nur in Ausnahmefällen Zugang in das Gebiet.

C'est la montagne centrale au sud de la forêt équatoriale de Mindanao qui a donné son nom aux Tasaday. Quatre ans après qu'un chasseur d'une tribu voisine les eut découverts, en 1967, l'Association privée pour les minorités nationales commença à effectuer des recherches sur la tribu. Les journalistes n'obtiennent qu'exceptionnellement l'accès à cette région.

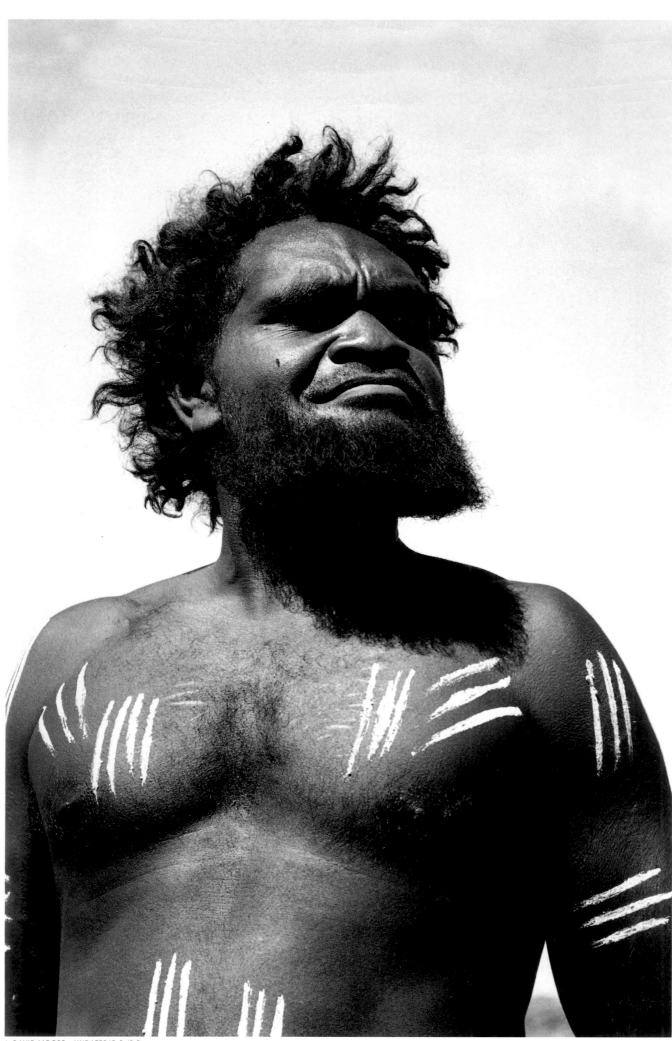

The Aborigines have lived on the continent of Australia for at least 40,000 years. The Europeans began colonizing in 1788. (1, 2) The "immigrant" David Moore erected photographic monuments to the threatened culture of the original inhabitants with his portraits of the Pitjantjatjara.

Die Aborigines leben seit mindestens 40 000 Jahren auf dem Kontinent Australien. 1788 begann die Kolonisation durch Europäer. (1, 2) Der bedrohten Kultur der Ureinwohner setzte der »Einwanderer« David Moore mit seinen Porträts der Pitjantjatjara fotografische Denkmäler.

Les Aborigènes vivent depuis au moins 40 000 ans sur le continent australien. La colonisation européenne commença en 1788. (1, 2) L'« immigrant » David Moore a dressé un monument photographique à la culture menacée des indigènes, avec ses portraits des Pitjantjatjara.

1 DAVID MOORE UNDATED/O.D./S.D.

ABORIGINES

David Moore (b. 1927 in Sydney) began his career as a photojournalist in London in 1951. He returned to Sydney in 1957. He worked for Black Star in Australia from 1957 until his retirement from photojournalism in 1995. Like most photographers of his era he successfully accomplished the transition to color photography. Moore creates color photographs with the same power and human depth that he brings to monochrome photography. This journalistic work is as respected as his artistic output.

ABORIGINES

David Moore (geb.1927 in Sydney) begann seine fotojournalistische Karriere 1951 in London. 1957 kehrte er nach Sydney zurück. Er arbeitete von 1957 bis zu seinem Rückzug aus dem Fotojournalismus 1995 für Black Star in Australien. Wie die meisten seiner Ära vollzog er den Wandel zur Farbfotografie. Moore kreiert Farbaufnahmen mit der gleichen Kraft und menschlichen Tiefe wie in Schwarz-Weiß. Seine journalistischen Bilder sind genauso anerkannt wie seine künstlerischen Arbeiten.

LES ABORIGÈNES

David Moore (né en 1927 à Sydney) a commencé sa carrière de photojournaliste en 1951 à Londres. En 1957, il rentre à Sydney. Il travailla de 1957 à 1995, jusqu'à son abandon du photojournalisme, pour Black Star en Australie. Comme la plupart de ses contemporains, il passe à la couleur. Ses prises de vue couleur égalent en puissance créative et en profondeur humaine le noir et blanc. Ses images journalistiques sont aussi reconnues que ses photos d'art.

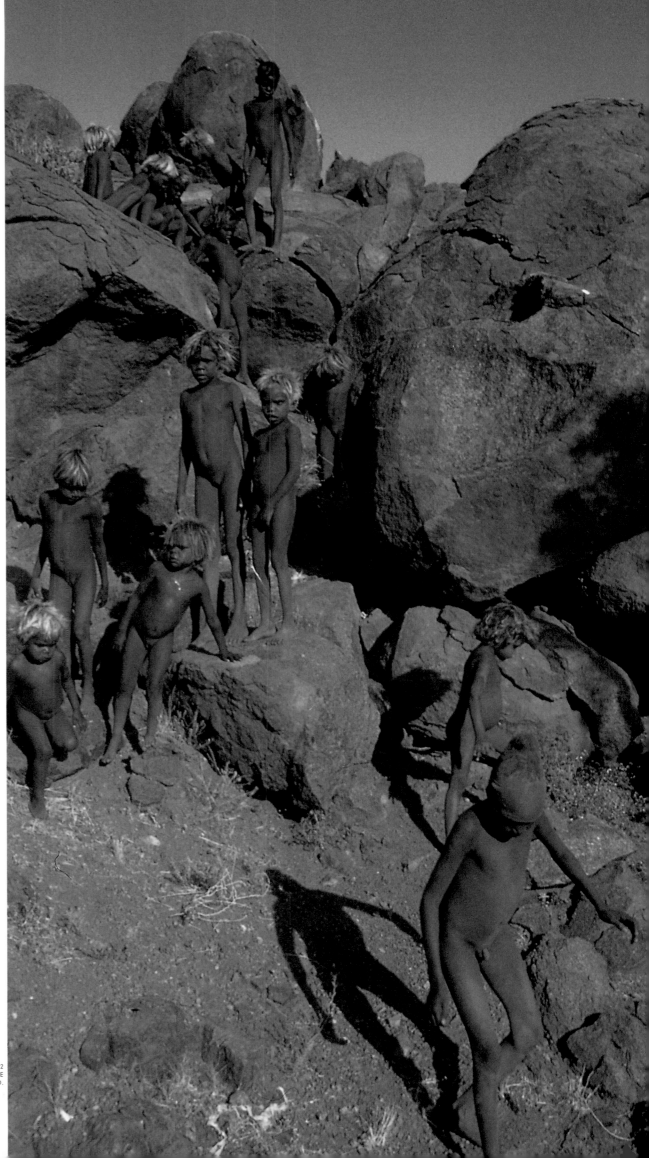

2
DAVID MOORE
UNDATED/O.D./S.D.

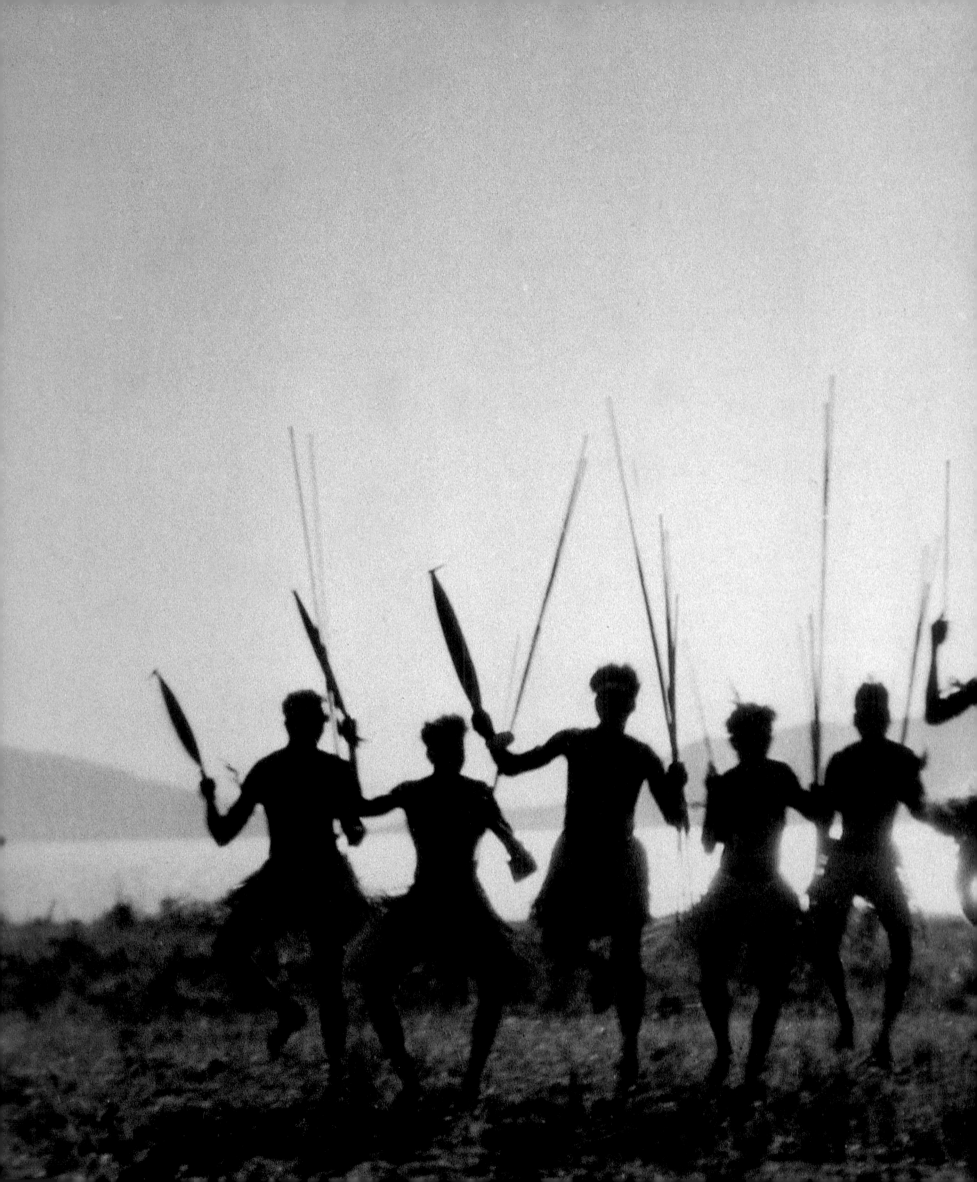

Aboriginal dance ceremony. Black Star occasionally purchased individual photographs of historical anthropological interest for the archive.

Tanzzeremonie der Aborigines. Black Star erwarb für das Archiv von Zeit zu Zeit einzelne historische anthropologische Aufnahmen.

Cérémonie dansée des Aborigènes. Il arrivait à Black Star d'acheter, pour ses archives, des photos ethnographiques isolées.

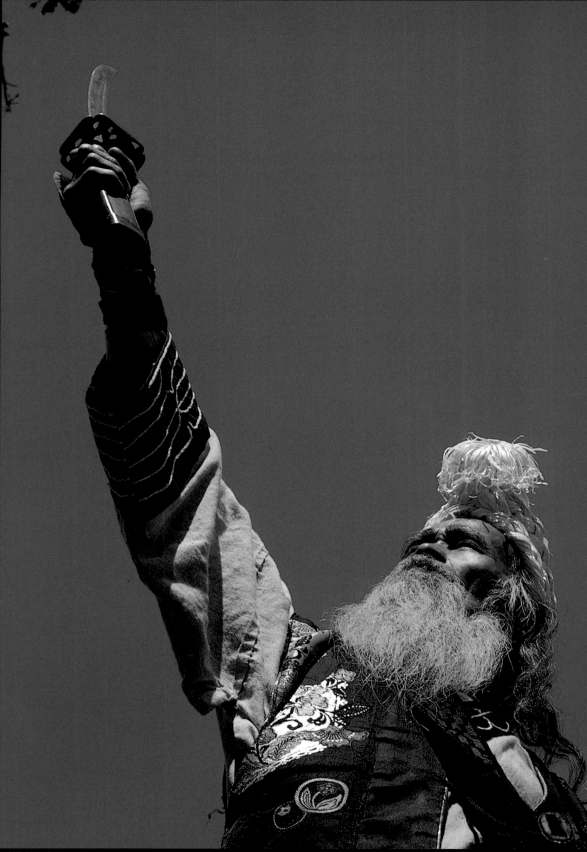

THE AINU ON HOKKAIDO

Eiji Miyazawa (b. 1929 in Tokyo) took photographs for 10 years for the newspaper group Pan-Asia after completing his studies. He has worked freelance for Black Star since 1963. "The Ainu story stands out as one of the biggest and most exciting assignments I have handled so far. For *National Geographic* I spent all four seasons from 1965 to 1966, three weeks each, living with these aborigines in the northernmost island of Japan." The Ainu, a people consisting of hunters, gatherers and fishermen, lived on the islands around Hokkaido for 7,000 years. Where they originate from is still a matter of debate, but their physical characteristics and their culture exclude Mongolia. The Ainu and the Japanese have become increasingly indistinguishable since the 15th century. At the time of the report the Ainu had virtually died out. Miyazawa discovered the last enclaves on Hokkaido.

DIE AINU AUF HOKKAIDO

Eiji Miyazawa (geb. 1929 in Tokio) fotografierte nach seinem Studium 10 Jahre für die Zeitungsgruppe Pan-Asia. Seit 1963 arbeitet er als Freelancer für Black Star. »Die Ainu-Reportage zählt bis heute zu meinen größten und spannendsten Aufträgen. Für *National Geographic* verbrachte ich bei den Ainu alle vier Jahreszeiten zwischen 1965 und 1966, jeweils drei Wochen, um mit den Ureinwohnern auf der nördlichsten Insel Japans zu leben.« Seit 7000 Jahren bewohnte dieses Volk von Jägern, Fischern und Sammlern die Inseln um Hokkaido. Ihre Herkunft ist bis heute umstritten, ihre Stammesmerkmale und -kultur schließen aber jede mongolische Abstammung aus. Seit dem 15. Jahrhundert schreitet die Japanisierung des Stammes immer weiter fort. Bereits zum Zeitpunkt der Reportage waren die Ainu fast ausgestorben. Miyazawa entdeckte die letzten Enklaven auf Hokkaido.

LES AINOUS A HOKKAIDO

Après ses études, Eiji Miyazawa (né en 1929 à Tokyo) travailla pendant dix ans pour le groupe de presse Pan-Asia, comme photographe. Depuis 1963, il travaille en freelance pour Black Star. « Le reportage sur les Aïnous reste l'une des commandes les plus excitantes que j'aie eu à faire. Pour le *National Geographic*, j'ai vécu les quatre saisons avec les Aïnous, entre 1965 et 1966, chaque fois trois semaines, avec les habitants autochtones de l'île la plus septentrionale du Japon. » Ce peuple de chasseurs, de pêcheurs et de cueilleurs vivait sur l'île d'Hokkaido depuis 7000 ans. Leur origine est toujours l'objet de controverses. Depuis le 15ᵉ siècle, la japonisation est en constante progression. A l'époque du reportage, les Aïnous avaient presque disparu. Miyazawa avait découvert les dernières enclaves de la vie traditionnelle à Hokkaido.

(1) An ekashi, one of the old priests of the tribe in a procession for a fisherman who has drowned in Lake Akan. Evil spirits cause accidents, fires, floods and illnesses.

(1) Ein Ekashi, einer der alten Priester des Stammes, bei einer Prozession für einen ertrunkenen Fischer am Akan-See. Böse Geister verursachen Unfälle, Brände, Überschwemmungen und Krankheiten.

(1) Un ekashi, l'un des plus vieux prêtres de la tribu, lors d'une procession dédiée à un pêcheur noyé dans le lac Akan. Les mauvais esprits provoquent les accidents, les incendies, les inondations et les maladies.

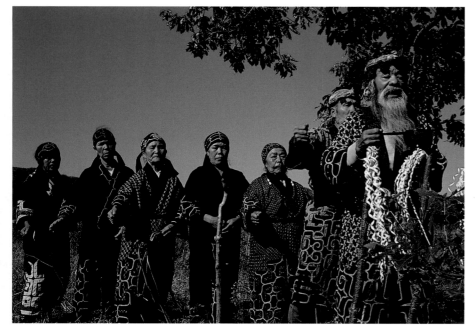

2 EIJI MIYAZAWA 1965/66

4 EIJI MIYAZAWA 1965/66

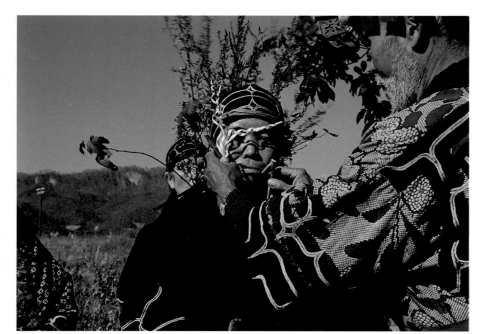

3 EIJI MIYAZAWA 1965/66

(2) A healing ceremony in Nibutani for a woman (center of picture) suffering from nervous facial twitches. The ekashi, followed by his praying congregation, brings a drink in offering to a tree. (3) Two small twigs in the mouth of the woman and light blows to her neck with a knife inside a switch made of leaves drive the evil spirit out of the woman's body.

(2) Heilungszeremonie in Nibutani für eine Frau (Mitte des Bildes), die unter nervösen Gesichtszuckungen leidet. Der Ekashi bringt ein Trinkopfer an einem Baum, gefolgt von seiner betenden Gemeinde. (3) Zwei kleine Äste im Mund der Kranken und sanfte Schläge auf den Nacken mit einem Messer in einer Rute aus Blättern treiben den bösen Geist aus dem Körper der Frau.

(2) A Nibutani, rituel de guérison pour une femme (au centre) souffrant de tics nerveux du visage. L'ekashi apporte une boisson en offrande devant l'arbre, accompagné des fidèles en prière. (3) Deux brindilles dans la bouche de la malade et de légers coups sur la nuque, avec un couteau enveloppé de feuilles, feront sortir le mauvais esprit de son corps.

(4) Nusa – the sacred fence and altar with bear skulls. The bear is the central god of the Ainu pantheon. Ethnologists observed the last bear festivals, the iyomande, in the 1950s. Ten years later they were prohibited by the Japanese authorities because of the cruelty of the ritual in which the bear's throat was slit.

(4) Nusa – der heilige Zaun und Altar mit Bärenschädeln. Der Bär ist der zentrale Gott im Pantheon der Ainu. Ethnologen beobachteten in den 50er Jahren die letzten Bärenfeste, die Iyomande. Zehn Jahre später wurden sie von den japanischen Behörden wegen des grausamen Rituals, bei dem der Bär erwürgt wurde, verboten.

(4) Nusa – la clôture et l'autel sacrés, ornés de crânes d'ours, cet animal étant la divinité principale du panthéon aïnou. Dans les années 50, les ethnologues purent observer les dernières fêtes consacrées aux ours, les iyomande. Dix ans plus tard, elles furent interdites par les autorités japonaises à cause de la cruauté du rituel, pendant lequel un ours était égorgé.

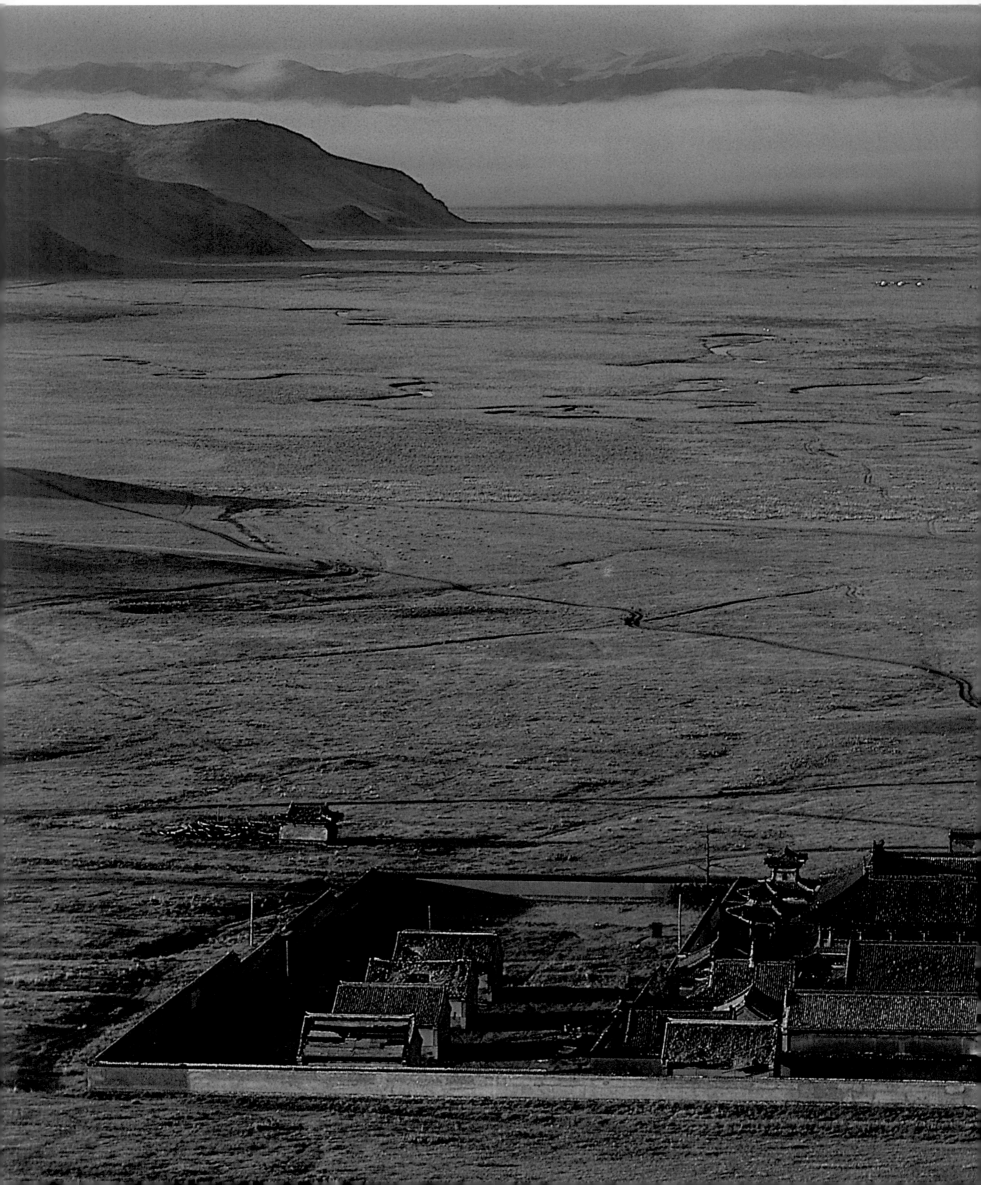

The Buddhist monastery Amarbayasgalant. After 767 monasteries were destroyed during the Stalinist atheist crusade in the 1930s, religious freedom prevails once more and the monasteries are being restored.

Das buddhistische Kloster Amarbayasgalant. Nachdem der stalinistische Atheismusfeldzug in den 30er Jahren 767 Klöster zerstörte, herrscht nun wieder Religionsfreiheit. Die Klöster werden restauriert.

Le monastère bouddhiste Amarbayasgalant. Lors des campagnes anti-religieuses staliniennes des années 30, 767 monastères furent détruits. Aujourd'hui, la liberté de culte règne à nouveau et des restaurations sont en cours.

HENNING
CHRISTOPH
1993

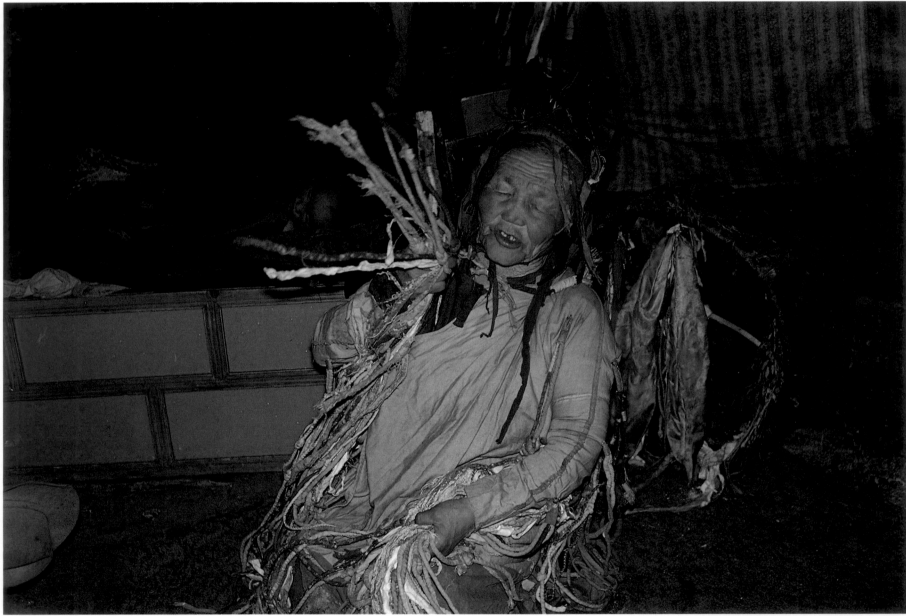

1 HENNING CHRISTOPH 1993

(1) The female shaman Baldshir in a trance during the healing of a child. Shamanism is not an independent religion but an ecstatic magic which manifests itself within various religions from Korea to Latin America. Since the Communists suppressed the Mongolian magicians, only historical ethnological photographs of shamans existed until Christoph succeeded in becoming the first photojournalist to capture on film this old woman practising her art.

(1) Die Schamanin Baldshir in Trance bei der Heilung eines Kindes. Der Schamanismus ist keine eigenständige Religion, sondern eine ekstatische Magie, die innerhalb verschiedener Religionen von Korea bis Lateinamerika anzutreffen ist. Die Kommunisten unterdrückten die mongolischen Magiere. Es existierten nur historische ethnologische Aufnahmen von Schamanen, bis es Christoph als erstem Fotojournalisten gelang, eine praktizierende greise Schamanin zu fotografieren.

(1) La chamanesse Baldshir en transes, pendant le rituel de guérison d'un enfant. Le chamanisme n'est pas une religion autonome, mais une magie extatique que l'on rencontre dans différentes religions, de la Corée à l'Amérique latine. Les communistes réprimaient les magiciens mongols. C'est pourquoi il n'existait que des prises de vues ethnographiques assez anciennes des chamanes, jusqu'à ce que Christoph parvienne à fixer sur la pellicule cette vieille femme dans l'exercice de son art.

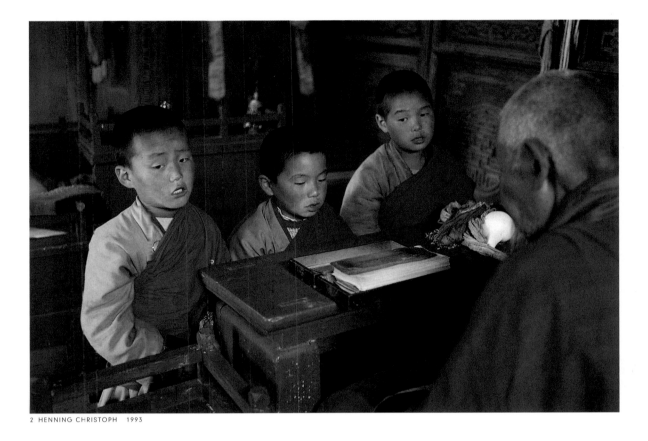

2 HENNING CHRISTOPH 1993

(2) Novices. The Mongolian people concealed their temple treasures for a long time and kept their religious services secret. Today, old monks are educating their sons once again in the teachings of the Tibetan Sutras. (3) The traditional dwellings of the nomads are called yurts. The novices' parents have pitched their yurts near the monastery and pay the monks in kind.

(2) Novizen. Lange Zeit hielten die Mongolen die Tempelschätze versteckt und verheimlichten ihre Gottesdienste. Heute erziehen greise Mönche ihre Söhne wieder im Sinne der tibetischen Sutras. (3) Jurten sind die traditionellen Behausungen der Nomaden. Die Eltern der Novizen haben ihre Jurten in der Nähe des Klosters aufgeschlagen und leisten Abgaben in Form von Naturalien an die Mönche.

(2) Novices. Longtemps, les Mongols dissimulèrent les trésors du temple et pratiquèrent leur religion en secret. Leurs fils sont aujourd'hui instruits par de vieux moines dans le sens des sutras tibétaines. (3) L'habitation traditionnelle des nomades est la yourte. Les parents des novices ont dressé leurs yourtes à proximité du monastère et apportent aux moines des offrandes en nature.

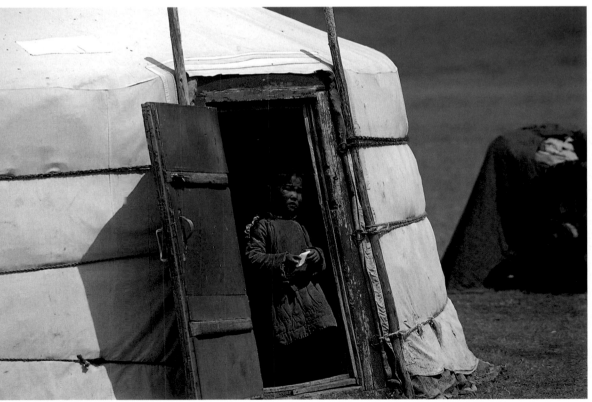

3 HENNING CHRISTOPH 1993

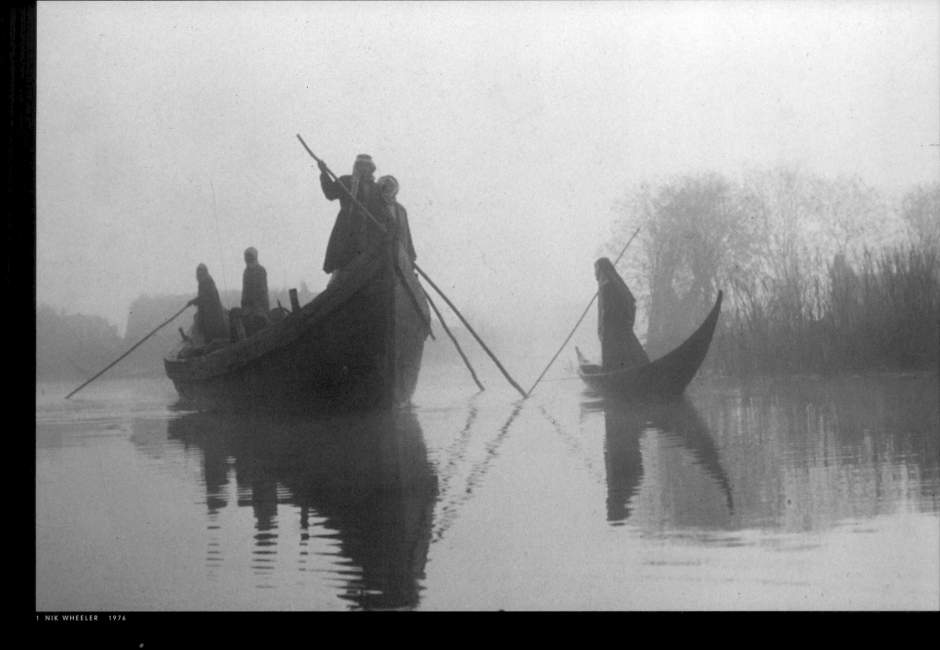

1 NIK WHEELER 1976

THE MA'DAN IN IRAQ

Since primeval times the Ma'dan have lived in reed
houses in the Southern Iraqi marshes which offered the
buffalo breeders a place of retreat from other tribes.
They regard themselves as Arabs of Shi'ite provenance.
Here in the marshland many systems of belief which are
not Islamic could also be preserved or develop anew.
Nik Wheeler published "Return to the Marshes" in 1977.

DIE MA'DAN IM IRAK

Seit Urzeiten leben die Ma'dan in Schilfhäusern in den
südirakischen Sümpfen, die den Büffelzüchtern eine Rück-
zugsmöglichkeit vor anderen Stämmen boten. Sie be-
trachten sich als Araber schiitischer Herkunft. Hier im
Sumpfland konnten sich aber viele nichtislamische Glau-
bensvorstellungen bewahren oder neu herausbilden. Nik
Wheeler publizierte 1977 das Buch »Return to the
Marshes«.

LES MA'DAN EN IRAK

Depuis la nuit des temps, les Ma'dan, éleveurs de buffles
dans les marais du sud de l'Irak, habitent des maisons en
roseaux qui leur offraient une possibilité de retraite en
cas de conflit avec les autres tribus. Ils se considèrent
comme Arabes et chiites, mais dans ces régions maré-
cageuses, de nombreuses croyances non-islamiques ont
pu se maintenir ou se former. Nik Wheeler a publié en
1977 le livre « Return to the Marshes » (« Retour aux
marais »).

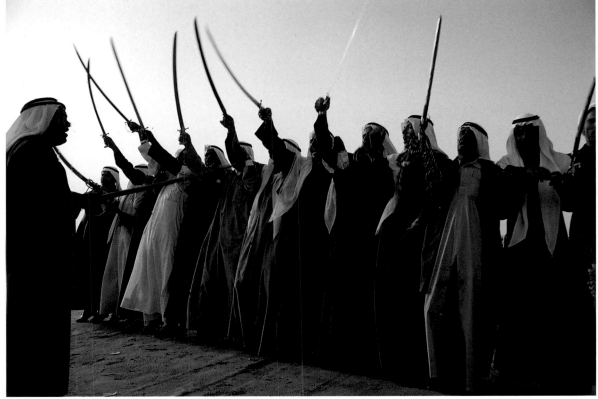

2 TOR EIGELAND 1968

KUWAIT

The Arabian Utub clan founded the emirate of Kuwait around 1850. It was a British protectorate from 1899 to 1961. (2, 3) Festivities in Kuurif. The oil industry brought great wealth to the country in the 20th century but the old Arab traditions have never been questioned.

KUWAIT

Der arabische Klan der Utub begründete das Emirat Kuwait um 1850. Von 1899 bis 1961 war es britisches Protektorat. (2, 3) Festtag in Kuurif. Die Ölindustrie brachte im 20. Jahrhundert großen Reichtum ins Land, die alten arabischen Traditionen standen jedoch nie in Frage.

LE KOWEIT

Le clan arabe des Utub fonda l'émirat du Koweit en 1850. De 1899 à 1961, il resta sous protectorat britannique. (2, 3) Jour de fête à Kuurif. L'industrie pétrolière a apporté la prospérité dans le pays au 20ᵉ siècle. Cependant, les anciennes traditions arabes ne furent jamais remises en question.

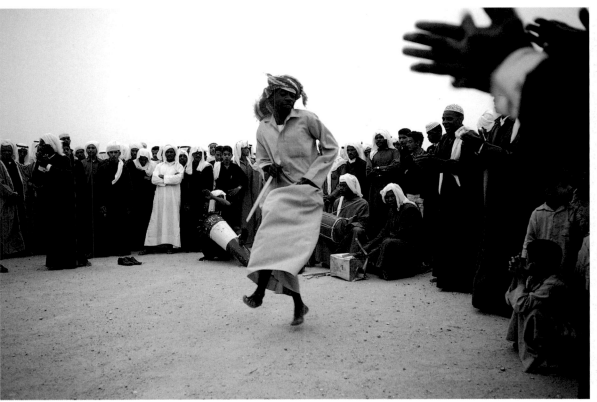

3 TOR EIGELAND 1968

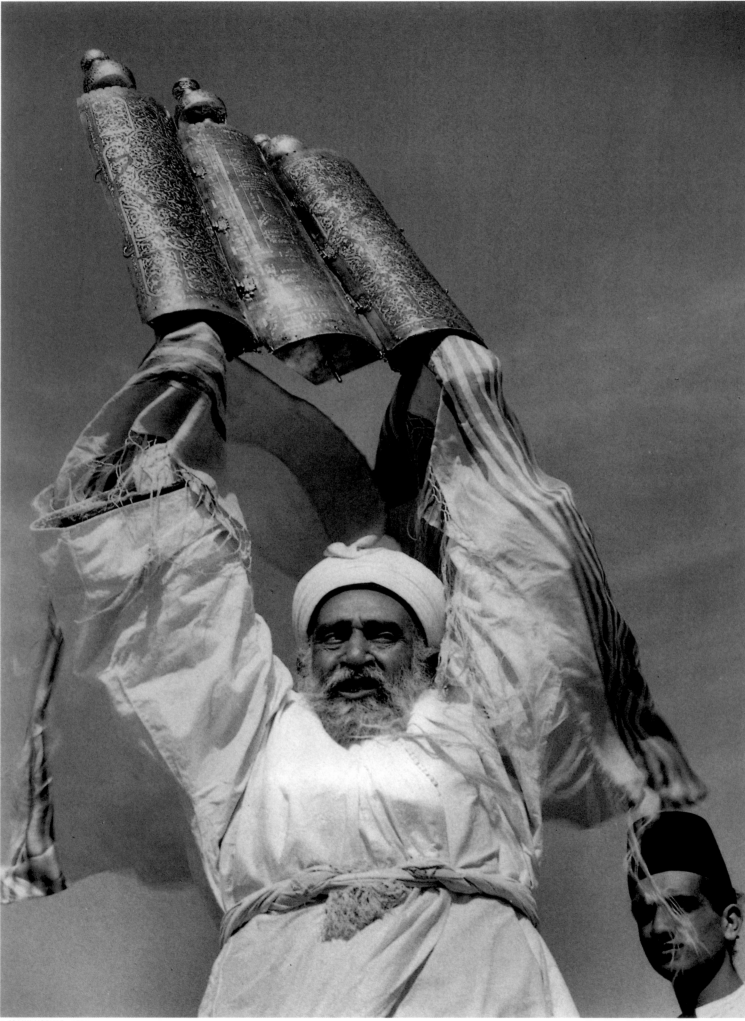

1 FRANK HORVAT 1954

THE SAMARITANS IN ISRAEL

(1) A high priest of the Samaritans with a Torah on the sacred Mount Garizim. Since the 7th century BC the Samaritans, who are of mixed descent from Israelites and settlers, have lived in Central Palestine. Their religion is a schism of Judaism which is thousands of years old. Today, however, they face extinction.

DIE SAMARITANER IN ISRAEL

(1) Ein Hohepriester der Samaritaner, die seit jeher im Schisma mit den Juden leben, mit einer Torah auf dem heiligen Berg Garizim. Seit dem 7. Jahrhundert v. Chr. siedelt dieses Mischvolk aus Israeliten und Kolonisten in Zentral-Palästina, ist heute jedoch vom Aussterben bedroht.

LES SAMARITAINS EN ISRAEL

(1) Un grand-prêtre samaritain, brandissant la Torah sur la montagne sainte de Garizim. Depuis le 7e siècle avant J.C., ce peuple issu d'une secte judaïque et de colons vit en Palestine centrale. Il est aujourd'hui menacé d'extinction.

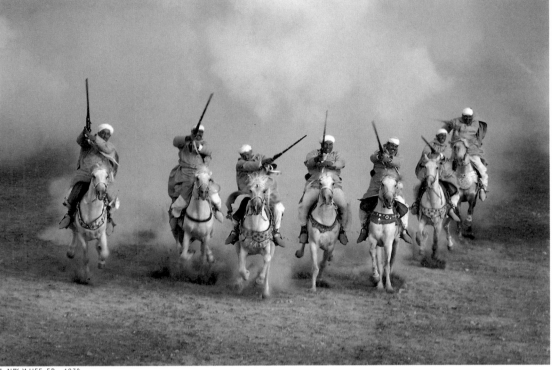

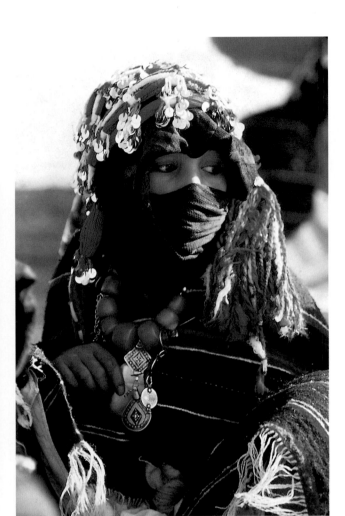

(2) Berber bride. The cruciform amulet which is typical of Berber culture indicates that she is available for marriage. The bridal couple will see each other for the first time at the market. (3) Equestrian games. The famous games are a regular feature of these "mass weddings."

(2) Berberbraut. Das für die Kultur typische Kreuzamulett signalisiert ihre Heiratsfähigkeit. Die Brautpaare sehen sich auf dem Markt zum ersten Mal. (3) Eine Fantasia. Die berühmten Reiterspiele sind fester Bestandteil dieser »Massenhochzeiten«.

(2) Jeune fille berbère. L'amulette typique, en croix, signale qu'elle est en âge d'être mariée. Les futurs époux se rencontrent sur le marché pour la première fois. (3) Fantasia. Ces célèbres jeux de cavaliers sont partie intégrante de ces « mariages en séries ».

BERBER WEDDING IN MOROCCO

Nik Wheeler (b. in Hitchin, England) now concentrates on travel photography after decades of working as a photojournalist. He also now writes articles. In 1978 he photographed a genuine Berber bridal market for *National Geographic* in the Moroccan Atlas Mountains. Until the Arab conquest in the 7th century the Berbers occupied all of the land from Morocco to as far east as Egypt. Today they are divided into many ethnic communities across the region. The bridal markets in the Rif Mountains take place once a year.

BERBER-HOCHZEIT IN MAROKKO

Nik Wheeler (geb. in Hitchin, England) konzentrierte sich nach Jahrzehnten fotojournalistischer Arbeit allein auf Reisefotografie und arbeitet nun auch als Textautor. 1978 fotografierte er für *National Geographic* einen genuinen Berberbrautmarkt im marokkanischen Atlasgebirge. Die Nomadenstämme der Berber besiedelten bis zur arabischen Eroberung im 7. Jahrhundert den gesamten Raum von Marokko bis Ägypten. Heute leben sie, in viele ethnische Einheiten aufgeteilt, in der Region. Die Brautmärkte im Rifgebirge finden einmal im Jahr statt.

MARIAGE BERBERE AU MAROC

Après des années de photojournalisme, Nik Wheeler (né à Hitchin, Angleterre) a fini par se concentrer sur la photo de voyages et publie désormais également des textes. En 1978, il a photographié pour le *National Geographic* un authentique marché aux épouses berbères dans le massif marocain de l'Atlas. Jusqu'à la conquête arabe, au 7ᵉ siècle de notre ère, les Berbères peuplaient toute la région qui va du Maroc à l'Egypte. Aujourd'hui, ils sont disséminés sur tout le territoire en de nombreux petits peuples. Dans la chaîne montagneuse du Rif, les marchés aux épouses se tiennent une fois par an.

North Africa and the Sahara:
(1) A Sudanese caravan leader at
the Libyan Berber oasis of Sukna.
Libyans, Hamites, Tubbus and
Haussas lived here.

Nordafrika und die Sahara:
(1) Sudanischer Karawanenführer in
der libyschen Berberoase Sukna.
Hier lebten Libyer, Hamiten, Tubbu
und Haussa.

Afrique du Nord et Sahara :
(1) Guide de caravane dans l'oasis
berbère libyenne de Sukna. Ici
vivaient Libyens, Hamites, Toubous
et Haussas.

1 EMIL SCHULTHESS 1959

(2) A Hamitic woman at the Libyan oasis Hun. The Hamites, a group of north African peoples, trace their ancestry back to their biblical father Ham, one of the three sons of Noah. Schulthess recalls: "She was reluctant to pose."

(2) Hamiten-Frau in der libyschen Oase Hun. Die nordafrikanische Ethnie der Hamiten beruft sich auf ihren biblischen Stammvater Ham, einen der drei Söhne Noahs. Schulthess' persönliche Erinnerung: »Sie posierte nur widerstrebend.«

(2) Femme hamite dans l'oasis libyenne de Hun. L'ethnie nord-africaine des Hamites tire son nom de son ancêtre biblique Ham, l'un des trois fils de Noé. Schulthess se rappelle : « Elle posait avec une certaine réticence. »

2 EMIL SCHULTHESS 1959

AFRICA

Emil Schulthess (b. 1913 in Zurich) was a visual all-round genius. He worked for the Swiss magazine *Du* from 1941 to 1957 as art director, picture editor and photographer. He then began his career as a freelance photographer, author and art director. He started his collaboration with Black Star in 1959. On two expeditions which both lasted five months in the mid 1950s, Schulthess traveled across Africa from Tunis in the north to the Cape of Good Hope in the south. "We visited primitive Negro villages and modern production plants; we stood on the shores of three seas and encountered people of the most diverse races and colors: black, brown and white, Pygmies and giants, naked savages and cultured town-dwellers. It all adds up to one tremendous adventure." His photographic discoveries of the "dark continent" were published in book form in 1959.

AFRIKA

Emil Schulthess (geb. 1913 in Zürich) war ein visuelles Allround-Genie. Für das Schweizer Magazin *Du* arbeitete er von 1941 bis 1957 als Art Director, Bildchef und Fotograf. Danach begann seine Karriere als freier Fotograf, Autor und Art Director. 1959 startete er seine Zusammenarbeit mit Black Star. Auf zwei Expeditionen von jeweils fünf Monaten Dauer durchquerte Schulthess Mitte der 50er Jahre Afrika von Tunis bis zum Kap der Guten Hoffnung. ›Wir besuchten primitive Neger-Dörfer und moderne Produktionsanlagen; wir standen an den Ufern dreier Meere und begegneten Menschen verschiedenster Rassen und Hautfarben: schwarzen, braunen und weißen, Pygmäen und Riesen, nackten Wilden und kultivierten Städtern. Alles in allem ein ungeheures Abenteuer.« Seine fotografischen Entdeckungen des »dunklen Kontinents« wurden 1959 als Buch veröffentlicht.

L'AFRIQUE

Emil Schulthess (né en 1913 à Zurich) a été doté d'un authentique génie visuel. De 1941 à 1957, il travailla comme directeur artistique, directeur de l'iconographie et photographe pour le magazine suisse *Du*. Après quoi il entame une carrière indépendante comme photographe, auteur et directeur artistique. Sa collaboration avec Black Star date de 1959. Au milieu des années 50, au cours de deux expéditions de cinq mois chacune, Schulthess traverse l'Afrique de Tunis au Cap de Bonne-Espérance. « Nous avons visité les villages primitifs des Noirs et les installations industrielles modernes ; nous nous sommes tenus sur les rivages de trois mers et nous avons rencontré des gens de races et de couleurs de peau les plus diverses : noir, marron, blanc, Pygmées et géants, sauvages nus et citadins cultivés. Au bout du compte, une aventure incroyable. » Ses photos du « continent noir » ont fait l'objet d'un livre, publié en 1959.

3 EMIL SCHULTHESS 1959

1 EMIL SCHULTHESS 1959

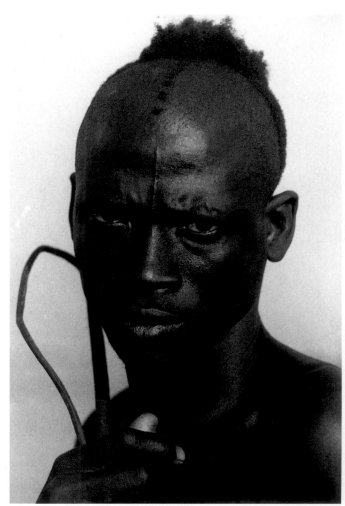

2 EMIL SCHULTHESS 1959

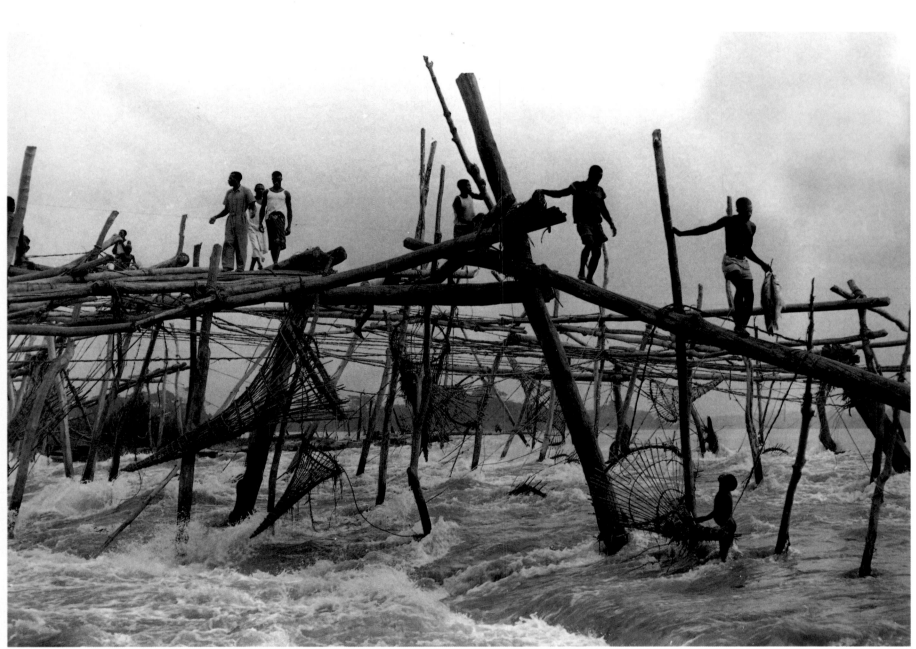

4 EMIL SCHULTHESS 1959

(1) Rhodesia: Tonga woman in traditional costume in a village near Sinazongwe, in what is now Zimbabwe. This village was flooded a few years later following the construction of the Kariba Dam. (2) French Equatorial Africa: A Massa boy with typical hairstyle and vertical decorative scars on his face. This tribe settled on the River Logone, which today forms the border between Chad and Cameroon. (3) An old Sara woman with lip plates in Kyabe, in what is now the Democratic Republic of Congo. "These women make a gurgling sound when they talk, and saliva runs in a continuous trickle over the lower plate." The calabash on her head and the notched ears are also typical. (4) Wagenia fishermen in the rapids of the Congo near Kisandji, Congo Kinshasa. The photographer reports: "In the dry season this Bantu tribe erects wooden platforms from which, in the rainy season, the men catch more or less all the fish in the river using conical fish traps – much to the chagrin of the tribes downriver."

(1) Rhodesien: Tonga-Frau in traditioneller Tracht in einem Dorf in der Nähe von Sinazongwe, heute Zimbabwe. Dieses Dorf wurde wenige Jahre später für den Kariba-Stausee geflutet. (2) Französisch-Äquatorialafrika: Ein Massa-Junge mit typischer Frisur und vertikalen Schmucknarben im Gesicht. Die Massa siedelten am Logone-Fluß, der heute die Grenze zwischen Tschad und Kamerun bildet. (3) Alte Sara-Frau mit Lippenplatten in Kyabe, heute Demokratische Republik Kongo. »Diese Frauen machen ein gurgelndes Geräusch beim Sprechen, und ein ständiger Speichelfluß läuft über die untere Platte.« Auch die Kalebasse auf dem Kopf und die gekerbten Ohren sind charakteristisch. (4) Wagenia-Fischer in den Stromschnellen des Kongo nahe Kisandji, Kongo-Kinshasa. Der Fotograf berichtet: »Dieser Bantu-Stamm errichtet in der Trockenperiode Holzplateaus, von denen aus die Männer in der Regenzeit mit konischen Fischfallen den reißenden Fluß mehr oder weniger leerfischen – zum Unmut der Stämme flußabwärts.«

(1) Rhodésie : Femme tonga en costume traditionnel dans un village à proximité de Sinazongwe, le Zimbabwe actuel. Ce village fut inondé quelques années plus tard par le lac de barrage de Kariba. (2) Afrique équatoriale française : Un jeune garçon Massa, avec la coiffure typique et les balafres ornementales sur le visage. Cette tribu vivait sur le fleuve Logone qui trace aujourd'hui la frontière entre le Tchad et le Cameroun. (3) Vieille femme Sara à plateaux, à Kyabe, dans la République démocratique du Congo actuelle. « Ces femmes font un bruit de gargarisme en parlant et un flux constant de salive dégouline sur le plateau inférieur. » Les calebasses sur la tête et les oreilles fendues sont également caractéristiques. (3) Pêcheur Wagenia dans les rapides du fleuve Congo près de Kisandji, Congo-Kinshasa. Le photographe rapporte : « Cette tribu bantoue dresse pendant la période sèche des plate-formes en bois d'où les hommes, en période de pluies, vident pratiquement le fleuve de ses poissons au moyen de pièges coniques – au grand déplaisir des tribus qui vivent en aval. »

(1, 2) Belgian Congo. Adanara festival in Kiavinionge, a fishing village on Lake Edward. Schulthess described the trance in which the young drummer is pictured here: "Every muscle in his body is tensed, his eyes are wide open, gazing into the distance and seeing nothing." (3) An Ndebele woman near Pretoria, South Africa. For Schulthess this was the first and most exciting expedition in his long career through an entire continent: "I feel that its salient feature is the almost incredible diversity of impressions."

(1, 2) Belgisch Kongo: Adanara Festival in Kiavinionge, einem Fischerdorf am Lake Edward. Den Trancezustand des jungen Trommlers beschrieb Schulthess: »Jeder Muskel seines Körpers ist angespannt, seine Augen sind weit offen, starren in die Entfernung und sehen nichts.« (3) Ndebele-Frau in der Nähe von Pretoria, Südafrika. Für Schulthess war es in seiner langen Karriere die erste und aufregendste Expedition durch einen ganzen Kontinent: »Die nahezu unglaubliche Vielfalt der Eindrücke macht, denke ich, das Charakteristikum [Afrikas] aus.«

(1, 2) Congo belge : Fête d'Adanara à Kiavinionge, un village de pêcheurs sur le lac Edouard. La transe du jeune percussionniste est ainsi décrite par Schulthess : « Chacun des muscles de son corps est tendu, ses yeux sont grands ouverts et regardent au loin sans rien voir. » (3) Femme Ndebele près de Pretoria, Afrique du Sud. Pour Schulthess, cette expédition à travers un continent entier fut la première et la plus excitante de toute sa longue carrière : « Il me semble que la caractéristique la plus remarquable [de l'Afrique] est l'incroyable diversité d'impressions qu'elle produit. »

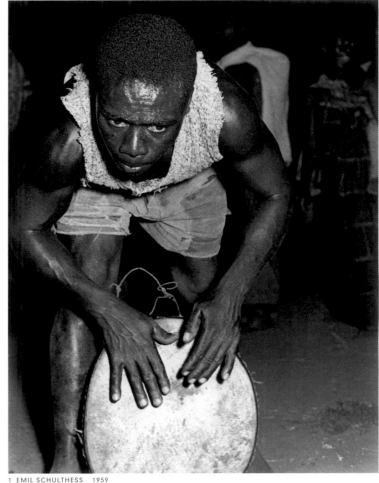

1 EMIL SCHULTHESS 1959

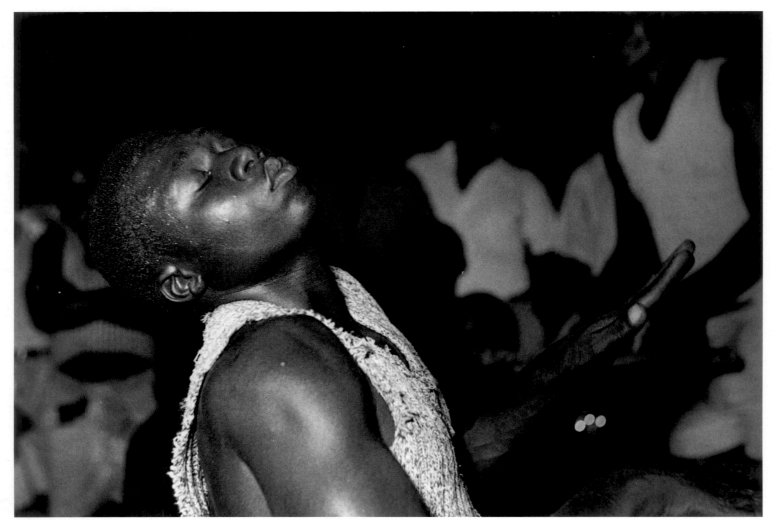

2 EMIL SCHULTHESS 1959

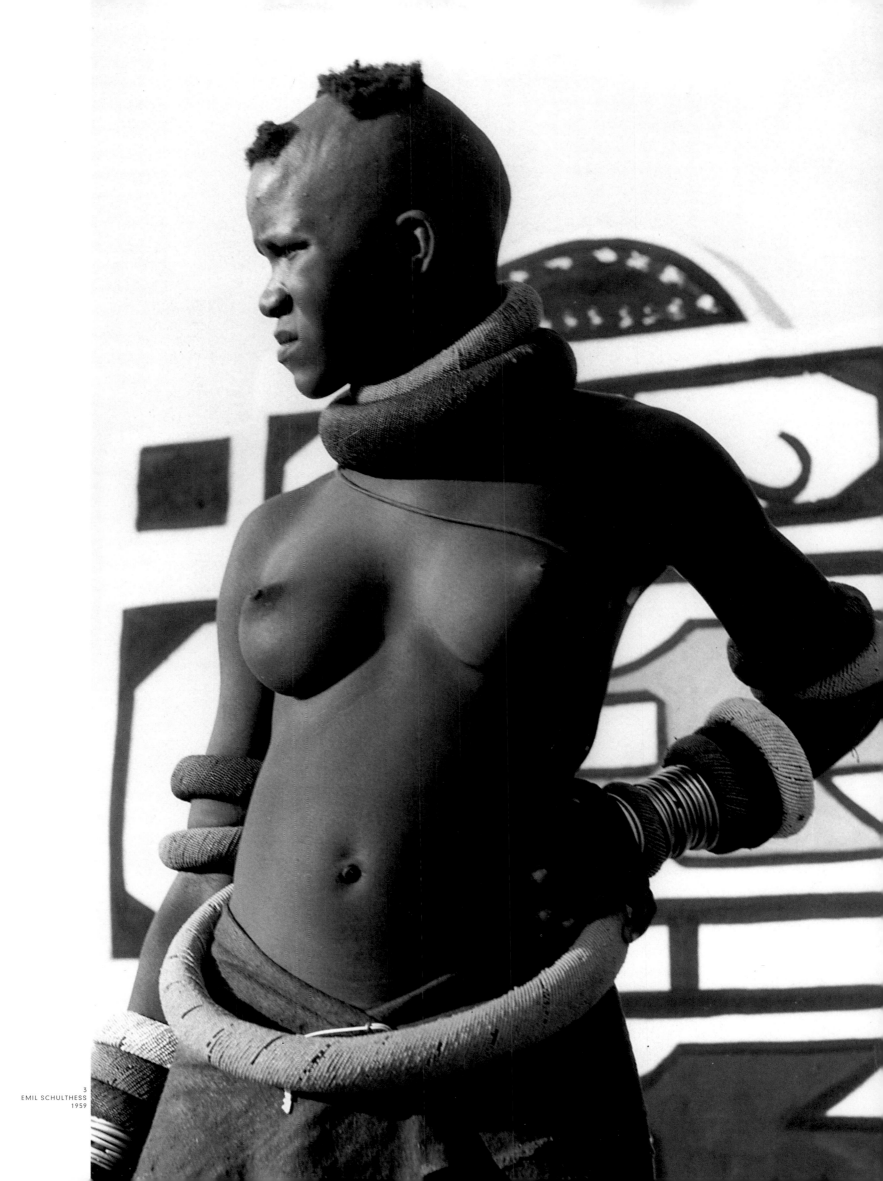

3
EMIL SCHULTHESS
1959

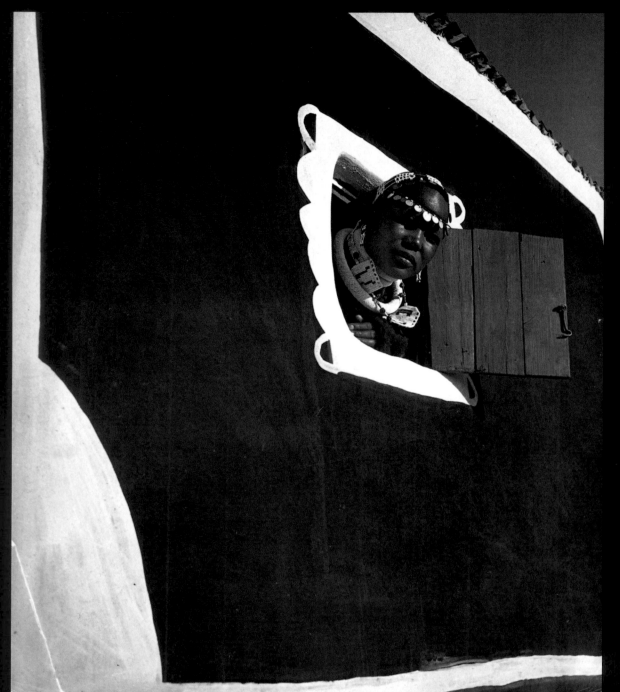

(1, 2) Ndebele women and the houses they have painted in the Transvaal. Today, Ndebele tribes live mostly from migratory work in homelands in South Africa and Zimbabwe following the destruction by South African colonial troops in around 1900 of the powerful Matabele Kingdom between the Zambezi and the Limpopo which was ruled by the Ndebele.

(1, 2) Ndebele-Frauen vor den von ihnen bemalten Häusern im Transvaal. Die Ndebele leben heute meist von der Wanderarbeit in Reservaten in Südafrika und Zimbabwe, nachdem um 1900 südafrikanische Kolonialtruppen das mächtige, von den Ndebele regierte Matabele-Reich zwischen Sambesi und Limpopo zerstörten.

(1, 2) Femmes Ndebele devant leurs maisons, peintes par elles-mêmes, dans le Transvaal. Les tribus Ndebele vivent aujourd'hui le plus souvent de travail saisonnier dans les réserves de l'Afrique du Sud et du Zimbabwe, les troupes coloniales ayant détruit, vers 1900, l'empire du Matabélé, gouverné par les Ndebele, entre le Zambèze et le Limpopo.

1 CONSTANCE STUART UNDATED/O.D./S.D.

NDEBELE WOMEN IN SOUTH AFRICA

Constance Stuart (b. in Pretoria) opened a portrait studio in her native city after studying photography in Europe. During the Second World War she was the first female African war correspondent to photograph the South African Sixth Division in Egypt and Italy. "For pleasure and with no thought of financial gain I became intensely interested in using my Rolleiflex Camera to document ethnic groups in my country." During her long career she remained faithful to black and white photography and to her credo: "Blessed with a natural eye for design I don't waste film and have never been interested in going click-click-click. Some of my best photographs are one shot only."

NDEBELE-FRAUEN IN SÜDAFRIKA

Constance Stuart (geb. in Pretoria) eröffnete nach dem Studium der Fotografie in Europa ein Porträtstudio an ihrem Geburtsort. Während des Zweiten Weltkrieges fotografierte sie als erste weibliche afrikanische Kriegskorrespondentin die südafrikanische 6. Division in Ägypten und Italien. »Zum Vergnügen und ohne einen Gedanken an finanziellen Gewinn wuchs mein Interesse, die Rolleiflex zur Dokumentierung der ethnischen Gruppen meines Landes einzusetzen.« Sie blieb während ihrer langen Karriere der Schwarz-Weiß-Fotografie und ihrem Credo treu: »Da ich mit einem natürlichen Auge für Gestaltung gesegnet bin, verschwende ich keine Filme. Einige meiner besten Fotos sind Einzelschüsse.«

FEMMES NDEBELE EN AFRIQUE DU SUD

Après des études de photographie en Europe, Constance Stuart (née à Pretoria) ouvrit un atelier de portraits dans sa ville natale. Pendant la Deuxième Guerre mondiale, première femme africaine correspondante de guerre, elle photographia la 6e Division sud-africaine en Egypte et en Italie. « Pour le plaisir et sans penser à un gain financier, l'idée d'utiliser mon Rolleiflex pour photographier les différents groupes ethniques de mon pays a commencé à me passionner. » Durant sa longue carrière, Constance Stuart est toujours restée fidèle au noir et blanc ainsi qu'à son credo : « Dotée d'un sens plastique naturel, je ne dilapide pas la pellicule. Quelques-unes de mes meilleures photos sont des prises uniques. »

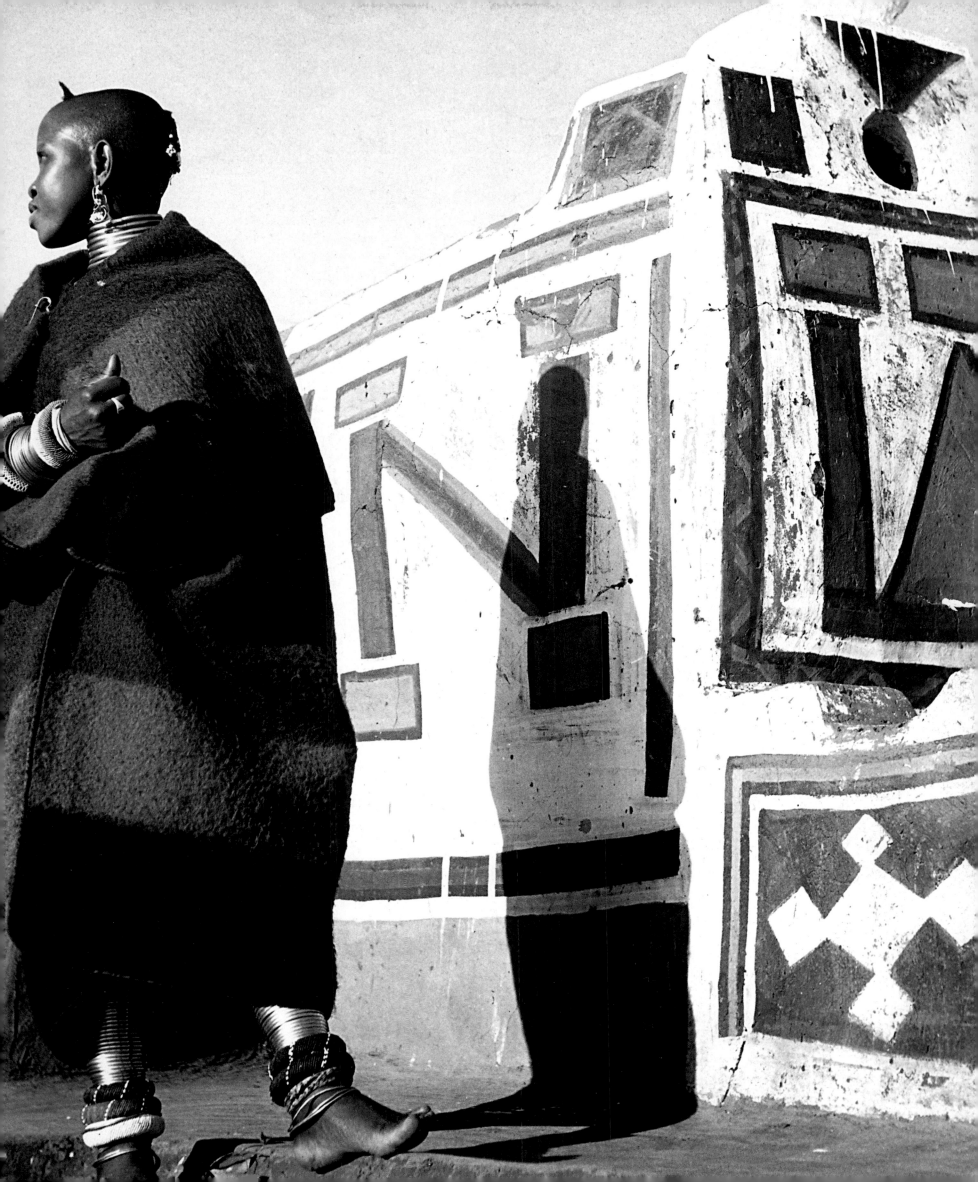

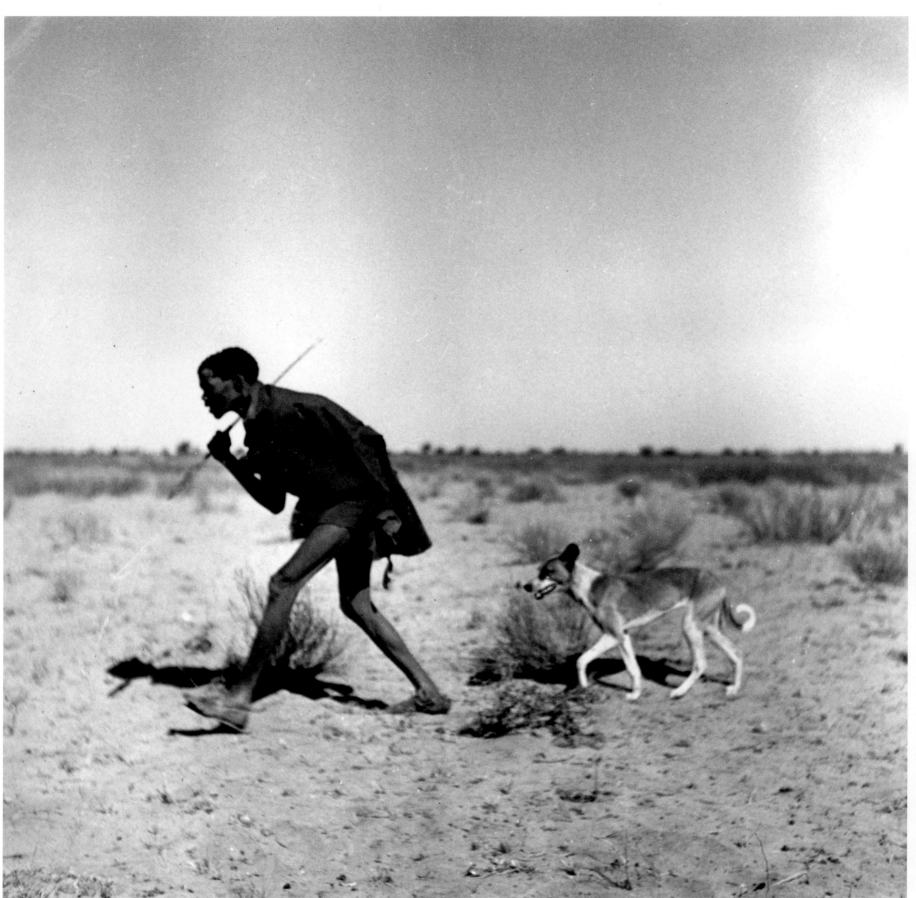

1 CONSTANCE STUART CA./ENV. 1950

2 DAVID TURNLEY 1996

BUSHMEN IN THE KALAHARI DESERT

In precolonial times the whole of Africa south of the Zambezi was settled by communities of hunters and gatherers who were characterized by the later European settlers as "bushmen". The Boers made a systematic attempt to wipe out these people in the 18th and 19th centuries. The majority of the Bushmen have become assimilated during the 20th century. Only a few small groups remain like those that are to be found in the Kalahari Desert. (1) Hunting with lethal poison arrows was always the preserve of the men, while gathering wild fruits was the task of women and children. (2) A boy eating a wild cucumber. This and other water-storing plants such as melons ensure survival during the dry season. The vegetation of the Kalahari is sparse and there is no direct access to water.

BUSCHMÄNNER IN DER KALAHARI-WÜSTE

In vorkolonialer Zeit siedelten im gesamten Afrika südlich des Sambesi die von den späteren europäischen Siedlern als »Buschmänner« bezeichneten Jäger- und Sammlergemein-schaften. Die Buren versuchten im 18. und 19. Jahrhundert dieses Volk systematisch auszurotten. Im 20. Jahrhundert lebt der Großteil von ihnen assimiliert. Es finden sich nur noch kleine Restgruppen wie in der Kalahari-Wüste: (1) Die Jagd mit den tödlichen Giftpfeilen war immer eine Domäne der Männer. Feldfrüchte wurden meist von Frauen und Kindern gesammelt. (2) Junge ißt wilde Gurke. Diese und andere wasserspeichernde Pflanzen wie Melonen sichern in bestimmten Jahreszeiten das Überleben in der kargen Vegetation, auch ohne direkten Zugang zu Wasser.

BUSHMEN DANS LE DESERT DU KALAHARI

Dès l'époque précoloniale, les communautés de chasseurs et de cueilleurs qui seront plus tard appelés « Bushmen » par les colons européens s'installent dans toute l'Afrique au sud du Zambèze. Aux 18e et 19e siècles, les Boers tentèrent d'exter-miner systématiquement ce peuple. Au 20e siècle, la plupart d'entre eux ont été assimilés. Quelques groupes subsistent encore ici et là, par exemple dans le désert du Kalahari : (1) La chasse aux flèches empoisonnées a toujours été le domaine des hommes. La récolte était réservée aux femmes et aux enfants. (2) Un garçon mangeant un concombre sau-vage, lequel, comme le melon et d'autres plantes aqueuses, permet d'assurer la survie en saison sèche et dans un environnement aride, même sans accès direct à l'eau.

San women dancing with a melon. Aside from ritual religious festivals, such as the magic of rainmaking, the bushmen often gather together and dance spontaneously in order to pray to their gods.

San-Frauen tanzen mit einer Melone. Neben den religiösen Festen wie z.B. ihrem Regenzauber versammeln sich und tanzen die Buschmänner oft spontan, um zu ihren Göttern zu beten.

Femmes San dansant avec un melon. Même en dehors des fêtes religieuses, comme par exemple le rituel de pluie, les Bushmen se rassemblent souvent spontanément pour danser et prier leurs dieux.

DAVID TURNLEY 1996

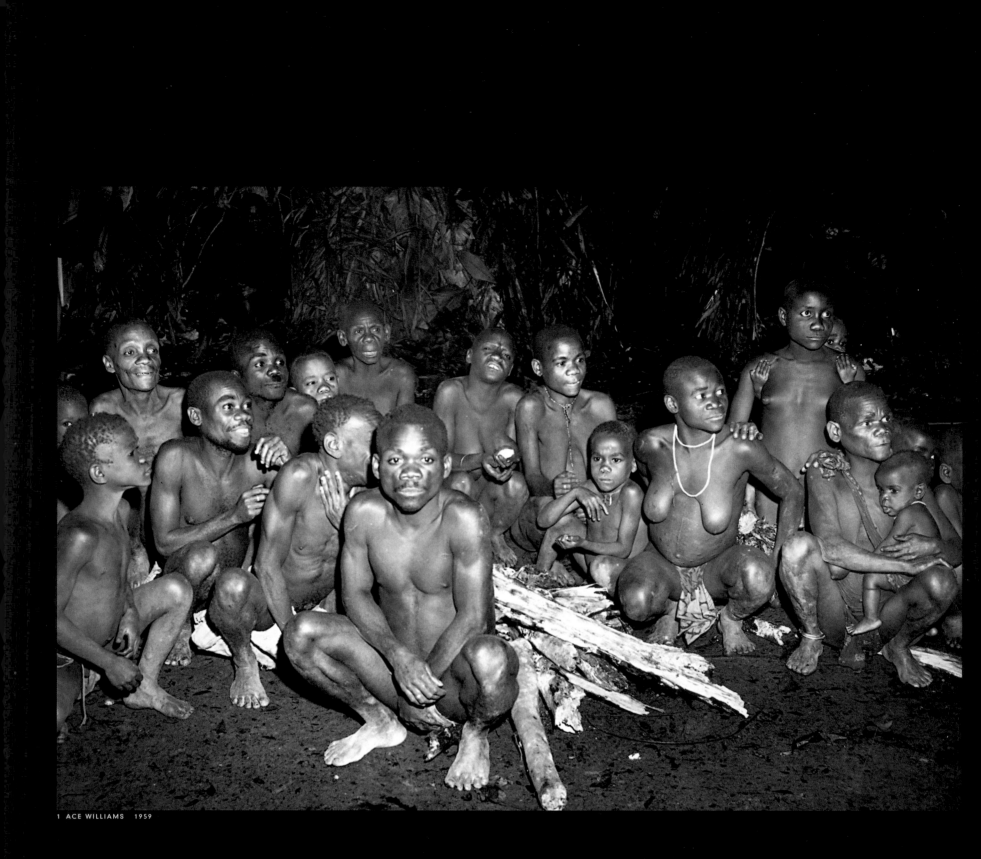

1 ACE WILLIAMS 1959

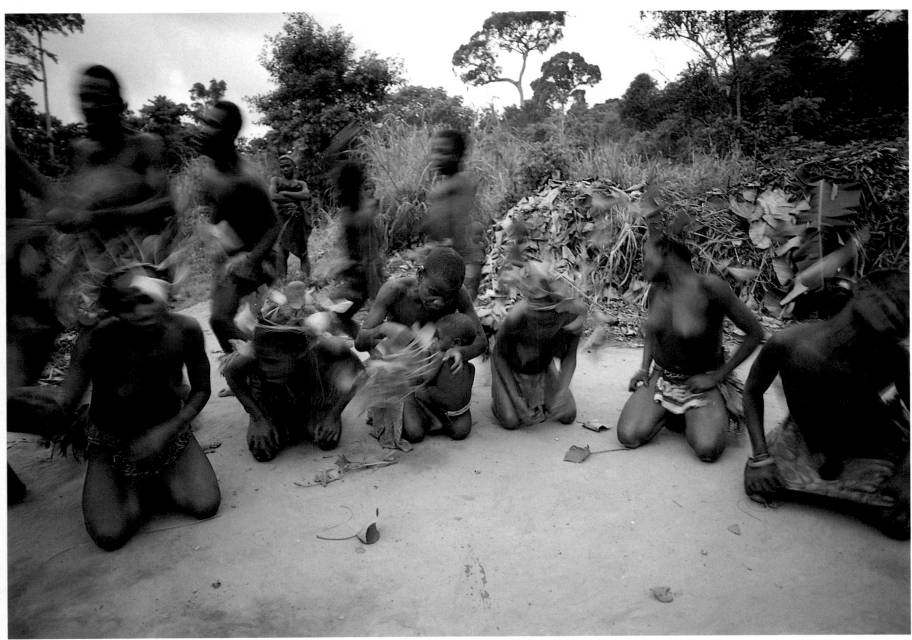

2 JAMES SUGAR 1982

BAMBUTI PYGMIES
OF THE ITURI FOREST

The Bambuti of the Ituri rain forest in North-eastern Zaire
(now the Democratic Republic of Congo) were for a long
time regarded as the model of a pygmy hunting culture in a
primeval forest. More recent research has revealed that the
composition of the Ituri Forest did not permit self-sufficiency
through hunting and gathering and that trading contacts with
the taller farmers nearby were vital for survival. (1) A hunting
camp. The camps are regularly moved to open up new land
for hunting and gathering. (2) Elima – the menstruation ritual
in which the young women of the community are initiated. In
all of the nature religion festivals of the Bambuti the forest
plays a central role. This is also the case with elima as the
leaf decorations of the girls show.

BAMBUTI-PYGMÄEN
IM ITURI-WALD

Die Bambuti des Ituri-Regenwaldes von Nordost-Zaire
(heute Demokratische Republik Kongo) galten lange Zeit als
Musterbeispiel einer pygmäischen Urwaldjäger-Kultur.
Neuere Forschungen haben jedoch nachgewiesen, daß die
Beschaffenheit des Ituri-Waldes keine autarke Versorgung
durch Jagen und Sammeln zuließ und die Handelskontakte
zu den umliegenden großwüchsigen Bauern lebensnotwen-
dig waren. (1) Ein Jagdlager. Die Lager werden regelmäßig
verlegt, um neue Jagd- und Sammelgründe zu erschließen.
(2) Elima – das Menstruationsfest, mit dem die jungen Frauen
in die Gemeinschaft der Erwachsenen aufgenommen wer-
den. In allen naturreligiösen Festen der Bambuti spielt der
Wald eine zentrale Rolle. Auch beim Elima, wie der Blatt-
schmuck der Mädchen zeigt.

PYGMEES BAMBUTI
DANS LA FORET D'ITURI

Les Bambuti, peuple de la forêt équatoriale Ituri, au nord-est
du Zaïre (la République démocratique du Congo actuelle),
ont passé longtemps pour l'exemple-type d'une civilisation
de chasseurs en forêt vierge. Des recherches plus récentes
ont cependant démontré que la structure de la forêt Ituri ne
permettait pas une autonomie par la chasse et la cueillette
et que les échanges avec les plus grands paysans des
environs étaient vitaux. (1) Un camp de chasseurs. Les
camps sont régulièrement déplacés afin de permettre
l'exploitation de nouveaux territoires de chasse et de
cueillette. (2) Elima – la fête des menstruations, lors de
laquelle les jeunes filles sont admises dans la communauté
des adultes. Dans toutes les fêtes de la religion naturelle des
Bambuti, la forêt joue un rôle central ; ainsi, les feuilles que
cette jeune fille porte en ornement.

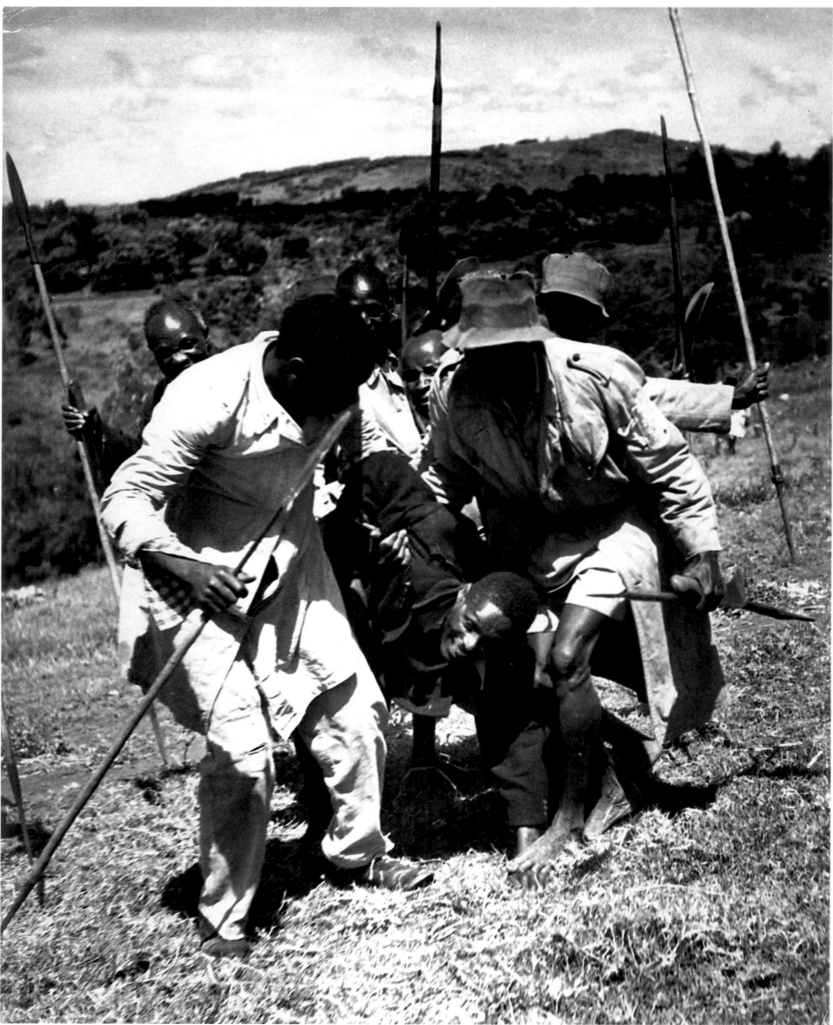

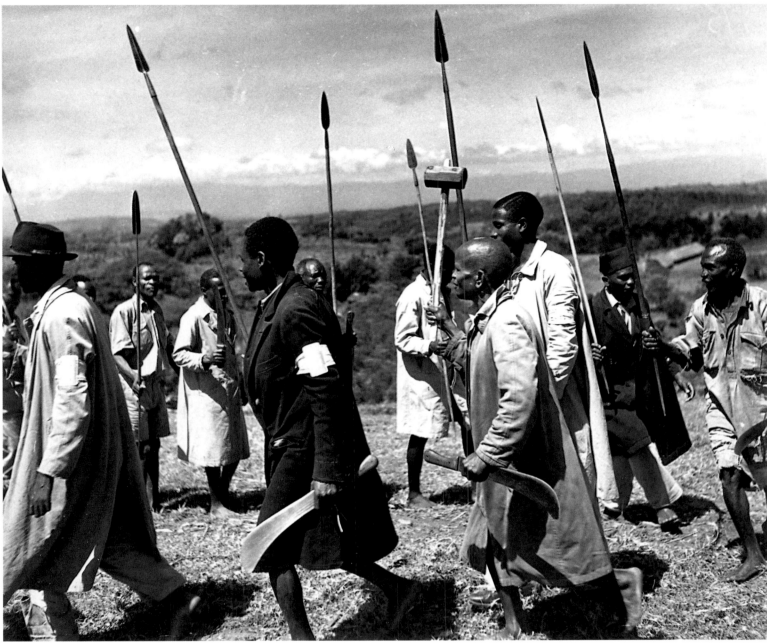

2 RUNE HASSNER 1954

THE MAU MAU UPRISING IN KENYA

The Mau Mau uprising in Kenya between 1952 and 1956 was a first signal to the whole of Africa in its struggle for independence from the colonial powers. (2) The largest tribe in Kenya, the Kikuyu, formed the Mau Mau underground organization at the end of the 1940s. It fought for "land and freedom" using terrorist methods with the intention of driving the white settlers and their black "collaborators" out of the highlands. (1) The arrest of a Kikuyu. War raged in the country from 1952 onwards with a wave of arrests beginning in April 1954. The British authorities held up to 90,000 people prisoner in camps. The Mau Mau uprising cost the lives of about 13,500 blacks and 95 whites.

DER MAU-MAU-AUFSTAND IN KENIA

Der Mau-Mau-Aufstand in Kenia 1952 bis 1956 war ein erstes Signal für ganz Afrika in seinem Kampf für Unabhängigkeit von den Kolonialmächten. (2) Die größte Ethnie Kenias, die Kikuyu, bildete Ende der 40er Jahre die Untergrundorganisation Mau-Mau. Sie kämpfte mit terroristischen Mitteln für »Land und Freiheit« und wollte die weißen Siedler und ihre schwarzen »Kollaborateure« aus dem Hochland vertreiben. (1) Verhaftung eines Kikuyu. Ab 1952 herrschte Krieg im Land, im April 1954 setzte eine Verhaftungswelle ein. Die britischen Behörden hielten bis zu 90 000 Menschen in Lagern gefangen. Der Mau-Mau-Aufstand kostete ca. 13 500 Schwarze und 95 Weiße das Leben.

LA REVOLTE DES MAU-MAU AU KENYA

La révolte des Mau-Mau, au Kenya, de 1952 à 1956, fut le premier signal pour toute l'Afrique, dans le combat pour l'indépendance et contre les puissances coloniales.
(2) La plus grande tribu du Kenya, les Kikouyou, forma vers la fin des années 40 une société secrète, les Mau-Mau. Elle recourut à des moyens terroristes dans sa lutte pour « la terre et la liberté » et tenta de chasser du massif montagneux les colons blancs et leurs « collaborateurs » noirs. (1) Arrestation d'un Kikouyou. A partir de 1952, la guerre fait rage dans tout le pays et en avril 1954 a lieu une vague d'arrestations. Les autorités britanniques retiennent jusqu'à 90 000 personnes emprisonnées dans des camps. La révolte des Mau-Mau a coûté la vie à environ 13 500 Noirs et à 95 Blancs.

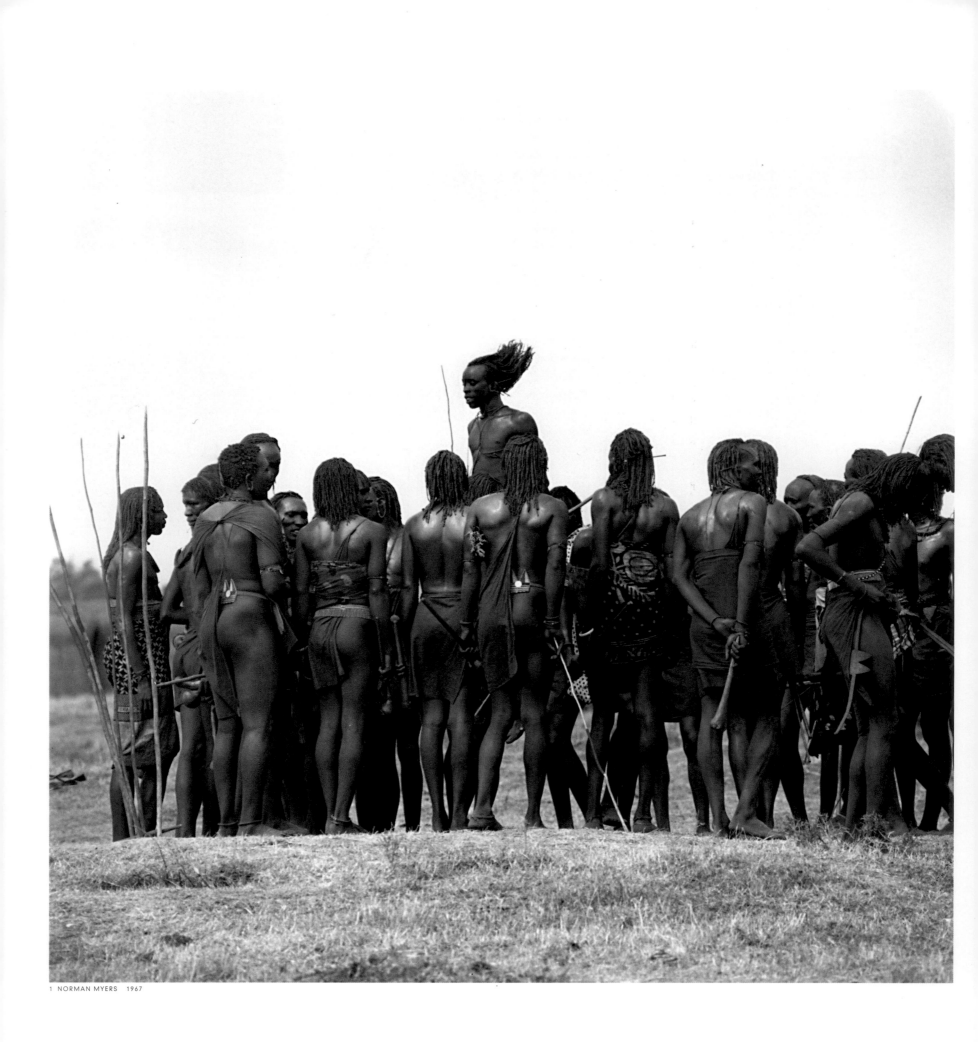

KENYAN INDEPENDENCE 1963

(2) 12 December 1963. The Kipsigi tribe on the day of Kenyan independence from the British. Jomo Kenyatta, sentenced to seven years imprisonment as the "secret leader" of the Kikuyu in the Mau Mau uprising in 1952, pledged the unity of all Kenyans when he was made first President of the country. He nevertheless gave preferential treatment to his own clique and tribe when it came to the political and economic building of the country. (1) Aside from Kenyatta's politics photographs of the proud warrior people of the Masai have always shaped the clichéd image of the Noble Savage outside of Africa. The young long-haired Ilmurran are the warriors and defenders of the settlements and cattle herds.

KENIAS UNABHÄNGIGKEIT 1963

(2) 12. Dezember 1963. Der Stamm der Kipsigi am Tag der kenianischen Unabhängigkeit von den Briten. Jomo Kenyatta, als »heimlicher Führer« der Kikuyu im Mau-Mau-Aufstand 1952 zu sieben Jahren Haft verurteilt, beschwor als erster Ministerpräsident die Einheit aller Kenianer. Er legte aber den politischen und wirtschaftlichen Aufbau des Landes bevorzugt in die Hände seines eigenen Klans und Stammes. (1) Ungeachtet der Politik Kenyattas bestimmten seit jeher Fotografien des stolzen Kriegervolks der Massai das außerafrikanische Klischee-Bild vom Edlen Wilden. Die jungen langhaarigen Ilmurran sind die Krieger und Verteidiger der Siedlungen und Viehherden.

L'INDEPENDANCE DU KENYA EN 1963

(2) 12 décembre 1963. La tribu des Kipsigi, le jour où le Kenya se libéra de la domination britannique et proclama son indépendance. Jomo Kenyatta, « chef secret » des Kikouyou pendant la révolte des Mau-Mau de 1952 et condamné à sept ans d'emprisonnement, devint Premier ministre et promit l'unité à tous les Kenyans. Il confia cependant l'édification politique et économique du pays en priorité aux membres de son propre clan et de sa tribu. (1) Nonobstant la politique Kenyattas, les photographies de ce fier peuple de guerriers, les Massaï, n'ont cessé d'alimenter le cliché extra-africain du « noble sauvage ». Les jeunes Ilmurran aux longs cheveux sont les guerriers et les défenseurs des villages et des troupeaux.

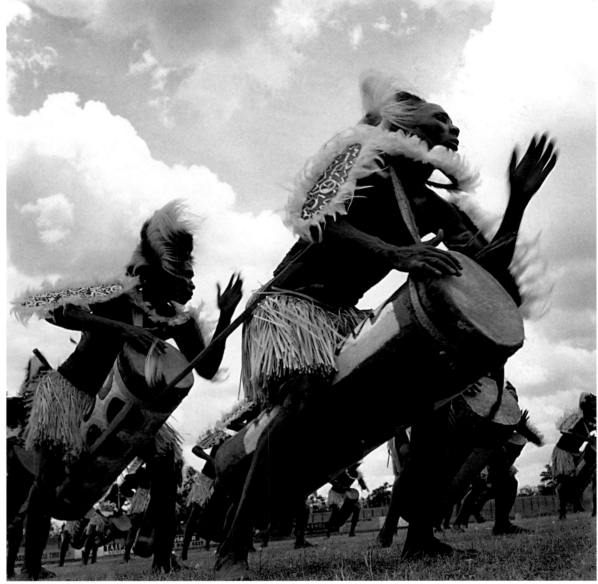

2 JOHN MOSS 1963

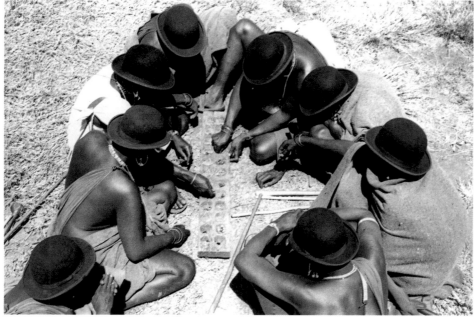

1 JOHN MOSS UNDATED/O.D./S.D.

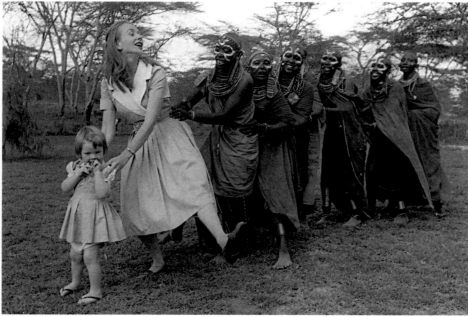

2 JOHN MOSS UNDATED/O.D./S.D.

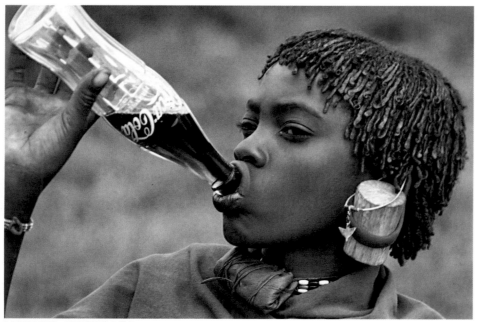

3 JOHN MOSS UNDATED/O.D./S.D.

COLONIAL KENYA

John Moss (b. 1928 in Southend, England) studied law and first worked in industry before discovering his love of photojournalism. Since his first story about South Africa for *National Geographic,* the "tribes of the world" have interested him in particular. Since 1960 he has worked for Black Star.

KOLONIALES KENIA

John Moss (geb. 1928 in Southend, England) studierte Jura und arbeitete zunächst in der Industrie, bevor er seine Liebe zum Fotojournalismus entdeckte. Seit seiner ersten Geschichte in Südafrika für *National Geographic* interessieren ihn vor allem die »Stämme der Welt«. Ab 1960 arbeitet er für Black Star.

LE KENYA COLONIAL

John Moss (né en 1928 à Southend, Angleterre) a étudié le droit et a commencé par travailler dans l'industrie, avant de se découvrir une passion pour le photojournalisme. Depuis ses premiers reportages en Afrique du Sud pour le *National Geographic,* il s'intéresse avant tout aux « tribus du monde entier ». Il travaille pour Black Star depuis de 1960.

In Kenya Moss captured the ineradicable traces of 1960s colonialism. (1) A circle of Masai men gathered around the boardgame "Chuzi". The bowler hats are more than a clear indication of Kenya's history as a British colony since 1895. (2) A female farm manager with Masai women. This black and white idyll must be seen against the historic background. The white settlers drove the Masai with their beef herds out of the fertile highlands. (3) Coca-Cola also became a symbol of the American way of life for this Masai boy.

In Kenia fing Moss in den 60er Jahren die unverwischbaren Spuren des Kolonialismus ein: (1) Eine Massai-Männerrunde über dem Brettspiel »Chuzi«. Die Melonen verweisen mehr als deutlich auf die Geschichte Kenias als britische Kolonie seit 1895. (2) Farm-Managerin mit Massai-Frauen. Schwarzweiße Idylle vor geschichtlichem Hintergrund: Die weißen Siedler verdrängten die Massai mit ihren Rinderherden aus dem fruchtbaren Hochland. (3) Coca Cola wurde auch für diesen Massai-Jungen zum Symbol des American way of life.

Dans le Kenya des années 60, John Moss a saisi les traces ineffaçables du colonialisme : (1) Un cercle de Massaï jouant au jeu de « chuzi ». Les melons renvoient clairement à l'histoire coloniale du Kenya depuis 1895. (2) Directrice d'exploitation avec femmes massaï. Image idyllique des relations entre Noirs et Blancs, sur fond d'histoire : les colons blancs avaient repoussé les Massaï avec leurs troupeaux de bœufs hors des terres fertiles du massif montagneux.
(3) Pour ce jeune garçon aussi, le Coca-Cola représente l'American way of life.

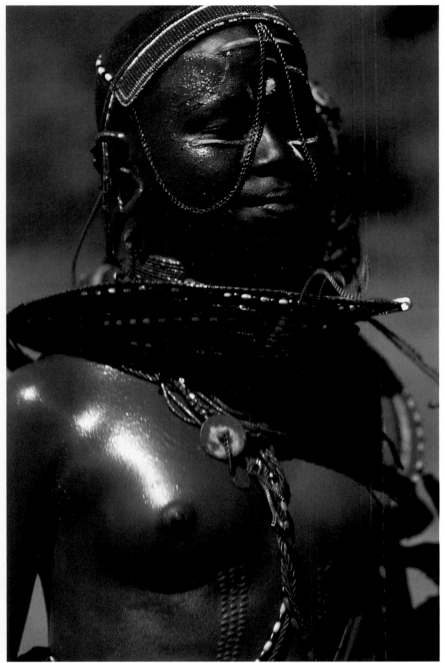

1 NIK WHEELER 1980

2 JOHN MOSS 1981

MASAI WOMEN IN KENYA

Whilst the life of Masai men is strictly divided into a class system based on age and specifically on the cycle child–warrior–herdsman–elder, the most important event in the life of the woman is excision. Until then the girls live together with the young warriors in separate villages. They enter the herdsmen's villages ready to marry and are integrated into the working programs of the community. The Masai herdsmen are in charge of the herds, although the actual work and care of the animals is the responsibility of the women and children. (1, 2) Masai women's jewelry is a status symbol and they wear it to all celebrations.

MASSAI-FRAUEN IN KENIA

Während das Leben der Massai-Männer in ein strenges Altersklassensystem der Lebensabschnitte Kind–Krieger–Hirte–Ältester eingebunden ist, stellt die Beschneidung für die Frauen den wichtigsten Lebenseinschnitt dar. Bis dahin leben die Mädchen gemeinsam mit den jungen Kriegern in separaten Dörfern. Heiratsfähig treten sie in die Dörfer der Hirten ein und werden in die Arbeitsabläufe der Gemeinschaft integriert. Die Massai-Hirten sind die Verwalter der Herden, die eigentliche Arbeit und Pflege der Tiere obliegt den Frauen und Kindern. (1, 2) Massai-Frauen legen zu allen Festlichkeiten ihren Schmuck als Statussymbol an.

FEMMES MASSAI AU KENYA

Chez les Massaï, si la vie des hommes est liée à un système de classes d'âge très strict, enfant, guerrier, berger, ancien, pour les femmes en revanche, le passage le plus important est l'excision. Jusque-là, les filles vivent avec les jeunes guerriers dans des villages séparés. Une fois en âge d'être mariées, elles s'installent dans les villages des bergers et sont intégrées dans les activités de la communauté. Les bergers massaï sont les administrateurs des troupeaux, mais le travail à proprement parler et les soins aux animaux sont confiés aux femmes et aux enfants. (1, 2) Toutes les festivités sont l'occasion pour les femmes massaï d'arborer les ornements qui indiquent leur statut.

1 JEFFREY ROTMAN 1984

The elders of the El Molo tribe put together a "hunting party" consisting of two young warriors and six veterans in the village which was full of excitement. In the distant hunting grounds of the North the hippopotamuses can only be hunted at night. The stalking hunter with the spear would have no chance by day. (1) After two vigilant nights and a long struggle one of the young warriors prepares to deliver the deathblow. (2) The "victor" at first enjoys the privilege of thanking the gods alone for his fortune in hunting. (3) The precise and detailed butchering of the animal takes the warriors eight hours.

Die Ältesten des Stammes El Molo stellten eine »Jagd-partie« aus zwei jungen Kriegern und sechs Veteranen im sehr aufgeregten Dorf zusammen. In den weit entfern-ten Jagdgründen im Norden können die Flußpferde nur nachts gejagt werden, tagsüber wäre der heranpirschen-de Jäger mit dem Speer chancenlos. (1) Nach zwei durchwachten Nächten und einem langen Kampf setzt einer der jungen Krieger zum Todesstoß an. (2) Der »Sieger« genießt das Privileg, zunächst allein den Göttern für sein Jagdglück zu danken. (3) In achtstündiger Klein-arbeit zerlegen die Krieger das Opfer vollständig.

Les anciens de la tribu d'El Molo organisent une « partie de chasse » composée de deux jeunes guerriers et de six vétérans, dans le village très excité. Sur les terres de chasse, loin au Nord, les hippopotames ne peuvent être chassés que de nuit, car le chasseur qui s'approche avec sa lance n'aurait aucune chance le jour. (1) Au bout de deux nuits de veille et d'une longue lutte, l'un des jeunes guerriers porte le coup fatal. (2) Le « vainqueur » jouit du privilège de remercier d'abord seul les dieux pour sa bonne fortune. (3) Le minutieux dépeçage de la victime par les guerriers dure huit heures.

HIPPO HUNTERS IN KENYA

Jeffrey Rotman (b. 1949 in Boston, USA) is one of the most famous underwater photographers in the world. His interest in water led him to discover one of Africa's smallest tribes on Lake Turkana in Kenya – the El Molo. In 1984 Rotman came upon the last 37 members of the tribe living in symbiosis with neighboring tribes along the banks of the lake from fishing and hunting. Yet hunting for hippopotamus and revering the animals as if they were gods always remained the preserve of the El Molo. Although such hunting has since been prohibited by the Kenyan authorities, a group of eight ritual warriors went stalking their revered prey with the photographer, a difficult and lengthy undertaking.

FLUSSPFERDJÄGER IN KENIA

Jeffrey Rotman (geb. 1949 in Boston, USA) ist einer der bekanntesten Unterwasserfotografen der Welt. Sein Interesse für das nasse Element ließ ihn am Lake Turkana in Kenia einen der kleinsten Stämme Afrikas entdecken – die El Molo. Rotman traf 1984 nur noch 37 Stammesmitglieder, die in Symbiose mit anderen Gruppen vom Fischfang und von der Jagd an den Ufern des Sees lebten. Die Jagd auf Flußpferde und die göttliche Verehrung der Tiere war aber seit jeher allein den El Molo vorbehalten. Obwohl die Jagd mittlerweile von den kenianischen Behörden verboten ist, machte sich eine Gruppe von acht Kriegern mit dem Fotografen auf die schwierige und langwierige Pirsch.

CHASSEURS D'HIPPOPOTAMES AU KENYA

Jeffrey Rotman (né en 1949 à Boston, Etats-Unis) est l'un des photographes subaquatiques les plus célèbres du monde. Son intérêt pour l'élément liquide l'a conduit jusqu'au lac Turkana au Kenya, où il a découvert l'une des plus petites tribus d'Afrique : les El Molo. En 1984, il ne trouva que 37 membres de la tribu, qui, en symbiose avec d'autres tribus, vivaient de pêche et de chasse sur les bords du lac. La chasse à l'hippopotame et la divinisation de cet animal étaient depuis toujours le privilège des El Molo. Bien que la chasse en ait été interdite par les autorités kenyanes, un groupe de huit guerriers rituels s'engage ici en compagnie du photographe dans une expédition longue et difficile.

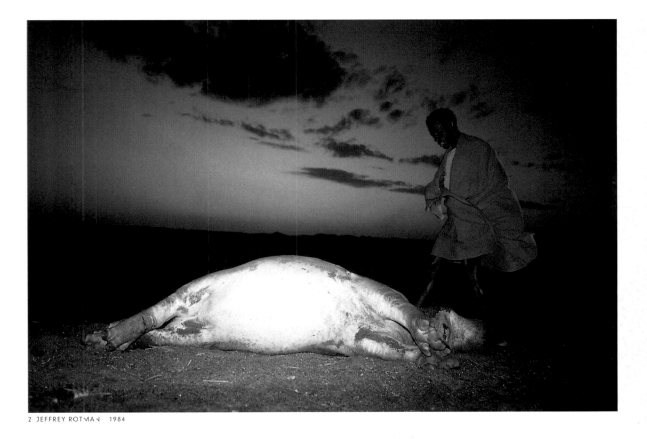

2 JEFFREY ROTMAN 1984

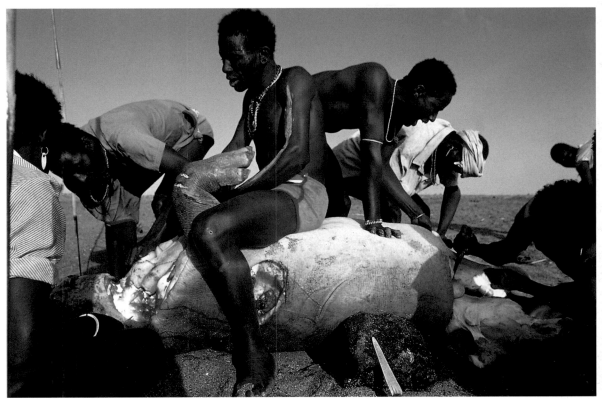

3 JEFFREY ROTMAN 1984

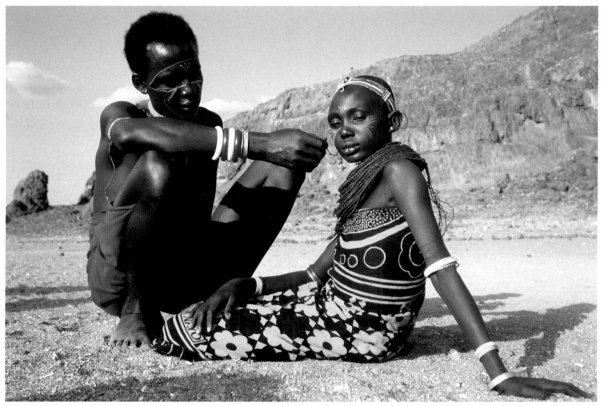

1 JEFFREY ROTMAN 1984

The successful hunt is followed by a ceremony. (1) The "victor" and his wife before the celebration. This was only the second hippopotamus he has killed in fifteen years. (2) A veteran. The earring made of bone marks him out as a successful hunter; the necklaces give the warriors their strength.

Auf die siegreiche Jagd folgt die Zeremonie: (1) Der »Sieger« und seine Frau vor dem Fest. In fünfzehn Jahren war dies sein zweites erlegtes Flußpferd. (2) Ein Veteran. Der Ohrring aus Knochen zeichnet ihn als erfolgreichen Jäger aus; die Ketten geben den Kriegern ihre Kraft.

Le succès de la chasse est suivi d'une cérémonie : (1) Le « vainqueur » et son épouse, avant la fête. En quinze ans, c'est le deuxième hippopotame qu'il tue. (2) Un vétéran. Le pendant d'oreille en os le désigne comme chasseur émérite ; les colliers confèrent leur puissance aux guerriers.

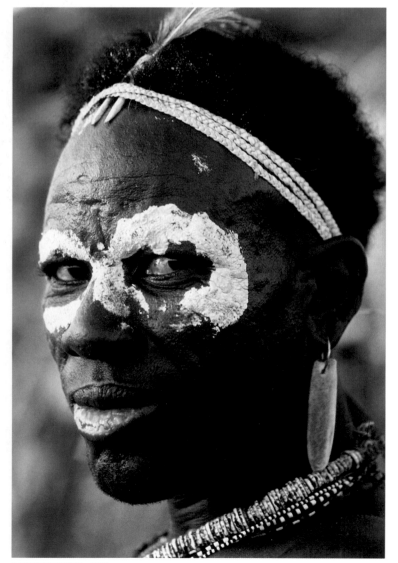

2 JEFFREY ROTMAN 1984

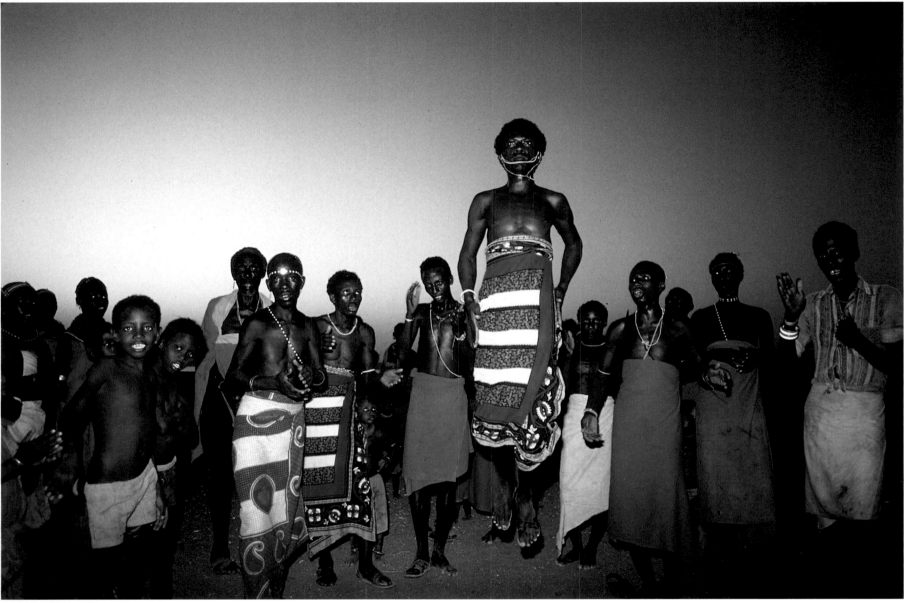

3 JEFFREY ROTMAN 1984

(3) The ceremony lasts for hours. Aside from its cultural significance, hunting up to four hippopotamus a year contributes substantially towards the food supplies of the El Molo.

(3) Die stundenlange Zeremonie. Neben der kulturellen Bedeutung dient die Jagd von bis zu vier Flußpferden im Jahr auch der wichtigen Ergänzung des Speiseplans der El Molo.

(3) La cérémonie dure plusieurs heures. Outre leur signification culturelle, les quatre hippopotames tués en moyenne chaque année apportent un complément important à l'alimentation des El Molo.

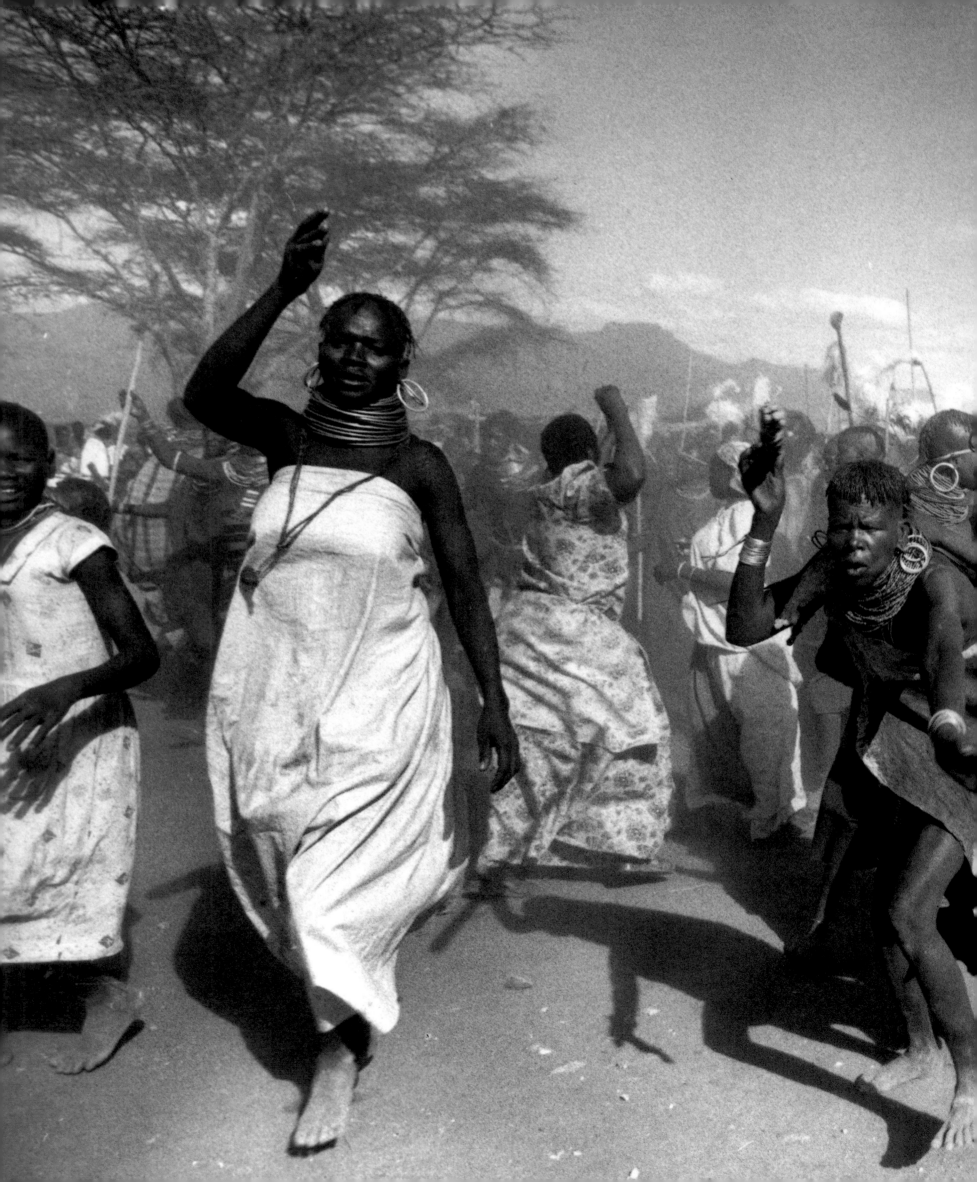

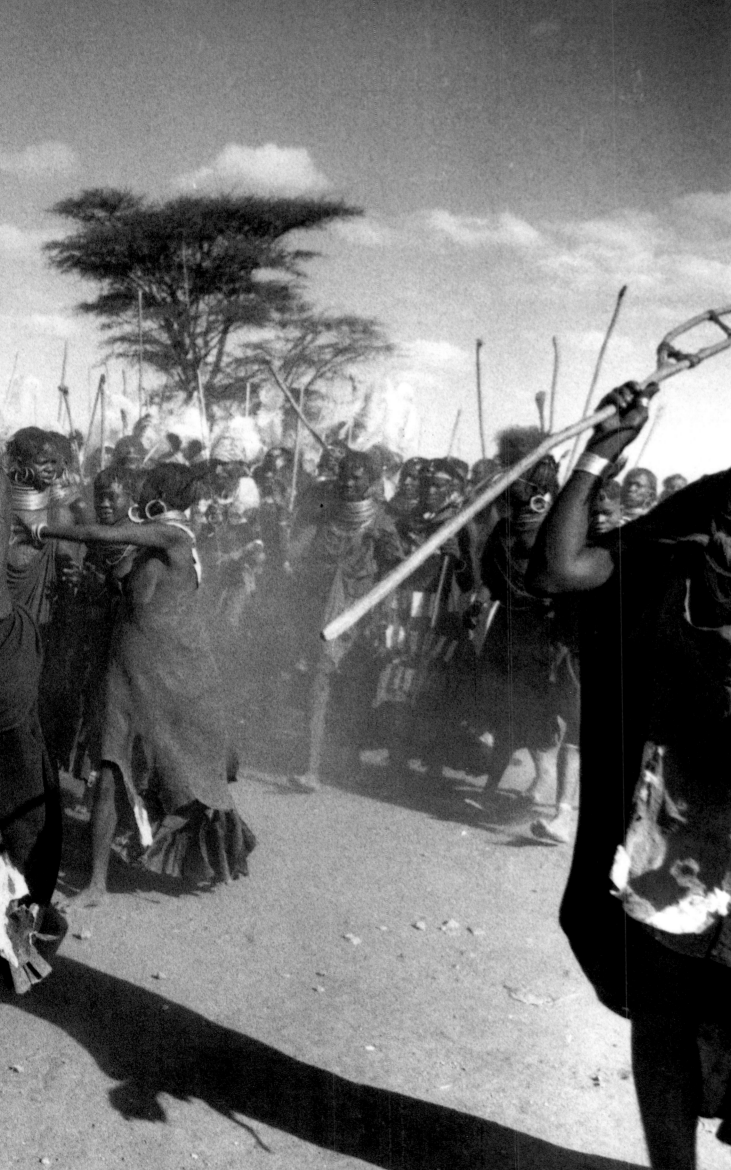

THE KARAMOJONG OF UGANDA

Market in Karamoja, the North-eastern province of Uganda. The pastoral people of the Karimojong who live mainly in this region are ethnically related to the peoples of the eastern Upper Nile. A procession of young girls is led by a priest (in the background with white headgear). For the Karamojong tribes, which consist of several widely distributed and interrelated groups, the meeting at the market provides an opportunity for their ritual dances and ceremonies.

DIE KARAMOJONG IN UGANDA

Markt in Karamoja, der nord-östlichen Provinz Ugandas. Das Hirtenvolk der Karamojong gehört zu der ethnischen Gruppe der Ost-Niloten und siedelt bevorzugt in dieser Region. Die Prozession der jungen Mädchen wird von einem Priester geleitet (im Hintergrund mit weißem Kopfschmuck). Die Karamojong-Stämme, die sich aus mehreren und weitverstreuten Verwandtschaftsgruppen zusammensetzen, nutzen das Treffen auf dem Markt auch für ihre rituellen Tänze und Zeremonien.

LES KARAMOJONG EN OUGANDA

Marché à Karamoja, la province du nord-est de l'Ouganda. Le peuple de bergers Karamojong appartient au groupe ethnique des Nilotes de l'Est et vit princi-palement dans cette région. La procession des jeunes filles est conduite par un prêtre (à l'arrière-plan, la tête parée). Les tribus Karamojong, composées de plusieurs groupes familiaux disséminés, profitent du lieu de rencontre qu'offre le marché pour y accomplir leurs danses et leurs cérémonies rituelles.

IVAN MASSAR
UNDATED/O.D./S.D.

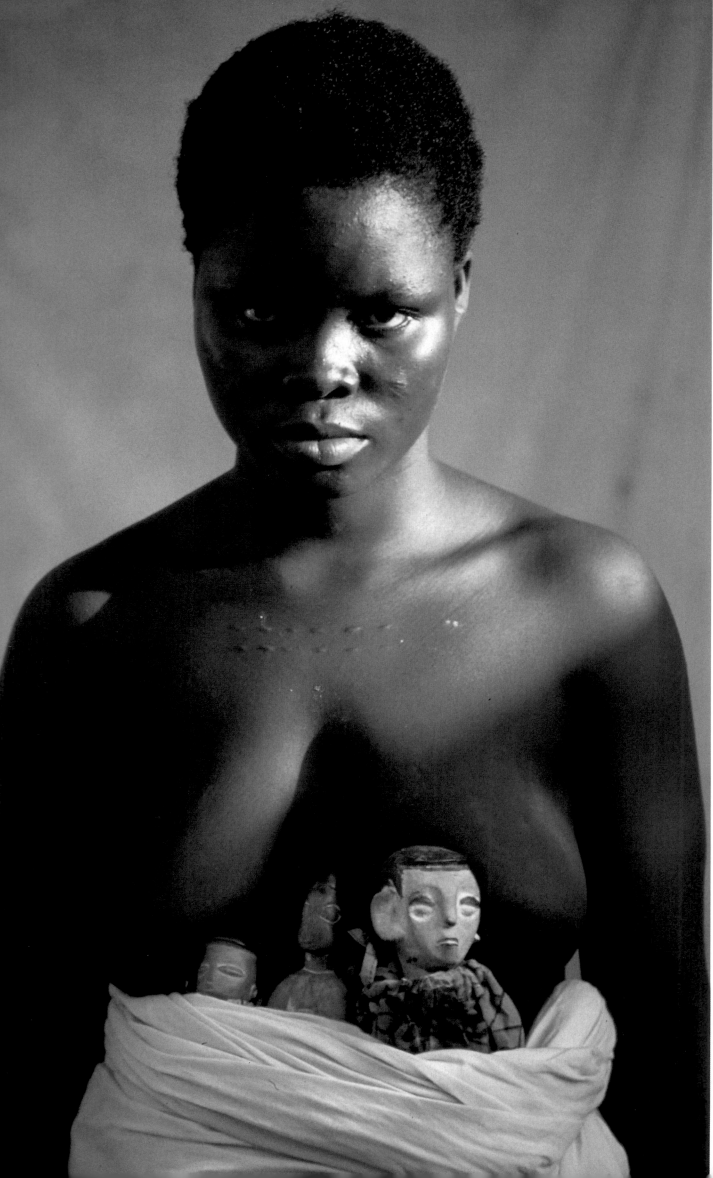

Voodoo's spiritual cosmos is dominated by the ancestors and countless individual gods. (1) A Mami-Wata initiate with figures of twins and another ancestral figure, all of which symbolize the dead. (2) A parade of the priestesses and initiates to the Mami Wata ceremony in Hountohoué. Voodoo ceremonies are always cultural highlights although their main function is to protect communities from evil spirits.

Im spirituellen Kosmos des Voodoo herrschen die Ahnen und unzählige, voneinander unabhängige Götter. (1) Eine Mami-Wata-Adeptin mit Zwillingsfiguren und einer weiteren Ahnenfigur, die die Verstorbenen symbolisieren. (2) Aufmarsch der Priesterinnen und Adepten zur Mami-Wata-Zeremonie in Hountohoué. Voodoo-Zeremonien sind immer kulturelle Höhepunkte, ihre Hauptfunktion ist aber der Schutz der Gemeinschaften vor bösen Geistern.

La cosmologie vaudou est dominée par les ancêtres et par d'innombrables dieux indépendants les uns des autres. (1) Une adepte de Mami-Wata avec des figurines jumelles et une figurine d'ancêtre, représentant les morts. (2) Procession des prêtresses et des adeptes pour le rituel de Mami-Wata à Hountohoué. Les cérémonies vaudou sont toujours des moments culminants de l'expression culturelle, mais leur fonction principale est la protection des communautés contre les esprits malfaisants.

1
HENNING CHRISTOPH
1993

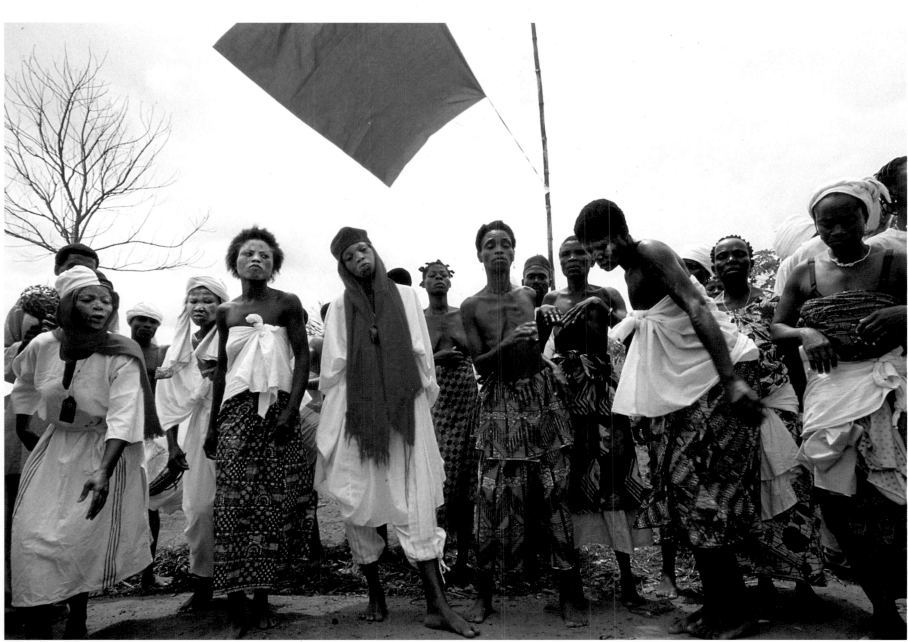

2 HENNING CHRISTOPH 1993

VOODOO –
SECRET POWER IN AFRICA

Henning Christoph has worked on the theme of voodoo for over five years. What began as a report for *Geo* about Benin in 1990, expanded to become an unprecedented documentation of what is really an animistic religion: "Voodoo is often not only misunderstood but is mainly identified with the Caribbean or Brazil. My intention was to show that the roots of this global religion with 60 million followers worldwide lies in Benin, the old Dahomey. I wanted to understand this mystery myself and contradict the prejudice that voodoo is mere hocus pocus." The photographic book "Voodoo – Secret Power in Africa," which appeared in 1995, conveys fundamental impressions of a religion whose power appears to be unlimited and which governs every aspect of the lives of West Africans.

VOODOC –
GEHEIME MACHT IN AFRIKA

Henning Christoph hat über fünf Jahre an dem Thema Voodoo gearbeitet. Was 1990 als *Geo*-Reportage über Benin begann, weitete sich zu einer beispiellosen Dokumentation dieser animistischen Religion aus: »Voodoo wird oft nicht nur mißverstanden, sondern meist mit der Karibik oder Brasilien identifiziert. Meine Intention war zu zeigen, daß die Wurzeln dieser Weltreligion mit weltweit 60 Millionen Anhängern im Benin, dem alten Dahomey, liegen. Ich selbst wollte dieses Mysterium verstehen und dem Vorurteil, daß Voodoo nur Hokus-Pokus sei, entgegenwirken.« Der 1995 erschienene Bildband »Voodoo – Geheime Macht in Afrika« vermittelt grundlegende Eindrücke einer Religion, deren Macht grenzenlos scheint und in alle Lebensbereiche der Westafrikaner hineinregiert.

LE VAUDOU – PUISSANCE
SECRETE EN AFRIQUE

Henning Christoph a travaillé pendant plus de cinq ans sur le thème du vaudou. Ce qui avait commencé en 1990 comme un reportage sur le Bénin a pris les proportions d'une documentation sans pareil sur cette religion animiste : « Non seulement le vaudou est souvent mal compris, mais il est de plus attribué aux Caraïbes ou au Brésil. Mon intention était de montrer que cette religion, qui compte 60 millions d'adeptes dans le monde entier, a ses racines au Bénin, l'ancien Dahomey. Moi-même, je voulais comprendre ce mystère et m'attaquer au préjugé qui apparente le vaudou à une simple manipulation. » Le livre illustré paru en 1995, « Le vaudou – puissance secrète en Afrique », offre une vision d'ensemble de cette religion, dont la puissance semble illimitée et qui régit tous les domaines de la vie des Africains de l'Ouest.

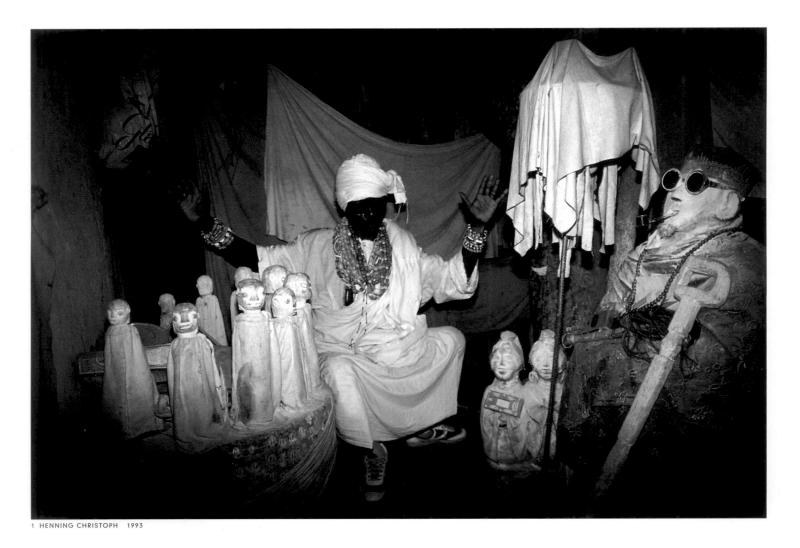

1 HENNING CHRISTOPH 1993

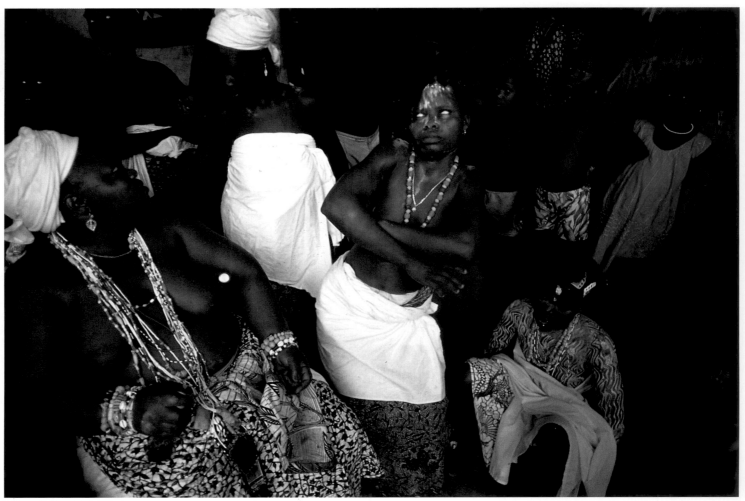

2 HENNING CHRISTOPH 1993

The Mami Wata ceremony in Hountohoué lasts for days.
(1) Djalé, the local priest, in his temple. He draws spiritual
strength from the fetishes of the ancestors (left) and his
personal god (right). Priests are generally judged according
to their spiritual achievements and can be defrocked by
vote. (3) A healing ceremony. Many priests are also natural
healers. This patient who was suffering from panic attacks as
a result of a conflict with his neighbor was symbolically freed
of his burden after treatment which lasted for weeks.
(2) Mami Wata initiate in a trance. The trance is the highest
form of communication with the gods. The individual
becomes a medium of divine power, or indeed the body of
the god itself.

Die Mami-Wata-Zeremonie in Hountohoué dauert Tage.
(1) Djalé, der Priester des Ortes, in seinem Tempel. Er tankt
spirituelle Kraft bei den Fetischen der Ahnen (links) und
seinem persönlichen Gott (rechts). Priester werden generell
nach ihren spirituellen Leistungen beurteilt und sind abwähl-
bar. (3) Eine Heilungszeremonie. Viele Priester sind auch
Naturheiler. Dieser Patient, der unter Angstzuständen infolge
eines Konfliktes mit seinem Nachbarn litt, wurde nach
wochenlanger Behandlung symbolisch von seiner Last
befreit. (2) Mami-Wata-Adeptin in Trance. Die Trance ist die
höchste Form der Kommunikation mit den Göttern. Der
Einzelne wird zum Medium göttlicher Kraft, zum Körper des
Gottes.

Le rituel de Mami-Wata, à Hountohoué, dure plusieurs jours.
(1) Le prêtre du village, Djalé, dans son temple. Il puise de la
force spirituelle chez les ancêtres (à gauche) et auprès de
son dieu personnel (à droite). Les prêtres sont généralement
jugés sur leurs performances spirituelles et peuvent être
destitués par vote. (3) Une cérémonie de guérison. Les
prêtres remplissent souvent des fonctions thérapeutiques. Ce
patient, qui souffrait d'anxiété à la suite d'un conflit avec son
voisin, a été libéré du poids qui l'oppressait par un traite-
ment de plusieurs semaines. (2) Une adepte de Mami-Wata
en transe. La transe est la forme supérieure de communica-
tion avec les dieux. L'individu devient un médium de la
puissance divine, une incarnation du dieu.

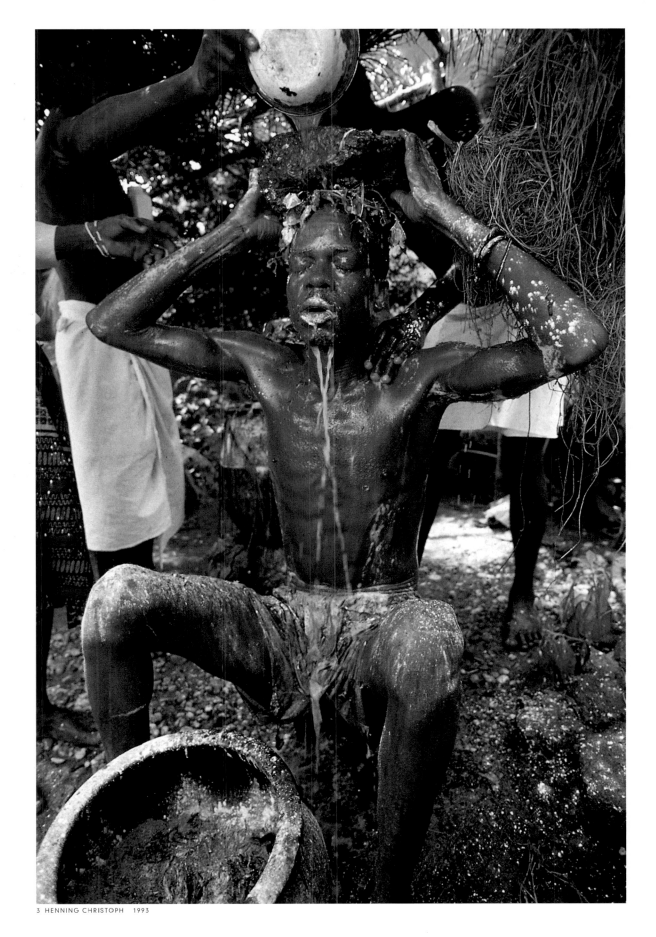

3 HENNING CHRISTOPH 1993

African slaves who were transported to America had only one certainty far from home – their belief in voodoo. Even in Catholic Brazil this belief has left clear traces. Over 15 million Brazilians from all levels of society adhere today to the syncretic religion of Macumba, also known as Candomblé, which consists of both Christian and African elements.
(1) Initiation of a boy in a cult building in Rio. After being isolated for weeks the initiate are accepted into the community.
(2) Priestesses in the cult building in Rio. The congregations are mainly led by women who select their personal gods from the pantheon of Macumba.

Die nach Amerika verschleppten afrikanischen Sklaven hatten nur eine Sicherheit in der Fremde – ihren Glauben Voodoo. Auch im katholischen Brasilien hat diese Tatsache deutliche Spuren hinterlassen. Über 15 Millionen Brasilianer jeglicher Schichten sind heute Anhänger der synkretistischen Religion Macumba oder auch Candomblé genannt, die sich aus christlichen und afrikanischen Elementen zusammensetzt.
(1) Initiation eines Jungen in einem Kulthaus in Rio. Nach einer wochenlangen Isolation werden die Erwählten in die Gemeinschaft aufgenommen.
(2) Priesterinnen im Kulthaus in Rio. Meist Frauen stehen den Gemeinden vor, die sich ihre persönlichen Götter aus dem Pantheon des Macumba erwählen.

Les esclaves emmenés en Amérique n'avaient pour soutien que leur religion, le vaudou. Le catholicisme brésilien a gardé des traces significatives de cet état de fait. Plus de 15 millions de Brésiliens issus de toutes les classes sociales sont aujourd'hui des fidèles de la religion syncrétique, le macumba, appelée aussi candomblé, composée d'éléments chrétiens et africains.
(1) Initiation d'un garçon dans une maison du culte à Rio. Au terme d'un isolement de plusieurs semaines, les élus sont admis dans la communauté.
(2) Prêtresses de la maison du culte de Rio. La plupart du temps, les communautés sont dirigées par des femmes qui choisissent leurs dieux personnels au sein du panthéon macumba.

1
CLAUS MEYER
UNDATED/O.D./S.D.

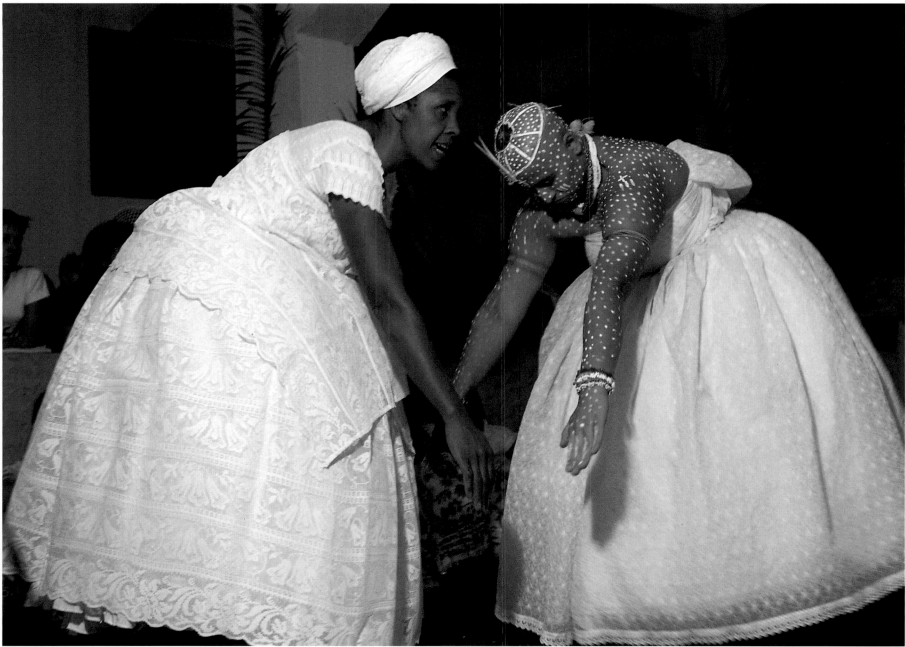

2 CLAUS MEYER UNDATED/O.D./S.D.

MACUMBA IN BRAZIL

Claus Meyer (b. 1944 in Düsseldorf, Germany, d. 1996) emigrated to New York in 1969 and worked for several years in the darkroom of a professional laboratory. He learned photojournalism through daily contact with photographic images and put his new knowledge to use in his leisure time. It was during this time that he came into contact with Black Star. Far away from the media metropolis, Meyer decided to try his luck as a photographer in Rio de Janeiro, and in so doing he laid the foundations of a meteoric career. As a generalist he had no preferences for particular subjects, his theme was Latin America.

MACUMBA IN BRASILIEN

Claus Meyer (geb. 1944 in Düsseldorf, gest. 1996) emigrierte 1969 nach New York und arbeitete einige Jahre in der Dunkelkammer eines Profi-Labors. Er lernte Fotojournalismus durch den täglichen Umgang mit den Fotos und setzte sein neues Wissen in seiner Freizeit um. Aus dieser Zeit rührt auch sein Kontakt mit Black Star. Mit dem Entschluß, in Rio de Janeiro sein fotografisches Glück fernab der Medien-Metropolen zu versuchen, legte er den Grundstein für eine steile Karriere. Als Generalist hatte er keine Vorlieben für bestimmte Sujets, sein Thema war Lateinamerika.

MACUMBA AU BRÉSIL

Claus Meyer (né en 1944 à Düsseldorf, Allemagne, décédé en 1996) émigra en 1969 à New York et travailla pendant quelques années dans un laboratoire professionnel. Il apprit le photojournalisme au contact quotidien des images et fit ses premiers essais pendant ses loisirs. Ses relations avec Black Star datent de cette période. Ayant résolu d'aller tenter sa chance loin des grandes métropoles de média, à Rio de Janeiro, il posa là les premiers jalons d'une carrière fulgurante. Généraliste, il ne nourrissait pas de passion pour les reportages thématiques ; son sujet, c'était l'Amérique latine.

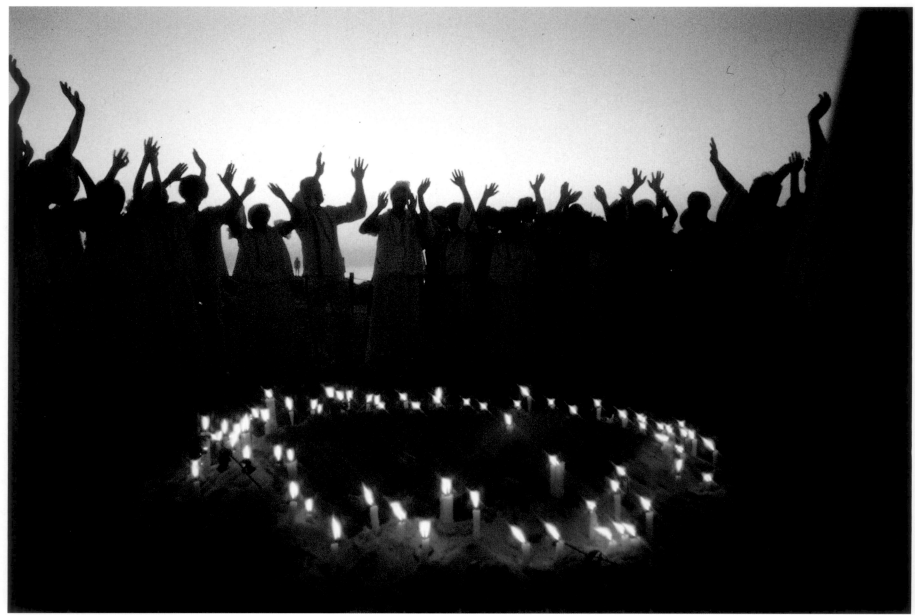

1 CLAUS MEYER UNDATED/O.D./S.D.

Year after year millions of Macumba followers gather on the beaches on New Year's Eve to receive the blessings of Iemanja, the goddess of the sea. (1) Midnight on the Copacabana. The Macumbeiros dance and sing around the Christian symbol of the cross. (2) A priestess falls into a trance. Shortly afterwards she will lead her initiates into the water in a ceremony of purification and sacrifice.

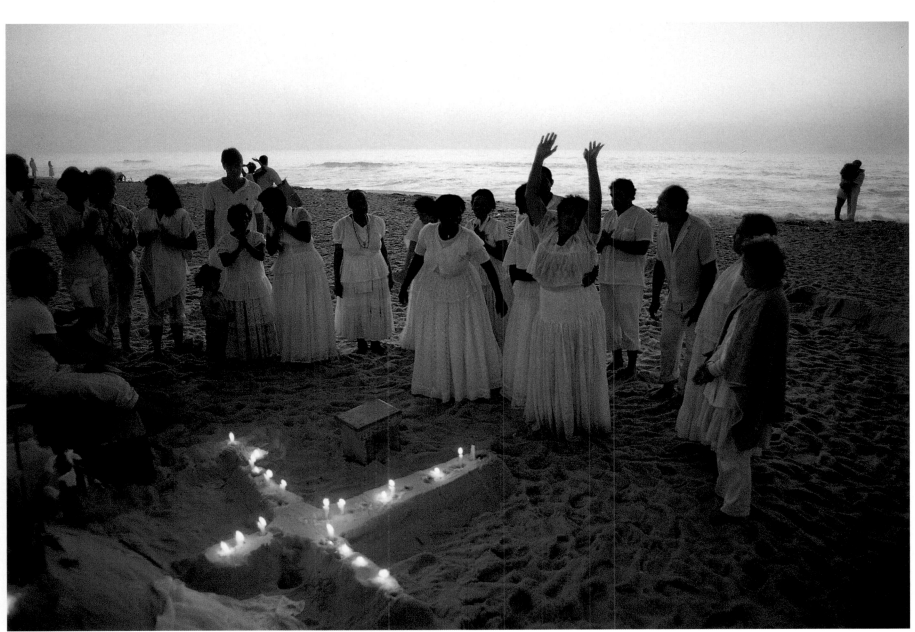

2 CLAUS MEYER UNDATED/O.D./S.D.

Jahr für Jahr versammeln sich zu Silvester Millionen Macumba-Anhänger an den Stränden, um die Segnungen Iemanjas, der Göttin des Meeres, zu empfangen. (1) Mitternacht an der Copacabana. Die Macumbeiros tanzen und singen um das christliche Kreuzsymbol herum. (2) Eine Priesterin fällt in Trance. Wenig später wird sie ihre Adepten zum Reinigungs- und Opferritual ins Wasser führen.

Chaque année à la Saint-Sylvestre, des millions de fidèles du macumba se rassemblent sur les plages pour recevoir la bénédiction de Iemanja, la déesse de la mer. (1) Minuit à Copacabana. Les macumbeiros dansent et chantent autour du symbole chrétien de la croix. (2) Une prêtresse entre en transe. Peu après, elle conduira les adeptes dans l'eau pour le rituel de purification et de sacrifice.

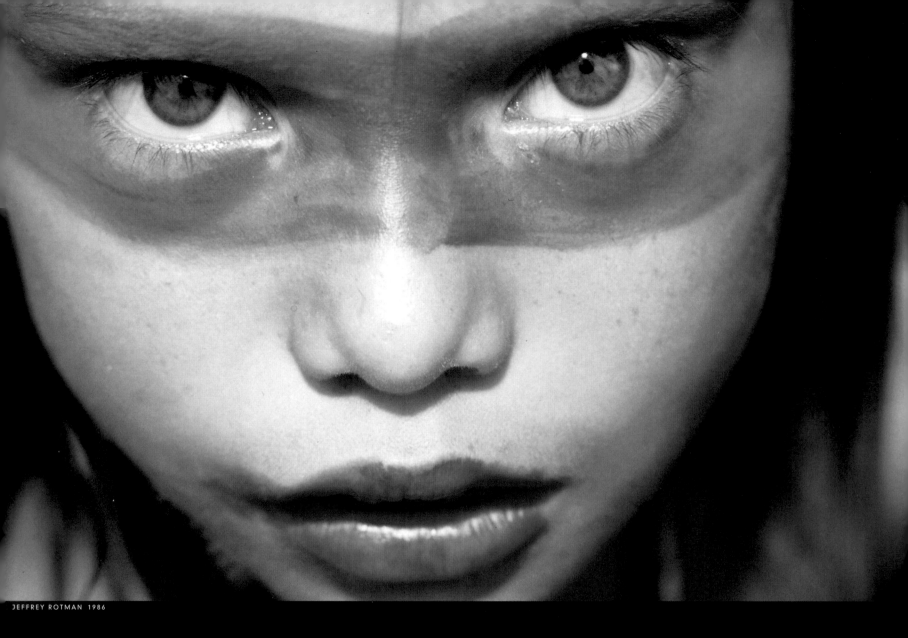

JEFFREY ROTMAN 1986

(1) With their facial painting the Matsé imitate the jaguar, the king of the animals in the rain forest. (2) Two hunters capture a sloth. Smaller animals such as monkeys were hunted with bow and arrow whilst traps were set for larger ones such as tapirs. To prepare themselves for the hunt, the Matsé took hallucinogenic drugs, which also served as medicines. (3) Plants which retain water guarantee survival a long way from the rivers.

(1) Die Matsé imitieren mit ihrer Gesichtsbemalung den König unter den Tieren des Regenwaldes – den Jaguar. (2) Zwei Jäger erbeuten ein Faultier. Kleinere Tiere wie Affen wurden mit Pfeil und Bogen gejagt, größeren wie Tapiren stellte man Fallen. Auf die Jagd stimmten sich die Matsé mit halluzinogenen Drogen ein, die auch als Medikament eingesetzt wurden. (3) Wasserspeichernde Pflanzen sichern das Überleben fern der Flüsse.

(1) Avec leurs peintures faciales, les Matsé imitent le roi des animaux de la forêt équatoriale, le jaguar. (2) Deux chasseurs capturent un paresseux. Les animaux les plus petits, comme les singes, étaient chassés à l'arc et aux flèches, tandis qu'on dressait des pièges aux plus grands par exemple les tapirs. Les Matsé se préparaient à la chasse au moyen de drogues hallucinogènes, également employées comme médicaments. (3) Les plantes aqueuses assurent la survie, même loin des cours d'eau.

THE MATSE IN PERU

Jeffrey Rotman photographed the Matsé Indians on an expedition led by ethnologist Peter Gorman in 1986. The Matsé were living in the extreme west of the Amazon Basin in the Peruvian rain forest as hunters and gatherers far away from civilization. Gorman's research which stretched over a period of eight years documents the decline of a tribe from the time it was first discovered. Rotman's photo-reportage shows a tribe which has died out.

DIE MATSE IN PERU

Jeffrey Rotman fotografierte 1986 auf einer Expedition des Ethnologen Peter Gorman die Matsé-Indianer, die im äußersten Westen des Amazonasbeckens als Jäger und Sammler fernab jeglicher Zivilisation im peruanischen Regenwald lebten. Gormans Arbeit über acht Jahre dokumentiert den Niedergang einer Kultur vom Zeitpunkt seiner ersten Entdeckung an. Rotmans Fotoreportage zeigt einen ausgestorbenen Stamm.

LES MATSE DU PEROU

C'est en 1986, lors d'une expédition de l'ethnologue Peter Gorman, que Jeffrey Rotman photographia les Indiens matsé, chasseurs et cueilleurs, vivant à l'extrême ouest du bassin amazonien, à l'écart de toute civilisation, dans la forêt équatoriale péruvienne. Les travaux de Gorman décrivaient sur huit ans le déclin d'une tribu depuis sa première découverte. Le reportage photo de Rotman montre une tribu qui a aujourd'hui disparu.

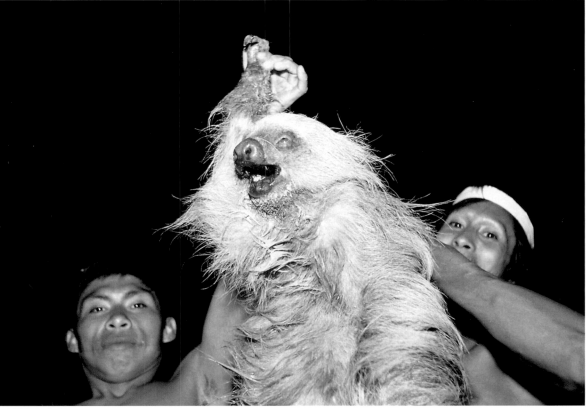

2 JEFFREY ROTMAN 1986

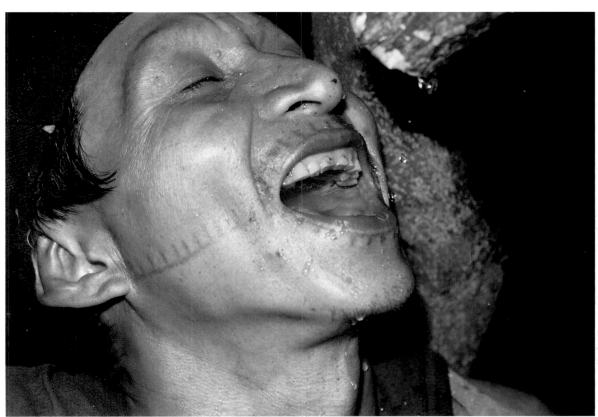

3 JEFFREY ROTMAN 1986

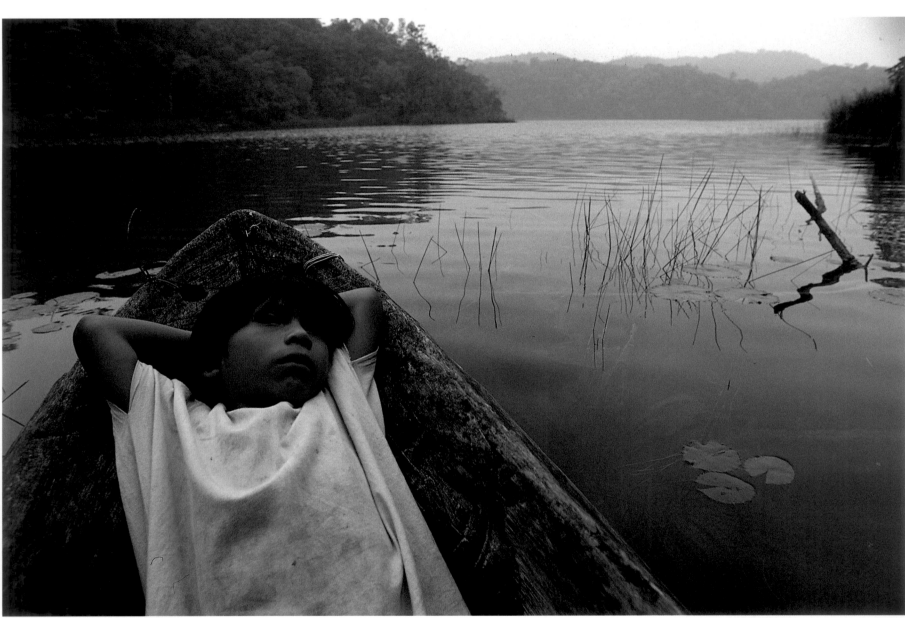

1 CINDY KARP 1991

THE LACANDON IN MEXICO

Cindy Karp (b. 1951 in Milwaukee) began her career as a photographer for UPI after studying journalism. She then worked for eight years as a contract photographer for *Time*. Karp's reports from Latin America and the Caribbean not only concentrate on current events but the fruits of her assignments also continually illuminate daily life in Central America: "The Lacandona rain forest, like its inhabitants, the Lacandon Maya Indians, is a testimony of survival. Both are reminders of the unity of man and nature. When I spent several weeks there in 1991, I knew that with every passing year, the tropical forest and the ancient culture it has protected were fast approaching their final destruction."

DIE LACANDON IN MEXIKO

Cindy Karp (geb. 1951 in Milwaukee) begann ihre Karriere nach dem Studium der Journalistik als Fotografin für UPI, danach arbeitete sie acht Jahre als Vertragsfotografin für *Time*. Karps Arbeiten aus Lateinamerika und der Karibik konzentrieren sich nicht nur auf die aktuellen Nachrichten, sondern ihre Reportageprojekte beleuchten auch immer wieder das tägliche Leben in Zentralamerika: »Der Lacandona-Regenwald ist, wie seine Bewohner, die Lacandon-Indianer, Zeugnis eines Überlebens. Beide sind Mahnmal der Einheit von Mensch und Natur. Als ich 1991 einige Wochen dort verbrachte, erkannte ich, daß der Regenwald und diese alte Kultur, die er geschützt hatte, mit jedem weiteren Jahr seiner endgültigen Zerstörung näher kam.«

LES LACANDON DU MEXIQUE

Après des études de journalisme, Cindy Karp (née en 1951 à Milwaukee) débute comme photographe pour UPI, puis travaille pendant huit ans sous contrat pour *Time*. Ses travaux sur l'Amérique latine et les Caraïbes ne se contentent pas d'apporter des informations d'actualité, mais ses séries de reportages mettent constamment en lumière la vie quotidienne en Amérique centrale : « La forêt équatoriale de Lacandona et ses habitants, les Indiens mayas lacandon, témoignent d'une survie et nous rappellent l'unité de l'homme et de la nature. En 1991, j'ai séjourné là-bas plusieurs semaines, et j'ai compris que chaque année qui passait rapprochait la forêt tropicale et la civilisation ancienne qu'elle avait abritée de leur destruction finale. »

(1) A Lacandon boy on Lake Naja. The unequaled heyday of the Maya civilization was in the era around 300 AD. Six centuries later this great civilization was already in decline and the Spanish conquistador finished it off in the 16th century. At the end of the 20th century, the Lacandon are one of only a few remaining Mayan tribes that have been able to preserve their old traditions and beliefs within the shelter of the rainforests. The area around Lake Naja in the Chiapas province of southern Mexico bordering Guatemala is one of three reserves which were established in the 1960s. (3) The clearing of land for agricultural purposes, road construction and oil extraction in nearby areas all threaten the natural habitat of the Lacandon in the Naja region. Pollution also endangers self-sufficient farming in the reserve. (2) It is the 104-year-old shaman Chan K'in Viejo alone who ensures that the traditional religion and culture are handed down to the young. However, the spiritual powers of this gray-haired shaman are dwindling along with the dying forest in this region.

(1) Lacandon-Junge am See Naja. 300 n. Chr. setzte in Mittelamerika eine beispiellose Blüte der Zivilisation der Maya ein, die sechs Jahrhunderte später ihren Zenit bereits überschritten hatte. Die spanischen Eroberer im 16. Jahrhundert zerstörten nur noch Überreste der einstigen Hochkultur. Die Lacandon sind Ende des 20. Jahrhunderts eine der letzten Maya-Ethnien, die im Schutz der Regenwälder alte Traditionen und ihren Glauben bewahren konnten. Das Gebiet um den See Naja in Süd-Mexiko ist eines von drei Reservaten, die seit Ende der 1960er Jahre bestehen. (3) Rodung, Straßenbau und die nahe Ölförderung bedrohten den natürlichen Lebensraum der Lacandon im Naja-Gebiet. Zudem gefährdete die Umweltverschmutzung den autarken Ackerbau im Reservat. (2) Nur Chan K'in Viejo, ein 104 Jahre alter Schamane, garantierte noch die Überlieferung des Glaubens und der Traditionen. Die spirituellen Kräfte des greisen Schamanen schwanden jedoch mit der zunehmenden Zerstörung des Waldes in dieser Region.

(1) Jeune Lacandon sur le lac Naja. En 300 après J.C., les Mayas entrèrent dans leur âge d'or. Six siècles plus tard, cette grande civilisation était déjà sur son déclin. Au 16e siècle, les conquérants espagnols achevèrent de la détruire. A la fin du 20e siècle, les Lacandon sont l'un des derniers peuples mayas ayant conservé les anciennes coutumes et la religion traditionnelle, protégés par la forêt équatoriale. La région qui entoure le lac Naja, au sud du Mexique, est l'une des trois réserves qui subsistent depuis la fin des années 60. (3) La déforestation, la construction des routes et les proches exploitations pétrolières menacent l'environnement des Lacandon de la région du Naja. En outre, la pollution menace l'autarcie de la réserve, basée sur l'agriculture. (2) Seul, Chan K'in Viejo, un chaman âgé de 104 ans, assure encore la transmission des traditions et de la religion, mais la puissance spirituelle du vieux chaman faiblit en proportion de la destruction croissante de la forêt dans cette région.

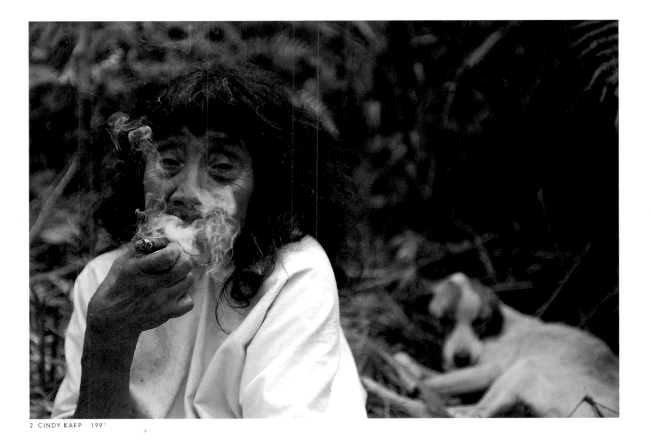

2 CINDY KARP 199·

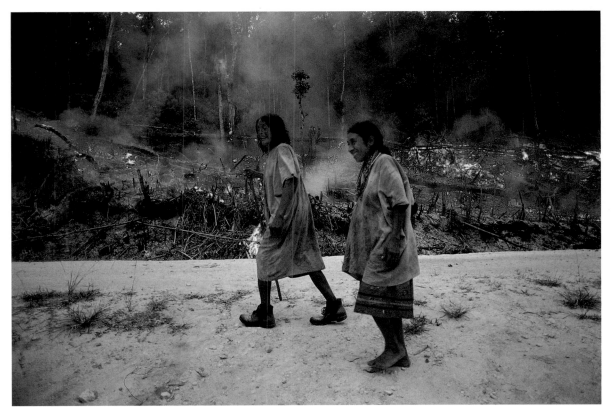

3 CINDY KARP 1991

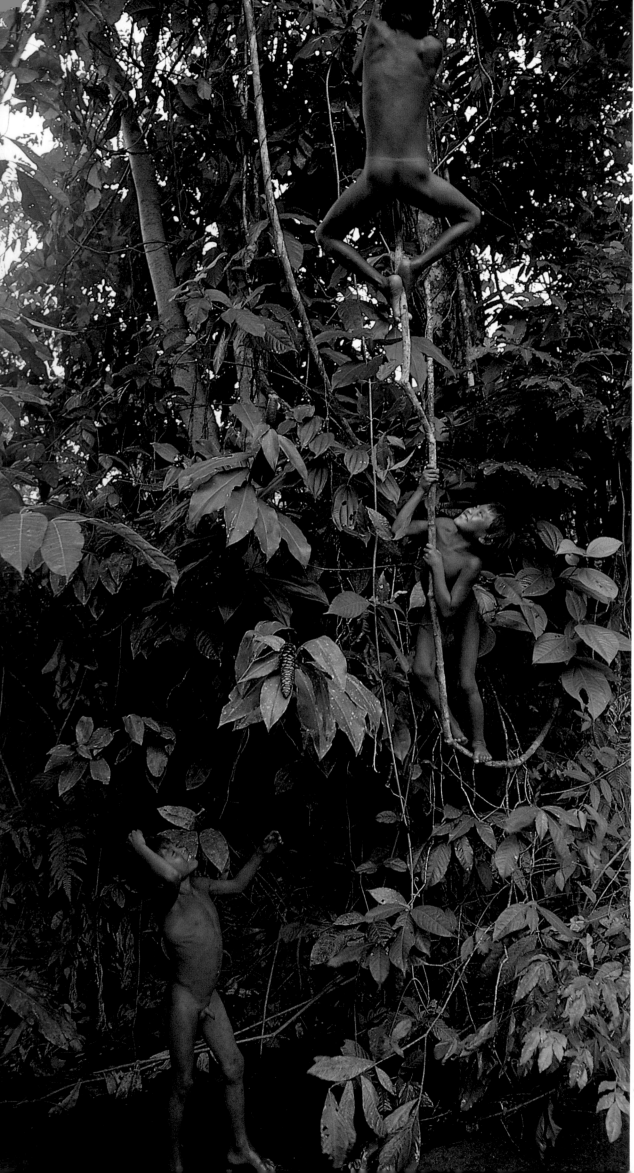

1
CLAUS MEYER
1990

THE YANOMAMI IN BRAZIL

Claus Meyer was entirely at home in the Amazonian rain forests for almost 30 years. A few months before his death in 1996 he wrote: "My discoveries of indigenous tribes through the camera, as with the Yanomami, have at the same time something very painful about them – I also know that my pictures will soon be history. An unusually sustained aggression on the part of missionaries, prospectors for gold, the mining and timber industries are in conflict with the tentative efforts of the authorities to protect the Indians." The treatment of ethnic minorities was extremely controversial in Brazil, and it led to a number of measures being taken by the authorities. One of these was the introduction of a ban in 1990 on the taking of photographs of the Yanomami, who numbered about 15,000. Nevertheless Meyer ignored this ban.

DIE YANOMAMI IN BRASILIEN

Claus Meyer war fast 30 Jahre in den Regenwäldern des Amazonas wie zu Hause. Wenige Monate vor seinem Tod 1996 schrieb er: »Meine Entdeckungen indigener Stämme mit der Kamera wie bei den Yanomami haben zugleich etwas sehr Schmerzvolles – ich weiß zugleich, daß meine Bilder schon bald Geschichte sein werden. Den zaghaften behördlichen Schutzbemühungen für die Indianer steht eine unverhältnismäßig konstante Aggression durch Missionare, Goldgräber, Minen- und Holzindustrie entgegen.« Die Behandlung ethnischer Minoritäten war in Brasilien äußerst umstritten, was u.a. 1990 zum Fotografierverbot der ca. 15 000 Yanomami führte – worüber Meyer sich allerdings hinwegsetzte.

LES YANOMAMI AU BRESIL

Claus Meyer a vécu près de 30 ans dans les forêts équatoriales d'Amazonie comme s'il y était chez lui. Quelques mois avant sa mort, en 1996, il écrivait : « Mes découvertes des tribus indigènes par l'objectif de l'appareil photo, comme avec les Yanomami, ont en même temps quelque chose de très douloureux – je sais que mes images appartiendront bientôt à l'histoire. Aux efforts timides de protection des Indiens par les autorités s'oppose une agression incommensurable, constante, par les missionnaires, les chercheurs d'or, l'industrie minière et celle du bois. » Le traitement des minorités ethniques au Brésil était très controversé, ce qui conduisit en 1990 à l'interdiction de photographier les quelque 15 000 Yanomami – ce dont se moquait bien Meyer.

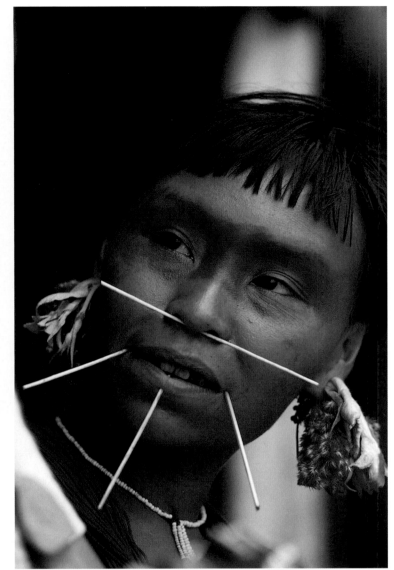

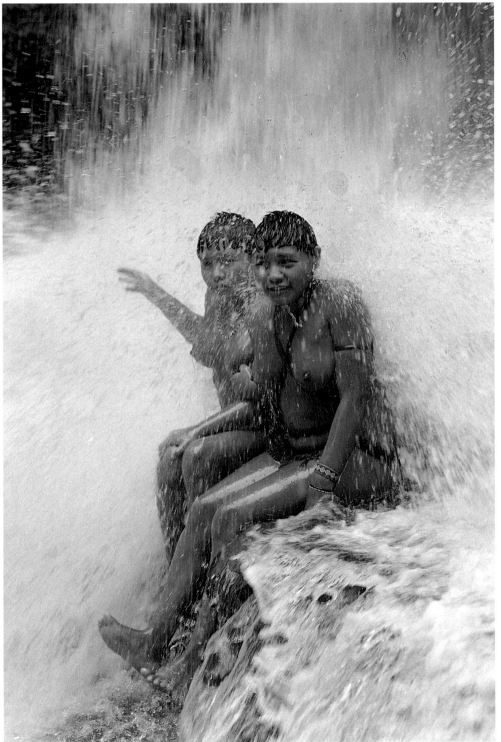

(1) A Yanomami village of a 79-member-tribe in Demini, to the South of Boa Vista. Their round villages, the shapono, lie widely scattered over about 40,000 square miles of mountain jungle in Brazil and Venezuela. (2) The warriors and hunters of the tribe were also reputed to be skilled in the art of healing. Tribal healing was, however, impotent in the face of the new diseases which were introduced into the region by people searching for gold. (3) Basically a woodland culture, the Yanomami kept away from the large rivers.

(1) Yanomami-Siedlung einer Gemeinschaft von 79 Mitgliederr in Demini, im Süden Boa Vistas. Ihre Runddörfer, die shapono, liegen weit verstreut über ca. 100 000 km² des brasilianisch-venezolanischen Bergurwaldes. (2) Die Krieger und Jäger hatten auch den Ruf gute Heilkundige zu sein. Die Naturmedizin versagte jedoch vor den Krankheiten, die durch die Goldsucher in die Region eingeschleppt wurden. (3) Die Yanomami mit ihrer Waldlandkultur hielten sich abseits der großen Flüsse.

(1) Village d'une tribu yanomami de 79 membres, à Demini, au sud de Boa Vista. Les villages arrondis, les shapono, sont dispersés sur les quelque 100 000 km² de la forêt vierge vénézuélo-brésilienne. (2) Les guerriers et les chasseurs de la tribu avaient également une réputation de guérisseurs. La médecine naturelle fut cependant impuissante, face aux maladies apportées dans la région par les chercheurs d'or. (3) Les Yanomami, avec leur culture forestière, se tenaient à l'écart des grands fleuves.

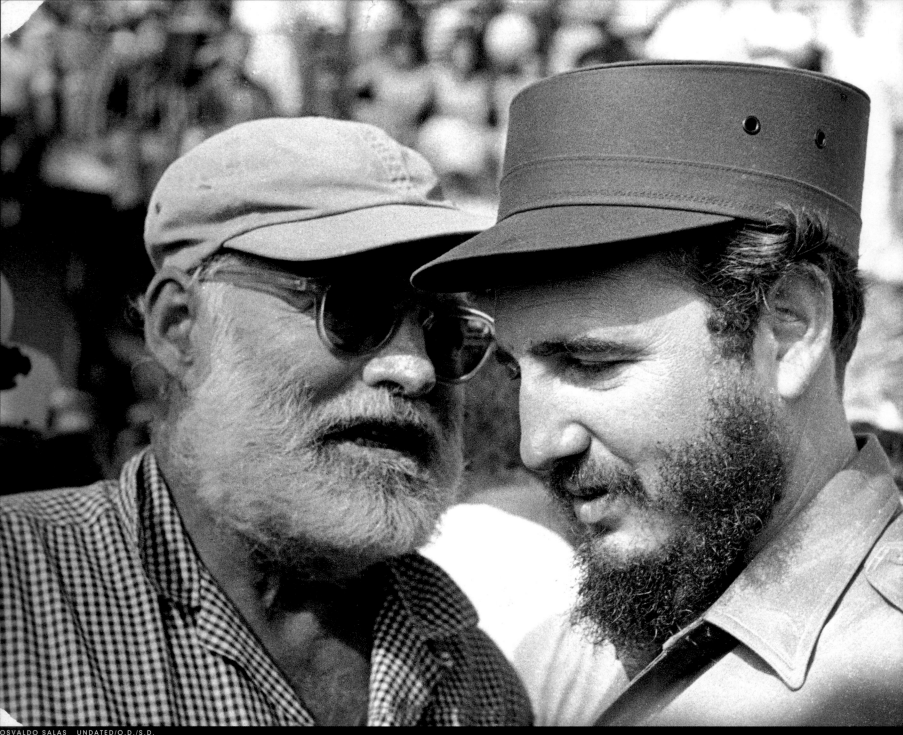

Snapshot and Symbol
Schnappschuß und Sinnbild
Portraits et instantanés

Ernest Hemingway (left) and Fidel Castro in Cuba.
Magazines like Life created an unprecedented
personality cult and liked to turn maverick personalities –
whether literary figure or guerrilla – into popstars.

Ernest Hemingway (links) und Fidel Castro auf Kuba. Ob
Literat oder Guerilla – Magazine wie Life kreierten einen
bisher unbekannten Persönlichkeitskult und kürten mit
Vorliebe exzentrische Persönlichkeiten zu Popstars.

Ernest Hemingway (à gauche) et Fidel Castro, à Cuba.
Des magazines comme Life furent les artisans d'un culte
de la personnalité d'un nouveau genre, traitant tout
personnage un peu original – fût-il littérateur ou guérillero
– à la manière d'une star de la musique pop.

Celebrities! The question as to which street in Liverpool played host to the Beatles' first musical attempts was not only a preoccupation for the teenagers of the 1960s. John Launois provided a photographic answer in a classic image of the working-class district on the Mersey (p. 294).

During the American election of 1992 the whole world asked who was this governor from Arkansas? P. F. Bentley created a photographic portrait of Bill Clinton behind the scenes of the election campaign and received a World Press Award (p. 248/249).

The personality cult in the 20th century media is based on the pronounced individualism of the bourgeois-capitalist society. The idea of bourgeois individualism stands in stark contrast to social reality which encloses the individual strongly in the broad mass by means of economic and social disciplining. "In such a society the positive hero must carry to an almost excessive extent the desire for independence and the dreams of power which the ordinary citizen cherishes but cannot satisfy," is Umberto Eco's formulation of this problem.

Photographers such as the Englishwoman Julia Margaret Cameron and the American Edward Steichen developed portrait photography into a high art with their studio photographs at the turn of the century. They concentrated on the guiding intellectual figures, the powerful and beautiful of the time in carefully constructed pictures which were lit in a dramatic fashion and created symbols which outgrew the individuals portrayed. After the First World War these images found their photographic home in magazines such as *Vanity Fair* and *Vogue.*

Photojournalism extended the range of what could be expressed in photographs in the 1930s. *Life* functioned as the "Showbook of the world" and became an important stage for the heroes of the time. Black Star established the relationship between the magazine and the emigrant Philippe Halsman, who nonetheless soon left the agency again and became one of the best cover photographers for *Life.* His journalistic realism chipped away at the public mask of celebrities and attempted to reveal unknown facets of these people in a way that was

Celebrities! Die Frage, in welcher Straße Liverpools die Beatles ihre ersten musikalischen Versuche wagten, beschäftigte nicht nur die Teenager der 60er Jahre. John Launois gab eine fotografische Anwort in einem klassischen Sinnbild des Arbeiterviertels am Mersey River (S. 294).

Im amerikanischen Wahlkampf 1992 fragte sich alle Welt, wer ist dieser Gouverneur aus Arkansas? P. F. Bentley zeichnete ein fotografisches Porträt von Bill Clinton hinter den Kulissen des Wahlkampfs und wurde mit einem World Press Award preisgekrönt (S. 248/249).

Der Persönlichkeitskult in den Medien des 20. Jahrhunderts liegt im ausgeprägten Individualismus der bürgerlich-kapitalistischen Gesellschaften begründet. Die Idee des bürgerlichen Individualismus steht im krassen Widerspruch zur sozialen Wirklichkeit, die das Individuum in der breiten Masse durch ökonomische und soziale Disziplinierung stark einschränkt. »In einer solchen Gesellschaft muß der positive Held die Selbständigkeitswünsche und Machtträume, die der einfache Bürger hegt, aber nicht befriedigen kann, geradezu exzessiv auf sich versammeln«, formuliert Umberto Eco.

Fotografen wie die Engländerin Julia Margaret Cameron und der Amerikaner Edward Steichen entwickelten die Porträtfotografie in ihren Studioaufnahmen um die Jahrhundertwende zur hohen Kunst. Sie widmeten sich in durchkomponierten Bildern und mit dramatisch inszeniertem Licht den Vordenkern, den Mächtigen und den Schönen der Zeit und schufen Sinnbilder, die über die Persönlichkeiten hinauswuchsen. Nach dem Ersten Weltkrieg fanden die Bilder eine fotografische Heimat in Magazinen wie *Vanity Fair* und *Vogue.*

Der Fotojournalismus erweiterte in den 30er Jahren die fotografischen Ausdrucksmöglichkeiten. *Life* fungierte gemäß dem Motto »Showbook of the world« als eine wichtige Bühne für die Helden der Zeit. Black Star knüpfte die Beziehung zwischen dem Magazin und dem Emigranten Philippe Halsman, der jedoch die Agentur schnell wieder verließ und zu einem der besten Coverfotografen in *Life* avancierte. Sein

Les célébrités! La question de savoir dans quelle rue de Liverpool les Beatles effectuèrent leurs premières tentatives musicales ne préoccupait pas que les adolescents des années 1960. John Launois apporta une réponse photographique à cette question à travers un portrait symbolique des quartiers ouvriers situés le long de la Mersey (p. 294).

Lors de la campagne électorale américaine de 1992, le monde entier se demandait qui était vraiment ce candidat démocrate, le gouverneur de l'Arkansas. P. F. Bentley réalisa un portrait photographique de Bill Clinton dans les coulisses de la campagne et fut récompensé par un World Press Award (p. 248/249).

Le culte de la personnalité qui envahit les médias au 20ᵉ siècle est lié à l'individualisme marqué des sociétés capitalistes et bourgeoises. L'idée même de l'individualisme bourgeois est en totale contradiction avec la réalité sociale, qui contrôle étroitement l'individu au sein de la collectivité par des moyens de pression économiques et sociaux. « Dans une société de ce type, le héros positif rassemble sur lui de manière presque excessive les désirs d'autonomie et les rêves de pouvoir que le simple citoyen ressent sans pouvoir les actualiser », écrit Umberto Eco.

Au début du siècle, des photographes comme l'Anglaise Julia Margaret Cameron et l'Américain Edward Steichen ont fait du portrait en studio un art à part entière. Avec leurs images très composées et leurs éclairages contrastés, ils ont créé des portraits dont la valeur symbolique dépasse les personnalités – maîtres à penser, hommes de pouvoir et beautés – auxquelles ils se sont consacrés. Après la Première Guerre mondiale, ces images s'installèrent dans des magazines comme *Vanity Fair* ou *Vogue.*

Dans les années 1930, le photojournalisme élargit le champ des possibilités expressives. *Life,* qui fonctionnait selon le principe du « catalogue du monde », était l'une des scènes importantes pour les héros d'alors. Black Star mit *Life* en relation avec Philippe Halsman, récemment immigré, qui quitta rapidement l'agence pour devenir l'un des photographes vedettes du magazine. Son réalisme journalistique égratignait le masque public des célébrités. Il mettait en relief des

often playful – as with his well-known portrait of Dalí in 1948. If one considers the portrait work of other Black Star photographers alongside Halsman's studio work the real originality of this era becomes clear. The journalistic images arose in the workplace of the writer or in the actors' breaks during filming. "Environmental portraits" showed the celebrities in hitherto unknown surroundings and turned then into apparently authentic and human figures for the magazines' readership. Effective portrait sitting, wherever it takes place, requires proper preparation on the part of the photographer and leisure for the actual work. A process of communication is condensed into a symbol of a lifetime.

As well as the portraits there are the journalistic snapshots. W. Eugene Smith's picture of Orson Welles shortly before attending a film premiere shows the strain of the great Thespian clearly etched on his face (p. 279). An unknown photographer succeeded in capturing the love of life of one of the most famous post-war German politicians when he photographed a relaxed Adenauer playing boules, for once not displaying his otherwise customary doleful expression. Snapshots thrive on the element of surprise and the unusual poses tempt the observer into laughing spontaneously without compromising the subject.

Portraits of the quality of Christopher Morris' Gorbachev photograph taken in Moscow in 1989 often document contemporary history. The Fossilized Reformer of the Soviet Empire in the Midst of Cement captivates the observer by means of its composition and allows the formal structure to become a symbol of the time against the background of our knowledge of contemporary history – the initiator of perestroika at the end of his power and at the end of an era. It is these images, whether they be studio portraits, snapshots or a decisive moment in contemporary history, which stand out from the sea of faces which the media offer us today.

journalistischer Realismus kratzte an der öffentlichen Maske der Berühmtheiten und versuchte, unbekannte Facetten dieser Personen oftmals spielerisch – u. a. durch Sprünge wie in seinem bekannten Dalí-Porträt von 1948 – zu offenbaren. Betrachtet man neben Halsmans Studioinszenierungen die Porträtarbeiten anderer Black-Star-Fotografen, wird das wirklich Neue dieser Ära deutlich. Die journalistischen Bilder entstanden am Arbeitsplatz des Schriftstellers oder in der Drehpause der Schauspieler. »Environmental portraits« zeigten die Berühmtheiten in bisher unbekannter Umgebung und ließen sie für die Leser der Magazine zu scheinbar authentischen und menschlichen Persönlichkeiten wachsen. Die effektive Porträtsitzung, egal an welchem Ort, braucht gute Vorbereitung von Seiten des Fotografen und Muße für die eigentliche Arbeit. Ein Kommunikationsprozeß, verdichtet in einem Sinnbild von Lebensdauer.

Neben die Porträts treten die journalistischen Schnappschüsse. W. Eugene Smiths Bild von Orson Welles kurz vor dem Besuch der Filmpremiere zeigt die Anspannung des großen Mimen, die ihm förmlich ins Gesicht geschrieben steht (S. 279). Mit dem ausgelassenen Adenauer beim Boule-Spiel, der einmal nicht die sonst übliche Leichenbittermiene zur Schau stellte, gelang es einem unbekannten Fotografen, die Lebenslust eines der berühmtesten deutschen Nachkriegspolitiker einzufangen. Schnappschüsse leben vom Überraschungseffekt, und die ungewohnten Posen reizen den Betrachter spontan zum Lachen, ohne die Person zu kompromittieren.

Porträts in der Qualität von Christopher Morris' Gorbatschow-Aufnahme in Moskau 1989 schreiben oftmals Zeitgeschichte. »Der versteinerte Reformator des Sowjet-Reiches inmitten von Beton« besticht durch seine Komposition und läßt die formale Struktur vor dem Hintergrund unseres zeitgeschichtlichen Wissens zu einem Symbol der Zeit wachsen – der Initiator der Perestroika am Ende seiner Kraft und am Ende einer Ära. Diese Ansichten sind es, ob nun Studio-Porträt, Schnappschuß oder ein entscheidender Moment der Zeitgeschichte, die aus dem Meer von Gesichtern herausragen, das die Medien uns heute anbieten.

facettes inconnues de leur personnalité par des techniques comme celle du saut – illustrée par le célèbre portrait de Salvador Dalí qu'il fit en 1948. Si l'on regarde, à côté des travaux en studio de Halsman, les portraits d'autres photographes de Black Star, les véritables nouveautés apportées par cette époque deviennent évidentes. Les clichés journalistiques montraient les écrivains sur leur lieu de travail et les acteurs pendant les pauses des tournages. Ces portraits «environnementaux», qui montraient les célébrités dans des milieux jusqu'alors inconnus, en firent d'un seul coup aux yeux des lecteurs des magazines des personnalités en apparence humaines et authentiques. Quel que soit l'endroit où la prise de vue a lieu, la réalisation d'un véritable portrait réclame une préparation soigneuse de la part du photographe et beaucoup de temps au moment de la séance de pose. C'est la qualité de la communication qui permet d'inscrire un cliché dans la durée.

A côté des portraits, on assiste au développement des instantanés. Le cliché de W. Eugene Smith qui montre Orson Welles juste avant la première de l'un de ses films montre si bien la tension qui l'habite qu'elle est pratiquement écrite sur son visage (p. 279). Un photographe anonyme a réussi à remplacer l'habituel masque figé du chancelier Adenauer – figure politique dominante de l'Allemagne de l'après-guerre – par une expression de joie de vivre en le photographiant, détendu, pendant qu'il jouait aux boules. Les instantanés tirent leur substance de l'effet de surprise. Les poses, inhabituelles, invitent à rire, sans pour autant compromettre l'image de la personne photo-graphiée.

Lorsque la qualité des clichés atteint celle du portrait de Gorbatchev réalisé par Christopher Morris à Moscou en 1989, la photographie écrit pratiquement l'histoire. «Le réformateur pétrifié de l'empire soviétique entouré de béton» impressionne par sa composition et transforme les structures situées en avant de l'arrière-plan en un puissant symbole de l'époque. Face à l'initiateur de la perestroïka, à bout de forces, on ressent très bien la fin de toute une ère. Qu'il s'agisse de portraits en studio, d'instantanés ou de moments historiques, ce sont ces images émergeant d'un océan de visages que les médias nous offrent aujourd'hui.

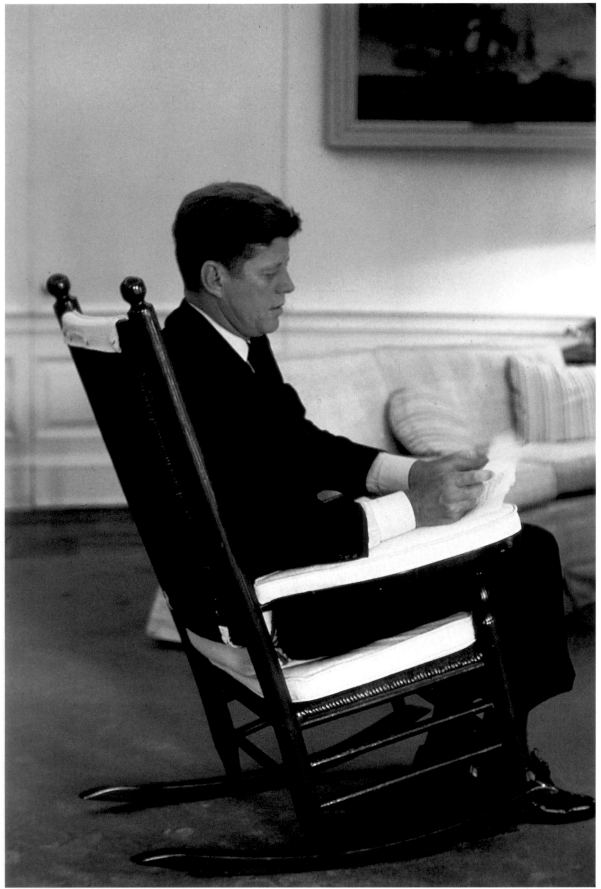

1 FRED WARD UNDATED/O.D./S.D.

Three portraits - three photographic viewpoints.
(1) Fred Ward staged this classic Kennedy portrait in the
White House. Today it still hangs in the entrance hall of the
agency in New York City. (3) This snapshot by Charles
Bonnay portrays the new First Lady, Jackie Kennedy, in her
full beauty and sovereignty at her husband's inauguration
ceremony in 1961. (2) Shortly after Kennedy's assassination,
even before the return flight from Dallas to Washington, his
vice-president, Lyndon B. Johnson, took the oath of office. On
his left is Kennedy's widow, Jackie – a historic moment is
poignantly captured in a photograph.

Drei Porträts – drei fotografische Sichtweisen. (1) Fred Ward
inszenierte dieses klassische Kennedy-Porträt im Weißen
Haus. Es hängt heute noch im Eingangsbereich der Agentur
in New York. (3) Dieser Schnappschuß von Charles Bonnay
zeigt die neue First Lady Jackie Kennedy in voller Schönheit
und Souveränität bei der Inauguration ihres Mannes 1961.
(2) Nach der Ermordung Kennedys wurde sein Vizepräsident
Lyndon B. Johnson noch vor dem Rückflug von Dallas nach
Washington vereidigt, zu seiner Linken die Witwe Jackie –
ein Porträt wird zu einem zeitgeschichtlichen Moment.

Trois portraits – trois regards. (1) Fred Ward a mis en scène
ce célèbre portrait de Kennedy à la Maison Blanche. Il figure
aujourd'hui encore dans l'entrée de l'agence, à New York.
(3) Cet instantané de Charles Bonnay montre la nouvelle
First Lady, Jackie Kennedy, dans toute sa beauté et sa
souveraineté, lors de l'investiture de son époux en 1961.
(2) Après L'assassinat de Kennedy, son vice-président,
Lyndon B. Johnson, prêta serment à Dallas avant même de
reprendre l'avion pour Washington. A sa gauche se tient
Jackie, la veuve de Kennedy. Un moment historique, saisi
par l'objectif du photographe.

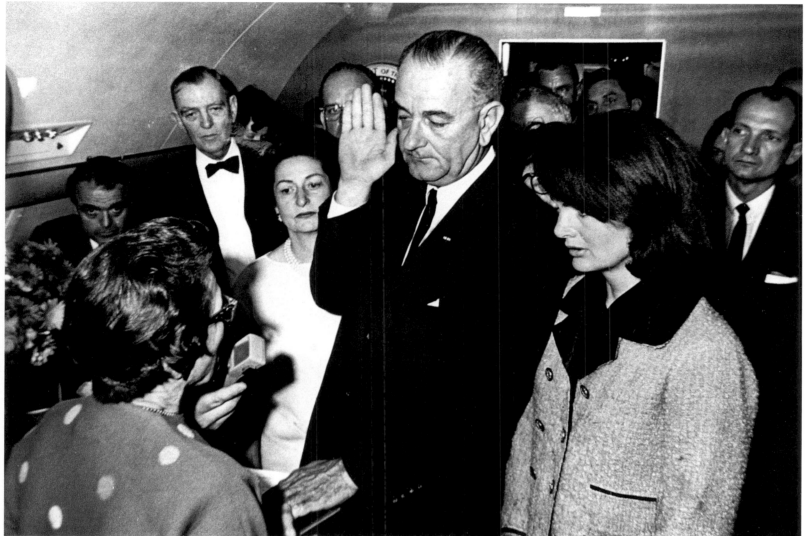

2 DAN McCOY 1963

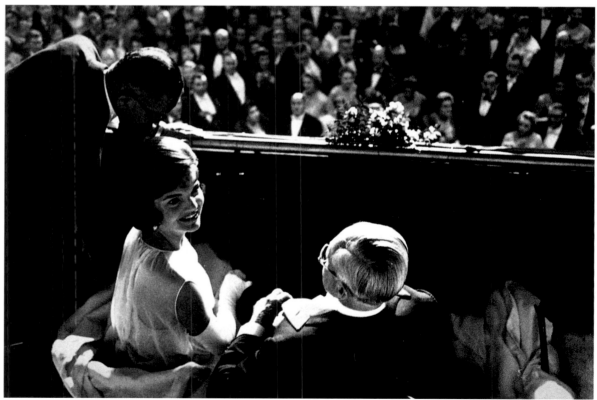

3 CHARLES BONNAY 1961

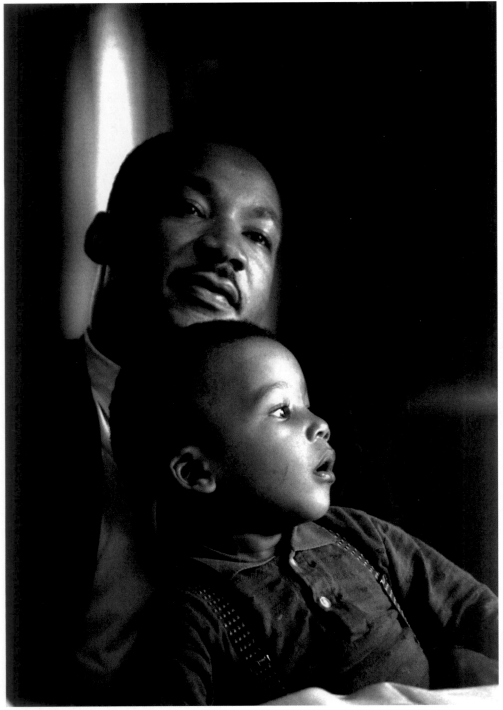

1 FLIP SCHULKE 1963

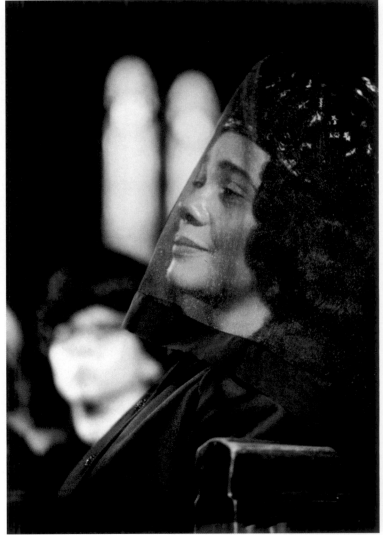

(1) King photographed in 1963 with his third son, Dexter, in his house in Atlanta. The civil rights campaigner had a very close relationship with his four children.
(2) Coretta Scott King at the funeral of her husband. Schulke was one of only three photographers allowed to attend the service. This photo was printed on the cover of the 19 May 1968 issue of Life.

(1) King mit seinem dritten Sohn Dexter in seinem Haus in Atlanta 1963. Der Bürgerrechtler hatte eine sehr enge Beziehung zu seinen vier Kindern. (2) Coretta Scott King bei der Beerdigung ihres Mannes. Schulke war einer von drei Fotografen, denen es erlaubt war, am Gottesdienst teilzunehmen. Life druckte dieses Bild auf dem Cover vom 19. Mai 1968.

(1) King avec son troisième fils Dexter dans sa maison d'Atlanta en 1963. Le défenseur des droits des citoyens était très proche de ses quatre enfants.
(2) Coretta Scott King à l'enterrement de son mari. Schulke fut l'un des trois photographes qui fut autorisé à assister au service religieux. Life reproduisit cette photo en couverture le 19 mai 1968.

2 FLIP SCHULKE 1968

A KING REMEMBERED

Flip Schulke (b. 1930 in New Ulm, Minnesota) studied sociology, politics and journalism. His first important subject was the black civil rights movement in the South of the USA. In the early 1950s he met Martin Luther King. Over the years Schulke developed a close and devoted friendship with King, unlike that of any other journalist. Both his books bear witness to this fact: "M.L.K. jr.: A Documentary – Montgomery to Memphis" (1976) and "A King Remembered" (1986).

IN MEMORIAM M.L.K.

Flip Schulke (geb. 1930 in New Ulm, Minnesota) studierte Soziologie, Politik und Journalismus. Sein erstes großes Thema wurde die schwarze Bürgerrechtsbewegung im Süden der USA. In den frühen 50er Jahren traf er Martin Luther King. Über die Jahre baute Schulke wie kein anderer Journalist eine vertrauensvolle Freundschaft zu King auf. Davon zeugen seine beiden Bücher »M.L.K. jr.: A Documentary – Montgomery to Memphis« (1976) und »A King Remembered« (1986).

« JE FAIS UN RÊVE »

Flip Schulke (né en 1930 à New Ulm, au Minnesota) étudia la sociologie, la politique et le journalisme. Son premier grand sujet fut le mouvement des droits civiques dans le Sud des Etats-Unis. Au début des années 50, il rencontra Martin Luther King et, au fil des ans, se lia d'amitié avec lui et gagna sa confiance comme aucun journaliste n'avait su le faire. Deux ouvrages en témoignent: «M.L.K. jr.: A Documentary – Montgomery to Memphis» (Documents – De Montgomery à Memphis, 1976) et «Je fais un rêve» (1986).

3 JOHN LAUNOIS 1964

4 JOHN LAUNOIS 1964

(4) Malcolm X grew up in a violent and criminal environment. During a long prison sentence he became politically active and converted to the Black Muslim faith. In the 1950s he popularized the previously obscure sect with his eloquence and agitating behavior. In contrast to the peaceful Civil Rights Movement in the American South, Malcolm X advocated the use of violence against the supremacy of the white race in America and propagated the race war. (3) Malcolm X in prayer at a mosque in Egypt in 1964. He had parted with the Black Muslims the previous year and founded his own religious organization. In 1965 he was assassinated.

(4) Malcolm X wuchs in einem gewalttätigen und kriminellen Milieu auf. Während einer langen Haftstrafe politisierte er sich und schloß sich den Black Muslims an. In den 50er Jahren machte er diese bis dahin unbedeutende Sekte durch seine Agitationskünste populär. Im Gegensatz zu der gewaltlosen Bürgerrechtsbewegung im Süden der USA predigte Malcom X Gewaltanwendung gegen die Vorherrschaft der weißen Rasse in Nordamerika und verkündete den Rassenkrieg. (3) Malcolm X beim Gebet in einer Moschee in Ägypten 1964. Im Jahr zuvor hatte er sich von den Black Muslims getrennt und eine eigene Organisation aufgebaut. 1965 fiel er einem Attentat zum Opfer.

(4) Malcolm X grandit dans la violence et la criminalité. C'est au cours d'une longue peine de prison que sa conscience politique se structura et qu'il rejoignit les Black Muslims. Dans les années 50, il fit connaître ce groupe, jusqu'alors peu significatif. Contrairement au mouvement non-violent des droits civiques, dans le Sud des Etats-Unis, Malcolm X prêchait la violence contre la suprématie blanche en Amérique du Nord et déclara la guerre raciale. (3) Malcolm X priant dans une mosquée en Egypte, en 1964. L'année d'avant, il avait quitté les Black Muslims pour créer sa propre organisation. En 1965, il fut victime d'un attentat.

1 EUGENE ANTHONY 1962

(1) As a leading Republican with vigorously anticommunist views, senator Richard Nixon was well-suited to become vice-president; and in 1953 he indeed became second-in-charge under Dwight D. "Ike" Eisenhower. After the Democrats' 1960 election victory, Nixon returned to his native California, where he took up his career as a lawyer again before returning to politics. In 1968, he was elected President of the USA.

(1) Als republikanischer Senator empfahl sich Richard Nixon durch seinen forschen Antikommunismus zum Vizepräsidenten; 1953 wurde er zweiter Mann hinter Dwight D. »Ike« Eisenhower. Nach dem Wahlsieg der Demokraten zog er sich zunächst nach Kalifornien zurück und übte wieder seinen Beruf als Rechtsanwalt aus, bevor er in die Politik zurückkehrte. 1968 wurde er zum Präsidenten der Vereinigten Staaten gewählt.

(1) Le sénateur républicain Richard Nixon obtint son siège de vice-président grâce à son anticommunisme résolu. En 1953, il devint le lieutenant de Dwight D. «Ike» Eisenhower. Après la victoire des démocrates, il rentra en Californie où il reprit son ancienne profession d'avocat avant de retourner à la politique. En 1968, il fut élu Président des Etats-Unis.

2 POOL PICTURE BY DENNIS BRACK 1978

(2) The historic embrace of two arch-enemies. Prime Minister Menachem Begin (center) and President Anwar As Sadat (left) laid the foundation for peace between Israel and Egypt at Camp David through the mediation of American President Jimmy Carter (right). Begin and Sadat shared the 1978 Nobel Peace Prize.

(2) Die historische Umarmung zweier Erzfeinde. In Camp David legten d e Präsidenten Menachem Begin (m.) und Anwar As Sadat (l.) unter Vermittlung des amerikanischen Präsidenten Jimmy Carter (r.) den Grundste n für den israelisch-ägyptischen Frieden, der 1979 geschlossen wurde. Begin und Sadat erhielten 1978 den Friedensnobelpreis.

(2) Accolade historique entre ennemis héréditaires. A Camp David, les deux présidents, Menahem Begin (au milieu) et Anouar el Sadate (à gauche) posèrent les bases de la paix israélo-égyptienne signée en 1979, avec la médiation du président américain Jimmy Carter (à droite). Begin et Sadate partagèrent le prix Nobel de la paix 1978.

1 P.F. BENTLEY 1992

(2) Bill Clinton, seen here in April during a saxophone jam with a High School band, was presented as the 46-year-old presidential candidate who loves rock'n'roll music. After 12 years of conservative Republican rule under Reagan and Bush, the New Democrat with his youthful image won over especially young voters and ethnic minorities of all ages. (1) In July, Clinton rejuvenates both body and voice in the sauna of a hotel in New York City before his appearance at the Democratic Convention. This Convention saw Clinton's inauguration as the party's presidential candidate. (3) In October, at the height of the presidential election campaign, everything is in full swing. Here Bentley's press colleagues join in the hustle and bustle. (Next double page) This photo of Bill and Hillary Clinton, which Rick Friedman took during the election campaign in New Hampshire in February 1992, was published across the world as "Billary's" victory photo.

(2) Im April. Bill Clinton, hier bei einer Saxophon-Jamsession mit einer High-School-Band, wurde mit seinen 46 Jahren als Rock'n'Roll-Präsidentschaftskandidat gefeiert. Der New Democrat mobilisierte nach 12 Jahren Reagan und Bush vor allem junge Wähler und ethnische Minoritäten jeden Alters für sich. (1) Im Juli. Clinton entspannt sich und seine Stimme in der Sauna eines Hotels in New York City, vor dem großen Auftritt auf der Democratic Convention – seiner Inthronisation als Kandidat. (3) Im Oktober. Die Wahlkampfmaschine läuft auf Hochtouren. Und Bentleys Kollegen spielen alle mit. (Nächste Doppelseite) Dieses Foto, das Rick Friedman während der Wahlkampagne in New Hampshire im Februar 1992 von Bill und Hillary Clinton machte, ging als »Billarys« Siegerbild um die ganze Welt.

(2) Avril. Bill Clinton improvise au saxophone avec un orchestre de lycéens : mise en situation d'un candidat revendiquant un rapport privilégié avec la jeunesse. Après 12 ans d'un conservatisme incarné par Reagan et Bush, ce nouveau démocrate mobilisa les voix des jeunes, mais aussi celles des minorités ethniques de tous âges. (1) Juillet. Moment de détente dans le sauna d'un hôtel new-yorkais, juste avant d'apparaître devant la convention des démocrates pour le rituel d'investiture du candidat par son parti. (3) Octobre. La machine électorale marche à plein régime. Les collègues de Bentley participent activement. (Double page suivante) Cette photo de Bill et Hillary Clinton, prise par Rick Friedman en février 1992 dans le New Hampshire, fut publiée un peu partout dans le monde comme « Billary ».

PORTRAIT OF VICTORY

P.F. Bentley, who studied in Hawaii, achieved fame through his intimate portraits of American politicians. In addition, he also covers international political events in Asia, Europe and Latin-America. He works mainly as a correspondent for *Time*, which commissioned him to accompany Bill Clinton for 11 months during the 1992 presidential election campaign. Critics always praise him for his extraordinary ability to achieve a personal closeness to leading figures without heroizing them. In 1993 his work appeared in a book with the title "Clinton: Portrait of Victory".

DER WEG ZUM SIEG

P.F. Bentley, der in Hawaii studierte, wurde vor allem durch seine intimen Porträts amerikanischer Politiker bekannt. Darüber hinaus dokumentiert er immer wieder Ereignisse der internationalen Politik in Asien, Europa und Lateinamerika. Vorwiegend arbeitet er als Korrespondent für *Time*. Das Magazin gab ihm auch den Auftrag, Bill Clinton elf Monate im Präsidentschaftswahlkampf 1992 zu begleiten. Das Lob der Kritiker hob immer wieder seine Fähigkeit hervor, persönliche Nähe zu Prominenten zu schaffen, ohne sie jedoch unkritisch zu heroisieren. 1993 erschien seine Arbeit auch als Buch mit dem Titel: »Clinton: Portrait of Victory«.

PORTRAIT OF VICTORY

P.F. Bentley, formé à Hawaï, s'est fait connaître surtout par ses portraits intimistes de politiciens américains. Il couvre aussi régulièrement les événements de politique internationale en Asie, Europe et Amérique Latine, travaillant le plus souvent pour le magazine *Time*, dont la rédaction lui confia en 1992 la mission de suivre la campagne électorale de Bill Clinton pendant 11 mois. Les photos de Bentley ont suscité l'admiration pour la proximité qu'elles créent avec les personnalités politiques, sans pour autant les héroïser ni abandonner tout sens critique. Ces photos furent réunies dans un livre publié en 1993 sous le titre : « Clinton : Portrait of Victory » (Clinton : Portrait d'une victoire).

2 P.F. BENTLEY 1992

3 P.F. BENTLEY 1992

RICK FRIEDMAN
1992

251

1 ERNEST MANEWNAL 1970

(1) Chilean President Salvador Allende photographed at a press conference in the year of his election, 1970. His main aim was to create a unique socialist system for Chile. This dream was shattered by the military coup of General Pinochet in 1973, during which Allende was murdered. (2) Together with his supporters in Panama City, the dictator Manuel Noriega celebrates the failure of a coup attempt in October 1989.

(1) Der chilenische Staatspräsident Salvador Allende bei einer Pressekonferenz im Jahr seiner Wahl 1970. Sein großes Ziel war ein eigener »chilenischer Weg zum Sozialismus«. Der Putsch General Pinochets im Jahr 1973 beendete diesen Traum – Allende wurde ermordet. (2) Der Diktator Manuel Noriega läßt sich nach dem gescheiterten Coup im Oktober 1989 von seinen Anhängern in Panama-Stadt feiern.

(1) Le président chilien Salvador Allende pendant une conférence de presse l'année de son élection, en 1970. Son objectif principal était de tracer « une voie chilienne vers le socialisme ». Le putsch du général Pinochet, en 1973, mit fin à ce rêve. Allende fut assassiné. (2) Le dictateur Manuel Noriega fêté par ses partisans à Panamá après le coup d'Etat manqué d'octobre 1989.

2 CHRISTOPHER MORRIS 1989

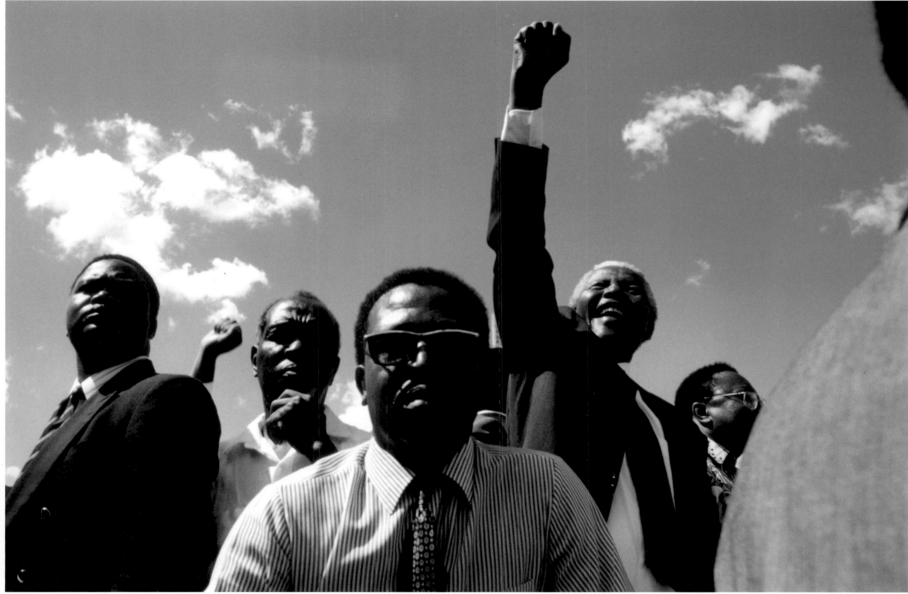

3 DAVID TURNLEY 1990

(3) After almost 28 years imprisonment Nelson Mandela was released from jail in 1990. Four years later he became South Africa's first freely-elected black president. Since his election he has pursued reconciliation between blacks and whites.

(3) Nach fast 28 Jahren wurde Nelson Mandela 1990 aus der Haft entlassen. Vier Jahre später wurde er Südafrikas erster frei gewählter schwarzer Präsident, dessen Politik seitdem für die Aussöhnung zwischen Schwarz und Weiß steht.

(3) Nelson Mandela fut libéré en 1990, après presque 28 ans de prison. Quatre ans plus tard, il devenait le premier président noir, librement élu pour sa politique de réconciliation entre Noirs et Blancs.

1 GERSHON MEYERS 1980

(1) Moshe Dayan – the name of Israel's most popular military leader is synonymous with the 1967 and 1973 wars in the Middle East. Serving as Foreign Minister from 1977 to 1979 he played a paramount role in the peace negotiations between Israel and Egypt. (2) Emperor Haile Selassie I was the last emperor of Ethiopia. After a 44-year reign he was deposed in a military coup. He died in 1975 while under house arrest. (3) Jawaharlal Nehru in 1962 after Indian troops were defeated by Chinese attacks in the north-east of the country. The first Prime Minister of independent India (since 1947) was caught off-guard by the Chinese aggression. His neutralist foreign policies were more directed towards breaking away from the West.

(1) Moshe Dayan – mit dem Namen von Israels populärstem Armeeführer verbindet man die Kriege im Nahen Osten 1967 und 1973. Als Außenminister in der Zeit von 1977–79 unterstützte er wesentlich die israelisch-ägyptischen Friedensbemühungen. (2) Haile Selassie I. war der letzte Kaiser von Äthiopien. Nach 44 Jahren Herrschaft wurde er vom Militär entmachtet und starb 1975 im Hausarrest. (3) Jawaharlal Nehru nach der Niederlage indischer Truppen gegen chinesische Angriffe im Nordosten des Landes 1962. Der erste Ministerpräsident des unabhängigen Indiens (seit 1947) wurde von der chinesischen Aggression überrascht, da sich seine Außenpolitik mittels Neutralität mehr auf die Loslösung vom Westen konzentrierte.

(1) Moshé Dayan : le nom du général le plus populaire d'Israël est associé aux guerres de 1967 et de 1973 au Proche-Orient. Ministre des Affaires étrangères de 1977 à 1979, son soutien fut essentiel pour les efforts en vue de la paix entre Israël et l'Egypte. (2) Haïlé Sélassié Ier fut le dernier empereur d'Ethiopie. Au bout de 44 ans de règne, il fut déposé par l'armée et mourut en résidence surveillée, en 1975. (3) Jawaharlal Nehru après la défaite des troupes indiennes contre les attaques chinoises dans le Nord-Est du pays, en 1962. Le premier chef du gouvernement de l'Inde indépendante (depuis 1947) se laissa surprendre par l'agression chinoise, sa politique extérieure étant davantage axée sur l'autonomisation par rapport à l'Occident.

2 JOHN MOSS UNDATED/O.D./S.D.

3 JOHN LAUNOIS 1962

1 WERNER WOLFF 1960

(2) Nikita Khrushchev, successor to Stalin, tried to give new momentum to the Communist Party of the Soviet Union. In 1956 at the 20th Party Congress of the CPSU, he introduced "coexistence" (a period of relaxed political relations with the West) as well as de-Stalinization. These political reforms were, however, short-lived. (1) During the 1960 UN General Assembly, Khrushchev, here with foreign minister Andrey Gromyko, gained notoriety for his unconventional behavior and verbal attacks. Foreign policy milestones during his period of office included the suppression of revolts in East Germany (1953) and Hungary (1956), the building of the Berlin Wall (1961) and the missile crisis in Cuba (1962). Khrushchev's willingness to reform was curtailed by the rigidity of the Cold War mentality.

(2) Nikita Chruschtschow versuchte als Nachfolger Stalins der kommunistischen Partei der Sowjetunion neue Impulse zu verleihen. Er leitete1956 auf dem 20. Parteitag der KPdSU die »Tauwetterperiode« und die Entstalinisierung ein. Diese politische Reformphase war jedoch nur von kurzer Dauer. (1) In der UN-Vollversammlung, hier mit dem Außenminister Andrej Gromyko 1960, war Chruschtschow berüchtigt für sein unkonventionelles Auftreten und seine Verbalattacken. Außenpolitische Marksteine in seiner Amtsphase waren die Niederschlagung der Aufstände in der DDR 1953 und in Ungarn 1956, der Mauerbau 1961 und die Raketenkrise auf Kuba 1962 – das Systemdenken des Kalten Krieges zwang den Reformwilligen schnell wieder auf Kurs.

(2) Succédant à Staline, Nikita Khrouchtchev tenta de donner une nouvelle impulsion au Parti communiste soviétique. Lors du XXᵉ congrès du PCUS, en 1956, il initia le « dégel » et la déstalinisation, mais cette période de réformes politiques fut de courte durée.
(1) A l'assemblée plénière de l'ONU, ici avec le ministre des Affaires étrangères Andrei Gromyko en 1960, Khrouchtchev s'était acquis une mauvaise réputation à cause de ses manières peu conventionnelles et de ses attaques verbales. Sa politique extérieure fut marquée par la répression des soulèvements en RDA en 1953 et en Hongrie en 1956, la construction du mur de Berlin en 1961 et la crise des fusées à Cuba en 1962. Les velléités de réforme de Khrouchtchev avaient été rapidement court-circuitées par le système de pensée en vigueur.

2 P. N. SHARMA UNDATED/O.D./S.D.

3 DAVID TURNLEY 1995

(4) Josip Tito on the Adriatic Sea in the summer of 1952. The former partisan leader succeeded in uniting Yugoslavia's various ethnic groups into a single state after the Second World War. His version of socialism broke away from the Soviet Union in 1948. Tito remained president until his death in 1980. The disintegration of the Republic of Yugoslavia in 1991 led to the outbreak of a long-standing war, concentrated in Bosnia Herzegovina. (3) General Radko Mladić (1995), the military leader of the Bosnian Serbs, was charged with numerous war crimes by the UN War Crimes Tribunal in The Hague.

(4) Josip Tito im Sommer 1952 an der Adria. Dem Ex-Partisanenführer gelang es nach dem Zweiten Weltkrieg, die verschiedenen Ethnien in einem Staat zu einen. Seine Variante des Sozialismus brach 1948 mit der Sowjetunion. Bis zu seinem Tod 1980 war Tito Staatspräsident. Der Zerfall der Republik Jugoslawien entfachte 1991 einen langjährigen Bürgerkrieg, der hauptsächlich in Bosnien-Herzegowina ausgetragen wurde. (3) General Radko Mladić 1995, der Kriegsführer der bosnischen Serben, wurde zahlreicher Kriegsverbrechen vor dem UN-Kriegsverbrechertribunal in Den Haag angeklagt.

(4) Josip Tito, durant l'été 1952, sur l'Adriatique. L'ancien chef de la Résistance yougoslave parvint, après la Deuxième Guerre mondiale, à réconcilier les différents peuples qui formaient le pays. Sa version du socialisme divergea en 1948 de celle de l'Union soviétique. Tito resta président jusqu'à sa mort, en 1980. En 1991, l'effondrement de la République yougoslave fut le début d'une longue guerre qui culmina en Bosnie-Herzégovine. (3) Le général Radko Mladić en 1995. Le chef militaire des Serbes de Bosnie fut accusé de nombreux crimes contre l'humanité par le Tribunal Pénal International de La Haye.

4 UCCLEBIT 1952

1 HENNING CHRISTOPH 1972

(2) Konrad Adenauer at Lake Como in 1958.
During the 14 years in which he served as
Chancellor, Adenauer left a distinct mark on
German post-war history, especially regarding
the integration of the Federal Republic of
Germany into the West and its reconciliation with
France. (1) Willy Brandt, the first social-democrat
to become Chancellor of the Federal Republic of
Germany, photographed in 1972. His foreign
policy towards the East Bloc countries, particularly
East Germany, was that of rapprochement. This
contributed considerably to the easing of
international tensions between the Eastern and
Western power blocs.

(2) Konrad Adenauer am Comer See 1958. In 14
Jahren Kanzlerschaft prägte Adenauer die
deutsche Nachkriegsgeschichte durch Entschei-
dungen wie die Westintegration der Bundes-
republik, u.a. die Aussöhnung mit Frankreich.
(1) Willy Brandt, der erste sozialdemokratische
Bundeskanzler der BRD, 1972. Er betrieb eine
Ostpolitik der Annäherung, die zur Überwindung
der Konfrontation zwischen den Machtblöcken
West und Ost beitrug.

(2) Konrad Adenauer sur le lac de Côme, en 1958.
En 14 ans de chancellerie, Adenauer marqua
l'histoire allemande de l'après-guerre par
l'intégration à l'Ouest de la République fédérale,
en particulier avec la réconciliation franco-
allemande. (1) Willy Brandt, premier chancelier
fédéral social-démocrate en RFA, 1972. Il promut
une politique du rapprochement avec l'Est, qui
contribua à surmonter les oppositions entre les
blocs de l'Ouest et de l'Est.

2 EDO KÖNIG 1958

3 FRANK HORVAT 1958

(4) Winston Churchill, British Prime Minister, photographed on 4 July 1945 during the Conservative Party's election campaign. After the war, Great Britain's social issues came to the fore again. Even before the end of the Potsdam Conference Churchill was voted out of power in a Labour Party sweep. (3) On 29 May 1958, at the height of the Algerian crisis, Charles de Gaulle became the Prime Minister of France. In the same year he became President of the newly-constituted Fifth French Republic, after having strengthened presidential powers considerably in a referendum.

(4) Der britische Premier Winston Churchill im Wahlkampf für die Konservative Partei am 4. Juli 1945. Nach Kriegsende rückten Großbritanniens soziale Probleme wieder in den Vordergrund. Noch während der Potsdamer Konferenz wurde Churchill mit dem Sieg der Labour Party als Premier abgelöst. (3) Am 29. Mai 1958, auf dem Höhepunkt der Algerienkrise, wurde Charles de Gaulle zum Ministerpräsidenten Frankreichs berufen. Im gleichen Jahr wurde er Staatspräsident, nachdem er dieses Amt per Volksabstimmung hatte stärken lassen.

(4) Winston Churchill, Premier ministre britannique, lors des élections du parti conservateur, le 4 juillet 1945. Après la fin de la guerre, les problèmes sociaux revinrent occuper le devant de la scène britannique. Alors que la Conférence de Potsdam n'était pas encore terminée, Churchill perdit les élections au profit du candidat travailliste. (3) Le 29 mai 1958, tandis que la crise d'Algérie était à son comble, Charles de Gaulle fut nommé chef du gouvernement français. La même année, il devint président de la République, après avoir renforcé les pouvoirs de cette fonction au moyen d'un référendum.

4 N.N. 1945

1 MARKUS DWORACZYK 1990

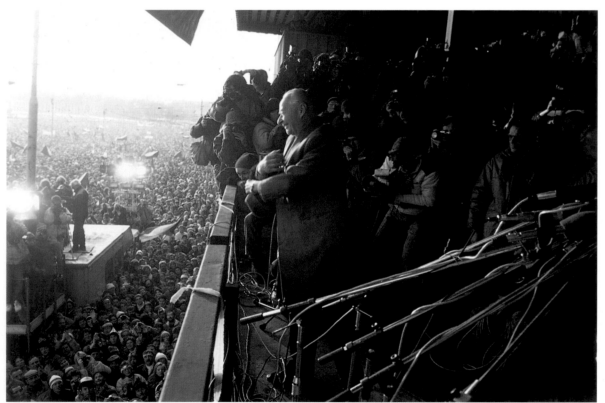

2 PETER TURNLEY 1989

(2) The democratic revolution in Czechoslovakia in 1989 reinstated the symbolic figure of the 1968 "Prague Spring", Alexander Dubček, a forestry official since 1970. Dubček inaugurated the new president, Václav Havel, in December 1989. (1) Lech Walesa, seen here in Cracow during the 1990 presidential election campaign, which he subsequently won. The role of the shipyard electrician developed along with the democracy movement in Poland – he was elected as chairperson of the illegal union "Solidarity" in 1981.

(2) Die demokratische Revolution in der Tschechoslowakei 1989 führte auch zur Rehabilitierung der Symbolfigur des »Prager Frühlings« von 1968. Alexander Dubček, der nach 1970 als Landarbeiter gelebt hatte, vereidigte im Dezember 1989 den neuen Präsidenten Václav Havel. (1) Lech Walesa, hier als Präsidentschaftskandidat im Wahlkampf von 1990 in Krakau, gewann die Wahl. Die Aufgaben des Elektromonteurs wuchsen mit der Demokratiebewegung in Polen – 1981 wählte die illegale Gewerkschaft »Solidarität« Walesa zu ihrem Vorsitzenden.

(2) La révolution démocratique en Tchécoslovaquie, en 1989, amena la réhabilitation d'une figure emblématique du « Printemps de Prague » de 1968. Alexandre Dubček, qui depuis 1970 travaillait comme ouvrier agricole, prit parti en décembre 1989 pour le nouveau président, Václav Havel. (1) Lech Walesa, ici candidat aux présidentielles de 1990 à Cracovie, remporta les élections. Les responsabilités de l'ancien ouvrier électricien grandirent en même temps que le mouvement démocratique polonais. En 1981, le syndicat illégal « Solidarité » avait élu Walesa comme représentant.

3 CHRISTOPHER MORRIS 1989

(3) Mikhail Gorbachev leaving the Lenin mausoleum after being shouted down at the May Day Parade in 1989. The architect of perestroika and glasnost was celebrated throughout the Western world as the symbol-bearer of hope. Yet, within the Soviet Union Gorbachev was by no means as successful as he was in his foreign politics.

(3) Michail Gorbatschow beim Verlassen des Lenin-Mausoleums, nachdem er bei der Mai-Parade 1989 niedergebrüllt worden war. Der Architekt von Perestroika und Glasnost, als Hoffnungsträger in der westlichen Welt gefeiert, war innenpolitisch längst nicht so erfolgreich wie in seiner Außenpolitik.

(3) Mikhaïl Gorbatchev quitte le mausolée de Lénine après avoir été hué par la foule lors du défilé du 1er mai 1989. L'artisan de la « perestroïka » et de la « glasnost », fêté en Occident comme l'homme du renouveau, rencontrait nettement moins de succès en politique intérieure.

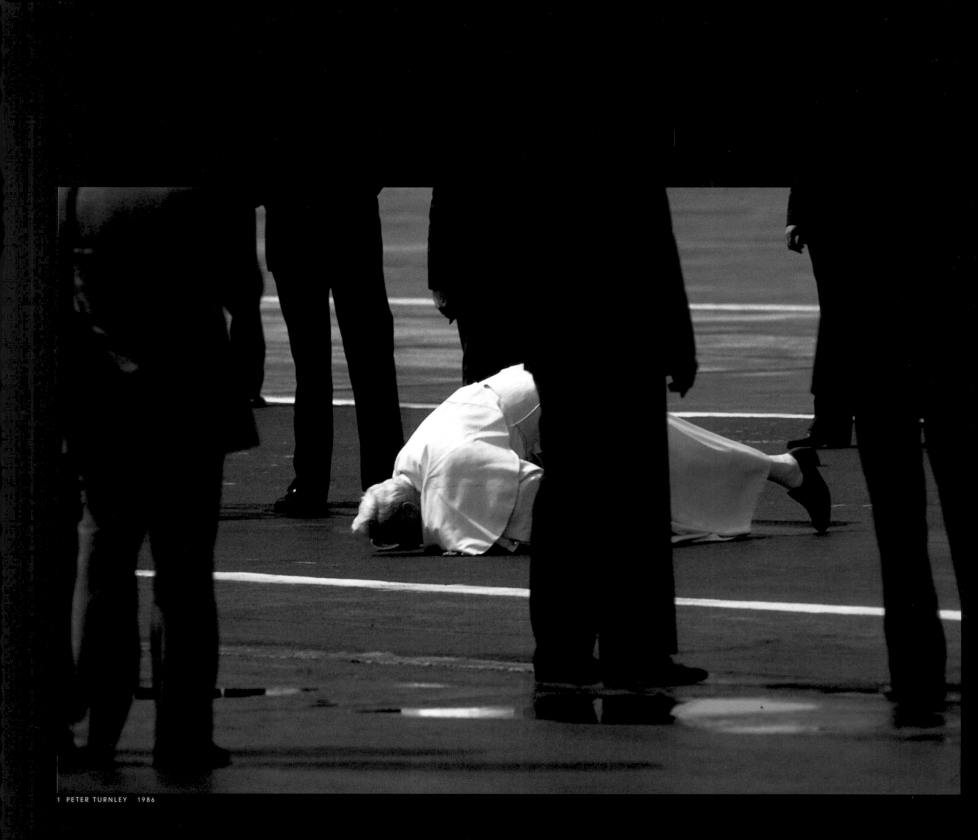

1 PETER TURNLEY 1986

(1) Pope John Paul II, the first non-Italian pope since 1523, always kisses the ground of the country he visits when traveling abroad. Here he kisses the soil of his native Poland during his third visit there in 1986. These visits served as an encouragement to the Polish church to hold their ground against the Communist regime.

(1) Papst Johannes Paul II. küßt bei jedem Auslandsbesuch den Boden des Gastlandes, auch 1986 bei seinem dritten Besuch in seinem Heimatland. Der erste nichtitalienische Papst seit 1523 stärkte mit seinen Besuchen in Polen der Kirche den Rücken gegen die kommunistische Regierung.

(1) A chacun de ses voyages à l'étranger, le pape Jean Paul II embrasse le sol du pays qui le reçoit. Ainsi en 1986, pour sa troisième visite dans son pays natal. Les visites en Pologne du premier pape non-italien depuis 1523 contribuèrent à y renforcer l'Eglise, opposée au pouvoir communiste.

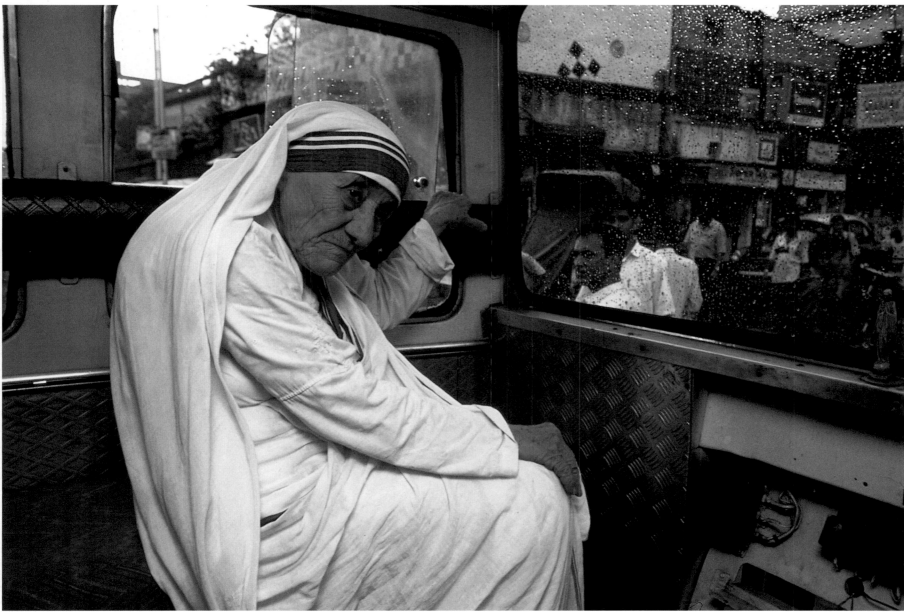

2 SWAPAN PAREKH 1995

(2) Mother Teresa during a journey through Calcutta in 1995.
In 1949 she opened the first slum school in the city and
founded the order of the Missionaries of Charity. In 1997, at
the age of 87, she stepped down as leader of the order,
which has been operating for many years on a world-wide
basis.

(2) Mutter Teresa bei einer Fahrt durch Kalkutta, 1995. 1949
eröffnete sie hier die erste Slumschule und gründete den
Orden der »Missionarinnen der Nächstenliebe«. Im Alter von
87 Jahren trat sie 1997 von der Führung des mittlerweile
weltweit agierenden Ordens zurück.

(2) Mère Teresa à Calcutta en 1995. C'est en 1949 qu'elle
ouvrit ici la première école des bidonvilles et qu'elle fonda
l'ordre des « missionnaires de l'amour du prochain ». En 1997,
à l'âge de 87 ans, elle se retira de la direction de cet ordre,
désormais actif dans le monde entier.

(1, 2) In world-wide campaigns on radio, television and film, the fundamentalist Baptist evangelist Billy Graham has been leading crusades since 1950 to awake "lukewarm Christendom".

(1, 2) Der fundamentalistische Baptistenprediger Billy Graham führt seit 1950 »Kreuzzüge zur Erweckung der lauen Christenheit« in weltweiten Kampagnen über Funk, Film und Fernsehen.

(1, 2) Le prédicateur baptiste fondamentaliste Billy Graham conduisait depuis 1950 ses « croisades pour le réveil de la chrétienté tiède », de grandes campagnes utilisant la radio, la télévision et le cinéma.

3 DENNIS BRACK 1980

(3) Various sects developed in California in the 1980s. Effusive preachers like Jerry Falwell sold a sectarian paradise to the socially underprivileged via television.

(3) In den 80er Jahren entwickelten sich in Kalifornien diverse Sekten. Exaltierte Prediger wie Jerry Falwell verkauften das sektiererische Paradies über Fernsehsender an sozial Unterprivilegierte.

(3) Dans les années 80, plusieurs sectes se répandirent en Californie. Des prédicateurs exaltés, comme ici Jerry Falwell, vendaient à la télévision un paradis sectaire aux classes sociales les plus défavorisées.

1 FRED STEIN UNDATED/O.D./S.D.

SNAPSHOT AND SYMBOL

(1) The German-Jewish emigrant, Fred Stein, is regarded as being one of the best portrait photographers of the past 60 years. Apart from photographing Albert Einstein and Frank Lloyd Wright, Stein also took this portrait of Bertolt Brecht during his Californian exile. Arguably the greatest dramatist of the twentieth century, Brecht was not particularly productive during these years and described his exile in America as feeling "like St. Francis of Assisi in an aquarium". (2) Jean-Paul Sartre, the key figure of European existentialism. In North America, however, only a few people acquired a taste for his philosophy, which he formulated as "Being and Nothingness", the title of his classic philosophical work, first published in 1943.

(1) Der deutsch-jüdische Emigrant Fred Stein gehört mit zu den besten Porträtfotografen der letzten 60 Jahre. Neben Aufnahmen von Albert Einstein oder Frank Lloyd Wright fotografierte er Bertolt Brecht in dessen kalifornischem Exil. Der wohl größte Dramatiker des 20. Jahrhunderts war in diesen Jahren nicht besonders produktiv und beschrieb seine Exil-Situation in Amerika mit den Worten: »wie franz von assisi im aquarium«. (2) Jean-Paul Sartre war die Schlüsselfigur des Existenzialismus in Europa, in Nordamerika hingegen freundeten sich nur wenige mit seiner Philosophie an, die er in »Das Sein und das Nichts« 1943 formulierte.

(1) Fred Stein, juif allemand émigré, compte parmi les meilleurs photographes de portraits des 60 dernières années. Outre Albert Einstein et Frank Lloyd Wright, il photographia aussi Bertolt Brecht durant son exil en Californie. Celui qui fut sans doute le plus grand dramaturge du 20ᵉ siècle ne fut guère productif lors de son exil qu'il décrivit en ces termes : « comme François d'Assises dans un aquarium ». (2) Jean-Paul Sartre fut en Europe la figure-clé de l'existentialisme. Par contre en Amérique du Nord, sa philosophie formulée en 1943 dans « L'être et le néant » ne séduisit qu'un petit nombre de personnes.

2 WERNER WOLFF UNDATED/O.D./S.D.

1 FRED STEIN 1943

(1) Thomas Mann during a visit to New York City in 1943. The prose of this sensitive analyst of the decadent German upper middle classes remained essentially Germanic during his stay in America – as did his personal life-style. Only a few emigrants were as affluent as Mann, who owned a villa in Pacific Palisades. (2) Ernest Hemingway in a rare contemplative moment on Finca Vigia in Cuba. In real life as well as in his novels, the acclaimed American author and Nobel Prize winner usually liked to be seen as the personification of the aggressive male hero.

(1) Thomas Mann 1943 bei einem Besuch in New York. Die Prosa des einfühlsamen Analytikers des dekadenten deutschen Großbürgertums blieb auch in Amerika genauso deutsch wie sein persönlicher Lebensstil. Nur wenigen Emigranten ging es materiell so gut wie Mann in seiner Villa in Pacific Palisades. (2) Ernest Hemingway in einem besinnlichen Moment auf der Finca Vigia in Kuba. Ansonsten liebte der vielgepriesene amerikanische Schriftsteller und Nobelpreisträger im Leben wie in seinen Romanen die Pose des männlich-kämpferischen Helden.

(1) Thomas Mann pendant un voyage à New York, en 1943. La prose de cet analyste très fin du déclin de la grande bourgeoisie allemande ne fut pas plus affectée que son style de vie par l'exil américain. Dans sa villa à Pacific Palisades, Mann eut la chance de vivre dans un confort matériel dont peu d'émigrants jouissaient à cette époque. (2) Ernest Hemingway, pensif, à la Finca Vigia, à Cuba. Le reste du temps, l'écrivain prix Nobel affectait volontiers, dans la vie comme dans ses romans, la pose du héros combatif et viril.

2 HANS MALMBERG UNDATED/O.D./S.D.

1) The surrealistic painter, sculptor and illustrator
Salvador Dalí in his house near Figueras on the Spanish
Costa Brava in 1965. In this portrait, John Launois
managed to reduce the persona of the manic self-
publicist Dalí to a minimum, but at the same he
succeeded in achieving maximum effect by means of the

(1) Der surrealistische Maler, Bildhauer und Grafiker
Salvador Dalí 1965 in seinem Haus bei Figueras an der
spanischen Costa Brava. John Launois schaffte es in
diesem Porträt, den Spielraum für den manischen
Selbstdarsteller Dalí auf ein Minimum zu begrenzen und
dennoch maximale Wirkung durch die surreale

(1) L'artiste surréaliste Salvador Dalí en 1965 dans sa
maison de Figueras, sur la Costa Brava, en Espagne. En
restreignant au minimum l'espace dévolu à ce maniaque
de la représentation de soi, John Launois a réussi, dans
ce portrait, à obtenir un effet maximal par la simple
composition spatiale.

2 ERICA LANSNER 1992

(2) Antonio Tápies photographed in Barcelona in front of one of his works in 1992. The painter uses a wide variety of materials, including stone, sand and various textiles in his paintings. In his hand he holds the model for a very controversial sculpture which was commissioned by the National Museum of Catalan Art.

(2) Anton o Tápies in Barcelona 1992 vor einem seiner Werke. Der Maler verarbeitet in seinen Bildern die unterschiedlichsten Materialien wie Stein, Sand und Textilien. In der Hand hält er ein höchst umstrittenes Modell für eine Skulptur, die das Nationalmuseum katalanischer Kunst bei ihm in Auftrag gegeben hatte.

(2) Antoni Tàpies devant ses tableaux à Barcelone, en 1992. Le peintre a intégré sur la toile les matières les plus diverses, pierre, sable ou tissus. Il tient à la main la maquette très controversée d'une sculpture commandée par le Musée national d'art catalan.

1 HATAMI 1961

(1) A snapshot of Pablo Picasso on the beach at Cannes in 1961. Many magazines were more interested in his colorful private life rather than in the work of Picasso, one of the most influential modern artists. (2) The illustrator, Norman Rockwell, portrayed the life of ordinary Americans in his work. He was best known for the covers he painted for the Saturday Evening Post, for which he illustrated such everyday happenings as a boy's first haircut or a town meeting.

(1) Schnappschuß von Pablo Picasso am Strand von Cannes, 1961. Viele Magazine interessierte das schillernde Privatleben des bedeutendsten Malers der Moderne mehr als sein Werk. (2) Der Illustrator Norman Rockwell beschrieb das Leben des Durchschnittsamerikaners. Er war vor allem bekannt für seine Zeichnungen auf dem Cover der Saturday Evening Post, in denen er z.B. den ersten Haarschnitt eines Jungen wie auch die Geschehnisse einer Stadtversammlung darstellte.

(1) Instantané de Pablo Picasso sur la plage de Cannes, en 1961. De nombreux magazines s'intéressaient davantage à la vie privée mouvementée qu'à l'œuvre de l'un des artistes les plus importants du 20ᵉ siècle. (2) L'illustrateur Norman Rockwell décrivait la vie de l'américain moyen. Il fut surtout connu pour ses dessins en couverture du Saturday Evening Post et qui représentaient par exemple la première coupe de cheveux d'un jeune garçon ou les péripéties d'une assemblée municipale.

2 KOSTI RUOHAMAA UNDATED/O.D./S.D.

1 STEVE SCHAPIRO UNDATED/O.D./S.D.

(1) Andy Warhol, one of the leading exponents of the Pop Art movement, was a multimedia artist who worked as a painter, illustrator, photographer and filmmaker. Warhol deliberately portrayed consumer goods and mass icons as art. Instead of trying to create unique specimens, he produced production-line art in his "Factory". Some of his critics described him as "nothingness incarnated". (2) The American graffiti artist Keith Haring attracted the attention of the international art scene with his comical stick figures in the subway stations of New York City. His meteoric career ended abruptly in 1990 when he died of Aids.

(1) Der Pop-Art-Künstler Andy Warhol arbeitete als Maler, Grafiker, Fotograf und Filmemacher multimedial. Warhol etablierte Gebrauchsgegenstände und Massen-idole in der Kunst; anstelle von Unikaten produzierte er in seiner »Factory« Fließ-bandkunst. Kritiker sahen in ihm »das inkarnierte Nichts«. (2) Der amerikanische Graffitikünstler Keith Haring zog mit seinen witzigen Kreidemännchen auf New Yorker U-Bahnhöfen die Aufmerksamkeit der internationalen Kunstszene auf sich. Seine steile Karriere endete jäh 1990 mit seinem Aids-Tod.

(1) Andy Warhol, l'une des grandes figures du pop art, s'est servi de toutes les techniques: peinture, dessin, gravure, photo et cinéma. Il a systématisé le recours à des objets utilitaires et à des idoles populaires, produisant des œuvres à la chaîne dans son atelier, « The Factory ». Certains critiques ont vu en lui « l'incarnation du néant ». (2) L'artiste de graffiti Keith Haring attira l'attention de la scène artistique internationale grâce à ses drôles de bonshommes dessinés à la craie dans les stations de métro new-yorkaises. Sa carrière fulgurante fut brutalement interrompue par sa mort du sida en 1990.

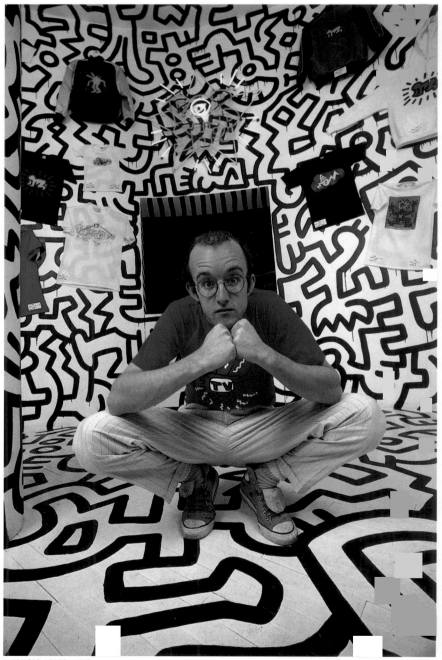

2 ARNOLD ADLER 1990

3 DAVID RUBINGER 1958

4 LEE LOCKWOOD 1959

(3) At the age of 74, the painter Marc Chagall returned home to France, having spent the war years in America. His later work includes monumental wall paintings, wall tapestries, mosaics and stained-glass windows. (4) In 1959, the architect Frank Lloyd Wright pays a last visit to the building site of his brainchild, the Guggenheim Museum in New York City, distinguished by its spiral-shaped interior design. Wright did not live to see the opening of the museum later that year.

(3) Der Maler Marc Chagall kehrte im Alter von 74 Jahren aus der amerikanischen Emigration nach Frankreich zurück. Sein Spätwerk bestimmten monumentale Wandbilder, Wandteppiche, Mosaiken und Glasfenster. (4) Der Architekt Frank Lloyd Wright 1959 bei seinem letzten Besuch auf der Baustelle des von ihm geplanten Guggenheim Museums in New York, das sich durch die spiralförmige Innenarchitektur auszeichnet. Die Eröffnung des Museums im gleichen Jahr erlebte Wright nicht mehr.

(3) Le peintre Marc Chagall rentra en France à l'âge de 74 ans de son exil américain. La dernière période de son œuvre fut marquée par des fresques monumentales ainsi que par des tapisseries murales, des mosaïques et des vitraux.
(4) L'architecte Frank Lloyd Wright lors de sa dernière visite en 1959 sur le site du Musée Guggenheim, à New York, dessiné par lui et qui se caractérise par un intérieur en spirale. Wright disparut peu avant l'ouverture du musée la même année.

1 JAMES SUGAR 1989

(1) Due to the effects of a neuromuscular disease, the British physics Professor, Stephen Hawking, can only communicate by means of a voice modulator. In his best-seller "A Brief History of Time" millions of readers have obtained an explanation, formulated in popular scientific terms, of the origin and evolution of the universe.

(1) Der britische Professor Stephen Hawking kann sich aufgrund seiner Krankheit nur mit einem Sprachcomputer verständigen. In seinem populärwissenschaftlichen Bestseller »Eine kurze Geschichte der Zeit« erklärte er Millionen von Lesern Ursprung und Evolution des Universums.

(1) Le scientifique britannique Stephen Hawking est atteint d'un handicap qu'il surmonte en s'exprimant au moyen d'un ordinateur. « Une brève histoire du temps » est un livre de vulgarisation scientifique dans lequel il explique à des millions de lecteurs l'origine et l'évolution de l'univers.

(2) Konrad Lorenz in his laboratory in 1969. The Austrian was the father of modern ethology, the study of animal behavior by means of comparative zoological methods. (3) In the 1950s the pediatrician Benjamin Spock was regarded as the supreme expert on the care and upbringing of children in America. Most American households had a paperback copy of his book "Baby and Child Care", first published in 1946. "Dr. Spock's" advice was consulted for all sort of ailments that the "little darlings" might have contracted.

(2) Konrad Lorenz 1969 in seinem Labor. Der Österreicher begründete die moderne Verhaltensforschung. (3) Der Kinderarzt Benjamin Spock war in den 50er Jahren der amerikanische Experte in Kinderpflege und -erziehung. Paperback-Kopien seines Buches »Baby and Child Care«, erstmals 1946 publiziert, waren in fast allen amerikanischen Haushalten zu finden. Gab es Probleme mit den »lieben Kleinen«, wurde zunächst einmal »Dr. Spock« zu Rate gezogen.

(2) Konrad Lorenz, en 1969, dans son laboratoire. Ce savant autrichien est le fondateur de l'éthologie. (3) Le pédiatre Benjamin Spock fut dans les années 50 le spécialiste de l'éducation et des soins aux enfants. Presque tous les foyers américains possédaient un exemplaire en édition de poche de son livre : « Comment soigner son enfant », publié la première fois en 1946. Au moindre problème avec les chers petits, on sortait son « Dr. Spock ».

1 FLIP SCHULKE 1969

(1) Jacques Cousteau on board a mini submarine. Capable of descending underwater to depths of approximately 1,000 feet, these submarines were equipped with both special film cameras and spotlights. (3) One of the submarines is lowered into the sea. (2) An underwater station on the seabed near Madagascar. (4) Life on board the Calypso. Jacques passed on to his son, Philippe (right), his yearning for discovery and adventure.

(1) Jacques Cousteau an Bord eines Mini-U-Boots, das mit Filmkameras und Scheinwerfern ausgerüstet war und bis zu 300 Meter tief tauchen konnte. (3) Einholung eines der U-Boote. (2) Unterwasserstation am Meeresgrund vor Madagaskar. (4) Leben an Bord der Calypso. Jacques' Forscher- und Abenteuergeist übertrug sich auch auf Sohn Philippe (r.).

(1) Jacques Cousteau à bord d'un mini-sous-marin équipé de caméras et de projecteurs, pouvant descendre jusqu'à 300 mètres de profondeur. (3) Halage d'un des sous-marins. (2) Station sous-marine basée au large de Madagascar. (4) La vie à bord de la Calypso. Le fils de Jacques Cousteau, Philippe (à dr.), a hérité de sa passion de la recherche et de l'aventure.

JACQUES COUSTEAU

In 1969 Flip Schulke photographed a very special kind of home story. The all-round professional went underwater with the French marine researcher, Jacques Cousteau. Schulke accompanied Cousteau to Madagascar on Cousteau's research ship Calypso – previously an American minesweeper which he had changed into a floating modern laboratory. Schulke revealed some interesting aspects about the work of the underwater legend, who had devoted his life to oceanography since 1951. Cousteau brought his scientific findings to the general public's attention in the world famous television series "The World of Jacques Cousteau".

JACQUES COUSTEAU

Flip Schulke fotografierte 1969 eine *home story* besonderer Art. Der Allround-Profi ging mit dem französischen Meeresforscher Jacques Cousteau ins Wasser. Schulke begleitete den Forscher auf dessen Forschungsschiff Calypso bei Studien in Madagaskar. Cousteau hatte das Schiff von einem amerikanischen Minenräumer zu einem schwimmenden modernen Laboratorium umgebaut. Schulke gab Einblicke in die Arbeit der Meereslegende Cousteau, der seit 1951 sein Leben der Erforschung der Ozeane widmete. Seine wissenschaftlichen Erkenntnisse faßte Cousteau in eine populäre Form, die weltbekannte Fernsehserie »Geheimnisse des Meeres«.

JACQUES COUSTEAU

En 1969, Flip Schulke fit un reportage d'un genre particulier. Ce superprofessionnel descendit sous l'eau avec Jacques Cousteau. Schulke accompagna le chercheur sur son bateau, la Calypso, jusqu'à Madagascar. D'un ancien dragueur de mines américain, Cousteau avait fait un véritable laboratoire moderne flottant. Les photos de Schulke donnent une idée des travaux de ce héros des fonds sous-marins qui depuis 1951 a consacré sa vie à l'exploration des mers. Cousteau a vulgarisé ses découvertes dans des films télévisés mondialement connus « Le monde du silence ».

2 FLIP SCHULKE 1969

3 FLIP SCHULKE 1969

4 FLIP SCHULKE 1969

1 W. EUGENE SMITH 1941

SNAPSHOT AND SYMBOL

(1) Orson Welles before the New York premiere of "Citizen Kane", in which he made his directing debut in 1941. The publisher, Randolph Hearst, tried to stop the premiere from taking place, because he saw the story of a newspaper magnate, with Welles in the leading role, as a critical interpretation of his own life. (2) Since his role as a defiant psychiatric patient in "One Flew Over the Cuckoo's Nest", Jack Nicholson has been one of the highest-paid actors in Hollywood. (3) America's best-known comedian, Jackie Gleason, was the star of the television show "The Honeymooners". (4) On 7 April 1949 Richard Rodgers' musical, "South Pacific", was staged for the first time in New York City.

(1) Orson Welles vor der Premiere seines Regie-Erstlingswerks »Citizen Kane« 1941 in New York. Der Verleger Randolph Hearst hatte versucht, die Premiere zu verhindern, da er sich in der Geschichte eines Zeitungsmagnaten, dargestellt von Welles, wiederzuerkennen meinte. (2) Jack Nicholson gehörte seit der Rolle eines aufsässigen Klinikinsassen in »Einer flog übers Kuckucksnest« zu den höchstbezahlten Schauspielern Hollywoods. (3) Amerikas berühmtester Komiker Jackie Gleason war der Star der Fernsehshow »The Honeymooners«. (4) Am 7. April 1949 wurde das Musical »South Pacific« von Richard Rodgers in New York uraufgeführt.

(1) Orson Welles, juste avant la première de son premier film « Citizen Kane », à New York en 1941. L'éditeur Randolph Hearst avait tenté d'interdire la projection, croyant se reconnaître dans le héros du film, un magnat de la presse comme lui. (2) Depuis son rôle d'interné insoumis dans une clinique psychiatrique dans « Vol au-dessus d'un nid de coucou », Jack Nicholson fait partie des acteurs les mieux payés de Hollywood. (3) Le plus célèbre comique américain, Jackie Gleason, était la star de la série télévisée « The Honeymooners ». (4) Le 7 avril 1949, première à New York de « South Pacific », une comédie musicale de Richard Rodgers.

1 IVO MELDOLESI 1949

2 MARTY MILLS UNDATED/O.D./S.D.

(1) The Swedish film star Ingrid Bergman met her second husband, the Italian director Roberto Rossellini, in 1948. One year later this photo of the film couple of the year, taken during the shooting of "Stromboli", was published in Life. (2) Even in his intimate family circle the Italian-American actor, Dean Martin, was always seen with a glass of whisky and a cigarette. He was best known for his role of the vain playboy. (3) Shirley Temple with her children. Hollywood's most successful child actress in the 1930s and 1940s. She later entered politics, eventually serving as Gerald Ford's head of protocol.

(1) Der schwedische Filmstar Ingrid Bergman lernte 1948 ihren zweiten Ehemann, den italienischen Regisseur Roberto Rossellini, kennen. Ein Jahr später druckte Life das Foto vom Filmpaar des Jahres während der gemeinsamen Dreharbeiten zu »Stromboli«. (2) Auch im Kreise seiner Familie war der Italo-Amerikaner Dean Martin nur mit Whisky-Glas und Zigarette anzutreffen. Seine Paraderolle war die des eitlen Playboys. (3) Shirley Temple mit ihren Kindern. Der erfolgreichste Kinderstar Hollywoods in den 30er und 40er Jahren wandte sich später u.a. als Protokollchefin Gerald Fords der Politik zu.

(1) La star suédoise Ingrid Bergman rencontra en 1948 le réalisateur italien Roberto Rossellini, qui allait devenir son second époux. Un an plus tard, Life publia cette photo du couple de l'année, prise pendant le tournage du film « Stromboli ». (2) Même dans l'intimité familiale, l'acteur italo-américain Dean Martin, dont l'image de marque était celle d'un séducteur oisif, avait toujours un verre de whisky et une cigarette à la main. (3) Shirley Temple avec ses enfants. La plus célèbre enfant-star du cinéma hollywoodien dans les années 30 se tourna plus tard vers la politique et devint chef du protocole de Gerald Ford.

3 MARVIN KONER UNDATED/O.D./S.D.

1 GENE DANIELS UNDATED/O.D.S.D.

(1) Marilyn Monroe was built up into the ultimate sex symbol by America's film industry. Never able to shake off the image of the stereotypical seductive "dumb blonde" in her film roles, Monroe was driven to suicide by self-doubt and drugs in 1962.

(1) Marilyn Monroe wurde von der amerikanischen Filmindustrie zum Sexsymbol Amerikas aufgebaut. Selbstzweifel und Drogen trieben die von der Rolle des »sinnlichen Dummchens« Verfolgte 1962 in den Selbstmord.

(1) L'industrie cinématographique américaine fit de Marylin Monroe un sex-symbol. En 1962, le manque de confiance en soi et les drogues conduisirent au suicide celle à qui l'on n'offrait jamais que des rôles de « ravissante idiote ».

2 W. MURLANDS UNDATED/O.D./S.D.

(3) Gina Lollobrigida was the most popular 1950s screen actress in Italy. "Gina Nazionale" achieved international recognition with her roles in "Beauties of the Night" and "The Hunchback of Notre Dame". (2) Lollobrigida's most serious rival was Sophia Loren, here with Carlo Ponti, the man who discovered and later married her. Loren also achieved international fame in numerous Hollywood roles.

(3) Gina Lollobrigida war in den 50er Jahren die beliebteste Schauspielerin Italiens. »Gina Nazionale« erlangte mit Rollen in »Die Schönen der Nacht« und »Der Glöckner von Notre Dame« auch internationale Anerkennung. (2) Lollobrigidas ernsthafteste Konkurrentin war Sophia Loren, hier mit ihrem Entdecker und späteren Ehemann Carlo Ponti. Auch die Loren spielte zahlreiche Hollywoodrollen.

(3) Dans les années 50, Gina Lollobrigida était l'actrice la plus populaire en Italie. Mais «Gina Nazionale» obtint également une reconnaissance internationale grâce à ses rôles dans «Les Belles de nuit» et dans «Notre-Dame de Paris». (2) La concurrente la plus sérieuse de Lollobrigida était Sophia Loren, ici avec Carlo Ponti, qui découvrit son talent, avant de l'épouser. Sophia Loren joua aussi dans de nombreuses productions hollywoodiennes.

3 GENE DANIELS UNDATED/O.D./S.D.

(1) Lauren Bacall achieved fame through her screen debut in "To Have and Have Not" (1944) opposite her later husband, Humphrey Bogart. Bacall's image as the cool, seductive femme fatale was already established in her first film, but the image was made unforgettable in the famous film noir movies. (2) Audrey Hepburn, by contrast, personified delicate innocence and natural charm. Her international breakthrough came with the role of an extroverted playgirl in "Breakfast at Tiffany's" (1960).

(1) Lauren Bacall wurde durch ihr Filmdebüt an der Seite ihres späteren Ehemannes Humphrey Bogart in »Haben oder Nichthaben« (1944) berühmt. Bacall spielte fortan den unterkühlt-verführerischen Frauentyp, vor allem in Filmen der »Schwarzen Serie«. (2) Audrey Hepburn verkörperte hingegen die zierliche Unschuld mit natürlichem Charme. Der internationale Durchbruch gelang ihr in der Rolle eines extrovertierten Playgirls in »Frühstück bei Tiffany« (1960).

(1) Lauren Bacall rencontra la célébrité dès ses débuts, dans « Le port de l'angoisse » (1944), aux côtés de Humphrey Bogart, qui allait devenir son époux. Elle incarna désormais des séductrices du type « feu sous la glace », jouant le plus souvent dans des films noirs. (2) Audrey Hepburn au contraire incarna des héroïnes innocentes et fragiles au charme naturel. Elle fit une percée internationale avec un rôle de jeune femme espiègle dans « Diamants sur canapé » (1960).

2 N.N. UNDATED/O.D./S.D.

3 JOHN LAUNOIS 1961

4 JOHN LAUNOIS 1961

(3, 4) Launois' portrait series of Shirley MacLaine during the filming of "My Geisha" made the cover of Life on 17 February 1961.

(3, 4) Launois' Porträtserie von Shirley MacLaine während der Dreharbeiten zu dem Film »My Geisha« war Life am 17. Februar 1961 einen Titel wert.

(3, 4) La série de portraits de Shirley MacLaine par John Launois sur le tournage de « Ma Geisha » fit la couverture de Life le 17 février 1961.

1 PIZZAMIGLIO · 1964

2 RALPH CRANE 1944

(1) Charlie Chaplin visiting Milan in 1964. In old-age Chaplin only vaguely resembled that famous creation of his – the classic silent film character with a bowler hat and brush mustache. (2) Two years before his death in 1944, Life wrote of W. C. Fields: "He just naturally looks the way a comic should." (3) Groucho was the "brain" of the legendary Marx Brothers. In their absurd comedies full of anarchistic humor, he personified the verbose intellectual. (4) Here Woody Allen mimes "man with an ant on a leash" for Steve Schapiro.

(1) Charlie Chaplin in Mailand, 1964. Im Alter erinnerte Chaplin nur noch wenig an die von ihm geschaffene klassische Stummfilmfigur, den Tramp mit Melone und Bürstenbärtchen. (2) Zwei Jahre vor seinem Tod, 1944, schrieb Life über W. C. Fields: »Er sieht einfach genau so aus, wie man sich einen Komiker vorstellt.« (3) Groucho war der Kopf der legendären Marx Brothers. In den absurden Komödien voller anarchistischer Komik verkörperte er den schwatzhaften Intellektuellen. (4) Für Steve Schapiro mimte Woody Allen den »Mann mit einer Ameise an einer Leine«.

(1) Charlie Chaplin à Milan, 1964. Avec l'âge, il ressemblait de moins en moins au personnage désormais classique qu'il avait créé pour le cinéma muet, le vagabond au melon et à la moustache en brosse.
(2) Deux ans avant sa mort, en 1944, Life écrivait à propos de W. C. Fields : « Il a tout naturellement l'apparence d'un comique. »
(3) Groucho était la tête pensante des légendaires Marx Brothers. Dans leurs comédies dévastatrices à ressort absurde, il incarnait l'intellectuel bavard. (4) Pour Steve Schapiro, Woody Allen mima « l'homme qui tient une fourmi au bout d'une laisse ».

3 RALPH CRANE 1944

4 STEVE SCHAPIRO 1964

1 PIERGIORGIO SCLARANDIS 1972

(1, 2) Alfred Hitchcock in his villa in Como, Italy, in 1972. He was one of the greatest film directors of the 20th century who, above all, knew how to present himself in front of the camera. In his films, Hitchcock was particularly interested in the hidden anxieties and obsessions of his fellow human beings. The photos in this series illustrated a 1972 New York Times Magazine cover story coinciding with the premiere of his film "Frenzy".

(1, 2) Alfred Hitchcock 1972 in seiner Villa in Como, Italien. Er war einer der großen Filmregisseure des 20. Jahrhunderts, der sich zudem auch selbst vor der Kamera zu inszenieren wußte. In seinen Filmen interessierten ihn vor allem die verborgenen Ängste und Obsessionen seiner Mitmenschen. Die Bilder aus dieser Serie illustrierten eine Titelgeschichte des New York Times Magazine 1972 anläßlich der Premiere seines Films »Frenzy«.

2 PIERGIORGIO SCLARANDIS 1972

(1, 2) 1972, Alfred Hitchcock dans sa villa de Côme en Italie.
Il fut l'un des plus grands cinéastes du 20ᵉ siècle et tint à
figurer dans tous ses films. Il s'intéressait avant tout aux
peurs et aux obsessions cachées de ses contemporains.
Cette série de photos illustre un article de première page du
New York Times Magazine en 1972, à l'occasion de la sortie
de son film « Frenzy ».

1 JOHN LAUNOIS UNDATED/O.D./S.D.

(1) Bob Dylan's passion for motor-bikes almost resulted in
a premature ending to his legendary and long career as
a musician – he suffered a serious accident in 1966.
Dylan's songs, like "The Times They Are A-Changin'",
became a symbol of the youthful zeitgeist of the 1960s.

(1) Bob Dylans Leidenschaft für Motorräder hätte beinahe
seine sagenhafte und lange Karriere als Musiker vorzeitig
beendet – 1966 hatte er einen schweren Unfall. Dylans
Songs wie »The Times They Are A-Changin'« wurden zu
Chiffren des jugendlichen Zeitgeistes in den 60er Jahren.

(1) La passion de Bob Dylan pour les motos, lui causant
un grave accident en 1966, faillit mettre prématurément
un terme à sa légendaire carrière musicale. Les chansons
de Dylan, comme « The Times They Are A-Changin' »,
symbolisaient l'esprit du temps pour la jeunesse des
années 60.

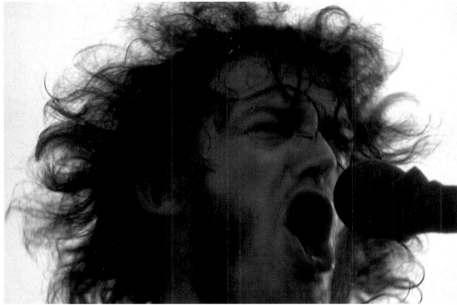

2 DAN McCOY 1969

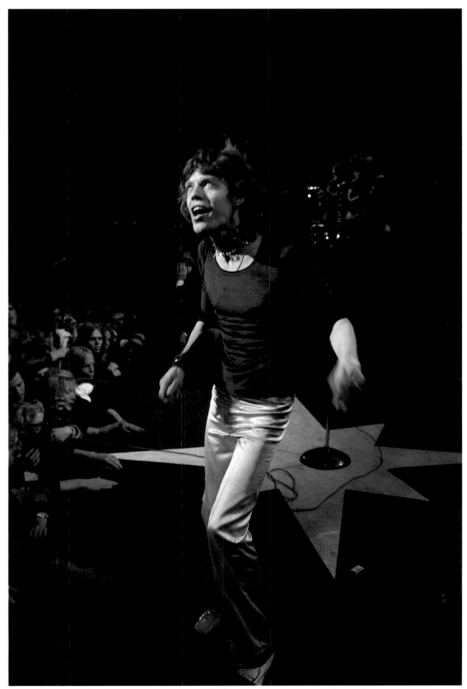

(3) Mick Jagger in Stockholm during the Rolling Stones' 1971 European Tour. The "bad boys of rock music" incarnated provocation against middle class morality in the 1960s and 1970s. Lead singer Jagger, a masterful stage performer, symbolized uninhibited and ecstatic sex. (2) Joe Cocker, "a living proof that one can be born in Sheffield and yet sound like a black man from Mississippi", at the Woodstock Festival in August 1969. This performance kick-started his international career.

(3) Mick Jagger auf der Europa-Tournee der Rolling Stones 1971 in Stockholm. Die »bad boys der Rockmusik« waren in den 60er und 70er Jahren die inkarnierte Provokation bürgerlicher Moralvorstellungen, Sänger Jagger symbolisierte als Performer der Band hemmungslosen und ekstatischen Sex. (2) Joe Cocker, »der lebende Beweis, daß man aus Sheffield kommen und trotzdem wie ein Schwarzer aus Mississippi klingen kann«, auf dem Woodstock-Festival im August 1969. Mit diesem Auftritt begann für ihn die internationale Karriere.

(3) Mick Jagger à Stockholm, pendant la tournée européenne des Rolling Stones en 1971. Dans les années 60, ces « mauvais garçons de la musique rock » incarnaient le diable pour la morale bourgeoise. Mick Jagger, le chanteur du groupe, fut l'un des porte-drapeaux de la libération sexuelle. (2) En 1969, au Festival de Woodstock, Joe Cocker, « la preuve vivante qu'on peut être né dans le Sheffield et avoir la voix d'un Noir du Mississippi ». Sa performance fut le début d'une carrière internationale.

3 DOMINIQUE BERETTY 1971

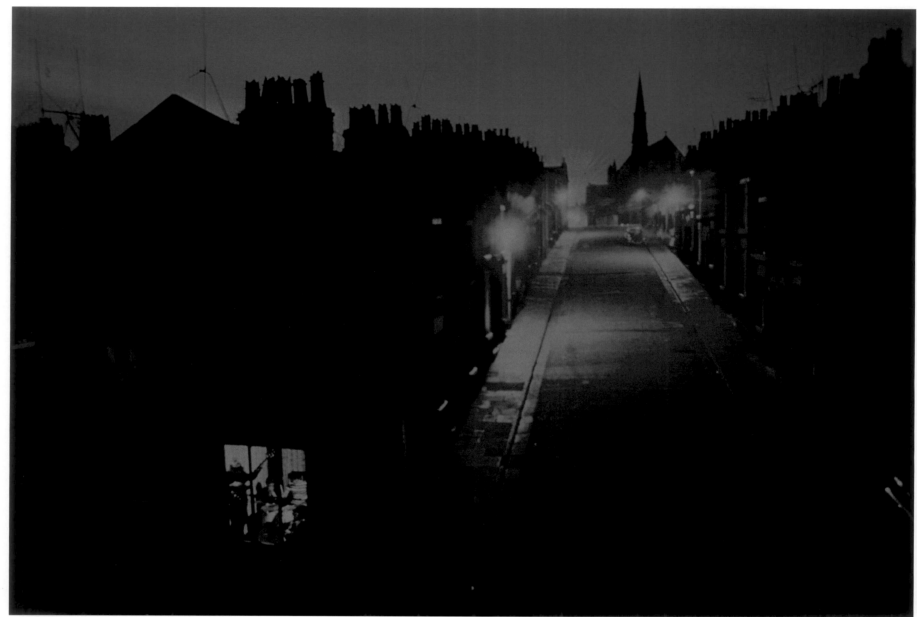

1 JOHN LAUNOIS 1964

(1) In 1957 Paul McCartney met John Lennon and joined his band the "Quarrymen." George Harrison became part of the group a few months later. It took until 1962 when Ringo Starr became the Beatles' drummer for the Fab Four to be complete. The same year, they had their first great hit with "Love Me Do." With the help of the four band members, John Launois staged a scene in 1964 that had never before occurred with that lineup: the Beatles in their old rehearsal studio in a working-class neighborhood along the Mersey River in Liverpool. The photographer thus created an image that virtually eclipses the band's actual history.

(1) 1957 lernte Paul McCartney John Lennon kennen und schloß sich dessen Band »Quarrymen« an. George Harrison kam wenige Monate später hinzu. Ringo Starr komplettierte die Fab Four erst 1962. Im gleichen Jahr landeten sie ihren ersten großen Hit, »Love Me Do.« John Launois inszenierte mit den vier Beatles 1964 eine Situation, die in dieser Besetzung nie stattgefunden hatte – die Beatles in ihrem alten Proberaum in einem Liverpooler Arbeiterviertel am Mersey River. Der Fotograf schuf damit ein Bild, das die reale Bandhistorie fast vergessen läßt.

(1) En 1957, Paul McCartney fit la connaissance de John Lennon et se joignit à son groupe «Quarrymen». George Harrison arriva quelques mois plus tard et ce n'est qu'en 1962 que Ringo Starr vint compléter les «Fab Four». La même année, ce fut leur premier succès «Love Me Do». En 1964, John Launois mit en scène avec les quatre Beatles une situation qui n'a jamais eu lieu – ces derniers dans leur salle de répétition d'un quartier ouvrier de Liverpool à Mersey River. Le photographe créa là une image qui fit presque oublier la véritable histoire du groupe.

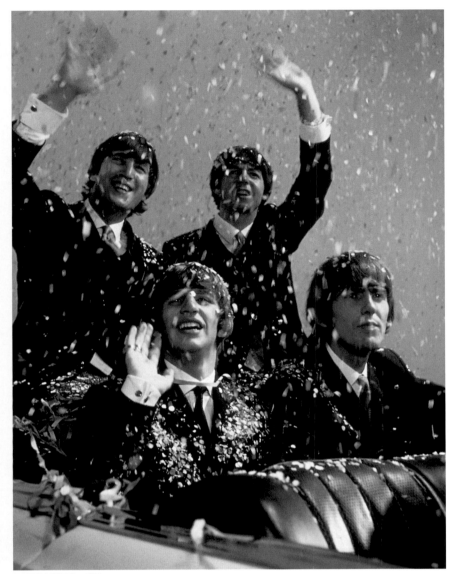

2 JOHN LAUNOIS 1964

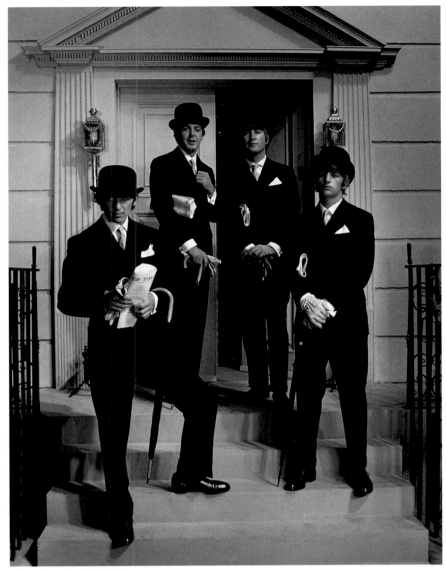

3 JOHN LAUNOIS 1964

THE BEATLES

John Launois did not take the rampant Beatlemania into account while planning these portraits of the Beatles, the undisputed kings of pop at the time. (3) "They had conquered America in 1964. They had become millionaires in English pounds which gave me the idea of photographing them wearing the typical financier's suits of London. The *Fab Four* took it as a spoof on the money men of London. Every detail of the Beatles shoot was highly confidential. They arrived in a chauffeured Rolls-Royce with darkened windows. I started to pose them when suddenly there was a mob of screaming girls. The boys ran to their cars. It was impossible to photograph them in a London street so we built an entire set in a London studio. The next week, the Beatles were on 1964's cover of the *Saturday Evening Post*." (2) This studio also gave birth to the "glamour-shots" of John Lennon (rear left), Paul McCartney (rear right), George Harrison (front right) and Ringo Starr (front left) in an open convertible.

DIE BEATLES

John Launois hatte bei seinen Porträtplänen der Beatles, den damaligen Königen des Pops, die zu dieser Zeit herrschende Beatlemania nicht bedacht. (3) »1964 eroberten sie Amerika. Weil sie mittlerweile Millionen von englischen Pfund verdient hatten, kam mir die Idee, sie als typische Vertreter der Londoner Finanzwelt zu fotografieren. Die *Fab Four* waren begeistert von dem Vorschlag und betrachteten das Foto als eine Parodie auf die Londoner Geldgrößen. Jedes Detail der Beatles-Aufnahmen unterlag strikter Geheimhaltung. Sie fuhren in einem Rolls-Royce mit abgedunkelten Scheiben und Chauffeur vor. Ich hatte gerade damit begonnen, sie für die Fotos aufzustellen, als plötzlich eine Menge kreischender Mädchen auftauchte. Die Jungs rannten zu ihrem Auto. Es war einfach unmöglich, sie in London auf der Straße zu fotografieren; also bauten wir die ganze Szene in einem Londoner Studio nach. In der darauffolgenden Woche erschienen die Beatles auf dem Cover der Jahres- ausgabe der *Saturday Evening Post*.« (2) In diesem Studio entstand auch die »Glamour-Aufnahme« im offenen Cabriolet von John Lennon (hinten links), Paul McCartney (hinten rechts), George Harrison (vorne rechts) und Ringo Starr (vorne links).

LES BEATLES

Quand il imagina de faire le portrait des Beatles, John Launois n'avait pas pris en compte la « Beatlemania ». (3) « Ils avaient conquis l'Amérique en 1964 et étaient devenus millionnaires en livres sterling, ce qui m'avait donné l'idée de les photographier en costumes de financiers londoniens. Les *Fab Four* l'ont pris comme une blague sur les hommes d'affaire de la *City*. Tous les détails de la prise de vue étaient gardés secrets. Ils sont arrivés dans une Rolls-Royce à vitres fumées conduite par un chauffeur. Au moment où ils prenaient la pose, il y a eu tout à coup une foule de filles en délire. Les garçons ont couru vers la voiture. Impossible de les prendre en photo dans la rue, alors on a construit tout un décor dans un studio londonien. La semaine suivante, les Beatles étaient en couverture du *Saturday Evening Post*. C'était en 1964. » (2) C'est également dans ce studio qu'eut lieu la photo « glamour », en décapotable de John Lennon (au fond à gauche), Paul McCartney (au fond à droite), George Harrison (devant à droite) et Ringo Starr (devant à gauche).

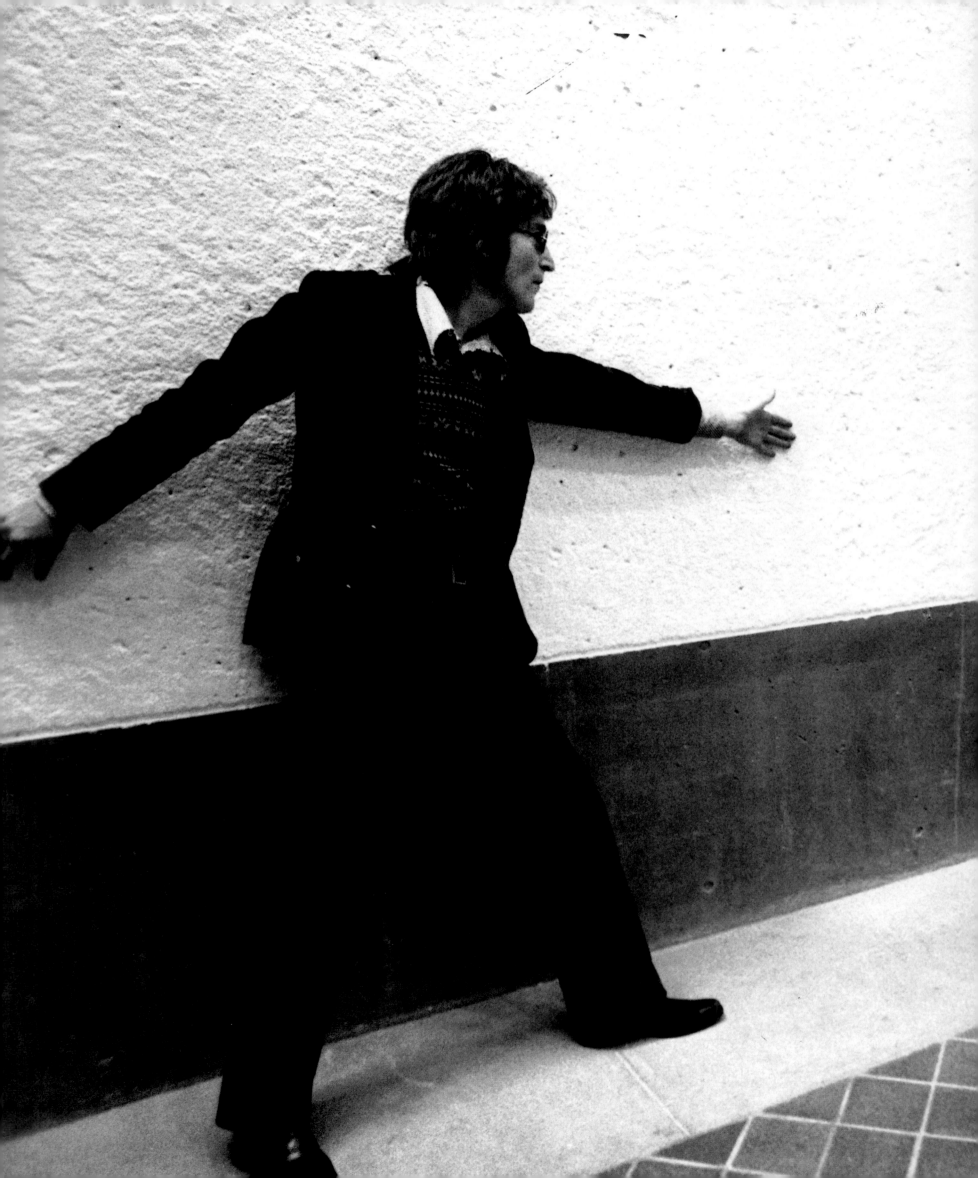

After the disintegration of the group in 1970, John Lennon lived with Yoko Ono, his second wife and a performing artist, in New York City. Many critics regarded this marriage as a disastrous liaison, "trivializing a great artist and idolizing a dubious performer." In 1980 Lennon was murdered.

John Lennon lebte nach der Trennung der Beatles 1970 mit seiner zweiten Frau Yoko Ono, einer Performance-Künstlerin, in New York. Vielen Kritikern galt diese Ehe als unheilvolle Liaison, »die einen großen Künstler trivialisiert und eine dubiose Artistin vergöttlicht«. Lennon erlag 1980 den Folgen eines Attentats.

Après la dissolution du groupe, en 1970, John Lennon vécut à New York avec sa seconde épouse, Yoko Ono, une artiste de happenings. De nombreux critiques jugèrent cette liaison funeste, « abaissant un grand artiste et divinisant une douteuse saltimbanque ». Lennon mourut en 1980 des suites d'un attentat.

NEAL SPITZER
UNDATED/O.D/S.D.

297

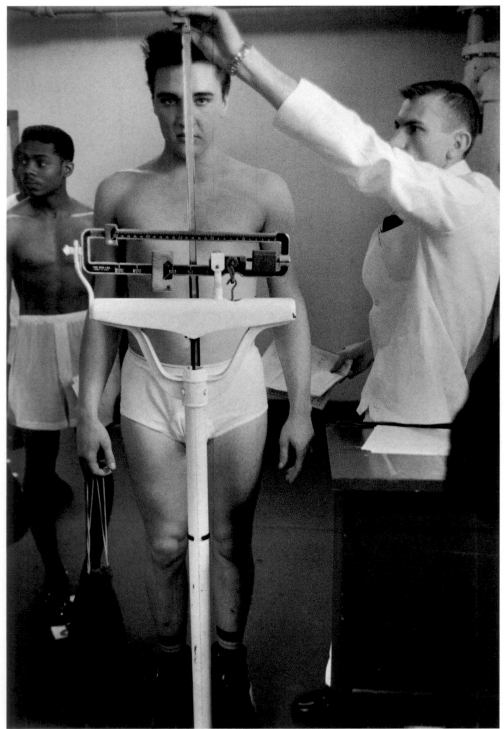

1 DON CRAVEN 1958

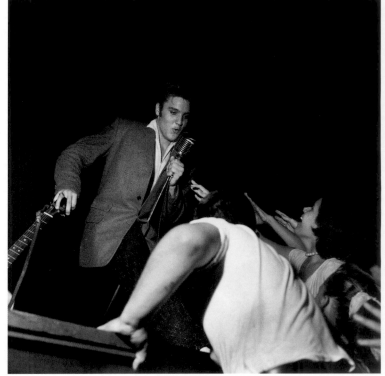

2 DON CRAVEN 1958

(1) Life gratefully jumped at the opportunity to present their readers with the half-naked body of Elvis "The Pelvis" Presley taken during a medical examination by a military doctor in 1958. (2) At the time the rock'n'roll singer had already been electrifying America's youth for two years with his erotic voice and sex-charged stage performances. His management made sure that the teenage idol remained in the headlines during his military service in Germany.

(1) Dankbar ergriff Life 1958 die Gelegenheit, den Lesern den halbnackten Körper von Elvis »The Pelvis« Presley bei der Musterung durch einen Militärarzt zu präsentieren.
(2) Seit zwei Jahren elektrisierte der Rock'n'Roll-Sänger die amerikanische Jugend durch seine erotische Stimme und seine sexgeladene Bühnenshow. Sein Management sorgte dafür, daß das Teenager-Idol auch während seiner Militärzeit in Deutschland in den Schlagzeilen blieb.

(1) En 1958, Life ne laisse pas passer cette occasion de présenter aux lecteurs le corps à demi-nu d'Elvis « The Pelvis » Presley, saisi pendant l'examen médical militaire.
(2) Depuis deux ans, la jeunesse américaine est électrisée par la voix et le jeu de scène du rock'n roller le plus sexy de l'époque. Son manager veilla à ce que l'idole des jeunes reste à la une des magazines pendant toute la durée de son service militaire, effectué en Allemagne.

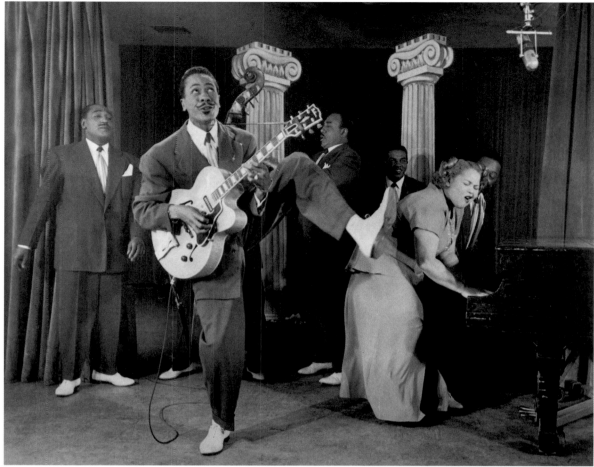

3 RALPH CRANE 1948

(3) Live performances were often broadcast during jazz disc jockey shows on American radio. Here Love Gibson and his Redcaps are having a jam session together with the pianist Paula Watson in a Los Angeles studio in 1948.
(4) One of America's most creative and productive jazz musicians, Duke Ellington, in a recording studio. Later in his life, his work was characterized by a more symphonic style, of which the suite "Harlem", dating from 1955, is a prime example.

(3) In den Jazz-Discjockey-Programmen der amerikanischen Radiosender gab es auch immer wieder Live-Auftritte. Hier in einem Studio in Los Angeles jammen Love Gibson und his Redcaps und die Pianistin Paula Watson, 1948. (4) Duke Ellington, einer der kreativsten und produktivsten Jazz-musiker Amerikas, im Aufnahmestudio. In seiner Spätphase dominierte der symphonische Stil, wie z.B. die Suite »Harlem« aus dem Jahr 1955.

(3) Les programmes de jazz de la radio américaine produisaient régulièrement des concerts live. Ici, Love Gibson and his Redcaps et la pianiste Paula Watson, en pleine jam session dans un studio de Los Angeles en 1948. (4) L'un des musiciens de jazz américains les plus inventifs et les plus productifs, Duke Ellington, en studio d'enregistrement. Dans sa dernière période, sa production fut dominée par un style symphonique, ainsi la suite « Harlem », en 1955.

4 O'CALLAGHAN UNDATED/O.D./S.D.

1 N.N. UNDATED/O.D./S.D.

JACK G

(1) Two musical pioneers at a joint rehearsal: trumpeter Louis Armstrong (left) popularized jazz towards the end of his career with songs such as "What a Wonderful World" (1968). The composer and conductor Leonard Bernstein (right) was equally successful at marrying serious and popular music. His compositions include the musical "West Side Story" (1957).
(2) Glenn Gould during an orchestral rehearsal in 1958. His musical genius and eccentric personality ensured him cult-status. He had an enormous impact on classical music which, among his contemporaries, can only be compared with "the Callas phenomenon".

(1) Zwei musikalische Grenzgänger bei einer gemeinsamen Probe – der Trompeter Louis Armstrong (links) popularisierte zum Ende seiner Karriere den Jazz mit Titeln wie »What a Wonderful World« (1968). Der Komponist und Dirigent Leonard Bernstein (rechts) trat genauso erfolgreich gegen die Trennung von ernsthafter und unterhaltender Musik ein und komponierte u.a. das Musical »West Side Story« (1957).
(2) Glenn Gould während einer Orchesterprobe, 1958. Seine musikalische Begabung und seine exzentrische Persönlich-keit prädestinierten den Pianisten zur Kultfigur mit einer Breitenwirkung, die in der klassischen Musik seiner Zeit nur mit dem Phänomen »Callas« zu vergleichen war.

(1) Deux musiciens qui se jouent des frontières répètent ensemble : le trompettiste Louis Armstrong (à gauche), qui, vers la fin de sa carrière, intéressa un public élargi avec des titres comme « What a Wonderful World » (1968) ; le compo-siteur et chef d'orchestre Leonard Bernstein (à droite), qui s'opposa avec le même succès à la séparation entre musique sérieuse et musique de divertissement, par exemple avec la comédie musicale « West Side Story » (1957).
(2) Glenn Gould pendant une répétition en 1958. Son talent musical et sa personnalité originale firent l'objet d'un véri-table culte et marquèrent la musique classique de son époque de manière comparable au phénomène « Callas ».

1 FRANCIS FUERST 1964

2 MANFRED KREINER UNDATED/O.D./S.D.

(1) Walt Disney, here in 1964 on a voyage from Italy to America, looked back on a splendid career. His cartoon characters, notably Mickey Mouse and Donald Duck, were international hits and created the financial basis for his legacy: the "Disneyworld" amusement parks. (2) Hugh Hefner in one of his Bunny clubs. In 1953 the publisher launched the successful "men's magazine", Playboy, which combined sex with serious upmarket journalism. Hefner marketed Playboy's trademark, the Bunnies, through a business empire of clubs and hotels which suffered financial difficulties in the 1980s.

(1) Walt Disney, hier 1964 auf einer Seereise von Italien nach Amerika, blickte auf einer Bilderbuch-Karriere zurück. Seine Comics wie Micky Maus und Donald Duck erzielten weltweite Erfolge und schufen die finanzielle Grundlage für sein Vermächtnis: die Freizeitparks »Disneyworld«. (2) Hugh Hefner in einer seiner Bunny-Clubs. Der Verleger startete 1953 das erfolgreiche Männermagazin Playboy, das Sex und anspruchsvollen Journalismus verband. Das Markenzeichen, die Bunnies, vermarktete Hefner in einem Konzern mit Clubs und Hotels, der allerdings in den 80er Jahren in die Krise geriet.

(1) Walt Disney, en 1964, sur un bateau qui le conduit d'Italie en Amérique, au terme d'une carrière digne d'un conte de fées. Ses personnages de dessins animés, comme Mickey Mouse et Donald Duck, ont obtenu un succès mondial et fourni la base financière du parc d'attraction « Disneyworld » qu'il laissera en héritage. (2) L'éditeur Hugh Hefner dans l'un de ses « Bunny-Clubs ». Il avait lancé en 1953 le « magazine pour hommes » Playboy, dont l'ambition était d'associer le sexe à un journalisme exigeant. Le lapin-symbole de la marque fut commercialisé par Hefner dans le cadre d'un consortium de clubs et d'hôtels, qui souffrit de la crise dans les années 80.

1 BENYAS KAUFMAN 1936

(1) The American athlete Jesse Owens at the 1936 Olympic
Games in Berlin. By winning four gold medals in sprinting
and long jump, he became an international star. His long-
jump world record of 26'9" (8.13 m) stood unequaled for 25
years.

(1) Der Amerikaner Jesse Owens bei den Olympischen
Spielen 1936 in Berlin. Mit vier Goldmedaillen im Sprint und
Weitsprung wurde er zum Weltstar. Sein Weitsprung-Welt-
rekord von 8,13 m bestand 25 Jahre.

(1) L'Américain Jesse Owens aux Jeux olympiques de 1936 à
Berlin. Avec quatre médailles d'or à la course de vitesse et
au saut en longueur, il devint une star mondiale. Son record
mondial au saut en longueur, 8,13 m, resta inégalé durant 25
ans.

2 GIL FRIEDBERG 1952

(2) Boxer Rocky Marciano (left) demonstrates the simple recipe of his success to his friend Tony de Marco: knock 'em out! In the year that this photo was taken, 1952, he became world boxing champion. (3) Cassius Clay before his boxing match against Sonny Liston in 1964. Clay subsequently won the world championship, but was stripped of his title in 1967, because he had joined the militant Black Muslims in 1965, changed his name to Muhammad Ali and refused to be enlisted into the US Army to fight in the Vietnam war.

(2) Rocky Marciano (links) zeigte 1952 seinem Freund Tony de Marco sein einfaches Erfolgsrezept: Hau drauf. Im gleichen Jahr wurde er Boxweltmeister. (3) Cassius Clay vor dem Boxkampf gegen Sonny Liston 1964. Clay gewann den Weltmeistertitel, der ihm jedoch 1967 wieder aberkannt wurde, denn der Boxer war 1965 den militanten Black Muslims beigetreten, änderte seinen Namen in Muhammad Ali und weigerte sich, im Vietnamkrieg zu kämpfen.

(2) En 1952, Rocky Marciano (à gauche) explique à son ami Tony de Marco une recette toute simple pour gagner : frapper. La même année, il devint champion du monde de boxe. (3) Cassius Clay avant le combat de boxe contre Sonny Liston, en 1964. Clay remporta le titre de champion du monde, qui lui fut retiré en 1967 pour cause de militantisme aux côtés des Black Muslims en 1965. Il avait changé son nom en Muhammad Ali et refusait de partir au Vietnam.

3 F. KAPLAN 1964

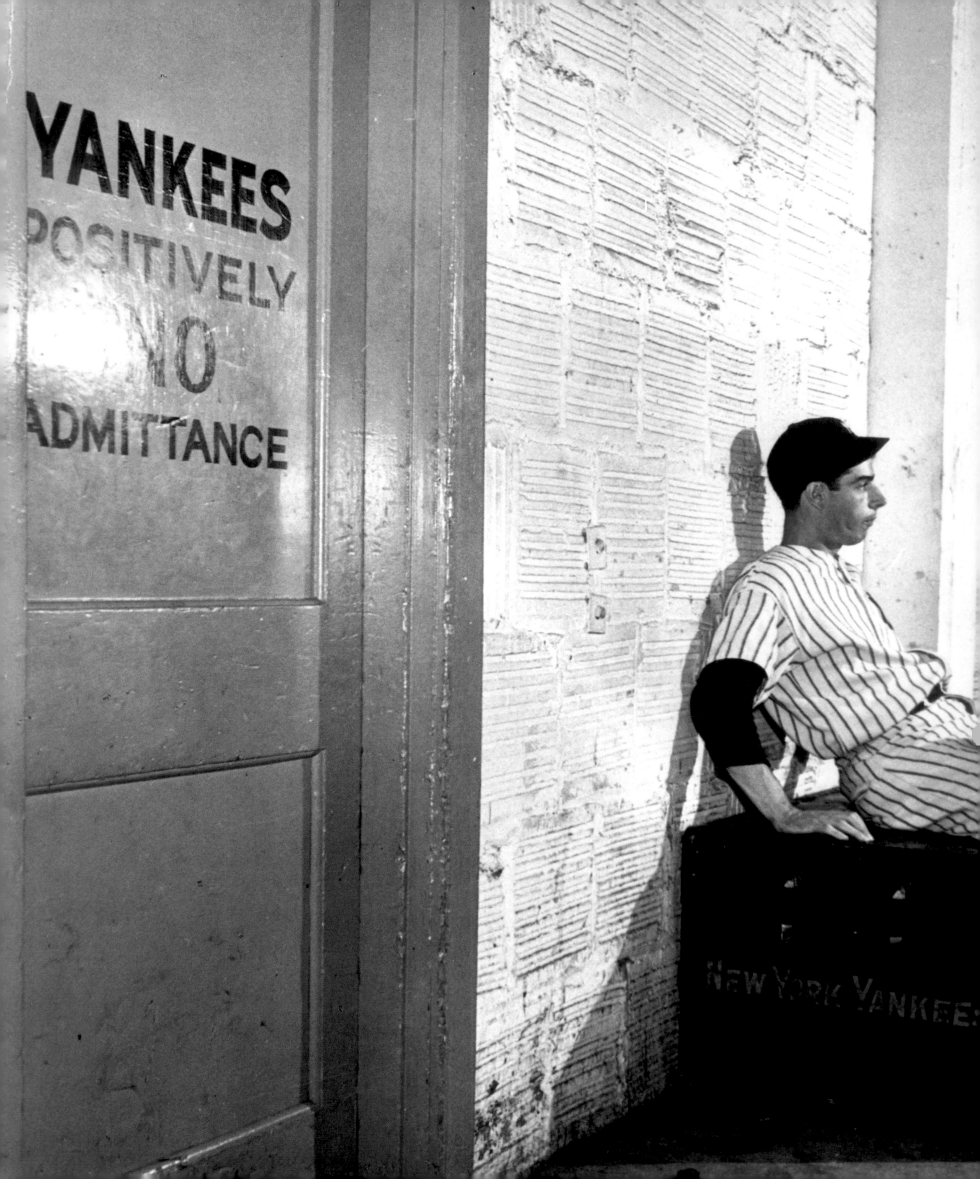

2 MICKEY OSTERREICHER 1996

GENE SMITH

(1) Baseball superstar Joe DiMaggio in front of the club house of the New York Yankees in 1941. Apart from his spectacular performances in the baseball park (one of his records stood for decades), his short marriage to Marilyn Monroe (1954–1956) caused quite an uproar in the media. (2) O. J. Simpson on his way to court. In 1996 the highly popular football star of the 1970s and 1980s was charged with murdering his wife and her lover. His much-publicized trial deeply split the American nation into Simpson supporters and Simpson opponents.

(1) Baseball-Superstar Joe DiMaggio vor dem Clubheim der New York Yankees, 1941. Neben seinem spektakulären Wirken auf dem Baseball-Feld – einer seiner Rekorde über- dauerte Jahrzehnte – erregte seine kurze Ehe mit Marilyn Monroe (1954–1956) Aufsehen in den Medien. (2) O. J. Simpson auf dem Weg zum Prozeß. Der überaus populäre Football-Star der 70er und 80er Jahre wurde 1996 ange- klagt, seine Ehefrau und deren Freund umgebracht zu haben und spaltete die US-Nation in Simpson-Verteidiger und -Ankläger.

(1) Joe DiMaggio, superstar de baseball, devant le club des Yankees en 1941. Outre ses performances spectaculaires au baseball – l'un de ses records resta inégalé pendant plusieurs décennies –, son bref mariage avec Marilyn Monroe (1954–1956) fit sensation dans les médias. (2) O. J. Simpson se rendant à son procès. Superstar du football dans les années 70 et 80, il fut accusé en 1996 d'avoir tué sa femme et l'amant de celle-ci. Le procès divisa l'Amérique entre accusateurs et défenseurs de Simpson.

Idyll and Paradise Lost
Idylle und
Verlorenes Paradies
Paysages de rêve et
paradis perdus

A satellite picture of the Earth taken in 1983. At the end of the 20th century an increasing number of ecosystems are collapsing, and press announcements of disaster are coming in thick and fast.

Satelliten-Blick auf die Erde, 1983. Im ausgehenden 20. Jahrhundert kollabieren immer mehr Ökosysteme, und die Katastrophenmeldungen überschlagen sich.

Image satellite de la Terre, 1983. En cette fin de 20ᵉ siècle, de plus en plus d'écosystèmes se désintègrent et les prévisions de catastrophes s'accumulent.

1 CLAUS MEYER UNDATED/O.D./S.D.

Ecosystems exist in a complex balance. (1) Still an idyll – the meandering Amazon. Around this great river the tropical rain forest is disappearing so dramatically due to uncontrolled logging that even state reforesting regulations cannot fill up the empty spaces. (3) Photos of the dying Aral sea in Central Asia would not have been available before Gorbachev's glasnost. Until then the Soviet Union had concealed all their environmental transgressions in a cloak of secrecy. The progressive shrinking of the Aral sea since 1918 is attributed to the construction of dams on its feeder rivers, built to ensure water supplies for the intensive irrigation required by cotton production.

Ökosysteme befinden sich in einem komplizierten Gleichgewicht. (1) Eine aussterbende Idylle – der mäandernde Amazonas. In seiner Nähe verschwindet der tropische Regenwald durch die unkontrollierte Holzwirtschaft so dramatisch, daß auch staatlich verordnete Wiederaufforstung die Lücken nicht schließen kann. (3) Bilder des sterbenden Aral-Sees in Zentralasien wären vor Gorbatschows »Glasnost« nicht möglich gewesen, denn die Sowjetunion hüllte bis dahin all ihre Umweltsünden unter einen Mantel des Schweigens. Dem Aral-See werden seit 1918 zugunsten der bewässerungsintensiven Baumwollproduktion die Zuläufe abgegraben.

Un écosystème est un équilibre complexe. (1) Mythe d'un paysage intact - l'Amazone aux innombrables méandres. De part et d'autre du fleuve, la forêt tropicale disparaît à telle allure, sous les coups d'une industrie du bois excessive, que les campagnes officielles de reboisement ne suffisent plus à colmater les brèches. (3) Ces images de la mer d'Aral en Asie centrale, où faune et flore sont en train de mourir, auraient été impossibles avant la glasnost de Gorbatchev. Jusqu'alors, toutes les abberrations écologiques de l'Union soviétique étaient tenues secrètes. Depuis 1918, tous les affluents de la mer d'Aral ont été détournés au profit de la culture intensive du coton.

(2) The dried-out Lake Isabelle in California documents the consequences of extensive agriculture and immense water misuse in America.

(2) Der ausgetrocknete Lake Isabelle in Kalifornien dokumentiert die Folgen von extensiver Land-wirtschaft und ungeheurem Wassermißbrauch in Amerika.

(2) En Californie, le lac asséché d'Isabelle donne une idée des dégats causés, aux Etats-Unis, par l'agriculture extensive et le gaspillage de l'eau.

2 NIK WHEELER UNDATED/O.D./S.D.

3 DAVID TURNLEY UNDATED/O.D./S.D.

1 R. L. RIDGWAY 1985

Vast amounts of carbon dioxide produced by burning fossil fuels contribute to the greenhouse effect, thought to be responsible for global warming. This warming in turn causes an increase in severe storms. (1) Tornado Ellis struck Kansas in 1985. These North American whirlwinds have a diameter of hundreds of feet and usually sweep over an area of only 12–20 miles. (2) Neither nature nor civilization places any obstacles in the way of sandstorms common to the Australian Outback.

Der Treibhauseffekt, verursacht durch Unmengen von CO_2-Abgasen, trägt wesentlich zum globalen Temperaturanstieg bei. Die Klimaveränderung läßt Häufigkeit und Intensität der Stürme zunehmen. (1) Tornado Ellis in Kansas 1985. Diese Wirbelstürme in Nordamerika haben einen Wirbeldurchmesser von einigen hundert Metern und bewegen sich meist nur über 20–30 Kilometer fort. (2) Das australische Outback bietet kaum natürliche oder künstlich angelegte Hindernisse für Sandstürme.

L'effet de serre, dû aux quantités de gaz carbonique rejetées dans l'atmosphère, contribue notablement au réchauffement général de la planète. Ce bouleversement climatique est à l'origine d'une augmentation de la fréquence et de l'intensité des tempêtes. (1) Tornade Ellis, Kansas, 1985. Certaines de ces tornades nord-américaines ont un diamètre de plusieurs centaines de mètres et se déplacent sur 20 ou 30 km. (2) En Australie, les tempêtes de sable trouvent peu d'obstacles naturels ou artificiels à l'intérieur des terres.

2 ROBERT GARVEY UNDATED/O.D./S.D.

3 FLIP SCHULKE 1961

(3) Hurricane Carla in Texas, 1961. This type of storm forms on the open sea of the Atlantic or Pacific Ocean. As a hurricane sweeps over islands and continents for periods of a few days up to a few weeks, it leaves an unequaled trail of devastation. (4) Scituate, a coastal town on the Atlantic Ocean in Massachusetts. Hurricane Hugo caused 5 billion US $ worth of damage in 1989.

(3) Hurrikan Carla in Texas, 1961. Hurrikans brauen sich auf der offenen See des Atlantik oder Pazifik zusammen und hinterlassen auf ihrem tage- bis wochenlangen Weg über Inseln und Festland eine beispiellose Spur der Verwüstung. (4) Scituate, eine kleine Stadt an der Atlantikküste in Massachusetts. Hurrikan Hugo verursachte 1989 in den USA 5 Milliarden Dollar Schaden.

(3) L'ouragan Carla, au Texas, 1961. Ce type de tempête se constitue au large de l'Atlantique ou du Pacifique et dévaste tout sur son passage, parcourant îles et terres durant des jours, parfois des semaines. (4) Scituate, une petite ville sur la côte atlantique, dans le Massachusetts. En 1989, l'ouragan Hugo provoqua des dommages s'élevant à 5 milliards de dollars.

4 RICK FRIEDMAN 1989

1 STEVE NORTHUP UNDATED/O.D./S.D.

The elemental forces of nature provide the onlooker with countless spectacles – yet, for those affected by it, such turmoils are serious trials of strength. (1) The atmosphere breaks into a magnificent extravaganza of lightning and thunder.

Urgewalten der Natur bieten dem Betrachter grenzenlose Schauspiele, dem Betroffenen meist folgenschwere Kraftproben. (1) Mit Blitz und Donner entlädt sich die Atmosphäre in einem effektvollen Schauspiel.

Les puissances naturelles à l'œuvre sont un spectacle incomparable pour l'observateur, mais parfois aussi des épreuves pénibles pour ceux qui en sont les victimes. (1) L'atmosphère se décharge de son électricité au moyen de l'éclair et du tonnerre.

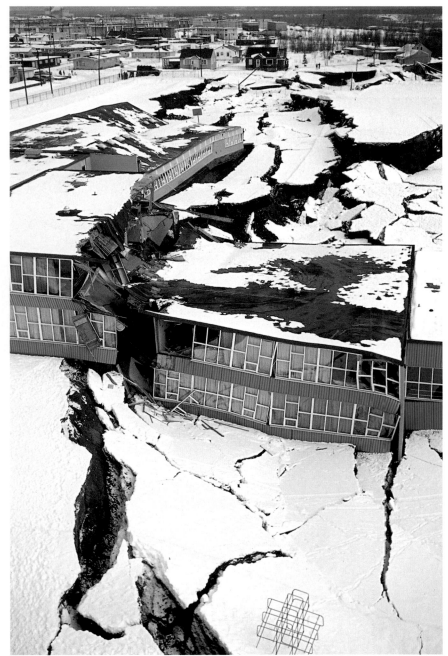

2 MARSHALL LOCKMAN UNDATED/O.D./S.D.

(2) Alaska is one of those parts of the world particularly at risk from earthquakes. Unstable and conflicting tectonic plates hold a latent danger for local inhabitants. (3) Annular eclipse of the sun – photographed by the "sun researcher" Emil Schulthess during his African expedition in the middle of the Rocher-Noir desert in Chad. This phenomenon can only be observed from this particular point in exact time intervals.

(2) Alaska gehört zu den erdbebengefährdeten Gebieten der Welt, in denen die unberechenbare Plattentektonik des Erdinneren eine latente Gefahr für die Bewohner darstellt. (3) Ringförmige Eklipse der Sonne – fotografiert vom »Sonnenforscher« Emil Schulthess auf seiner Afrika-Expedition inmitten der Wüste Rocher-Noir im Tschad. Dieses Phänomen ist nur in bestimmten Zeitabständen von dieser Stelle aus zu beobachten.

(2) L'Alaska fait partie des régions où les tremblements de terre, provoqués par les mouvements imprévisibles de la tectonique des plaques, menacent les habitants en permanence. (3) Anneau d'une éclipse de soleil, photographié par le « chercheur solaire » Emil Schulthess lors d'une expédition dans le désert du Rocher-Noir, au Tchad. Ce phénomène ne s'observe qu'à de rares périodes à un même endroit.

3 EMIL SCHULTHESS 1958

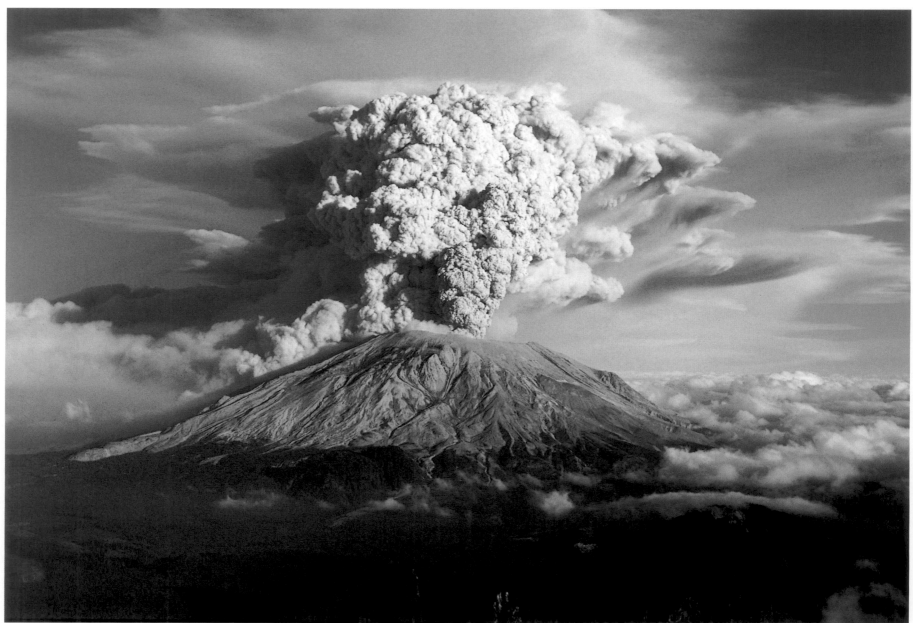

1 JAMES MASON 1980

Volcanoes regularly remind us that the center of the Earth consists of glowing masses of molten rock. (1) At exactly 8.39 a.m., on the morning of 18 May 1980, Mount St. Helens, one of the few active volcanoes on the American continent, which had been dormant since 1857, erupted. Scientists and journalists waited for weeks – and then the volcano transformed day into night in a matter of seconds. Ten people lost their lives. (2) On Hawaii, on the other hand, eruptions are almost a part of daily life. In the period between 1982 and 1984 Crater Kilauea erupted fire and lava on 17 different occasions.

Vulkane erinnern uns immer wieder daran, daß der Kern der Erde aus glühender Gesteinsmasse besteht. (1) Exakt um 8.39 Uhr, am Morgen des 18. Mai 1980, brach der Mount St. Helens aus, einer der wenigen noch aktiven Vulkane auf dem amerikanischen Kontinent. Seit 1857 war er nicht mehr aktiv. Wochenlang warteten Wissenschaftler und Presse – und dann verwandelte der Vulkan innerhalb von Sekunden den Tag in die Nacht und forderte 10 Menschenleben. (2) Auf Hawaii dagegen gehören Eruptionen fast zum Alltag. Im Zeitraum von 1982 bis 1984 spie der Kilauea 17 mal Feuer und Lava.

Les volcans nous rappellent en permanence que le noyau du globe terrestre est une masse minérale en fusion. (1) C'est à 8 heures 39 exactement, le matin du 18 mai 1980, que le mont Sainte-Hélène, un des rares volcans encore en activité sur le continent américain, entra en éruption. Il était resté inactif depuis 1857. Scientifiques et journalistes s'y attendaient depuis des semaines, mais en quelques secondes le volcan transforma le jour en nuit et coûta la vie à dix personnes. (2) A Hawaï au contraire, les éruptions font pratiquement partie du quotidien. De 1982 à 1984, le Kilauea a craché 17 fois le feu et la lave.

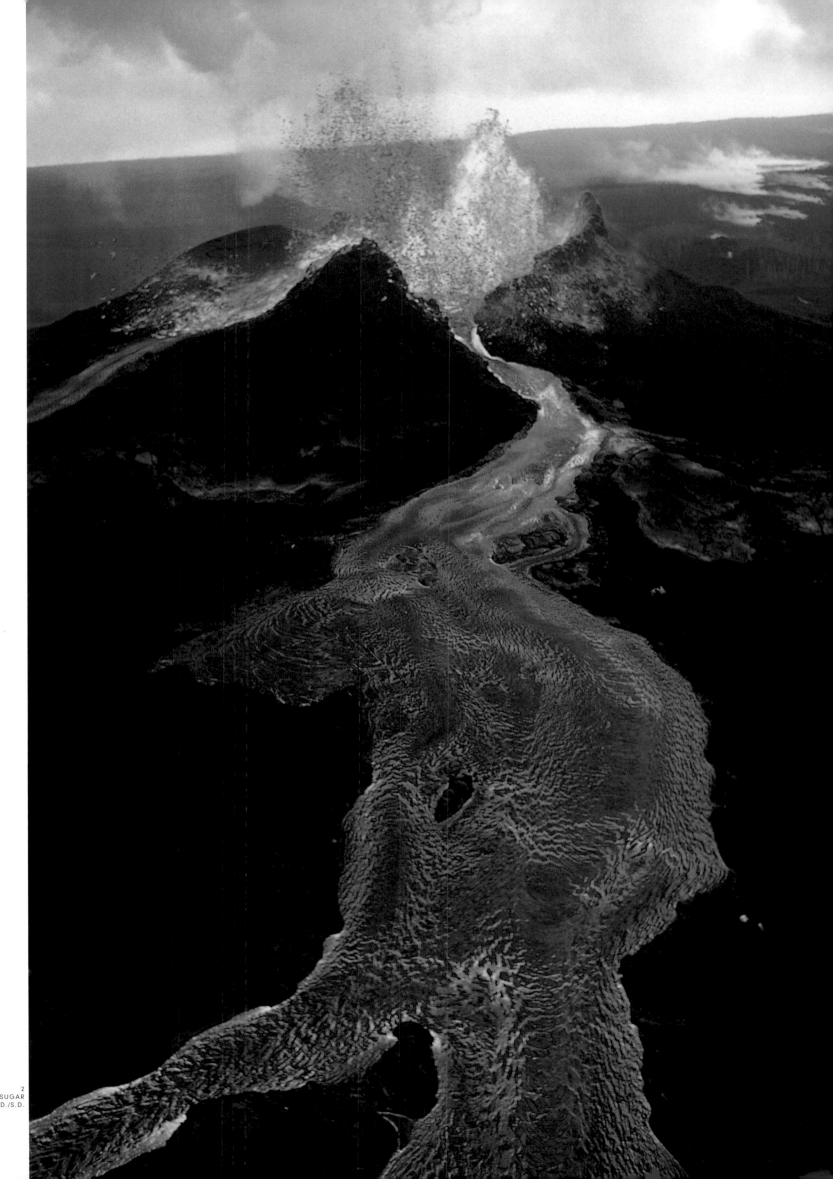

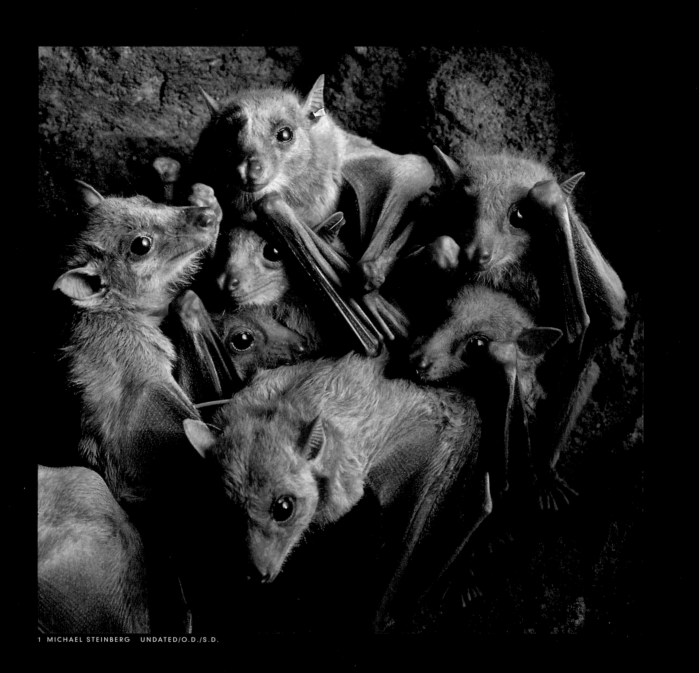

1 MICHAEL STEINBERG UNDATED/O.D./S.D.

(1) Every fourth mammal is a bat, and yet very little is known about this creature which lives in tropical and subtropical regions.

(1) Jedes vierte Säugetier ist eine Fledermaus, und trotzdem ist kaum etwas über diese Gattung bekannt. Sie ist in den Tropen und Subtropen heimisch.

(1) Un mammifère sur quatre est une chauve-souris et pourtant on sait peu de choses de cette espèce tropicale et subtropicale.

2 CLAUS MEYER UNDATED/O.D./S.D.

Claus Meyer worked in South America for over 30 years. He traveled in the rain forests with a tent studio and minimal lighting equipment in order to portray the animals better in the dark tropical jungle. (2) Humming birds. The rearing of the young is the sole responsibility of the female. (4) The humming bird beats its wings very fast when hanging in the air. Its name is derived from the humming sound this wing vibration resembles.(3) This scarce species of the Amazona genus parrot distinguishes itself by a very loud squawking.

Über 30 Jahre hat Claus Meyer in Südamerika gearbeitet. In die Regenwälder reiste er später immer mit einem Zeltstudio und einer minimalen Lichtausrüstung, um im düsteren tropischen Urwald die Tiere besser in Szene setzen zu können. (2) Kolibris. Die Aufzucht der Jungen ist allein Sache der Muttervögel. (4) Der rasend schnelle Flügelschlag der Kolibris erzeugt ein summendes Geräusch, von dem sich auch der englische Name humming bird herleitet. (3) Sonnensittiche sind eine sehr seltene Papageienart, die durch lautes Gekreische auf sich aufmerksam machen.

Claus Meyer a travaillé 30 ans en Amérique du Sud. Par la suite il a voyagé dans les forêts tropicales, équipé d'une tente-studio et d'un matériel d'éclairage sommaire lui permettant de portraiturer les animaux au sein de l'obscure forêt. (2) Colibris. L'élevage des petits est uniquement l'affaire de la mère. (4) Le très rapide battement d'ailes du colibri produit un bourdonnement qui lui a donné son nom anglais, humming bird. (3) Le conure soleil est une espèce très rare qui se distingue par ses cris aigus.

3 CLAUS MEYER UNDATED/O.D./S.D.

4 CLAUS MEYER UNDATED/O.D./S.D.

1 ROBERT GARVEY UNDATED/O.D./S.D.

2 FRED WARD UNDATED/O.D./S.D.

3 CLAUS MEYER UNDATED/O.D./S.D.

4 M. P. KAHL UNDATED/O.D./S.D.

(1) Australia. Young kangaroos soon become too big to fit into their mothers' pouches. Yet, they are dependent on their mother's milk for 17 months. (2) North America. In the spring the female raccoon usually has a litter of 3 to 6; the young stay with their mother for about 6 months. (3) The Amazon. As a rule, the jaguar is a solitary animal. However, males and females live as a couple for a few weeks in the mating season. (4) Africa. Male lions are extremely egoistic. If they succeed in breaking into a new pride, they kill all the offspring of their predecessor and secure their own genetic pool.

(1) Australien. Junge Känguruhs sind schon bald zu groß, um in den Beutel der Mutter zurückzukehren. Sie sind aber 17 Monate auf Muttermilch angewiesen. (2) Nordamerika. Im Frühling werfen die Waschbärweibchen in der Regel 3 bis 6 Junge, die ein halbes Jahr bei ihnen bleiben. (3) Amazonas. Der Jaguar lebt gewöhnlich alleine, doch bleiben Männchen und Weibchen in der Fortpflanzungszeit ein paar Wochen zusammen. (4) Afrika. Löwenmännchen sind äußerst selbstsüchtig. Brechen sie siegreich in ein neues Rudel ein, töten sie die Kinder der Vorgänger und pflanzen sich selbst fort.

(1) Australie. Les jeunes kangourous sont bien vite trop grands pour rester dans la poche de leur mère, mais ils continuent à vivre du lait maternel pendant 17 mois. (2) Amérique du Nord. Au printemps, la femelle du raton-laveur met bas 3 à 6 petits qui restent auprès d'elle pendant six mois. (3) Amazonie. Le jaguar vit le plus souvent seul, mais mâle et femelle passent ensemble quelques semaines pendant la période de reproduction. (4) Afrique. Le lion est foncièrement égoïste. Quand un mâle a remporté la victoire sur un autre et conquis sa troupe, il tue les petits de son prédécesseur et procède à la fondation d'une nouvelle lignée.

In the middle of the jungle in his tent studio, Claus Meyer fed carnivorous plants with insects to capture the "meat-eaters" in action. (1) A Venus-fly-trap, Dionaea muscipula. (2) A plant with a sticky trapping device of the genus Drosera binata.

Mitten im Urwald in seinem Zeltstudio fütterte Claus Meyer die Carnivoren mit Insekten und foto-grafierte die fleischfressenden Pflanzen in Aktion. (1) Eine Venusfliegenfalle, Dionaea muscipula. (2) Eine Klebfallenpflanze der Gattung Drosera binata.

Au milieu de la forêt vierge, dans sa tente-studio, Claus Meyer fournissait leur ration d'insectes aux plantes carnivores et pouvait ainsi les photo-graphier en action. (1) Dionaea muscipula, ou dionée tue-mouche. (2) Piège adhésif du genre Drosera binata.

1 CLAUS MEYER UNDATED/O.D./S.D.

2 CLAUS MEYER UNDATED/O.D./S.D.

3 JEFF ROTMAN UNDATED/O.D./S.D.

(3) The Clown Fish in the Red Sea live in a symbiotic relationship with sea anemones. The fish live among the poisonous tentacles of the plants, sheltered from predatory fish, and only leave this safe enclave for short periods to find food. (4) The first encounter of a newly-born tree-frog with the rain forest in Costa Rica. These insect-eating amphibians are well adapted to their natural habitat due to their incredible agility and the suction pads found underneath their limbs.

(3) Die Clownsfische im Roten Meer leben in Symbiose mit Seeanemonen. Die Fische leben zwischen den giftigen Fühlern der Pflanzen geschützt vor Raubfischen und verlassen diese nur kurz zur Nahrungsaufnahme. (4) Die erste Begegnung eines neugeborenen Laubfroschs mit dem Regenwald in Costa Rica. Mit Haftscheiben an den Gliedenden und einer ungeheuren Beweglichkeit überleben diese Amphibien als baumbewohnende Insektenfresser.

(3) Les poissons-clowns de la mer Rouge vivent en symbiose avec les anémones de mer. Le poisson se met à l'abri des prédateurs entre les tentacules vénéneuses de la plante qu'il ne quitte que brièvement pour se nourrir. (4) Premiers contacts du bébé grenouille verte avec la forêt tropicale, au Costa Rica. Grâce à leurs doigts pourvus de disques adhésifs et à leur incroyable rapidité, ces amphibies survivent sur les arbres en se nourrissant d'insectes.

4 STEVE WINTER UNDATED/O.D./S.D.

(1) The sand shark that lives off the North American coast is a predatory fish distinguished by its long, sharp teeth. Sharks continually lose their teeth, which are replaced by new ones.

(1) Der Sandhai, heimisch an der nordamerikanischen Küste, ist ein Raubfisch, der vor allem durch seine langen, spitzen Zähne auffällt. Haie verlieren andauernd Zähne, die durch nachwachsende ersetzt werden.

(1) Le requin de sable des côtes nord-américaines est un poisson carnassier qui se distingue par ses longues dents pointues. Les requins perdent continuellement leurs dents, qui repoussent régulièrement.

1 JOHN TROHA UNDATED/O.D./S.D.

2 JOHN EVERINGHAM UNDATED/O.D./S.D.

(2) A crocodile, here photographed in Australia, has a prominent long muzzle with numerous conical teeth. This predator grabs hold of its prey with its huge front teeth, and even chases its quarry under water (3) The piranha, which is generally found in the northern parts of South America, especially in the Amazon River basin, is armed with strong jaws and triangular, razor-sharp teeth. Piranhas live in groups and tear into the flesh of their victims with these fearfully efficient devices.

(2) Das Krokodil, hier in Australien fotografiert, ist berüchtigt wegen seiner langen Schnauze mit den vielen kegelförmigen Zähnen. Mit den großen Vorderzähnen packt es die Beute, die auch unter Wasser gejagt wird. (3) Der Piranha, der vor allem im Norden Südamerikas und dort im Amazonasbecken verbreitet ist, ist mit starken Kiefern und rasiermesserscharfen, dreieckigen Zähnen bewaffnet. Piranhas leben in Schwärmen und zerfleischen ihre Opfer auf schreckliche Weise.

(2) Un autre carnassier, le crocodile d'Australie, avec sa gueule allongée et ses nombreuses dents coniques. Ses grandes dents de devant lui servent à attraper sa proie, qu'il chasse jusque sous l'eau. (3) Le piranha, présent surtout dans le Nord de l'Amérique latine et dans le bassin amazonien, est pourvu d'une mâchoire puissante et de dents triangulaires aussi tranchantes qu'un rasoir. Il vit en bancs et mord la chair de ses victimes avec une efficacité saisissante.

3 CLAUS MEYER UNDATED/O.D./S.D.

1 M. P. KAHL UNDATED/O.D./S.D.

2 CLAUS MEYER UNDATED/O.D./S.D.

(1) A cheetah in Kenya. This predatory cat depends primarily on its extraordinary eyesight when it is out on the prowl, usually during daylight hours. Once it spots its prey, the cheetah stalks and then runs it down in a single, rapid charge. (2) A fer-de-lance (tropical pit viper) in the Amazon. This extremely venomous snake has sensory pits on both sides of its head underneath the eyes. These sensory organs help it locate its warm-blooded quarry during its nocturnal hunts.

(1) Ein Gepard in Kenia. Diese Raubkatze ist tag-aktiv, ihre Augen sind bei der Jagd der wichtigste Faktor. Wenn der Gepard seine Beute erspäht hat, schleicht er sich an und überrumpelt sie nach einem kurzen Sprint. (2) Eine Lanzenotter am Amazonas. Diese nachtaktiven Giftschlangen haben Sinnesgruben an beiden Seiten des Kopfes unter den Augen, mit denen sie warmblütige Beutetiere lokalisieren können.

(1) Guépard, au Kenya. Ce félin carnassier est un chasseur diurne et son meilleur atout est son regard aigu. Quand il a repéré sa proie, il s'approche en silence, puis lui saute dessus après une course-éclair. (2) Vipère fer-de-lance en Amazonie. Ce serpent nocturne et venimeux possède sous les yeux des fosses sensorielles qui lui permettent de localiser ses proies à sang chaud.

3 EMIL SCHULTHESS UNDATED/O.D./S.D.

4 FRED WARD UNDATED/O.D./S.D.

5 DAVID STONE UNDATED/O.D./S.D.

6 JAMES SUGAR UNDATED/O.D./S.D.

Animals' eyes are well adapted to their natural habitat. (4) The compound eye of the grasshopper provides it with all-round (360°) vision. The lens eye of vertebrates, on the other hand, enables these animals to focus. (3) A Nile crocodile, (5) an iguana on the Galapagos islands, (6) a hippopotamus in Zaire.

Die Augen der Tiere sind jeweils verhaltensangepaßt. (4) Das Facettenauge eines Grashüpfers ist auf Rundumsicht ausgerichtet. Die Linsenaugen der Wirbeltiere hingegen fokussieren: (3) Ein Nilkrokodil, (5) ein Leguan auf den Galapagos-Inseln, (6) ein Flußpferd in Zaire.

Les yeux des animaux sont toujours adaptés à leurs besoins : (4) L'œil à facettes d'une sauterelle lui donne une vision d'ensemble circulaire. L'œil à cristallin des vertébrés, au contraire, leur permet de focaliser le regard : (3) un crocodile du Nil, (5) un iguane aux îles Galapagos, (6) un hippo-potame au Zaïre.

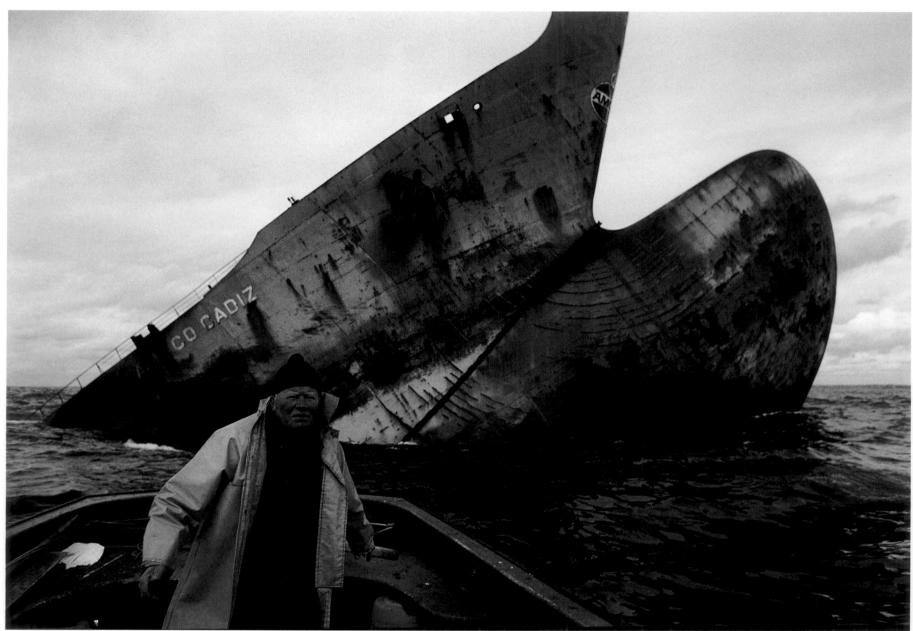

1 JOHN LAUNOIS 1978

Occasional alarms created by massive environmental disasters bring to international public attention the reality of ongoing water and air pollution as well as the daily destruction of flora and fauna on the "blue planet." (1) On 16 March 1978 the Amoco Cadiz, a tanker sailing under a Liberian flag of convenience, ran aground on the Breton coast and was subsequently smashed to pieces during a storm. No solution could be found to control the disastrous effect of the oil pollution on the environment.

Umweltkatastrophen machen die Weltöffentlichkeit von Zeit zu Zeit darauf aufmerksam, daß die Verschmutzung von Wasser und Luft sowie die Vernichtung von Flora und Fauna auf dem blauen Planeten täglich fortschreitet. (1) Am 16. März 1978 lief der unter liberianischer Billigflagge fahrende Tanker Amoco Cadiz vor der bretonischen Küste auf Grund und zerbarst im Sturm. Es stellte sich heraus, daß es kaum wirksame Mittel zur Katastrophenbekämpfung dieser Ölpest gab.

Les grandes catastrophes écologiques montrent périodiquement au public mondial la progression de la pollution de l'air et de l'eau, ainsi que de la destruction de la flore et de la faune de la « planète bleue. » (1) Le 16 mars 1978, le pétrolier libérien Amoco Cadiz coula au large de la côte bretonne et se disloqua dans la tempête. On découvrit alors qu'il n'existait aucun moyen efficace de lutter contre la pollution provoquée par ce type de catastrophe pétrolière.

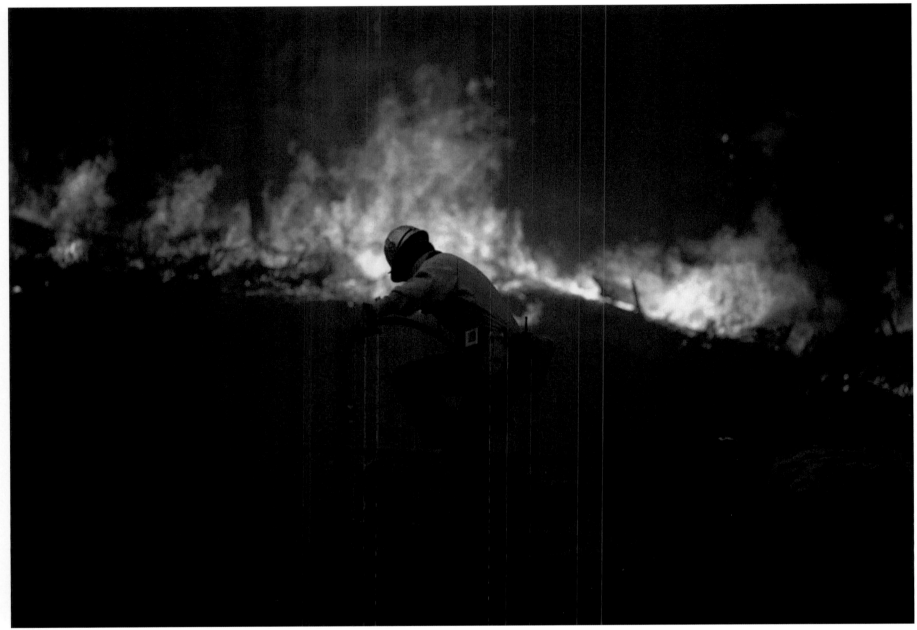

2 TED WOOD 1988

(2) Fires raging in Yellowstone Park in 1988. Almost half the forest was destroyed during this inferno. Gross human negligence combined with increasingly long periods of drought all too frequently result in the destruction of vast parts of forests.

(2) Brände im Yellowstone Park 1988. Fast die Hälfte des gesamten Waldgebietes wurde bei diesem Brand vernichtet. Grober menschlicher Leichtsinn, gepaart mit immer längeren Dürreperioden, zerstören weltweit große Waldflächen.

(2) Incendie dans le parc de Yellowstone, en 1988. Près de la moitié du domaine forestier fut anéanti par le feu. L'inconscience humaine, associée à des périodes de sécheresse toujours plus longues, provoque partout dans le monde la destruction d'immenses surfaces boisées.

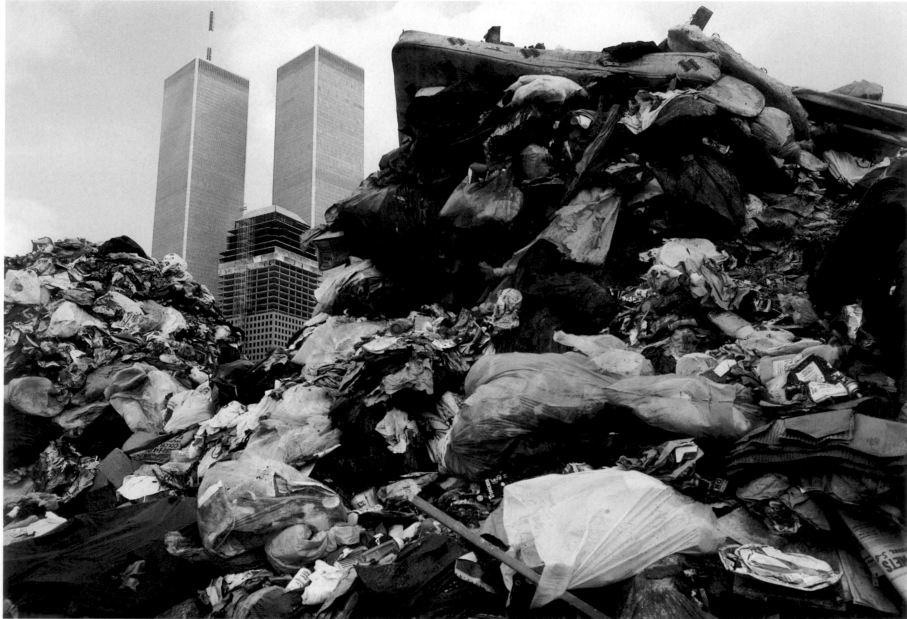

1 HAROLD STUCKER 1991

Despite virtuous efforts to conserve the environment, catastrophic scenarios are all too common. (1) New York City's garbage mountains almost completely conceal Manhattan's Skyline. In 1991, the USA was the world's biggest producer of domestic garbage.

Allem Umweltschutz zum Trotz finden sich immer wieder Horrorszenarien. (1) Die Müllberge von New York City verdecken fast Manhattans Skyline. 1991 produzierten die USA die größte Hausmüllmenge weltweit.

En dépit de tous les efforts de protection de la nature, les scénarios-catastrophe se multiplient. (1) Les décharges de la ville de New York obscurcissent l'horizon de Manhattan. En 1991, les Etats-Unis sont le plus grand producteur de déchets domestiques du monde.

2 CHARLES MASON 1989

(2) An unnecessary accident with grievous consequences off Alaska. The Exxon Valdez ran into a reef on 24 March 1989 and spilt 44,000 tons of oil. Some 2.6 million sea birds and marine mammals fell victim to the subsequent oil pollution which stretched along a 700 mile long coastline.
(3) A mysterious lake of death in Cameroon. One night in August 1986 a strange gas appeared from Lake Lwi and killed both the people and animals in the town of Nios. Since then scientists from across the world have flocked to Cameroon in an attempt to unravel the secret.

(2) Ein folgenschwerer Unfall ohne Not vor Alaska. Die Exxon Valdez lief am 24. März 1989 auf ein Riff. 44 000 Tonnen Öl verursachten auf 1100 km Küste eine Ölpest, an der ca. 2,6 Millionen Seevögel und Meeressäuger verendet sind.
(3) Der mysteriöse See des Todes in Kamerun. Eines Abends im August 1986 strömte ein Gas aus dem See Lwi und tötete im Dorf Nios Menschen und Tiere. Seitdem kamen Wissenschaftler aus der ganzen Welt, um dieses Rätsel zu ergründen.

(2) Un accident lourd de conséquence et parfaitement inutile, près de l'Alaska. Le 24 mars 1989, l'Exxon Valdez heurta un rocher. 44 000 tonnes de pétrole se répandirent sur 1100 km d'une côte peuplée de 2,6 millions d'oiseaux de mer et de mammifères marins, provoquant un désastre écologique. (3) Le mystérieux lac de la mort, au Cameroun. Un soir d'août 1986, un nuage gazeux s'éleva sur le lac Lwi et tua hommes et bêtes dans le village de Nios. Depuis, les scientifiques affluent du monde entier pour tenter de résoudre cette énigme.

3 PETER TURNLEY 1986

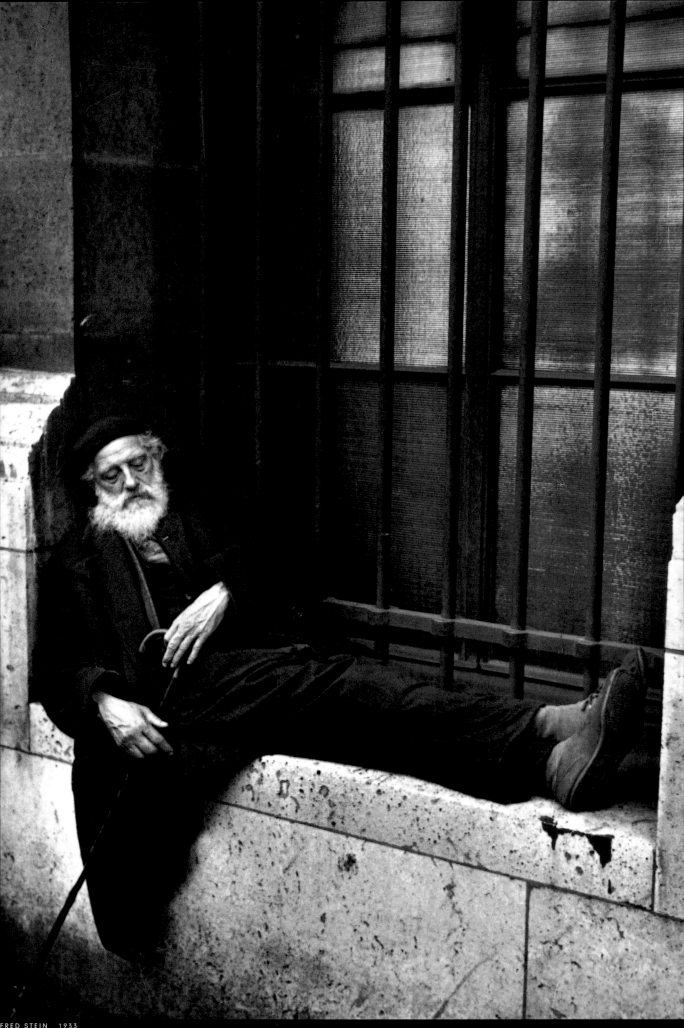

FRED STEIN 1933

Ordinary People – Extraordinary Lives
Kleine Leute – Großer Auftritt
Petites gens – grandes photos

A *clochard* in Paris, photographed in 1933. The dark side of human existence is a constant and dominant theme in the history of photojournalism.

Ein Clochard in Paris, 1933. Die Schattenseiten des menschlichen Daseins sind ein durchgängiges und dominantes Motiv in der Geschichte des Fotojournalismus.

Un clochard à Paris, 1933. Les côtés de l'ombre de l'existence humaine sont un motif général et prédominant dans l'histoire du photojournalisme.

ORDINARY PEOPLE, EXTRAORDINARY LIVES

The stories that are written by life are the essence of photojournalism. The social documenters Jacob Riis and Lewis Hine fought with their cameras against child labor and the catastrophic working conditions in American factories. The life of the "ordinary people" and the suffering of the "oppressed" were the founding theme for photojournalism. In 1933, US President Franklin D. Roosevelt declared a state of national emergency. His New Deal transformed American society into a liberal welfare state. Aside from big industry the agricultural sector suffered particularly during the crisis. It was the responsibility of the Farm Security Administration photographers, amongst them Walker Evans, Dorothea Lange and Carl Mydans, to document the farmers' misery and the work of political reform. They were all working for the Democrat government in order to convince its critics of the consequences of the crisis, but also to convey the effectiveness of Roosevelt's liberal social policies – with images which told of the daily lives of workers and farmers. It can therefore be seen that photojournalism began at a time when the reporting of human misery was not only politically advantageous but was also directly commissioned by government authorities. However, the threat of war transformed conditions and the Farm Security director Roy Stryker gave the order to conjure up an image of a thriving society. When America entered the war in 1941 it was not only the project photographers who were placed under the command of the Office of War Information. The authorities now ordered war reporting and encouraging news from the home front. With the normalization of daily life after the war, the era of the story-teller of everyday life began. As regards this subject, Howard Chapnick prized above all the lack of excitement in everyday experiences and the search for the unknown in what is apparently familiar: "Indecisive moments can be photographed decisively. W. Eugene Smith's reportage on the Spanish Village is a classic example. Smith documented the stuff of life with depth, intelligence, form, content, and meaning. Indecisive moments are all around us, waiting for energetic and observant photographers to shoot. 'Daily Life'-photography offers individuals more freedom to seek out their own vision and the opportunity to develop a recognizable style."

Howard Chapnick in his plea for everyday stories formulated the ideal. In retrospect Smith certainly appears to be a master of this area of photojournalism, his first attempts made at Black Star. Another agency photographer, hitherto largely unnoticed but equally talented, is Kosti Ruohomaa. For 20 years of his life this melancholy exiled Finn

KLEINE LEUTE, GROSSER AUFTRITT

Geschichten, die das Leben schreibt – sie sind die Essenz des Fotojournalismus. Bereits die Sozialdokumentaristen Jacob Riis und Lewis Hine kämpften mit ihren Kameras gegen Kinderarbeit und katastrophale Arbeitsbedingungen in amerikanischen Fabriken. Das Leben der »kleinen Leute« und das Leid der »Unterdrückten« war das fotojournalistische Thema der ersten Stunde. 1933 rief der US-Präsident Franklin D. Roosevelt den nationalen Notstand aus und baute mit seiner Politik des New Deal die amerikanische Gesellschaft zu einem liberalen Sozialstaat um. Neben der Großindustrie litt die Landwirtschaft besonders unter der Krise. Die Misere der Farmer und die politische Reformarbeit zu dokumentieren, war die Aufgabe der Farm-Security-Administration-Fotografen, unter ihnen Walker Evans, Dorothea Lange und Carl Mydans. Sie alle arbeiteten für die Regierung der Demokraten, um deren Kritiker von der Tragweite der Krise, aber auch von der Wirksamkeit der sozialliberalen Politik Roosevelts zu überzeugen – mit Bildern, die aus dem täglichen Leben der Arbeiter und Farmer erzählten. Der Fotojournalismus startete also zu einer Zeit, in der die Berichterstattung über menschliches Elend nicht nur als politisch opportun galt, sondern direkt von Regierungsbehörden in Auftrag gegeben wurde. Die drohende Kriegsgefahr wandelte jedoch die Vorzeichen, und der Farm-Security-Direktor Roy Stryker gab die Devise aus: »Beschwört das Bild des Überflusses!« Mit dem amerikanischen Kriegseintritt 1941 waren nicht nur die Projektfotografen dem Office of War Information unterstellt. Nun verordneten die Behörden Kriegsberichterstattung und aufmunternde Berichte von der Heimatfront. Mit der Normalisierung des täglichen Lebens nach dem Krieg setzte die Zeit der Geschichtenerzähler des menschlichen Alltags ein. Howard Chapnick schätzte an diesem Sujet vor allem die Unaufgeregtheit alltäglicher Erfahrungen und die Suche nach dem Unbekannten im scheinbar Bekannten: »Unentschiedene Augenblicke können entschieden fotografiert werden. W. Eugene Smiths Essay über das spanische Dorf ist ein klassisches Beispiel dafür. Smith dokumentiert den Stoff des Lebens mit Intensität, Intelligenz, Form, Inhalt und Bedeutung. Unentschiedenen Augenblicken begegnen wir ständig – und sie warten auf entschlossene und wachsame Fotografen, die sie festhalten. Alltags-Fotografie eröffnet dem Individuum mehr Freiheit, den eigenen Blick zu suchen und gibt ihm Gelegenheit, einen eigenen Stil zu entwickeln.«

Howard Chapnick formulierte in seinem Plädoyer für Alltagsgeschichten das Ideal. Im Rückblick erscheint Smith sicherlich als ein Meister auf diesem Feld des Fotojournalismus, der bei Black

PETITES GENS, GRANDES PHOTOS

Les histoires écrites par la vie sont l'essence même du photojournalisme. Jacob Riis et Lewis Hine luttaient déjà avec leur appareil photo contre le travail des enfants et les conditions de travail catastrophiques dans les fabriques américaines. La vie des petites gens et la souffrance des opprimés furent des thèmes photojournalistiques de la première heure. En 1933, le président américain Franklin D. Roosevelt déclarait l'état d'urgence et transformait les États-Unis avec sa politique du New Deal en un État social-libéral. L'industrie lourde et l'agriculture surtout souffraient particulièrement de la crise. La tâche des photographes de la Farm Security Administration, comme Walker Evans, Dorothea Lange et Carl Mydans, était de documenter la misère des fermiers et le travail de réforme politique. Travaillant tous pour le gouvernement démocrate, afin de convaincre ses détracteurs de l'ampleur de la crise, mais aussi pour justifier l'efficacité de la politique sociale de Roosevelt, ils montraient la vie quotidienne des ouvriers et des fermiers. Le photojournalisme commença ainsi à une époque où le reportage consacré à la misère humaine n'était pas seulement considéré comme opportun sur le plan politique, mais encore directement commandé par les autorités. Avec la montée progressive du risque de guerre, le mot d'ordre du directeur de la Farm Security, Roy Stryker, changea : « Montrez-nous des images d'excédents ! » L'entrée en guerre des États-Unis, en 1941, plaça les photographes sous l'autorité de l'Office of War Information, qui leur demanda non seulement des reportages de guerre, mais aussi des images rassurantes de ce qui se passait aux États-Unis même, sur le « front du pays ». La normalisation de l'après-guerre vit naître l'ère des reportages dédiés à la vie quotidienne. Dans ce domaine, Howard Chapnick était surtout intéressé par l'immuabilité des événements quotidiens et par la recherche de l'inconnu dans l'apparemment connu : « Les moments d'indécision peuvent être photographiés de manière décisive », répétait-il. Le travail de W. Eugene Smith sur « le Village espagnol » en est un exemple classique. Smith y a décrit la vie en profondeur et avec intelligence, apportant la forme, le contenu et le sens. Les moments d'indécision sont tout autour de nous, attendant d'être saisis par des photographes attentifs et prompts à réagir. « La photographie de la vie quotidienne offre à chacun plus de liberté pour déterminer sa propre vision et développer un style caractéristique », écrivait Chapnick.

Le plaidoyer de Howard Chapnick pour la photographie de la Daily Life posait un idéal. Avec le recul, Smith, qui fit ses premiers pas de photojournaliste chez Black Star, apparaît comme l'un des maîtres du genre. Le travail d'un autre photographe

photographed virtually exclusively his new home of Maine and the surrounding New England states. He created high photographic art, as in his "Winterstories," which were collected in the anthology of the ten best *Life* essays. The exhibition "Family of Man" established and honored these everyday journalistic stories of the 1940s and 1950s as an art form. The further developments of the next decades are apparent in the Harlem reportages and specific portraits of children and youth by agency photographers presented in the current volume. Fred Stein's "Street Photography" of the 1950s concentrated on the idyllic play of children in the street. John Launois' color portrait of an adolescent with a bare torso in the 1960s thrives on the tension between the body language of machismo and childishly aggressive gestures and facial expressions. Joseph Rodriguez' children and youngsters at the end of the 1980s live in a mire of criminality, narcotics and family violence; the look in their eyes is one of deep despair. Whilst the social situation has certainly worsened with the passing of time, it is apparent by contrast that with the passing of time the photographers are making an ever more critical and humanly-involved intervention in the conflict situation which already existed in the 1950s. American photojournalism of the last 60 years, presented here in the documented work of Black Star photographers, has remained faithful to the original theme of human misery and social conflicts. These images tell of racism, sectarianism, narcotics addiction, criminality and illness and read like a horror trip through the obsessions of everyday life. The stories written by life in the last decades have become ever more brutal. Howard Chapnick was not the man to keep his eyes naively closed to this fact, but equally a view of the world that solely presented its darker aspects was too one-sided for him, and so he gave photojournalists and editors a serious piece of advice two years before his death in 1996, in his book "Truth Needs No Ally": "A documentary photographer can see the world as a montage of madness, death and destruction, or he can appreciate the rich variety of life. People experience joy as well as despair. Documentary photography is all-encompassing, and it has room for both points of view." Concluding words which are more forward-looking would be hard to find in a mediumistic age which is always simply engaged in the search for the latest trend and newest sensations, an age where the journalist is becoming ever less the traditional reporter and ever more the trendsetter himself.

Star seine ersten Gehversuche machte. Ein anderer Fotograf der Agentur, bisher weitgehend unbeachtet, steht gleichberechtigt neben ihm: Kosti Ruohomaa, der melancholische Exilfinne, fotografierte 20 Jahre seines Lebens fast ausschließlich seine neue Heimat Maine und die umliegenden New-England-Staaten. Er kreierte dabei hohe fotografische Kunst wie in seinen »Winterstories«, die in den Sammelband der zehn besten *Life*-Essays aufgenommen wurden. Die Ausstellung »Family of Man« etablierte und würdigte diese journalistischen Alltagsgeschichten der 40er und 50er Jahre auch als Kunstform. Die Weiterentwicklung in den nächsten Jahrzehnten zeigt sich in den im vorliegenden Band präsentierten Harlem-Essays der Agenturfotografen und ihren spezifischen Kinder- und Jugendbildern. Fred Steins »Street Photography« der 50er Jahre konzentrierte sich auf das idyllische Spiel der Kinder auf der Straße. John Launois' Farbporträt eines Halbwüchsigen mit freiem Oberkörper in den 60ern lebt von dem Spannungsfeld der Machismo-Körpersprache und der kindlich-aggressiven Mimik. Joseph Rodriguez' Kinder und Jugendliche leben Ende der 80er Jahre in einem Sumpf von Kriminalität, Drogen und familiärer Aggression; ihre Blicke strahlen eine tiefe Verzweiflung aus. Zwar hat sich die soziale Situation im Lauf der Zeit verschärft, doch im Vergleich fällt auf, daß die Fotografen parallel dazu immer kritischer und menschlich tiefer in die Konfliktsituation, die bereits in den 50er Jahren existierte, eindringen. Der amerikanische Fotojournalismus der letzten 60 Jahre, hier in den Arbeiten der Black-Star-Fotografen präsentiert, ist dem Thema der ersten Stunde, dem menschlichen Elend und den sozialen Konflikten, treu geblieben. Diese Bilder künden von Rassismus, Sektierertum, Drogensucht, Kriminalität und Krankheit und lesen sich wie ein Horrortrip durch die Obsessionen des menschlichen Alltags. Die Geschichten, die das Leben der letzten Jahrzehnte schreibt, werden immer härter. Howard Chapnick war kein Mann, der vor dieser Tatsache naiv die Augen verschlossen hielt. Ihm war diese ausschließliche Sicht der Welt jedoch zu einseitig, und so gab er zwei Jahre vor seinem Tod 1996 den Fotojournalisten und Redakteuren einen ernstzunehmenden Hinweis in seinem Buch »Truth Needs No Ally«: »Ein Dokumentarfotograf kann die Welt als Montage aus Wahnsinn, Tod und Zerstörung sehen – oder aber er schätzt gerade die reiche Vielfalt des Lebens. Die Menschen erleben beides, Freude ebenso wie Verzweiflung. Dokumentarfotografie ist allumfassend – sie hat Raum für beide Perspektiven.« Zukunftweisendere Schlußworte lassen sich nicht finden in einer medialen Zeit, die immer nur auf der Suche nach dem letzten Trend und den neuesten Sensationen ist. In einer Zeit, in der der Journalist sich immer weiter von der traditionellen Rolle des Berichterstatters entfernt und selbst zum Trendsetter wird.

de l'agence, jusqu'à présent méconnu, ne lui cède en rien. Kosti Ruohomaa, Finlandais d'origine, photographia pendant 20 ans le Maine, où il s'était installé, et les États environnants de la Nouvelle-Angleterre. Il a ainsi produit des chefs-d'œuvre de l'art photographique comme ses «Winterstories» («Histoires d'hiver»), qui furent publiées dans le recueil des dix meilleurs reportages de *Life*. L'exposition «Family of Man» donna à ces reportages consacrés à la vie quotidienne des années 1940–1950 leurs lettres de noblesse et en fit une forme d'art à part entière. L'évolution des années suivantes est présentée dans cet ouvrage par la série de reportages consacrés par les photographes de l'agence à Harlem et à la jeunesse. Dans les années 1950, la «photographie de rue» de Fred Stein se concentra sur une vision idéalisée des jeux des enfants dans la rue. Réalisé dans les années 1960, le portrait en couleurs d'un adolescent torse nu de John Launois joue à plein de l'ambivalence entre une attitude «macho» et une gestuelle agressive et enfantine. A la fin des années 1980, les enfants et les adolescents de Joseph Rodriguez basculent dans un univers de criminalité, de drogue et d'agressions. Leurs regards expriment un malaise profond. Certes, la violence dans les rapports sociaux s'est progressivement accrue, mais parallèlement aussi on assiste à une implication de plus en plus profonde, humaine et critique, des photographes dans les situations conflictuelles. Le photojournalisme américain des soixante dernières années, présenté ici à travers le travail des photographes de Black Star, est resté fidèle à son thème initial, la misère humaine et les conflits sociaux. Misère qui se manifeste sous forme de racisme, de sectarisme, de dépendance à la drogue, de criminalité et de maladie. Ces images, véritable plongée dans l'horreur, résument les drames et les obsessions qui marquent la vie quotidienne de l'homme, dont les témoignages sont devenus sans cesse plus durs au cours des dernières décennies. Howard Chapnick fut le dernier à garder les yeux obstinément et naïvement fermés face à cette vision du monde, trop unilatérale et exclusive à son goût. Deux ans avant sa mort, survenue en 1996, il donna un avertissement sérieux aux photographes et aux journalistes à travers son livre «Truth Needs No Ally» («la Vérité n'a pas besoin d'allié»). «Un photographe peut voir le monde comme un assemblage de folie, de mort et de destruction, mais il peut aussi apprécier l'immense variété de la vie. Les gens éprouvent tout aussi bien la joie que le désespoir. La photographie documentaire est réceptive à tout et offre de la place pour les deux points de vue», écrit-il. Mais les conseils permettant de défricher l'avenir ne sont plus de mise dans une époque médiatique perpétuellement en quête de modes et de sensations nouvelles. Une époque où le journaliste s'éloigne de plus en plus de son rôle traditionnel de témoin pour devenir lui même un «faiseur de modes».

1 PAUL BUCHANAN / (ANN HAWTHORN) UNDATED/O.D./S.D.

THE PICTURE MAN

Paul Buchanan (b. in Hawk, North Carolina, 1910, d. 1987) described himself throughout his life as only a "Picture Man" – never as a photographer or artist. Fom 1920 to 1951 he traveled, first on foot and later by car, through the mountainous regions of North Carolina, where he earned his livelihood as an itinerant photographer. Buchanan never staged his photos. He always left it to his clients to decide how they wanted to present themselves in front of the camera. No details are available about the people he photographed. His works are unequaled documents of how the Appalachians saw themselves. The photojournalist, Ann Hawthorne, discovered these gems in the 1970s and published them in the 1993 book "The Picture Man."

THE PICTURE MAN

Paul Buchanan (geb. 1910 in Hawk, North Carolina, gest. 1987) hat sich zeitlebens immer nur als *Picture Man* bezeichnet und sich nie als Fotograf oder Künstler betrachtet. Von 1920 bis 1951 reiste er zu Fuß und später mit dem Auto durch die Bergregionen North Carolinas und verdiente sein Geld als Wanderfotograf. Buchanan hat seine Fotos nie inszeniert. Immer hat er es seinen Kunden überlassen, wie sie sich vor seiner Kamera präsentieren wollten. Angaben über die Porträtierten gibt es nicht. Seine Arbeiten sind einzigartige Dokumente der Selbstsicht der Appalachen. Die Fotojournalistin Ann Hawthorne entdeckte diese Schätze in den 70er Jahren und gab sie 1993 in dem Buch »The Picture Man« heraus.

THE PICTURE MAN

Paul Buchanan (né en 1910 à Hawk, Caroline du Nord, décédé en 1987) se dénommait lui-même *Picture Man,* l'homme-image, et ne s'est jamais vu ni comme un photographe, ni comme un artiste. De 1920 à 1951, il se déplaça à pied, puis en voiture, à travers les régions montagneuses de la Caroline du Nord, gagnant sa vie comme photographe ambulant. Il ne mettait jamais en scène ses prises de vues, mais laissait ses clients se présenter devant l'appareil comme ils le souhaitaient. Aucune donnée ne subsiste sur l'identité de ses sujets. Ses travaux sont des documents uniques sur la vision qu'avaient d'eux-mêmes les Appalaches. La photojournaliste Ann Hawthorne a découvert ces trésors dans les années 70 et les a publiés en 1993 sous le titre « The Picture Man ».

2 PAUL BUCHANAN / (ANN HAWTHORN) UNDATED/O.D./S.D.

3 PAUL BUCHANAN / (ANN HAWTHORN) UNDATED/O.D./S.D.

4 PAUL BUCHANAN / (ANN HAWTHORN) UNDATED/O.D./S.D.

1 FRED STEIN UNDATED/O.D./S.D.

PARIS, NEW YORK

Fred Stein (b. 1909 in Dresden, d. 1967 in New York) studied law during the Weimar Republic, where he was committed to the left-wing socialist movement. After the National Socialists came to power in 1933, the newly-wedded Stein fled to France, with the Leica he had received as a wedding present in his meagre luggage. Paris in the early 1930s was the attractive mecca for many Jewish and political emigrants from Germany. Stein moved in the intellectual circles of the city and began to portray local poets and philosophers with his Leica. It was not long before he developed considerable photographic abilities.

PARIS, NEW YORK

Fred Stein (geb. 1909 in Dresden, gest. 1967 in New York) studierte zur Zeit der Weimarer Republik Jura und engagierte sich in der sozialistischen Bewegung. Nach der Machtergreifung der Nationalsozialisten 1933 floh der frisch Verheiratete nach Frankreich, im kargen Gepäck die zur Hochzeit geschenkte Leica. Paris war Anfang der 30er Jahre das Zentrum für viele jüdische und politische Emigranten aus Deutschland. Stein bewegte sich in den intellektuellen Zirkeln der Stadt und begann, mit seiner Leica die mit ihm befreundeten Dichter und Denker zu porträtieren. Schnell entwickelte er erstaunliche Fähigkeiten.

PARIS, NEW YORK

Fred Stein (né en 1909 à Dresde, décédé en 1967 à New York) fit des études de droit sous la République de Weimar et s'engagea dans le mouvement socialiste. Après la prise de pouvoir national-socialiste en 1933, il émigra en France, emportant dans son maigre bagage un Leica reçu pour son récent mariage. Au début des années 30, Paris était un centre pour beaucoup d'exilés juifs et politiques d'Allemagne. Stein évoluait dans les cercles intellectuels de la ville et se mit à portraiturer ses amis poètes et penseurs à l'aide de son Leica. Son étonnant talent se développa rapidement.

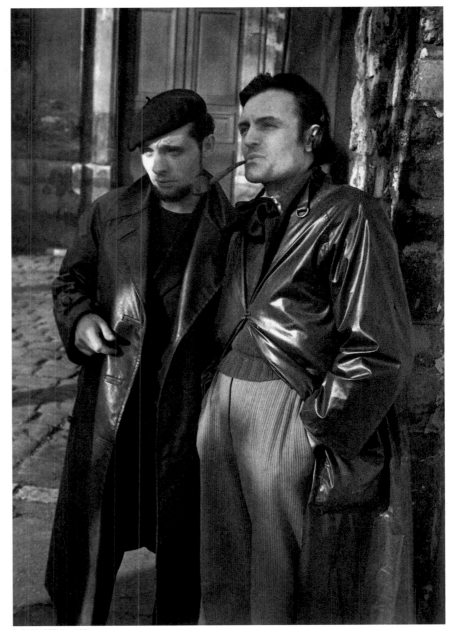

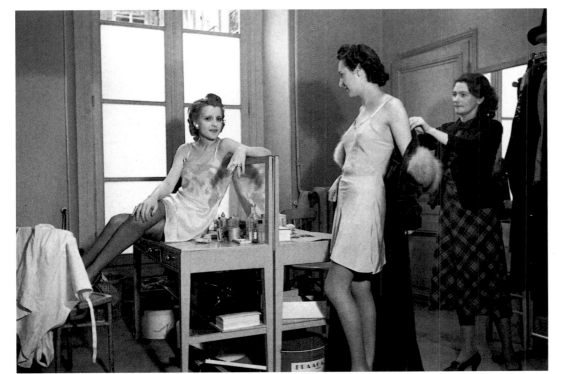

(1, 2, 4) Apart from portrait photography, Fred Stein also conquered with his camera the newly discovered terrain of his exile – Paris and the Parisians. (3) Two friends in 1936. Although he enjoyed studio work, his great passion was capturing the photojournalistic spontaneous portrait.

(1, 2, 4) Neben der Porträtfotografie eroberte Fred Stein mit der Kamera auch das für ihn neue Terrain des Exils – Paris und die Pariser. (3) Zwei Freunde 1936. Neben der Arbeit im Studio liebte er das fotojournalistische spontane Porträt.

(1,2,4) Outre la photographie de portrait, Fred Stein conquit avec son appareil un autre territoire, tout aussi nouveau pour lui : Paris et les Parisiens. (3) Deux amis, en 1936. Le photographe sortait volontiers de son studio pour réaliser des portraits plus spontanés, dans un style journalistique.

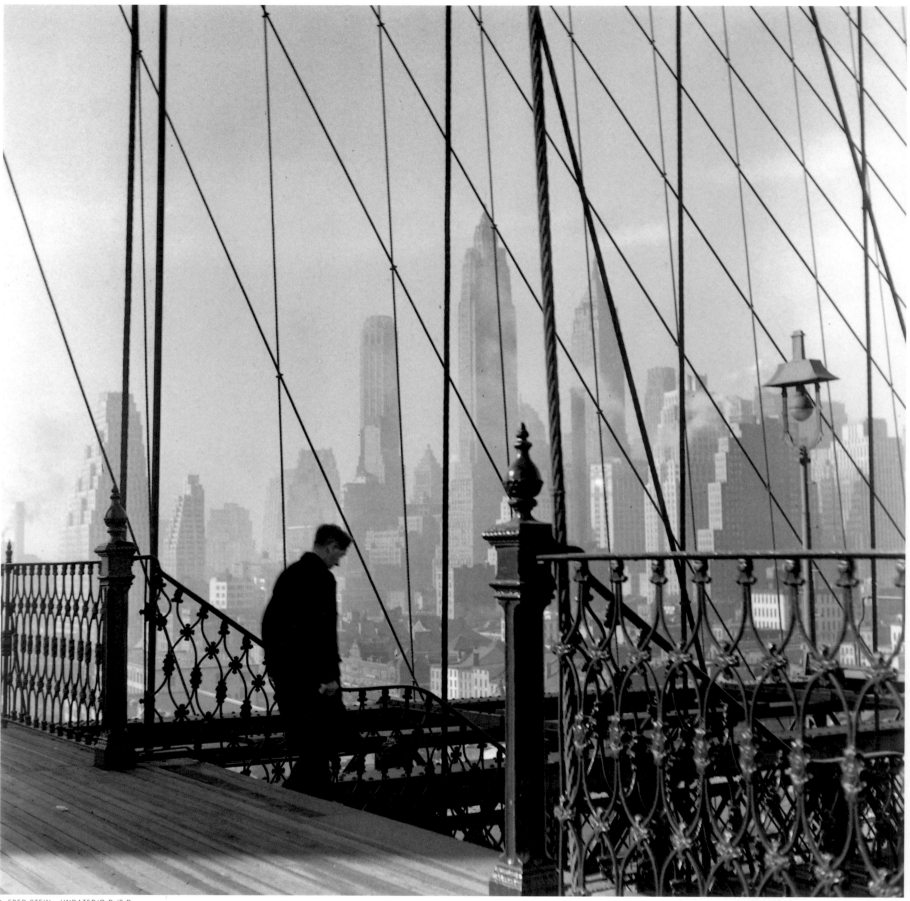

1 FRED STEIN UNDATED/O.D./S.D.

(1) Stein preferred to work without being commissioned by a magazine. In this way his personal high aesthetic standards were his only commitment. (2, 3) 5th Avenue was the lifeline of Manhattan in the 1940s. (4) Stein's photography is characterized by his gift for finding an unusual perspective for insignificant matters.

(1) Stein zog es vor, nicht im Auftrag eines Magazins zu arbeiten. So war er nur seinen eigenen ästhetischen Standards verpflichtet. (2, 3) 5th Avenue war in den 40er Jahren die Lebensader Manhattans. (4) Steins Fotografie zeichnet sich dadurch aus, daß er auch für das Rand-geschehen immer eine ungewöhnliche Perspektive fand.

(1) Stein travaillait de préférence hors contrat. Ainsi, il n'était engagé qu'envers ses propres critères esthétiques. (2, 3) Dans les années 40, 5th Avenue était le pouls de Manhattan. (2) La photographie de Stein se distingue par l'acuité du regard posé sur les événements périphériques.

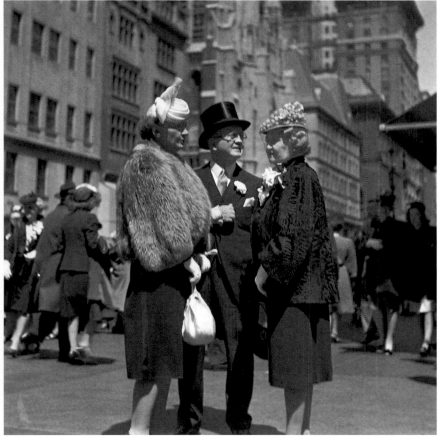

2 FRED STEIN UNDATED/O.D./S.D.

3 FRED STEIN UNDATED/O.D./S.D.

4 FRED STEIN UNDATED/O.D./S.D.

Fred Stein and his wife, Lilo, had to flee the Nazis after the German occupation of France. In 1941 they escaped to New York City, where Stein continued to work as a photographer and found his photographic home in exile with Black Star. He said of his work: "One moment is all you have. Like a hunter in search of a target, you look for the one sign that is more characteristic than all the others."

Fred Stein und seine Frau Lilo mußten nach der deutschen Okkupation Frankreichs vor den Nationalsozialisten fliehen. 1941 entkamen sie nach New York. Stein setzte auch dort seine fotografische Arbeit fort und fand bei Black Star seine fotografische Heimat im Exil. Seine Arbeit charakterisierte er selbst: »Man hat nur einen einzigen Augenblick. Wie ein Jäger auf der Suche nach seiner Beute sucht man nach einem Zeichen, das charakteristischer ist als alle anderen.«

Fred Stein et son épouse Lilo durent fuir les nazis, quand la France fut occupée par les Allemands. En 1941, ils se réfugièrent à New York où Stein poursuivit ses travaux, se trouvant à Black Star une nouvelle patrie. De son travail il disait : « Un instant, c'est tout ce qu'on a. Comme un chasseur à la poursuite d'une cible, on cherche le signe qui est plus caractéristique que tous les autres. »

1 RALPH CRANE UNDATED/O.D./S.D.

AMERICAN YOUTH

The Swiss emigrant Ralph Crane (b. 1913 in Geneva) came to New York in 1940. During the 1950s, he chronicled America's youth through his photographs. From 1941 to 1951, he worked exclusively for Black Star. Later on he also photographed for *Life*. "Black Star helped me tremendously by supplying excellent ideas for picture stories and did a great job in selling them." In old age he returned to Switzerland.

AMERIKANISCHE JUGEND

Der Schweizer Emigrant Ralph Crane (geb. 1913 in Genf) kam 1940 nach New York und wurde vor allem in den 50er Jahren mit seinen Bildern zum Chronisten der amerikanischen Jugend. Von 1941 bis 1951 arbeitete er ausschließlich für Black Star, später dann für *Life*. »Black Star half mir enorm bei der Suche nach guten Ideen für Fotostories und sorgte für einen hervorragenden Verkauf meiner Bilder.« Crane wählte seinen Alterssitz in der Schweiz.

JEUNESSE AMERICAINE

L'émigré suisse Ralph Crane (né en 1913 à Genève) arriva à New York en 1940 et devint, surtout dans les années 50, le chroniqueur photographique de la jeunesse américaine. De 1941 à 1951, il travailla exclusivement pour Black Star, plus tard pour *Life*. «Black Star m'a énormément aidé en me donnant d'excellentes idées de reportages et a fait du très bon travail en les vendant.» Pour ses vieux jours, Crane a choisi de retourner en Suisse.

2 RALPH CRANE UNDATED/O.D./S.D.

(1) One of Ralph Crane's pictures, which was chosen by Edward Steichen for the famous "Family of Man" exhibition, aptly captures the behavior of postwar California. (2) "Chicken" was a widely played game at that time. To test their youthful nerve, postwar hot-rodders raced customized jalopies at speeds of 70 mph until somebody "chickened out" by grabbing the steering wheel to keep the car from running into another car or into a tree. Crane remarked wryly: "Surprisingly, some of this generation of young Californians survived."

(1) Edward Steichen wählte u.a. dieses Bild von Crane für die Ausstellung »Family of Man«, um den Lebensstil der Nachkriegsjugend in Kalifornien zu illustrieren.
(2) Chicken war ein weitverbreitetes Spiel zu dieser Zeit. Um ihre jungen Nerven zu testen, rasten hot-rodders mit alten Schrottautos mit ca. 110 km/h, bis jemand von ihnen die Nerven verlor und das Steuer ergriff, was sie chickened out nannten. Crane konstatierte trocken: »Überraschenderweise überlebten einige aus dieser Generation junger Kalifornier.«

(1) Edward Steichen choisit entre autres cette photo de Crane pour l'exposition « Family of Man » afin d'illustrer le mode de vie de la jeunesse d'après-guerre en Californie.
(2) Le chicken était un jeu très répandu à l'époque. Pour tester leurs nerfs juvéniles, les hot-rodders des années 50 « gonflaient » leurs voitures et les lançaient à 110 km/h jusqu'à ce que l'un d'eux se « dégonfle » et saisisse le volant pour empêcher sa voiture d'en emboutir une autre ou un arbre. Crane constatait froidement :« Le plus surprenant est que certains de ces jeunes Californiens ont survécu. »

1 JOHN REES UNDATED/O.D./S.D.

2 JOE COVELLO UNDATED/O.D./S.D.

3 ROSS MADDEN UNDATED/O.D./S.D.

AMERICAN EVERYDAY LIFE IN THE 1940S AND 1950S

(1) In 1953 two thirds of all households had a television set, by 1957 it was already an estimated 85 percent. In the beginning of the television era enormous socio-political expectations were projected for the new medium. (2) The American manufacturer IBM took a leading position in the computer world in the 1960s with its System 360. This mainframe computer was used for activities such as bookkeeping, stock control and the booking of plane tickets. (3) Mass vaccinations, intro-duced during the 1950s Eisenhower era, paved the way for the subsequent defeat of polio. (4) Life peeps behind the screens of a fashion production in 1944. (5) The proud owner of a private nuclear blast-proof bunker tests the radioactivity of his new domicile with a Geiger counter. In the postwar period, the nuclear bomb was systematically trivialized both in politics and by the media.

AMERIKANISCHER ALLTAG DER 40ER UND 50ER JAHRE

(1) 1953 stand in zwei Dritteln aller Haushalte ein Fern-sehapparat, 1957 sprach man bereits von 85 Prozent. Zu Beginn des Fernsehzeitalters wurden große gesellschafts-politische Erwartungen an das neue Medium gestellt. (2) Der amerikanische Hersteller IBM baute in den 60er Jahren mit seinem System 360 seine führende Stellung in der Computerbranche aus. Die Kunden nutzten die Groß-rechner für die Buchführung und Lagerverwaltung bis hin zur Buchung von Flügen. (3) In der Eisenhower-Ära der 50er Jahre wurde mit Massenimpfungen der Grundstein für den Sieg gegen die Kinderlähmung gelegt. (4) Life schaute 1944 gerne hinter die Kulissen einer Modepro-duktion. (5) Der stolze Besitzer eines privaten Atom-bunkers testet mit dem Geigerzähler die Radioaktivität seines neuen Domizils. In der Nachkriegszeit wurde die Atombombe systematisch durch Politik und Medien bagatellisiert.

LA VIE DE TOUS LES JOURS DANS L'AMERIQUE DES ANNEES 40 ET 50

(1) En 1953, deux tiers des foyers possédaient un télé-viseur. En 1957, on parlait déjà de 85%. Au début de l'ère télévisuelle, on mit de grandes espérances sociales et politiques dans le nouveau medium. (2) La société américaine IBM édifia sa position dominante dans le monde de l'informatique dès les années 60 avec le System 360. Les supercalculateurs étaient utilisés pour la comptabilité, le stockage, ou encore les réservations de vols. (3) Dans les années 50, sous Eisenhower, fut entre-prise l'éradication de la poliomyélite, avec la vaccination systématique des enfants. (4) En 1944, Life se glissait volontiers derrière les coulisses de la mode. (5) Le fier possesseur d'un abri anti-atomique privé teste, avec un compteur Geiger, la radioactivité de son nouveau domicile. Après la guerre, la bombe atomique et ses dangers étaient systématiquement minimisés par les politiciens et les médias.

4 RALPH CRANE 1944

5 GORDON TENNEY 1955

6 CHARLES STEINHEIMER 1941

7 JOE COVELLO 1956

(6) In 1941 a couple practicing "boompsadaisy dancing" in the jazz club "Leon and Eddie's." Jazz and its associated music styles, such as swing, represented not only freedom, movement and improvisation but also sexual emotions. (7) Twist dancers, here in a New York rock'n'roll club fifteen years later, move freely on the dance floor. It looked as if everybody was dancing with everybody else, which in itself was already seen as muddling up conventional relationship structures.

(6) Im Jazz-Klub »Leon and Eddie's« übte sich 1941 ein Paar im *Boompsadaisy Dancing*. Neben Freiheit, Bewegung und Improvisation wurden auch schon sexuelle Emotionen mit Jazz und seinen Stilrichtungen wie Swing verbunden. (7) 15 Jahre später. Die Twisttänzer, hier in einem New Yorker Club, bewegten sich offen über die Tanzfläche, jeder schien mit jedem zu tanzen. Allein damit brachten sie das konventionelle Beziehungsgefüge durcheinander.

(6) 1941, chez « Leon and Eddie's », un club de jazz: un couple danse le *Boompsadaisy*. Le jazz et le swing ont toujours été associés à la liberté, au mouvement, à l'improvisation, mais aussi à l'émoi sexuel. (7) 15 ans plus tard. Les danseurs de twist, ici dans un club rock'n'roll de New York, se déplacent sur toute la piste, chacun dansant avec chacun, ce qui bouleversait les rapports conventionnels.

(1–3) Rees' child stories depict the idyll of the middle class. American educationalists of the 1940s and 1950s also idealized this milieu and saw material security as a prerequisite for the opportunity to develop freely.

(1–3) Rees' Kindergeschichten zeichnen die Mittelstands-Idylle. Auch amerikanische Pädagogen der 40er und 50er Jahre idealisierten dieses Milieu und setzten materielle Sicherheit gleich mit freien Entfaltungsmöglichkeiten für Kinder.

(1–3) Les vignettes de Rees décrivent le monde protégé de la classe moyenne américaine. Les pédagogues américains des années 40 et 50 idéalisaient ce milieu, en considérant la sécurité matérielle comme la condition nécessaire et suffisante d'un développement équilibré de l'enfant.

2 JOHN REES UNDATED/O.D./S.D.

3 JOHN REES UNDATED/O.D./S.D.

CHILDREN

John Rees (b. 1925 in Ohio) studied photography in New York and was recommended to Black Star by his professor in 1951. He returned to Ohio and specialized in depicting everyday life. He particularly enjoyed working with children. The following features were all done by him without an assignment – with great success. Today Rees is retired and lives in Ohio; his work lives on in numerous books and calendars.

KINDER

John Rees (geb. 1925 in Ohio) studierte Fotografie in New York und wurde 1951 von seinem Professor an Black Star empfohlen. Er ging zurück nach Ohio und spezialisierte sich auf Alltagsgeschichten. Besonders liebte er die Arbeit mit Kindern. All diese Geschichten machte er ohne Auftrag – mit großem Erfolg. Rees wohnt heute als Rentner in Ohio, seine Arbeit lebt in zahllosen Büchern und Kalendern weiter.

ENFANTS

John Rees (né en 1925 en Ohio) fut recommandé à Black Star par l'un de ses professeurs de photographie à New York. Il rentra dans l'Ohio et se spécialisa dans les histoires du quotidien, aimant surtout travailler avec les enfants. Toutes ses séries furent réalisées hors contrat – avec succès. Rees passe aujourd'hui sa retraite dans l'Ohio, ses travaux ont illustré de nombreux livres et calendriers.

"I AM A KOREAN WAR WIDOW"

Cal Bernstein (b. 1920 in New York) worked as a freelance photographer for Black Star and was based all over the USA. His photo reportages prove that it is no comedown for a photographer to focus his lens on the countryside. The Korean War (1950–1953) was declared by the US President without congressional approval. The very unpopular war did not result in flag-waving patriotism – neither at the front nor at home. It exacted a heavy toll: on the American side there were some 33,000 fatalities and more than 100,000 were wounded. Bernstein's photo reportage from Salt Lake City captivates in a powerful way the despair of the bereaved loved ones back at home. It reveals insight into the thoughts of the widow of a 29-year-old marine officer, Robert Dern.

»ICH BIN EINE KOREA-KRIEGSWITWE«

Cal Bernstein (geb. 1920 in New York) fotografierte als Freelancer für Black Star in den Vereinigten Staaten. Seine Fotoessays waren der Beweis dafür, daß das Augenmerk auf Geschichten aus der Provinz keinen fotografischen Rückschritt bedeutet. Den Koreakrieg (1950–1953) führten die USA, ohne den Kongreß um Erlaubnis gefragt zu haben. Kriegsbegeisterung und Hurra-Patriotismus herrschten weder an der Front noch in der Heimat. Der Krieg forderte auf amerikanischer Seite 33 000 Tote und mehr als 100 000 Verletzte. Die Verzweiflung der Hinterbliebenen faßte Bernstein in seinen exemplarischen Fotoessay aus Salt Lake City und zeichnete die Gedanken der Witwe des 29jährigen Marineoffiziers Robert Dern auf.

«JE SUIS UNE VEUVE DE LA GUERRE DE COREE»

Cal Bernstein (né en 1920 à New York) travaille en *freelance* pour Black Star aux Etats-Unis. Ses essais photographiques offrent la preuve que l'attention portée à des événements provinciaux n'exprime pas une régression. Les Etats-Unis entrèrent dans la guerre de Corée (1950–1953) sans l'aval du Congrès. L'enthousiasme guerrier ne régnait ni sur le front ni à domicile. La guerre fit 33 000 morts et plus de 100 000 blessés du côté américain. Le désespoir des familles fut saisi par Bernstein dans son travail exemplaire sur Salt Lake City, comme ici, où il parvient à nous montrer les pensées de la veuve de l'officier de marine Robert Dern, 29 ans.

1
CAL BERNSTEIN
1953

2 CAL BERNSTEIN 1953

3 CAL BERNSTEIN 1953

4 CAL BERNSTEIN 1953

With his feature on the widow Lola Dern and her children, Vicki and Terry, Bernstein gave a very personal touch to the Cold War. (2) "When I read about the truce talks and the prisoner exchange, I thought if only he could have lasted another little while." (1) "In the last letter that I got from Bob he foresaw his fate. The letter told me what to do in case he didn't return." The widow however drew new courage from her anguish. (4) "My first impulse after the shock was to get right down on the floor with those kids and act like Bob always used to." (3) "After so much thinking, talking and planning, my eldest daughter Vicki and I decided to go back to Morehead City and start a nursery school."

Bernstein verlieh mit seiner Geschichte über die Witwe Lola Dern und die Kinder Vicki und Terry dem Kalten Krieg eine ganz persönliche Note. (2) »Als ich von den Waffenstillstandsverhandlungen und dem Gefangenenaustausch las, dachte ich: Wenn er doch nur ein wenig länger durchgehalten hätte.« (1) »Im letzten Brief, den ich von Bob erhielt, schien er sein Schicksal vorauszusehen. Er schrieb mir, was ich tun sollte, wenn er nicht zurückkäme.« Die Witwe schöpfte aber aus der Verzweiflung neuen Mut. (4) »Mein erster Impuls nach dem Schock war, mich mit den Kindern auf den Boden zu legen und mit ihnen so zu spielen, wie Bob es immer getan hatte.« (3) »Nach langem Nachdenken und vielen Gesprächen und Überlegungen beschlossen meine älteste Tochter Vicki und ich, nach Morehead City zurückzugehen und einen Kindergarten aufzumachen.«

Avec son reportage sur Lola Dern et ses enfants, Vicki et Terry, Bernstein a donné à la guerre froide une note particulière. (2) « Quand je lisais qu'on en était aux pourparlers de trève et aux échanges de prisonniers, je pensais: si seulement il avait pu tenir encore un tout petit peu. » (1) « Dans la dernière lettre que j'ai reçue de Bob, il entrevoyait sa fin. Il m'indiquait quoi faire s'il ne revenait pas. » Mais du fond de son désespoir, Lola Dern trouva un nouveau courage. (4) « Mon premier élan, après le choc, fut de me mettre par terre et de jouer avec les enfants comme Bob avait l'habitude de le faire. » (3) « Au bout de tant de réflexions, de paroles, de plans, ma fille aînée Vicki et moi avons décidé de rentrer à Morehead City et d'ouvrir un jardin d'enfants. »

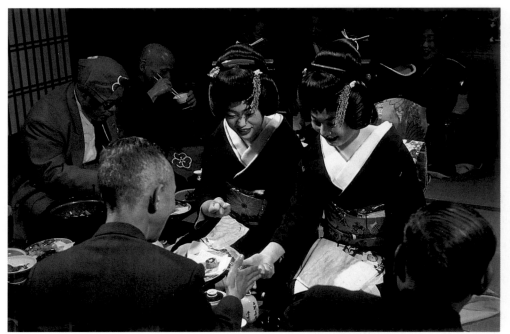

(1) Geisha parties traditionally take place in Gion. (2) In addition to some of the classic arts, such as ikebana and calligraphy, the 3-stringed lute, the samisen, is also played. (3) "Geisha's knife cuts guest's paper". The geishas entertain their guests with the game jan ken pon, an old handsymbol game.

(1) In Gion finden die Geisha-Parties statt. (2) Zu den klassischen Künsten wie Ikebana oder Kalligraphie gehört auch das Spiel der dreisaitigen Laute, der Samisen. (3) »Geishas Messer schneidet Papier des Gastes«. Die Geishas unterhalten die Gäste mit dem Spiel jan ken pon, dem alten Hand-Symbolspiel.

(1) A Gion, les geishas organisent des fêtes. (2) Aux arts classiques de l'ikebana ou de la calligraphie s'ajoute la maîtrise du samisé, un instrument à trois cordes. (3) « Le couteau de la geisha coupe le papier de l'hôte. » Les geishas distraient leurs hôtes avec le jan ken pon, un jeu de symboles à main très ancien.

(4) Geisha literally means "artistic person" (gei = art; sha = person). Aesthetics define her entirely. Nothing is too expensive and no training is too long to achieve that personification of entertaining art. Her kimonos are priceless and, above all, she must master the complete repertoire of the classic Japanese arts.

(4) Geisha bedeutet wörtlich übersetzt »Kunstperson«. Ästhetik ist ihre oberste Maxime. Dafür ist ihr nichts zu teuer und keine Ausbildung zu lang. Ihre Kimonos sind unschätzbar wertvoll, zudem beherrscht sie das gesamte Repertoire klassischer japanischer Künste.

(4) En traduction littérale, geisha signifie « personne d'art ». La beauté est leur plus haute mission et rien n'est trop cher et aucune formation trop longue pour l'accomplir. Leurs kimonos sont d'une valeur inestimable et elles maîtrisent parfaitement tout le répertoire des arts classiques japonais.

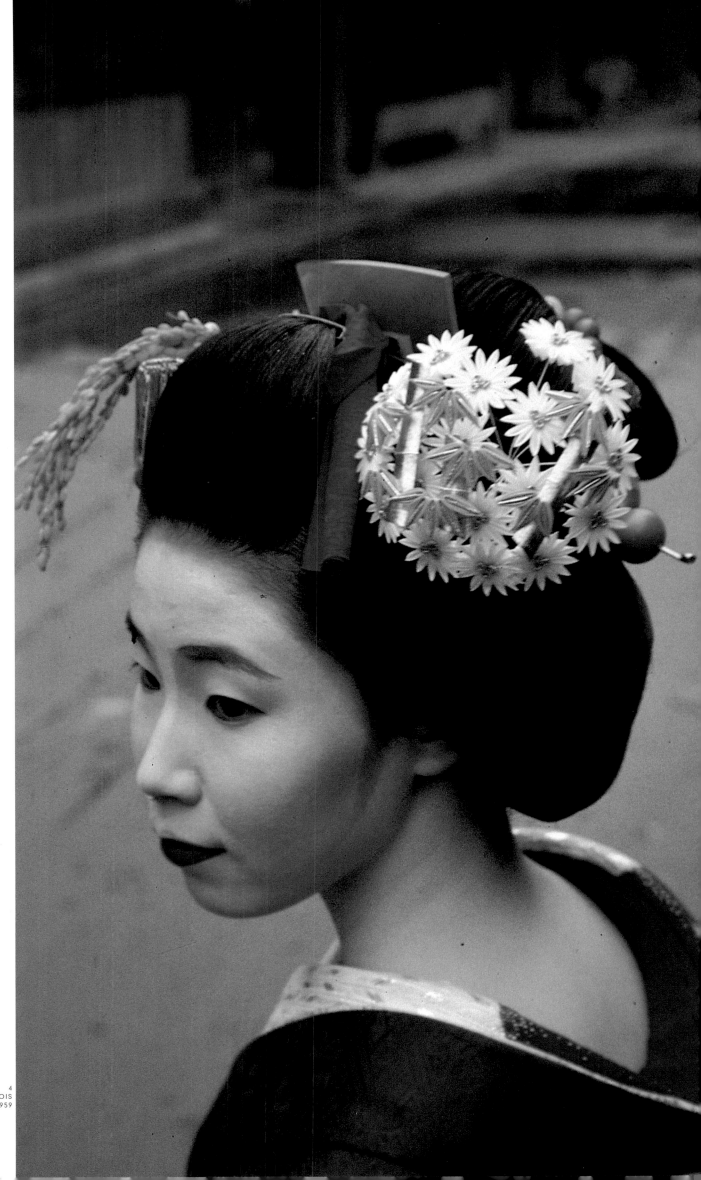

GEISHAS

John Launois, who was based in Japan during his military service, returned to Japan in 1955 and started reporting for Black Star on Asia. In a 1959 feature he photographed geishas, the epitome of Japanese femininity to Western eyes since "Madame Butterfly" in Kyoto. This profession, which some Western reporters mistakenly portray as the Japanese version of the prostitute, personifies the high discipline of the female companion or hostess.

GEISHAS

John Launois, der seinen Militärdienst in Japan abgeleistet hatte, kehrte 1955 wieder zurück und begann für Black Star aus dem asiatischen Raum zu berichten. 1959 fotografierte er in Kyoto in einem Feature den Inbegriff japanischer Weiblichkeit seit »Madame Butterfly« – die Geishas. Dieser Beruf, in dem westliche Berichterstatter gerne das japanische Pendant zur westlichen Hure sehen, verkörpert die hohe Schule der Gesellschaftsdame.

GEISHAS

John Launois, ayant effectué son service militaire au Japon, rentra en 1955 et se mit à faire des reportages en Asie pour Black Star. A Kyoto en 1959, il photographia l'idéal de la féminité japonaise depuis « Madame Butterfly », les geishas. Les Occidentaux aiment à y voir un équivalent de la prostituée occidentale, mais le métier de geisha est la plus haute école des dames de société.

4
JOHN LAUNOIS
1959

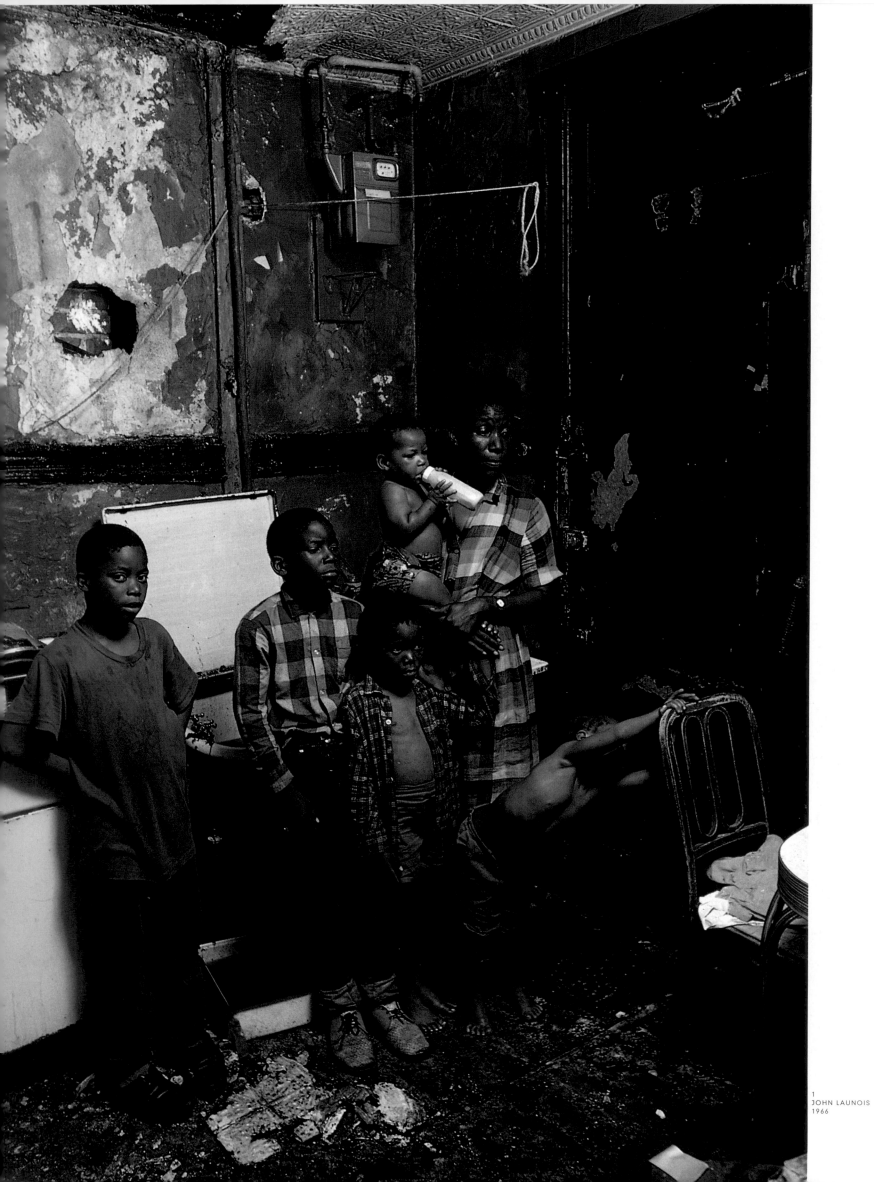

1
JOHN LAUNOIS
1966

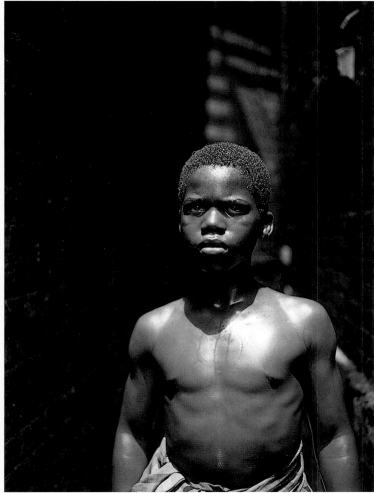

2 JOHN LAUNOIS 1966

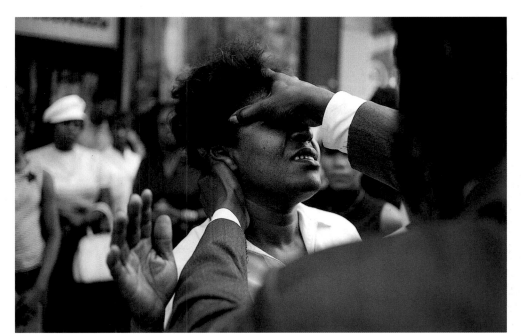

3 JOHN LAUNOIS 1966

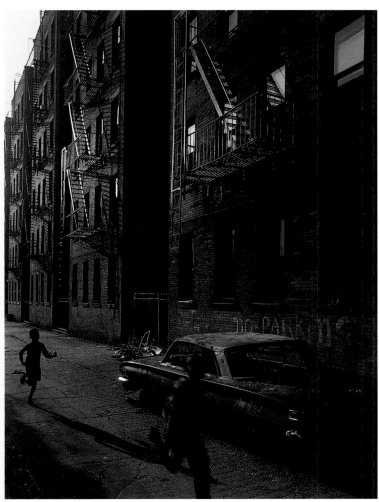

4 JOHN LAUNOIS 1966

John Launois came to the district two years after the Harlem Riots of 1964: "All the poverty, misery and suffering I had seen in Asia did not prepare me to cover the poverty in Harlem in the summer of 1966. I found myself stunned and shocked, asking myself how can we Americans, with our great wealth, let a part of our people live in such inhuman conditions." (1–4) Launois's reportage of the 1960s took a clear social stance, but the distance between the white reporter and the blacks he photographed appeared to be insurmountable.

John Launois kam zwei Jahre nach den Harlem-Riots 1964 in den Stadtteil: »All die Armut, das Elend und das Leiden, das ich in Asien gesehen habe, konnten mich nicht auf die Armut in Harlem im Sommer 1966 vorbereiten. Ich war bestürzt und zutiefst schockiert und fragte mich, wie wir Amerikaner es trotz unseres großes Reichtums zulassen können, daß ein Teil unseres Volkes unter derart unmenschlichen Bedingungen leben muß.« (1–4) Launois' Sozialreportage der 60er Jahre ergriff Partei, doch es bleibt eine scheinbar unüberwindliche Distanz zwischen dem weißen Reporter und den Schwarzen bestehen.

John Launois arriva dans le quartier en 1966, deux ans après les émeutes de Harlem : « Tout ce que j'avais vu de pauvreté, de misère et de souffrances en Asie ne m'avait pas préparé à ce que je vis à Harlem, l'été 1966. J'étais frappé de stupeur, et je me demandais comment il se faisait que nous, Américains, avec nos immenses richesses, laissions certains d'entre nous vivre dans ces conditions inhumaines. » (1–4) Mais si le reportage à contenu social de Launois prend parti, il reste une distance apparemment infranchissable entre le reporter blanc et les noirs du ghetto.

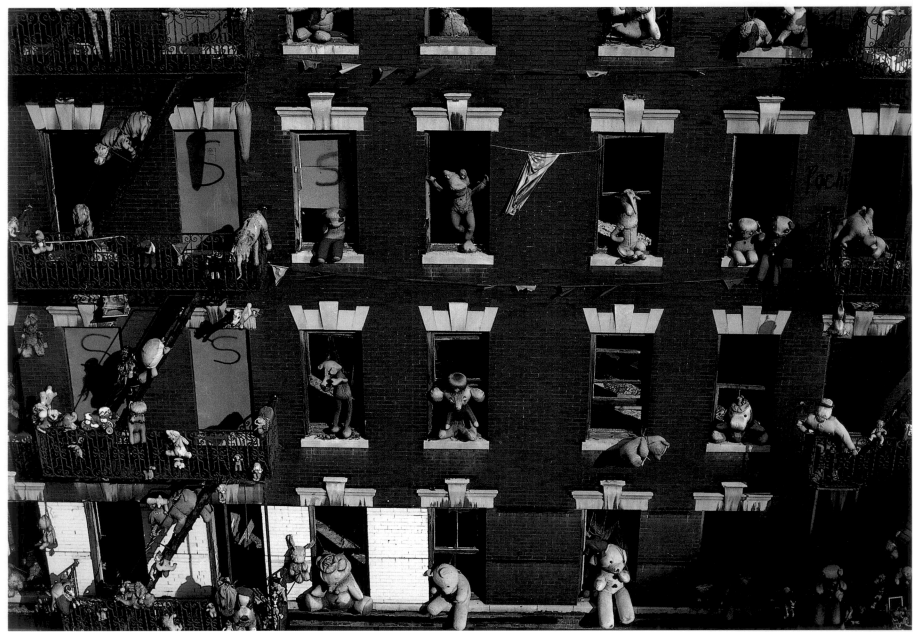

1 JOSEPH RODRIGUEZ 1990

ORDINARY PEOPLE, EXTRAORDINARY LIVES

Joseph Rodriguez is himself a descendant of Hispanic immigrants and East Harlem is his ethnic home. El Barrio is the oldest and biggest Puerto Rican enclave. It has developed side by side with Black Harlem. In this long-term photographic project Rodriguez depicts a slum of criminality and drugs (3) – the sources on which a great deal of the district's economy is based. (2) Children like this four-year-old are born with a heroin dependency. (1) Yet, Rodriguez also discovered signs of self-confidence and a sense of responsibility. One such example is a ramshackle house whose windows had been decorated with soft toys by local parents as a sign of defiance against crack dealers. (4) Many of these people have no hope other than religious belief. Referring to their circumstances, Rodriguez often heard people say: "This is the only answer I know." In his work, Rodriguez shows an intimate perspective of one of New York's ethnic minorities in a way only possible to an insider. This monumental opus appeared in 1990 as a cover story for *National Geographic* and in 1995 it was published as a book under the title "Spanish Harlem."

Joseph Rodriguez ist selbst ein Nachfahre hispanischer Einwanderer und East Harlem sein ethnischer Hinterhof. El Barrio ist die älteste und größte puertoricanische Enklave, die sich Schulter an Schulter mit Black Harlem entwickelt hat. Sein fotografisches Langzeit-Projekt erkundete den Sumpf von Kriminalität und Drogen (3), auf den sich die Wirtschaft des Viertels zum Großteil gründet. (2) Kinder wie dieser Vierjährige werden bereits heroinabhängig geboren. (1) Rodriguez entdeckte aber auch Zeichen des Selbstvertrauens und der Verantwortung, etwa das Abbruchhaus, dessen Fenster Eltern mit Stofftieren schmückten als Protest gegen Crack-Dealer. (4) Für viele bleibt aber nicht viel mehr als religiöse Hoffnung, und oft hörte Rodriguez angesichts der Verhältnisse den Satz: »Das ist die einzige Antwort, die ich kenne.« Rodriguez' Arbeit nimmt die Innenperspektive einer ethnischen Minorität in New York City ein, die nur Mitgliedern der ethnischen Gruppe möglich ist. Dieses monumentale Opus erschien 1990 als Titelstory im *National Geographic* und 1995 als Buch unter dem Titel »Spanish Harlem«.

Joseph Rodriguez est issu d'immigrants hispaniques et East-Harlem, c'est l'arrière-cour de son enfance. El Barrio, le plus ancien et le plus grand quartier portoricain, s'est développé parallèlement au quartier noir de Harlem. Au cours d'un long reportage, Rodriguez a enquêté sur ce territoire où prolifèrent la criminalité et la drogue (3), qui contribue largement à l'économie du quartier. (2) Des enfants comme celui-ci (quatre ans) naissent déjà intoxiqués par l'héroïne. (1) Le photographe a aussi trouvé des signes de confiance en soi et de sens des responsabilités. Ainsi, cet immeuble promis à la destruction, dont les fenêtres ont été décorées d'animaux en peluche en guise de protestation contre les revendeurs de crack. (4) Beaucoup trouvent un appui dans la religion et le photographe entendit plus d'une fois cette phrase: « C'est la seule réponse que je trouve ». Le travail de Rodriguez est un point de vue de l'intérieur sur cette minorité new-yorkaise, et n'était réalisable que par un membre de cette communauté. Cette œuvre monumentale a paru en 1990 dans le *National Geographic* et en 1995 dans un livre intitulé « Spanish Harlem ».

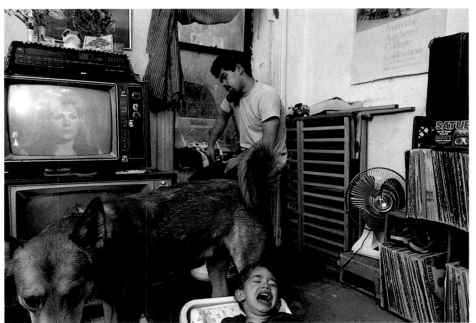

2 JOSEPH RODRIGUEZ 1990

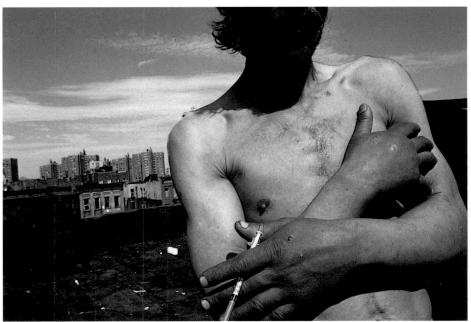

3 JOSEPH RODRIGUEZ 1990

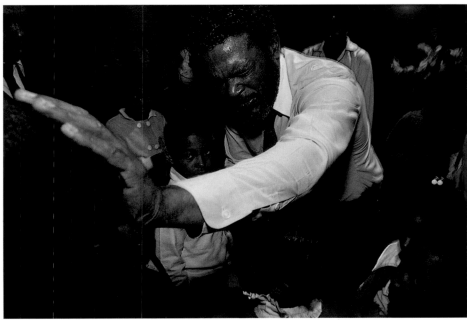

4 JOSEPH RODRIGUEZ 1990

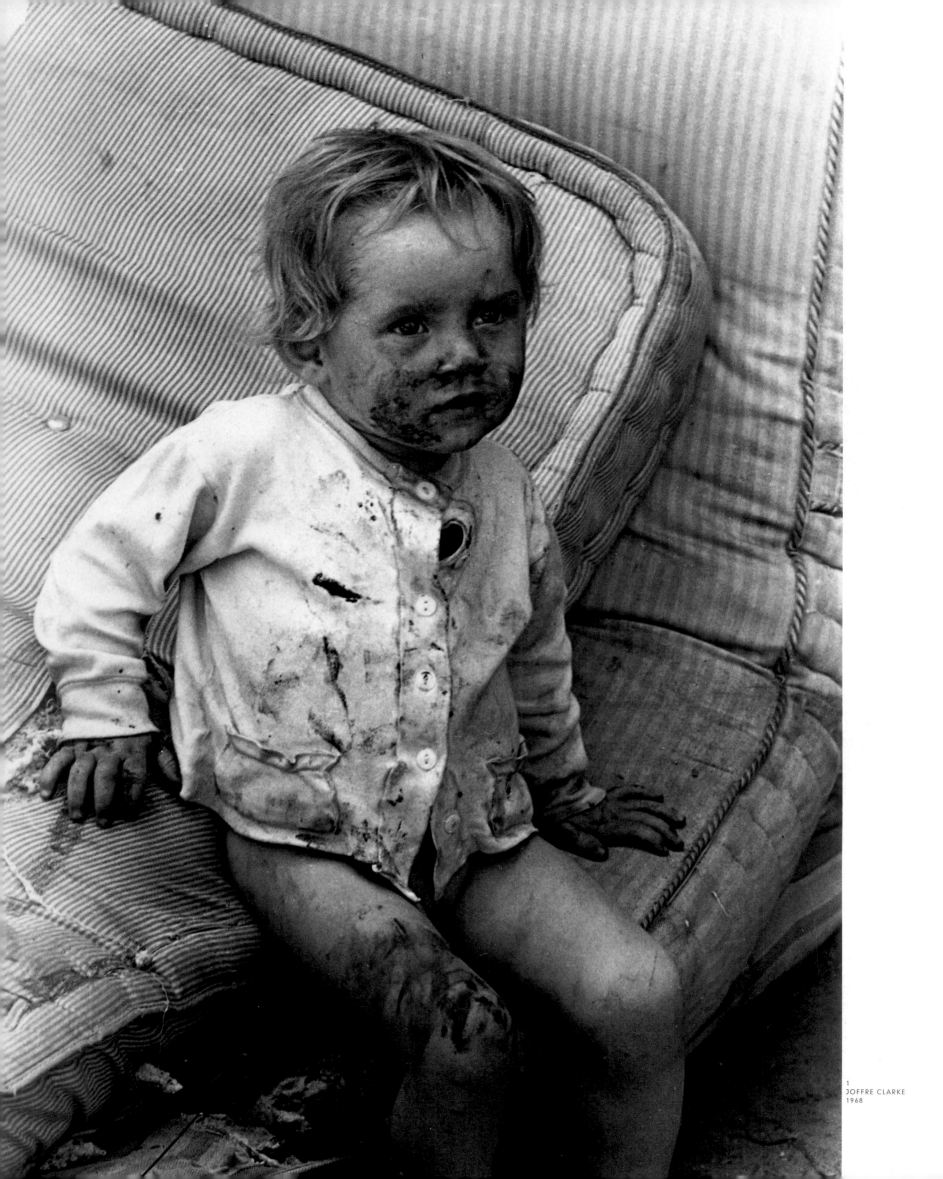

1
JOFFRE CLARKE
1968

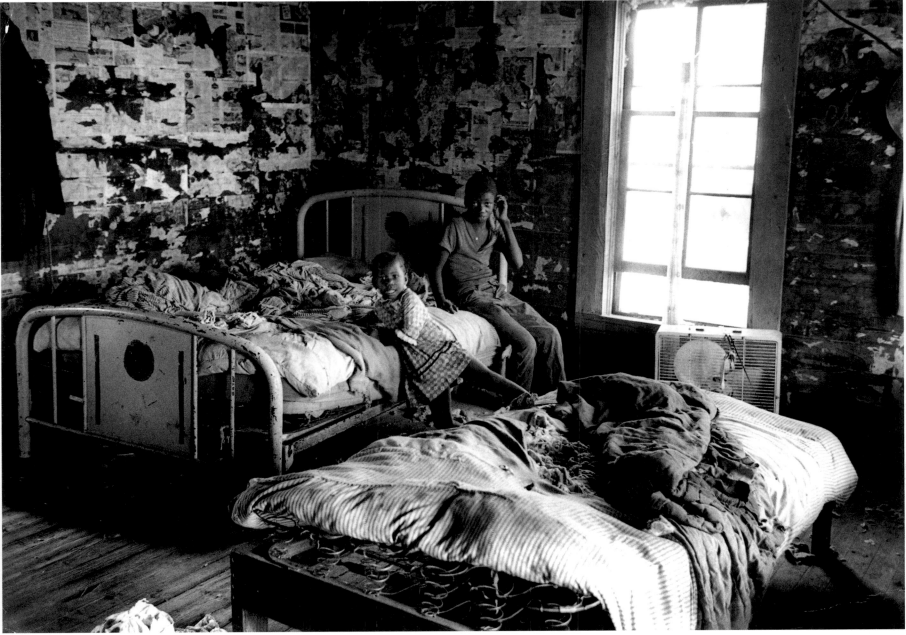

2 MIKE MAUNEY 1965

USA – REQUIREMENT AND REALITY

Mark Twain had already demanded a "New Deal" for the poor in the United States in 1880. Yet, it was not until 1933 that Roosevelt implemented social reforms as a "New Deal." However, social inequality increased despite the much-propagated policy of equal opportunities and all the various political efforts and reforms designed to combat it. (1) The child of an itinerant worker in Washington State in 1968. Poverty was no rarity in the sixties. (2) The father of these children worked on a plantation in Mississippi and lived with his nine children and wife in this ramshackle house.

USA – ANSPRUCH UND WIRKLICHKEIT

Einen New Deal gegen die wachsende soziale Ungerechtigkeit in den USA hatte um 1880 bereits der Schriftsteller Mark Twain gefordert; erst 1933 leitete Präsident Roosevelt Reformen unter diesem Namen ein – doch die soziale Ungerechtigkeit wuchs, der vielpropagierten Chancengleichheit und aller poltitischer Lösungsversuche zum Trotz. (1) Das Kind einer Wanderarbeiterfamilie im Staat Washington 1968. Armut war auch in den 60er Jahren keine Seltenheit. (2) Der Vater dieser Kinder arbeitete auf einer Plantage in Mississippi und wohnte mit neun Kindern und seiner Frau in diesem Abbruchhaus.

ETATS-UNIS: REVENDICATION ET REALITE

Dès 1880, Mark Twain avait préconisé un New Deal pour les pauvres. L'idée fut reprise plus tard par Roosevelt, mais l'inégalité sociale ne cessait de croître en dépit de toutes les tentatives de solutions politiques et de la propagande sur l'égalité des chances. (1) L'enfant d'une famille de travailleurs saisonniers dans l'Etat de Washington, en 1968. Dans les années 60 non plus, la pauvreté n'était pas rare. (2) Le père de cet enfant travaillait sur une plantation dans le Mississippi et vivait avec sa femme et leurs neuf enfants dans cette maison promise à la démolition.

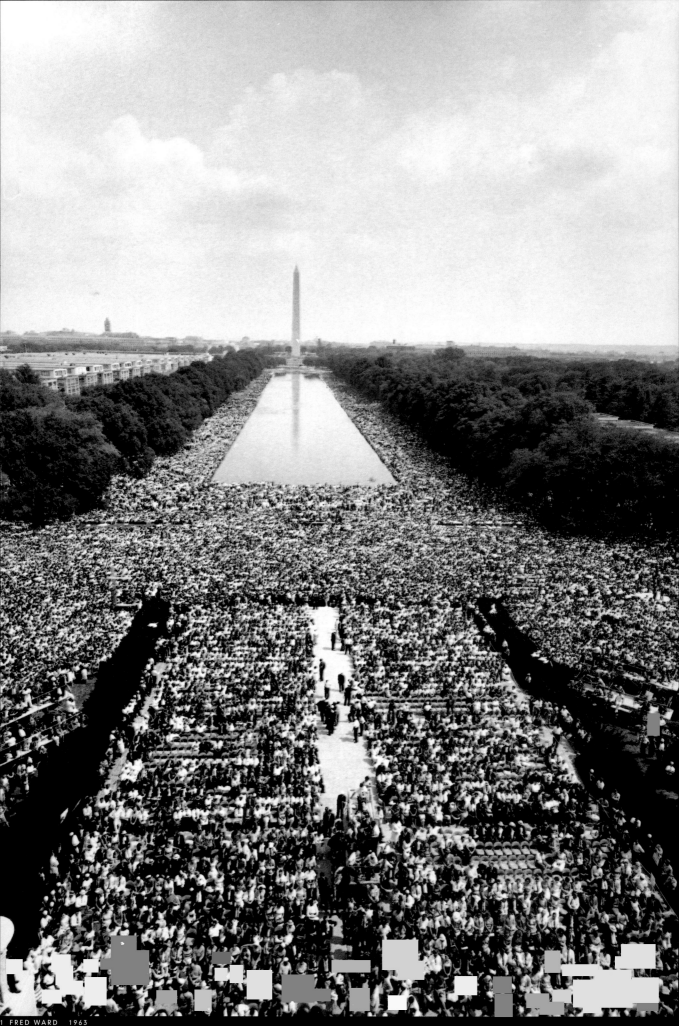

(1) On 28 August 1963 more than 250,000 people – blacks and whites – marched to Washington, to demonstrate in favor of the implementation of equal civil rights for all Americans. The highlight of the event was Martin Luther King's famous "I have a dream" speech. (3) Increasing criminality was interpreted as one way through which black anger about social injustice was vented. This attack took place in the north-west of Miami. The man who had been attacked was hunting the robber down with his automatic pistol (note how his back pocket is turned inside-out) with the help of the police in a dramatic shoot-out. With great empathy for the victim, the photographer stated: "For Harry Clark, the experience was a bitter reminder of how much the neighborhood he grew up in, has changed." A macabre example of American self-justice. (2) The black attacker suffered minor gunshot wounds.

(1) Am 28. August 1963 marschierten mehr als 250 000 Bürgerrechtler, schwarz und weiß, nach Washington, um für die endgültige Durchsetzung der Bürgerrechte für alle Amerikaner zu demonstrieren. Den Höhepunkt bildete Martin Luther Kings Rede: I have a dream. (3) Die steigende Kriminalität wurde in den 60er Jahren zugleich als Ventil für den Zorn der Schwarzen über die soziale Ungleichheit interpretiert. Dieser Überfall ereignete sich im Nordwesten Miamis, der Überfallene (man beachte die nach außen gestülpte Gesäßtasche) brachte mit Hilfe seiner Automatikpistole und Unterstützung der Polizei die Räuber in »einem dramatischen Shootout zur Strecke«. Der Fotograf notierte mit viel Empathie für das Opfer weiter: »Für Harry Clark war dieses Erlebnis die bittere Bestätigung der Tatsache, daß sich das Viertel, in dem er aufwuchs, sehr verändert hat.« Ein makabres Beispiel amerikanischer Selbstjustiz. (2) Die schwarzen Angreifer erlitten leichte Schußverletzungen.

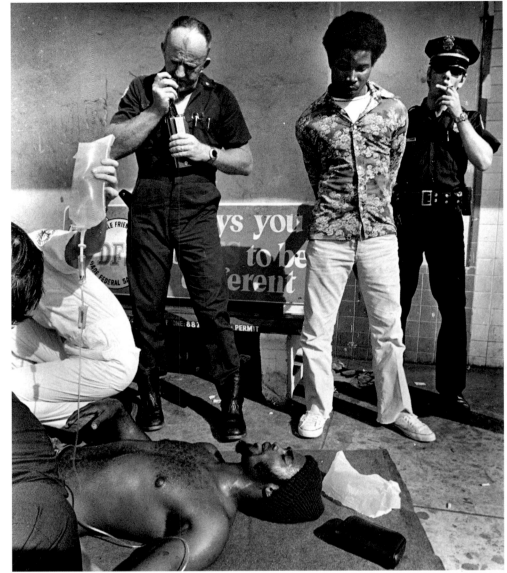

2 MICHAEL O'BRIEN UNDATED/O.D./S.D.

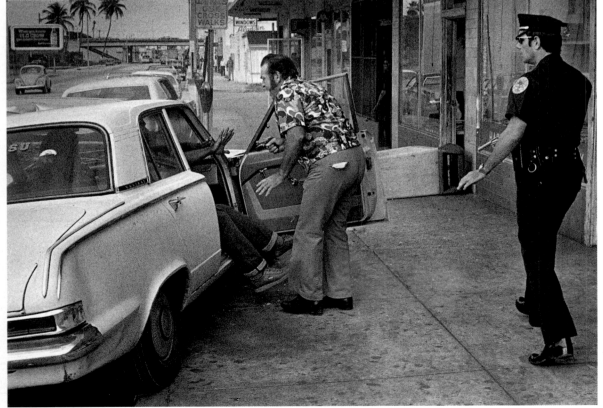

3 MICHAEL O'BRIEN UNDATED/O.D./S.D.

(1) Le 28 août 1963, plus de 250 000 manifestants noirs et blancs se dirigent vers Washington pour exiger le bénéfice des droits civiques pour tous les Américains. Le moment le plus fort de la manifestation fut le discours de Martin Luther King : I have a dream. (3) L'accroissement de la criminalité était interprété comme une soupape à la colère des noirs contre les inégalités sociales des années 60. Cette agression a eu lieu au nord-ouest de Miami ; l'agressé – observer la poche arrière retournée de son pantalon – tira sur les bandits avec son pistolet automatique, avec l'appui de la police, dans une fusillade spectaculaire. Le photographe ajoutait, avec beaucoup de sympathie pour la victime : « Pour Harry Clark, cette expérience n'était qu'un amer rappel des transformations subies par le quartier où il avait grandi. » Sinistre exemple du principe d'autodéfense. (2) Les agresseurs noirs furent légèrement blessés par les tirs.

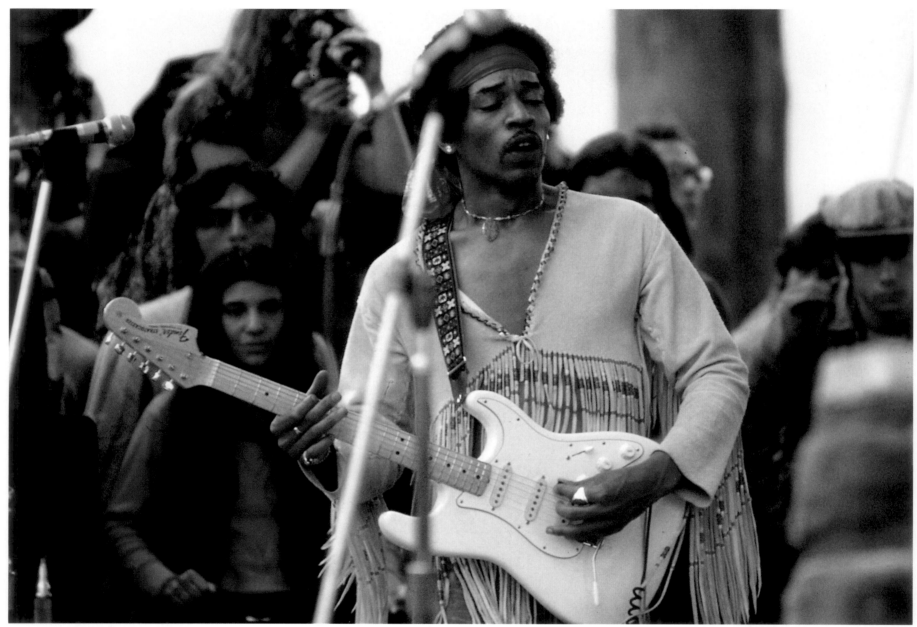

1 DAN McCOY 1969

(1) The performance by Jimi Hendrix was one of the most memorable moments of the festival, especially when he improvized the American national anthem, ripping the star-spangled banner electronically to pieces.
(2) Together, musicians and spectators combined to create a very impressive swansong to the American way of life.

(1) Der Auftritt von Jimi Hendrix wurde zu einem der Höhepunkte des Festivals, als er die amerikanische Nationalhymne improvisierte und dabei das Star Spangled Banner elektronisch zerfetzte. (2) Musiker wie Zuschauer inszenierten gemeinsam einen eindrucksvollen Abgesang auf den American way of life.

(1) L'un des moments culminants du festival fut l'apparition de Jimi Hendrix. Son improvisation sur l'hymne national américain fut une mise en pièce symbolique et électrique de la bannière étoilée.
(2) Musiciens et spectateurs composèrent ensemble une version hallucinée de l'American way of life.

WOODSTOCK 1969

Dan McCoy (b. 1936 in Johnson City) captured the historic music festival on film in 1969. And at the same time Woodstock became the epitome and embodiment of hippie culture. "Some 400,000 youngsters camped in cars and tents, copulated in sleeping bags and puffed so much marijuana, that one became high from just breathing in the air." The festival was not as chaotic as expected, and through their performance 32 bands wrote the soundtrack for the festival of love and peace.

WOODSTOCK 1969

Dan McCoy (geb. 1936 in in Johnson City) bannte eines der gigantischsten Festivals in der Geschichte der Popmusik auf Zelluloid. Und gleichzeitig ist Woodstock zum Inbegriff der Hippie-Kultur geworden. »Etwa 400 000 Jugend- liche kampierten in Autos und Zelten, kopulierten in Schlafsäcken und pafften soviel Marihuana, daß man schon vom Einatmen der Luft benebelt war.« Das befürchtete Chaos blieb aus, und 32 Bands schrieben mit ihren Auftritten den Soundtrack für das Festival der Liebe und des Friedens.

WOODSTOCK 1969

Dan McCoy (né en 1936 à Johnson City) mettait en pellicule l'un des festivals les plus gigantesques de l'histoire de la pop-music. Woodstock est aussi devenu le symbole de la culture hippie. « Environ 400 000 jeunes campaient dans des voitures ou des tentes, faisaient l'amour dans des sacs de couchage et absorbaient tellement de marihuana qu'il suffisait de respirer l'air ambiant pour se sentir embrumé. » On craignait des désordres, mais tout se déroula sans heurts et 32 groupes participèrent à l'enregistrement de la bande sonore du festival de l'amour et de la paix.

2 DAN McCOY 1969

1 DAN McCOY 1969

(2) Neither rain nor storm could dampen the atmosphere of the "Woodstock nation" at their rock and drug picnic. (1) This generation and their offspring changed the meaning of the belligerent "V"-sign into "Peace" without much ado.

(2) Weder Regen noch Sturm konnten die Stimmung der »Woodstock Nation« bei ihrem Rock-and-Drug-Picknick trüben. (1) Diese Generation und ihre Sprößlinge deuteten das kriegerische »V«-Zeichen kurzerhand in »Peace« um.

(2) Ni la pluie ni l'orage ne purent troubler l'ambiance de pique-nique « rock-and-drug » de la « Woodstock nation » . (2) Le « V » de la victoire devint un signe de paix pour cette génération et pour ses rejetons.

2 DAN McCOY 1969

WOODSTOCK 1994

Attempts to revive the myth 25 years later at the same venue failed. Woodstock 1994 was an uninspiring and entirely typical big festival. Masses of teenagers, who seemed to have a lot of fun imitating hippie attitudes, posed for the next generation of photographers. Among them was Erica Lansner (b. 1958 in New York) who photographed the event on behalf of Black Star. (3) The class of '94 had their version of the mud bath in a slightly more acrobatic way than their parents. (4) Cannabis consumption was still obligatory.

WOODSTOCK 1994

Der Versuch, den Mythos 25 Jahre später an gleicher Stelle wiederzubeleben, scheiterte. Woodstock 1994 war ein ordinäres Großfestival. Der nächsten Fotografengeneration, unter ihnen auch Erica Lansner (geb. 1958 in New York) für Black Star, bot sich eine Riesenmenge Jugendlicher, die offensichtlich ihren Spaß hatte und sich dabei in Hippie-Attitüden übte. (3) Die Schlacht im Schlamm betrieben die 94er etwas athletischer als ihre Väter. (4) Der Konsum von Cannabis war immer noch obligatorisch.

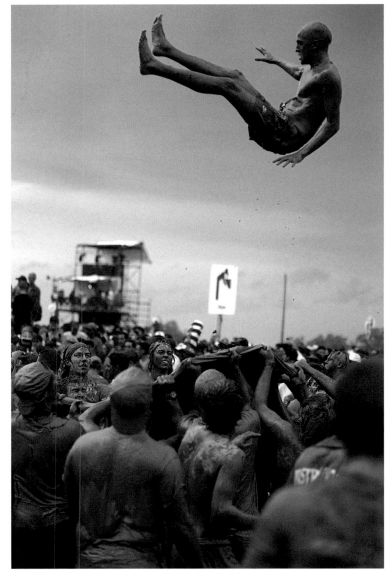

3 ERICA LANSNER 1994

4 ERICA LANSNER 1994

WOODSTOCK 1994

La tentative de faire revivre le mythe 25 ans plus tard fut un échec. Woodstock 94 ne fut qu'un banal grand festival. La nouvelle génération de photographes dont fait partie Erica Lansner (née en 1958 à New York) rencontra une foule de jeunes qui s'amusaient manifestement beaucoup à mimer les attitudes des hippies. (3) La bataille de boue de 94 prit un tour plus athlétique que celle de 69. (4) La consommation de cannabis restait impérative.

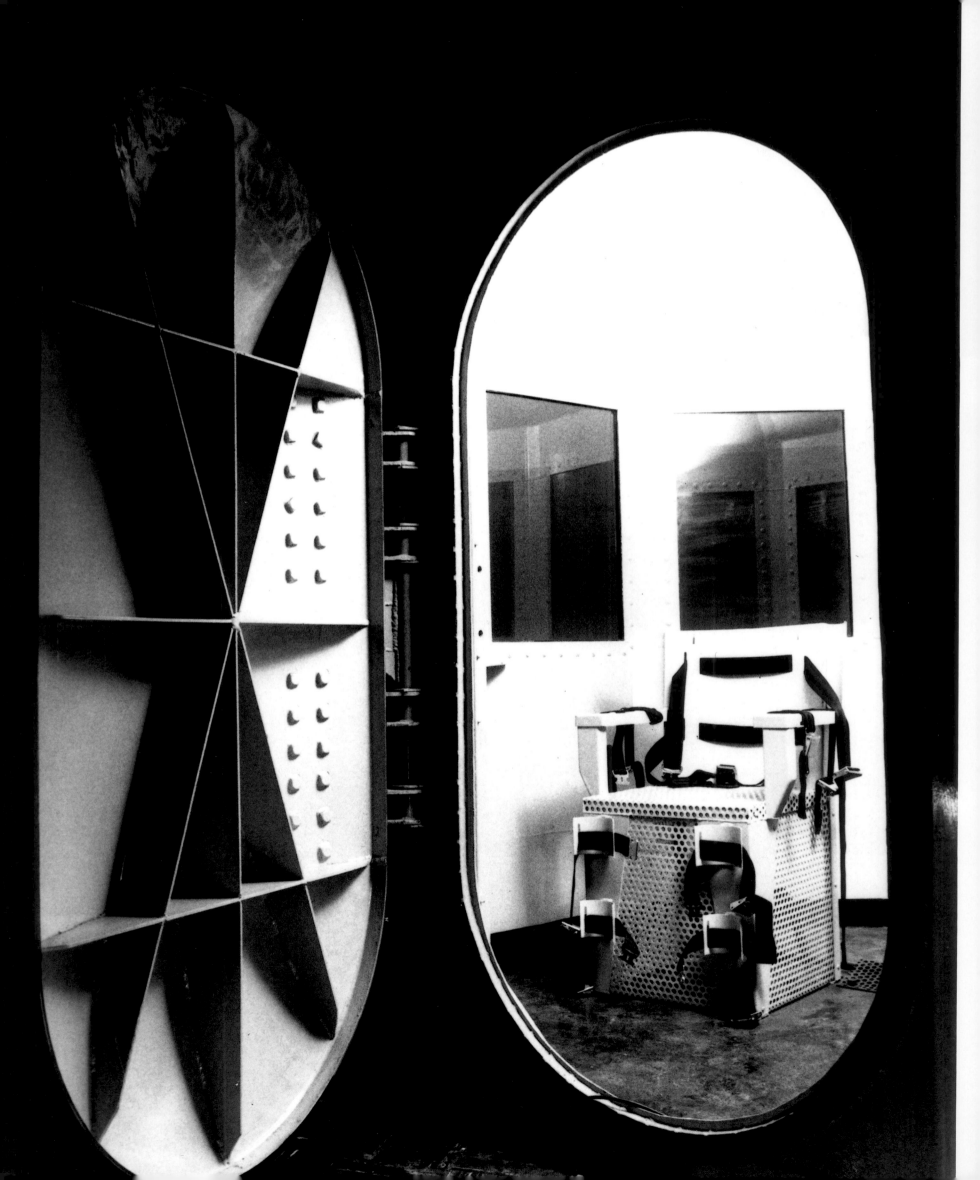

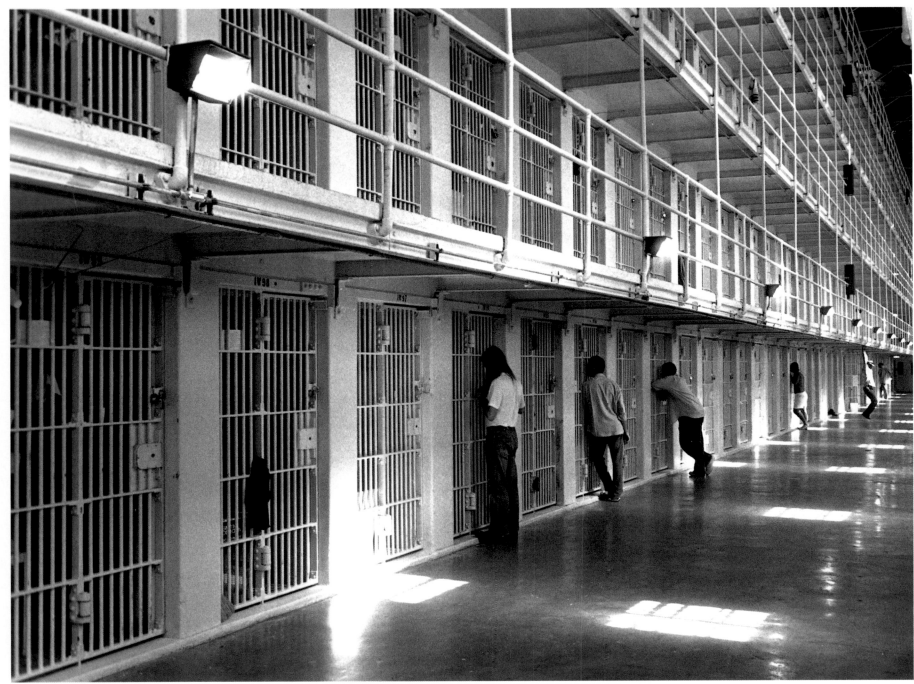

2 MAX RAMIREZ UNDATED/O.D./S.D.

THE MODERN HANGMAN

(1) After 25 years of inoperation, the gas chamber in San Quentin was put to use again in 1990. Since the first execution with the "electric chair" in 1900, new methods have always been sought to improve mechanical execution. (2) Death row in San Quentin. Years often go by between the passing of a death sentence and its subsequent execution. In 1987, 25 people were executed while 2,000 awaited reprieve, postponement or execution. While it is yet to be proved with certainty that the death penalty is an effective crime deterrent, in the mid-1980s three in every four Americans were in favor of it.

◀1 MAX RAMIREZ
UNDATED/O.D./S.D.

DER MODERNE HENKER

(1) Die Gaskammer in San Quentin wurde 1990 nach 25 Jahren erstmals wieder eingesetzt. Nach der ersten Hinrichtung mit dem »Elektrischen Stuhl« im Jahr 1900 arbeitete man ständig an der Weiterentwicklung der mechanischen Hinrichtung. (2) Todeszellen in San Quentin. Zwischen Urteil und Vollstreckung vergehen oft Jahre. 1987 wurden 25 Menschen hingerichtet, 2 000 warteten auf Begnadigung, Aufschub oder Vollstreckung. Eine abschreckende Wirkung der Todesstrafe konnte bislang nicht eindeutig nachgewiesen werden. Trotzdem plädierten Mitte der 80er Jahre drei von vier Amerikanern für die Todesstrafe.

LE BOURREAU DES TEMPS MODERNES

(1) La chambre à gaz de San Quentin fut remise en service en 1990, après 25 ans d'inactivité. Depuis la première exécution à la chaise électrique, en 1900, les moyens techniques au service des exécutions n'ont cessé de se développer. (2) Couloir de cellules à San Quentin. Entre la sentence et son application, il se passe souvent des années. En 1987, 25 personnes furent exécutées, 2 000 attendaient la décision d'une grâce, d'un délai ou d'une exécution. Il n'a jamais pu être démontré que la peine de mort avait un effet sur le taux de criminalité. Pourtant, au milieu des années 80, trois Américains sur quatre en souhaitaient l'application.

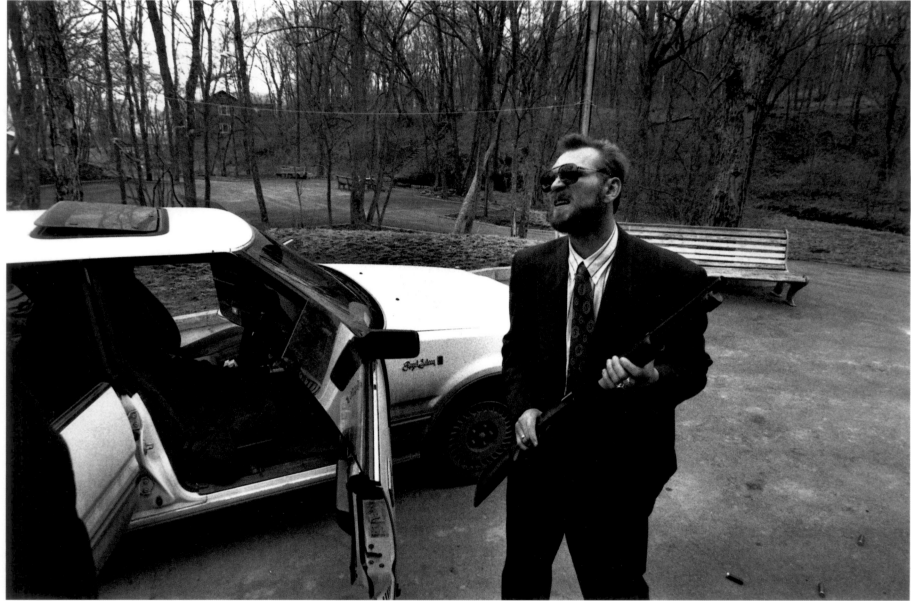

1 MALCOLM LINTON 1991

(1) An automatic Winchester accompanied Sergei Bukharin everywhere and he was seldom seen without his bodyguards. The former chauffeur and Afghanistan war veteran personified the new type of Mafioso who bases his illegal business activities on the ruins of the former Communist regime. (2) Two prostitutes wait for Sergei. The status symbols of these "entrepreneurs" are the same all over the world: fast cars and pretty women. (3) A party in a sauna club. The local police regularly attended these parties. (4) Sergei indulging in the nouveau riche-style good life with his friends. Yet, he led a secluded life with his family in a run-down two-room flat. In 1995 he died in a shoot-out in the Belorussian capital, Minsk.

(1) Die automatische Winchester begleitete Sergej Bucharin überallhin, und selten war er ohne Leibwächter anzutreffen. Der ehemalige Chauffeur und Afghanistan-Veteran verkörperte den neuen Typus des Mafioso, der auf den Ruinen des Kommunismus illegale Geschäfte aufbaut. (2) Zwei Prostituierte warten auf Sergej. Die Statussymbole dieser »Unternehmer« sind weltweit gleich: schnelle Wagen und schöne Frauen. (3) Eine Party in einem Saunaklub. An diesen Parties nahm auch regelmäßig die örtliche Polizei teil. (4) Mit seinen Freunden genießt der Neureiche den Luxus. Mit seiner Familie lebte er zurückgezogen in einer heruntergekommenen Zwei-zimmerwohnung. 1995 starb er bei einer Schießerei in der weißrussischen Hauptstadt Minsk.

(1) Sergueï Boukharine ne se séparait jamais de sa Winchester automatique et rarement de ses gardes du corps. L'ancien chauffeur, vétéran d'Afghanistan, était le type même du nouveau mafioso, qui édifie tout un commerce illégal sur les ruines du communisme. (2) Deux prostituées attendent Sergueï. Les attributs statutaires de ces nouveaux « entrepreneurs » sont universels : voitures rapides et jolies femmes. (3) Soirée dans un club sauna. La police locale était fréquemment invitée à ces soirées. (4) Le nouveau-riche partage son luxe avec ses amis et vit avec sa famille dans un deux-pièces discret et délabré. Boukharine est mort en 1995 au cours d'une fusillade à Minsk.

A MAFIOSO IN SIBERIA

Malcolm Linton has been working in the disintegrating Soviet Union since the coup in Moscow in 1991. A news photographer usually rushes from one crisis to the next. However, this British photographer is always on the lookout for a story of substance, of which this reportage about a Russian Mafioso in Vladivostok is a good example. "The day I met Sergei Bukharin I was looking for a gangster. I had wanted to shoot a Russian Mafia story for some time but never managed to get access. Bakhurin was the boss of the Chinese Market and was pleased at the attention. The toughest part of doing a story on him was surviving the substance abuse, lack of sleep and high speed driving." Linton made two trips to Siberia to get a glance behind the scenes of the "Wild East".

EIN MAFIOSO IN SIBIRIEN

Malcolm Linton arbeitete nach dem Coup in Moskau 1991 immer wieder in der auseinanderbrechenden Sowjetunion. Ein Newsfotograf wie Linton eilt meist von Krise zu Krise. Der Brite sucht aber auch immer nach Geschichten wie in seiner Reportage über einen russischen Mafioso in Wladiwostok. »Als ich Sergej Bucharin traf, war ich gerade auf der Suche nach einem Gangster. Ich wollte schon eine ganze Weile eine Fotostory über die Russenmafia machen, hatte aber nie Zugang zu deren Kreisen erhalten. Bucharin, der Boß des Chinesischen Markts, fühlte sich geschmeichelt von so viel Aufmerksamkeit. Das Schwierigste bei der Geschichte über ihn war, den hohen Drogenmißbrauch, den Schlafmangel und die rasanten Autofahrten zu überleben.« Zwei Reisen unternahm Linton nach Sibirien, um hinter die Kulissen im Wilden Osten zu schauen.

UN MAFIOSO EN SIBERIE

Depuis le renversement de Moscou en 1991, Malcolm Linton est retourné régulièrement dans l'ancienne Union soviétique. En général, un reporter d'actualité comme Linton passe son temps à courir de crise en crise. Mais le Britannique est toujours à la recherche de nouvelles histoires, comme avec son reportage sur un mafioso russe de Vladivostok. «Je cherchais un gangster, quand j'ai rencontré Serguëi Boukharine. Ca faisait un moment que je voulais faire un reportage sur la mafia russe, mais je n'étais jamais parvenu à trouver un contact. Boukharine était le chef du marché chinois et était ravi qu'on s'intéresse à lui. Le plus dur a été de survivre à l'abus de substances diverses, au manque de sommeil et à la vitesse en voiture.» Linton s'est rendu deux fois en Sibérie, derrière les coulisses de l'Est sauvage.

2 MALCOLM LINTON 1991

3 MALCOLM LINTON 1991

4 MALCOLM LINTON 1991

1 CHRISTOPHER MORRIS 1989

(1) Civil officers of the DOC patrolling the streets at night. (3) A corpse is removed for an autopsy. The murderers came through the bedroom window. They tortured, raped and finally killed this young female victim. (2) A 22-year-old man hanged himself with a silk stocking while awaiting trial. The reason remains unknown. What is well-known however is the Mafia's infiltration of the police and other defence forces and the fact that illegal attacks against political opponents are the order of the day.

(1) Zivile Beamte des DOC patrouillieren durch die nächtlichen Straßen. (3) Abtransport zur Autopsie. Die Mörder kamen durch das Schlafzimmerfenster und folterten, vergewaltigten und töteten diese junge Frau. (2) Ein 22jähriger Mann hat sich in der Untersuchungshaft mit einem Seidenstrumpf erhängt. Das Motiv blieb ungeklärt. Fest steht jedoch, daß Polizei und Streitkräfte von der Mafia unterwandert und auch illegale Übergriffe gegen politisch Oppositionelle an der Tagesordnung sind.

(1) Fonctionnaires civils de la DOC patrouillant dans les rues, la nuit. (3) Transport pour autopsie. Les assassins sont entrés par la fenêtre de la chambre à coucher et ont torturé, violé et tué cette jeune femme. (2) Un jeune homme de 22 ans s'est pendu avec un bas de soie pendant sa détention préventive, sans que la cause ait pu en être déterminée. Ce qui est sûr, c'est que la police et les forces armées sont infiltrées par la mafia, et des mesures illégales contre des opposants politiques sont à l'ordre du jour.

MEDELLIN:
THE CAPITAL OF VIOLENCE

In 1989, when Christopher Morris first came to Medellín, the second biggest city in Colombia, he felt like he was entering "the gates of hell." He accompanied a group of civilian para-militaries and judges in their losing battle against crime in the capital of violence. At this time, 14 to 15 murders were being committed every day. In the chaos of rival bosses, guerrillas, hired killers and marauding youth gangs, the success rate against crime was zero.

MEDELLIN:
HAUPTSTADT DER GEWALT

Christopher Morris fühlte sich 1989 in Medellín, der zweitgrößten kolumbianischen Stadt, als ob er »den Vorhof der Hölle« betreten hätte. Er begleitete eine polizeiliche Ziviltruppe und Richter bei ihrem aussichtslosen Kampf gegen das Verbrechen in der Hauptstadt der Gewalt. Die Todesrate lag zu dieser Zeit bei 14 bis 15 Morden pro Tag. In dem Chaos von rivalisierenden Drogenbossen, Guerilleros, Auftragskillern und marodierenden Jugendbanden ging die Aufklärungsquote der Verbrechen gegen Null.

MEDELLIN:
CAPITALE DE LA VIOLENCE

Christopher Morris dit qu'en 1989, à Medellín, deuxième ville de Colombie, il eut l'impression d'être entré dans «l'antichambre de l'enfer». Il suivit une troupe de police civile et de juges dans leur combat sans issue contre le crime dans la capitale de la violence. A cette époque il y avait 14 ou 15 meurtres par jour. Dans le chaos régenté par les rivalités entre patrons de la drogue, guérilleros, tueurs à gages et bandes de jeunes maraudeurs, le taux d'élucidation des crimes avoisinait zéro.

2 CHRISTOPHER MORRIS 1989

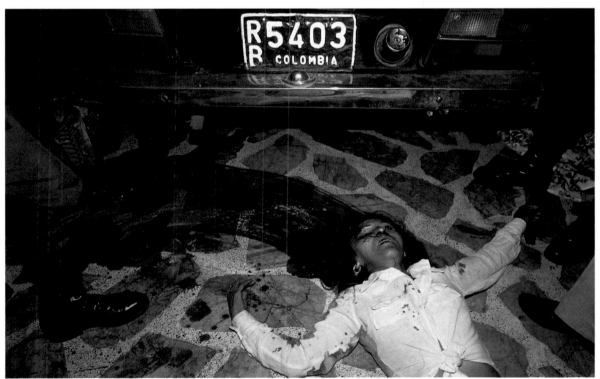

3 CHRISTOPHER MORRIS 1989

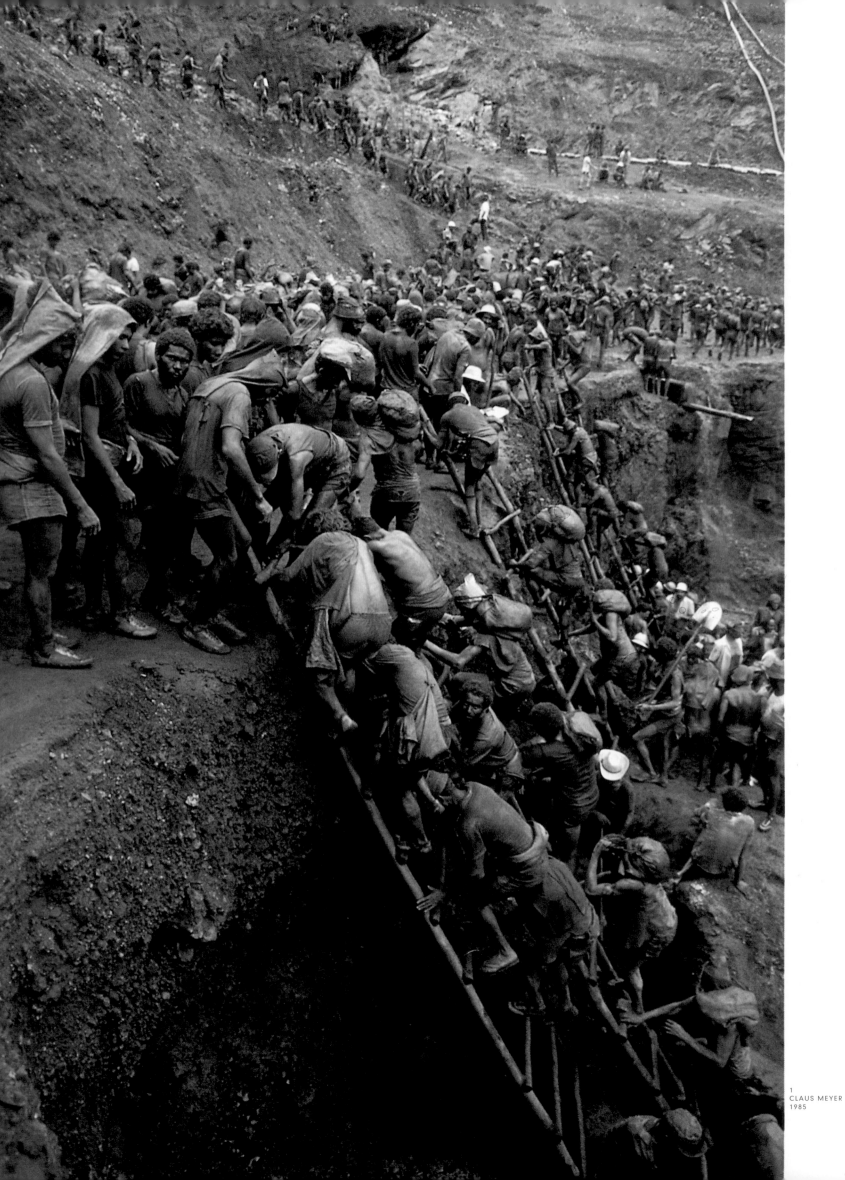

CLAUS MEYER
1985

THE TREASURES
OF THE SERRA PELADA

(1–3) Claus Meyer always claimed that in 1985 he was the first journalist to have discovered the Brazilian Klondike in the province of Pará: "It is a surreal scenario … up to 50,000 garimpeiros search for gold on an area the size of a football field."

DIE SCHÄTZE
DER SERRA PELADA

(1–3) Claus Meyer behauptete immer, daß er 1985 als erster Journalist das brasilianische Klondike im Bundesstaat Pará entdeckt hatte: »Es ist ein surreales Szenario, wie … bis zu 50 000 Garimpeiros auf einer Fläche eines Fußballfeldes nach Gold suchen.«

LES TRESORS
DE LA SERRA PELADA

(1–3) Claus Meyer a toujours affirmé avoir été le premier journaliste à découvrir le « Klondike » brésilien du Pará : « C'est un scénario surréaliste, de voir … 50 000 garimpeiros fouiller une surface de la dimension d'un terrain de football pour trouver de l'or. »

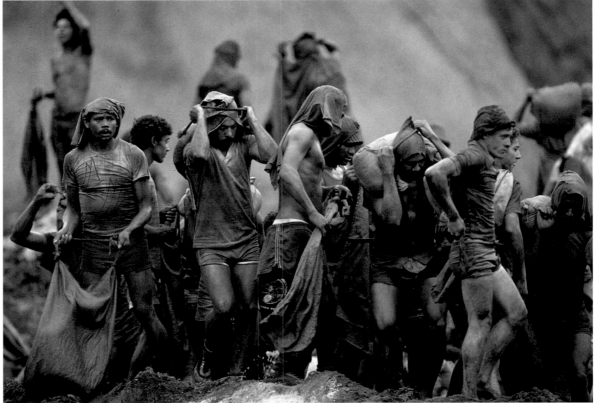

2 CLAUS MEYER 1985

3 CLAUS MEYER 1985

1 SWAPAN PAREKH 1995

THE ORPHANS OF TERRORISM

Swapan Parekh (b. 1966 in Bombay) studied photojournalism at the ICP in New York. In 1995 Parekh traveled to the Punjab area where a ten-year-long civil war between the Sikh separatist movement and the national police had cost countless lives. The terror on both sides was far from over at the time of Parekh's visit. One of the leaders of the Khalistan Freedom Movement, Balkar Singh, had, however, already turned his back on violent resistance years ago and built a sanctuary for the orphans and widows of the Movement. (1) Singh works around the clock and rarely finds a moment's rest. (2) Baba and the children on their way to the farm which provides all the food necessary to sustain the sanctuary.

DIE WAISEN DES TERRORISMUS

Swapan Parekh (geb. 1966 in Bombay) studierte Fotojournalismus am ICP in New York. 1995 reiste Parekh in die Pandschab-Region; über zehn Jahre Bürgerkrieg zwischen der Separatismus-Bewegung der Sikhs und der staatlichen Polizei haben dort unzählige Opfer gefordert. Einer der Köpfe der Khalistan-Freiheitsbewegung kehrte jedoch vor Jahren der Gewalt den Rücken – Balkar Singh baute für die Waisen und Witwen aus der Bewegung eine Zufluchtsstätte. (1) Singh arbeitet rund um die Uhr und selten findet er einen Moment Ruhe. (2) Baba und die Kinder auf dem Weg zu der Farm, die die Selbstversorgung mit Lebensmitteln gewährleistet.

LES ORPHELINS DU TERRORISME

Swapan Parekh (né en 1966 à Bombay) a étudié le photojournalisme à l'ICP de New York. En 1995, Parekh s'est rendu dans le Pendjab. En dix ans de guerre civile entre le mouvement séparatiste sikh et la police nationale, d'innombrables victimes ont trouvé la mort. L'un des dirigeants du mouvement de libération du Khalistan décida pourtant voici plusieurs années de tourner le dos à la violence. Balkar Singh construisit des refuges pour les veuves et les orphelins du mouvement. (1) Singh travaille sans discontinuer et trouve rarement un moment de repos. (2) Baba et les enfants en chemin vers la ferme qui leur assure l'autonomie alimentaire.

2
SWAPAN PAREKH
1995

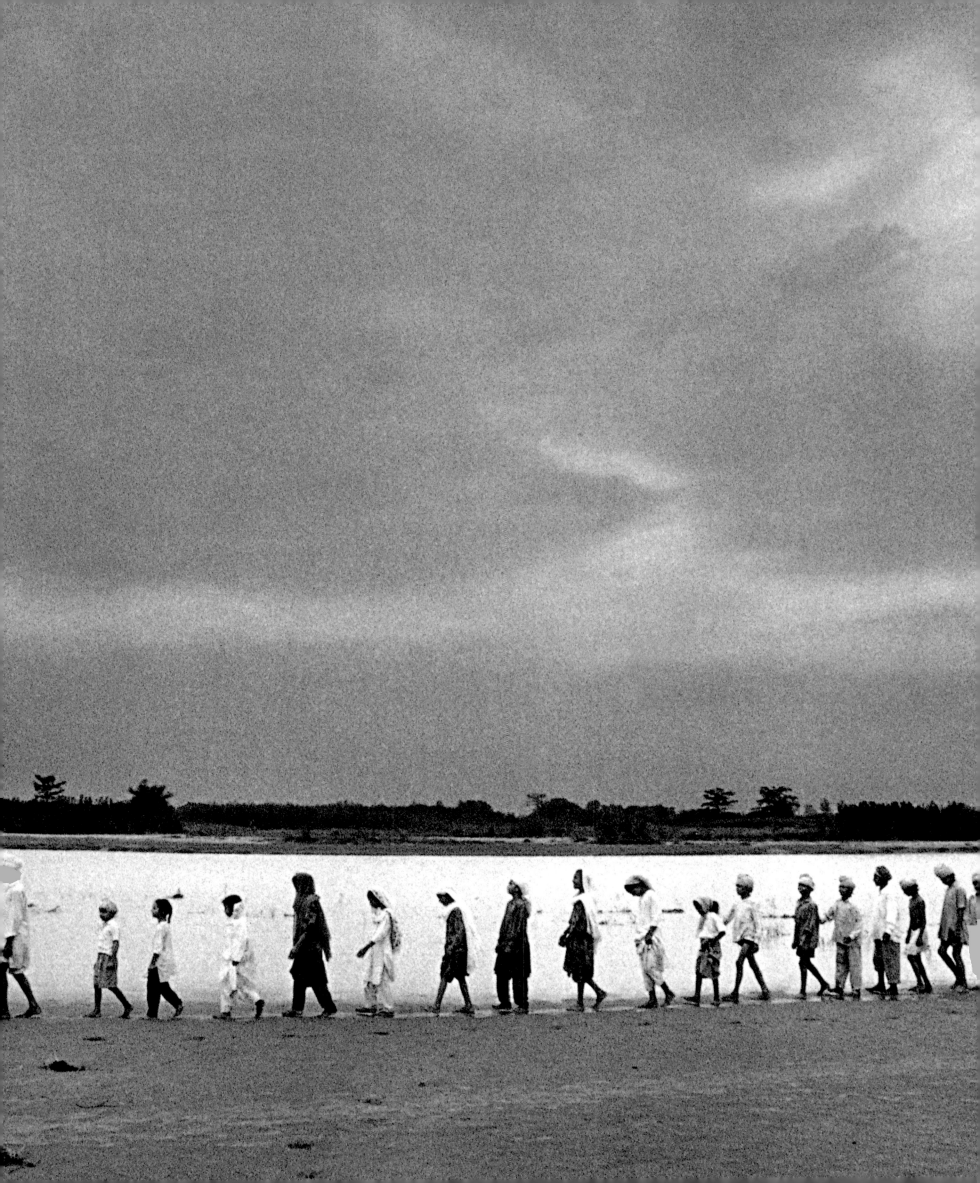

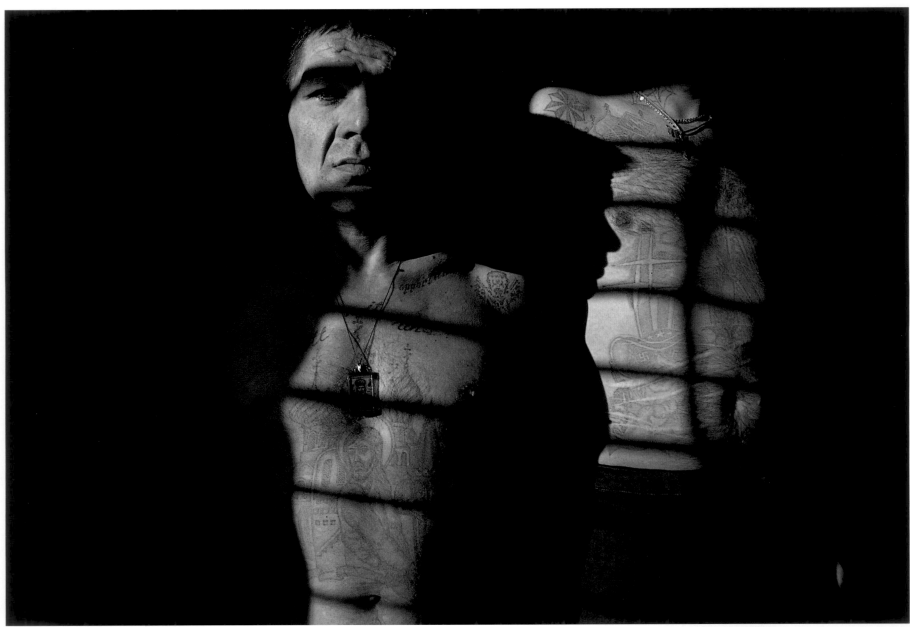

1 KLAUS REISINGER 1991

REVIVAL OF THE RUSSIAN ORTHODOX RELIGION

Klaus Reisinger moved to Moscow in 1991 when he was 20 years old to chronicle the collapse of the Soviet Union. He discovered how alive the traditional orthodox religion remained despite the atheist dogma under the Communist regime. He also learned that religion gives people inner security in a time of great social upheaval. In an independent project he occasionally followed the revival of tradition in Russia with the help of the Russian orthodox priest, Svietoslav. "I was able to penetrate ceremonies and intimate moments, usually reserved only for true Russian believers. In search of the more positive stories on earth, this one has really changed my life. War and conflict issues have a very short life-span. Timeless positive stories, on the contrary, survive."

WIEDERAUFLEBEN DER RUSSISCH–ORTHODOXEN RELIGION

Klaus Reisinger zog 1991, im Alter von 20 Jahren, nach Moskau, um den Zusammenbruch des alten Sowjetreiches zu fotografieren. Er entdeckte, wie lebendig die alte orthodoxe Religion trotz des Atheismus-Dogmas geblieben war und welchen Halt die Religion den Menschen nun in der unsicheren Umbruchssituation gab. In einem freien Projekt verfolgte er von Zeit zu Zeit mit Hilfe des Priesters Swietoslaw das Wiedererwachen der religiösen Tradition in Rußland. »Ich war bei Zeremonien und intimen Momenten anwesend, die sonst nur den Gläubigen selbst vorbehalten sind. Auf der Suche nach positiven Geschichten dieser Welt hat diese Story mein Leben verändert. Kriegs- und Konfliktthemen besitzen alle nur eine sehr kurze Lebensdauer; dagegen bleiben zeitlos positive Geschichten immer aktuell.«

RENAISSANCE DE LA RELIGION ORTHODOXE RUSSE

En 1991, à vingt ans, Klaus Reisinger se rendit à Moscou et couvrit l'effondrement de l'ancien empire soviétique. Il découvrit la vitalité conservée par la vieille religion orthodoxe en dépit de l'athéisme officiel, ainsi que le soutien qu'elle offrait aux gens dans le désarroi ambiant. A ses moments perdus, Reisinger suivit pour son propre compte le réveil de la tradition russe, guidé par le prêtre russe-orthodoxe Svietoslav. « J'eus la possibilité d'assister à des cérémonies et à des moments privés, habituellement réservés aux vrais croyants russes. Dans ma quête d'images plus positives sur cette terre, ce reportage a complètement changé ma vie. La guerre et les conflits durent très peu de temps, tandis que les histoires positives survivent à tout et résistent au temps ».

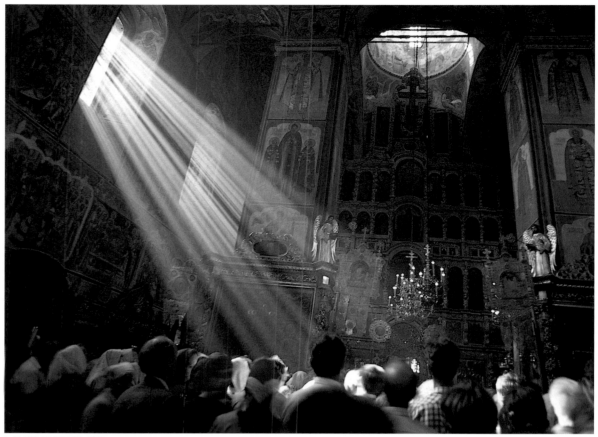

2 KLAUS REISINGER 1991

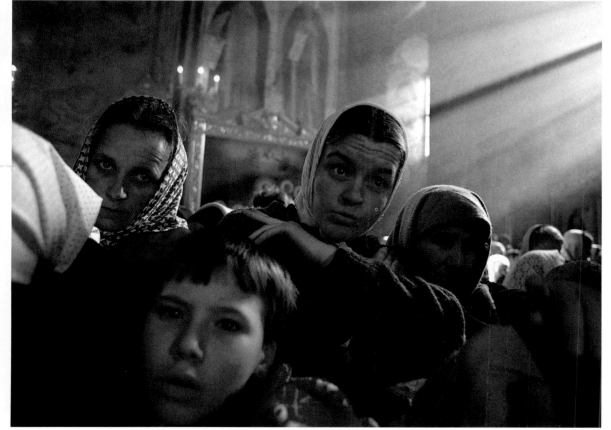

3 KLAUS REISINGER 1991

(1) Inmates of the prison in Tver. The man in the foreground proudly shows off his religious tattoos and his pendant with a holy picture. On the body in the background the American Uncle Sam is carelessly intertwined with the fascist symbols of the swastika and SS runes, bearing witness to confused ideological alliances. (2) An early morning church service in a country church in Yaroslavl. (3) Members of the Orthodox faith in Zagorsk.

(1) Häftlinge in der Anstalt in Twer. Der Mann im Vordergrund stellt stolz seine religiösen Tattoos und seinen Anhänger mit Heiligenbild zur Schau. Auf dem Körper im Hintergrund lauert der amerikanische Uncle Sam, versetzt mit den faschistischen Symbolen Hakenkreuz und SS-Runen, und erzählt von wirren ideologischen Allianzen. (2) Morgendliche Liturgie in einer Landkirche bei Jaroslawl. (3) Orthodoxe Gläubige in Zagorsk.

(1) Détenus de la prison de Tver. L'homme au premier plan montre fièrement ses tatouages religieux et son pendentif-icône. L'homme qui est derrière lui porte un « Oncle Sam » flanqué d'une croix gammée et du symbole SS, association qui signale une certaine confusion idéologique. (2) Office matinal dans une église de campagne, près de Yaroslavl. (3) Fidèles orthodoxes à Zagorsk.

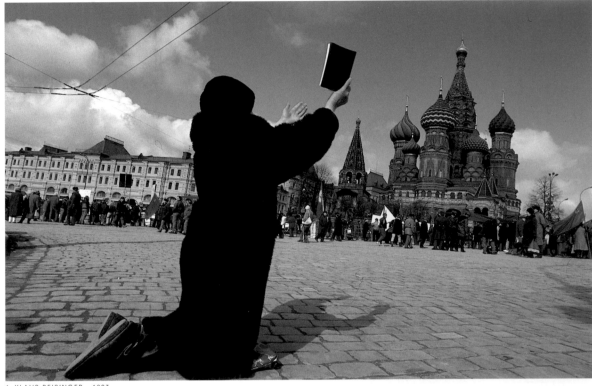

1 KLAUS REISINGER 1993

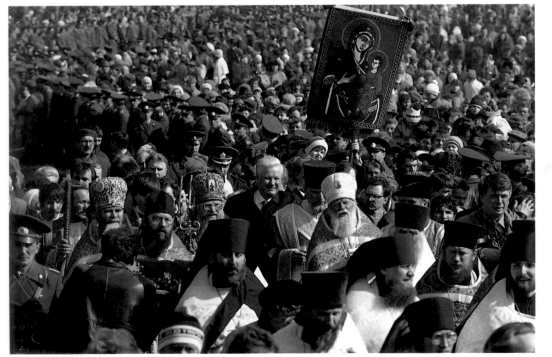

2 KLAUS REISINGER 1993

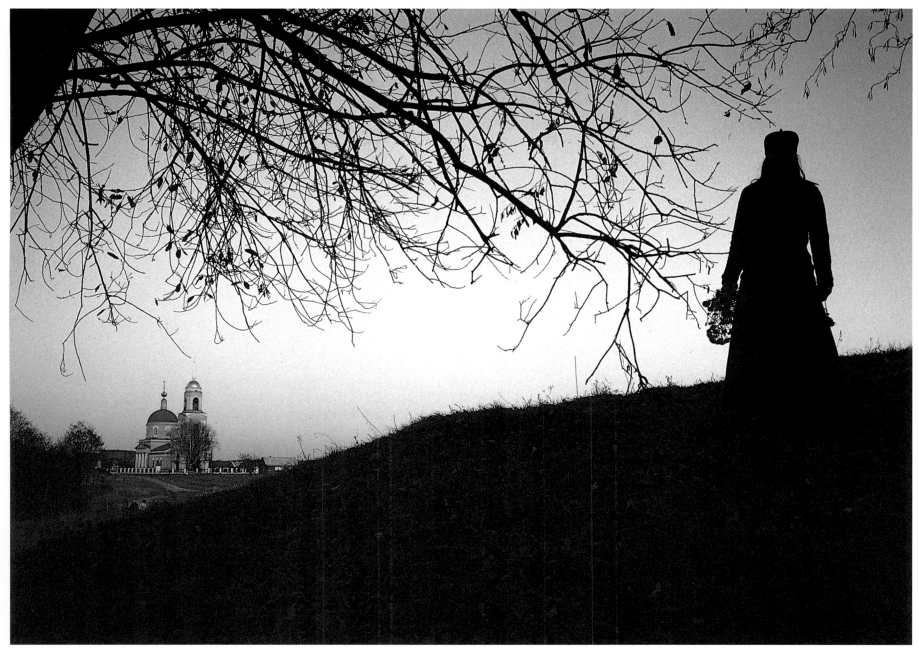

3 KLAUS REISINGER 1993

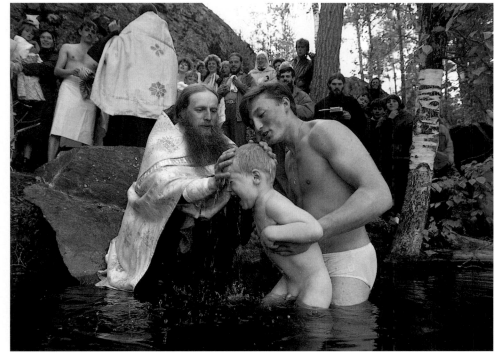

4 KLAUS REISINGER 1993

(1) Spring 1993. An old Muscovite says her prayers on Red Square, while communist hard-liners demonstrate in the background. (2) President Boris Yeltsin participated in the 1993 Easter procession in Vladimir and thereby publicly professed his support for the religious roots of Russian culture. (3) An orthodox monk in the Pskova Pichori monastery in Radonezh where Saint Sergius was born, (4) where Reisinger also photographed this baptism.

(1) Frühjahr 1993. Eine alte Moskauerin betet auf dem Roten Platz, während im Hintergrund kommunistische Hardliner demonstrieren. (2) Der Präsident Boris Jelzin nahm an der Osterprozession 1993 in Wladimir teil und bekannte sich auch so zu den religiösen Wurzeln russischer Kultur. (3) Ein orthodoxer Mönch des Pskowa-Pitschori-Klosters in Radonesch, dem Geburtsort des Sankt Sergej, (4) wo Reisinger auch diese Taufe fotografierte.

(1) Printemps 1993. Sur la Place rouge, une vieille Moscovite prie sur fond de manifestation de communistes purs et durs. (2) En 1993, le président Boris Eltsine prit part à la procession de Pâques à Vladimir, ce qui équivalait à reconnaître la religion traditionnelle russe. (3) Un moine orthodoxe du monastère de Pskova Pitchori à Radonezh, lieu de naissance de saint Sergueï, (4) où Reisinger photographia également ce baptême.

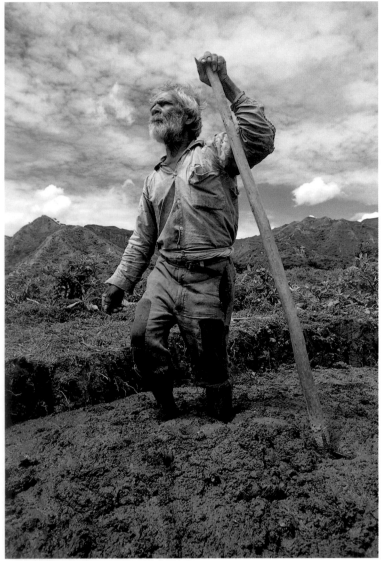

(1) For decades Jose Maria Roa (87) had been wading through the clayey mud to produce the raw material for adobe bricks manufactured in the Vilcabamba mountain range. Apart from an occupational foot complaint, the old man was as fit as a fiddle. (2) Miguel Carpio (125) still visited the barber every two months. He continued to practice his vocation as a hunter until he was 75 years old. His daughter described his lifestyle: "He smokes and drinks and still enjoys flirting with the girls." (3) Quosta Arukhadze, 110 years old, with his great-great-grandchildren. (4) Never a day went by that Khfaf Lasuria, over 130 years old, did not have her glass of vodka before breakfast or smoked her daily packet of cigarettes. She had given up working as a tea picker only two years before, but she still took care of the household.

(1) Jose Maria Roa, 87, watete schon seit Jahrzehnten durch den lehmigen Schlamm, um den Grundbaustoff für die Adobebauten in Vilcabamba im Hochland herzustellen. Außer einem berufsbedingten Fußleiden war der Alte kerngesund. (2) Miguel Carpio, 125, besuchte alle zwei Monate den Friseur. Bis ins Alter von 75 ging er seinem Beruf als Jäger nach. Seine Tochter beschrieb seinen Lebenswandel: »Er raucht und trinkt und flirtet immer noch gerne mit den Mädchen.« Abchasien im Kaukasus. (3) Quosta Arukhadze, 110 Jahre alt, mit seinen Urur-Enkeln. (4) Khfaf Lasuria, über 130 Jahre alt, verzichtete nie auf einen Wodka vor dem Frühstück und eine Schachtel Zigaretten am Tag. Sie hatte vor zwei Jahren die Teepflückerei aufgegeben, kümmerte sich aber immer noch um das Haus.

(1) Jose Maria Roa, 87 ans, pataugeait depuis des dizaines d'années dans les boues de glaises pour produire la matière première des constructions en adobe à Vilcabamba, dans les montagnes. A part des douleurs aux pieds, dues à son métier, le vieillard était en pleine santé. (2) Miguel Carpio, 125 ans, se rendait chez le coiffeur tous les deux mois. Jusqu'à 75 ans, il avait été chasseur. Sa fille décrivait son mode de vie : « Il boit, fume et aime toujours faire la cour aux filles. » (3) Quosta Arukhadze, 110 ans, avec ses arrière-arrière-petits-enfants. (4) Khfaf Lasuria, plus de 130 ans, n'a jamais renoncé au verre de vodka au petit-déjeuner ni au paquet de cigarettes quotidien. Elle avait arrêté la cueillette du thé deux ans plus tôt, mais s'occupait toujours de la maison.

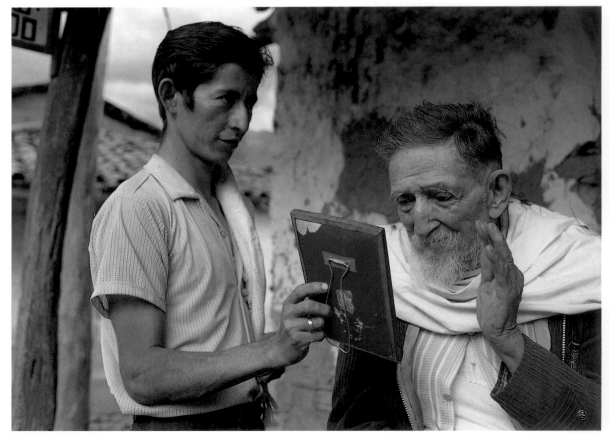

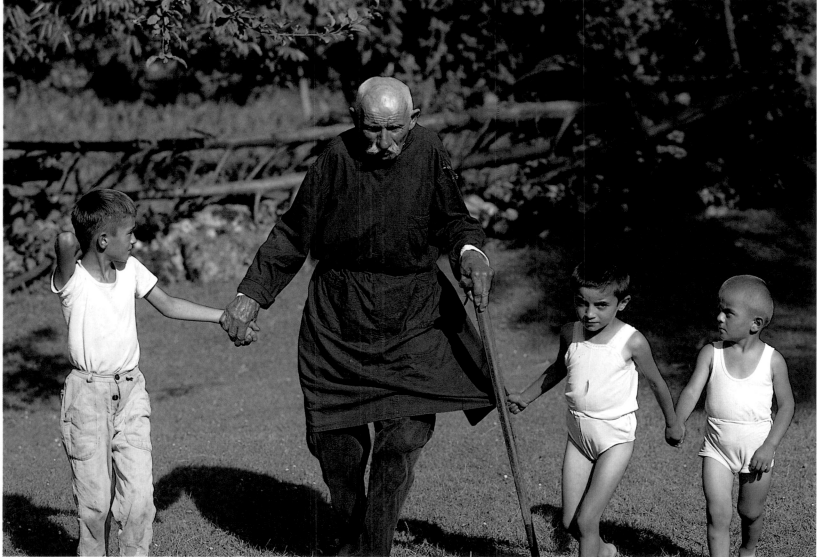

3 JOHN LAUNOIS 1972

YOUTH IN OLD AGE

John Launois was fascinated by research on old age, performed in Ecuador by the scientist Alexander Leaf. Together with Black Star Launois developed the idea of doing a reportage on longevity. This idea inspired the editors of *National Geographic* so much that they took it on board and expanded it. Not only did they send Launois and Leaf to Ecuador in 1972, but also to the Hunza in the Pakistani part of the Himalayas and Abkhazia in the former Soviet Union. People "as old as the hills" in three completely different cultures were investigated and subsequently portrayed in the reportage.

JUGEND IM HOHEN ALTER

John Launois war fasziniert von den Altersstudien des Wissenschaftlers Alexander Leaf in Ecuador. Gemeinsam mit Black Star entwickelte Launois eine Reportage-Idee über das lange Leben, die auch die Redakteure von *National Geographic* begeisterte. Sie schickten Launois und Leaf 1972 nicht nur nach Ecuador, sondern auch zu den Hunza in Pakistan und zu den Abchasiern in der damaligen Sowjetunion. Die Reportage untersuchte »steinalte« Menschen in drei völlig unterschiedlichen Kulturen.

LA JEUNESSE DU GRAND AGE

John Launois avait été impressionné par les études du scientifique Alexander Leaf sur les vieillards en Equateur. En association avec Black Star, le photographe forma un projet de reportage sur les très longues vies, qui séduisit également la rédaction du *National Geographic*. Launois et Leaf partirent en 1972 en Equateur, mais aussi chez les Hunza de l'Himalaya pakistanais, et chez les Abkhazes, en Union soviétique. L'enquête portait sur les grands vieillards dans trois civilisations différentes.

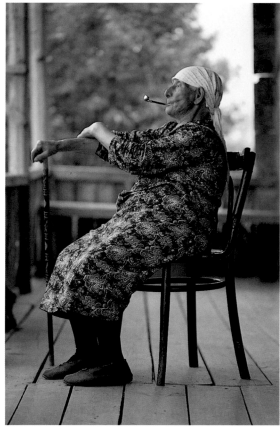

4 JOHN LAUNOIS 1972

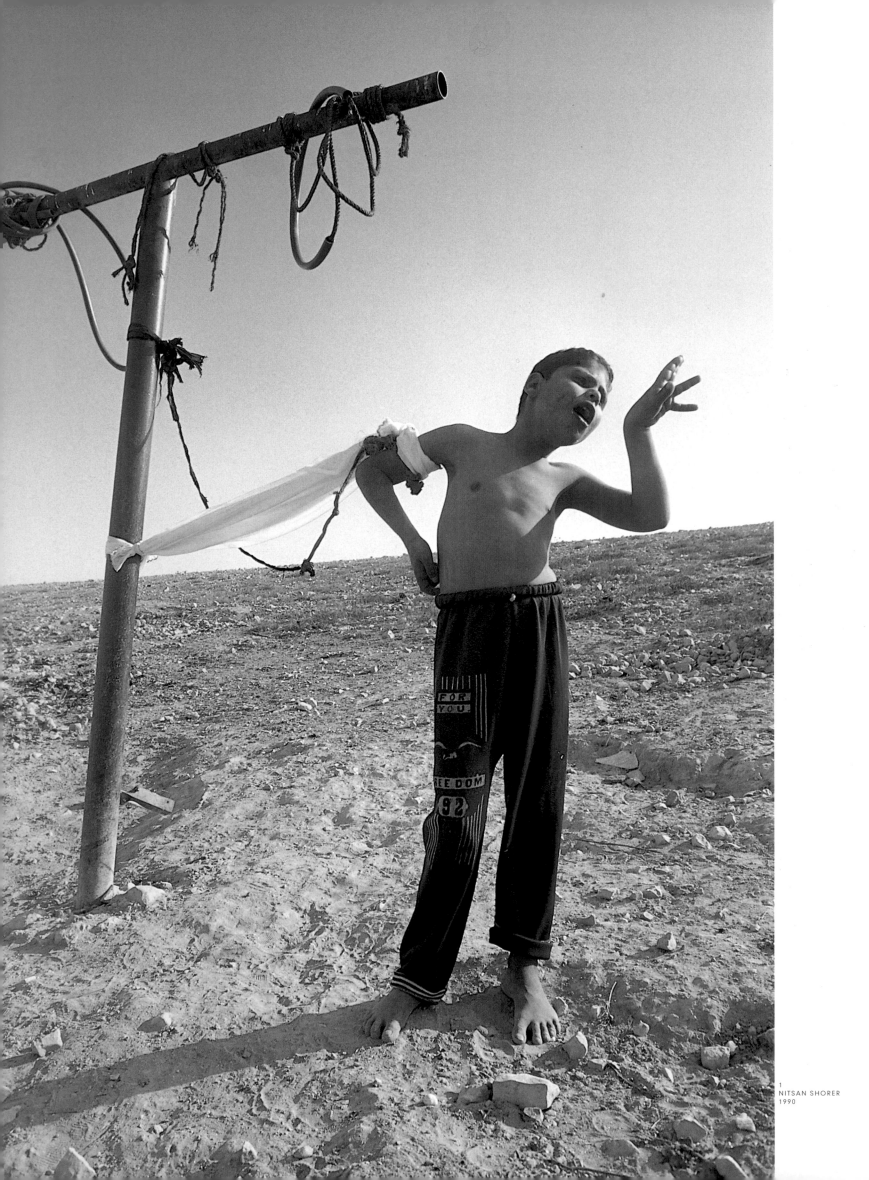

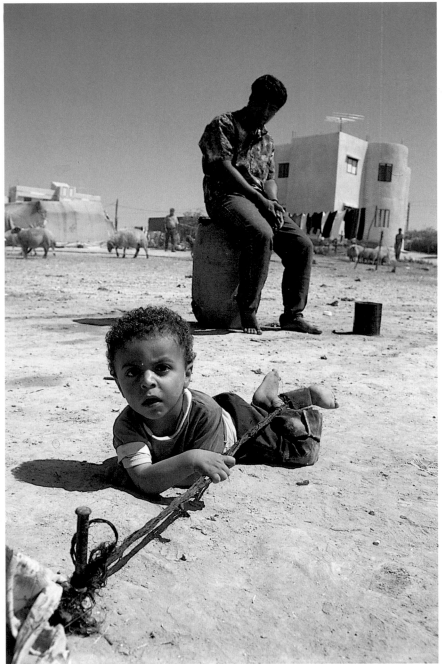

2 NITSAN SHORER 1990

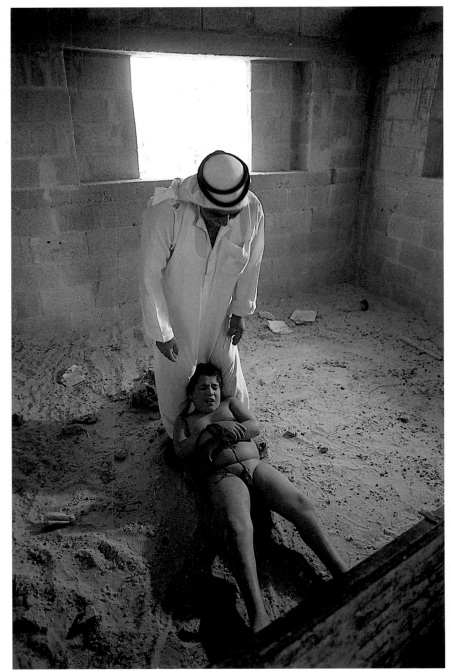

3 NITSAN SHORER 1990

GOD'S FORGOTTEN CHILDREN

Nitsan Shorer (b. 1955 in Tel Aviv) is still enraged when he reminisces about the reportage he did in 1990 on the life of handicapped Bedouin children in the Negev desert. The handicap rate is exceptionally high due to the incestuous nature of the Bedouin lifestyle. However, the majority of Bedouin parents with handicapped children can expect little support from the Israeli government. (2) Handicapped toddlers are tied to a post like dogs by their parents. (3) This 12-year-old severely disabled and blind boy spends the morning in an institution, in the afternoons he is tied up and locked into this hole by his father. (1) This equally seriously handicapped 12-year-old gets tethered inside or outside, depending on the weather. "He is considered the family's shame, nobody comes near him", reported the photographer.

GOTTES VERGESSENE KINDER

Nitsan Shorer (geb. 1955 in Tel Aviv) empört sich immer noch, wenn er an die Reportage über das Leben behinderter Beduinenkinder in der Negev-Wüste 1990 denkt. Die Anzahl Behinderter ist durch den inzestuösen Charakter der Beduinengesellschaft recht hoch, die israelischen Behörden lassen die meisten Beduinen-Eltern jedoch mit ihren Problemen allein. (2) Behinderte Kleinkinder wurden von ihren Eltern wie Hunde angepflockt. (3) Der 12jährige schwerbehinderte und blinde Junge verbrachte den Morgen im Heim, am Nachmittag wurde er von seinem Vater in diesem Schuppen gefesselt und eingesperrt. (1) Dieser ebenfalls schwerbehinderte Zwölfjährige wurde täglich, je nach Witterung drinnen oder draußen, angebunden. »Er gilt als Schande der Familie, und niemand kommt ihm zu nahe«, berichtet der Fotograf.

LES ENFANTS OUBLIES DE DIEU

Nitsan Shorer (né en 1955 à Tel-Aviv) est toujours en colère quand il pense à son reportage de 1990 sur des enfants bédouins handicapés dans le désert du Négev. La proportion de handicaps est relativement haute chez les Bédouins à cause de l'endogamie. La société israélienne laisse seuls avec leurs problèmes la plupart des parents bédouins d'enfants handicapés. (2) Des nourrissons handicapés sont attachés à des piquets par leurs parents. (3) Cet enfant de 12 ans, aveugle et handicapé profond, a passé la matinée dans une institution. L'après-midi, son père l'a attaché et enfermé dans un hangar. (1) Cet autre garçon de 12 ans, également débile profond, était attaché quotidiennement, soit à l'intérieur, soit à l'extérieur. « Il est perçu comme la honte de la famille, personne ne s'approche de lui », rapporte le photographe.

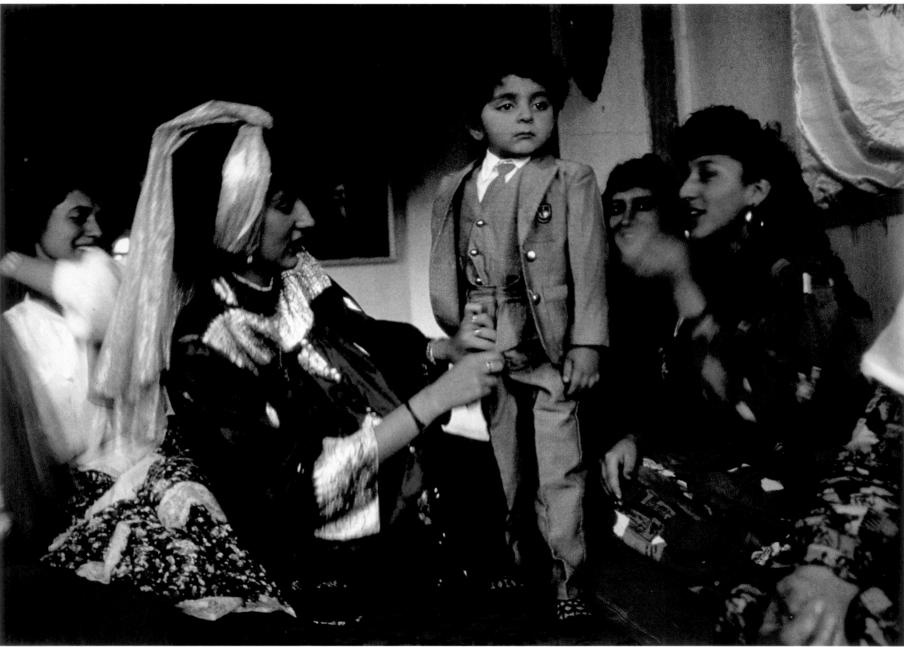

1 KLAUS REISINGER 1992

CHILDREN OF THE WORLD

Across the world children are the innocent victims of war, repression, poverty, rigid rolemodels and prejudices. Because of their innocent simple-mindedness, they are often the first contact a photographer has with the local population when undertaking a reportage visit abroad. Yet, it is usually a long, difficult road to get past the outer facade of the first pose for the camera.

KINDER DER WELT

Überall auf der Welt sind Kinder Opfer von Krieg, staatlichen Repressionen, Armut, festgefügten Rollenmustern und Vorurteilen. Aufgrund ihrer kindlichen Unbedarftheit sind sie meist der erste Kontakt des Fotografen während einer Reportagereise – es ist jedoch ein langer Weg, um über das erste Posieren hinaus hinter die Fassade zu gelangen.

ENFANTS DU MONDE

Partout dans le monde, des enfants sont les victimes innocentes des guerres, des répressions, de la misère, des modèles sociaux préfabriqués et des préjugés. Leur spontanéité en fait souvent les premiers interlocuteurs du photographe en reportage, même s'il faut parfois beaucoup de patience pour découvrir, derrière les poses et les jeux, ce qui se trame en coulisses.

(1) Klaus Reisinger pays a visit to the patriarch of a family in Afghanistan in 1992. (2) In his reportage about the street children of Rio de Janeiro, Claus Meyer discovered this 17-year-old transvestite on the roadside. (3) When journalists like Simona Calí Cocuzza investigate the topic of child labor, those involved are usually diffcult to track down, like this little man working as a coal vendor in El Salvador in 1988.

(1) Diesen Stammhalter besuchte Klaus Reisinger 1992 in Afghanistan. (2) Claus Meyer fand 1987 in seiner Reportage über Straßenkinder in Rio de Janeiro diesen 17jährigen ermordeten Transvestiten am Straßenrand.
(3) Wenn Journalisten wie Simona Calí Cocuzza das Thema Kinderarbeit bearbeiten, dann sind die Betroffenen schwer ausfindig zu machen, wie dieser kleine Mann in El Salvador 1988, der als Kohlenverkäufer arbeitete.

(1) Un futur chef de famille sous l'objectif de Klaus Reisinger en 1992 en Afghanistan. (2) Pendant son reportage sur les enfants des rues à Rio de Janeiro en 1987, Claus Meyer trouva ce travesti de 17 ans laissé au bord d'une rue.
(3) Quand des journalistes enquêtent sur le travail des enfants, comme Simona Calí Cocuzza en 1988, ils trouvent difficilement les intéressés, ici un petit Salvadorien vendeur de charbon.

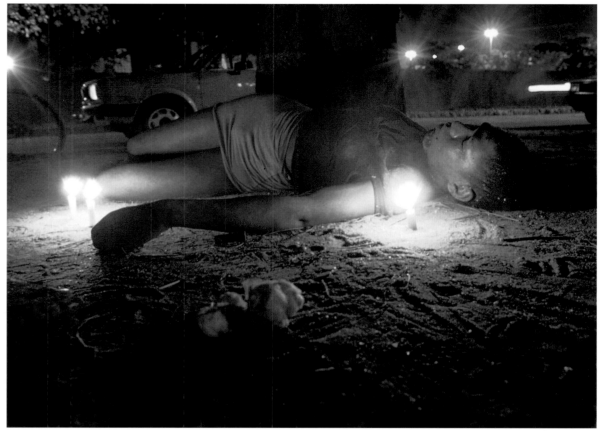

2 CLAUS MEYER 1987

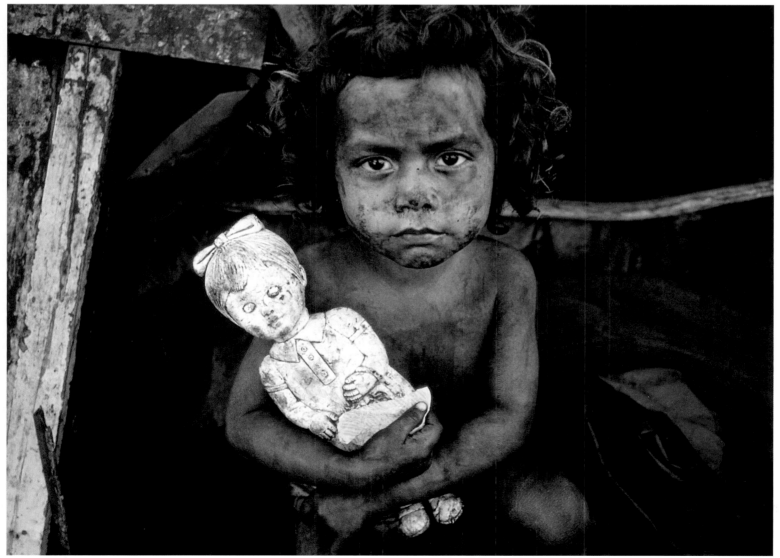

3 SIMONA CALÍ COCUZZA 1988

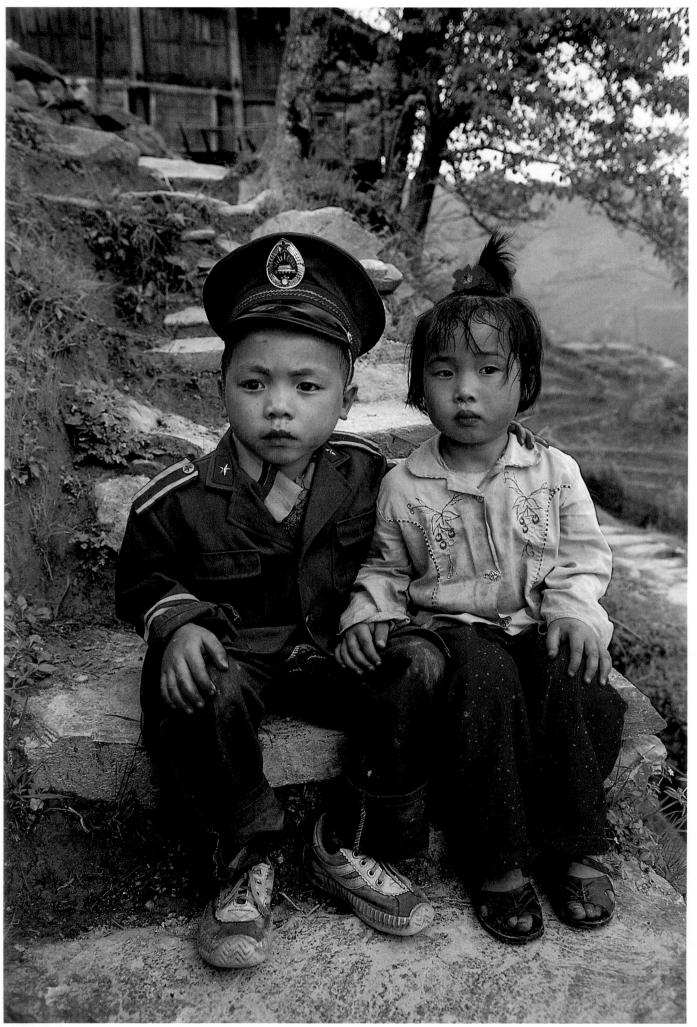

1 CLAUS MEYER 1989

(1) This couple was discovered in south-west China by Claus Meyer in 1989. (2) Michael Coyne came across these children of Hutu refugees in a provisional camp in Burundi in 1994. (3) David Turnley captured this moment of sheer happiness amidst the misery and poverty of a South African township in 1985. (4) Tor Eigeland found this unfeigned manifestation of the uncomplicated friendship between an Australian colonialist and an aboriginal in 1967.

(1) Dieses Paar entdeckte Claus Meyer 1989 im Südwesten Chinas. (2) Michael Coyne traf 1994 auf die Kinder der Hutu-Flüchtlinge in einem provisorischen Lager in Burundi. (3) David Turnley konservierte 1985 diesen Moment von Lebenslust in der Tristesse eines südafrikanischen Townships. (4) Die unkomplizierte Verbrüderung zwischen australischem Ureinwohner und Kolonialist spürte Tor Eigeland 1967 auf.

(1) Claus Meyer découvrit ce petit couple dans le Sud-Est chinois en 1989. (2) Michael Coyne rencontra en 1994 ces enfants de réfugiés hutus dans un camp provisoire au Burundi. (3) En 1985, David Turnley fixa ce moment de joie de vivre dans la tristesse d'un township sud-africain. (4) Fraternisation sans complication entre indigène et colonialiste en Australie, saisie par Tor Eigeland en 1967.

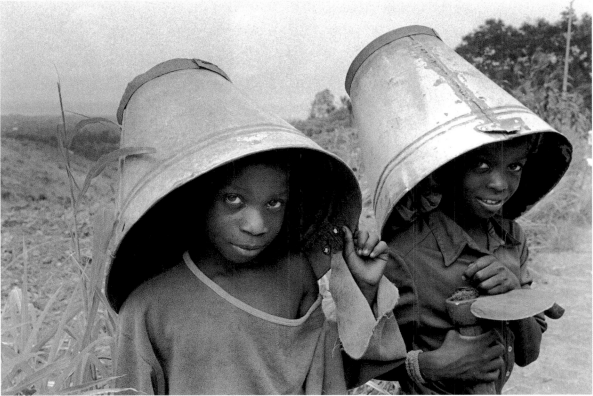

2 MICHAEL COYNE 1994

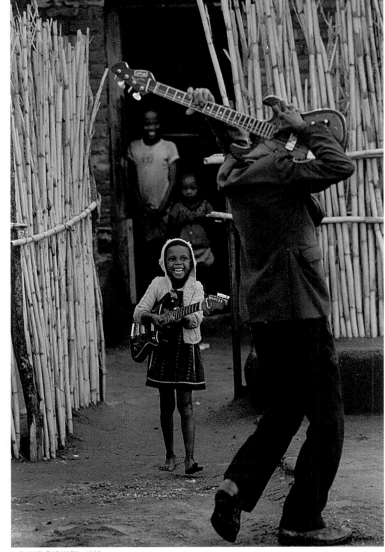

3 DAVID TURNLEY 1985

4 TOR EIGELAND 1967

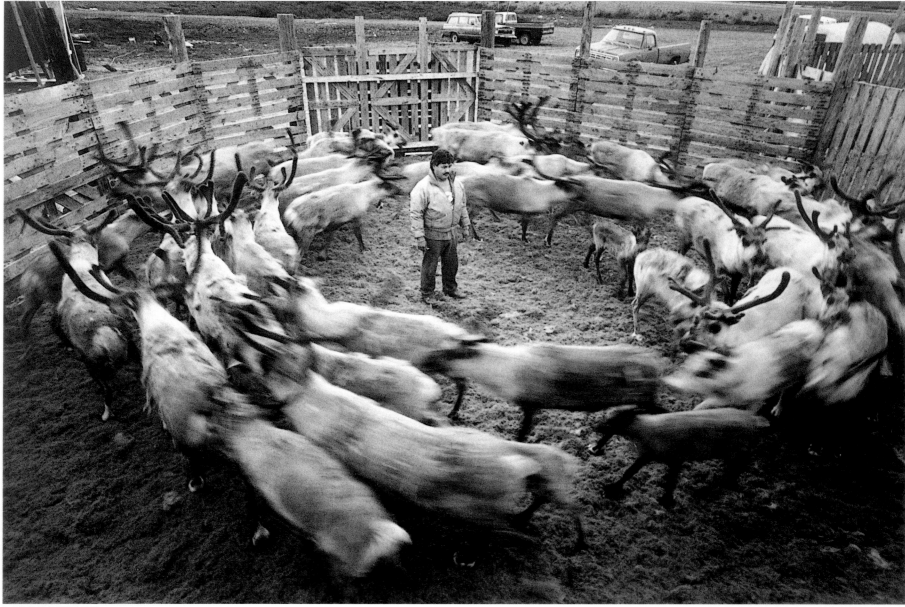

1 CHARLES MASON 1989

Reindeer were imported from Siberia to Alaska in 1892 by the Christian missionary Sheldon Jackson, who wanted to help create a more stable means of existence and income for the nomadic Eskimo. (1) A small helicopter is used to drive the reindeer into the corral in Nome. The animals are nervously running in circles.

Rentiere sind 1892 von dem christlichen Missionar Sheldon Jackson von Sibirien aus nach Alaska eingeführt worden. Der Missionar wollte den ehemals nomadischen Eskimos neue Lebens- und Einkommensgrundlagen verschaffen. (1) Mit einem kleinen Helikopter werden die Rentiere in das Korral in Nome getrieben. Nervös laufen die Tiere im Kreis herum.

En 1892, le missionnaire chrétien Sheldon Jackson introduisit des rennes de Sibérie en Alaska, dans le but d'offrir aux anciens nomades qu'étaient les Eskimos de nouvelles bases de vie et de revenus. (1) Les rennes sont rabattus dans le corral de Nome à l'aide d'un petit hélicoptère. Nerveux, les animaux courent en rond.

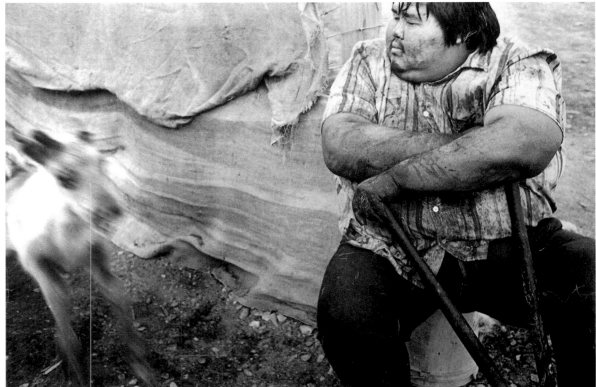

2 CHARLES MASON 1989

(2) Today the antlers are worth much more than the meat.

(2) Heutzutage sind die Geweihe wertvoller als das Fleisch.

(2) De nos jours, les bois des rennes ont plus de valeur que leur chair.

REINDEER HERDING IN ALASKA

Charles Mason (b. in Lexington) launched his photographic career at a daily newspaper in Fairbanks, Alaska. Since 1990 he has been a lecturer in photojournalism at the University of Fairbanks. "This financial security gave me the freedom to do the story 'Reindeer Herding' in black and white. If I were commissioned by a magazine, they would no doubt have insisted on color photographs. Of all the stories I have shot in my career, this pleases me most. Since it is one of those which, in my research, has not been photographed since about 1903, I had no preconceived images in my head when approaching the corral that first night. Viewers of my story often volunteer a comment on how good it looks in black and white. In this age of digitally provided all-color fill-flash autofocus photojournalism, the traditionalist in me sits back and smiles."

RENTIER-HERDEN IN ALASKA

Charles Mason (geb. in Lexington) begann als Tageszeitungsfotograf in Fairbanks, Alaska. Seit 1990 lehrt er an der dortigen Universität Fotojournalismus. »Diese ökonomische Sicherheit gab mir auch die Freiheit, die Geschichte ›Reindeer Herding‹ in schwarzweiß zu produzieren, denn ein Magazin hätte sicherlich auf einen Farbauftrag gedrungen. Von all den Stories, die ich im Laufe meiner Karriere gemacht habe, gefiel mir diese am besten. Da Fotos dieser Art – meines Wissens – zum letzten Mal 1903 gemacht wurden, hatte ich keine vorgefertigten Bilder in meinem Kopf, als ich mich in dieser Nacht der Koppel zum ersten Mal näherte. Häufig höre ich von den Betrachtern meiner Bilder, wie gut die Aufnahmen in schwarzweiß wirken – und das in dieser Zeit des digital gesteuerten, farbintensiven Blitz-Autofocus-Fotojournalismus. In solchen Momenten lehnt sich der Traditionalist in mir zurück und lächelt.«

TROUPEAU DE RENNES EN ALASKA

Charles Mason (né à Lexington) a débuté comme photographe d'un quotidien à Fairbanks, Alaska. Depuis 1990, il enseigne le photojournalisme à l'Université de cette ville. « Cette sécurité financière m'a aussi donné la liberté de réaliser le reportage sur les rennes en noir et blanc, car un magazine m'aurait sûrement imposé la couleur. De tous les reportages que j'ai faits dans ma carrière, c'est celui qui me plaît le plus. D'après mes recherches, rien n'avait été fait sur ce sujet depuis 1903, je n'avais donc pas d'images préconçues dans la tête quand j'ai approché le corral pour la première fois cette nuit-là. Les gens qui voient mes photos commentent souvent la beauté du noir et blanc. A notre époque où le photojournalisme est tout-couleur-tout-flash, autofocus et qualité digitale, le traditionaliste en moi ne peut s'empêcher de sourire ».

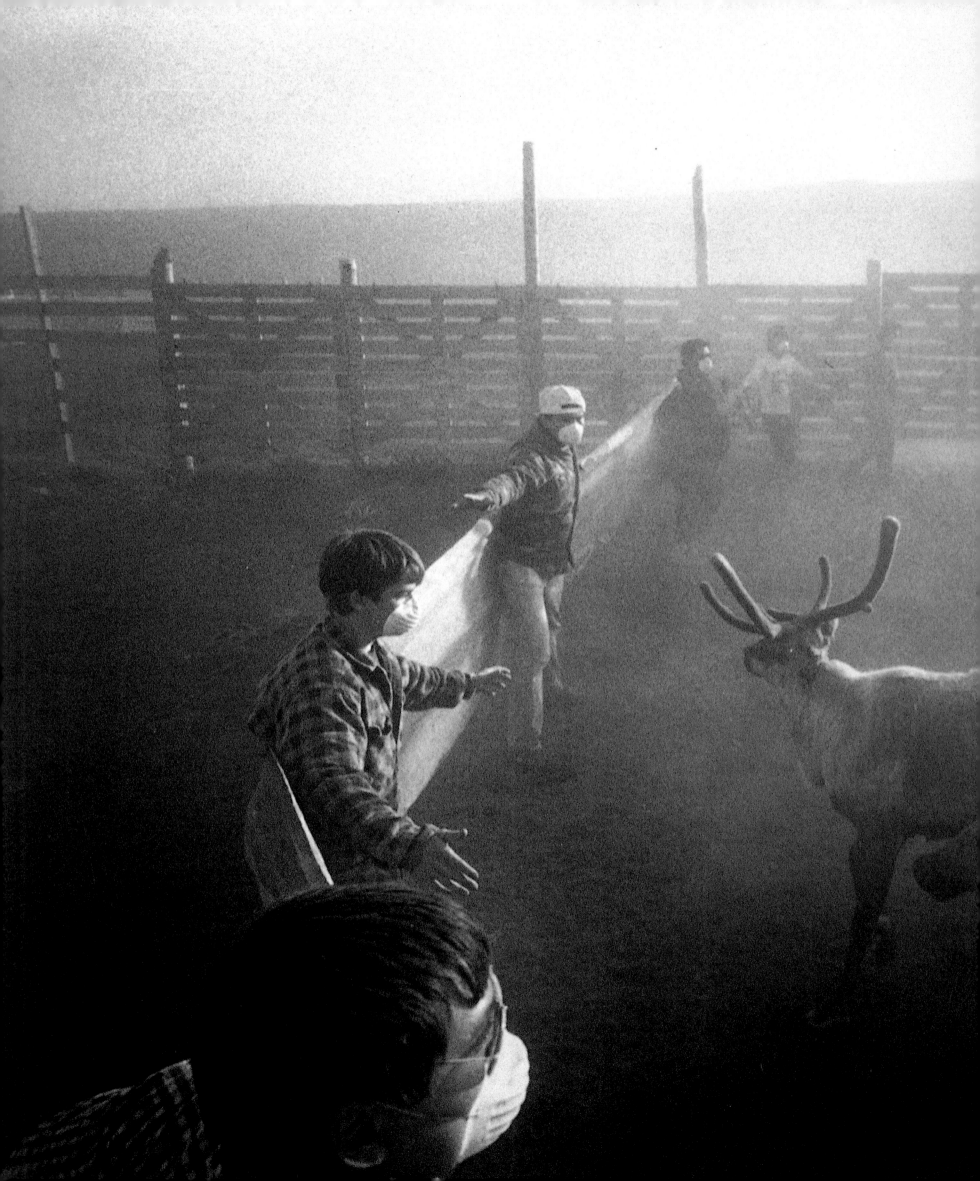

2 CHARLES MASON UNDATED/O.D./S.D.

(1) Once a year all the reindeer are driven into the corral to have their antlers cut off. In a good year a big pair of antlers can fetch up to US$ 1,000. (2) According to biologists the animals have no nerves in their antlers. At first, blood circulates through the horn, but the horn dries out during the growth process. The raw material of this fast-growing horn is used as a basis for the production of aphrodisiacs, sold particularly in the Far East.

(1) Einmal im Jahr werden die Rentiere zusammengetrieben, um die Geweihe zu beschneiden. In guten Jahren bringt ein großes Geweih bis zu 1000 US $. (2) Untersuchungen zufolge haben die Tiere in den Geweihen keine Nerven. Zunächst durchblutet, trocknet das Geweih während des Wachstums aus. Die jährlich nachwachsenden Rohstoffe bilden die Basis für die Produktion von Aphrodisiaka, die vor allem im Fernen Osten gekauft werden.

(1) Une fois l'an, les rennes sont rassemblés pour être dépouillés de leurs bois. Les bonnes années, une grande ramure peut rapporter jusqu'à 1000 $. (2) D'après les biologistes, les bois ne sont pas innervés. D'abord irrigués par le sang, ils s'assèchent au cours de leur croissance et fournissent la matière première, renouvelable annuellement, d'un aphrodisiaque acheté surtout en Asie.

1
CHARLES MASON
UNDATED/O.D /S.D.

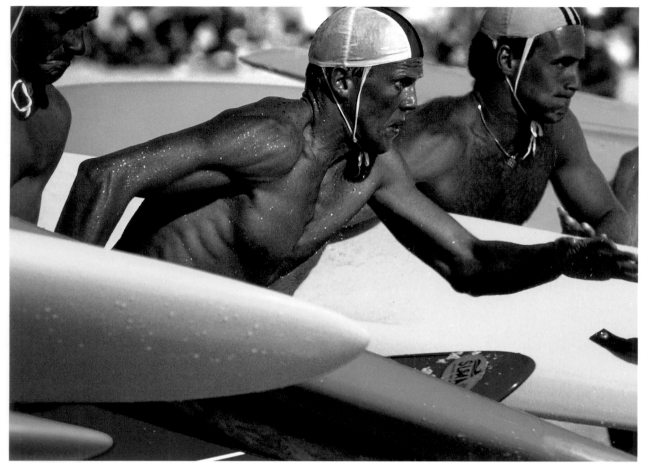

1 ROBERT GARVEY 1987

2 ROBERT GARVEY 1987

SPORT

(1) Australian surf-lifesavers at the start of the surfboard race at Scarboro Beach. This competition has a long tradition and in 1987, when this photo was taken, almost 4,000 members of various surf-lifesaving clubs got together for their Olympics. On weekends and during school holidays the surf-lifesavers unfailingly guard Australia's wide and often dangerous beaches on a voluntary basis. When they are deployed, it is always a matter of life and death. (2) In the same year Robert Garvey also followed the boat "Stars and Stripes" at the highlight of the open sea regatta season. Skipper Dennis Conner and his American crew won the America's Cup that year.

SPORT

(1) Australische Surf-Lebensretter beim Start zum Surf-Board-Rennen in Scarboro Beach. Der Wettbewerb hat eine lange Tradition, so trafen sich auch 1987 an die 4 000 Mitglieder der Surf Lifesaving Clubs zu ihrer Olympiade. An den Wochenenden und in den Schulferien bewachen sie ehrenamtlich die weiten und oft gefährlichen Strände; bei ihren Einsätzen geht es immer um Leben und Tod. (2) Robert Garvey verfolgte im gleichen Jahr auch das Boot Stars and Stripes beim Höhepunkt der Hochsee-Regatta-Saison. Die amerikanische Crew unter Skipper Dennis Conner gewann den America's Cup.

SPORT

(1) Sauveteurs surfistes australiens au départ de la course de surf de Scarboro Beach. Cette compétition est issue d'une longue tradition qui a fait se rencontrer en 1987 4 000 membres des clubs de sauveteurs surfistes pour leurs jeux olympiques. Les week-ends et les vacances scolaires, ils surveillent scrupuleusement d'immenses et souvent dangereuses plages. Leurs interventions sont toujours des questions de vie ou de mort. (2) La même année, au plus fort de la saison des régates de haute-mer, Robert Garvey suivit le bateau américain Stars and Stripes qui remporta l'America's Cup avec Dennis Conner comme skipper.

(3) In 1985 James Sugar photographed this peculiarity in American air sports: two inventors combined the design principles of the zeppelin air ship and the bicycle. During the test phase, they had already successfully completed a nine-hour non-stop flight over California. (4) At the end of the 1970s, Black Star sent a feature-story on jogging to all its clients and agencies: "America does everything in excess! The most recent preoccupation of 'the ME generation' is in the area of physical conditioning. One walks along the streets of New York or the pastoral byways of rural America and one sees people dressed in sweatsuits running, running, and running." Charles Rogers's photo of the Peach Tree Marathon in Atlanta served as the lead photograph.

(3) James Sugar fotografierte 1985 eine Kuriosität des amerikanischen Luftsports. Zwei Erfinder verbanden das Prinzip des Zeppelins und des Fahrrads miteinander. Während der Testphase war bereits ein neunstündiger ununterbrochener Testflug über Kalifornien gelungen. (4) Black Star verschickte Ende der 70er Jahre eine Feature-Geschichte über das Joggen an seine Kunden und Agenten: »Amerika macht alles im Übermaß! Die neueste Lieblingsbeschäftigung der ICH-Generation ist die Verbesserung der körperlichen Fitness. Ob auf den Straßen New Yorks oder den idyllischen Wegen des ländlichen Amerika: überall sieht man Menschen in Trainingsanzügen, die laufen und laufen und laufen.« Als Aufmacher diente Charles Rogers' Bild vom Peach Tree-Marathon in Atlanta.

(3) En 1985, James Sugar photographia une curiosité du sport aérien américain. Deux inventeurs avaient réalisé un hybride du zeppelin et du vélo. Dès la phase des tests, ils avaient réussi à survoler la Californie en neuf heures sans arrêt. (4) A la fin des années 70, Black Star diffusa un reportage sur le jogging : « L'Amérique fait de tout un excès ! Le dernier souci de la génération du MOI, c'est l'amélioration de sa forme physique. Dans les rues de New York comme sur les chemins de campagne, on voit partout des gens en survêtement qui courent, courent, courent. » Le reportage s'ouvrait sur le marathon de Peach Tree, à Atlanta.

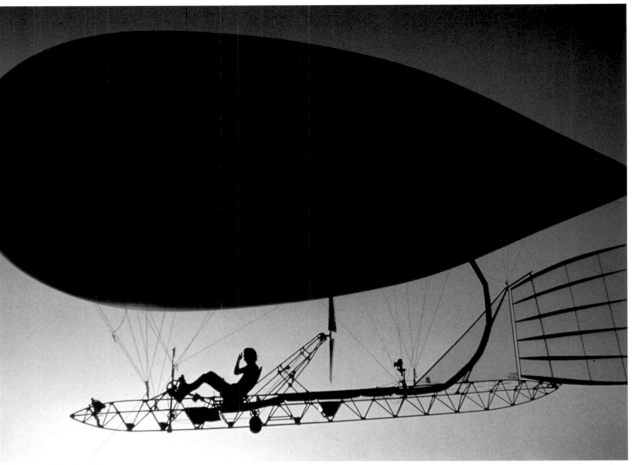

3 JAMES A. SUGAR 1985

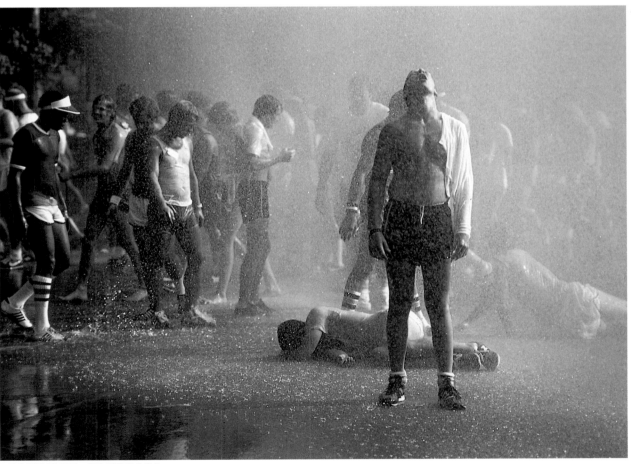

4 CHARLES ROGERS UNDATED/O.D./S.D.

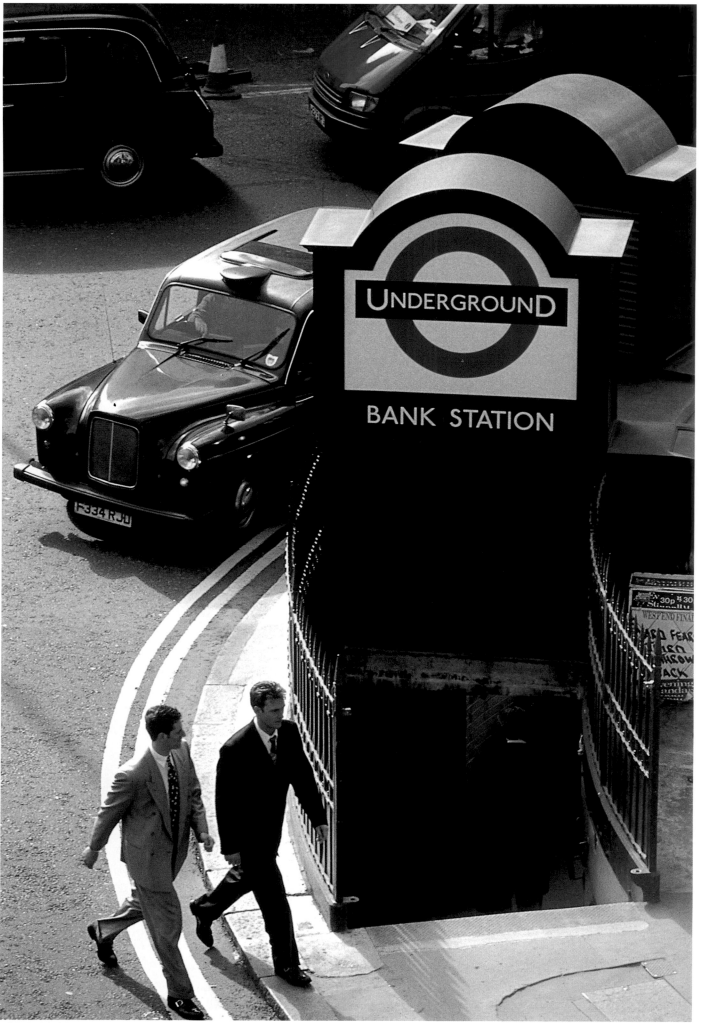

1 DAVID LEVENSON 1994

ORDINARY PEOPLE, EXTRAORDINARY LIVES

(1) In the heart of London lies the "City", one of the world's major financial districts. (2) The guards at the main entrance to the Bank of England in Threadneedle Street already give an indication of the tradition of the house.

(1) Im Herzen der City von London liegt der Finanzdistrikt, einer der größten der Welt. (2) Der Wächter am Haupt-eingang der Bank of England in der Threadneedle Street signalisiert bereits die Tradition des Hauses.

(1) Au cœur de la City se trouve le district des finances, l'un des plus étendus du monde. (2) Le gardien de l'entrée principale de la banque anglaise, sur la Threadneedle Street, signale d'emblée le style de la maison.

2 DAVID LEVENSON 1994

BANK OF ENGLAND

David Levenson (b. 1959 in Harrow, England) was a permanent member of the Buckingham Palace press team in the 1980s. His work during this era filled 16 books, prominent among them Charles and Diana's First Royal Tour. But then he decided to make a career change and devoted himself to photojournalism. In 1994 a coup came his way: he was permitted into the sacred halls of the Bank of England on the occasion of the institute's tercen-tenary. This honor had been bestowed on a jour-nalist only once before – during the bicentenary 100 years ago. However, the assignment was in itself a compromise: "An institution like the Bank of England prides itself on its ability to keep out prying eyes, my purpose was to reveal all their activities … to the world outside." Levenson does not disclose any secrets, but his photos essentially capture the typically British charm of this international financial institution. The London *Daily Telegraph* magazine printed the reportage on the jubilee in a 12-page special feature.

BANK OF ENGLAND

David Levenson (geb. 1959 in Harrow, England) arbeitete in den 80er Jahren als festes Mitglied des Presse-Corps des Buckingham Palace. Seine Arbeit aus dieser Zeit füllt 16 Bücher, u.a. »Charles and Diana's First Royal Tour«. Dann wandte er sich aber dem Fotojournalismus zu. 1994 gelang ihm der Coup, zum 300jährigen Jubiläum in die heiligen Hallen der Bank of England vorgelassen zu werden. Dies war bisher nur einem Fotografen gelungen, zum Jubiläum 100 Jahre zuvor. Doch die Arbeit war ein Kompromiß an sich: »Mein Ziel war es, die geheimen Aktivitäten der Bank of England – einer Institution, die stolz darauf ist, ihre Tätigkeit vor neugierigen Augen zu verbergen – für die Öffent-lichkeit zu enthüllen.« Levenson verrät uns keine Geheimnisse, dafür fing er in seinen Bildern den typisch britischen Charme dieser Weltfinanz-institution ein. Die Reportage wurde in der Beilage des Londoner *Daily Telegraph* zum Jubiläum auf zwölf Seiten veröffentlicht.

LA BANQUE D'ANGLETERRE

David Levenson (né en 1959 à Harrow, Angle-terre) travailla dans les années 80 comme membre permanent du service de presse de Buckingham Palace. Ses travaux d'alors remplissent 16 volumes, parmi lesquels figurent les « Premiers déplacements royaux de Charles et Diana ». Par la suite, il se tourna vers le photojournalisme. En 1994, pour le tricentenaire de la Banque d'Angle-terre, il réussit à pénétrer dans le saint des saints de la fameuse institution. Un seul photographe y était parvenu avant lui, un siècle plus tôt pour le bicentenaire. Le projet était un défi : « Une institu-tion comme la Banque d'Angleterre s'enorgueillit de sa discrétion, et mon but était de révéler au monde du dehors tout ce travail secret. » Levenson ne trahit aucun secret, mais il a capté le charme typiquement britannique de cette doyenne de la finance mondiale. Le reportage fut publié sur 12 pages dans le supplé-ment du quotidien Londonien *Daily Telegraph* pour le tricentenaire.

1 DAVID LEVENSON 1994

2 DAVID LEVENSON 1994

3 DAVID LEVENSON 1994

4 DAVID LEVENSON 1994

5 DAVID LEVENSON 1994

(1) The domain of the Bank's senior management. (2) The design of banknotes is produced on a computer, then it is transposed to film and subsequently a printing plate is constructed. (3) Gold bars to the value of millions of pounds lie stacked up in the vaults of the Bank. (4) Printed sheets of £5 notes are transported to the inspection unit. (5) New printing plates for £5 notes are examined.

(1) Ein Blick in die Etage des Senior Bank Management. (2) Das Design der Banknoten wird am Computer erstellt, auf Film übertragen und dann als Druckplatte bereit-gestellt. (3) In den Tresorräumen lagern Goldbarren im Wert von Millionen Pfund. (4) Transport von 5-Pfund-Druck-bögen zur Kontrolle. (5) Neue Druckplatten für 5-Pfund-Noten werden geprüft.

(1) Un regard dans les étages de la Senior Bank Management. (2) Le dessin des billets de banque est réalisé à l'ordinateur, transposé sur film, puis sur planche à imprimer. (3) Dans les salles du trésor se trouvent pour plusieurs millions de livres de lingots d'or. (4) Transport au contrôle de nouveaux billets. (5) Test de nouvelles planches à imprimer pour des billets de 5 livres.

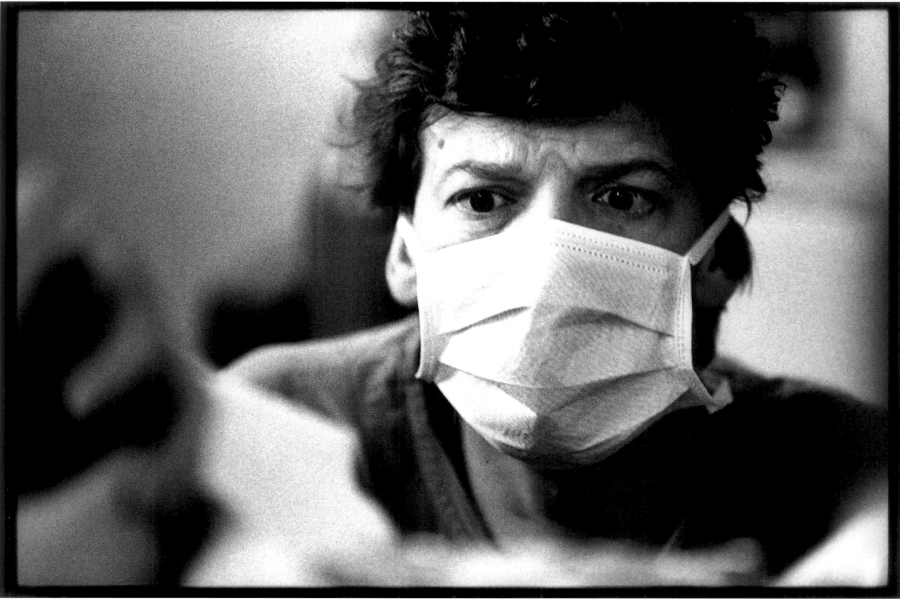

1 CHRISTOPHER MORRIS UNDATED/O.D./S.D.

(1) A doctor during an operation. He admitted to the photographer that his thoughts were always, even at work, with his wife and two children, who fled to Norway shortly after the outbreak of the war. He had not seen them since then.

(1) Ein Arzt während einer Operation. Er gestand dem Fotografen, daß er auch während seiner Arbeit ständig an seine Frau und seine beiden Kinder denken müsse, die kurz nach Ausbruch des Krieges nach Norwegen geflohen waren. Ein Wiedersehen gab es bis dahin nicht.

(1) Un médecin au cours d'une opération. Il avoua au photographe que même pendant son travail, il pensait constamment à sa femme et à ses enfants, réfugiés en Norvège peu après le début de la guerre. Il ne les avait pas revus depuis.

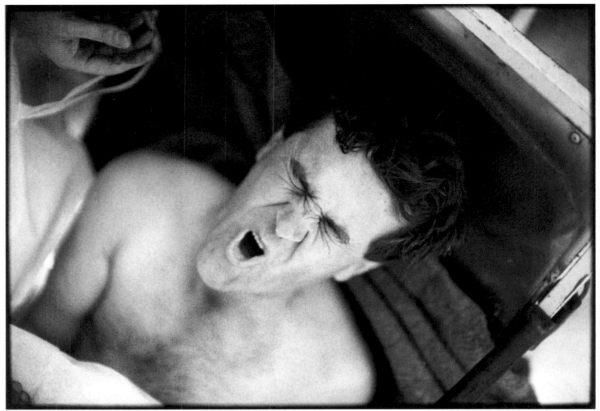

(2) There were days when a continuous stream of wounded people were admitted to the hospital. Shrapnel was removed without anesthetics from this man's back. The staff had to use resources very sparingly.

(2) Es gab Tage, an denen am laufenden Band Verletzte eingeliefert wurden. Diesem jungen Mann wurde das Schrapnell ohne Betäubung aus dem Rücken entfernt. Das Klinikpersonal mußte an Ressourcen sparen, wo sie konnten.

(2) Certains jours, les blessés arrivaient en flux continu. On retira à ce jeune homme un éclat d'obus du dos sans anesthésie. Le personnel de la clinique devait économiser le matériel chaque fois que c'était possible.

2 CHRISTOPHER MORRIS UNDATED/O.D./S.D

LIFE AND DEATH IN THE TRAUMA UNIT OF KOSOVO HOSPITAL

Christopher Morris documented the almost hopeless yet untiringly determined struggle of the staff at the trauma unit of Sarajevo's Kosovo hospital during the civil war in the former Yugoslavia. The never-ending flow of emergency cases often had to be attended to without direct water supplies, with very unreliable electricity supplies and with a permanent shortage of medication. Disposable plastic gloves and gauze bandages had to be washed and reused. The location of the hospital aggravated the situation even further. It came under constant fire from Serbian marksmen. Morris recalls: "Most doctors and nurses demonstrate remarkable adaptability. They cope surprisingly well with all that emotional stress, which almost all of them alleviate by chain smoking and some by playing chess."

LEBEN UND TOD AUF DER TRAUMA-STATION DES KOSOVO-KRANKENHAUSES

Christopher Morris dokumentierte während des Krieges im früheren Jugoslawien den fast hoffnungslosen und doch unermüdlich geführten Kampf der Belegschaft der Unfallklinik des Kosovo-Hospitals in Sarajevo. Die nicht abreißende Kette der Verletzten mußten sie ohne direkte Wasserleitung, mit schlechter Stromversorgung und ständigem Mangel an Medikamenten behandeln. Einweg-Handschuhe und Mullbinden mußten gewaschen und wiederverwendet werden. Verschärft wurde die Situation noch durch die äußere Lage der Klinik. Serbische Scharfschützen nahmen das Hospital immer wieder unter Beschuß. Morris erinnert sich: »Die meisten Ärzte und Schwestern zeigten eine erstaunliche Beweglichkeit in diesem emotionalen Streß, den fast alle durch Kettenrauchen und einige durch Schachspielen kompensierten.«

VIE ET MORT A L'UNITE DE TRAUMATOLOGIE DE L'HOPITAL KOSEVO

Christopher Morris a suivi pendant la guerre en ex-Yougoslavie, le combat presque désespéré et pourtant infatigable du personnel de la clinique de traumatologie de l'hôpital Kosevo, à Sarajevo. Les blessés arrivaient sans discontinuer et il fallait les soigner sans eau courante, avec du courant électrique par intermittence et un manque permanent de médicaments. Les gants jetables et les bandes de gaze étaient lavés et réutilisés. La situation était encore aggravée par la position géographique de la clinique. Les snipers serbes prenaient régulièrement l'hôpital pour cible de leurs tirs. Morris se souvient : « La plupart des médecins et des infirmières ont fait preuve d'une étonnante disponibilité si l'on pense à la tension émotionnelle, que presque tous compensaient en fumant des cigarettes à la chaîne et certains en jouant aux échecs. »

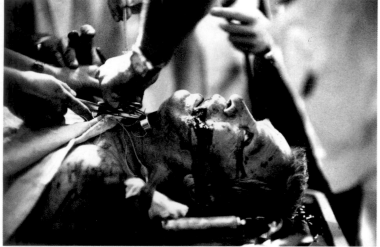

1 CHRISTOPHER MORRIS UNDATED/O.D./S.D.

(1) This old man was the victim of shrapnel. At first it did not seem as though he was seriously injured, but when he started showing heavy uncontrollable bleeding from the mouth, the staff had to rush him to the theater. (2) The hospital morgue. Of all Sarajevo's war victims, 85 per cent were civilians. One doctor stated that by that time he had seen more than 800 fatalities in the hospital. The number of those saved by the hospital's staff was fortunately much higher than that.

(1) Dieser alte Mann wurde Opfer von Granatsplittern. Zunächst schien er nicht ernsthaft verletzt, mußte dann aber schleunigst in den Operationssaal gebracht werden, da er einen heftigen Blutsturz aus dem Mund erlitt. (2) Das Leichenschauhaus der Klinik. 85 Prozent der Kriegsopfer in Sarajevo waren Zivilisten. Ein Arzt berichtete, daß er bereits über 800 Tote in dem Hospital gesehen hatte, die Zahl der Geretteten lag glücklicher-weise weit höher.

(1) Ce vieil homme avait reçu des éclats de grenade. Tout d'abord, il ne semblait pas sérieusement blessé, mais il eut une hémorragie et on l'opéra d'urgence. (2) La morgue de la clinique. 85% des blessés de guerre, à Sarajevo, étaient des civils. Un médecin rapporta qu'il avait déjà vu plus de 800 morts à l'hôpital. Par bonheur, le nombre des gens sauvés était plus élevé.

2
CHRISTOPHER MORRIS
UNDATED/O.D./S.D.

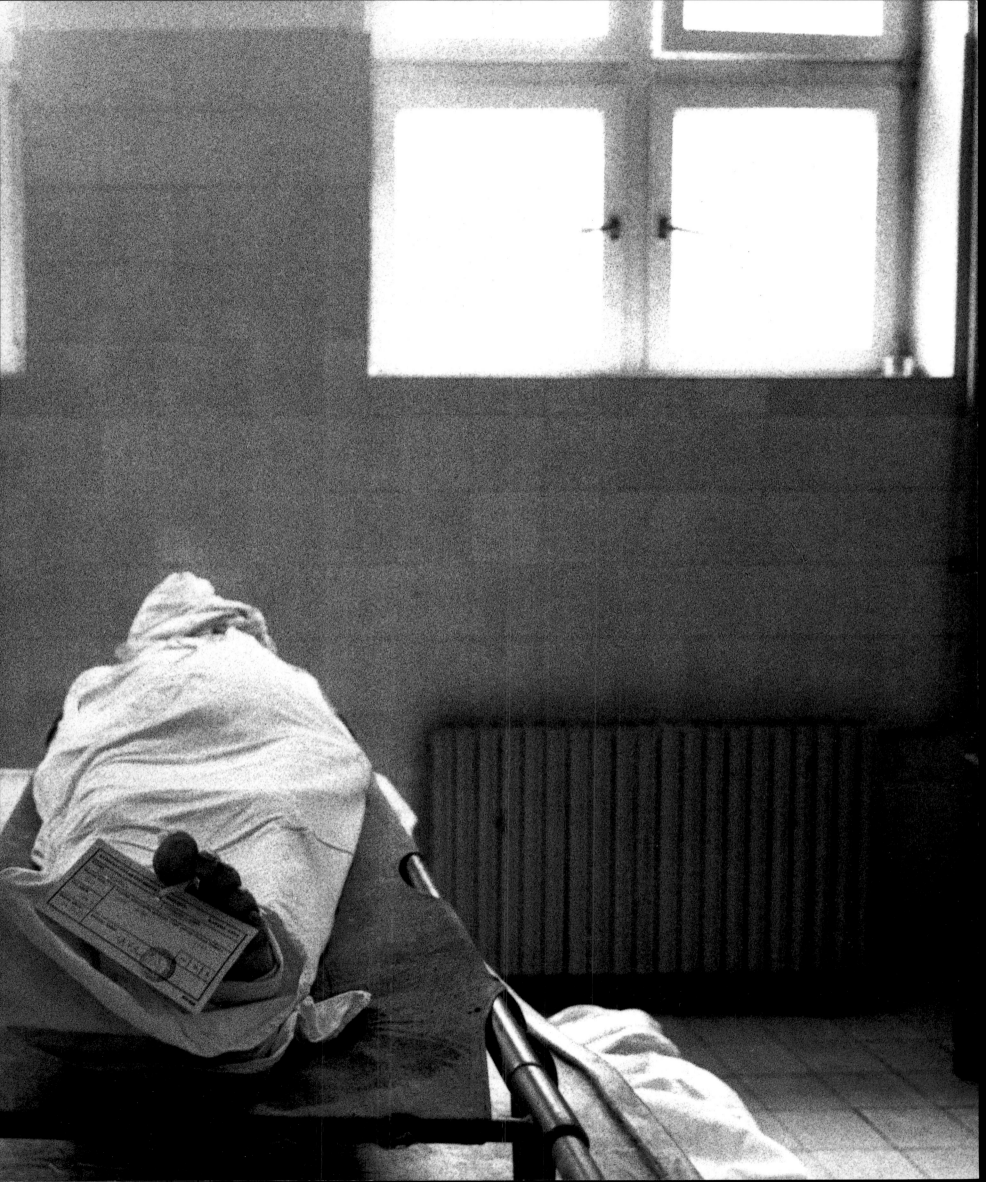

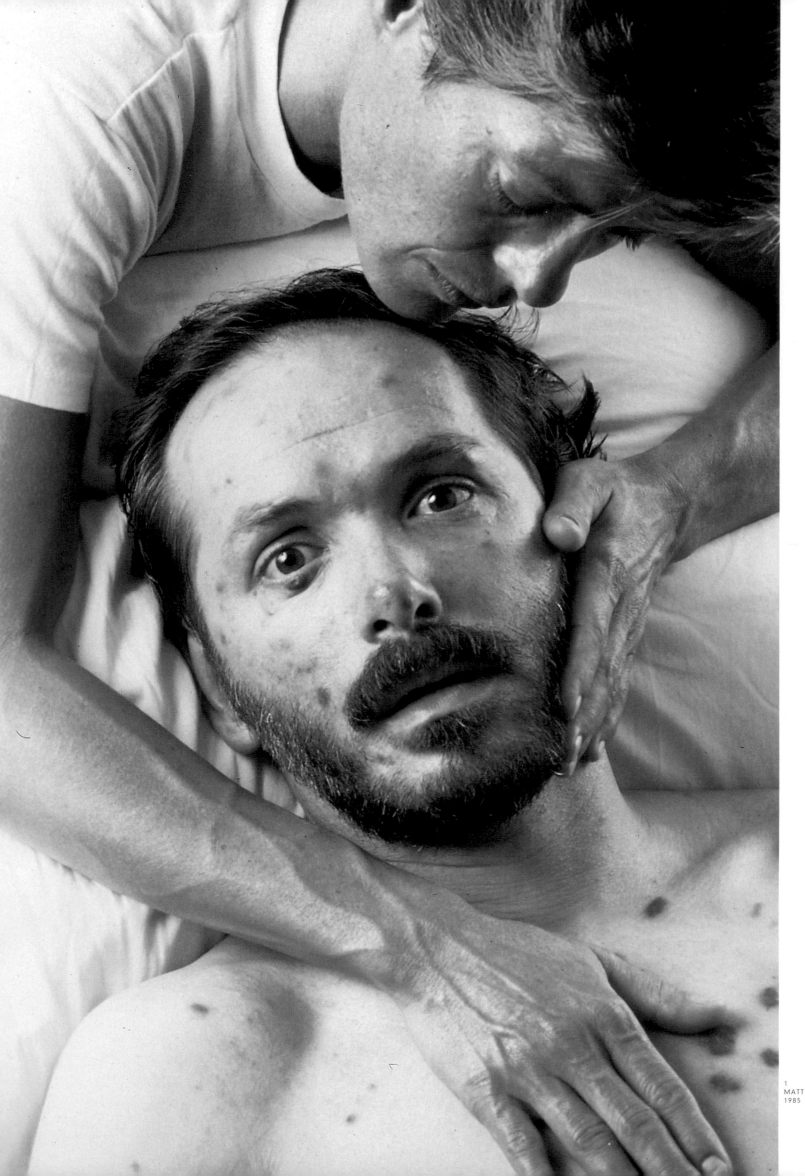

1
MATT HERRON
1985

AIDS

(1) An Aids sufferer in 1985 two weeks before his death. The world-wide discovery of Aids in the early 1980s was followed by shocking photos like this one taken by Matt Herron. Herron was the first Black Star photographer to shoot a background story about the life and death of people with Aids. (2) Dr. Jim Mahoney with a chimpanzee in "Lemsip", a laboratory near New York. One of Mahoney's main undertakings in the 1990s was to perform experiments on primates infected with the Aids virus. He discovered that the HIV I virus had no effect on the chimpanzees, when infected with HIV II viruses however, they showed similar symptoms to human beings. Mahoney defended himself against the objections of animal right campaigners: "Deep down I am convinced that we have no right to perform this research on animals, but it is really unavoidable." These photos by Steve Winter reveal the emotional closeness between research subject and researcher. The German magazine Stern published them in 1995 in a 9-page feature.

AIDS

(1) Ein Aids-Kranker 1985, zwei Wochen vor seinem Tod. Der weltweiten Entdeckung von Aids Anfang der 80er Jahre folgten schockierende Bilder wie das von Matt Herron. Herron war der erste Black-Star-Fotograf, der eine Hintergrund-Geschichte über das Leben und Sterben von Aids-Kranken fotografierte. (2) Dr. Jim Mahoney mit einem der Schimpansen im Lemsip, einem Labor bei New York. Für Mahoney gehörten in den 90er Jahren Experimente an Primaten mit Aids-Erregern für internationale Forschergruppen zur Hauptarbeit. Die Infektion mit HIV-I-Viren ging schadlos an den Affen vorbei, bei HIV-II-Viren zeigten sie ähnliche Symptome wie Menschen. Mahoney wehrte den Protest von Tierschützern ab: »Ich bin tief davon überzeugt, daß wir kein Recht haben, diese Versuche zu unternehmen, aber sie sind notwendig.« Steve Winter erzählt in seinen Fotos von der emotionalen Nähe zwischen Forschungsobjekt und -subjekt, der Stern druckte die Reportage 1995 auf neun Seiten.

SIDA

(1) Un malade du sida en 1985, deux semaines avant sa mort. La découverte du sida au début des années 80, dans le monde entier, fut suivie d'images-choc comme celle-ci. Matt Herron fut le premier photographe de Black Star à réaliser une enquête de fond sur la vie et la mort des malades du sida. (2) Le Dr. Jim Mahoney avec un chimpanzé au laboratoire Lemsip, près de New York. Dans les années 90, le travail principal de Mahoney consistait à inoculer expérimentalement des virus du sida à des primates, dans le cadre de projets internationaux de recherche. L'injection du virus HIV I ne provoquait rien chez les singes. Le HIV II avait les mêmes effets que chez les humains. Aux défenseurs des animaux, Mahoney répondait : « Je suis profondément convaincu que nous n'avons aucun droit d'entreprendre ces expériences, mais elles sont nécessaires. » Les photos de Steve Winter rendent compte de la proximité affective qui existe entre le chercheur et l'animal. Elles furent publiées par le magazine Stern sur neuf pages, en 1995.

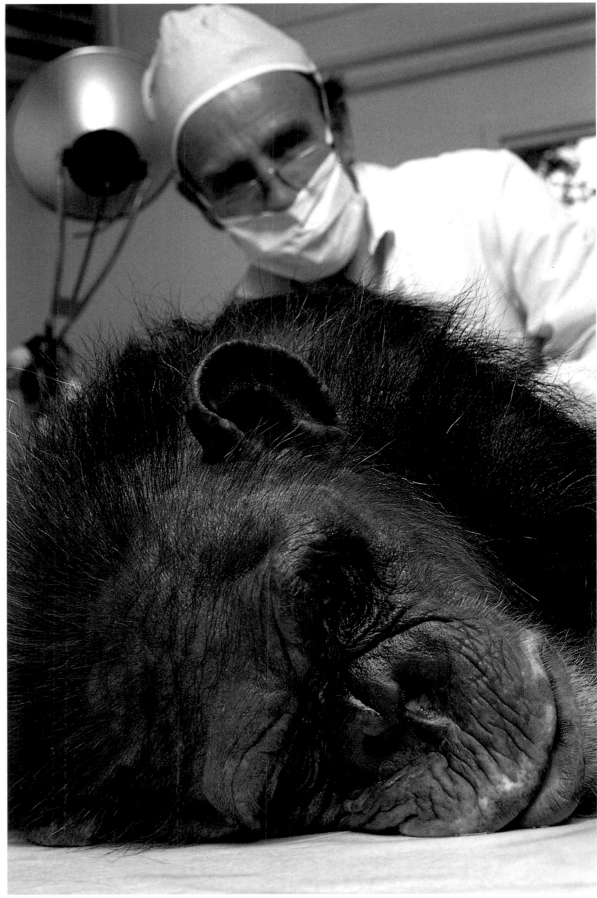

2 STEVE WINTER 1995

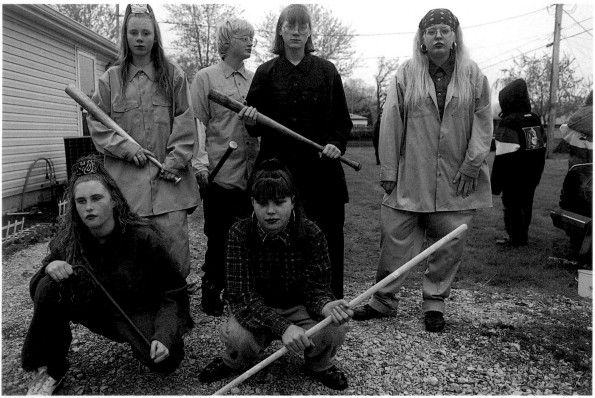

1 JOSEPH RODRIGUEZ 1995

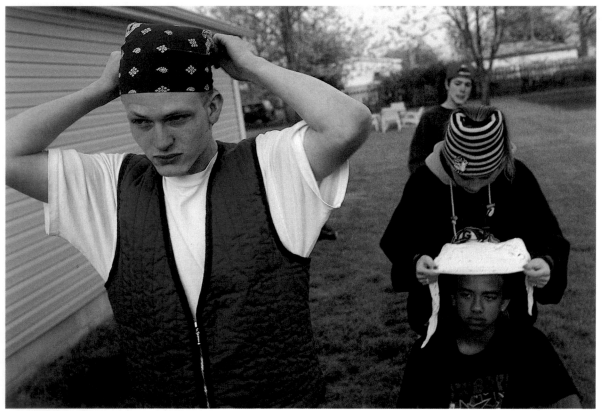

2 JOSEPH RODRIGUEZ 1995

The town of Roselawn is surrounded by endless wheat-fields. (1) In the midst of this idyll – "a place where nothing happens and there's nowhere to go" – is the meeting point of the hip hop girls and their friends. Their "black" dress code, copying their MTV-idols like Snoop Doggy Dog, turns them into "wiggers" in the eyes of the "Rednecks." After the "traitors" had suffered numerous assaults and permanent threats, the girls formed an anti-racist group and started arming themselves. (2) The "nigger" JJ (right) and his friend JW work on their "gangsta look." JJ was the only black person in the town and outside of the gang he lived a completely isolated life. His mother was attacked, but was then reported to the police accused of the attack. (3) JW usually lived with the family of his girlfriend, Melissa. While her mother worked night-shifts, Melissa and JW looked after the little ones.

Die Kleinstadt Roselawn liegt inmitten endloser Korn-felder. (1) In dieser Idylle liegt der Treffpunkt der Hip Hop Girls und ihrer Freunde – »ein Ort, wo nichts passiert und man nirgendwo hingehen kann.« Ihr »schwarzer« dress code, ihren MTV-Idolen wie Snoop Doggy Dog entlehnt, macht sie jedoch in den Augen der Rednecks zu wiggers. Nach mehreren Überfällen und ständigen Drohungen gegen die Nestbeschmutzer haben die Mädchen eine antirassistische Gruppe gegründet und bewaffnen sich. (2) Der nigger JJ (rechts) und sein Freund JW arbeiten an ihrem Gangsta look. JJ war seit kurzem der einzige Schwarze in der Stadt und lebte außerhalb der Gang vollkommen isoliert. Seine Mutter wurde überfallen, gleichzeitig aber dieses Überfalls angezeigt. (3) JW lebte meist bei der Familie seiner Freundin Melissa. Ihre Mutter arbeitete in der Nachtschicht, Melissa und JW kümmerten sich um die Kleinen.

La petite ville de Roselawn est entourée de champs de maïs. (1) C'est dans ce paysage magnifique que se retrouvent les filles du groupe de hip hop et leurs amis : « il ne s'y passe rien et il n'y a nulle part où aller. » Leur code vestimentaire « noir » imitant leurs idoles de MTV comme Snoop Doggy Dog, les classent, aux yeux des habitants, parmi les wiggers. Après plusieurs attaques-surprises et de constantes menaces, les filles fondèrent un groupe anti-raciste et s'armèrent. (2) JJ et son ami JW travaillent leur gansta look. Il y a peu, JJ était le seul noir de la ville et vivait complètement isolé. Sa mère avait été attaquée et, dans le même temps, accusée de l'aggression. (3) JW vivait le plus souvent dans la famille de son amie Melissa, dont la mère travaillait de nuit. Melissa et JW s'occupaient des enfants.

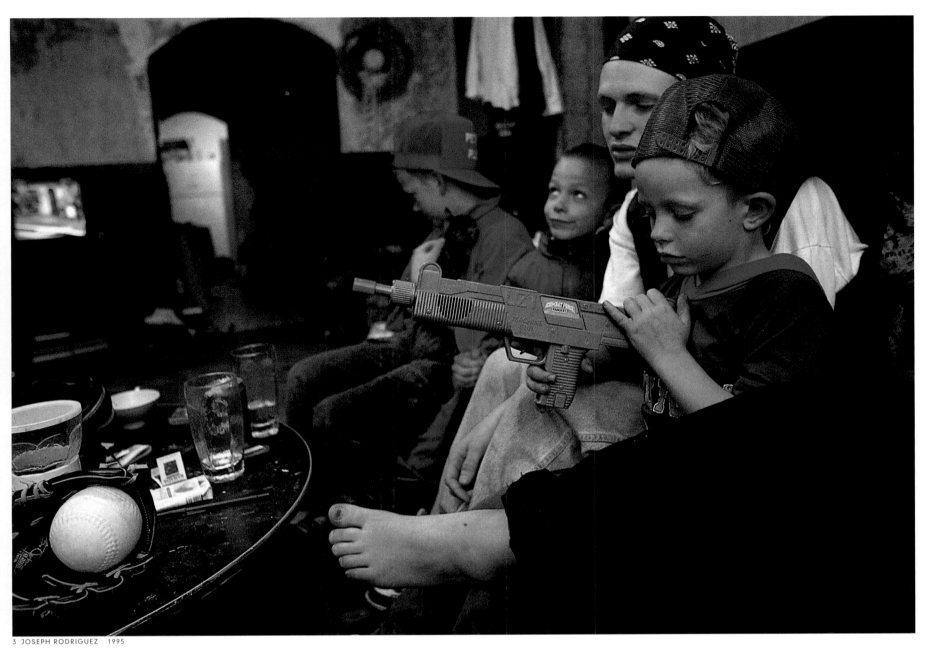

3 JOSEPH RODRIGUEZ 1995

WHITE
RAGE TEENS

Joseph Rodriguez chronicles how behavioral patterns typical of big cities, like "gangsta style" and hip hop, radically swept across America's small town mores. In Roselawn, Indiana, the racist "Rednecks" felt threatened by a female hip hop gang and their black friend JJ – the first black person in the town who had recently moved there along with his white mother. Before his appearance, the "Rednecks" had only laughed at the "fake gangsta shit" of the "wiggers" (short for "white niggers") who copied the black gangsters of the big cities. However, faced with the first real "nigger" in their midst, intense racism in the tradition of the Ku Klux Klan was set loose on the harmless imitators. In his reportage for *Vibe* in 1995, Rodriguez succeeded in depicting this tragedy of boredom and poverty, without denouncing the kids in their desperation. Shortly after, JJ and some of his friends fled Roselawn.

RASSENHASS WEISSER
JUGENDLICHER

Joseph Rodriguez erzählt davon, wenn schwarze Großstadtphänomene wie *Gangsta Style* und Hip Hop Amerikas Provinz erobern. In Roselawn, Indiana, fühlte sich die rassistische Redneck-Kultur durch eine weibliche Hip Hop Gang und ihren schwarzen Freund bedroht. Dieser war als erster und einziger Schwarzer erst kürzlich mit seiner weißen Mutter in die Kleinstadt gezogen. Bis dahin hatten die Rednecks über den *fake gangsta shit* der *white niggers*, kurz *wiggers*, nur gelacht, doch angesichts des ersten realen *niggers* schlug der geballte Rassenhaß in Ku Klux Klan-Tradition auf die harmlosen Epigonen der *gangstas* aus den Großstädten ein. Dieses Trauerspiel aus Langeweile und Armut in der Provinz fing Rodriguez in seiner Reportage für *Vibe* 1995 ein, ohne die Kids in ihrer Verzweiflung zu denunzieren. Kurz nach der Reportage flohen JJ und einige seiner Freunde aus der Stadt.

LA HAINE RACIALE
DES JEUNES BLANCS

Joseph Rodriguez raconte l'irruption, dans les petites villes du sud de l'Amérique, du *gangsta style* ou du hip hop, phénomènes culturels issus des grandes villes. A Roselawn, bourgade blanche de l'Indiana, les rednecks commencèrent à sentir leur vieux racisme menacé par un groupe féminin de *hip hop* et par un de leurs amis, un garçon noir nouvellement installé avec sa mère, une blanche. Jusque-là, les rednecks n'avaient fait que rire de ces « nègres blancs » qui « jouent aux gang », disaient-ils, ces *wiggers*. Mais à la vue d'un vrai noir, la violente haine raciale représentée par le Ku Klux Klan s'abattit sur les inoffensives épigones des *gangsta* urbains. Rodriguez s'attacha à restituer ce drame de la misère et de l'ennui provincial dans un reportage pour *Vibe* en 1995, avec beaucoup de délicatesse envers ces jeunes sans horizon. Peu après, JJ et quelques-uns de ses amis quittèrent la ville.

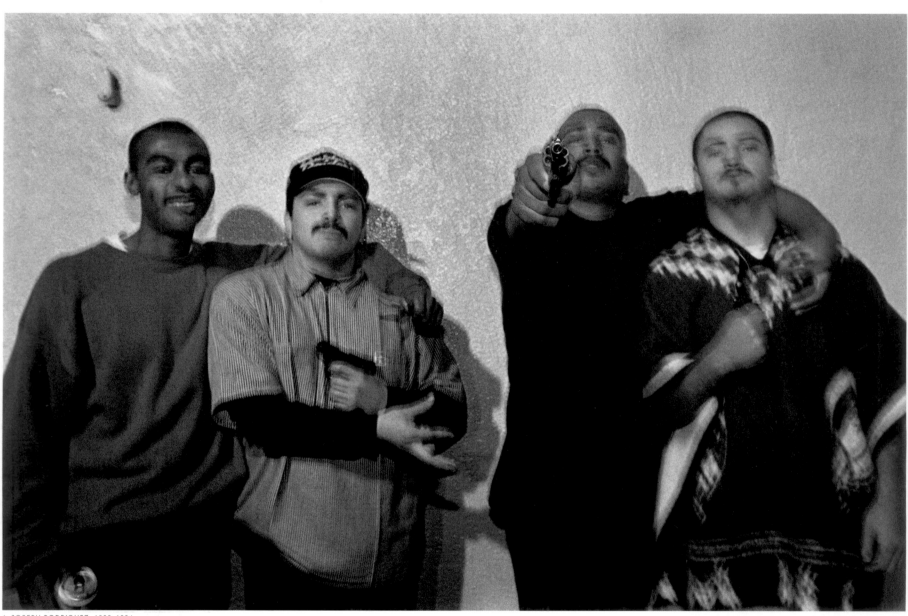

1 JOSEPH RODRIGUEZ 1992–1994

(1) Homeboys of the "Evergreen Boys" in East LA with their firearms. Although the gang war amongst blacks in the south of the city was resolved in 1992, the Chicano gangs in the east are still at war with one another. According to police estimates, there are some 1,500 gangs with about 150,000 members in L.A.

(1) Homeboys der Evergreen Boys in East L.A. mit ihren Waffen. Während im Südteil der Stadt der schwarze Bandenkrieg 1992 beigelegt werden konnte, bekriegen sich die hispanischen Gangs im Osten immer noch. Die Polizei schätzt die Gesamtzahl in L.A. auf 1500 Gangs mit 150 000 Mitgliedern.

(1) Membres en armes des Evergreen Boys d'East L.A. Alors qu'au sud de la ville, la guerre des gang avait pu être maîtrisée en 1992, les gangs hispaniques à l'est continuaient à se combattre. La police évaluait à 1500 le nombre total des gangs et à 150 000 celui de leurs membres.

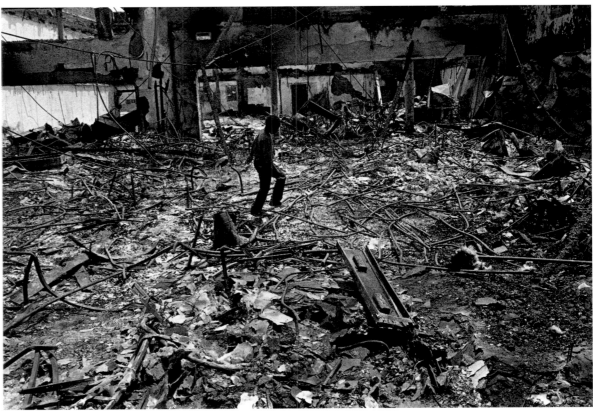

(2) A child plays in the ruins of what used to be a Korean textile shop in South Central L.A. Shortly after the racial unrest of 1992, triggered by the acquittal of a white policemen who had assaulted a black man, Rodriguez launched his gang project.

(2) Ein Kind spielt in den Ruinen eines ehemaligen koreanischen Textilgeschäfts in South Central L.A. Kurz nach den Rassenunruhen 1992, die durch den Freispruch eines Polizisten nach Mißhandlung eines Schwarzen losbrachen, begann Rodriguez mit seinem Gang-Projekt.

(2) Un enfant joue dans les ruines d'un ancien magasin de tissus coréen à South Central L.A. Le reportage de Rodriguez débute peu après les troubles de 1992, déclenchés par l'acquittement d'un policier blanc qui avait maltraité un noir.

2 JOSEPH RODRIGUEZ 1992–94

GANG LIFE IN EAST L.A.

Joseph Rodriguez (b. 1951 in New York) studied photography at the ICP in New York. His first project, "Spanish Harlem," in which he went behind the scenes of the slum districts of his native city, brought him world-wide recognition. His strong interest in rap music made him particularly sensitive to the problems of the West Coast: "I felt that these kids had something very important to say in their music. I felt connected in some sense, coming out of the streets of New York myself." In 1992, the year of the racial unrest in Los Angeles, he commenced a three-year project: "As I discussed with the editors – if you want to break down prejudices in people's minds it is important to depict the gang members with some respect even if they have committed grievous crimes." With the support of a scholarship and at considerable personal risk, he plunged into the Chicano gang scene in Los Angeles. His "East Side Stories," published in 1996 in book-form, reflect the respect and trust which Rodriguez had won among the gang members. His photographs give a human edge to an existence marked by violence and a lack of perspective. This is achieved without patronizing the people he photographed.

GANG LIFE IN EAST L.A.

Joseph Rodriguez (geb. 1951 in New York) studierte am ICP in New York Fotografie. Sein erstes Projekt »Spanish Harlem«, in dem er hinter die Kulissen des Krisengebietes seiner Heimatstadt abgetaucht war, brachte ihm weltweite Anerkennung. Sein starkes Interesse für Rap-Musik sensibilisierte ihn auch für die Probleme an der Westküste: »Mir fiel auf, daß die Kids mit ihrer Musik etwas sehr Wichtiges zu sagen hatten. Da ich selbst auf den Straßen von New York aufgewachsen bin, fühlte ich mich mit ihnen in gewisser Weise verbunden.« 1992, im Jahr der Rassenunruhen in Los Angeles, begann er ein Drei-Jahres-Projekt: »Wie ich es mit den Herausgebern besprochen hatte – denn wenn man die Vorurteile in den Köpfen anderer abbauen will, ist es wichtig, den Bandenmitgliedern mit Respekt zu begegnen, selbst wenn sie schwere Verbrechen begangen haben.« Mit Hilfe eines Stipendiums und unter großem persönlichem Risiko tauchte er in die Szene der Chicano-Gangs in Los Angeles ein. Seine »East Side Stories«, 1996 als Buch veröffentlicht, spiegeln den Respekt und das Vertrauen wider, das sich Rodriguez in der Gangszene erarbeitet hatte. Seine Fotografien eröffnen menschliche Einblicke in ein von Gewalt und Perspektivlosigkeit geprägtes Dasein, ohne sich dabei anzubiedern.

LA VIE DES GANGS A EAST L.A.

Joseph Rodriguez (né en 1951 à New York) a étudié la photo à l'ICP de New York. Son premier projet, « Spanish Harlem », pour lequel il a enquêté dans les quartiers en crise de sa ville natale, lui a procuré une reconnaissance internationale. L'intérêt qu'il voue à la musique rap le sensibilisait aux problèmes de la côte ouest : « Je sentais que ces gosses avaient quelque chose de très important à dire à travers leur musique. Je me sentais concerné, peut-être parce que je venais de la rue, à New York. » En 1992, l'année des troubles raciaux à Los Angeles, il se lança dans un projet de trois ans : « Comme je l'ai dit aux éditeurs, si on veut défaire les préjugés dans l'esprit des gens, il est important de montrer les membres des gangs avec un certain respect, même s'ils ont commis des crimes graves. » Soutenu par une bourse et prenant de grands risques personnels, Rodriguez s'immergea dans les gangs chicanos de Los Angeles. Ses « East Side Stories », publiées en volume en 1996, reflètent le respect et la confiance qu'il s'est acquis dans le monde des gangs. Ses photos sont un regard humain et sans complaisance posé sur des existences marquées par la violence et l'absence d'espoir.

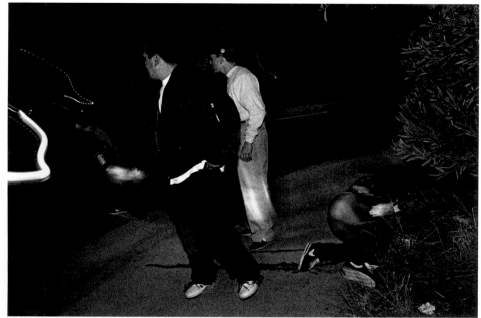

1 JOSEPH RODRIGUEZ UNDATED/O.O/S.D.

2 JOSEPH RODRIGUEZ UNDATED/O.O/S.D.

3 JOSEPH RODRIGUEZ UNDATED/O.O/S.D.

Daily gang life on the East Side. (1) Seconds after a drive-by shooting attack. One of their members was hit. (2) Gang members are stopped by a special unit of the police force in Carson, a neighboring town of Los Angeles. (3) A police station in East L.A. A member of the Rock Mara gang, arrested for possession of drugs, gives a hand signal to identify himself as a member of the gang. In compiling this story, Rodriguez focused particularly on the activities of the Evergreen Boys.

Daily East Side Gang Life. (1) Sekunden nach einem Drive by shooting-Anschlag. Eines ihrer Mitglieder war getroffen worden. (2) Eine Spezialeinheit der Polizei stoppt Gang-Mitglieder in Carson, einer Nachbarstadt von Los Angeles. (3) Eine Polizeistation in East L.A. Ein Angehöriger der Rock-Mara-Gang, der wegen Drogenbesitz verhaftet wurde, gibt sich über das Handzeichen der Gang zu erkennen. In den Mittelpunkt seiner Geschichte stellte Rodriguez die Evergreen Boys.

La vie quotidienne d'un gang de l'East Side. (1) Quelques secondes après des tirs d'une voiture. L'un des garçons a été touché d'une balle. (2) Une unité spéciale de police arrête un membre de gang à Carson, une ville voisine de Los Angeles. (3) Un poste de police à East L.A. Un membre des Rock Mara, arrêté pour possession de drogue, se fait reconnaître au signe de main de son gang. Les Evergreen Boys sont au centre du reportage de Rodriguez.

4 JOSEPH RODRIGUEZ UNDATED/O.D/S.D.

5 JOSEPH RODRIGUEZ UNDATED/O.D/S.D.

(4) Homeboys having an early-morning haircut on the verandah. (5) A dangerous flirtation. A gang member makes eyes at a girl from another neighborhood. (6) The junkies Mike and Steve after sharing a shot of heroin on the Evergreen cemetery. They are childhood friends.

(4) Die Homeboys am frühen Morgen bei der Frisur auf der Veranda. (5) Gefährlicher Flirt. Ein Mitglied macht sich an ein Mädchen aus einem anderen Viertel heran. (6) Die Junkies Mike und Steve nach einem gemeinsamen Schuß Heroin auf dem Evergreen-Friedhof. Sie sind seit ihrer Kindheit befreundet.

(4) Les homeboys au petit matin, séance de coiffure sur la véranda. (5) Un flirt risqué. Un garçon aborde une fille d'un autre quartier. (6) Mike et Steve après une prise d'héroïne, dans le cimetière d'Evergreen. Ils sont amis depuis l'enfance.

6 JOSEPH RODRIGUEZ UNDATED/O.D/S.D.

(1, 3) Children of the Evergreen Boys. (2) Gang member Danny with his wife, daughter and his arsenal of weapons. The photographer sums up: "Many of the gang families I spoke with felt they had been forgotten. There is no difference to the social situation after the Watts Riots of 1965."

(1, 3) Die Kinder der Evergreen Boys. (2) Gang-Mitglied Danny mit Frau und Tochter und Waffenarsenal. Der Fotograf resümiert: »Viele der Bandenfamilien, mit denen ich sprach, sind der Ansicht, daß man sie vergessen hat. Es gibt keinen Unterschied im Vergleich zur sozialen Situation nach den Unruhen in Watts 1965.«

(1, 3) Les enfants des Evergreen boys.
(2) Danny avec sa femme, sa fille et son arsenal. Le photographe résume : « Beaucoup, parmi les familles du gang avec qui j'ai parlé, se sentaient oubliés du monde. Il n'y a pas de différence avec la situation sociale qui a suivi les émeutes de Watts en 1965. »

1 JOSEPH RODRIGUEZ. UNDATED/O.D/S.D.

2 JOSEPH RODRIGUEZ UNDATED/O.D/S.D.

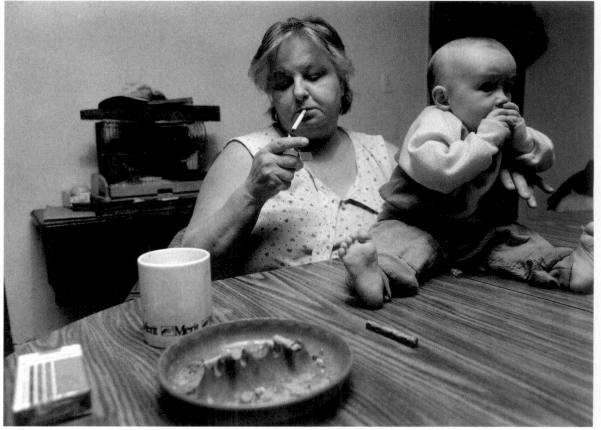

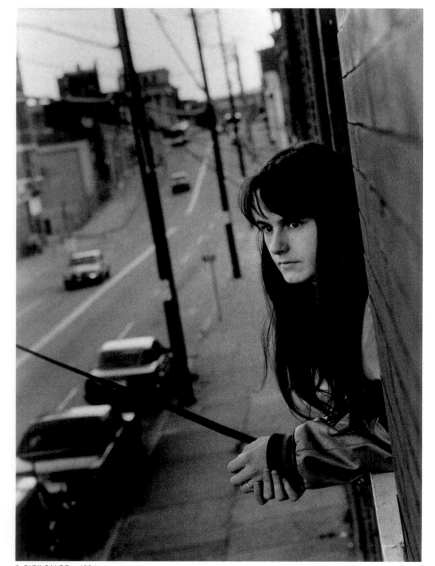

(2) Geri, 19 years old and already the mother of two children. In the 1990s the USA's teenage pregnancy rate was the highest amongst comparable countries. Moreover, amongst whites living below the poverty line 44 per cent of all such births were illegitimate. (1) Geri's mother baby-sits the children while her daughter attends High School.

(2) Geri, 19 Jahre alt und Mutter zweier Kinder. In den USA gab es in den 90er Jahren unter vergleichbaren Ländern die höchste Schwangerschaftsrate bei Minderjährigen, zudem waren bei weißen Frauen, die unter der Armutsgrenze leben, 44 Prozent aller Geburten unehelich. (1) Geris Mutter behütet die Kinder, während ihre Tochter in der High School ist.

(2) Geri, 19 ans et mère de deux enfants. Dans les années 90, le taux de grossesses chez les mineures est plus élevé aux Etats-Unis que dans tous les autres pays de niveau économique comparable, 44 % de ces naissances ont lieu hors mariage. (1) La mère de Geri s'occupe des enfants pendant que sa fille va au lycée.

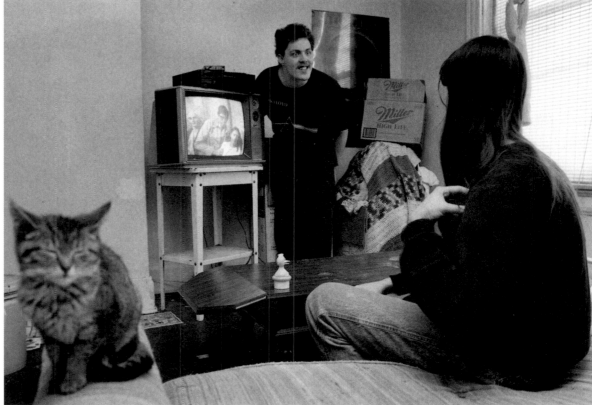

3 RICK FALCO 1994

(3) Geri and her boyfriend in their apartment. The social program LEAP strengthened the self-confidence of the young woman: "I won't always be dependent upon the whims of the man in my life."

(3) Geri und ihr Freund in ihrem Appartment. Das Sozial-programm LEAP hat das Selbstbewußtsein der jungen Frau gestärkt: »Ich werde nicht bis an mein Lebensende von den Launen des Mannes in meinem Leben abhängig sein.«

(3) Geri et son ami dans leur appartement. Le programme social LEAP a aidé la jeune femme à reprendre confiance en elle: «Je ne dépendrai pas toujours des caprices d'un homme.»

MOTHER, BUT STILL A CHILD

In 1994 Rick Falco photographed a 19-year-old mother, living with her two illegitimate children in Cincinnati, Ohio. "She is on welfare. Her life is not easy. She has a long road ahead of her if she is to break the cycle of poverty that engulfs her." In Ohio teenage mothers are helped through a social program which enables them to get a High School diploma and combine their studies with their family responsibilities. In a very short time Ohio's program had achieved great success. This provided an even bigger inspiration for Falco to focus his lens on these mothers. Since this is a country in which social services are traditionally underdeveloped and social conflict has increased in the twentieth century, Falco sees the role of the photojournalist as not only to disclose the misery, but also to reveal possibilities for finding a way out.

MUTTER ... UND DOCH NOCH KIND

Rick Falco porträtierte 1994 eine 19jährige Mutter, die mit ihren zwei unehelichen Kindern in Cincinnati, Ohio, lebt. »Sie lebt von der Sozialhilfe. Ihr Leben ist nicht gerade einfach. Und sie hat noch einen langen, harten Weg vor sich, wenn sie den Teufelskreis der Armut durchbrechen will, in dem sie gefangen ist.« In Ohio wird Teenage-Müttern mit einem sozialen Programm geholfen, den High-School-Abschluß und ihre familiären Aufgaben miteinander zu verbinden. Das Programm in Ohio brachte in kurzer Zeit große Erfolge. Für Falco ein Grund mehr, seine Aufmerksamkeit dieser Mutter zu widmen. Denn in einem Land, in dem die staatliche Fürsorge traditionell unterentwickelt ist, in dem sich aber die sozialen Konflikte im 20. Jahrhundert immer weiter verschärft haben, sieht Falco die Aufgaben des Fotojournalisten nicht nur darin, immer wieder das Elend zu zeigen, sondern auch über die Möglichkeiten für einen Ausweg zu berichten.

MERE – ET QUAND MEME ENFANT

Rick Falco a fait en 1994 à Cincinnati, Ohio, le portrait d'une mère de 19 ans vivant avec ses deux enfants nés hors mariage. «Elle touche le chômage. Sa vie n'est pas simple. Elle aura un long chemin à parcourir pour sortir de l'engrenage de pauvreté qui l'engloutit.» Dans l'Ohio, les mères adolescentes sont prises en charge par un programme social qui leur permet de terminer leurs études secondaires tout en remplissant leurs obligations familiales. Ce programme a obtenu de grands succès en peu de temps. Raison de plus, pour Falco, de s'intéresser à ces jeunes femmes. Car dans un pays où l'assistance sociale est notoirement sous-développée et où les conflits sociaux n'ont cessé de s'aggraver au cours du 20e siècle, Falco considère que la tâche du photojournalisme est non seulement de montrer la détresse, mais aussi d'indiquer les solutions en voie d'expérimentation.

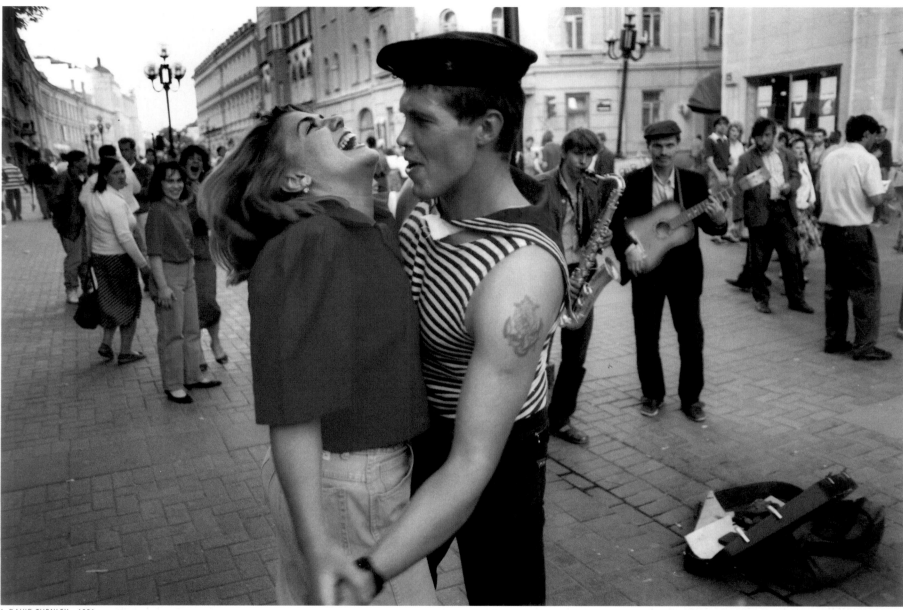

1 DAVID TURNLEY 1991

(1) The boisterous atmosphere prevailing on National Navy Day on the Arbat in Moscow, renowned for its street traders and informal musicians, came as a surprise to the photographer.

(1) Die ausgelassene Kulisse am nationalen Ehrentag der Marine auf dem Arbat in Moskau, der wegen seiner Händler und Musiker bekannt ist, überraschte den Fotografen.

(1) Le jour de la fête nationale de la marine, l'ambiance détendue la place Arbat, à Moscou, célèbre pour ses marchands et ses musiciens, étonna le photographe.

(2) A miner in Prokopyevsk in Siberia admitted openly to David Turnley: "None of us would be here if we had the choice."

(2) Ein Bergarbeiter im sibirischen Prokopjewsk gab David Turnley gegenüber offen zu: »Niemand von uns wäre hier, wenn er die Wahl hätte.«

(2) Un mineur de Prokopyevsk, en Sibérie, confia à David Turnley ouvertement : « Personne ne serait ici s'il en avait le choix. »

2 DAVID TURNLEY 1991

THE RUSSIAN HEART

In 1991, David Turnley traveled through fifteen cities and seven republics of the Soviet Union for three months. The purpose of this visit was to portray the state of a nation in the era of perestroika and glasnost through his photos and diary entries. Everywhere he came across great uncertainty on the one hand and an almost stoic zest for life on the other. Turnley's reportage, which was published as a book in 1992 under the title "The Russian Heart: Days of Crisis and Hope", makes the reader come to the author's realization: "Every time when I think that I am beginning to understand the Russian psyche, I have an experience that proves to me how little I actually know." Shortly before the end of his visit, the news came over the radio that rebels were in Moscow. Turnley rushed to the capital on August 20 and saw the tanks rolling. Although the attempted coup against the President failed, the Gorbachev era had reached its end.

DAS RUSSISCHE HERZ

David Turnley reiste 1991 drei Monate durch fünfzehn Städte und sieben Republiken der Sowjetunion, um die Befindlichkeit eines Volkes im Zeitalter von Perestroika und Glasnost in seinen Fotos und Tagebuchaufzeichnungen wiederzugeben. Überall traf er auf große Unsicherheit auf der einen und eine geradezu stoische Lebensfreude auf der anderen Seite. Turnleys Reportage, die 1992 als Buch unter dem Titel »The Russian Heart: Days of Crisis and Hope« (»Das russische Herz: Tage der Krisen und der Hoffnung«) erschien, läßt uns mit dem Fotografen eigentlich zu der Erkenntnis kommen: »Immer wenn ich denke, daß ich die russische Psyche zu verstehen beginne, habe ich ein Erlebnis, das mir zeigt, wie wenig ich wirklich weiß.« Kurz vor Abschluß seiner Reise vermeldeten die Radios: Putschisten in Moskau. Turnley hetzte am 20. August in die Hauptstadt und sah die Panzer rollen. Der Putsch gegen den Staatspräsidenten scheiterte zwar, dennoch ging die Ära Gorbatschow zu Ende.

LE CŒUR RUSSE

En 1991, David Turnley a sillonné en 3 mois 15 villes et 7 républiques d'Union soviétique, dans le but de rendre compte de la situation d'un peuple à l'époque de la perestroïka et de la glasnost, au travers de photos et de notes de voyage. Partout, il a rencontré un sentiment d'insécurité, mais aussi stoïcisme et même joie de vivre. Paru en 1992 sous le titre « The Russian Heart : Days of Crisis and Hope » (« Le cœur russe : jours de crises et d'espoir »), le reportage de Turnley nous amène à cette conclusion du photographe : « Chaque fois qu'il me semble que je commence à comprendre l'âme russe, une nouvelle expérience me montre combien j'en sais peu. » Peu avant la fin de son voyage, les radios annoncent un putsch à Moscou. Le 20 août, arrivé en hâte à Moscou, Turnley voit les chars entrer dans la ville. Le coup d'Etat échoua, mais signa la fin de l'ère Gorbatchev.

(1) Before the work shift commences in the Mozhaysk women's prison. One of the women openly stated: "I could have been released before serving the whole of my sentence..., but to be honest with you, the way things are right now, I do not know what I will do once I get out of here."

(1) Vor Beginn der Schicht im Frauengefängnis von Moshajsk. Eine der Frauen gab zu Protokoll: »Ich hätte vorzeitig entlassen werden können (...) aber offengestanden, so wie die Dinge liegen, weiß ich nicht, was ich nach meiner Entlassung tun soll.«

(1) Avant le travail, dans la prison de femmes de Mozhaïsk. L'une des femmes déclara : « J'aurais pu profiter d'une libération anticipée, mais franchement, comme les choses vont, je ne sais pas ce que je ferai quand je sortirai. »

1 DAVID TURNLEY 1991

2 DAVID TURNLEY 1991

3 DAVID TURNLEY 1991

(2) A 10,000 Rouble wedding and everyday life on a collective farm in Lvov in the Ukraine. (3) Most of the 450 families in Lvov shared the conviction: "The Soviet Union would not have any food supply problems if we were allowed to be independent farmers." (4) The putsch in Moscow. As Turnley noted in his diary: "The Russians are waiting to see how things develop."

(2) Eine 10 000 Rubel-Hochzeit und der Kolchosen-Alltag in Lwow in der Ukraine. (3) Die meisten der 450 Familien in Lwow waren einhelliger Meinung: »Die Sowjetunion hätte keine Probleme mit dem Hunger, wenn wir selbständige Bauern sein könnten.« (4) Putsch in Moskau. Und Turnley notiert: »Die Russen warten ab, wie sich die Dinge entwickeln.«

(2) Le mariage à 10 000 roubles et le quotidien d'un kolkhoze à Lvov, en Ukraine. (3) La plupart des 450 familles à Lvov étaient du même avis : « Il n'y aurait pas de problème d'alimentation en Union soviétique si nous pouvions être des paysans indépendants. » (4) Le putsch de Moscou. Turnley note : « Les Russes attendent de voir comment les choses vont tourner. »

4 DAVID TURNLEY 1991

1 BOB KRIST 1987

2 BOB KRIST 1987

AMERICANA

America over the past two decades. In the following pages a small collection of Black Star photographs are presented – all making definite statements on how American photographers view their compatriots. (1, 2) Bob Krist portrays the myth of the American hero in an officer's uniform at the elite military training college, West Point. (3) The pride of having played an important role in the defeat of fascism in Europe is clearly evident from Peter Turnley's photo of an American D-Day veteran, 50 years after the landing of the allies in Normandy. (4) In this photo of three Vietnam veterans in front of the Vietnam Memorial in Washington, D.C., Christopher Morris reminds the nation that the greatest American military humiliation in history was above all a human tragedy.

3 PETER TURNLEY 1994

AMERICANA

Bilder aus dem Amerika der letzten zwei Jahrzehnte. Die folgenden Doppelseiten versammeln eine kleine Auswahl von Black-Star-Fotografien, die Statements von amerikanischen Fotojournalisten über ihre Landsleute geben. (1, 2) Bob Krist setzt den Mythos des amerikanischen Helden in Offiziersuniform an der Kaderschmiede West Point in Szene. (3) In Peter Turnleys Bild des *D-Day*-Veterans in der Normandie 50 Jahre nach der Landung der Alliierten schwingt der Stolz mit, als Amerikaner entscheidend zur Niederlage des Faschismus in Europa beigetragen zu haben. (4) Christopher Morris erinnert mit seinem Bild der drei Veteranen vor dem Vietnam Memorial in Washington daran, daß die größte militärische Schmach der Amerikaner im 20. Jahrhundert vor allem auch eine menschliche Tragödie war.

AMERICANA

Images de l'Amérique des deux dernières décennies. Les doubles pages qui suivent présentent un choix de points de vue de photographes américains sur leurs con-citoyens. (1, 2) Bob Krist nous présente le mythe du héros américain en uniforme d'officier, à l'académie militaire de West Point. (3) Portrait, par Peter Turnley, d'un vétéran du *D-Day*: 50 ans après le débarquement allié en Normandie, il vibre de la fierté d'avoir participé, en tant qu'Américain, à la défaite du fascisme en Europe. (4) Avec ces trois vétérans devant le mémorial du Viêtnam, à Washington, Christopher Morris nous rappelle que la plus grande humiliation militaire de l'Amérique au 20e siècle fut avant tout une tragédie humaine.

4 CHRISTOPHER MORRIS 1985

1 RICK FRIEDMAN 1988

"The show must go on!" (1) The Republicans electing George Bush as their presidential candidate at their party convention in 1988 – (2) and the Democrats doing the same with Bill Clinton in 1992. Both events resulted in a political spectacle – portrayed by Dennis Brack and Rick Friedman respectively – in which everything was meticulously planned to the smallest detail.

»The show must go on!« (1) Ob die Republikaner 1988 in ihrem Parteikonvent George Bush zum Präsidentschaftskandidaten kürten, oder ob die Demokraten 1992 mit Bill Clinton das Gleiche taten (2), es war ein minutiös geplantes Politspektakel, aufgenommen von Rick Friedman und Dennis Brack.

« The show must go on ! » (1) La désignation de George Bush comme candidat à la présidence, lors de la convention républicaine en 1988 – (2) tout comme celle de Bill Clinton lors du rassemblement des démocrates en 1992, furent des spectacles politiques minutieusement mis en scène, photographiés par Rick Friedman et Dennis Brack.

2 DENNIS BRACK 1992

3 PAUL MILLER 1990

(3, 4) Paul Miller attended the 50th anniversary of the Black Hills Motor Classic in Sturgis and saw how the small town with its 7,000 souls was transformed into one gigantic hurly-burly for a week, offering 300,000 bikers a stage for self-expression.

(3, 4) Paul Miller war beim 50jährigen Jubiläum der Black Hills Motor Classic in Sturgis dabei, als das Provinznest mit 7 000 Seelen eine Woche lang zur Bühne für die Selbstinszenierung von 300 000 Bikern wurde.

(3, 4) Paul Miller était présent au cinquantenaire du Black Hills Motor Classic, dans la petite ville de Sturgis, 7 000 habitants, envahie une semaine durant par 300 000 motards.

4 PAUL MILLER 1990

1 MAX RAMIREZ 1994

2 MAX RAMIREZ 1994

(1, 2) The relaxed revolt. The Cyberpunk's image consists of martial-arts look and habits, combined with soft drinks and an escape into the wide world of cyberspace. In 1994 Max Ramirez tracked down this tribe in San Francisco.

(1, 2) Die relaxte Revolte. Martialisches Aussehen und Habitus, Soft Drinks und die Flucht in die weite Welt des Cyberspace kombinieren die Cyberpunks. Max Ramirez stieß auf diesen Jugendstamm 1994 in San Francisco.

(1, 2) La révolte détendue. Aspect martial, boissons non alcoolisées, fuite dans le vaste monde du cyberspace, tel est l'univers des cyberpunks. Max Ramirez a déniché cette tribu de jeunes en 1994 à San Francisco.

3 KEN SAKAMOTO 1989

"Turn on – tune in – drop out" – American youth
has always been searching for new means of
escaping reality, without being held back by
the fear of excess. (4) The consequences of
heroin-use soon proved the absurdity of
messianic chants by drug priests like Timothy
Leary, who argued in favor of mind-expanding
hallucinatory drugs. This photograph of a man
shooting up heroin was captured in 1971 by
Dan McCoy. (3) In the 1980s numerous new
types of synthetic drugs like crack and ice, here
photographed by Ken Sakamoto, appeared on
the market.

»Turn on – tune in – drop out« – Die amerikani-
sche Jugend suchte immer wieder der Realität
zu entfliehen, ohne dabei vor Exzessen zurück-
zuschrecken. (4) Rauschgift wie Heroin führte
die messianischen Gesänge der Drogenpäpste
wie Timothy Leary für den bewußtseinserwei-
ternden Gebrauch halluzigener Stoffe schnell
ad absurdum. Dan McCoy fing diesen Heroin-
schuß 1971 ein. (3) In den 80er Jahren tauchten
unkalkulierbare synthetische Drogen wie Crack
oder Ice auf, hier von Ken Sakamoto
fotografiert.

« Turn on – tune in – drop out » – Dans son désir
d'échapper à la réalité, la jeunesse américaine
ne reculait devant aucun excès. (4) Dans leurs
hymnes messianiques, des papes de la drogue
tels Timothy Leary prônaient jusqu'à l'absurde
l'emploi d'héroïne et d'autres psychotropes
dans le but d'élargir le champ de la con-
science. Cette image d'un shoot à l'héroïne fut
saisie par Dan McCoy en 1971. (3) Dans les
années 80 sont apparues des drogues synthé-
tiques aux effets incontrôlables, comme le
crack ou l'ice. Photo de Ken Sakamoto.

4 DAN McCOY 1971

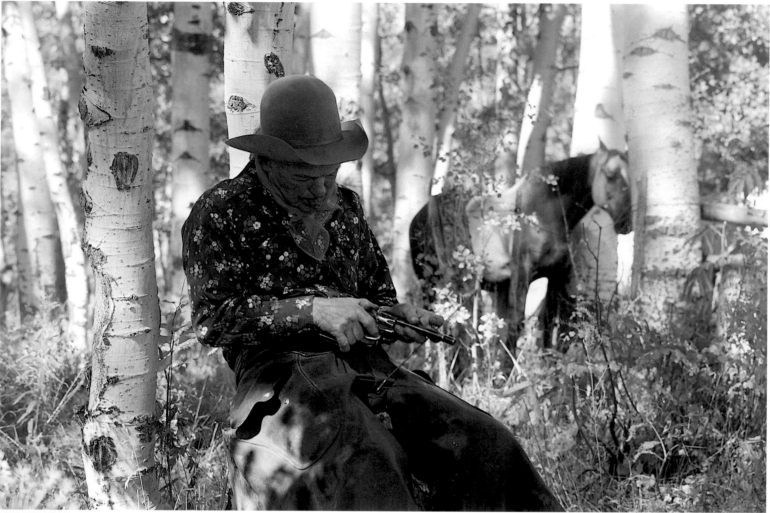

1 CHARLES MOORE 1975

The changing face of the Wild West. (1, 2) In 1975 Charles Moore discovered Cowboy Sam and his authentic cowboy existence.

Der Wilde Westen im Wandel der Zeit. (1, 2) Charles Moore traf 1975 noch auf die intakte Idylle des Cowboys Sam.

Visages du wild west. (1, 2) En 1975, Charles Moore rencontra Sam, authentique cowboy de légendes.

2 CHARLES MOORE 1975

3 THERESE FRARE 1993/94

(3, 4) In 1993 and 1994 Therese Frare accompanied homosexuals and portrayed in her pictures how the American myth of manliness was dismantled at their Gay Rodeos.

(3, 4) Therese Frare begleitete 1993 und 1994 Homosexuelle und fing auf ihren Gay-Rodeos mit der Kamera ein, wie der amerikanische Männlichkeitsmythos konterkariert und gründlich demontiert wurde.

(3, 4) En 1993 et 1994, Therese Frare suivit un groupe d'homosexuels et découvrit les rodéos gays, où le mythe viril américain est quelque peu mis à mal.

4 THERESE FRARE 1993/94

1 ERICA LANSNER 1995

(1) Million Man March on Washington, D.C., in 1995. African-Americans have been fighting for justice since the 1950s. Although officially abolished, discrimination continues to exist 40 years on. (2) In jails and boot camps, ethnic people are discriminated against and constitute the majority.

(1) Million Man March nach Washington 1995. Seit den 50er Jahren kämpften die African-Americans für soziale Gerechtigkeit. Die Diskriminierung war zwar prinzipiell abgeschafft, bestand aber auch 40 Jahre später fort. (2) Diskriminierte Ethnien stellten die Überzahl in Gefängnissen und Boot-Camps.

(1) Million Man March vers Washington en 1995. Depuis les années 50, les Afro-Américains se battent pour la justice sociale. La ségrégation raciale, bien qu'abolie en principe, existe toujours 40 ans plus tard. (2) Les ethnies faisant l'objet de discriminations sont les plus nombreuses dans les prisons et les boot-camps.

2 MICHAEL GREENLAR 1987

3 DAN McCOY 1971

(3) Clansmen in the southern states have fought to uphold colonial privilege since 1865. (4) The Ku Klux Klan has been more or less a constant presence in the twentieth century as the hate organization of white Americans in the South, fighting its opponents, usually under cover of darkness.

(3) Clansmen in den Südstaaten kämpften seit 1865 für die Aufrechterhaltung kolonialer Privilegien. (4) Der Ku Klux Klan als Haßorganisation weißer Amerikaner im Süden war im 20. Jahrhundert immer mehr oder weniger präsent und bekämpfte seine Gegner in militanter Form, meist im Schutz der Dunkelheit.

(3) Les clansmen des Etats du Sud luttent depuis 1865 pour le maintien des privilèges coloniaux. (4) Le Ku Klux Klan, organisation violemment xénophobe des Américains blancs du Sud, était encore plus ou moins active au 20ᵉ siècle et combattait ses adversaires de manière organisée, le plus souvent dans l'obscurité propice.

4 ROB NELSON 1985

1 DAVID LEVENSON UNDATED/O.D./S.D.

ORDINARY PEOPLE, EXTRAORDINARY LIVES

(1) "Big boys" in their club colors sharing a joke at the Henley Regatta. (2) An al fresco picnic as intermezzo during the opera festival at Glyndebourne, Sussex.

(1) »Große Jungs« in den Clubfarben scherzen miteinander anläßlich der Henley-Regatta. (2) Ein al fresco-Picknick als Intermezzo bei den Opernfestspielen in Glyndebourne, Sussex.

(1) Les « grands garçons » aux couleurs de leur club plaisantent ensemble à l'occasion de la régatte Henley. (2) Pique-nique en intermezzo, pendant le festival d'opéra de Glyndebourne dans le Sussex.

2 DAVID LEVENSON UNDATED/O.D./S.D.

THE ENGLISH SOCIAL SEASON

David Levenson followed the spectacle of the *English Social Season* with his camera. Every summer, the aristocracy, the rich, the famous and the beautiful travel across the country to work through a lengthy calendar of social events. Every occasion, whether sport, art, festival or ball, has a particular, though unwritten, dress code. Entrance tickets are highly desired, but not obtainable on the open market. "Previously the hereditary nobility and strict etiquette set the tone, but nowadays the moneyed aristocracy has gained some ground." Levenson regards this reportage as one of his personal favorites. It reflects the conflicting attitudes the British have toward the quirks of their upper classes: "To many its all just harmless fun, to some, a shameless flaunting of wealth, but whatever your view, its all quintessentially … English."

DAS ENGLISCHE GESELLSCHAFTSLEBEN

David Levenson verfolgte mit seiner Kamera das Schauspiel der *English Social Season*. Jeden Sommer reisen die Aristokraten und Reichen, Berühmten und Schönen durch das Land, um den Veranstaltungskalender der »Oberen Zehntausend« abzuarbeiten. Jeder Anlaß, ob Sport, Kunst, Festival oder Ball, hat einen speziellen, jedoch ungeschriebenen *dress code*, Eintrittskarten sind heiß begehrt und auf dem freien Markt kaum zu haben. »Früher regierte hier nur der Erbadel und die Etikette, heute hat der Geldadel an Terrain gewonnen.« Levenson zählt diese Reportage mit zu seinen persönlichen *Favourites*. Sie spiegelt das zwiespältige Gefühl der Briten gegenüber den Marotten ihrer Oberklasse: »Für viele ist es nur ein harmloses Vergnügen, für manche die schamlose Zurschaustellung von Reichtum. Aber wie geteilt die Meinungen auch immer sind: Das Ganze ist typisch … englisch.«

LA VIE SOCIALE EN ANGLETERRE

David Levenson a suivi avec son appareil le spectacle de l'*English social season*. Chaque été, grandes fortunes et noms à particules, célébrités et beautés sillonnent le pays pour respecter l'agenda mondain de la haute société. Chaque occasion – manifestation sportive ou artistique, festival ou bal – a son code non écrit d'habillement. Les places sont recherchées et presque introuvables sur le marché. « Naguère, la noblesse héréditaire et l'étiquette dictaient leurs lois, aujourd'hui, la noblesse d'argent a gagné du terrain. » Ce reportage figure au hit-parade personnel de Levenson, parce qu'il reflète l'ambiguïté des Britanniques envers les marottes de leurs classes riches : « La plupart des gens pensent que ce ne sont que des amusements inoffensifs, pour d'autres, c'est une débauche éhontée de richesses, mais tout le monde est d'accord sur une chose : tout ça est fondamentalement … anglais. »

1 DAVID LEVENSON UNDATED/O.D./S.D.

2 DAVID LEVENSON UNDATED/O.D./S.D.

(1) The hat fashions at England's racecourses never fail to deliver surprises and plenty of topics for discussion. (2) A champagne breakfast in the car park at the racetrack in Epsom on Derby Day.

(1) Die Hutmode auf Englands Rennplätzen bietet immer wieder Überraschungen und Gesprächsstoff. (2) Champagnerfrühstück auf dem Parkplatz der Rennbahn in Epsom am Tag des Derbys.

(1) La mode des chapeaux sur les champs de courses britanniques est une source inépuisable de surprises et de conversations. (2) Petit-déjeuner au champagne sur le parking du champ de course d'Epsom, le jour du Derby.

3 DAVID LEVENSON UNDATED/O.D./S.D.

(3, 4) The upper classes attend elite educational institutions like Eton. Here, Fourth of June festivities, celebrating the birthday of King George III.

(3, 4) Die Kaderschmieden der »Guten Gesellschaft« finden sich in pädagogischen Institutionen wie in Eton. Hier die Feierlichkeiten zum 4. Juni.

(3, 4) C'est dans des institutions scolaires comme Eton que se forment les membres de la bonne société. Ici, festivités du 4 juin.

4 DAVID LEVENSON UNDATED/O.D./S.D.

1 DAVID LEVENSON UNDATED/O.D./S.D.

2 DAVID LEVENSON UNDATED/O.D./S.D.

(1) A must for the ladies – the Chelsea Flower
Show. (2) Debutantes at Queen Charlotte's
Ball. The daughters of the aristocracy are
introduced to society.

(1) Ein »Muß« für die Damen – die Chelsea
Flower Show. (2) Auf Queen Charlottes Ball
werden die Hohen Töchter in die Gesellschaft
eingeführt.

(1) Un must pour les dames : l'exposition florale
de Chelsea. (2) C'est au bal de la reine
Charlotte que les filles de l'aristocratie font leur
entrée dans le monde.

(3, 4) The Royal Caledonian Ball in London is the absolute highlight of the season and brings the aristocracy from north and south of the border together once a year.

(3, 4) Der Royal Caledonian Ball in London ist der absolute Höhepunkt der Saison und führt die Aristokratie aus Nord und Süd einmal im Jahr zusammen.

(3,4) Le Royal Caledonian Ball, à Londres, est l'apogée de la saison et rassemble une fois par an les aristocrates de tout le pays.

3 DAVID LEVENSON UNDATED/O.D./S.D.

4 DAVID LEVENSON UNDATED/O.D./S.D.

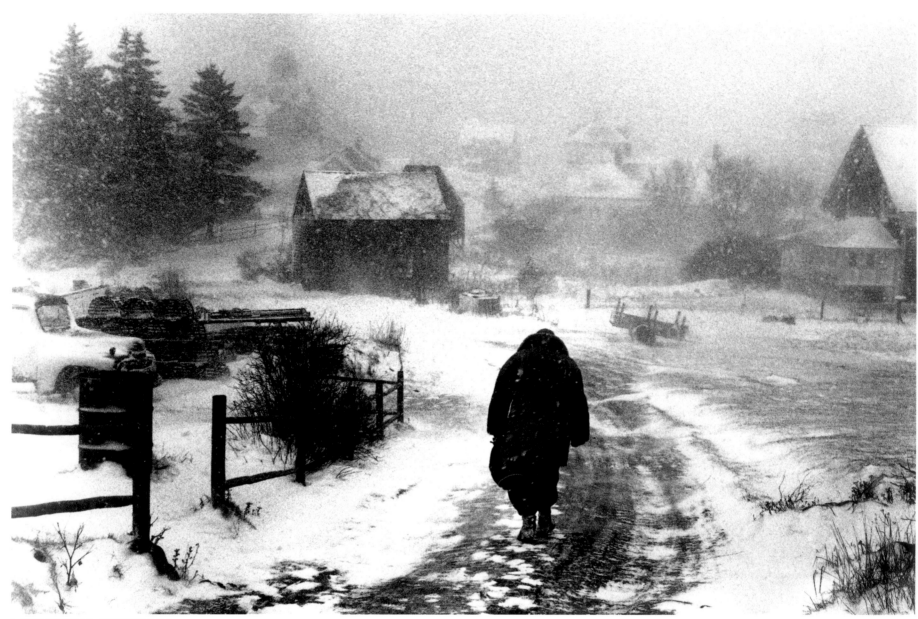

1 KOSTI RUOHAMAA UNDATED/O.D./S.D.

(1) A lobster fisherman on Monhegan Island. "These men work under rough winter conditions; and I needed bad weather to show this. And luck was with me, there were two full days of snow and wind." In summer, however, the island was by then already one of the most popular holiday destinations for Americans living in Maine.

(1) Ein Hummer-Fischer auf Monhegan Island. »Diese Männer arbeiten im Winter unter härtesten Bedingungen, und ich brauchte schlechtes Wetter, um das dokumentieren zu können. Ich hatte Glück – zwei Tage hintereinander gab es nur Schnee und Wind.« Im Sommer hingegen zählte auch damals schon die Insel mit zu den beliebtesten Ferienquartieren der Amerikaner in Maine.

(1) Un pêcheur de homards sur l'île de Monhegan. « Ces hommes travaillent dans de rudes conditions de l'hiver ; il me fallait du mauvais temps pour montrer cela. La chance fut de mon côté, il y eut deux jours entiers de neige et de vent. » En été au contraire, l'île était alors déjà l'un des lieux de villégiature favoris des Américains dans le Maine.

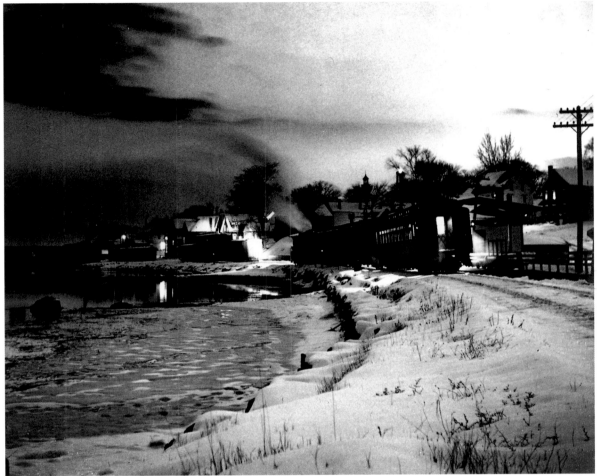

2 KOSTI RUOHAMAA UNDATED/O.D./S.D.

(2) In winter it seems as though time comes to a complete standstill. "The earth turns ... and the night train still waits at the wayside station."

(2) Im Winter bleibt die Zeit fast stehen. »Die Erde dreht sich ... und der Nachtzug wartet immer noch an der Zwischenstation.«

(2) En hiver, le temps est presque arrêté. « La terre tourne ... et le train de nuit attend toujours à la station du bord de route. »

MAINE

Kosti Ruohamaa (b. 1914 in Finland, died 1961) emigrated with his parents to New England and will be forever linked with his new home through his photographs. "God made Maine, and Kosti photographed it." His "Winter Nights" was taken up in a collection of the ten best *Life* essays. In his incomparable style he portrayed two decades of a country and its people, especially Maine. Black Star counts him as one of their greatest, yet most unrecognized photographers: "Kosti was an artist ... and being a photographer with little technical knowledge allowed him to take risks that better trained photographers would have been afraid to take. He seemed desperate to preserve images of country America before it disappeared." He died at the age of 47, a victim of alcoholism.

MAINE

Kosti Ruohamaa (geb. 1914 in Finnland, gest. 1961) emigrierte mit seinen Eltern nach New England und wird wegen seiner Fotografien wohl für immer mit seiner neuen Heimat verbunden sein. »Gott erschuf Maine, und Kosti fotografierte es.« Seine »Winter Nights« finden sich im Sammelband mit den zehn besten *Life*-Essays. In seinem unvergleichlichen Stil porträtierte er über zwei Jahrzehnte Land und Leute, vor allem in Maine. Die Agentur zählt ihn mit zu den bedeutendsten, zugleich aber auch verkanntesten Black-Star-Fotografen: »Kosti war ein Künstler ... und als Fotograf mit nur geringen technischen Kenntnissen ging er Risiken ein, die besser ausgebildete Fotografen nie auf sich genommen hätten. Er versuchte fast verzweifelt, das ländliche Amerika in Bildern festzuhalten, bevor es für immer verschwinden würde.« Auf Grund seiner Alkoholkrankheit starb er im Alter von 47 Jahren.

MAINE

Kosti Ruohamaa (né en 1914 en Finlande, mort en 1961), émigré en Nouvelle-Angleterre avec ses parents, restera sans doute toujours associé à sa nouvelle patrie par les photos qu'il en a faites. « Dieu a fait le Maine, Kosti l'a photographié. » Ses « Winter Nights » (« Nuits d'hiver ») sont publiées dans le livre des dix meilleurs reportages de *Life*. Pendant deux décennies, il a fait le portrait d'un pays, le Maine, et de ses habitants, dans un style incomparable. L'agence le compte parmi l'un de ses plus grands photographes, mais aussi l'un des plus méconnus : « Kosti était un artiste... et le fait d'avoir peu de connaissances techniques lui a permis de prendre des risques devant lesquels des photographes mieux formés auraient reculé. Il semblait vouloir désespérément conserver des images de la campagne américaine avant qu'elle ne disparaisse. » Il mourut à 47 ans des suites de l'alcoolisme.

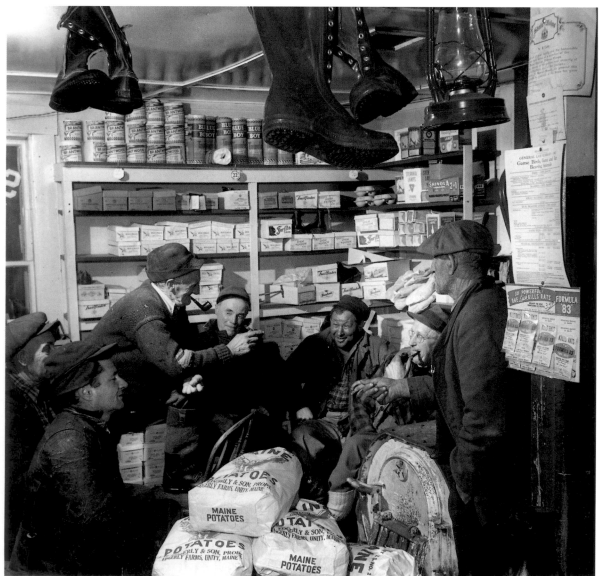

1 KOSTI RUOHAMAA UNDATED/O.D./S.D.

(1) Citizens of the State of Maine appeared to him as the last bastion of democracy: "Like the passion play or the classic western movie, the Maine town meeting is essentially a reenactment. The actors change, but the roles are timeless. Maine people have a passion for local autonomy and are jealous of the right to govern themselves as they see fit."

(1) Die Bewohner von Maine erschienen ihm als letzte Bastion der Demokratie: »Eine Gemeindeversammlung in Maine ist im Grunde eine Neuinszenierung, wie ein Passionsspiel oder ein klassischer Western. Die Schauspieler wechseln, aber ihre Rollen sind zeitlos. Die Menschen aus Maine lieben ihre lokale Autonomie und wachen eifersüchtig über das Recht zur Selbstverwaltung – so, wie sie ihnen paßt.«

(1) Les citoyens du Maine lui apparaissaient comme le dernier bastion de la démocratie : « Comme le jeu de la Passion ou le western classique, les assemblées municipales du Maine ont quelque chose d'essentiellement rituel. Les acteurs changent, mais les rôles sont hors du temps. Les gens du Maine ont la passion de l'autonomie locale et veillent jalousement sur leur droit de se gouverner comme bon leur semble. »

(2) Fisherman on the Maine Grand Bank. "The trawlerman has changed little over the centuries ... tough, stubborn, unshriven, ... he fishes because he's a fisherman... for him fishing is a calling and a life commitment."

(2) Fischer auf der Maine Grand Bank. »Die Fischer haben sich im Laufe der Jahrhunderte kaum verändert ... rauh, starrköpfig, unbeugsam ... sie fischen, weil sie Fischer sind ... das Fischen ist für sie Berufung und lebenslange Verpflichtung.«

(2) Pêcheur sur le Maine Grand Bank. « Le pêcheur au chalut a peu changé au cours des siècles ... coriace, obstiné, immuable ... il pêche parce qu'il est pêcheur ... pour lui, la pêche est un appel et un engagement. »

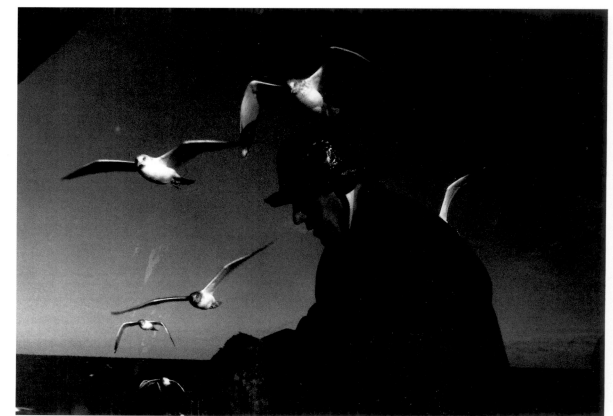

2 KOSTI RUOHAMAA UNDATED/O.D./S.D.

3 KOSTI RUOHAMAA 1947

(3) A self-portrait of the photographer at Cape Hatten in
1947. Ruohamaa transformed his spiritual affinity with
Maine into photographs. (4) Damariscotta, Maine.
Ruohamaa's portrait of this eighty-year-old couple was
his contribution to the exhibition "Family of Man."

(3) Selbstporträt des Fotografen am Cape Hatten 1947.
Ruohamaa setzte seine Seelenverwandtschaft mit Maine
in Fotografie um. (4) Damariscotta, Maine. Ruohamaas
Porträt des achtzigjährigen Ehepaars war sein Beitrag zu
der Ausstellung »Family of Man«.

(3) Autoportrait du photographe à Cape Hatten, 1947.
Ruohamaa a su transposer dans cette image son affinité
spirituelle avec le Maine. (4) Damariscotta, Maine. Le
portrait de ce couple d'octogénaires fut la contribution de
Ruohamaa à l'exposition « Family of Man ».

4 KOSTI RUOHAMAA UNDATED/O.D./S.D.

BIOGRAPHIES

Over the decades Black Star has worked with hundreds of photographers. The New York agency often did not know the photographers personally because it was partner agencies across the world and not the photographers themselves who supplied Black Star with photographs. This situation has unfortunately made it impossible to provide biographies of all the photographers whose pictures appear in this book.

Figures in italics refer to corresponding page numbers.

MICHAEL ABRAMSON started out as a photojournalist in New York City in the 1970s specializing in hippies and women's issues. *103*

ARNOLD ADLER was born in 1957 in New York. Since 1985 he has been committed to capturing images with a sense of creativity for publications and corporations. He is a member of the American Society of Media Photographers and of the National Press Photographers Association. *274*

EUGENE ANTHONY came to Black Star in the mid to late 1960s working out of San Francisco. He became a well-known journalistic photographer, covering the hip scene in the Haight-Ashbury area of San Francisco. He relocated to Brazil for a period of several years. He has been known throughout his career for his coverage of the Beat Generation and many youth-oriented subjects. *246*

BART BARTHOLOMEW grew up in Detroit during the 1960s. He saw first-hand the urban violence that gripped America's cities. During that turbulent time in America he studied photojournalism. He covered the anti-Vietnam march on Washington and the National Guard occupation of New Haven during the Bobby Seal trial. Since 1975, he has been represented by Black Star. His pictures have been published in *Newsweek, Time, U.S. News & World Report* and *The New York Times*. His photographic eye has led him around the world, visiting 45 countries while covering the news. His exclusive photographs have earned him the coveted Publisher's Award. He was a Pulitzer Prize nominee in 1992. *281*

P.F. BENTLEY

P. F. BENTLEY grew up in Hawaii. He has covered every U.S. presidential campaign, and photographed every serious presidential contender since 1980. His skill at getting close to his subjects without intruding on the events being recorded has earned him several first-place awards in the elections campaign category of the prestigious Pictures of the Year competition, the most recent being in March 1996. He is a special correspondent for *Time* and has been published in *The New York Times Magazine, The Washington Post,* and around the world. He has captured on film some of the world's most closely followed political events, such as the crisis in Fidel Castro's Cuba or Kim Dae Jung's return to South Korea. Bentley has also been featured in most of the "Day In The Life" book series. His best selling-book, "Clinton: Portrait of Victory," received critical praise for his ability to capture the soul of a politician during hectic and historic times using his exclusive access to the candidate. His latest book, about speaker Newt Gingrich, "Newt: Inside the Revolution," was published in 1997. *248, 249*

BENYAS KAUFMAN is Bob Benyas and Jack Kaufman who are partners in Detroit and represented Black Star there for 25 years. They were known for Americana style stories that were common between the 1950s and the 1970s. *304*

CAL BERNSTEIN joined Black Star in the 1950s in New York. His ability to find stories and create them as a photojournalist made Denver and Salt Lake City two of the busiest locations in the United States. In

BIOGRAPHIEN

Black Star hat über die Jahrzehnte mit Hunderten von Fotografen zusammen-gearbeitet. Vielfach waren die Fotografen selbst den New Yorker Agenten nicht persönlich bekannt; Partneragenturen aus aller Welt lieferten deren Bilder an Black Star. Aus diesem Grund war es auch nicht möglich, die Biographien aller Fotografen der in diesem Buch abgedruckten Bilder zu ermitteln.

Kursive Ziffern verweisen auf die entsprechenden Seiten.

MICHAEL ABRAMSON begann in den 70er Jahren als Fotojournalist in New York City zu arbeiten und spezialisierte sich auf Geschichten über Hippies sowie auf Frauenthemen. *103*

ARNOLD ADLER wurde 1957 in New York geboren. Seine fotografische Arbeit für Magazine und Unternehmen zeichnet sich seit 1985 durch ausgeprägte Kreativität aus. Er ist Mitglied der American Society of Media Photographers sowie der National Press Photographers Association. *274*

EUGENE ANTHONY kam Mitte der 60er Jahre zu Black Star, als er an Reportagen über die Hip-Szene in der Gegend von Haight-Ashbury in San Francisco arbeitete. Anfang der 70er Jahre ging er nach Brasilien. Seine Berichte über die »Beat Generation« und andere Jugendbewegungen sind charakteristisch für seine gesamte Karriere. *246*

BART BARTHOLOMEW wuchs in den 60er Jahren in Detroit auf und wurde dort hautnah mit der in amerikanischen Großstädten herrschenden Gewalt konfrontiert. In dieser unruhigen Zeit studierte er Fotojournalismus. Er berichtete über die Anti-Vietnam-Demonstration in Washington und die Besetzung New Havens durch die Nationalgarde während des Bobby-Seal-Prozesses. Seit 1975 wird er von Black Star vertreten. Bilder von ihm erschienen in *Newsweek, Time, U.S. News & World Report* und in der *New York Times*. Er hat den ganzen Erdball durch sein Kameraobjektiv gesehen und aus 45 Ländern über das Geschehen in der Welt berichtet. Seine anspruchsvollen Fotografien brachten ihm den begehrten Publisher's Award ein. 1992 wurde er für den Pulitzer-Preis nominiert. *281*

P. F. BENTLEY wuchs in Hawaii auf. Seit 1980 hat er über alle Präsidentschaftskampagnen berichtet und dabei jeden ernstzunehmenden Kandidaten fotografiert. Seine Fähigkeit, sich Personen und Ereignissen mit der Kamera zu nähern, ohne sich ihnen aufzudrängen, hat ihm mehrere erste Preise im renommierten Pictures-of-the-Year-Wettbewerb eingebracht, zuletzt im März 1996. Er ist Sonderkorrespondent für *Time,* und seine Arbeiten sind im *New York Times Magazine,* der *Washington Post* sowie rund um den Globus veröffentlicht worden. Er hat viele politische Ereignisse festgehalten, die die Welt in Atem hielten, u.a. die Kubakrise oder Kim Dae Jungs Rückkehr nach Südkorea. Bentley ist auch in den meisten der »Day In The Life«-Bücher präsent. Für sein meistverkauftes Buch, »Clinton: Portrait of Victory«, wurde er von der Kritik für seine Fähigkeit gelobt, die Persönlichkeit eines Politikers in einer ebenso hektischen wie historisch bedeutsamen Zeit herauszuarbeiten. Sein jüngstes Buch über den Sprecher des Repräsentantenhauses Newt Gingrich mit dem Titel »Newt: Inside the Revolution« erschien 1997. *248, 249*

BENYAS KAUFMAN sind die Fotografen Bob Benyas und Jack Kaufman, die Black Star 25 Jahre lang in Detroit vertraten. Sie waren bekannt für ihre typisch amerikanischen Geschichten, die in den 50er bis 70er Jahren sehr starke Verbreitung fanden. *304*

CAL BERNSTEIN kam in den 50er Jahren zu Black Star nach New York. Seine Fähigkeit, auch in der Provinz Geschichten aufzuspüren und sie als Fotojournalist aufzubereiten, ließ Denver und Salt Lake City in den Medien zu zwei der meistbeachteten Städte Amerikas werden. heute ist er in Kalifornien als Fotograf und in der Filmindustrie tätig. *350, 351*

DOMINIQUE BERRETTY wurde 1927 in den Niederlanden geboren und emigrierte nach Paris, wo er bis zu seinem Tod 1980 lebte. Im Laufe seiner Tätigkeit als Fotojournalist lieferte er bewegende Berichte über Nordafrika während des Algerienkonflikts, u.a. für *Life* und *Paris*

BIOGRAPHIES

Des décennies durant, Black Star a collaboré avec des centaines de photographes que les agents new-yorkais ne connaissaient pas toujours personnellement car, ne l'oublions pas, Black Star travaillait avec des agences du monde entier. C'est la raison pour laquelle il nous a été impossible de rassembler les biographies de tous les auteurs des photographies reproduites dans le présent ouvrage.

Les chiffres en italique correspondent aux pages.

MICHAEL ABRAMSON a commencé sa carrière de photoreporter dans les années 70 à New York en se spécialisant dans des sujets consacrés aux hippies et aux thèmes féminins. *103*

ARNOLD ADLER est né en 1957 à New York. Depuis 1985, il s'est efforcé de saisir avec créativité des images destinées à des publications et des institutions. Il est membre de l'American Society of Media Photographers et de la National Press Photographers Association. *274*

EUGENE ANTHONY collabore avec Black Star à partir de 1965. Il couvre les quartiers à la mode de Haight-Ashbury à San Francisco. Il s'établit au Brésil au début des années 70. Il s'est distingué pour ses clichés sur la « Beat Generation » et un grand nombre de sujets ayant trait à la jeunesse. *246*

BART BARTHOLOMEW grandit à Detroit dans les années 60, où il est le témoin direct de la violence urbaine dans les cités américaines. Durant cette période troublée, il fait des études de photoreportage. Il couvre la marche des opposants à la guerre du Viêtnam sur Washington, et l'occupation de New Haven par la Garde Nationale pendant le procès de Bobby Seal. Depuis 1975, il est représenté par Black Star. Ses articles ont été publiés dans *Newsweek, Time, U.S. News & World Report* et le *New York Times*. Sa passion pour l'information l'a entraîné dans 45 pays du monde entier. Ses photos exclusives lui ont valu le très convoité Publisher's Award. En 1992, il a été nominé pour le Pulitzer. *281*

P. F. BENTLEY grandit à Hawaii. Il a couvert toutes les campagnes présidentielles américaines, et photographié les principaux candidats à la présidence depuis 1980. P. F. Bentley a le don d'approcher ses sujets sans se mêler des événements en cours, ce qui lui a valu plusieurs premiers prix dans le prestigieux concours Pictures of the Year, le dernier en mars 1996. Correspondant spécial au *Time,* il a été publié dans le *New York Times Magazine* et le *Washington Post,* ainsi que dans le monde entier. Il a immortalisé certains des événements les plus couverts du monde, comme la crise cubaine ou le retour de Kim Dae Jung en Corée du Sud. Bentley est aussi présent dans la plupart des ouvrages de la série « Day In The Life ». Son best-seller, « Clinton : Portrait of Victory », a été salué par la critique pour avoir su saisir l'âme d'un homme politique pendant une campagne mouvementée et historique. Son dernier ouvrage, sur le porte-parole de la Chambre, Newt Gingrich, « Newt : Inside the Revolution », est publié en 1997. *248, 249*

BENYAS KAUFMAN sont deux associés, Bob Benyas et Jack Kaufman, installés à Detroit où ils représentent Black Star depuis 25 ans. Ils sont célèbres pour leurs histoires typiquement américaines en vogue dans les années 50 jusqu'aux années 70. *304*

CAL BERNSTEIN a rejoint Black Star à New York dans les années 50. Il a su trouver des sujets et les transformer en reportages qui faisaient de Denver et Salt Lake City les endroits les plus excitants des Etats-Unis. Aujourd'hui, il vit en Californie où il poursuit sa carrière de photographe tout en travaillant pour l'industrie du cinéma. *350, 351*

DOMINIQUE BERRETTY est né en 1927 en Hollande et meurt à Paris en 1980, ville qu'il n'a plus quittée après y avoir émigré. Au cours de sa carrière, il a réalisé de nombreux scoops sur la guerre d'Algérie pour *Life* et *Paris Match*. Par la suite, installé à Paris, il se consacre à des sujets d'une actualité moins brûlante mais plus profonds. *82/83, 84, 292*

SEBASTIAN BOLESCH vit à Bonn en Allemagne où il est né en 1971. Il étudie la photographie auprès de Henning Christoph, dont il est l'assistant à l'agence Das Fotoarchiv. S'intéressant plus particulièrement aux

California he continues still photography as well as work in the film industry. *350, 351*

DOMINIQUE BERRETTY was born in 1927 in Holland and emigrated to Paris where he lived until his death in 1980. During his career he did a number of breaking news stories on North Africa during the Algerian conflict for *Life* and *Paris Match*. He later expanded his photojournalism to less news-oriented and more in-depth coverage. *82/83, 84, 292*

SEBASTIAN BOLESCH was born in 1971 in Bonn, Germany. He studied under Henning Christoph, working as assistant to him in his agency Das Fotoarchiv. His interest lies in crisis situations and social problems. Bolesch's first major story was on German Neo-Nazis. These photos were printed internationally – *Newsweek* ran a cover, *Time*, *Stern*, *Paris Match* and many others running the stories. He has done stories on the Kurds, the Israeli/Palestinian conflict, war in Bosnia, Young Jews in Jerusalem, and Northern Ireland. *24*

CHARLES BONNAY was born in France and was with the French paratroopers at Dien Bien Phu where he was a military cameraman. He was on the last flight out of Dien Bien Phu before it was overrun. He emigrated to the United States and associated with Black Star, dealing with major stories such as the Cuba Omega Seven group which tried to overthrow Castro in the mid to late 1960s, as well as doing extensive coverage on the OAS rebellion in Algeria against the French government. At the time when General Raoul Salan, the head of the OAS, was under a formal sentence of death in France, Bonnay not only photographed Salan in hiding for *Life* magazine, but also went out with the OAS on a raid where he showed French soldiers being killed by the rebel group. For his actions in covering that story, he was condemned to death *in absentia* in France, and was unable to go home for years until an amnesty was granted. He continued to cover stories until his death from hepatitis in the mid 1980s in Central America. *10, 243*

WALTER BOSSHARD was born in 1892 in Richterswil, Switzerland. He studied Art History and Educational Theory at the University of Zurich from 1910 to 1914. In the 1920s, he traveled to India, Sumatra, and Siam as a plantation worker and gem agent and photographed with the German Central Asia Expedition in Tibet and Turkestan under German photographer and explorer Emil Trinkler. He worked for the Dephot Agency in Berlin in 1930 and acted as a correspondent and photographer, specializing in Asian topics, for Ullstein Publishers of Berlin between 1930 and 1935. He was associated with Black Star from 1935 to 1939, and was a correspondent based in Washington, D.C., for the Swiss *Neue Zürcher Zeitung* newspaper from 1942 to 1945. During this time he also reported on stories in the Balkans and Middle East. After the war, he continued to travel, write, and photograph around the world. Many of his photographs were lost in Peking during the Communist takeover in 1949. He was forced to abandon photography in 1953 following an accident in Korea, but he continued to write and publish until 1960 when he retired to Spain. During his career, he published half a dozen books, as well as in-depth photo reportages and accompanying articles in European magazines. His archive of 15,000 negatives was bequeathed to the Stiftung für die Photographie, Zurich, in 1975. His work was the subject of one-man shows at the Kunsthaus Zürich in 1977, and the ICP, New York in 1978. *16, 32*

DENNIS BRACK was born in 1939 in Great Bend, Kansas. He graduated from Washington and Lee University in 1962 and from George Washington Law School in 1965. For more than three decades he covered the Washington, D.C. beat for Black Star. He is an accredited photographer to the White House and he has accompanied every president since Lyndon B. Johnson on summit meetings and international trips. Although no combat photographer, he was, on an assignment for *Time*, one of the photojournalists selected to cover the Gulf War and his pictures were published as covers of *Time*, *Newsweek*, *U.S. News & World Report* and a variety of international news magazines. He has won awards from the National Newspaper Photographers Association, the White House News Photographers Association and the World Press Association. Over the past years, he has been on the five-member board of the standing committee of the U.S. Senate Press Photographers' Gallery. Recently, he has been selected to be a member of the Executive Board of the White House News Photographers Association. For two years he photographed all aspects of the National

Match. Neben dem Tagesjournalismus widmete er sich später vermehrt fundierten Bildreportagen. *82/83, 84, 292*

SEBASTIAN BOLESCH wurde 1971 in Bonn geboren. Seine fotografische Karriere begann er als Praktikant und Assistent von Henning Christoph in der Agentur Das Fotoarchiv. Seine Hauptinteressen liegen in der Kriegs- und Krisenfotografie und in sozialdokumentarischer Arbeit. Seine erste große Reportage fotografierte er über Neo-Nazis in Deutschland. Diese Fotos wurden international publiziert (*Newsweek*-Cover, *Time*, *Stern*, *Paris Match* u.a.). Weitere Reportagen waren: Kurdische Flüchtlinge, der israelisch-palästinensische Konflikt, Krieg in Bosnien, junge Juden in Jerusalem, Nordirland-Konflikt. *24*

CHARLES BONNAY, geboren in Frankreich, war Militärkameramann bei den französischen Fallschirmjägern in Dien Bien Phu. Mit einem der letzten Flugzeuge kehrte er zurück, bevor die französischen Truppen überwältigt wurden. Er emigrierte in die Vereinigten Staaten und wurde Mitglied von Black Star. Bonnay beschäftigte sich mit Themen wie der Gruppe Cuba Omega Seven, die Mitte bis Ende der 60er Jahre Castro zu stürzen versucht hatte. Daneben berichtete er ausführlich über den Aufstand der OAS gegen die französische Regierung in Algerien. Nachdem die Regierung de Gaulles den Führer der OAS, General Raoul Salan, formell zum Tode verurteilt hatte, machte Bonnay für *Life* nicht nur versteckte Fotos von Salan, er begleitete die OAS sogar bei einem Überfall und fotografierte dabei französische Soldaten, die von Rebellen getötet wurden. Für solche Aktivitäten wurde er von der französischen Regierung in Abwesenheit zum Tode verurteilt und konnte mehrere Jahre lang nicht in seine Heimat zurück, bis eine Amnestie erlassen wurde. Er arbeitete als Fotojournalist bis Mitte der 80er Jahre und starb in Folge einer Hepatitis-Erkrankung in Mittelamerika. *10, 243*

WALTER BOSSHARD wurde 1892 in Richterswil in der Schweiz geboren. Von 1910 bis 1914 studierte er an der Universität Zürich Kunstgeschichte und Erziehungswissenschaften. Die 20er Jahre verbrachte er in Indien, Sumatra und Siam als Plantagenarbeiter und Edelsteinhändler. 1927 bis 1929 reiste er durch Tibet und Turkestan als Fotograf für die Deutsche Zentralasien-Expedition. 1930 arbeitete er für die Agentur Dephot in Berlin und bis 1935 für den Berliner Ullstein Verlag als Korrespondent und Fotograf für Asien. Er war von 1935 bis 1939 mit Black Star assoziiert und arbeitete von 1942–45 als Washington-Korrespondent für die *Neue Zürcher Zeitung*. Während dieser Zeit berichtete er auch über Ereignisse auf dem Balkan und im Nahen Osten. Nach dem Krieg setzte er seine Reisen als Journalist und Fotograf rund um den Globus fort. 1949 gingen bei der Machtübernahme der Kommunisten in Peking viele seiner Fotografien verloren. Ein Unfall in Korea zwang ihn 1953 das Fotografieren aufzugeben, er schrieb und publizierte aber weiter, bis er sich 1960 in Spanien zur Ruhe setzte. Im Verlauf seiner Karriere veröffentlichte er ein halbes Dutzend Bücher sowie fundierte Hintergrundreportagen in europäischen Zeitschriften. Sein Archiv mit 15000 Negativen vermachte er kurz vor seinem Tod 1975 der Zürcher Stiftung für die Photographie. Sein Werk wurde in Einzelausstellungen 1977 im Kunsthaus Zürich und 1978 im ICP in New York gezeigt. *16, 32*

DENNIS BRACK

DENNIS BRACK wurde 1939 in Great Bend in Kansas geboren. Er graduierte 1962 an der Washington and Lee University sowie 1965 an der George Washington Law School. Mehr als drei Jahrzehnte lang hat er für Black Star aus Washington berichtet. Er ist akkreditierter Fotograf im Weißen Haus und hat jeden Präsidenten seit Lyndon B. Johnson zu Gipfelgesprächen und auf internationalen Reisen begleitet. Wenngleich kein Kriegsberichterstatter, beobachtete er als Fotojournalist für *Time* den Golfkrieg. Seine Bilder füllten die Titelseiten internationaler Nachrichtenma-

situations de crise et aux problèmes sociaux, Bolesch livre un premier grand reportage sur les néo-nazis allemands qui sera publié dans la presse internationale, faisant la une de *Newsweek* avant d'être distribué dans *Time*, *Stern*, *Paris Match* et bien d'autres magazines encore. Il a également réalisé des sujets sur les Kurdes, le conflit israélo-palestinien, la Bosnie, les jeunes Juifs à Jérusalem et l'Irlande du Nord. *24*

CHARLES BONNAY est né en France. Cameraman militaire au sein des troupes françaises à Diên Biên Phu, il réussit à prendre le dernier avion avant que Diên Biên Phu ne tombe aux mains des forces ennemies. Emigré aux Etats-Unis, il collabore avec Black Star et réalise de grands reportages dont un sur le groupe Cuba Omega Seven qui tente de renverser Castro dans le milieu des années 60. Il couvre aussi les actions terroristes menées par l'OAS contre le gouvernement français en Algérie. Bonnay réalise pour le magazine *Life* un reportage sur le Général Raoul Salan, chef de l'OAS, qui vit caché après avoir été condamné à mort par le gouvernement de Gaulle. Il réussit même à accompagner l'OAS dans un de ses raids et à photographier les soldats français tués par les membres de l'organisation. Ce reportage lui vaut d'être condamné à mort *in absentia* par le gouvernement français. Ce n'est que des années plus tard, après avoir été amnistié, qu'il pourra rentrer dans son pays. Il a réalisé des reportages jusqu'à sa mort en Amérique centrale au milieu des années 80 des suites d'une hépatite. *10, 243*

WALTER BOSSHARD est né en Suisse à Richterswil. De 1910 à 1914, il fait des études d'Histoire de l'art et de Pédagogie à l'Université de Zurich. Dans les années 20, il travaille comme planteur et représentant en pierres précieuses en Inde, à Sumatra et au Siam et comme photographe et chercheur à l'expédition allemande d'Asie Centrale au Tibet et au Turkestan. Il entre à l'agence Dephot à Berlin en 1930. Entre 1930 et 1935, il est correspondant et photographe spécialiste de l'Asie pour la maison d'édition Ullstein. De 1935 à 1939, il s'associe à Black Star et travaille comme correspondant à Washington pour le quotidien suisse *Neue Zürcher Zeitung* de 1942 à 1945. A la même époque, il effectue aussi des reportages dans les Balkans et au Proche-Orient. Après la guerre, il continue de voyager, d'écrire et de photographier dans le monde entier. Une grande partie de ses photos ont été perdues à Pékin lors de la prise du pouvoir par les communistes en 1949. Forcé d'abandonner la photographie à la suite d'un accident en Corée, il continue d'écrire et de publier jusqu'en 1960, date à laquelle il prend sa retraite en Espagne. Au cours de sa carrière, il a publié une demi-douzaine d'ouvrages, ainsi que des essais illustrés de photos et des articles très approfondis dans des magazines européens. Peu de temps avant sa mort, il a légué les 15000 négatifs de ses archives à la Stiftung für die Photographie de Zurich en 1975, et son œuvre a fait l'objet d'expositions personnelles à la Kunsthaus Zürich en 1977, et à l'ICP de New York en 1978. *16, 32*

DENNIS BRACK est né à Great Bend au Kansas en 1939. Il est sorti diplômé de la Washington and Lee University en 1962, et de la George Washington Law School en 1965. Pendant plus de trente ans, il a couvert tous les scoops de Washington pour Black Star. Il travaille comme photographe accrédité à la Maison-Blanche ; depuis Lyndon Johnson, il accompagne tous les présidents lors des sommets et voyages à l'étranger. Bien qu'il ne soit pas correspondant de guerre, il a accepté un engagement de *Time* pour couvrir la guerre du Golfe. Ses clichés sont publiés dans *Time*, *Newsweek*, *U.S. News & World Report* et de nombreux magazines internationaux. Il a été récompensé par la National Newspaper Photographers Association, la White House News Photographers Association et la World Press Association. Les dernières années, il a fait partie du conseil du comité permanent de l'U.S. Senate Press Photographer's Gallery. Récemment, il a été élu membre du bureau exécutif de la White House News Photographers Association. Pendant deux ans, il a photographié la National Gallery of Art de Washington pour un livre publié par le musée à l'occasion de ses 50 ans d'existence. *81, 94, 95, 103, 265, 422*

KURT BREKER *68*

PAUL BUCHANAN, né vers 1910, a vécu toute sa vie à Hawk, en Caroline du Nord. Il se lance dans la photo vers ses 16 ou 17 ans sur les conseils de son père, lui-même photographe amateur. Des années 20 à 1951, son appareil à la main, il sillonne les comtés montagneux en Caroline du Nord. Il ne s'est jamais considéré comme un photographe, mais comme un « homme-image ». La majorité de ses photos sont des portraits. Paul

Gallery of Art in Washington for a book that the gallery published to celebrate its fiftieth anniversary.

PAUL BUCHANAN

PAUL BUCHANAN was born around 1910. He spent his entire life in Hawk, North Carolina. He started taking pictures when he was 16 or 17, getting instruction from his father who was also a photographer. For nearly thirty years, from the 1920s until 1951, he wandered the North Carolina mountain counties and took many photographs. He did not think of himself as a photographer; he was the "picture man." Most of his pictures were portraits. He died in 1987. Ann Hawthorne, a present-day photographer, discovered his photographs and edited his work in a book, "The Picture Man," in 1992.

SIMONA CALI' COCUZZA was born in 1959 in Catania, Sicily. In 1980, she enrolled in the Faculty of Political Sciences at the university of Catania, attended a photographic school in Palermo, and started working for local newspapers as well as for *L'Espresso* and *L'Europeo*. In 1986, she traveled through South America for nine months, making many reports for the Italian magazine *King,* including one on the drug traffickers in the Amazonian Forest. After that she spent five months in Central America, where she followed the Civil War in El Salvador and traveled to Nicaragua. These reports were the beginning of her international career.

HENNING CHRISTOPH was born in 1944 in Grimma, Germany. He studied Anthropology and Journalism in Washington, D.C. After further studies at the Folkwang-Schule in Essen, he began his career as a photojournalist in 1968, and has been widely published in international magazines. Since 1976 he has been the author of 28 photo essays in *Geo* magazine. Six of them have won World Press awards. Christoph is co-founder and director of the Essen picture agency Das Fotoarchiv. During the 1990s he concentrated on working in Africa, which he calls his "second home." His work on the Voodoo project lasted five years and was published in magazines worldwide and the book "Voodoo. The Secret Power of Africa" (1995). Since 1994 he has been working on his new long-term project "The Soul of Africa" to discover the spiritual roots of the African.

ALAN COPELAND was born in Canada. He came to prominence as part of the Berkley crew in the late 1960s, a group of young photographers and journalists who covered the scene during the foment that took place in the late 1960s, ending with the Kent State massacre in 1970. He has now returned to Canada and produces a regional magazine.

gazine wie *Time, Newsweek* und *U.S. News & World Report.* Ihm wurden Preise der National Newspaper Photographers Association, der White House News Photographers Association und der World Press Association zuteil. In den letzten Jahren war er Mitglied des ständigen Komitees der U.S. Senate Press Photographers' Gallery, erst kürzlich wurde er in den Vorstand des Pressefotografenverbandes des Weißen Hauses gewählt. Zwei Jahre lang hat er die National Gallery of Art in Washington für ein Buch porträtiert, das anläßlich ihres 50jährigen Bestehens herausgegeben wurde.

PAUL BUCHANAN wurde um 1910 geboren. Er verbrachte sein ganzes Leben in Hawk, North Carolina. Mit 16 oder 17 Jahren, als sein Vater, der ebenfalls Fotograf war, ihn zu unterweisen begann, machte er seine ersten Bilder. Von den 20er Jahren an bis 1951 war er in den Bergen von North Carolina unterwegs, um Aufnahmen zu machen. Er verstand sich nicht als Fotograf, sondern nannte sich »Bildermann«. Die Mehrzahl seiner Bilder waren Porträts. Buchanan starb 1987. Die Fotografin Ann Hawthorne entdeckte seine Fotografien und veröffentlichte sie 1992 unter dem Titel »The Picture Man«.

SIMONA CALI' COCUZZA wurde 1959 in Catania auf Sizilien geboren. Sie studierte dort Politologie, besuchte gleichzeitig eine Fotoschule in Palermo und begann für die lokale Tageszeitung, *L'Espresso* sowie *L'Europeo* zu arbeiten. 1986 bereiste sie neun Monate lang Südamerika und machte zahlreiche Reportagen für die italienische Zeitschrift *King,* darunter einen Bericht über die Drogenhändler im tropischen Regenwald Amazoniens. Danach lebte sie fünf Jahre in Mittelamerika, verfolgte den Bürgerkrieg in El Salvador und reiste durch Nicaragua. Die dort entstandenen Reportagen begründeten ihre internationale Karriere.

HENNING CHRISTOPH wurde 1944 in Grimma bei Leipzig geboren und studierte Anthropologie und Journalismus in Washington. Nach weiteren Studien an der Folkwang-Schule in Essen begann er 1968 seine Laufbahn als Fotojournalist. Seine Reportagen erschienen in zahlreichen internationalen Magazinen. Seit 1976 veröffentlichte er 28 Fotoessays in der Zeitschrift *Geo.* Sechs davon wurden mit World Press Awards ausgezeichnet. Henning Christoph ist Mitbegründer und Geschäftsführer der Essener Bildagentur Das Fotoarchiv. Während der 90er Jahre fotografierte er vor allem in Afrika, das er als seine zweite Heimat bezeichnet. Er arbeitete fünf Jahre an einem Voodoo-Projekt, das in internationalen Magazinen und 1995 unter dem Titel »Voodoo. The Secret Power of Africa« als Buch erschien. Seit 1994 widmet er sich einem neuen Langzeitprojekt, »The Soul of Africa«, um die spirituellen Wurzeln der Afrikaner zu ergründen.

ALAN COPELAND wurde in Kanada geboren. In den späten 60er Jahren wurde er als Mitglied der Berkley-Crew bekannt, einer Gruppe junger Fotografen und Journalisten, die über die angespannte Situation in den späten 60er Jahren berichtete, welche schließlich 1970 im Massaker von Kent endete. Heute lebt er in Kanada und ist Herausgeber eines regionalen Magazins.

JOE COVELLO war in der Armee zum Fotografen ausgebildet worden. Nach seiner Rückkehr aus dem Zweiten Weltkrieg begann er mit Black Star zusammenzuarbeiten und war für Magazine wie *Time, Life, American Weekly* und *This Week* tätig. Sein Werk umfaßt auch Dokumentationen von Persönlichkeiten, wie seine Reportage für *This Week* über Art Buchwald belegt. Er war ein Vorreiter in der elektronischen Bildverarbeitung und half Black Star bei der Produktion einer der ersten fernsehtauglichen Diashows für NBC. Covello starb Mitte der 80er Jahre.

MICHAEL COYNE wurde 1945 im englischen Daventry geboren. Im Alter von 15 Jahren ging er nach Australien. Als Mitarbeiter von Black Star arbeitete er für *Newsweek, Time, Life,* das Magazin des Londoner *Obser-*

Buchanan est mort en 1987. La photographe Ann Hawthorne a redécouvert son œuvre et l'a présentée dans un livre, « The Picture Man », en 1992.

SIMONA CALI' COCUZZA est née en 1959 à Catane en Italie. En 1980, elle commence ses études de Sciences Politiques, fréquente un studio photo à Palerme, et commence à travailler pour des journaux locaux, ainsi que pour *L'Espresso* et *L'Europeo*. En 1986, elle sillonne l'Amérique du Sud pendant neuf mois, et fait de nombreux reportages pour le magazine italien *King,* dont un sur des trafiquants de drogues de la jungle amazonienne. Ensuite, elle passe cinq ans en Amérique Centrale, couvre la guerre civile au Salvador et voyage au Nicaragua – reportages qui lui ouvrent les portes d'une carrière internationale.

HENNING CHRISTOPH

HENNING CHRISTOPH est né en 1944 à Grimma en Allemagne. Après des études d'anthropologie et de journalisme à Washington puis à la Folkwang-Schule d'Essen, il entame en 1968 sa carrière de photoreporter. Ses photos paraissent dans de nombreuses revues internationales. Depuis 1976, il a réalisé 28 photoreportages pour le magazine *Geo,* dont 6 ont été récompensés par World Press. Henning Christoph est le cofondateur et directeur de l'agence de photos Das Fotoarchiv à Essen. Depuis le début des années 90, il travaille essentiellement en Afrique qu'il appelle sa « deuxième patrie ». Son travail sur le Vaudou, qui a duré 5 ans, a été publié dans le monde entier et dans un livre intitulé « Voodoo. The Secret Power of Africa » en 1995. Il a commencé en 1994 un nouveau projet de longue haleine, « The Soul of Africa », à la recherche des racines spirituelles de l'Afrique.

ALAN COPELAND est né au Canada. Il se fait connaître alors qu'il fait partie de la bande de Berkley, un groupe de jeunes photographes et journalistes qui couvre les mouvements de contestation de la fin des années 60 jusqu'au massacre du Kent en 1970. Aujourd'hui, il vit au Canada où il dirige un magazine régional.

JOE COVELLO a appris le métier de photographe à l'armée quitte l'armée. Après la Deuxième Guerre mondiale il s'associe immédiatement à Black Star. Il travaille pour des magazines tels que *Time, Life, American Weekly* et *This Week.* Son travail comprend des portraits dont une série sur Art Buchwald réalisée pour *This Week.* Il devient un des précurseurs de l'image électronique et contribue avec Black Star à réaliser l'un des premiers films de montage de photographies en séquences rapides pour NBC. Il meurt dans le milieu des années 80.

MICHAEL COYNE est né en 1945 à Daventry, en Angleterre. A 15 ans, il part pour l'Australie. Représenté par Black Star, il a travaillé pour *Newsweek, Time, Life,* l'*Observer* londonien, et pour des publications françaises et allemandes. En 1984, il fait un premier séjour en Iran – séjour suivi de nombreux autres qui aboutiront à un reportage de 28 pages sans précédent dans le *National Geographic*. Puis, pendant huit ans, il couvre la révolution iranienne. Un travail couronné par la National Press Photographers Association of America, et l'Overseas Press Club. Ses livres sur l'Australie ont été récompensés par des prix nationaux et internationaux. Le

JOE COVELLO had trained as a photographer in the Army. After World War II he became associated with Black Star and did work for magazines including *Time, Life, American Weekly,* and *This Week*. His work also included personality material such as his Art Buchwald story for *This Week* magazine. He became a forerunner in electronic imaging and for NBC he helped Black Star to produce one of the first quick action pieces of editorial work on film using quick cut still photography. He died in the mid 1980s. *71, 281, 346, 347*

MICHAEL COYNE

MICHAEL COYNE was born 1945 in Daventry, England. At the age of fifteen, he went to Australia. Represented by Black Star, he has worked for *Newsweek, Time, Life,* London's *Observer* magazine and French and German publications. In 1984, he made the first of many trips to Iran, which resulted in a virtually unprecedented 28-page spread in *National Geographic* magazine, and worked for eight years covering the Iranian Revolution. This attracted awards from the National Press Photographers Association of America and the Overseas Press Club. His books on Australia have resulted in national and international awards. The National Museum of Australia has bought a complete collection of the photographs from his book "A World of Australians." *108, 109, 387*

RALPH CRANE was an émigré from Germany who came to the United States in the late 1930s. He became a Black Star contract photographer for several years, was then a *Life* contract photographer through Black Star, and eventually a *Life* staff photographer. He became known, not only for his journalistic-style photography, but for his wonderful technical expertise. During his association with *Life,* he did major lighting to light up the San Francisco Golden Gate Bridge, as well as other large lighting projects that helped him bring strong illustrative point picture to his journalistic work. He retired to Switzerland where he died in the 1980s.
65, 286, 288, 299, 344, 345, 347

DON CRAVEN had an association with *Life* magazine for a number of years. He specialized in stories about Kentucky and the Appalachian region, both in human interest and in social issues. He died in the late 1970s. *298*

PETER CÜRLIS *68/69, 70*

GENE DANIELS was associated with Black Star from the mid 1950s on. He was Black Star's staff photographer in Los Angeles, covering much of the Hollywood scene, the Academy Awards, and California lifestyle for 25 years. He later became the picture editor of *Boys Life* magazine, the publication of the Boy Scouts of America. He died in the early 1990s. *284, 285*

YVES DEBRAINE was born in 1925 in Paris, France. He worked as a press photographer at the Agence France-Presse in Paris, then in 1948 worked for two years in a press agency in Switzerland. At the beginning of the 1950s, he became a freelance photographer and did his first assignment for *Life* magazine for the wedding of King Farouk in Cairo. In the 1960s he began doing assignments for Black Star, *Paris Match, Epoca, Stern, Bunte Illustrierte* and various Swiss magazines. From 1953 to 1973 he specialized in motor racing (Formula One) and produced a book of this work entitled "Automobile Year." At the same time he was doing art reproductions in European museums for the Time-Life book division. In Switzerland he also became the personal photographer of Charlie Chaplin. He still lives in Switzerland and is the editor of a Swiss monthly magazine. *277*

VICTOR DE PALMA *76*

ver sowie französische und deutsche Presseorgane. 1984 reiste er zum ersten Mal in den Iran. Dort entstand eine 28seitige Dokumentation von beispielloser Aussagekraft, die in *National Geographic* erschien. Acht Jahre lang berichtete er über die Revolution im Iran. Seine Arbeiten brachten ihm Preise der National Press Photographers Association und des Overseas Press Club ein. Auch seine Bücher über Australien sind mit nationalen und internationa en Preisen ausgezeichnet worden. Das Australische National-museum hat alle Fotografien aus seinem Buch »A World of Australians« erworben. *108, 109, 387*

RALPH CRANE kam in den späten 30er Jahren als deutscher Emigrant in die Vereinigten Staaten. Er arbeitete mehrere Jahre für Black Star, wurde dann zunächst Vertrags- und schließlich Staff-Fotograf bei *Life*. Nicht nur sein fotojournalistischer Stil machte ihn bekannt, sondern auch sein außerordentlicher technischer Sachverstand. Während seiner Zeit bei *Life* beleuchtete er mit aufwendigen Lichtinstallationen die Golden Gate Bridge in San Francisco. Weitere große Lichtinstallationen halfen ihm, in seiner journalistischen Arbeit einen stark illustrativen Stil zu entwickeln. Er zog sich in die Schweiz zurück, wo er in den 80er Jahren starb.
65, 286, 288, 299, 344, 345, 347

DON CRAVEN arbeitete mehrere Jahre lang für *Life*. Er spezialisierte sich auf sozialkritische Reportagen und Geschichten aus dem täglichen Leben vornehmlich in Kentucky und den Appalachen. Er starb in den späten 70er Jahren. *298*

PETER CÜRLIS *68/69, 70*

GENE DANIELS arbeitete seit Mitte der 50er Jahre mit Black Star zusammen. Er war Staff-Fotograf der Agentur in Los Angeles und berichtete 25 Jahre lang über Hollywood, die Academy Awards und den kalifornischen Lebensstil. Dann wurde er zum Bildredakteur von *Boys Life*, der Zeitschrift der amerikanischen Boy Scouts. Er starb in den frühen 90er Jahren. *284, 285*

YVES DEBRAINE, geboren 1925 in Paris, arbeitete zunächst als Pressefotograf bei der Agence France Presse in Paris, dann ab 1948 zwei Jahre lang bei einer Schweizer Presseagentur. Anfang der 50er Jahre wurde er freischaffender Fotograf und bekam seinen ersten Fotoauftrag für das Magazin *Life* über die Hochzeit von König Farouk in Kairo. In den 60er Jahren begann er, u.a. im Auftrag von Black Star, für Magazine wie *Paris Match, Epoca,* den *Stern,* die *Bunte Illustrierte* und verschiedene Schweizer Magazine zu arbeiten. In den Jahren 1953 bis 1973 spezialisierte er sich auf Formel-1-Autorennen und brachte ein Buch mit dem Titel »Automobile Year« heraus. Zur gleichen Zeit machte er in europäischen Museen Kunstaufnahmer für die Time-Life-Buchabteilung. In der Schweiz wurde er zum persönlichen Fotografen von Charlie Chaplin. Debraine lebt in der Schweiz und ist Herausgeber eines Schweizer Monatsmagazins. *277*

VICTOR DE PALMA *76*

MARKUS DWORACZYK wurde 1961 im polnischen Teil Oberschlesiens geboren. Er entwickelte sich vom Autodidakten zum professionellen Fotografen. Kaum älter als neunzehn, arbeitete er für alle polnischen Magazine und Zeitungen. Über die deutsche Fotoagentur Das Fotoarchiv kam er Ende der 80er Jahre mit Black Star in Kontakt. Er arbeitete für deutsche Magazine wie den *Spiegel, Focus* und *Stern,* seine Fotografien erschienen aber auch in der internationalen Presse. Er hat sich auf kritische Sozialreportagen spezialisiert und seine Liebe zu Oberschlesien in drei Bildbänden dokumentiert. Er starb 1996 an Leukämie. *260*

TOR EIGELAND, 1931 in Oslo geboren, erhielt seine Ausbildung in Norwegen Kanada, Mexiko und Miami. Seine schriftstellerischen und fotografischer Arbeiten fanden weltweite Verbreitung. 1987 fuhr er auf der Seidenstraße von Istanbul nach China. Er gehört zu den wenigen Menschen, die die gesamte Strecke auf dem Landweg bereisten. Er berichtete auch über andere Themen wie die Baskische Terror-Organisation ETA oder Aids in der Sub-Sahara. Ende des Jahres 1991 schloß er eine Studie über den unberührten Teil des Regenwaldes auf Borneo ab, die in verschiedenen Ländern veröffentlicht wurde. 1992 reiste er für *National Geographic Traveler* nach Oman und Singapur. *195, 387*

National Museum of Australia a acquis une collection complète des clichés de son ouvrage « A World of Australians ». *108, 109, 387*

RALPH CRANE quitte l'Allemagne pour les Etats-Unis à la fin des années 30. Il travaille plusieurs années comme photographe pour Black Star d'abord, puis pour *Life* par l'intermédiaire de Black Star, avant de devenir photographe maison de *Life*. Il se fait connaître non seulement par ses photos de style journalistique mais aussi par son extraordinaire savoir-faire technique. Pendant son séjour à *Life,* il illumina à l'aide d'installations complexes le Golden Gate Bridge de San Francisco. D'autres importantes installations lumineuses l'aidèrent à développer dans son travail de journaliste un genre très proche de l'illustration. Il s'installe en Suisse où il meurt dans les années 80. *65, 286, 288, 299, 344, 345, 347*

DON CRAVEN a collaboré avec *Life* pendant de nombreuses années. Il s'est spécialisé dans des reportages sur le Kentucky et la région des Appalaches qui témoignent de son intérêt pour les gens et les problèmes sociaux. Il meurt à la fin des années 70. *298*

PETER CÜRLIS *68/69, 70*

GENE DANIELS collabore avec Black Star dès le milieu des années 50. Il est pendant 25 ans le photographe attitré de Black Star à Los Angeles et couvre les grands événements de Hollywood, les Academy Awards, et le style de vie californien. Il devient ensuite rédacteur du service photo pour *Boys Life,* la revue des Boy Scouts of America. Il meurt au début des années 90. *284, 285*

YVES DEBRAINE est né en 1925 à Paris. Il travaille comme photographe de presse à l'Agence France-Presse à Paris, puis en 1948, collabore pendant deux ans avec une agence de presse en Suisse. Au début des années 50, il devient photographe free-lance et couvre le mariage du roi Farouk au Caire pour *Life,* puis devient reporter pour Time-Life jusqu'en 1973. Dans les années 60, il fait des reportages pour Black Star, *Paris Match, Epoca* et *Bunte Illustrierte,* et pour différents magazines suisses. De 1953 à 1973, il se spécialise dans les courses de Formule 1, et sort un livre de ses clichés intitulé « Automobile Year ». A la même époque, il s'occupe de reproductions d'œuvres dans des musées d'Europe pour le service Livre de Time-Life. En Suisse, il devient le photographe personnel de Charlie Chaplin. Installé en Suisse, il est aujourd'hui rédacteur en chef d'un mensuel suisse. *277*

VICTOR DE PALMA *76*

MARKUS DWORACZYK est né en 1961 dans la partie polonaise de la haute Silésie. D'autodidacte, il devient photographe professionnel et, à l'âge de 19 ans, travaille déjà pour toute la presse polonaise. Il entre en contact avec Black Star par l'intermédiaire de son agence de photos Das Fotoarchiv à la fin des années 80. Il travaille pour des magazines allemands comme le *Spiegel, Focus* et *Stern* et ses clichés sont également publiés dans la presse internationale. Spécialisé dans le document social, il a aussi réalisé trois ouvrages illustrés consacrés à la passion qu'il porte au pays de son enfance, la haute Silésie. Il meurt d'une leucémie en 1996. *260*

TOR EIGELAND est né en 1931 à Oslo en Norvège. Il a fait ses études en Norvège, ainsi qu'au Canada, en Mexique et à Miami. Son œuvre d'écrivain et de photographe connaît un immense succès dans le monde entier. En 1987, il suit toute la Route de la Soie depuis Istanbul jusqu'en Chine, ce qui le met au nombre de la centaine de gens à avoir fait le trajet complet par voie de terre. Ses reportages traitent aussi bien de l'organisation terroriste basque ETA, que du Sida en Afrique subsaharienne. Fin 1991, il termine une étude sur la forêt tropicale vierge de Bornéo, publiée dans plusieurs pays. En 1992, il fait des reportages à Oman et Singapour pour le compte du *National Geographic Traveler*. *195, 387*

ROBERT ELLISON, né en 1945, étudia à l'Université de Floride, où ses travaux sur la violence raciale à Selma, Alabama, furent publiés dans des magazines américains. Il a une vingtaine d'années lorsqu'il collabore avec Empire News, un groupe de photographes qui travaille pour Black Star et qui représente l'agence au Viêtnam dans les années 60. Il a réalisé de nombreux sujets au Viêtnam, dont le siège de Khe Sanh. L'ironie du sort veut qu'il meurt à Khe Sanh en 1968, non pas sous le feu des armes mais dans un accident d'avion lors d'une mission de ravitaillements. *96, 97, 100*

MARKUS DWORACZYK was born in 1961 in the Polish part of Upper Silesia. An autodidact, he became a professional photographer. After the age of nineteen he worked for all of the Polish press publications. Through his German photo agency, Das Fotoarchiv, he came into contact with Black Star in the late 1980s. He worked for German magazines, including *Der Spiegel, Focus,* and *Stern,* but his photographs have also been published internationally. He specialized in social reportages and documented his love for his native region, Upper Silesia, in three illustrated books. He died of leukaemia in 1996. *260*

TOR EIGELAND was born in 1931 in Oslo, Norway. Educated in Norway, Canada, Mexico, and Miami, he is a writer as well as a photographer. His work has been published widely around the world. He traveled the entire Silk Road from Istanbul to China in 1987, and he is one of only a few hundred people in history to have traveled the whole length by land. His stories have also covered subjects including the Basque terrorist organization ETA, and AIDS in sub-Saharan Africa. Towards the end of 1991, he completed a study on the virgin rain forest in Borneo which was published in various countries. In 1992, he did stories for *National Geographic Traveler* in Oman and Singapore. *195, 387*

ROBERT ELLISON was born in 1945. He studied at the University of Florida, where his photographs of racial violence in Selma, Alabama were published in American magazines. He went to work for Empire News, a group of photographers doing work for, and representing, Black Star in Vietnam during the 1960s. He covered a number of Vietnam stories, including the siege of Khe Sanh. He died in 1968. Ironically enough, at Khe Sanh, but not under fire. The plane that was flying him in on a supply mission crashed and Ellison was killed. *96, 97, 100*

RICHARD EMBLIN was born in 1966 in Caracas, Venezuela. After graduating from the University of Toronto in History and English, he embarked on his photography career after an internship at *The Independent* newspaper, London. For *The Independent* and *The Sunday Telegraph,* he covered the violent Colombian presidential elections in 1990. In 1994, he won the Bronze medal for photojournalism from the International Society of Newspaper Design for his photography of the civil war in Angola. He completed his first photography book "The Darien Gap" in 1996 and is working on his second "Magic Realism: The Colombia of Gabriel García Marquez." Today, he lives in Canada and works for Black Star's international magazine and newspaper clients. *22*

JOHN EVERINGHAM was born in 1949 in Australia. At 16 he journeyed to London, then to Thailand and Laos in 1967, and after that to Vietnam in early 1968 where he found himself in the famous Viet Cong Tet offensive on Saigon. He began taking photos to sell to the wire services, and by the end of the war in 1975 was working in Laos as a reporter for the BBC, *The Far Eastern Economic Review,* and *Newsweek.* From 1975 to 1977, he was the only western photojournalist remaining in the three newly "liberated" countries of Indochina until the Lao communists threw him into jail and then out of the country. From 1978, he moved to Bangkok, specializing on S.E. Asia for European and U.S. magazines. In the late 1980s he began publishing himself. *327*

RICHARD FALCO was born in 1953. He has worked as a professional photographer based in New York and has traveled throughout the world working on assignments. His focus has always been on stories related to the human condition and the diversity found in the human spirit, ranging from medicine, welfare, contemporary lifestyle to travel and culture. His photographs regularly appear in publications including *Le Figaro, U.S. News & World Report, New York Magazine, Geo, Life, Newsweek, Stern* and *The New York Times.* He is also the author of the book "Medics: A Documentation of Paramedics in the Harlem Community." His work has been exhibited in galleries, including the New York and New Jersey Art Directors Clubs and the Nikon Galleries in Tokyo. He joined Black Star in 1993. He has taught and lectured at a number of schools and institutions and is presently a member of the faculty at the New School for Social Research. He has done work for a number of major corporations and institutions including American Express and the United Nations. *172, 173, 174, 175, 414, 415*

THERESE FRARE landed her first job at *The Cape Codder* before graduation at Boston University. After several years, she moved on to Asso-

ROBERT ELLISON wurde 1945 geboren und studierte in Florida, wo seine Fotografien über rassistische Gewalt in Selma, Alabama, in verschiedenen amerikanischen Magazinen publiziert wurden. Er war Mitte Zwanzig, als er für Empire News zu arbeiten begann, eine Gruppe von Fotografen, die Aufträge für Black Star übernahm und die Agentur während der 60er Jahre in Vietnam vertrat. Er machte zahlreiche Berichte von dort, u.a. über die Belagerung von Khe Sanh. Beim Absturz eines Versorgungsflugzeugs kam er 1968 ums Leben; paradoxerweise wurde es nicht abgeschossen, sondern zerschellte bei einem Unfall. *96, 97, 100*

RICHARD EMBLIN wurde 1966 in Caracas, Venezuela, geboren. Nach Abschluß seines Geschichts- und Englischstudiums in Toronto und eines Praktikums beim Londoner *Independent* begann er seine Laufbahn als Fotograf. Zunächst berichtete er über die Gewaltaktionen bei den Präsidentschaftswahlen von 1990 in Kolumbien für den *Independent* und den *Sunday Telegraph.* 1994 gewann er die Bronzemedaille für Fotojournalismus der International Society of Newspaper Design für seine Fotografien vom Bürgerkrieg in Angola. 1996 erschien sein erster Fotoband mit dem Titel »The Darien Gap«. Heute lebt er in Kanada und arbeitet für die internationalen Magazin- und Zeitungskunden von Black Star und an seinem zweiten Buch »Magic Realism: The Colombia of Gabriel García Marquez«. *22*

JOHN EVERINGHAM wurde 1949 in Australien geboren. Mit 16 Jahren reiste er zunächst nach London, 1967 nach Thailand und Laos und Anfang 1968 nach Vietnam, wo er sich während der Tet-Offensive in Saigon wiederfand. Er begann, selbst Fotos zu machen, die er an Nachrichtenagenturen verkaufte. 1975, mit Ende des Krieges, arbeitete er in Laos als Reporter für die BBC, die *Far Eastern Economic Review* und für *Newsweek.* Von 1975 bis 1977 war er der einzige westliche Fotojournalist, der in den drei gerade »befreiten« Ländern Indochinas blieb, bis ihn die Kommunisten in Laos 1977 inhaftierten und des Landes verwiesen. 1978 ging er nach Bangkok und versorgte europäische und amerikanische Zeitschriften mit Fotoberichten über den südostasiatischen Raum. Ende der 80er Jahre begann er, seine Aufnahmen im Eigenverlag zu veröffentlichen. *327*

RICHARD FALCO

RICHARD FALCO, geboren 1953, arbeitet als Berufsfotograf in New York. Auftragsarbeiten führten ihn fast in die ganze Welt. Er beschäftigt sich mit medizinischen und sozialen Themen sowie mit Lifestyle, Reisen und Kultur. Seine Fotografien erscheinen regelmäßig u.a. im *Figaro,* in *U.S. News & World Report,* im *New York Magazine,* in *Geo, Life, Newsweek,* im *Stern* und in der *New York Times.* Er ist Autor des Buches »Medics: A Documentation of Paramedics in the Harlem Community«. Seine Arbeiten wurden in verschiedenen Galerien ausgestellt, darunter die New York und New Jersey Art Directors Clubs und die Nikon-Galerien in Tokio. 1993 kam er zu Black Star. Er hat an renommierten Hochschulen und Institutionen gelehrt; zur Zeit ist er an der New School for Social Research. Er hat für viele Unternehmen und größere Institutionen gearbeitet, darunter American Express und die Vereinten Nationen. *172, 173, 174, 175, 414, 415*

THERESE FRARE bekam ihren ersten Job beim *Cape Codder,* noch bevor sie ihr Studium in Boston abgeschlossen hatte. Nach einigen Jahren wechselte sie zu Associated Press und dann zum *Providence Journal-Bulletin.* Von der Ohio University's School of Visual Communication erhielt sie ein Graduiertenstipendium. Ihr erstes Projekt widmete sie einer Betreuungseinrichtung für Aids-Infizierte in Ohio. Ein Foto aus dieser Serie, »Final

Né en 1966 à Caracas au Venezuela, RICHARD EMBLIN fait des études d'Histoire et d'Anglais à l'université de Toronto, puis se lance dans une carrière de photographe après un stage à l'*Independent* à Londres. Il a couvert l'élection présidentielle mouvementée en Colombie en 1990, pour l'*Independent* et le *Sunday Telegraph.* En 1994, il remporte la médaille de bronze de l'International Society of Newspaper Design pour ses photos de la guerre civile en Angola. Il a terminé son premier recueil de photos «The Darien Gap» en 1996. Aujourd'hui, il vit au Canada et travaille pour les magazines clients de de Black Star et sur son second livre, «Magic Realism: The Colombia of Gabriel García Marquez». *22*

JOHN EVERINGHAM est né en 1949 en Australie. A l'âge de 16 ans, il entame un voyage à Londres puis en Thaïlande et au Laos. Il arrive au Viêtnam au début de l'année 68 et se trouve pris dans la célèbre offensive du Têt menée par les Viêt-congs contre Saïgon. Sur place, il prend des clichés qu'il vend aux agences. En 1975, à la fin de la guerre, il travaille au Laos comme correspondant pour la BBC, le *Far Eastern Economic Review* et *Newsweek.* De 1975 à 1977, il est le seul photoreporter occidental à couvrir les 3 pays d'Indochine nouvellement «libérés». En 1977, les communistes de Laos le jettent en prison avant de l'expulser. En 1978, il s'établit à Bangkok, couvrant toute l'Asie du sud-est pour des journaux européens et américains. A la fin des années 80, il se lance dans l'édition. *327*

RICHARD FALCO est né en 1953. Basé à New York, il a travaillé comme photographe professionnel et a voyagé dans le monde entier. Ses reportages traitent de thèmes tels que la médecine, la protection sociale, la vie moderne, les voyages et la culture. Ses photos sont régulièrement publiées dans *Le Figaro, U.S. News & World Report, New York Magazine, Geo, Life, Newsweek, Stern* et le *New York Times.* Il est également l'auteur de «Medics: A Documentation of Paramedics in the Harlem Community». Son œuvre a fait l'objet d'expositions dans plusieurs galeries, dont les New York et New Jersey Art Directors Clubs, et les Nikon Galleries à Tokyo. Il a rejoint Black Star en 1993. Il donne des conférences dans de nombreuses écoles et institutions, actuellement, il enseigne à la New School for Social Research. Il a travaillé pour de grandes entreprises et institutions, dont l'American Express et les Nations unies. *172, 173, 174, 175, 414, 415*

THERESE FRARE obtient son premier job au *Cape Codder* avant qu'elle n'ait achevé ses études à Boston. Quelques années plus tard, elle entre à l'Associated Press à Boston, puis au *Providence Journal-Bulletin.* Elle accepte une bourse d'études pour l'Ohio University's School of Visual Communication. Son premier projet traite d'un foyer-mouroir pour les malades du Sida dans l'Ohio. Une photo tirée de ce reportage «Final Moment» fait une double page dans *Life* en 1990 et remporte le Budapest Award pour sa «compréhension des relations entre les gens», et un deuxième prix du concours World Press Photo en 1991. Cette photo, reprise par Benetton dans une campagne publicitaire en 1992, est l'objet d'une controverse. Installée à Seattle, elle poursuit une carrière free-lance. *427*

GIL FRIEDBERG *264, 305*

RICK FRIEDMAN, né en 1952 à Boston, est membre de Black Star depuis plus de 15 ans. Ses photos sont sorties dans *Time, Newsweek, U.S. News & World Report,* le *New York Times, Stern, Discover* et bien d'autres journaux et magazines internationaux. Son livre sur Hillary Clinton a été publié en 1993. Il a reçu de nombreuses récompenses des associations de photographes de presse américains. *250/251, 315, 422*

FRANCIS FUERST *302*

ROBERT GARVEY est un des photographes australiens les plus respectés qui soient. Il s'est spécialisé dans la photographie de site et travaille plus particulièrement en entreprise, dans l'industrie et en milieu naturel. Son travail lui a valu 7 «Photographer of the Year» et 18 récompenses nationales. En 1995, il obtient le «Master of Photography». En 1978, après avoir terminé sa promotion de photographie, il poursuit ses études pendant trois ans en Europe et à New York où il travaille comme assistant pour de nombreux studios prestigieux. Il entame alors une carrière de photographe free-lance pour des journaux comme le *New York Times.* Black Star est son agence depuis 1986. Le géant australien BHP et le Royal Brunei Polo Club font partie de ses clients. *314, 322, 394*

ciated Press in Boston and then to *The Providence Journal-Bulletin*. She accepted a scholarship to pursue graduate studies at Ohio University's School of Visual Communication. Her first project was about a hospice-approach home for people with AIDS in Ohio. A photo from that series, "Final Moment," ran as a double-truck in *Life* magazine in 1990 and also won the Budapest Award for understanding relationships among people and second place in the 1991 World Press Photo Competition. This image was published in a 1992 Benetton advertising campaign and became the subject of controversy as some were offended by its commercial use. In Seattle she pursued a freelance career. *427*

RICK FRIEDMAN was born in 1952 in Boston and has been a member of Black Star for over fifteen years. His work appears in *Time, Newsweek, U.S. News & World Report, The New York Times, Stern, Discover* and many other publications around the world. His book on Hillary Clinton was published in 1993. He has received numerous awards from American press photographer organizations. *250/251, 315, 422*

ROBERT GARVEY is one of Australia's most respected photographers. He is a versatile location specialist working primarily in the corporate, industrial and natural history sectors. The winner of seven Photographer of the Year awards and 18 national awards, he was made a Master of Photography in 1995. After graduating in photography in 1978, he spent three years studying in Europe and New York, where he assisted at a number of prominent studios and undertook freelance assignments for the likes of *The New York Times*. He has been represented by Black Star since 1986. His clients include Australian resources giant BHP and the Royal Brunei Polo Club. *314, 322, 394*

FRITZ GORO was born in Bremen, Germany. In the early 1920s he studied at the Unterrichtsanstalt des staatlichen Kunstgewerbemuseums in Berlin and at the Weimar Bauhaus. He was employed as a writer, editor, designer, and art director for Ullstein Publishers, Berlin, and worked as an assistant to the Managing Director of the *Münchner Illustrierte* until 1933, when he fled Germany. He was a freelance photographer in Paris, where his work was published in *Vue* and *Vogue*. In 1936, he moved to New York, again working as a freelance photographer – until 1940 with Black Star. He began a long association with *Life* at this time, becoming a staff Science Photographer until 1966. He continued to work for *Life,* was again a freelance photographer for publications such as *Scientific American* and for the Polaroid Corporation. He is the recipient of numerous awards, and his work has been included in group shows such as "The Family of Man" and "Photographs from *Life*." He has also been honored with solo exhibitions. He has been a pioneer of science photography since the late 1930s and is highly accomplished in a number of fields from microphotography to radio astronomy. *17*

MICHAEL GREENLAR was born in 1953 in Rochester, New York. He worked at newspapers for seven years and ten years as a freelance photographer for magazines including *Business Week, Time* and *Newsweek*. In 1988, *Life* published his picture story entitled "Shock Incarnation Camp in Georgia." He has won various awards for his work. He is currently doing freelance work and lives in Syracuse, New York. *428*

RUNE HASSNER was born in 1928 in Sweden. He has worked as a photojournalist and historian, as well as a TV-producer. *212, 213*

MATT HERRON has been affiliated to Black Star for more than 30 years. In the 1960s, he sailed with his family around the world and documented the entire effort. He was known for his civil rights photography of the 1960s. He is a past president of the American Society of Media Photographers, and is still active on a consulting basis. *404*

Moment«, das 1990 als Doppelseite in *Life* abgedruckt wurde, gewann den Budapest Award für die Darstellung zwischenmenschlicher Beziehungen und belegte einen zweiten Platz im World-Press-Photo-Wettbewerb 1991. Die Verwendung dieses Fotos für eine Werbekampagne von Benetton löste 1992 eine kontroverse Diskussion aus. Frare arbeitet in Seattle als freischaffende Fotografin. *427*

RICK FRIEDMAN

RICK FRIEDMAN, 1952 in Boston geboren, ist seit über 15 Jahren Mitglied von Black Star. Seine Arbeiten erscheinen bei *Time, Newsweek, U.S. News & World Report, Discover,* im *Stern,* in der *New York Times* und vielen anderen Printmedien in der Welt. Mitte 1993 wurde sein Buch über Hillary Clinton veröffentlicht. Er hat zahlreiche Auszeichnungen amerikanischer Pressefotografen-Organisationen erhalten.

250/251, 315, 422

ROBERT GARVEY gehört zu den angesehensten Fotografen Australiens. Er gilt als vielseitiger Spezialist für Außenaufnahmen und arbeitet vorwiegend im Bereich der Magazin- und Industriefotografie sowie über Fauna und Flora. Der Träger von sieben Photographer of the Year Awards und 18 nationalen Preisen wurde 1995 zum Master of Photography ernannt. Nachdem er 1978 sein Fotografie-Studium abschloß, studierte er drei Jahre in Europa und in New York, wo er in mehreren bekannten Studios assistierte und als Freischaffender Fotoaufträge übernahm, darunter für die *New York Times*. Seit 1986 wird er von Black Star vertreten. Zu seinen Kunden gehören u.a. der australische Rohstoffgigant BHP und der Royal Brunei Polo Club. *314, 322, 394*

FRITZ GORO wurde in Bremen geboren. In den frühen 20er Jahren studierte er an der Unterrichtsanstalt des staatlichen Kunstgewerbemuseums in Berlin und am Weimarer Bauhaus. Bis zu seiner Flucht aus Deutschland 1933 war er zunächst Schriftsteller, Herausgeber, Designer und Art Director beim Ullstein Verlag in Berlin, später Assistent des leitenden Direktors der *Münchner Illustrierten*. In Paris arbeitete er als freischaffender Fotograf und veröffentlichte seine Arbeiten in *Vue* und *Vogue*. Nach seiner Emigration nach New York 1936 arbeitete er zunächst weiter als freier Fotograf und übernahm bis 1940 Aufträge für Black Star. Auf die Agentur geht auch seine langjährige Verbindung mit *Life* zurück, wo Goro schließlich Redaktionsmitglied wurde und bis 1966 Wissenschaftsfotograf war. Als selbständiger Fotograf war er für Magazine wie *Scientific American* und für die Polaroid Corporation tätig und übernahm weiterhin regelmäßig Aufträge für *Life*. Er hat zahlreiche Preise erhalten und seine Arbeiten waren in den Gruppenausstellungen »The Family of Man« und »Photographs from Life« sowie in Einzelausstellungen zu sehen. Er gehört seit den späten 30er Jahren zu den Pionieren der Wissenschaftsfotografie und hat sich auf zahlreichen Gebieten eine hohe Qualifikation erworben, von der Mikrofotografie bis hin zur Radioastronomie. *17*

MICHAEL GREENLAR wurde 1953 in Rochester, New York, geboren. Er arbeitete sieben Jahre bei einer Zeitung und zehn Jahre als Freelance-Fotograf für Magazine wie *Business Week, Time* und *Newsweek*. Eine

FRITZ GORO est né à Brême, en Allemagne. Au début des années 20, il étudie à l'Unterrichtsanstalt des staatlichen Kunstgewerbemuseums à Berlin et à la Bauhaus à Weimar. Il travaille comme écrivain, rédacteur, designer et directeur artistique pour la maison d'édition Ullstein à Berlin et est assistant du président directeur-général de la *Münchner Illustrierte* jusqu'à 1933, date à laquelle il quitte l'Allemagne. Il est photographe free-lance à Paris, et ses photos sont publiées dans *Vue* et *Vogue*. En 1936, il s'installe à New York, toujours comme photographe free-lance, jusqu'à 1940 avec Black Star qui le fait entrer en contact avec *Life*. Commence alors une longue association avec *Life* en tant que photographe scientifique jusqu'en 1966. Tout en travaillant régulièrement pour *Life*, il est aussi photographe free-lance pour des publications comme *Scientific American*, et pour la Polaroid Corporation. Il a reçu de nombreuses récompenses, et ses photos ont fait partie d'expositions collectives telles que « The Family of Man » et « Photographs from *Life* ». Elles ont également fait l'objet d'expositions personnelles. Depuis les années 30, il est considéré comme un pionnier de la photographie scientifique, et un photographe émérite dans de nombreux domaines, de la microphotographie à la radioastronomie. *17*

MICHAEL GREENLAR est né en 1953 à Rochester dans l'Etat de New York. Il a travaillé pendant 7 ans pour différents journaux puis comme photographe free-lance pendant 10 ans pour divers magazines, dont *Business Week, Time, Newsweek*. En 1988, *Life* a publié un de ses reportages intitulé « Shock Incarnation Camp in Georgia ». Son travail lui a valu diverses récompenses de l'AP News. Basé à Syracuse dans l'Etat de New York, il travaille actuellement comme free-lance. *428*

RUNE HASSNER est né en Suède en 1928. Il a été photoreporter et historien, ainsi que producteur pour la télévision. *212, 213*

MATT HERRON a collaboré avec Black Star pendant plus de 30 ans. Dans les années 60, il entreprend avec sa famille un tour du monde en bateau et photographie toute l'équipée. Il est connu pour sa couverture du mouvement des droits civiques dans les années 60. Ancien président de l'American Society of Media Photographers, il est encore actif en tant que consultant. *404*

FRANK HORVAT est né en 1928 en Italie. Après avoir débuté dans le photoreportage, il a continué sa carrière comme photographe de mode. *196, 259*

CHARLES FENNO JACOBS est né en 1904. Au début des années 30, il est photographe free-lance à New York. Il travaille pour l'administration agricole, puis est l'un des six membres de l'unité de photographie navale d'Edward Steichen pendant la Seconde Guerre mondiale. Après la guerre, il voyage et exerce dans le monde entier. Il abandonne la photo au début des années 60 pour ouvrir un restaurant gastronomique dans le New Hampshire. Il meurt en 1975. *7*

Né en 1934 à Indianapolis, dans l'Indiana, MARVIN PHILIP KAHL est docteur en Zoologie. Il a obtenu de nombreuses bourses d'études, dont la NSF Postdoctoral Fellowship ; la National Geographic Society Research Grant ; l'American Ornithologists' Union et la MacArthur Fellowship. Il est l'auteur d'une étude très sérieuse sur le comportement et l'environnement des cigognes, des flamants et des spatules. En 1996, il enquête sur le comportement des éléphants au Zimbabwe. Il vit à Sedona, en Arizona. *323, 328*

PETER B. KAPLAN est né en 1939. Ce photographe américain s'est spécialisé dans les villes et leur architecture. *305*

CINDY KARP est née en 1951 à Milwaukee, dans le Wisconsin. Après des études de Sciences sociales et de Journalisme, elle entame une carrière de photographe pour UPI. Ensuite, elle travaille comme photographe sous contrat pour *Time*. Elle est surtout connue pour ses photoreportages sur l'Amérique Latine et les Caraïbes. Installée à Miami, elle couvre l'actualité de pays comme Haïti et Cuba, ainsi que celle des Etats-Unis, abordant des

FRANK HORVAT was born in 1928 in Italy. He began his career as a photojournalist and later on took up fashion photography. *196, 259*

CHARLES FENNO JACOBS was born in 1904. By the early 1930s he was a freelance photographer in New York. He photographed for the Farm Security Administration and was one of six members of Edward Steichen's Naval photographic unit during World War II. After the war he traveled and photographed throughout the world. In the early 1960s he retired from photography to open a gourmet restaurant in New Hampshire. He died in 1975. *7*

MARVIN PHILIP KAHL was born in 1934 in Indianapolis, Indiana. He studied Zoology in Indianapolis, where he gained a PhD. He has received a number of fellowships including the NSF Postdoctoral Fellowship, the National Geographic Society Research Grant and the MacArthur Fellowship. He did formal research on the behavior/ecology of storks, flamingos and spoonbills. In 1996, he was doing research on elephant behavior in Zimbabwe. He lives in Sedona, Arizona. *323, 328*

PETER B. KAPLAN was born in 1939. This American photographer has specialized in portraits of towns and architecture. *305*

CINDY KARP was born in 1951 in Milwaukee, Wisconsin. She studied Social Science and Journalism. She began her career as a photographer for UPI and then worked as a contract photographer for *Time*. She photographed the wars and social strife of Central America. Now based in Miami, she continues to cover news and feature stories in countries such as Haiti and Cuba, although she works to cover issues in the United States such as domestic violence, health and environmental issues. She works for a broad variety of magazine and newspaper clients and continues to develop personal projects distributed by Black Star. Her work has been exhibited in international galleries. *234, 235*

MARVIN KONER *283*

EDO KÖNIG *258*

KORDA *73*

MANFRED KREINER was the photographer and the bureau chief in New York City for *Bunte Illustrierte* for almost 30 years. He is well known for the series of pictures that he took in the early 1960s prior to Marilyn Monroe's death. He retired to Florida where he lives today. *303*

BOB KRIST is a photojournalist whose work appears regularly in publications such as *National Geographic, Travel and Leisure, Islands* and *National Wildlife*. His assignments have taken him from the remote glaciers of Iceland, to secret voodoo ceremonies in the jungles of Trinidad, to active volcanic craters off the coast of North Africa. He is also a sought-after photographer in the world of corporate annual report photography. *420, 421*

ERICA LANSNER was born in 1958 in New York. She graduated in Art History from Vassar College. From 1981 to 1986 she worked at CBS News in Rome and New York prior to pursuing photography as a career. She joined Black Star in 1990. While living abroad (Barcelona, Paris), she covered a wide variety of news and feature stories, particularly on the social and cultural aspects of these societies. Her black-and-white photo essay on Barcelona's Jewish community was exhibited in the "Primavera Fotografica" Festival in Barcelona in 1992. She covered the Democracy Movement in Tiananmen Square, spending six weeks among the students. In 1993, she documented China, focusing on the current modernization and economic boom. For her photo "The New China," she won the Award for Excellence, Magazine Feature category in Picture of the Year in 1994 and in the same year she documented the events in Gaza, Jerusalem and the West Bank. She covered the aftermath of the Hebron massacre in February of that year. She has worked on assignment and is widely published in numerous magazines including *Newsweek, U.S. News & World Report, Business Week, Time, Life, Le Nouvel Observateur* and *Der Spiegel*. *9, 145, 271, 367, 428*

JOHN LAUNOIS was born in 1928 in France. He has always worked exclusively as a freelance photographer. He has contributed regularly to such magazines as the *Saturday Evening Post, Life, National Geographic,* and *Fortune*. In 1960, he gained fame for traveling to the former Soviet

seiner bekanntesten Reportagen, »Shock Incarnation Camp in Georgia«, erschien 1988 in *Life*. Für seine Arbeiten hat er mehrere Preise erhalten. Gegenwärtig ist er als freischaffender Fotograf tätig und lebt in Syracuse, New York. *428*

HENRY GROSSMAN *78*

RUNE HASSNER wurde 1928 in Schweden geboren. Er arbeitete als Fotojournalist und Historiker sowie als Fernsehproduzent. *212, 213*

HATAMI *272*

MATT HERRON arbeitete über 30 Jahre mit Black Star zusammen. In den 60er Jahren umsegelte er mit seiner Familie die Welt und dokumentierte diese Reise in einem Fotoessay. Bekannt ist er für seine Fotografien der Bürgerrechtsbewegung in den 60er Jahren. Er war Präsident der American Society of Media Photographers, die er noch heute berät. *404*

FRANK HORVAT wurde 1928 in Italien geboren. Er begann seine Laufbahn als Fotojournalist und widmete sich später der Mode-Fotografie. *196, 259*

CHARLES FENNO JACOBS wurde 1904 geboren. In den frühen 30er Jahren arbeitete er als freischaffender Fotograf in New York. Er fotografierte für die Farm Security Administration und gehörte während des Zweiten Weltkriegs der sechsköpfigen Fotografeneinheit der Marine unter Edward Steichen an. Nach dem Krieg bereiste er mit seiner Kamera die Welt. In den frühen 60er Jahren beendete er seine Fotografenlaufbahn, um ein Gourmet-Restaurant in New Hampshire zu eröffnen. Er starb 1975. *7*

MARVIN PHILIP KAHL wurde 1934 in Indianapolis geboren. Er studierte dort Zoologie und erwarb den Doktorgrad. Er hat einige Stipendien erhalten, darunter das NSF Postdoctoral Fellowship, den National Geographic Society Research Grant und das MacArthur Fellowship. Neben seinen Forschungen über das Verhalten und die Lebensbedingungen von Störchen, Flamingos und Löffelreihern widmete er sich 1996 in Zimbabwe der Verhaltensforschung bei Elefanten. Er lebt in Sedona in Arizona. *323, 328*

PETER B. KAPLAN wurde 1939 geboren. Der Amerikaner hat sich auf Stadt- und Architekturfotografie spezialisiert. *305*

CINDY KARP wurde 1951 in Milwaukee, Wisconsin, geboren. Sie studierte Sozialwissenschaften und Journalismus. Ihre Laufbahn als Fotografin begann sie bei UPI, danach arbeitete sie als Vertragsfotografin für *Time*. Sie lieferte Bilder über die Kriege und sozialen Kämpfe in Mittelamerika. Heute lebt sie in Miami und berichtet aus Ländern wie Haiti und Kuba. Daneben beschäftigt sie sich aber auch mit Themen aus dem amerikanischen Alltag wie Gewalt in der Familie, Gesundheits- und Umweltfragen. Sie arbeitet für eine breite Palette von Magazinen und Zeitungen, entwickelt aber auch eigene Projekte, die von Black Star vertrieben werden. Ihre Arbeiten sind in internationalen Galerien ausgestellt worden. *234, 235*

MARVIN KONER *283*

EDO KÖNIG *258*

KORDA *73*

MANFRED KREINER war nahezu zwanzig Jahre lang Fotograf und Chef des New Yorker Büros der *Bunten Illustrierten*. Er war für eine Reihe von Aufnahmen bekannt, die er vor dem Tod Marilyn Monroes Anfang der 60er Jahre machte. Heute lebt er in Florida. *303*

BOB KRIST ist einer der Fotojournalisten, dessen Arbeiten regelmäßig in Magazinen wie *National Geographic, Travel and Leisure, Islands* und *National Wildlife* erscheinen. Seine Aufträge haben ihn von den entlegenen Gletschern Islands bis hin zu geheimen Voodoo-Zeremonien im Dschungel von Trinidad geführt und weiter zu den aktiven Vulkankratern vor der Küste Nordafrikas. Er gehört aber auch zu den gefragtesten Fotografen im Bereich der Geschäftsberichte. *420, 421*

sujets comme la violence domestique, la santé et l'environnement. Elle travaille pour un grand nombre de magazines et de journaux tout en réalisant des projets personnels distribués par Black Star. Ses travaux ont fait l'objet d'expositions internationales. *234, 235*

MARVIN KONER *283*

EDO KÖNIG *258*

KORDA *73*

MANFRED KREINER a été pendant près de 20 ans le photographe et le responsable de *Bunte Illustrierte* à New York. Il est célèbre pour la série de photos qu'il a prise de Marylin Monroe peu de temps avant sa mort au début des années 60. Il vit en Floride. *303*

BOB KRIST est un photoreporter dont les travaux paraissent régulièrement dans le *National Geographic, Travel and Leisure, Islands* et *National Wildlife*. Ses reportages l'ont entraîné sur les lointains glaciers d'Islande, les volcans en activité au large des côtes nord-africaines, et dans les cérémonies secrètes vaudou de la jungle de Trinidad. C'est également un photographe très prisé pour les bulletins annuels d'entreprises privées. *420, 421*

ERICA LANSNER, née en 1958 à New York, a fait des études en Histoire de l'art à l'Université Vassar. De 1981 à 1986, elle travaille à CBS News à Rome et New York avant d'entamer une carrière de photographe. Elle rejoint Black Star en 1990. Lors de séjours à Barcelone et Paris, elle couvre de nombreux événements touchant l'actualité sociale et culturelle des sociétés de ces pays. Son essai photographique en noir et blanc sur la communauté juive de Barcelone a été exposé au Primavera Fotografica Festival de Barcelone en 1992. Elle réalise aussi de nombreux projets personnels dans diverses régions du monde, en particulier la Chine. Elle passe six semaines avec les étudiants au moment des manifestations pour la démocratie place Tian'anmen. En 1993, elle montre la modernisation et le boom économique qui émergent en Chine. En 1994, son reportage «The New China» lui vaut un Award of Excellence du concours Picture of the Year. En 1994, elle suit les événements à Gaza, Jérusalem et en Cisjordanie. Parmi ses commanditaires, citons *Newsweek, U.S. News & World Report, Business Week, Time, Life, le Nouvel Observateur* et le *Spiegel*. *9, 145, 271, 367, 428*

JOHN LAUNOIS

JOHN LAUNOIS est né en France en 1928, et a travaillé exclusivement comme photographe free-lance. Il a régulièrement collaboré à diverses parutions, le *Saturday Evening Post, Life*, le *National Geographic, Newsweek* et *Fortune*. En 1960, son reportage pour *Life* «The Trans-Siberian Express», un périple à travers l'Union Soviétique, lui apporte la célébrité. En effet, c'est la première fois depuis 1945 qu'un journaliste occidental est autorisé à se rendre en Sibérie. En 1967, son essai photographique «50 Years of Communism» est publié dans le *Saturday Evening Post*. En 1973, ses clichés des Tasaday, publiés dans le *National Geographic*, lui valent le World Understanding Award de l'University of Missouri. Il a également produit des films et des réalisations multimédia. Aujourd'hui, il travaille à son autobiographie. *18, 176, 178, 179, 180, 181, 245, 255, 270, 287, 292, 294, 295, 330, 352, 353, 356, 357, 382, 383*

DAVID LEVENSON est né en 1959 à Harrow, en Angleterre. En 1977, il débute comme assistant d'un photographe à Fox Photos, à Londres. En 1980, il entre dans le staff des photographes de Keystone Press Agency. Pendant les années 80, il parcourt le monde en qualité de membre de

Union to do a story for *Life*, "The Trans-Siberian Express." This photo essay marked the first time a Western journalist had been allowed in Siberia since 1945. In 1967, his photo essay "50 Years of Communism" was published in the *Saturday Evening Post*. In 1973, he received the World Understanding Award from the University of Missouri for his photographs of the Tasaday people, published in *National Geographic*. He has also produced films and mixed-media presentations. He is currently writing his autobiography. *18, 176, 178, 179, 180, 181, 245, 255, 270, 287, 292, 294, 295, 330, 352, 353, 356, 357, 382, 383*

DAVID LEVENSON

DAVID LEVENSON was born in in Harrow, England. In 1977, he began work as a photographer's assistant at Fox Photos in London. In 1980, he became a staff photographer with the Keystone Press Agency. Throughout the 1980s he traveled the globe as a member of the Buckingham Palace accredited press corps. Sixteen books of his work have been published in England. Two of his books, "Charles and Diana's First Royal Tour" and "Charles and Diana in Canada," were on the *Sunday Times* best-seller list for 1983. Since 1984 he has worked as a freelance photographer. In 1994, he was one of the few photographers to be granted access to the Bank of England and his photographs were published worldwide. His work has been exhibited by the World Press Foundation and the Press Photographers Association. *396, 397, 398, 399, 430, 431, 432, 433, 434, 435*

MALCOLM LINTON was born in 1956 in Great Britain. He worked as a print and radio journalist before taking up photography in 1989. He covered the El Salvador guerrilla offensive and the U.S. invasion of Panama for Reuters in 1989, when he was injured in crossfire. In 1990, he worked as Reuters' chief photographer in Nicaragua, then freelanced in England for the Associated Press and *Observer* newspaper. At the end of 1990 he covered Jordan during the Gulf War. He traveled all over the former Soviet Union as well as shooting stories in Yugoslavia, Thailand and the Philippines. He joined Black Star in late 1992 and moved to Nairobi in mid-1994 to cover stories in Yemen, Zaire, Sudan, Rwanda and Burundi. He is best known for his coverage of war and civil unrest in former Soviet Georgia and Tajikistan as well as in Russia. In the 1994 Pictures of the Year contest he won a first prize for his portrait of a Georgian soldier in combat in Abkhazia. He left Black Star in 1997. *124, 160, 162, 370, 371*

MARSHALL LOCKMAN was associated with Black Star as their Seattle photographer for a number of years. He did a great deal of work for *Life* and other major publications. His journalistic ability centered on human interest and he looked for interesting sidebar stories. *317*

LEE LOCKWOOD was born in 1932 in New York. From 1956 to 1959 he was a correspondent for *Bunte Illustrierte* magazine and in 1960 he joined Black Star as a staff photographer where he continued to work for over 30 years. He has published several books including "Castro's Cuba" and "Cuba's Fidel." In 1967 he was awarded an Overseas Press Club award for a *Life* cover story on North Vietnam during the bombing. He has also had major stories published in magazines such as *Life, Look, Stern, Paris Match, Epoca, Time* and *Newsweek*. He lives in Massachusetts where he is writing a biography of Che Guevara. *74, 75, 76, 275*

ARNOLD MAAHS *164, 168, 169, 170, 171*

ERICA LANSNER, 1958 in New York geboren, graduierte in Kunstgeschichte am Vassar College. Bevor sie ihre Laufbahn als Fotografin begann, arbeitete sie bei CBS News in Rom und New York (1981–86). Sie kam 1990 zu Black Star. Während ihrer Aufenthalte in Barcelona und Paris deckte sie mit ihren Fotoreportagen über soziale und kulturelle Aspekte dieser Gesellschaften eine breite Palette an Themen ab. Ihr Schwarzweiß-Fotoessay über die jüdische Gemeinde Barcelonas wurde 1992 beim Primavera-Fotografica-Festival in Barcelona ausgestellt. Darüber hinaus verbrachte sie sechs Wochen unter den Pekinger Studenten und berichtete über die Demokratiebewegung auf dem Platz des Himmlischen Friedens. 1993 dokumentierte sie die Modernisierungsbestrebungen und den wirtschaftlichen Boom in China. Mit ihrer Aufnahme »The New China« gewann sie 1994 eine Auszeichnung im Pictures-of-the-Year-Wettbewerb. Sie berichtete über die Ereignisse im Gazastreifen, in Jerusalem und der West Bank. Zahlreiche Magazine zählen zu ihren Auftraggebern, u.a. *Newsweek, U.S. News & World Report, Business Week, Time, Life*, der *Nouvel Observateur* und der *Spiegel*. *9, 145, 271, 367, 428*

JOHN LAUNOIS, 1928 in Frankreich geboren, arbeitete immer als Freelancer. Seine Beiträge erschienen regelmäßig in Zeitungen wie der *Saturday Evening Post*, in *Life, National Geographic* und *Fortune*. 1960 wurde er bekannt, als er die Sowjetunion bereiste, um für *Life* über die Transsibirische Eisenbahn zu berichten. Er war der erste westliche Journalist seit 1945, dem es erlaubt war, nach Sibirien zu reisen. 1967 erschien sein Fotoessay »50 Years of Communism« in der *Saturday Evening Post*. 1973 wurde ihm für seine in *National Geographic* erschienenen Fotografien des Tasaday-Stamms der World Understanding Award der Universität von Missouri verliehen. Nach diversen Filmproduktionen und multimedialen Präsentationen schreibt er heute an seiner Autobiographie. *18, 176, 178, 179, 180, 181, 245, 255, 270, 287, 292, 294, 295, 330, 352, 353, 356, 357, 382, 383*

DAVID LEVENSON wurde 1959 in Harrow, England, geboren. 1977 begann er als Fotoassistent bei Fox Photos in London. Ab 1980 gehörte er zum Fotografen-Stab der Keystone Press Agency. Während der 80er Jahre reiste er als Mitglied des akkreditierten Pressekorps des Buckingham-Palasts rund um den Globus. Sechzehn Bücher mit seinen Arbeiten sind in England veröffentlicht worden; zwei davon, »Charles and Diana's First Royal Tour« und »Charles and Diana in Canada«, führten 1983 die Bestseller-Liste der *Sunday Times* an. Seit 1984 arbeitete er als freischaffender Journalist. 1994 gehörte er zu den wenigen Fotografen, denen Zutritt zur Bank of England gewährt wurde. Seine Fotografien erschienen weltweit. Bei der World Press Foundation und der Press Photographers Association ist sein fotografisches Werk ausgestellt worden. *396, 397, 398, 399, 430, 431, 432, 433, 434, 435*

MALCOLM LINTON wurde 1956 in Großbritannien geboren. Er arbeitete als Printmedien- und Radiojournalist, bevor er 1989 zu fotografieren begann. In jenem Jahr berichtete er für die Nachrichtenagentur Reuters über die Guerrilla-Offensive in El Salvador und die US-Invasion in Panama, wo er in einem Kreuzfeuer verletzt wurde. 1990 arbeitete er als Cheffotograf für Reuters in Nicaragua, dann als freier Fotograf in England für die Associated Press und den *Observer*. Ende 1990 berichtete er aus Jordanien während des Golfkriegs. Er bereiste die gesamte frühere Sowjetunion und machte Aufnahmen in Jugoslawien, Thailand und den Philippinen. Ende 1992 kam er zu Black Star. Mitte 1994 ging er nach Nairobi, um über die Ereignisse im Jemen, im Sudan, in Zaire, Ruanda und Burundi zu berichten. Bekannt wurde er mit seiner Berichterstattung über die Krisen in Georgien, Tadschikistan und Rußland. Im Bilder-des-Jahres-Wettbewerb gewann er 1994 einen ersten Preis für seine Aufnahme eines kämpfenden georgischen Soldaten in Abchasien. Linton verließ Black Star 1997. *124, 160, 162, 370, 371*

MARSHALL LOCKMAN arbeitete als Fotograf in Seattle etliche Jahre mit Black Star zusammen und war für *Life* und andere große Magazine tätig. Sein journalistisches Interesse galt in erster Linie alltäglichen Geschichten. *317*

LEE LOCKWOOD wurde 1932 in New York geboren. Von 1956 bis 1959 arbeitete er als Korrespondent für die *Bunte Illustrierte*. 1960 kam er als Staff-Fotograf zu Black Star und blieb über 30 Jahre bei der Agentur. Er hat verschiedene Bücher veröffentlicht, darunter »Castro's Cuba« und »Cuba's Fidel«. 1967 wurde seine *Life*-Titelgeschichte über Nordvietnam während

l'équipe de presse accréditée par Buckingham Palace. 16 volumes retraçant son travail ont été publiés en Angleterre. Deux de ses ouvrages, « Charles and Diana's First Royal Tour » et « Charles and Diana in Canada » ont fait partie des best-sellers du *Sunday Times* en 1983. Depuis 1984, il travaille comme photographe freelance. Il a également travaillé pour de grandes sociétés. En 1994, il a été l'un des rares photographes autorisé à entrer dans la Bank of England, et ses photos ont été reproduites dans le monde entier. Son travail a également été exposé par la World Press Photo Foundation et la Press Photographers Association. *396, 397, 398, 399, 430, 431, 432, 433, 434, 435*

MALCOLM LINTON, né en 1956 en Grande-Bretagne, a travaillé comme journaliste dans la presse et la radio, avant de se lancer dans la photo en 1989. Cette année-là, pour l'agence Reuters, il couvre l'offensive de la guerilla au Salvador et l'invasion américaine au Panama, où il est blessé au cours d'une fusillade. En 1990, il devient chef photographe de Reuters au Nicaragua, avant de travailler comme free-lance en Angleterre pour l'Associated Press et le journal l'*Observer*. Fin 1990, il couvre la Jordanie pendant la guerre du Golfe. Il voyage en ex-URSS et fait des reportages en Yougoslavie, en Thaïlande et aux Philippines. Il rejoint Black Star fin 1992 et s'installe à Nairobi mi-94 pour réaliser des sujets au Yémen, au Zaïre, au Soudan, au Rwanda et au Burundi. Il est surtout connu pour sa couverture de la guerre civile en Géorgie et au Tadjikistan, et de la crise politique qui agite actuellement la Russie. Lors du concours Pictures of the Year, il remporte un premier prix pour son portrait d'un soldat géorgien pendant un combat en Abkhazie. Il a quitté l'agence en 1997. *124, 160, 162, 370, 371*

MARSHALL LOCKMAN a été pendant de nombreuses années le photographe de Black Star pour Seattle. Il a également travaillé pour *Life* et d'autres grands journaux. Son travail se singularise par sa capacité à évoquer la vie des gens. *317*

LEE LOCKWOOD est né en 1932 à New York. De 1956 à 1959, il est correspondant pour le *Bunte Illustrierte*, et en 1960, entre à Black Star en tant que photographe maison, fonction qu'il exerce pendant 30 ans. Il a publié plusieurs recueils de photos dont « Castro's Cuba » et « Cuba's Fidel ». En 1967, il reçoit l'Overseas Press Club Award pour un reportage paru dans *Life* sur le Viêtnam du Nord pendant les bombardements. D'autres grands reportages ont été publiés dans *Look, Stern, Paris Match, Epoca, Time* et *Newsweek*. Il vit dans le Massachussetts, où il travaille sur une biographie de Che Guevara. *74, 75, 76, 275*

ARNOLD MAAHS *164, 168, 169, 170, 171*

ROSS MADDEN *346*

HANS MALMBERG est né en 1927 en Suède. Spécialisé dans le document social, il a également fait des portraits. Il est décédé en 1977. *269*

ERNEST MANEWAL vit en Argentine et a fait plusieurs fois le tour du monde. Il s'est spécialisé dans les sujets de voyage. *252*

CHARLES MASON est né à Lexington, en Virginie. Pendant ses années de lycée, il fait des piges pour le journal local. En 1984, il termine ses études de Sciences Naturelles et de Mathématiques et devient photographe au *Daily News-Miner* à Fairbanks. Après un cursus en photographie documentaire à l'Illinois State University en 1988, il revient au journal avec le titre de monteur photo, tout en continuant à prendre des commandes en tant que photographe. Ses photos du sauvetage de trois baleines prises dans les glaces circulent dans le monde entier, et il est récompensé par l'Oscar Barnack Award. Ce travail débouche sur d'autres missions en Alaska pour des publications nationales et internationales, et sur une collaboration avec Black Star. Il travaille comme correspondant pour *Time*, comme correspondant en Alaska pour l'Associated Press et l'*Anchorage Daily News*. Depuis 1990, il est professeur assistant en photoreportage à l'Université d'Alaska à Fairbanks. En 1991, il a reçu le prix d'excellence au concours Pictures of the Year. Il a réalisé deux livres, « A Child's Alaska » et « Friendship Across Arctic Waters », un livre pour enfants. Ses photos ont parues dans des magazines internationaux, dont *Life, Audubon, Geo*, le *New York Times Sunday Magazine, Equinox, Paris Match, National Wildlife*, le *Los Angeles Times*, et le *Daily Télégraph* londonien, et font partie de la collection permanente du Anchorage Museum of History and Art, et du musée de l'Université d'Alaska. *333, 390, 391, 392/393, 393*

HANS MALMBERG was born in 1927 in Sweden. Above all, he photographed social documentations, but also did portrait work. He died in 1977. *269*

ERNEST MANEWAL lives in Argentina and specializes in worldwide travel topics. He has traveled around the whole world. *252*

CHARLES MASON

CHARLES MASON was born in Lexington, Virginia. While at high school, he served as stringer for the local newspaper. In 1984, he graduated in natural science and mathematics and accepted the position of staff photographer with the *Fairbanks Daily News–Miner*. After graduating in documentary photography from Illinois State University in 1988, he returned to the paper as Photo Editor, while trying to continue to do shooting assignments. His photographs of the rescue of three ice-trapped whales received wide circulation around the world. He received the Oscar Barnack Award and it led to other assignments in Alaska and to a relationship with Black Star. He was a stringer for *Time* magazine, an interior Alaska stringer for Associated Press and *Anchorage Daily News*. Since 1990 he has worked as Assistant Professor of Photojournalism at the University of Alaska at Fairbanks. In 1991, he received the Pictures of the Year Award of Excellence for a newspaper photo story. He has also produced two books, "A Child's Alaska," and "Friendship Across Arctic Waters," a children's book. His photographs appeared in international magazines including *Life, Audubon, Geo, The New York Times Sunday Magazine, Equinox, Paris Match, National Wildlife, Los Angeles Times,* and the London *Daily Telegraph*. His work is in the permanent collections of the Anchorage Museum of History and Art and the University of Alaska Museum. *333, 390, 391, 392/393, 393*

JAMES MASON was born in 1948 in Portland, Oregon. He studied Russian and Croatian in Zagreb. He worked as a stringer for Associated Press in Portland and for a newspaper in Washington. In 1982, he began freelancing, when he photographed the eruption of Mt. St. Helens. At that time he joined Black Star. In San Francisco he did corporate photography in Silicon Valley. In 1985, he photographed on a more personal level and also continued some newspaper work. After the fall of the Berlin Wall he went to Eastern Europe. *318*

IVAN MASSAR was born in 1924. He has worked as a photographer for the Farm Security Administration. He photographed the steel mills of Pittsburgh, covered the march from Selma to Montgomery, delivered medicine to Vietnam as part of a Quaker Action group, traced the origins of Unitarianism in Transylvania, and lived in the Seychelles in search of a simpler lifestyle. He also proves that ideas for the photojournalist are not always found in the world's news. With his photographs Howard Chapnick edited two books, "The Illustrated World of Thoreau," and "Take up the Song." *222/223*

der Bombardierung vom Overseas Press Club prämiert. Große Reportagen von ihm erschienen auch in *Life, Look, Paris Match, Epoca, Time, Newsweek* und im *Stern*. Lockwood lebt in Massachusetts und schreibt an einer Biographie Che Guevaras. *74, 75, 76, 275*

HANS MALMBERG wurde 1927 in Schweden geboren. Er widmete sich als Fotograf in erster Linie Sozialdokumentationen, machte aber auch Porträtarbeiten. Er starb 1977. *269*

ERNEST MANEWAL lebt in Argentinien. Als Reisejournalist hat er die ganze Welt gesehen. *252*

CHARLES MASON wurde in Lexington, Virginia, geboren. Bereits in der High School arbeitete er für die lokale Zeitung. 1984 graduierte er in Naturwissenschaften und Mathematik und wurde dann Staff-Fotograf beim *Fairbanks Daily News–Miner*. Nach seinem Abschluß in Dokumentarfotografie an der Illinois State University 1988 kehrte er als Bildredakteur zu der Zeitung zurück. Gleichzeitig nahm er weiterhin Fotoaufträge an. Seine Fotografien von der Rettung dreier im Eis gefangener Wale fanden weltweit Verbreitung und brachten ihm den Oscar-Barnack-Preis ein. Weitere Aufträge in Alaska folgten und führten zur Verbindung mit Black Star. In der Folge arbeitete er für *Time* und als Alaska-Reporter für Associated Press und die *Anchorage Daily News*. Seit 1990 ist er wissenschaftlicher Assistent für Fotojournalismus an der Universität in Fairbanks. 1991 erhielt er eine Bild-des-Jahres-Auszeichnung. Er ist Autor zweier Bücher: »A Child's Alaska« und »Friendship Across Arctic Waters«, ein Bildband für Kinder. Seine Fotografien sind u.a. in *Life, Audubon, Geo,* dem *New York Times Sunday Magazine, Equinox, Paris Match, National Wildlife,* der *Los Angeles Times* und im Londoner *Daily Telegraph* erschienen und sind Teil der ständigen Sammlung des Museums für Geschichte und Kunst in Anchorage sowie des Museums der Universität von Alaska. *333, 390, 391, 392/393, 393*

JAMES MASON, 1948 in Portland, Oregon, geboren, studierte Russisch und Kroatisch in Zagreb. Er arbeitete als Reporter für Associated Press in Portland und für eine Zeitung in Washington. 1982 begann er als Freelancer und fotografierte den Ausbruch des Vulkans Mount St. Helens. In dieser Zeit stieß er zu Black Star. In San Francisco fotografierte er im Auftrag von Unternehmen im Silicon Valley. 1985 widmete er sich persönlicheren Arbeiten und übernahm daneben weiterhin Aufträge von Zeitungen. Nach dem Fall der Berliner Mauer ging er nach Osteuropa. *318*

IVAN MASSAR, geboren 1924, fotografierte für die Farm Security Administration die Stahlmühlen von Pittsburgh, berichtete über den Marsch von Selma nach Montgomery, er lieferte in Zusammenarbeit mit einer Initiative der Quäker Medizin nach Vietnam, erforschte die Ursprünge des Unitarianismus in Siebenbürgen und zog schließlich auf der Suche nach einem einfacheren Leben auf die Seychellen. Seine Arbeiten belegen, daß Ideen für Fotojournalisten nicht immer in den Weltereignissen zu finden sind. Howard Chapnick gab zwei Bücher mit seinen Fotografien heraus: »The Illustrated World of Thoreau« und »Take up the Song«. *222/223*

MIKE MAUNEY lebt in Chicago. Seit er für Black Star als Fotojournalist zu arbeiten begann, hat er viele Aufträge für *Life* übernommen. Er widmete sich zunehmend der Werbefotografie. *361*

MAYO 38

DAN McCOY wurde 1936 in Johnson City, Tennessee, geboren. Mit sechzehn entdeckte er sein ideales Handwerkszeug – die Kamera. Seine ersten praktischen Erfahrungen sammelte er bei einer Zeitung. 1961 verließ er den *Miami Herald*, um als freier Fotograf für Black Star zu arbeiten. Während dieser Zeit berichtete er über die Bürgerrechtsproteste und bereiste die Welt für zahlreiche Zeitschriften und kommerzielle Kunden. Heute arbeitet er in Massachusetts und auf St. John in der Karibik. Er hat sich auf Wissenschaft, Reisen und Grafik-Design spezialisiert. Seine Arbeiten sind in einem Großteil der Weltpresse erschienen, darunter *National Geographic, Life, Geo, Omni, Newsweek, Time* und *U.S. News & World Report*. *243, 292, 364, 365, 366, 425, 429*

JAMES MASON est né en 1948 à Portland, dans l'Oregon. Il a étudié le russe et le croate à Zagreb. Il est d'abord correspondant pour l'Associated Press à Portland et pour un journal à Washington. Il débute dans une carrière free-lance en 1982 en photographiant l'éruption du Mont Saint-Helens. A la même époque, il rejoint Black Star. A San Francisco, il fait des photos pour des entreprises à Silicon Valley. En 1985, il aborde un aspect plus personnel de son travail tout en poursuivant sa collaboration avec des journaux. Après la chute du mur de Berlin, il se rend en Europe de l'Est. *318*

IVAN MASSAR est né en 1924. Il a photographié les aciéries de Pittsburgh pour la Farm Security Administration, couvert la marche de Selma à Montgomery, et distribué des médicaments au Viêtnam en tant que membre d'un groupe d'action Quaker. Il a retracé les origines de l'Unitarianisme en Transylvanie, et vécu aux Seychelles. Il a aussi démontré que pour un photoreporter, les idées ne se trouvent pas toujours dans l'actualité mondiale. Howard Chapnick a publié deux ouvrages de ses photos : « The Illustrated World of Thoreau » et « Take up the Song ». *222/223*

MIKE MAUNEY, qui vit à Chicago, a collaboré avec Black Star comme photoreporter tout en travaillant étroitement avec *Life*. Il s'est consacré de plus en plus à la photographie publicitaire. *361*

MAYO 38

DAN McCOY est né en 1936 à Johnson City, dans le Tennessee. A l'âge de 16 ans, il découvre l'instrument parfait : l'appareil-photo. Il fait ses premières armes en travaillant dans un journal. En 1961, il quitte le *Miami Herald* pour se lancer dans une carrière free-lance au sein de Black Star. Durant ces années, il couvre les manifestations du mouvement des droits civiques, et voyage dans le monde entier pour de nombreux magazines et clients commerciaux. Aujourd'hui, il travaille dans le Massachussetts, ou dans l'île St John, Caraïbes, et s'est spécialisé dans la science, les voyages et le graphisme. Ses photos ont été publiées dans la presse internationale, dont le *National Geographic, Life, Geo, Omni, Newsweek, Time* et *U.S. News & World Report*. *243, 292, 364, 365, 366, 425, 429*

CLAUS C. MEYER, né en 1944 à Düsseldorf, en Allemagne, est devenu un des plus grands photographes du Brésil après avoir commencé sa carrière en séchant des épreuves dans un studio-photo utilisé par Black Star. Il s'installe à Rio de Janeiro, au Brésil, où il est engagé comme photographe chez Editores Bloch, une des plus grandes maisons d'éditions brésiliennes. Après avoir passé quelque temps chez Bloch, il monte sa propre agence, l'Agence Tyba, en collaboration avec d'autres photographes. Pendant vingt ans, il a vécu et travaillé à Rio, et a été représenté par Black Star. Son œuvre a été couronnée par plusieurs récompenses, dans le Grand Prix Nikon International au Japon en 1981, et la médaille d'or au Salon Photographique International du Japon en 1988. Il a aussi collaboré à des livres : « Library of Nations », « South of Brazil » « Cyberspace 24 Hours », et un numéro spécial sur le Brésil dans *Photo*. Ses photos ont paru entre autres dans *Time, Newsweek, le New York Times, Elle, Quick, Bunte Illustrierte, Life, Geo, Stern,* le *Sunday Telegraph, Epoca, Smithsonian, Wildlife, L'Express, Fortune* et *Travel & Leisure*. Il est mort à Rio de Janeiro en 1996. *228, 229, 230, 231, 236, 237, 312, 321, 322, 324, 327, 328, 374, 375, 386, 389*

PAUL JOHN MILLER est né en 1958 à Whittier, en Californie. Il a étudié la photographie à San Francisco et travaillé d'abord comme photographe aérien pour le service des Forêts. En 1985, il obtient son diplôme en Photoreportage. Il a travaillé pour plusieurs journaux dont le *Hartford Courant*, le *San Francisco Examiner* et le *Seattle Times*. En 1986, il devint free-lance et effectue des reportages pour Black Star, dont un sur le Ku Klux Klan. Il a travaillé en particulier en Amérique du Sud, en Asie, mais aussi en URSS et en Bulgarie. Ses reportages étaient publiés dans *Newsweek, Time, Geo, Smithsonian,* le *New York Times, Stern,* et le *Spiegel*. En 1990, il est nominé pour le prix Pulitzer et a reçu un prix Picture of the Year. *423*

EIJI MIYAZAWA est né en 1929 à Tokyo. Il est diplômé du Nihon University Art Department. En 1962, après avoir travaillé pendant dix ans

MIKE MAUNEY lives in Chicago. He started with Black Star on a photojournalistic basis and did a great deal of work for *Life*. He has moved more and more into corporate work over the years. *361*

DAN McCOY was born in 1936 in Johnson City, Tennessee. At sixteen he discovered his perfect tool – the camera. He did his early training on a job for a newspaper. In 1961, he left the *Miami Herald* to freelance through Black Star. During these years he covered the civil rights protests and traveled the world for numerous magazines and commercial clients. Today he works out of the Berkshires of Massachusetts and the island of St. John in the Caribbean, specializing in science, travel and graphic design. His work has appeared in much of the world's press, including *National Geographic, Life, Geo, Omni, Newsweek, Time* and *U.S. News & World Report*. *243, 292, 364, 365, 366, 425, 429*

CLAUS C. MEYER

CLAUS C. MEYER was born in 1944 in Düsseldorf, Germany. In the early 1970s, he went from drying prints in a commercial darkroom in New York to becoming one of Brazil's leading photographers. When he moved to Rio de Janeiro, Brazil, he was hired as a staff photographer with Editores Bloch, one of Brazil's largest magazine publishers. After a stint with Bloch, he started his own agency, the Agencia Tyba. He lived and worked in Rio de Janeiro for twenty years, where he was represented by Black Star. He received several awards for his work, including the Grand Prize Nikon international and the Gold Medal at the international Photographic Salon of Japan. He also participated on books, "Library of Nations," "South of Brazil," "Cyberspace 24 Hours," and a special edition on Brazil of *Photo*. His photographs have appeared in magazines including *Time, Newsweek, The New York Times, Elle, Quick, Bunte Illustrierte, Life, Geo, Stern, The Sunday Telegraph, Epoca, Smithsonian, Wildlife, L'Express, Fortune,* and *Travel & Leisure*. He died in Rio de Janeiro in 1996. *228, 229, 230, 231, 236, 237, 312, 321, 322, 324, 327, 328, 374, 375, 386, 389*

PAUL JOHN MILLER was born in 1958 in Whittier, California. From 1976 to 1978 he studied Photography at the San Francisco City College and first worked as a aerial photographer for the U.S. Forest Service in San Francisco, then in Atlanta, Georgia. In 1985, he graduated from San Francisco State University in Photojournalism. He has worked as a photojournalist for several newspapers, including *The Hartford Courant* in Connecticut, the *San Francisco Examiner* and *The Seattle Times*. In 1986, he became a freelancer and began covering stories for Black Star, including one on the Ku Klux Klan. He particularly photographed in South America, Asia, but also in the USSR and Bulgaria. He has had stories published in *Newsweek, Time, Geo, Smithsonian, The New York Times, Stern,* and *Der Spiegel*. Among other awards, he was nominated for the Pulitzer Prize and he won a Picture of the Year award. *423*

CLAUS C. MEYER, 1944 in Düsseldorf geboren, trocknete in den frühen 70er Jahren in einem New Yorker Fotolabor Abzüge. Er brach nach Rio de Janeiro auf, wo er bald zu einem der führenden Fotografen Brasiliens und Staff-Fotograf bei den Editores Bloch, einem der größten Zeitschriftenverlage Brasiliens, wurde. Nach kurzer Zeit gründete er mit einigen anderen Fotografen seine eigene Agentur, die Agencia Tyba. Über 20 Jahre lang lebte und arbeitete er in Rio de Janeiro. Seine Arbeiten wurden von Black Star vertreten und mit mehreren Preisen ausgezeichnet, u.a. mit dem internationalen Großen Nikon-Preis und der Goldmedaille beim Japanischen Fotosalon. Er war auch an Buchveröffentlichungen wie der »Library of Nations«, »South of Brazil«, »Cyberspace 24 Hours«, und an einer Spezialausgabe über Brasilien von *Photo* beteiligt. Seine Fotografien sind u.a. in *Time, Newsweek, Elle, Quick, Life, Geo, Epoca, Wildlife, L'Express, Fortune, Travel & Leisure,* in der *New York Times,* der *Bunten Illustrierten,* im *Stern, Sunday Telegraph* und im *Smithsonian* erschienen. Er starb 1996 in Rio de Janeiro. *228, 229, 230, 231, 236, 237, 312, 321, 322, 324, 327, 328, 374, 375, 386, 389*

PAUL JOHN MILLER wurde 1958 in Whittier, Kalifornien, geboren. Er studierte Fotografie in San Francisco und arbeitete zunächst als Luftbildfotograf für den US-Forst. 1985 graduierte er in Fotojournalismus und arbeitete für einige Zeitungen wie den *Hartford Courant* in Connecticut, den *San Francisco Examiner* und die *Seattle Times*. 1986 begann er, als freischaffender Fotograf zu arbeiten, und berichtete für Black Star u.a. über den Ku Klux Klan. Er fotografierte insbesondere in Südamerika und Asien, aber auch in der UdSSR und in Bulgarien. Er veröffentlichte seine Geschichten in *Newsweek, Time, Geo,* im *Smithsonian,* in der *New York Times,* im *Stern* und im *Spiegel*. Unter anderem wurde er für einen Pulitzer-Preis nominiert und erhielt eine Bild-des-Jahres-Auszeichnung. *423*

EIJI MIYAZAWA wurde 1929 in Tokio geboren. Er graduierte an der Kunstfakultät der Nippon-Universität. Nachdem er zehn Jahre lang Staff-Fotograf beim Pan-Asia-Zeitungsverbund gewesen war, begann er ab 1962 als Freelancer zu arbeiten. Seit 1963 ist er bei Black Star unter Vertrag 1967 erhielt er seinen ersten Auftrag von *National Geographic,* einen Bericht über die Ainu. *186, 187*

CHARLES MOORE wurde 1931 in Tuscumbia, Alabama, geboren. Beim U.S. Marine Corps wurde er zum Front-Kameramann ausgebildet. Später studierte er am Brooks-Institut für Fotografie in Santa Barbara in Kalifornien. 1957 arbeitete er zunächst als Staff-Fotograf für den *Montgomery Advertiser* und das *Alabama Journal,* später wurde er Cheffotograf. Moore entwickelte sich zu einem der besten Dokumentaristen der Bürgerrechtsbewegung. 1962 wurde er Mitglied bei Black Star. Von da an gingen seine Fotos um die Welt. Später nahm er die unterschiedlichsten Auftragsarbeiten an und berichtete über die politische Gewalt in Venezuela und Haiti und den Bürgerkrieg in der Dominikanischen Republik, ebenso wie über den Jazz in New Orleans. Seine Fotografien erschienen weltweit in fast allen großen Zeitschriften. Er hat viele Auszeichnungen erhalten für seine Dokumentation der Bürgerrechtskämpfe von 1958 bis 1965, für Unternehmens- und Industriefotografie sowie für seine Reisefotografien. Neben DuPont, IBM, Exxon, Singapore Airlines und CBS hat er für viele andere Kunden gearbeitet. Zugleich entstanden viele Porträtarbeiten, u.a. von Elizabeth Taylor, Richard Burton, Gregory Peck, Kim Novak, Liza Minelli und den amerikanischen Präsidenten Eisenhower, Kennedy, Johnson und Nixon. Unter dem Titel »The Mother Lode« hat er ein Buch über den Goldrausch in Kalifornien herausgegeben. 1991 erschien »Powerful Days, The Civil Rights Photography of Charles Moore«. *86, 87, 88, 89, 90, 91, 92, 93, 281, 426*

DAVID MOORE begann seine fotografische Laufbahn 1947 in einem Fotostudio in Sydney. Von 1951 bis 1958 arbeitete er in London und übernahm Fotoaufträge in Europa, Afrika und den Vereinigten Staaten. Seine Arbeiten erschienen im *Observer,* in *Life, Look* und in der *New York Times* und sind Bestandteil mehrerer Sammlungen, darunter die Australische Nationalgalerie, das New York Museum of Modern Art, die Bibliothèque Nationale in Paris und die Smithsonian Institution in Washington. 1993 erschien sein Buch »Sydney Harbor«. *182, 183*

comme photographe au sein de la Pan-Asia Newspaper Alliance, il devient photographe free-lance. Il effectue des reportages de commande pour Black Star depuis 1963. Son sujet sur les Aïnous, publié en 1967, est le premier réalisé pour le compte du *National Geographic*. *186, 187*

CHARLES MOORE

CHARLES MOORE est né en 1931 à Tuscumbia, en Alabama. Dans la Marine US il suit une formation de correspondant de guerre. Il poursuit ses études au Brooks Institute of Photography à Santa Barbara, en Californie. En 1957, il est engagé comme photographe au *Montgomery Advertiser* et à l'*Alabama Journal* et, plus tard, devient chef photographe. C'est alors qu'il commence à couvrir le mouvement des droits civiques. En 1962, il se lance dans une carrière free-lance et devient membre de Black Star. Ses photos commencent alors à faire le tour du monde. Il couvre entre autres la violence politique au Venezuela et Haïti, la guerre civile en République Dominicaine, et le jazz à la Nouvelle-Orléans. Ses photos ont fait la couverture de presque tous les principaux magazines internationaux. Il a reçu de nombreuses récompenses pour son travail dans le domaine de l'industrie privée, ainsi que pour ses photos de voyages et sur la lutte pour les droits civiques. Il a travaillé pour DuPont, IBM, Exxon, les Singapore Airlines, CBS-TV et bien d'autres. Il a aussi photographié de nombreuses personnalités du cinéma, dont Elizabeth Taylor, Richard Burton, Gregory Peck, Kim Novak et Liza Minelli, ainsi que les présidents Eisenhower, Kennedy, Johnson et Nixon. Il a sorti un livre sur la région de la ruée vers l'or, au pied des sierras californiennes, intitulé «The Mother Lode». En 1991 sort son dernier ouvrage, intitulé « Powerful Days, The Civil Rights Photography of Charles Moore ». *86, 87, 88, 89, 90, 91, 92, 93, 281, 426*

DAVID MOORE entame sa carrière professionnelle en 1947 à Sydney. De 1951 à 1958, il travaille à Londres et fait des reportages de commande en Europe, en Afrique et aux Etats-Unis. Ses photos paraissent dans l'*Observer, Life, Look* et le *New York Times*. Ses travaux figurent dans plusieurs collections, dont l'Australian National Gallery, le Museum of Modern Art de New York, la Bibliothèque Nationale à Paris et la Smithsonian Institution à Washington. En 1993, son livre « Sydney Harbor » paraît. *182, 183*

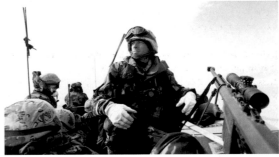
CHRISTOPHER MORRIS

CHRISTOPHER MORRIS est né en 1958 en Floride. Il étudie la photographie à l'Art Institute de Fort Lauderdale. En 1980, il obtient une bourse de l'International Center of Photography, et trouve un emploi à mi-temps à la photothèque de Black Star. En 1981, il travaille comme correspondant pour Black Star. En 1983, il couvre les manifestations antinucléaires en Allemagne de l'Ouest. En 1986, il couvre l'élection présidentielle aux Philippines. En 1989, il se rend en Europe de l'Est pour les événements révolutionnaires en Tchécoslovaquie, et à Berlin au moment de la chute du Mur. Son reportage sur les combats lors de l'invasion américaine au Panama lui vaut le deuxième prix au concours World Press Contest 1990. En 1990, il est sous contrat avec *Time* et couvre tous les

EIJI MIYAZAWA was born in 1929 in Tokyo. He graduated from Nihon University Art Department. In 1962, after being a staff photographer for ten years at the Pan-Asia Newspaper Alliance, he became a freelance photographer. He has been on assignment for Black Star since 1963. The Ainu story was his first assignment for *National Geographic* magazine, featured in 1967. *186, 187*

CHARLES MOORE was born in 1931 in Tuscumbia, Alabama. At the U.S. Marine Corps he trained to be a combat cameraman. He studied at the Brooks Institute of Photography in Santa Barbara, California. In 1957, he began working as a staff photographer for the *Montgomery Advertiser and Alabama Journal*, later becoming Chief Photographer. His photography of the Civil Rights movement began. In 1962, he began a freelance career and became a member of Black Star. From then on, his pictures went round the world. He also shot assignments as diverse as the political violence in Venezuela, Haiti, the civil war in the Dominican Republic, and jazz in New Orleans. His editorial photography has appeared worldwide in almost every major magazine. He has received many awards of merit and awards of excellence for his corporate/industrial photography and travel photography. He has worked for DuPont, IBM, Exxon, Singapore Airlines, CBS-TV and many others. Personalities photographed by him include Elizabeth Taylor, Richard Burton, Georgy Peck, Kim Novak, Liza Minelli and U.S. Presidents Eisenhower, Kennedy, Johnson and Nixon. He produced a book on the gold rush country in the foothills of the California Sierras entitled "The Mother Lode." In 1991, his latest book, "Powerful Days, The Civil Rights Photography of Charles Moore," appeared.
86, 87, 88, 89, 90, 91, 92, 93, 281, 426

DAVID MOORE commenced his professional photographic career in Sydney in a photographic studio in 1947. From 1951 to 1958 he worked in London and carried out assignments in Europe, Africa and the United States. His work appeared in *The Observer, Life, Look* and *The New York Times*. His photographs are in several institutional collections, including the Australian National Gallery, the New York Museum of Modern Art, la Bibliothèque Nationale in Paris and the Smithsonian Institution in Washington, D.C. His book "Sydney Harbor" was published in 1993. *182, 183*

CHRISTOPHER MORRIS was born in 1958 in Florida. He graduated in Photography from the Art Institute of Fort Lauderdale. During his scholarship from the International Center of Photography in 1980, he worked part-time in the Black Star photographic library. In 1981, he was a stringer photographer for Black Star. In 1983, he began his foreign photojournalist work with coverage of the anti-nuclear demonstrations in West Germany. In 1986, he covered the Presidental elections in the Philippines. In 1989, he traveled to Eastern Europe to cover the revolutionary events in Czechoslovakia and Berlin, when the Wall came down. His coverage of the fire fights during the U.S. invasion of Panama won him the Second Place Award at the 1990 World Press Contest. In 1990, he became a contract photographer for *Time* and covered all aspects of changing faces throughout the Soviet Union. His coverage of Liberia's civil war and London's poll tax riots earned him the Overseas Press Club Olivier Rebbot Award. In 1990/91 he covered the Gulf War. In Yugoslavia he documented the Civil War in Croatia for *Time*. In 1992, he won numerous awards for his work covering the break-up of Yugoslavia during 1991: the Robert Capa Gold Medal Award from Overseas Press Club and the Magazine Photographer of the Year Award from Picture of the Year contest for his portfolio.
8, 114, 115, 124, 125, 126, 127, 128, 129, 130, 146, 147, 148, 149, 150, 151, 155, 158, 159, 163, 252, 261, 372, 373, 400, 401, 402, 402/403, 421

JOHN MOSS was born in 1928 in Southend, England. He received a law degree from Oxford University and spent several years as a businessman before he became a photographer. His first freelance job, on a tribe in South Africa, was sold to *National Geographic*. He has been with Black Star since 1960. He has lived and worked in Africa, Latin America, the United States and Europe. His photographs have appeared in publications including *The Sunday Times, The New York Times, Ebony, Fortune, Le Figaro, Quick, Stern, Newsweek,* and he has carried out corporate work for industrial/international groups such as the World Health Organization and the World Bank. He has photographs on permanent display at the Smithsonian Institution in Washington, D.C. and has won awards for medical, archi-

CHRISTOPHER MORRIS wurde 1958 in Florida geboren. Er graduierte in Fotografie in Fort Lauderdale. Während seines Stipendiums des International Center of Photography 1980 arbeitete er im Fotoarchiv von Black Star. 1981 wurde er Fotoreporter für die Agentur. 1983 dokumentierte er die Anti-Atomkraft-Demonstrationen in Westdeutschland. 1986 berichtete er über die Präsidentschaftswahlen auf den Philippinen. 1989 reiste er durch Osteuropa, um über die revolutionären Ereignisse in der Tschechoslowakei und den Fall der Berliner Mauer zu berichten. Für seine Berichte über die US-Invasion in Panama gewann er 1990 einen zweiten Platz beim World-Press-Wettbewerb. Im gleichen Jahr wurde er Vertragsfotograf bei *Time* und berichtete umfassend über den Wechsel der politischen Führung in der Sowjetunion. Für seine Reportagen über den Bürgerkrieg in Liberia und die Aufstände gegen die Kopfsteuer in London erhielt er den Olivier-Rebbot-Preis des Overseas Press Club. 1990/91 berichtete er über den Golfkrieg. In Jugoslawien dokumentierte er den Bürgerkrieg für *Time*. 1992 gewann er zahlreiche Preise für seine Reportagen über das Auseinanderbrechen Jugoslawiens, darunter die Robert-Capa-Goldmedaille vom Overseas Press Club für seine Fotoberichte aus Kroatien 1991 und den »Magazinfotograf des Jahres« beim Bild-des-Jahres-Wettbewerb für sein Portfolio. Morris lebt heute in New York.
8, 114, 115, 124, 125, 126, 127, 128, 129, 130, 146, 147, 148, 149, 150, 151, 155, 158, 159, 163, 252, 261, 372, 373, 400, 401, 402, 402/403, 421

JOHN MOSS wurde 1928 in Southend in England geboren, schloß in Oxford ein Studium der Rechtswissenschaft ab und arbeitete einige Jahre in der Wirtschaftsberatung, bevor er sich der Fotografie zuwandte. Sein erstes Projekt als freischaffender Fotograf über einen afrikanischen Stamm verkaufte er an *National Geographic*. Seit 1960 ist er bei Black Star. Er hat in Afrika, Lateinamerika, den Vereinigten Staaten sowie in Europa gelebt und gearbeitet, und seine Fotografien sind u.a. in *Newsweek, Ebony, Fortune, Quick,* der *Sunday Times,* der *New York Times,* im *Figaro* und im *Stern* erschienen. Darüber hinaus war er für Industrieunternehmen und internationale Organisationen wie die Weltgesundheitsorganisation und die Weltbank tätig. Einige seiner Fotografien sind Teil der ständigen Ausstellung der Smithsonian Institution in Washington. Für seine Medizin-, Architektur- und Industriefotografien ist er mehrfach ausgezeichnet worden. In seinen jüngsten Arbeiten beschäftigte er sich mit den Minderheiten in China.
215, 216, 217, 255

W. MURLANDS *285*

NORMAN MYERS lebt in Ostafrika und hat sich auf die Tierwelt Kenias spezialisiert. Seit 1970 produzierte er zahlreiche journalistische Dokumentationen. *214*

YOUNOSUKE NATORI gehörte vor dem Zweiten Weltkrieg zu den japanischen Fotografen, die autorisiert waren, die japanischen Truppen zu begleiten. Für Black Star hielt er die Mandschurei-Krise, 1937 die japanische Invasion in China und schließlich den Beginn des Zweiten Weltkriegs in Bildern fest. *2, 33, 34*

ROB NELSON wurde 1953 in Atlanta, Georgia, geboren. Bevor er 1983 Freelancer wurde, arbeitete er in Chicago und Indianapolis sieben Jahre lang als Fotograf und Bildredakteur für Tageszeitungen und Associated Press. Nach seiner Rückkehr in seine Heimat Georgia 1984 richtete er sein journalistisches Hauptaugenmerk auf die Aktivitäten des Ku Klux Klan und auf Bürgerrechtsdemonstrationen. 1989 kam er zu Black Star. Seine Arbeiten wurden u.a. in *Time, Newsweek, U.S. News & World Report, Fortune, Forbes, Business Week, Paris Match* und im *Stern* veröffentlicht. Drei seiner Fotografien wurden zu besten Bildern des Jahres gewählt. *429*

ROBERT N. NICHOLS wurde 1926 in Emmett, Idaho, geboren. 1988 war er Finalist beim Pulitzer-Wettbewerb und wurde vom Weißen Haus offiziell akkreditiert. *15*

STEVE NORTHUP wurde 1941 in Amarillo in Texas geboren. Ab 1961 arbeitete er als Staff-Fotograf in den Agenturen der United Press International in San Francisco, Miami und Saigon. 1966 begann er bei der *Washington Post* und 1971 bei *Time* in den Büros in Washington und Houston. 1988 wurde er Mitherausgeber und Fotograf beim *Santa Fe Reporter*, und von 1991 bis 1994 war er Grafik-Ressortleiter beim *Santa Fe New Mexican*. Er ist 1974 von der Harvard-Universität mit einem Nieman-Stipen-

aspects du changement en Union Soviétique. Grâce à un reportage sur la guerre civile au Liberia et un autre sur les émeutes déclenchées par les impôts locaux à Londres, il remporte le prix du meilleur photoreportage à l'étranger décerné par l'Overseas Press Club Olivier Rebbot. En 1990–1991, il couvre la guerre du Golfe, ainsi que la guerre civile en Croatie pour *Time*. En 1992, son travail sur l'éclatement de la Yougoslavie en 1991 lui rapporte de nombreuses distinctions : pour son reportage en Yougoslavie, la Médaille d'Or du prix Robert Capa décerné par l'Overseas Press Club ; pour son dossier, le prix du Magazine Photographer of the Year, concours Picture of the Year. Aujourd'hui, il vit à New York.
8, 114, 115, 124, 125, 126, 127, 128, 129, 130, 146, 147, 148, 149, 150, 151, 155, 158, 159, 163, 252, 261, 372, 373, 400, 401, 402, 402/403, 421

JOHN MOSS est né en 1928 à Southend, en Angleterre. Licencié en droit de l'université d'Oxford, il a travaillé plusieurs années dans les affaires avant de devenir photographe. Son premier travail comme free-lance, un reportage sur une tribu d'Afrique du Sud, est vendu au *National Geographic*. Il est membre de Black Star depuis 1960. Il a vécu et travaillé en Afrique, en Amérique Latine, aux Etats-Unis et en Europe. Ses photos ont paru dans le *Sunday Times,* le *New York Times, Ebony, Fortune, Le Figaro, Quick, Stern* et *Newsweek*. Il travaille aussi pour de grands groupes industriels ou des organismes internationaux comme l'Organisation Mondiale de la Santé ou la Banque Mondiale. Certaines de ses photos font partie d'une exposition permanente à la Smithsonian Institution de Washington. Il a été récompensé pour ses clichés dans les domaines de la médecine, de l'architecture et de l'industrie. Son travail le plus récent porte sur les minorités en Chine.
215, 216, 217, 255

W. MURLANDS *285*

NORMAN MYERS, qui vit en Afrique de l'Est, est un spécialiste de la vie des animaux sauvages au Kenya. Depuis les années 70, il n'a pas cessé de réaliser des documentaires et des reportages photos. *214*

YOUNOSUKE NATORI est un photographe japonais qui, avant la Deuxième Guerre mondiale, a été autorisé à accompagner les troupes japonaises. Il a ainsi pu photographier la campagne de Mandchourie en 1931, l'invasion de la Chine par les Japonais en 1937 et le début de la Deuxième Guerre mondiale. *2, 33, 34*

ROB NELSON est né en 1953 à Atlanta, en Géorgie. Pendant sept ans, il travaille près d'Indianapolis et à Chicago, en qualité de photographe et de directeur du service photo pour un quotidien et pour l'Associated Press, avant de devenir free-lance en 1983. Depuis son retour en Géorgie en 1984, il a couvert les activités du Ku Klux Klan et des manifestations pour les droits civiques. En 1989, il entre chez Black Star. Son œuvre est publié dans *Time, Newsweek, U.S. News & World Report, Fortune, Forbes, Business Week, Paris Match* et *Stern*. Trois de ses photos ont été couronnées meilleure photo de l'année. *429*

ROBERT N. NICHOLS est né en 1926 à Emmett dans l'Idaho. Il a obtenu le Prix Pulitzer de la Photographie en 1988 avant d'être désigné photographe officiel à la Maison Blanche. *15*

STEVE NORTHUP est né en 1941 à Amarillo, au Texas. En 1961, il est photographe pour United Press International dans les agences de San Francisco, Miami et Saigon. En 1966, il entre au staff des photographes du *Washington Post,* et en 1971, à celui du *Time* à Washington et à Houston. En 1988, il est rédacteur adjoint et photographe au *Santa Fe Reporter,* et de 1991 à 1994, assistant du rédacteur en chef au service graphisme au *Santa Fe New Mexican*. Il a été nommé Nieman Fellow de l'Université d'Harvard en 1974, et nominé plusieurs fois pour le Pulitzer. Certaines de ses photos sont exposées dans des collections permanentes. Aujourd'hui, il travaille en free-lance à Santa Fe, au Nouveau-Mexique. *316*

MICHAEL O'BRIEN, né en 1950, a travaillé de nombreuses années en free-lance pour Black Star à Detroit. *363*

O'CALLAGHAN *299*

JOHN OLSON *98*

tectural and industrial photography. His most recent work has been on the minority groups in China. *215, 216, 217, 255*

W. MURLANDS *285*

NORMAN MYERS lives in East Africa and specializes in the wildlife of Kenya. Since the 1970s, he has produced documentary and journalistic photographic material. *214*

YOUNOSUKE NATORI was a Japanese photographer who, before World War II, was able to accompany Japanese troops and photograph the Manchurian situation of 1931 for Black Star, the Japanese invasion of China in 1937, and the beginnings of World War II. *2, 33, 34*

ROB NELSON was born in 1953 in Atlanta, Georgia. He worked in Indianapolis and Chicago as a staff photographer and picture editor for daily newspapers and the Associated Press for seven years prior to becoming a freelancer in 1983. Since his return to Georgia in 1984, he has mainly covered the activities of the Ku Klux Klan and civil rights demonstrations. He joined Black Star in 1989. His work has appeared in publications such as *Time, Newsweek, U.S. News & World Report, Fortune, Forbes, Business Week, Paris Match* and *Stern.* Three of his photographs have been recognized as best pictures of the year. *429*

ROBERT N. NICHOLS was born in 1926 in Emmett, Idaho. He was awarded Pulitzer Prize Finalist in Photography in 1988 and had a White House Assignment. *15*

STEVE NORTHUP was born in 1941 in Amarillo, Texas. From 1961 to 1966 he worked as a staff photographer at United Press International, in their agencies in San Francisco, Miami and Saigon. In 1966, he began working as a staff photographer at *The Washington Post* and in 1971 at *Time*'s Washington and Houston bureaus. In 1988, he became the Associate Editor and photographer at the *Santa Fe Reporter* and from 1991 to 1994 Assistant Managing Editor/Graphics at the *Santa Fe New Mexican.* He has been awarded honors such as Nieman Fellow, Harvard University in 1974 and several Pulitzer nominations. He has photographs in several permanent collections. He is now a freelancer, living in Santa Fe, New Mexico. *316*

MICHAEL O'BRIEN was born in 1950. He spent many years working as a freelancer for Black Star in Detroit. *363*

O'CALLAGHAN *299*

JOHN OLSON *98*

MICKEY OSTERREICHER was born in 1952 in New York. In 1973, he graduated in Photojournalism from Buffalo. Until 1982, he worked as a staff photographer for the *Buffalo Courier-Express* and from 1982 to 1996 for *Eyewitness News* and WKBW-TV. He worked as a freelancer for *Time, Newsweek, The New York Times,* ABC News, NBC Sports and others. He was the personal photographer for Jack Kemp during his 1988 presidential bid. *307*

OWEN D.B. *247*

SWAPAN PAREKH was born in 1966. He is based in Bombay and has been represented by Black Star since 1989. He studied photojournalism at the International Center of Photography in New York from 1988 to 1989. His work has been published in *Life, Time, U.S. News & World Report, American Photo,* the London *Independent* and *El Pais.* His winning work was published in "The Best of Photojournalism 1994." His portfolios received the First and Second Place Awards for under 35s in a contest held by the Alliance Française for 1993 and 1994. His work was selected as a part of "The Circle of Life" book and travel exhibition. He received awards from Nikon World Photo in 1987, 1991 and 1992. *23, 263, 376, 376/377*

ROBERT PHILLIPS *71*

JIM PICKERELL was born in 1936. In 1963, he began his career as a freelance photojournalist in the Far East. His first major sale, a cover for *Life* magazine, was a stock photo of the overthrow of the Ngo Dinh Diem government in Saigon, Vietnam. He spent the next ten to fifteen years

dium geehrt worden und hat mehrere Pulitzer-Nominierungen erhalten. Seine Fotografen sind Teil mehrerer ständiger Ausstellungen. Heute arbeitet er als selbständiger Fotograf in Santa Fe, New Mexico. *316*

MICHAEL O'BRIEN, 1950 geboren, arbeitete jahrelang für Black Star als freischaffender Fotograf in Detroit. *363*

O'CALLAGHAN *299*

JOHN OLSON *98*

MICKEY OSTERREICHER wurde 1952 in New York geboren. 1973 graduierte er in Fotojournalismus in Buffalo. Bis 1982 war er als Staff-Fotograf für den *Buffalo Courier-Express,* von 1982 bis 1996 für *Eyewitness News* und den Fernsehkanal WKBW tätig. Er hat als Freelancer u.a. für *Time, Newsweek,* die *New York Times,* ABC News und NBC Sports gearbeitet. 1988 war er persönlicher Fotograf von Jack Kemp während dessen Präsidentschaftskampagne. *307*

OWEN D.B. *247*

SWAPAN PAREKH wurde 1966 geboren. Er lebt in Bombay und wird seit 1989 von Black Star vertreten. 1988 bis 1989 studierte er Fotojournalismus am ICP in New York. Seine Arbeiten sind in *Life, Time, U.S. News & World Report, American Photo,* dem Londoner *Independent* und *El Pais* veröffentlicht worden, seine preisgekrönten Arbeiten sind u.a. in »The Best of Photojournalism 1994« erschienen. Mit seinen Portfolios belegte er 1993 und 1994 den ersten und zweiten Platz in der Gruppe der unter 35jährigen bei einem Wettbewerb der Alliance Française. Sein Werk wurde für das Buch und die Wanderausstellung »The Circle of Life« ausgewählt. 1987, 1991 und 1992 war er Preisträger von Nikon World Photo. *23, 263, 376, 376/377*

ROBERT PHILLIPS *71*

JIM PICKERELL wurde 1936 geboren. 1963 begann er seine Laufbahn als freier Fotojournalist im Fernen Osten. Sein erster größerer Erfolg, ein Cover für *Life,* war ein Archivfoto vom Sturz des Ngo-Dinh-Diem-Regimes in Vietnam. In den folgenden Jahren übernahm er vor allem Auftragsarbeiten, zunächst als Magazin-, später als Werbefotograf. 1989 veröffentlichte er die erste Ausgabe von »Negotiating Stock Photo Prices«, einem Führer, der zum Bestseller wurde und von dem für 1997 eine Neuauflage geplant ist. *28, 98, 99, 101*

PIZZAMIGLIO *288*

MAX RAMIREZ wurde 1955 in New York geboren. Er studierte Fotografie in New York und San Francisco. Von 1985 bis 1986 ging er nach Mittelamerika, um über die Flüchtlingslager und das Leben im kriegsgeschüttelten Nicaragua und El Salvador zu berichten. Die dort entstandenen Fotos wurden u.a. im *San Francisco Chronicle* veröffentlicht. Er hat für mehrere internationale Publikationen gearbeitet. *368, 369, 424*

HARRY REDL wurde 1926 in Österreich geboren. 1950 emigrierte er nach Kanada, wo er 1953 mit kommerzieller Fotografie begann. 1956 ging er nach San Francisco, um von der Begeisterung der Beat Generation über die Wiedergeburt der Dichtung zu berichten. Aufnahmen davon erschienen in der *Evergreen Review.* 1960 waren sie Gegenstand einer Ausstellung im San Francisco Museum of Art. 1961 ging er nach Hong Kong und arbeitete für Magazine wie *Life* und *Time.* Während der Kulturrevolution war Redl einer der wenigen Berufsfotografen in China. 1967 kehrte er nach Wien zurück, berichtete fünf Jahre lang für verschiedene Magazine über die Tschechoslowakei und Deutschland und verbrachte ein weiteres Jahr in Hong Kong. Heute lebt er in Vancouver in Kanada. *10*

JOHN REES nahm 1946 an einem zweijährigen Programm für die Schönen Künste im Staat Ohio teil und studierte am New York Institute of Photography. 1951 graduierte er am Art Center College of Design. Zurück in Ohio übernahm er Auftragsarbeiten für Black Star und machte eigene Produktionen. Kurze Zeit später bot man ihm an, in die Rocky Mountains zu ziehen, um dort zu arbeiten. Nach vielen Jahren kehrte er nach Ohio zurück und widmete die meiste Zeit dem Fotografieren von Familien für

MICKEY OSTERREICHER est né en 1952 à New York. En 1973, il obtient son diplôme en photoreportage à Buffalo. Jusqu'à 1982, il travaille au *Buffalo Courier-Express* comme photographe, et de 1982 à 1996, pour *Eyewitness News* et WKBW-TV. Il travaille en free-lance pour *Time, Newsweek,* le *New York Times,* ABC News et NBC Sports, entre autres. Il est le photographe attitré de Jack Kemp pendant sa campagne présidentielle en 1988. *307*

OWEN D.B. *247*

SWAPAN PAREKH

SWAPAN PAREKH est né en 1966. Il vit à Bombay, en Inde, et est représenté par Black Star depuis 1989. Il a fait des études de photoreportage à l'International Center of Photography à New York de 1988 à 1989. Son travail a été publié entre autres dans *Life, Time, U.S. News & World Report, American Photo,* l'*Independent* de Londres et *El Pais.* Il a reçu plusieurs prix, et son travail a d'ailleurs été publié dans « The Best of Photojournalism 1994 ». Ses dossiers ont été classés premier et second, catégorie moins de 35 ans, dans le concours organisé par l'Alliance Française pour 1993 et 1994. Son reportage a été choisi pour figurer dans le livre et l'exposition itinérante « The Circle of Life ». Il a été récompensé par Nikon World Photo en 1987, 1991 et 1992. *23, 263, 376, 376/377*

ROBERT PHILLIPS *71*

JIM PICKERELL, né en 1936, se lance dans une carrière de photo-reporter free-lance en 1963 en Extrême-Orient. Sa première grosse vente, une couverture pour *Life,* est devenu une photo d'archives du renversement du gouvernement de Ngô Dinh Diem à Saigon, au Viêtnam. Pendant les dix à quinze années suivantes, il se consacre à des reportages de commande, d'abord pour la presse, puis dans la publicité. En 1989, il publie la première édition de « Negotiating Stock Photo Prices », un guide best-seller qui doit être réactualisé en 1997. *28, 98, 99, 101*

PIZZAMIGLIO *288*

MAX RAMIREZ est né en 1955 à New York. Il fait des études de photographie à New York et San Francisco. Il se rend en Amérique Centrale de 1985 à 1986, pour réaliser des sujets sur les camps de réfugiés et la façon dont les gens vivent au Nicaragua et au Salvador, deux pays déchirés par la guerre. Les photos de ces voyages sont publiées dans le *San Francisco Chronicle* et d'autres journaux. Il a travaillé pour plusieurs grandes publications. *368, 369, 424*

HARRY REDL est né en 1926 en Autriche. En 1950, il émigre au Canada et entame en 1953 une carrière de photographe commercial. En 1956, il s'installe à San Francisco où il se met à rendre compte de l'enthousiasme de la Beat Generation pour la renaissance de la poésie. Ses premiers clichés ont paru dans l'*Evergreen Review.* En 1960, son travail fait l'objet d'une exposition au San Francisco Museum of Art. En 1961, il s'installe à Hong-Kong et commence alors une carrière de photo-reporter pour *Life, Time* et d'autres magazines. Quand survient la Révolution Culturelle en Chine, Redl est l'un des rares photographes professionnels sur place. En

focusing on assignment work, first as an editorial photographer and later in the corporate area. In 1989, he published the first edition of "Negotiating Stock Photo Prices," a best-selling guide which is due to be updated in 1997. *28, 98, 99, 101*

PIZZAMIGLIO *288*

MAX RAMIREZ was born in 1955 in New York. He studied photography in New York and in San Francisco. Then he went to Central America from 1985 to 1986 to document the refugee camps and life in war-torn Nicaragua and El Salvador. The photos from these trips were published in the *San Francisco Chronicle* and other newspapers. Since then he has worked for several major news publications. *368, 369, 424*

HARRY REDL was born in 1926 in Austria. In 1950, he emigrated to Canada and then in 1953 he began a commercial photography business. In 1956, he moved to San Francisco, where he started recording the excitement that the Beat Generation initiated at the start of the poetry renaissance. His first pictures appeared in the *Evergreen Review*. In 1960, he held an exhibit at the San Francisco Museum of Art and then in 1961, he relocated to Hong Kong, working for *Life* and *Time*. During the Cultural Revolution, Redl was one of only a few professional photographers in China. In 1967, he moved to Vienna and, for the next five years, he covered Czechoslovakia and Germany for various magazines. He returned to Hong Kong for one year and now lives in Vancouver, Canada. *10*

JOHN REES spent two years on a Fine Arts Program in Ohio State from 1945. He studied at the New York Institute of Photography. In 1951, he graduated from the Art Center College of Design. Back in Ohio, he did assignments and stories on speculation for Black Star. After a short time he was asked to relocate to the Rocky Mountains area to work. After many years he returned to Ohio and spent a good deal of time on assignment for *Life* and the *Saturday Evening Post*, photographing families. He has retired and still lives in Ohio. *277, 346, 348, 349*

KLAUS REISINGER was born in 1971 in Vienna. At fourteen he photographed for a local newspaper after school. At sixteen the newspaper sent him to Poland and France to photograph stories on religion. When he graduated from high school in Vienna, he worked freelance for the Austrian Television Photo Department. In 1989, he started working for Reuters Eastern Europe, covering the exodus from East Germany, Czechoslovakia and Hungary. His pictures of the Romanian Revolution were the first off the wire. He joined Black Star in 1990 and moved to Jordan during the Gulf War, reporting from Iraq and Iran. In 1991, he covered the plight of the Kurdish refugees in Turkey. While based in Moscow, he traveled widely for *U.S. News & World Report* in the former Soviet Union, where his subjects included Boris Yeltsin's campaign for the Russian presidency. In 1992, he was awarded the Young Photographer Award by the International Center of Photography. He is the youngest winner ever of the prize. His stories during this year of conflicts in the former Soviet Republics, a long term story on opium in Afghanistan and a report on Somalia were published in *Time, Newsweek, U.S. News & World Report* and *Stern*. In 1993, he covered the drug trade in Central Asia, the Orthodox Church in Russia and the political turmoil in Moscow. In 1994, his work included a report from the civil war in Yemen and the American intervention in Haiti. In 1995, he won the Picture of the Year Award of Excellence for his photography in Rwanda and began working on the production of television documentaries.
131, 156, 157, 158, 161, 378, 379, 380, 381, 388

GEORGES REISNER *36*

JIM RICHARDSON was born in 1947 in Kansas. He first worked with newspapers and then in 1986 as an independent photographer. His ongoing black-and-white documentary photojournalism of rural America has won him international recognition. For *National Geographic* his coverage has explored the relationships among individuals, institutions and natural resources. His works have been published in major magazines such as *Life, Time* and *American Photographer*. He has also produced several large-subject books. He has received numerous awards and his work has been shown in many different countries. *19*

Life und die *Saturday Evening Post*. Er hat sich zur Ruhe gesetzt und lebt in Ohio. *277, 346, 348, 349*

KLAUS REISINGER

KLAUS REISINGER, 1971 in Wien geboren, fotografierte bereits mit 14 Jahren nach der Schule für eine lokale Zeitung. Mit sechzehn schickte ihn diese Zeitung für Fotoberichte über religiöse Themen nach Polen und Frankreich. Nach der Matura in Wien arbeitete er als Freelancer für die Fotoredaktion des ORF. 1989 begann er für Reuters in Osteuropa zu arbeiten. Er dokumentierte die allgemeine Aufbruchsstimmung in Ostdeutschland, der Tschechoslowakei und Ungarn. Seine Bilder von der Rumänischen Revolution waren die ersten, die gesendet wurden. 1990 kam er zu Black Star. Während des Golfkriegs ging er nach Jordanien und berichtete aus dem Irak und Iran. 1991 hielt er die Not der kurdischen Flüchtlinge in der Türkei in Bildern fest. Während seiner Arbeit in Moskau bereiste er für *U.S. News & World Report* große Teile der früheren Sowjetunion und berichtete daneben auch über die Präsidentschaftskampagne Boris Jelzins. 1992 wurde Reisinger der jüngste Gewinner des ICP Young Photographer Awards. Im Anschluß produzierte er große Reportagen über den Drogenhandel in Zentralasien, die russisch-orthodoxe Kirche und die politischen Unruhen in Moskau. 1994 widmete er sich u.a. dem Bürgerkrieg im Jemen und der US-Intervention in Haiti. 1995 gewann er den Picture of the Year Award of Excellence für seine Fotografien aus Ruanda und begann, Dokumentarfilme für das Fernsehen zu produzieren.
131, 156, 157, 158, 161, 378, 379, 380, 381, 388

GEORGES REISNER *36*

JIM RICHARDSON wurde 1947 in Kansas geboren. Zunächst arbeitete er für Zeitungen, ab 1986 dann als freischaffender Fotograf. Seine Schwarzweißdokumente des ländlichen Amerikas haben ihm internationales Ansehen verschafft. Für *National Geographic* hat er in seinen Arbeiten die Verhältnisse zwischen Individuen, Institutionen und natürlichen Ressourcen erforscht. Er erhielt zahlreiche begehrte Auszeichnungen, seine Arbeiten wurden in wichtigen Magazinen wie *Life, Time* und *American Photographer* veröffentlicht, und in etlichen Ländern ausgestellt. Darüber hinaus hat er mehrere Bücher über weite Themengebiete veröffentlicht. *19*

ARTHUR RICKERBY, 1921 in den Vereinigten Staaten geboren, erlangte mit seinen fotojournalistischen Arbeiten einen großen Bekanntheitsgrad. Er spezialisierte sich auf den Sport und gehörte zum festen Mitarbeiterstab von *Life*. Er starb 1972. *80*

R.L. RIDGWAY *314*

1967, Redl repart en Europe et, basé à Vienne, il couvre la Tchécoslovaquie et l'Allemagne pour différents magazines. Puis il a passé un an à Hong-Kong. Aujourd'hui, Redl vit à Vancouver au Canada. *10*

JOHN REES a passé deux ans dans un Programme de Beaux Arts de l'Ohio en 1945, avant de suivre des cours à l'Institut de la Photographie de New York. En 1951, il sort diplômé de l'Art Center College of Design. De retour dans l'Ohio, il fait des reportages et des articles pour Black Star. Peu de temps après, on lui demande de s'installer dans la région des Rocheuses pour y travailler. Des années plus tard, il retourne dans l'Ohio et travaille pendant un long moment pour *Life* et le *Saturday Evening Post*, photographiant des familles. Aujourd'hui en retraite, il vit dans l'Ohio.
277, 346, 348, 349

KLAUS REISINGER est né en 1971 à Vienne, en Autriche. A 14 ans, il fait des photos pour un journal local après les cours. A 16 ans, ce journal l'envoie en Pologne et en France pour illustrer des reportages sur la religion. Après avoir passé son baccalauréat à Vienne, il travaille en freelance pour le service Photo de la télévision autrichienne. En 1989, il couvre l'exode des réfugiés d'Allemagne de l'Est, de Tchécoslovaquie et de Hongrie pour Reuters. Ses photographies sur la révolution roumaine sont les premiers à parvenir à l'agence. Il devient membre de Black Star en 1990, part en Jordanie au moment de la guerre du Golfe qu'il couvre en Irak et en Iran. En 1991, il témoigne des mauvaises conditions de vie des réfugiés kurdes en Turquie. Basé à Moscou, il voyage ensuite beaucoup pour le compte de *U.S. News & World Report*, couvrant des sujets comme la campagne de Boris Eltsine pour la présidence russe. En 1992, l'International Center of Photography lui remet la Young Photographer Award. C'est le plus jeune gagnant de tous les temps à remporter ce prix. En 1993, il couvre le trafic de drogues en Asie Centrale, l'Eglise orthodoxe en Russie, et la situation politique trouble à Moscou. En 1994, il travaille entre autres sur la guerre civile au Yémen et l'intervention américaine à Haïti. En 1995, il remporte le Picture of the Year Award of Excellence pour ses photos du Rwanda, et se lance dans la production de documentaires vidéo.
131, 156, 157, 158, 161, 378, 379, 380, 381, 388

GEORGES REISNER *36*

JIM RICHARDSON

JIM RICHARDSON est né en 1947 dans le Kansas. Il commence à travailler dans des journaux puis devient, en 1986, photographe indépendant. Ses photoreportages en noir et blanc sur l'Amérique rurale lui ont valu une reconnaissance internationale. Pour le *National Geographic*, il a exploré les relations entre individus, institutions et ressources naturelles. Ses photos ont été publiées dans les plus grands magazines dont *Life, Time* et *American Photographer* et exposées dans de nombreux pays. Il a également fait plusieurs livres sur des thèmes plus vastes. *19*

ARTHUR RICKERBY est né en 1921 aux Etats-Unis. Spécialisé dans le sport, il était réputé pour son travail de photoreporter. Il faisait partie de l'équipe de *Life*. Il est décédé en 1972. *80*

R.L. RIDGWAY *314*

ARTHUR RICKERBY was born in 1921 in the United States. He was well known for his photojournalistic work and specialized in sport. He was on the staff of *Life*. He died in 1972. 80

JOSEPH RODRIGUEZ

JOSEPH RODRIGUEZ was born in 1951 in New York. He studied Photography at the School of Visual Arts and Photojournalism/Documentary at the International Center of Photography in New York. Currently affiliated with Black Star, his work has appeared in major international publications such as *The New York Times Magazine* and *National Geographic*. He got support for his work from the Mother Jones International Fund for Documentary Photography, the Alicia Patterson Fellowship, Konstnarsnamnden Stipendium by the Swedish Arts Council and the New York State Foundation for the Arts. He also received Pictures of the Year awards in 1990 and 1992. His book "Spanish Harlem" is a series of penetrating and intimate photographs documenting life in the Hispanic community and was published in 1995. His new book "East Side Stories," a documentary about gang life, is due for publication in September 1997.
26, 358, 359, 406, 407, 408, 409, 410, 411, 412, 413

CHARLES "CHUCK" ROGERS was born in Lake Wales, Florida. He was a wirephoto operator for the *Orlando Sentinel* where he later served as a news and feature photographer. In West Palm Beach, he worked as a photographer and graphic artist for Wirk-TV. He also covered the Palm Beaches for *The Palm Beach Post-Times* and national news services. From 1970, he was an official missile photographer at Cape Canaveral for twelve years. He is well known for everything from award-winning annual reports for large corporations to album covers of top recording artists. His photographs have appeared in magazines including *Life, Time, Fortune, Business Week, Newsweek, National Geographic* and *Paris Match*. He lives in Atlanta, Georgia. 395

JEFF ROTMAN was born in 1949 in Boston. He is one of the most famous underwater photographers in the world. He has published numerous books and his articles appear regularly in the leading international magazines such as *Life, Time, The Smithsonian, The New York Times, Ego, Stern* and *Le Figaro*. In 1995, he won the annual Pictures of the Year competition. Macrophotography is his true specialty. Over the years he has developed a singular passion for sharks. Relentless in his pursuit of perfection, he is as sensitive as an artist. In 1990, his book "The Colors of the Deep" was published. *218, 219, 220, 221, 232, 233, 325*

DAVID RUBINGER was born in 1924 in Vienna. He went to Palestine in 1939 and at the age of 18 joined the British Army in. It was in service with the Jewish Brigade in Europe that he became interested in taking pictures. Returning to civilian life he settled in Jerusalem, determined to turn what was a hobby into his life's work. Free-lancing for

JOSEPH RODRIGUEZ, 1951 in New York geboren, studierte Fotografie an der School of Visual Arts und Fotojournalismus/Dokumentation am ICP in New York. Seit Ende der 80er Jahre arbeitet er mit Black Star zusammen. Seine Arbeiten erschienen in wichtigen internationalen Publikationen wie dem *New York Times Magazine* und *National Geographic*, und wurden von der internationalen Mother-Jones-Stiftung für Dokumentarfotografie, der Alicia-Patterson-Stiftung, dem Konstnarsnamnden Stipendium des Schwedischen Kunstrates und der New York State Foundation for the Arts unterstützt. Er erhielt außerdem 1990 und 1992 Bild-des-Jahres-Auszeichnungen. Sein 1995 erschienenes Buch »Spanish Harlem« enthält eine Reihe von eindringlichen und intimen Fotografien, die das Leben in der hispanischen Gemeinde von Los Angeles dokumentieren. Sein neues Buch »East Side Stories«, eine Dokumentation über das Leben in Gangs, soll 1997 erscheinen.
26, 358, 359, 406, 407, 408, 409, 410, 411, 412, 413

CHARLES »CHUCK« ROGERS wurde in Lake Wales, Florida, geboren. Er arbeitete als Bildfunker für den *Orlando Sentinel*, wo er später News- und Feature-Fotoreporter war. In Palm Beach war er als Fotograf und Grafiker für Wirk-TV tätig, gleichzeitig berichtete er über die Palmenstrände für die *Palm Beach Post-Times* und für nationale Presseagenturen. Von 1970 an war er zwölf Jahre lang offizieller Fotograf am Cape Canaveral. Er ist gleichermaßen bekannt für seine preisgekrönten Jahresberichte großer Unternehmen wie für die Schallplattenhüllen bekannter Musikstars. Seine Fotografien erschienen in *Life, Time, Fortune, Business Week, Newsweek, National Geographic* und *Paris Match*. Er lebt in Atlanta, Georgia. 395

JEFFREY ROTMAN, 1949 in Boston geboren, ist einer der berühmtesten Unterwasserfotografen der Welt. Er hat zahlreiche Bücher veröffentlicht, und seine Artikel erscheinen regelmäßig in *Life, Time, Ego*, der *New York Times*, dem *Smithsonian, Stern* und *Figaro*. 1995 gewann er den Bild-des-Jahres-Wettbewerb. Makrofotografie ist sein eigentliches Metier. Über die Jahre hat er ein besonderes Interesse für Haie entwickelt. Rotmans Perfektionismus ist gepaart mit dem Einfühlungsvermögen eines Künstlers. 1990 erschien sein Buch »The Colors of the Deep«.
218, 219, 220, 221, 232, 233, 325

DAVID RUBINGER wurde 1924 in Wien geboren. 1939 ging er nach Palästina. 1942 trat er in die britische Armee ein. Als er im Dienst der jüdischen Brigade in Europa war, begann er sich für die Fotografie zu interessieren. Nach der Rückkehr ins Zivilistenleben ließ er sich in Jerusalem nieder und machte sein Hobby zu seinem Beruf. Nachdem er mehrere Jahre als freischaffender Fotograf gearbeitet hatte, bot man ihm 1951 eine Stelle bei dem Magazin *Ha'Olam-Hazeh* an. 1954 bekam er seinen ersten Fotoauftrag von *Time*, die Berichterstattung über den Kastner-Grunwald-Prozeß. Weitere Aufträge von *Time* und *Life* folgten. Von dieser Zeit an berichtete er für Time-Life über fast jedes geschichtsträchtige Ereignis im Nahen Osten. 1976 wurde er Vertragsfotograf bei *Time*. 1997 erhielt er für sein journalistisches Lebenswerk den Israel-Preis. 275

KOSTI RUOHAMAA wurde 1914 in Finnland geboren und emigrierte mit seinen Eltern nach Neuengland. Er war wohl der größte Essayist unter den Fotografen von Black Star. Das Wetter lieferte ihm die Themen, die er in Fotoessays über Regen und Nebel verwandelte. Sein Essay »Winter Nights« wurde als einer der zehn besten *Life*-Essays in ein Buch aufgenommen. Er starb im Alter von 47 Jahren als Opfer des Alkoholismus. *273, 436, 437, 438, 439*

KEN SAKAMOTO wurde 1938 in Kanada geboren. Er fotografierte von 1965 bis 1974 für den *Calgary Herald* und lebt heute in Hawaii, wo er seit 1974 als Staff-Fotograf beim *Honolulu Star* tätig ist. Für internationale Magazine hat er über so unterschiedliche Themen wie den Fall der Berliner Mauer, die Antarktis, Asien und das Britische Königshaus berichtet. In und um Hawaii hat er Ferdinand Marcos' Exil und die Südpazifischen Inseln fotografiert. Für seine Fotoreportagen erhielt er zahlreiche Auszeichnungen. 425

JOSEPH RODRIGUEZ est né en 1951 à New York. Il a étudié la photographie à la School of Visual Arts, et le photoreportage documentaire à l'International Center of Photography. Actuellement membre de Black Star, ses travaux ont paru dans les principales publications internationales, dont le *New York Times Magazine* et le *National Geographic*. Il a obtenu le soutien du Mother Jones International Fund for Documentary Photography, de l'Alice Patterson Fellowship, du Konstnarsnamnden Stipendium du Conseil de l'Art suèdois et du New York State Foundation for the Arts. Il a également été récompensé lors du concours Picture of the Year en 1990 et 1992. Son livre « Spanish Harlem », une série de photos pénétrantes et intimes sur la vie de la communauté hispanique, a été publié en 1995. Son ouvrage le plus récent, « East Side Stories », un document sur la vie des gangs, doit paraître en 1997.
26, 358, 359, 406, 407, 408, 409, 410, 411, 412, 413

CHARLES « CHUCK » ROGERS est né à Lake Wales, en Floride. Il débute comme bélinographiste pour l'*Orlando Sentinel*, puis comme photographe d'information et photoreporter. A West Palm Beach, il est photographe et graphiste pour Wirk-TV. Il travaille également pour le *Palm Beach Post-Times* et les services d'information nationaux. De 1970 à 1982, il est photographe officiel à Cape Canaveral. Sa réputation n'est plus à faire dans des domaines aussi variés que la réalisation de bulletins annuels primés pour de grandes entreprises, ou de pochettes de disques pour des artistes de renom. Ses photos ont été publiées dans *Life, Time, Fortune, Business Week, Newsweek, National Geographic*, et *Paris Match*. Il vit à Atlanta, en Géorgie. 395

Né en 1949 à Boston, JEFF ROTMAN est considéré comme un des meilleurs photographes sous-marins du monde. Il a publié de nombreux ouvrages, et ses articles paraissent régulièrement dans les plus grands magazines internationaux : *Life, Time*, le *Smithsonian*, le *New York Times, Ego, Stern*, et *Le Figaro*. En 1995, il a remporté le concours Picture of the Year. C'est un spécialiste de la macrophotographie. Au fil des années, il s'est pris de passion pour les requins. Perfectionniste, il a la sensibilité d'un artiste. En 1990, son ouvrage « The Colors of the Deep » a paru.
218, 219, 220, 221, 232, 233, 325

DAVID RUBINGER, né en 1924 à Vienne, quitte l'Autriche en 1939 pour la Palestine. Après quelques années passées dans un kibboutz, il s'engage, en 1942, dans l'Armée britannique. C'est durant son service auprès de la Brigade juive en Europe qu'il commence à prendre des photos. De retour dans la vie civile, il s'installe avec sa famille à Jérusalem et se consacre entièrement à la photographie. Il travaille en free-lance pendant plusieurs années avant d'être invité en 1951 à rejoindre le magazine *Ha'Olam-Hazeh*. Cette collaboration durera trois ans. En 1954, il obtient une première mission pour le magazine *Time* et couvre le procès Kastner-Grunwald. D'autres reportages suivent, pour le *Time* et *Life*. Depuis, il a couvert presque tous les événements historiques au Proche-Orient pour Time-Life. En 1976, *Time* le prend sous contrat. En 1997, il reçoit le prix Israélien pour son œuvre journalistique. 275

Né en 1914 en Finlande, KOSTI RUOHAMAA a émigré avec ses parents en Nouvelle-Angleterre. C'est peut-être le plus grand essayiste de tous les photographes de Black Star. Trouvant son inspiration dans tout ce qui l'entourait, il réalisa entre autres des essais sur le brouillard et la pluie. Son sujet intitulé « Winter Nights » devint des dix meilleurs essais du magazine *Life*. Alcoolique, il mourut à 47 ans. *273, 436, 437, 438, 439*

KEN SAKAMOTO est né en 1938 au Canada. De 1965 à 1974, il est photographe pour le *Calgary Herald*, et depuis 1974, il vit à Hawaii et travaille pour le *Honolulu Star*. Il a couvert des événements internationaux comme la chute du mur de Berlin, il a été en Arctique, en Asie, et a photographié la famille royale britannique. A Hawaii et sa région, il a couvert l'exil de Ferdinand Marcos et les îles du Pacifique Sud. De nombreux prix lui ont été attribués pour ses reportages photos. 425

several years, he was invited in 1951 to join *Ha 'Olam-Hazeh* magazine. In 1954, he received his first assignment from *Time* magazine, covering the Kastner-Grunwald trial. Other assignments for *Time* and *Life* followed. Since then he has covered nearly every history-making event in the Middle East for Time-Life. In 1976, he became a contract photographer with *Time*. In 1997 he won the Israel Prize for Lifetime Achievement in Journalism.

275

HOWARD RUFFNER *103*

KOSTI RUOHAMAA was born in 1914 in Finland. He emigrated with his parents to New England. He may have been the greatest essayist of all Black Star photographers. His essay, "Winter Nights," is included in the book commemorating the ten best *Life* magazine essays. He died at the age of 47, a victim of alcoholism. *273, 436, 437, 438, 439*

JERRY RUTBERG *66*

KEN SAKAMOTO was born in 1938 in Canada. He photographed for *The Calgary Herald* from 1965 to 1974 and is based in Hawaii, where he has been a staff photographer for *The Honolulu Star* since 1974. He has covered international assignments such as the collapse of the Berlin Wall, the Arctic, Asia and the British Royal family at Windsor Castle. In and around Hawaii he has covered Ferdinand Marcos' exile and the South Pacific Islands. He has won numerous awards for his photo reportage. *425*

OSVALDO SALAS *72, 238*

SALDMAN *64*

WALTER SANDERS was born in 1897. He worked as a photojournalist and was on the staff of *Life*. *64*

STEVE SCHAPIRO grew up in New York City. He started his photographic career at a number of recording studios and doing several record covers in the 1960s. He became associated with Black Star in the early 1960s and covered civil rights. He has lived in California since the 1970s and specialized in personality photography and theatrical coverage. *20, 78, 274, 289*

FLIP SCHULKE was born in 1930 in New Ulm, Minnesota, where he graduated from Macalester College in Political Science and Journalism. He has established a world-wide reputation for his work, especially his total coverage of the problems of the Southern States and the Civil Rights activities for *Jet, Ebony* and *Life*. "Martin Luther King, Jr.: A Documentary – Montgomery to Memphis," was published in 1976 and ran over two decades. "A King Remembered" was a 1986 Book-of-the-Month. He fully illustrated two more books in 1988: "Martin Luther King, Jr." and "The Measure of a Man." "Martin Luther King, Jr." won the 1988 United Kingdom Senior Educational Information Book Award for 10–16 year-olds.

80, 83, 84, 244, 278, 279, 315

EMIL SCHULTHESS was born in 1913 in Zurich. For thirty years, he has combined the role of photojournalist with that of travel, nature, aerial, and popular scientific photographer. He has overcome enormous technical difficulties, designing special lenses, printing with multiple negatives, inventing new techniques, to present his public with novel visual information and metaphors. He was a graphics apprentice to Alex Walter Diggelmann from 1928 to 1932. He then studied photography at Zurich's Kunstgewerbeschule, and art in Paris at the Académie de la Grande Chaumière. He was a graphic artist in Zurich from 1932 to 1941. He was associated with *Du* magazine as art director, picture editor, and photographer from 1941 to 1957. During the past twenty-five years he has worked primarily for Artemis Publishers, Zurich. He has published numerous books for which he was designer and printing supervisor. He is the recipient of numerous honors including U.S. Camera Awards in 1959 and 1967; the Award from the American Society of Magazine Photographers in 1958; the Prix Nadar in 1960; the Culture Prize of the Deutsche Gesellschaft für Photographie in 1964; and the Goldene Blende in 1972. His work has been shown in many solo, group and traveling exhibitions.

18, 198, 199, 200, 201, 202, 203, 317, 329

PIERGIORGIO SCLARANDIS was born in 1939 in Turin, Italy. In 1967, he opened his own studio. From 1969 to 1970 on behalf of the

OSVALDO SALAS *72, 238*

SALDMAN *64*

WALTER SANDERS, geboren 1897, arbeitete als Fotojournalist und gehörte zum frühen Mitarbeiterstab von *Life*. *64*

STEVE SCHAPIRO wuchs in New York City auf. Sein Fotografenleben begann bei mehreren Tonstudios, für die er in den 60er Jahren etliche Plattencover machte. Er arbeitete mit Black Star zusammen und berichtete über die Bürgerrechtsbewegung. Seit den 70er Jahren lebt er in Kalifornien und hat sich auf das Fotografieren von Persönlichkeiten und auf Theaterberichte spezialisiert. *20, 78, 274, 289*

FLIP SCHULKE wurde 1930 in New Ulm in Minnesota geboren, wo er in Politikwissenschaften und Journalismus graduierte. Er ist weltweit bekannt, insbesondere für seine Dokumentation der Südstaatenprobleme und der Bürgerrechtsaktivitäten, in *Jet, Ebony* und *Life*. »Martin Luther King, Jr.: A Documentary – Montgomery to Memphis« erschien 1976 und verkaufte sich über zwei Jahrzehnte; »A King Remembered« wurde 1986 zum Buch des Monats gewählt. 1988 illustrierte er zwei weitere Bücher, »Martin Luther King, Jr.« und »The Measure of a Man«. »Martin Luther King, Jr.« wurde 1988 als bestes erzieherisches Buch für die Altersgruppe der 10- bis 16jährigen ausgezeichnet. *80, 83, 84, 244, 278, 279, 315*

EMIL SCHULTHESS wurde 1913 in Zürich geboren. 30 Jahre lang hat er die Rolle des Fotojournalisten mit der des Reise-, Natur-, Luft- und populärwissenschaftlichen Fotografen verbunden. Durch die Konstruktion spezieller Linsen, das gleichzeitige Belichten mehrerer Negative und die Erfindung neuer Techniken hat er es vermocht, dem Betrachter seine Bilder auf ganz neue Art nahezubringen. Von 1928 bis 1932 war er Grafikschüler bei Alex Walter Diggelmann. Danach studierte er an der Zürcher Kunstgewerbeschule Fotografie und anschließend Kunst an der Académie de la Grande Chaumière in Paris. Von 1932 bis 1941 war er als Grafiker in Zürich tätig. 1941 bis 1957 war er Art Director, Bildredakteur und Fotograf für die Zeitschrift *Du*. Während der vergangenen 25 Jahre hat er vorwiegend für den Artemis-Verlag in Zürich gearbeitet. Als sein eigener Designer und Printing-Superviser hat er zahlreiche Bücher verlegt. Er hat viele Ehrungen erhalten, u.a. die U.S. Camera Awards 1959 und 1967, die Auszeichnung der American Society of Magazine Photographers 1958, den Prix Nadar 1960, den Kulturpreis der Deutschen Gesellschaft für Photographie 1964 und die Goldene Blende 1972. Sein Werk wurde in mehreren Gruppen-, Einzel- und Wanderausstellungen gezeigt.

18, 198, 199, 200, 201, 202, 203, 317, 329

PIERGIORGIO SCLARANDIS kam 1939 in Turin zur Welt. 1967 eröffnete er sein eigenes Fotostudio. Von 1969 bis 1970 fotografierte er im Auftrag der Italienischen Archäologischen Delegation im Irak die alten Tempelanlagen von Hatra, die Ausgrabungen von Ninive und die Zikkurat von Agar-quf. 1970 ging er nach New York; damals begann seine Zusammenarbeit mit Black Star. Von 1975 bis 1987 arbeitete er für den Informationsminister der Vereinigten Arabischen Emirate. In dieser Zeit entstanden zahlreiche Fotobeiträge für *Atlante, Dove, GeoMundo, Gente Viaggi, Infinito, Merian, Tuttoturismo, World* und den *Smithsonian*. Er hat zudem mehrere Bücher veröffentlicht. *290, 291*

P.N. SHARMA *256*

STEVE SHELTON wurde in Seattle im Bundesstaat Washington geboren. Nach dem Examen in Kommunikationswissenschaften lebte er in Europa und in der Türkei. Kaum hatte er seine erste Kamera, begann er, Fotografien zu machen, wurde Reporter für lokale Zeitungen und studierte noch Fotojournalismus. Von ihm stammen die Fotoessays »Boot Camp« und »Taking up Serpents«. *4/5*

NITSAN SHORER wurde 1955 in Tel Aviv, Israel, geboren. Als freischaffender Fotojournalist arbeitet er mit israelischen und ausländischen Zeitungen und Zeitschriften zusammen. Seine Fotografien sind u.a. in der *New York Times*, in *National Geographic, Newsweek* und *Time* erschienen. *384, 385*

MARK SIMON arbeitet in Berlin und Moskau und hat für Magazine wie *National Geographic, Time, Newsweek, U. S. News & World Report, Art*

SALDMAN *64*

Né en 1897, WALTER SANDERS a été photoreporter au magazine *Life*. *64*

STEVE SCHAPIRO a grandi à New York. Dans les années 60, il entame une carrière de photographe en travaillant pour de nombreux studios d'enregistrement et en réalisant quelques couvertures de disques. Il collabore avec Black Star et couvre le mouvement des droits civiques. Installé en Californie depuis les années 70, il s'est spécialisé dans le portrait de personnalités et le théâtre. *20, 78, 274, 289*

FLIP SCHULKE est né en 1930 à New Ulm, dans le Minnesota, où il sort diplômé du Macalester College en Sciences Politiques et Journalisme. Il est connu dans le monde entier pour son travail, en particulier ses reportages sur les problèmes dans les Etats du Sud et sur les mouvements pour les droits civiques – reportages couverts pour *Jet, Ebony* et *Life*. « Martin Luther King, Jr. : A Documentary – Montgomery to Memphis » a paru en 1976 et a été vendu plus de vingt ans ; « A King Remembered », publié en 1986, fut élu Livre du Mois. En 1988, il illustre deux autres ouvrages : « Martin Luther King, Jr. » et « The Measure of a Man ». En 1988, « Martin Luther King, Jr. » a remporté le prix pour le meilleur livre éducatif (10–16 ans). *80, 83, 84, 244, 278, 279, 315*

EMIL SCHULTHESS est né en 1913 à Zurich, en Suisse. Pendant trente ans, il est photoreporter et photographe, spécialisé dans les voyages, la nature, la photo aérienne et la photo scientifique. Il a surmonté d'énormes difficultés techniques, mettant au point des objectifs spéciaux, tirant des épreuves à partir de plusieurs négatifs, inventant de nouvelles techniques, pour offrir au public des informations visuelles originales et métaphoriques. De 1928 à 1932, il suit une formation de graphiste auprès d'Alex Walter Diggelmann, avant d'étudier la photo à la Kunstgewerbeschule de Zurich, et l'art à l'Académie de la Grande Chaumière à Paris. Il exerce ensuite comme graphiste free-lance à Zurich de 1932 à 1941. De 1941 à 1957, il collabore au magazine *Du* aux postes de directeur artistique, directeur du service photo et photographe. Ces 25 dernières années, il a travaillé principalement pour Artemis Edition, Zurich. Il est responsable de l'édition, de la conception et de l'impression de nombreux ouvrages. Il a reçu de nombreux prix et récompenses, parmi lesquelles les U.S. Camera Awards en 1959 et 1967 ; le prix de l'American Society of Magazine Photographers en 1958 ; le Prix Nadar en 1960 ; le prix de la culture de la Deutsche Gesellschaft für Photographie en 1964 ; et la Goldene Blende en 1972. On a pu contempler son œuvre lors d'expositions collectives, itinérantes et personnelles. *18, 198, 199, 200, 201, 202, 203, 317, 329*

PIERGIORGIO SCLARANDIS est né en 1939 à Turin, en Italie. En 1967, il ouvre son propre studio. De 1969 à 1970, il est engagé par la mission archéologique italienne en Irak pour photographier les temples antiques de Hatra, les fouilles de Ninive, et la ziggourat d'Agar-quf. En 1970, il part pour New York et devient membre de Black Star. De 1975 à 1987, il travaille avec le ministère de l'Information des Emirats arabes unis, une coopération qui se solde par de nombreuses publications comme *Atlante, Dove, GeoMundo, Gente Viaggi, Smithsonian, Infinito, Merian, Traveller, Tuttoturismo* et *World*. Il a également publié plusieurs livres. *290, 291*

P.N. SHARMA *256*

STEVE SHELTON est né à Seattle dans l'Etat de Washington. Après une licence en Communications, il travaille en Europe et en Turquie. Il acquiert son premier appareil-photo, réalise des photos pour les journaux locaux, et étudie le photojournalisme. Il est l'auteur de reportages illustrés comme « Boot camp » et « Taking up Serpents ». *4/5*

NITSAN SHORER est né en 1955 à Tel Aviv, en Israël. Photographe free-lance, il travaille pour des journaux et magazines israéliens et étrangers. On a pu voir ses photos entre autres dans le *New York Times, National Geographic, Newsweek* et *Time*. *384, 385*

MARK SIMON travaille à Berlin et Moscou. Parmi ses clients, on peut citer les magazines *National Geographic, Time, Newsweek, Smithsonian, Stern, Spiegel, U.S. News & World Report, Art* (Amérique), *Washington Post, New York Times, Business Week, Fortune* et *Granta*. Il a réalisé de nombreux reportages sur la Russie, l'Allemagne, la Turquie, l'Inde, le Rwanda, l'Alba-

Italian Archeological mission in Iraq he documented the old temples of Hatra, the excavations of Nineveh and the ziggurat of Agar-quf. In 1970, he went to New York and began his affiliation with Black Star. From 1975 to 1987 he collaborated with the Minister of Information of the United Arab Emirates, resulting in numerous contributions to *Atlante, Dove, GeoMundo, Gente Viaggi, The Smithsonian, Infinito, Merian, Tuttoturismo* and *World*. He has also published numerous books. *290, 291*

P.N. SHARMA *256*

STEVE SHELTON was born in Seattle, Washington. After receiving his B.A. in Communications, he worked in Europe and Turkey. Shortly after he picked up his first camera he began making prints for local community newspapers and studying photojournalism. He has generated picture essays such as "Boot Camp" and "Taking up Serpents." *4/5*

NITSAN SHORER was born in 1955 in Tel Aviv, Israel. He is a freelance photographer working with Israeli and foreign newspapers and magazines. His photographs have appeared in publications including *National Geographic, The New York Times, Newsweek* and *Time*. *384, 385*

MARK SIMON

MARK SIMON is based in Berlin and Moscow. His editorial clients have included *National Geographic, Time, Newsweek, The Smithsonian, Stern, Der Spiegel, U.S. News & World Report, Art* (America), *The Washington Post, The New York Times, Business Week, Fortune* and *Granta*. His photo reportages include stories on Russia, Germany, Turkey, India, Rwanda, Albania/Kosovo, the United States and Brazil. He has, in addition, edited full-length documentary films. He is currently working on a book on Extremism. *25*

W. EUGENE SMITH was born in 1918 in Wichita, Kansas. He studied photography at the University of Notre Dame, Indiana. In 1938, he became a *Newsweek* staff photographer in New York, then he was a contract photographer for *Life*. From 1939 to 1943 he worked for Black Star. From 1942 to 1944 he was a war correspondent in the Pacific theater for *Popular Photography*. In 1944, he returned to *Life* as a correspondent-photographer. He was badly wounded at Okinawa in 1945. He became a member of the Magnum Photo Agency in 1954. During the next five years he contributed photo essays to *Life, Sports Illustrated*, and *Popular Photography*. Between 1959 and 1977 he worked as a freelance photographer. His last major story, concerning the mercury poisoning of the fishing village of Minamata, Japan, was completed in the early 1970s. He was the recipient of Guggenheim Fellowships in 1956, 1957, and 1968. He was voted one of the world's ten greatest photographers in a poll of 1958. His work was exhibited in group shows such as "Photography in the Twentieth Century" at the National Gallery of Canada in Ottawa, "Photography in America" at the Whitney Museum of American Art in New York. He died in 1978. *280, 306*

TOM SOBOLIK trained as a photojournalist at Boston University. He began his career as a newspaper photographer in New Hampshire. In New York he served as photography editor and creative director of Medical Tribune Group. Since 1981 he has been associated with Black Star. His photographic career has led him to such places as the rural regions of China, an island paradise in the Philippines, and Czechoslovakia. His work has been published in magazines including *Life, Time, U.S. News & World Report, Geo, Stern, Brutus, Paris Match* and *Actualité*. He lives in Tarrytown, New York. *12*

(Amerika), *Business Week, Fortune, Granta*, den *Smithsonian, Stern, Spiegel*, die *Washington Post* und die *New York Times* Aufträge übernommen. Neben zahlreichen Fotoessays, die er über Rußland, Deutschland, die Türkei, Indien, Ruanda, Albanien/Kosovo, die Vereinigten Staaten und Brasilien verfaßt hat, war er an Dokumentarfilmen beteiligt. Gegenwärtig arbeitet er an einem Buch über Extremismus. *25*

W. EUGENE SMITH wurde 1918 in Wichita, Kansas, geboren. Er studierte an der University of Notre Dame in Indiana Fotografie. 1938 wurde er Staff-Fotograf bei *Newsweek* in New York, dann Vertragsfotograf für *Life*. In der Zeit von 1939 bis 1943 arbeitete er für Black Star. Von 1942 bis 1944 war er als Kriegsberichterstatter für *Popular Photography* im Pazifik. 1944 kehrte er als Fotokorrespondent zu *Life* zurück. 1945 wurde er in Okinawa schwer verletzt. 1954 kam er zur Fotoagentur Magnum. In den nächsten fünf Jahren veröffentlichte er Fotoessays bei *Life, Sports Illustrated* und *Popular Photography*. 1959–77 arbeitete er als freischaffender Fotograf. Seine letzte große Reportage über die Quecksilbervergiftungen im Fischerdorf Minamata in Japan stellte er in den frühen 70er Jahren fertig. Ihm wurden 1956, 1957 und 1968 Guggenheim-Stipendien zuteil, 1958 wählte man ihn bei einer Umfrage zu einem der zehn größten Fotografen der Welt. Sein Werk wurde in mehreren Gruppenausstellungen gezeigt, u.a. »Fotografie im 20. Jahrhundert« in der Nationalgalerie von Kanada in Ottawa und »Fotografie in Amerika« im Whitney Museum of American Art in New York. Er starb 1978 *280, 306*

TOM SOBOLIK erfuhr seine Ausbildung zum Fotojournalisten an der Bostoner Universität. Er begann als Zeitungsfotograf in New Hampshire. In New York war er Fotoredakteur und künstlerischer Direktor bei der Medical Tribune Group. Seit 1981 arbeitet er mit Black Star zusammen. Seine Fotografenlaufbahn führte ihn ins ländliche China, zu einem Inselparadies auf den Philippinen und in die Tschechoslowakei. Seine Arbeiten wurden in vielen Magazinen veröffentlicht, darunter *Life, Time, Newsweek, U.S. News & World Report, Geo, Stern, Brutus, Paris Match* und *Actualité*. Er lebt in Tarrytown, New York. *12*

NEAL SPITZER *296/297*

FRED STEIN wurde 1909 in Dresden geboren. Der ausgezeichnete Jurastudent wurde zu einem leidenschaftlichen Gegner des Nazi-Regimes. 1933 mußte er nach Paris fliehen. Sein Umgang mit vielen im Exil lebenden Künstlern und Intellektuellen brachte ihn zur Fotografie. Als der Krieg ausbrach, kam er in ein Internierungslager für feindliche Ausländer, aus dem er beim Einmarsch der Nazis in Paris fliehen konnte. Das New York der 40er Jahre verschaffte ihm Zutritt zu den großen Künstlern und Denkern unseres Zeitalters. Bemerkenswerte Porträts entstanden in dieser Zeit, u.a. von Albert Einstein, Carl Sandburg, Thomas Mann und Frank Lloyd Wright. Die Freiheit und das Andersartige der Neuen Welt inspirierten seine Reportagen, die überall auf der Welt erschienen. Sein Werk hat eine Reihe von Einzelausstellungen erfahren. Er starb 1967.
266, 268, 334, 340, 341, 342, 343, 354, 355

MICHAEL STEINBERG graduierte 1968 in Chemie und Politologie. 1972 hat er im Friedenskorps auf Saint Lucia zum ersten Mal die Kamera in die Hand genommen. Als er in die Vereinigten Staaten zurückkehrte, war er zunächst als Zeitungsfotograf, später als Assistenzfotograf tätig. 1980 begann er als Magazinfotograf zu arbeiten und Aufnahmen für Jahresberichte zu machen. Gegenwärtig beschäftigt er sich mit elektronischer Bildverarbeitung *320*

CHARLES STEINHEIMER *347*

DAVID STONE *329*

BILL STRODE ist Werbe-, Industrie- und Magazinfotograf. Seine Arbeiten wurden von *Time, Life, Fortune, Geo, National Geographic, Sports Illustrated, Town and Country, Esquire, Nation's Business, Forbes*, der *New York Times*, der *Washington Post*, dem *Smithsonian*, und dem *Stern* veröffentlicht. Während seiner Laufbahn sind ihm einige der höchsten Ehren zuteil geworden (u.a. Pulitzer-Preise, Overseas Press Club Award, World Press Award). Seine Fotografien sind international ausgestellt worden. Er ist Autor von zehn Büchern, hat an mehreren fotojournalistischen Lehrbüchern mitgewirkt und war Präsident des Pressefotografenverbands NPPA. *13*

nie/le Kosevo, les Etats-Unis et le Brésil. De plus, il a participé à la réalisation de films documentaires. Actuellement, il travaille sur un livre consacré aux mouvements extrémistes. *25*

W. EUGENE SMITH est né en 1918 à Wichita, au Kansas. Il étudie la photo à l'University of Notre Dame dans l'Indiana de 1936 à 1937. En 1938, il est engagé par *Newsweek* à New York, avant de travailler sous contrat pour *Life*. De 1939 à 1943, il est photographe pour Black Star. De 1942 à 1944, il est correspondant de guerre dans le Pacifique pour *Popular Photography*. Il retravaille pour *Life* en 1944 en qualité de correspondant-photographe, mais est gravement blessé à Okinawa en 1945. Il démissionne de *Life* pour entrer à l'agence Magnum en 1954. Pendant les cinq années suivantes, il fait des reportages photographiques pour *Life, Sports Illustrated* et *Popular Photography*, en particulier un important documentaire photo sur Pittsburgh. De 1959 à 1977, il travaille en free-lance. Au début des années 70, il termine son dernier grand reportage, qui traite de l'empoisonnement au mercure du village japonais de pêcheurs de Minamata. Il obtient la Guggenheim Fellowship en 1956, 1957 et 1968, et est élu l'un des dix meilleurs photographes du monde par *Popular Photography* en 1958. Son œuvre a figuré dans les expositions collectives « Photography in the Twentieth Century » à la Galerie Nationale canadienne à Ottawa et « Photography in America » au Whitney Museum of American Art à New York. Il meurt en 1978. *280, 306*

TOM SOBOLIK

TOM SOBOLIK a fait des études de photoreportage à l'Université de Boston. Après avoir débuté comme photographe pour un journal du New Hampshire, il s'établit à New York et travaille comme rédacteur du service photo et directeur artistique de Medical Tribune Group. Depuis 1981, il entame une collaboration avec Black Star. Au cours de sa carrière, il a effectué des reportages en Chine rurale, aux Philippines sur une île paradisiaque et en Tchécoslovaquie. Son travail a paru dans la presse internationale dont *Life, Time, U.S. News & World Report, Geo, Stern, Brutus, Paris Match* et *Actualité*. Sobolik vit à Tarrytown dans l'Etat de New York. *12*

NEAL SPITZER *296/297*

FRED STEIN est né en 1909 à Dresde, en Allemagne. Il réussit de brillantes études juridiques et se révèle un fervent opposant au régime nazi. En 1933, il est contraint de s'enfuir à Paris. Evoluant dans un cercle d'artistes et d'intellectuels expatriés, il se lance dans la photographie. Quand la guerre éclate, il est emprisonné dans un camp d'internement pour les ressortissants des pays ennemis, mais parvient à s'enfuir quand les nazis arrivent à Paris. Dans le New York des années 40, il côtoie les grands artistes et penseurs qui ont façonné ce siècle. Parmi les célèbres portraits de cette période, il y a ceux d'Albert Einstein, Carl Sandburg, Thomas Mann et Frank Lloyd Wright. Ses portraits et ses reportages ont paru dans des magazines du monde entier. Il a fait l'objet de nombreuses expositions personnelles. Il meurt en 1967. *266, 268, 334, 340, 341, 342, 343, 354, 355*

MICHAEL STEINBERG est diplômé en Chimie et en Sciences Politiques en 1968. C'est en 1972, alors qu'il est basé sur l'île de Saint-Lucia avec le corps de la paix, qu'il se retrouve pour la première fois avec un appareil-photo entre les mains. De retour aux Etats-Unis, il travaille

FRED STEIN was born in 1909 in Dresden, Germany. He became a brilliant law student and was a fervent anti-Nazi activist. In 1933, he was forced to flee to Paris. Living among a circle of expatriate artists and intellectuals, he took up photography. When war was declared, he was put in an internment camp for enemy aliens. He managed to escape as the Nazis were entering Paris. New York in the 1940s gave him access to the great artists and thinkers who shaped our age. Notable portraits from this period include well-known photographs of Albert Einstein, Carl Sandburg, Thomas Mann, and Frank Lloyd Wright. The freedom and diversity of the New World inspired his reportage which appeared throughout the world; he had held a number of solo exhibitions. He died in 1967.

MICHAEL STEINBERG graduated in Chemistry and Political Science in 1968. In 1972, on the island of Saint Lucia while in the Peace Corps he first picked up a camera. When he returned to the United States, he worked as a newspaper photographer, then as a photographer's assistant. In 1980, he did editorial and annual reports photography. He is currently involved in electronic imaging.

CHARLES STEINHEIMER

DAVID STONE

BILL STRODE is an advertising, industrial and editorial photographer. His work is published by *Time, Life, Fortune, Geo, National Geographic, Sports Illustrated, Town and Country, The Smithsonian, Stern, Esquire, Nation's Business, Forbes, The New York Times* and *The Washington Post*. In his career, he has received some of the highest honors, among them Pulitzer Prizes, the Overseas Press Club Award and the World Press Award. His photographs have been exhibited internationally. He is also the author of ten books and a contributor to several photojournalism textbooks. He was President of the National Press Photographers Association.

CONSTANCE STUART LARRABEE was born in Pretoria, South Africa. After graduation she went to England and Munich. Three years later she opened a portrait studio in Pretoria. She became interested in documenting the native cultures of Southern Africa. In 1983, she founded the Washington College Friends of the Arts, and the Constance Stuart Larrabee Arts Center was opened in 1990. In 1995, the Yale Center for British Art gave her a major retrospective, showing 120 photographs spanning sixty years in photography.

HAROLD STUCKER

JAMES A. SUGAR was born in Baltimore, Maryland, and studied Social Science and Communications. In 1967, he began his photographic career as a summer intern at *National Geographic* and was made a full-time contract photographer in 1969. His work includes stories on Iceland, Ireland, Ukrainian Easter eggs, Ethiopian villages and aviation advances. Around 1992, he became an expert in the computer graphics area. He is also a regular contributor to *Smithsonian Air & Space Magazine* and *National Geographic*. In 1972, he was first runner up in the Pictures of the Year contest and, most recently, he won First Place in the 24 Hours in Cyberspace contest. He has also taught photographic workshops at Center of the Eye in Aspen, Colorado and at the University of Missouri. He is currently living in Mill Valley where he continues doing freelance photography.

DICK SWANSON started with Black Star and was one of their staff photographers for a number of years. He developed a close association with *Life* magazine and became a contract photographer. He worked extensively in Vietnam, both during the war and afterwards. He now lives in Washington, D.C.

GORDON TENNEY was with Black Star for 20 years. He had a close association with *Life* magazine, for which he did many major essays.

JOHN TOPHAM

CONSTANCE STUART LARRABEE kam in Pretoria in Südafrika zur Welt. Nach dem Schulabschluß ging sie für drei Jahre nach England und München, um dann ein Porträtfotostudio in Pretoria zu eröffnen. Sie begann, sich mit der Dokumentation der Kultur der Ureinwohner von Südafrika zu beschäftigen. 1983 gründete die Fotografin das Washington College Friends of the Arts. 1990 wurde das Constance Stuart Larrabee Arts Center eröffnet. Das Yale Center for British Art veranstaltete 1995 eine große Retrospektive ihres Werkes mit 120 Fotografien aus 60 Jahren.

HAROLD STUCKER

JAMES A. SUGAR wurde in Baltimore, Maryland, geboren und studierte Sozial- und Kommunikationswissenschaften. Seine Fotografenlaufbahn begann 1967 mit einem Praktikum bei *National Geographic;* 1969 wurde er Vertragsfotograf. In seinen Arbeiten berichtete er über Island und Irland, über ukrainische Ostereier, äthiopische Dörfer sowie Fortschritte in der Flugzeugtechnik. Ab 1992 entwickelte er sich zum Experten im Computergrafikbereich. Daneben übernahm er regelmäßig Aufträge für das *Smithsonian Air & Space Magazine* und für *National Geographic*. 1972 war er der Zweitplazierte im Bilder-des-Jahres-Wettbewerb, und er errang kürzlich den ersten Platz im Wettbewerb »24 Stunden im Cyperspace«. Er lehrte Fotografie u.a. am Center of the Eye in Aspen in Colorado und an der Universität von Missouri. Zur Zeit lebt er in Mill Valley und arbeitet als freier Fotograf.

DICK SWANSON begann bei Black Star und gehörte viele Jahre als fester Fotograf zur Agentur. Er arbeitete eng mit *Life* zusammen und wurde dort schließlich Vertragsfotograf. Während und nach dem Vietnamkrieg machte er umfangreiche Reportagen über Vietnam. Heute lebt er in Washington.

GORDON TENNEY war zwanzig Jahre lang bei Black Star. In enger Zusammenarbeit mit *Life* entstanden viele große Essays für das Magazin.

JOHN TOPHAM

JOHN TROHA wurde in Maryland geboren. In den 70er Jahren begann er als Fotograf zu arbeiten. In seiner Laufbahn ist er mit den unterschiedlichsten Themen in Berührung gekommen, vom Fotojournalismus bis zur High-Tech-Industriefotografie. Seine Arbeiten sind mit zahlreichen Preisen bedacht worden. Er lebt in Maryland.

DAVID TURNLEY wurde 1955 in Indiana geboren. 1977 schloß er ein Studium der Französischen Literatur an der University of Michigan ab. Von 1980 an war er Staff-Fotograf bei der *Detroit Free Press*. Er begann für Black Star zu arbeiten, als er zwischen 1985 und 1987 in Südafrika war. Für die dort entstandenen Arbeiten erhielt er 1985 einen Oscar-Barnack-Preis, den Overseas Press Club Award und den Canon Essay Award. Neben zahlreichen anderen Preisen wurden ihm unzählige Auszeichnungen der World Press Photo Foundation sowie fünf weitere Overseas Press Club Awards zuteil. Ein Buch mit seinen Fotografien von einem Trip quer durch die Ex-Sowjetunion erschien 1992 unter dem Titel »The Russian Heart«. 1990 wurden ihm der Pulitzer-Preis und der Robert Capa Award für seinen Bericht über die Revolutionen in Osteuropa und die Demokratiebestrebungen in China verliehen. Mit seinem Zwillingsbruder Turnley hat er zwei Bücher herausgegeben, »Moments of Revolution: Eastern Europe« und »Beijing Spring«. Seine Arbeiten erscheinen häufig in Publikationen wie *Life, Paris Match, National Geographic, Geo* und der Londoner *Sunday Times*. Seit 1988 lebt er in Paris.

PETER TURNLEY wurde 1955 in Indiana geboren. Er graduierte an der Universität von Michigan, der Sorbonne in Paris und dem Institut d'Etudes Politiques de Paris. Turnley arbeitet als Vertragsfotograf für *Newsweek* und seine Bilder werden weltweit von Black Star vertrieben. Er lebt seit 1979 in Paris und hat in den letzten Jahren über fast jedes große Ereignis von internationaler Bedeutung berichtet, einschließlich des Golfkrieges und der Konflikte in Bosnien, Somalia, Ruanda, Südafrika, Tschechien und Haiti sowie über den israelisch-palästinensischen Konflikt. Seine Bilder

comme photographe professionnel d'informations, puis comme assistant-photographe. En 1980, il se lance dans la photo de couverture et l'illustration de bulletins annuels. Il s'intéresse actuellement à l'imagerie électronique.

CHARLES STEINHEIMER

DAVID STONE

BILL STRODE s'est spécialisé dans la photographie publicitaire, industrielle et éditoriale. Ses clichés ont parus dans *Time, Life, Fortune, Geo, National Geographic, Sports Illustrated, Town and Country*, le *Smithsonian, Stern, Esquire, Nation's Business, Forbes*, le *New York Times* et le *Washington Post*. Son travail lui a valu quelques-unes des plus prestigieuses récompenses, dont des Prix Pulitzer, l'Overseas Press Club Award et le prix World Press. Ses photographies ont été exposées dans le monde entier. Ancien président de National Press Photographer's Association, il est également l'auteur de dix livres et a contribué à plusieurs ouvrages illustrés.

CONSTANCE STUART LARRABEE est née à Pretoria, en Afrique du Sud. Après ses études, elle visite l'Angleterre et Munich. Trois ans plus tard, elle ouvre un studio spécialisé dans le portrait à Pretoria, et s'intéresse aux cultures indigènes du sud de l'Afrique. En 1983, la photographe fonde le Washington College Friends of the Arts. Le Constance Stuart Larrabee Arts Center est inauguré en 1990. En 1995, le Yale Center for British Art organise une importante rétrospective de son œuvre, « Time Exposure », où les 120 clichés exposés retracent 60 ans de photographie.

HAROLD STUCKER

JAMES A. SUGAR

JAMES A. SUGAR est né à Baltimore, dans le Maryland. Il étudie les Sciences sociales et la Communication. En 1967, il débute dans la photographie grâce à un stade d'été au *National Geographic*, et est engagé comme photographe en 1969. Il fait des reportages sur l'Islande, l'Irlande, les œufs de Pâques en Ukraine, les villages éthiopiens et les progrès de l'aviation. En 1992, il se spécialise dans l'infographie. Il collabore régulièrement au *Smithsonian Air & Space Magazine and National Geographic*. Il est arrivé second du concours Picture of the Year en 1972. Plus récemment, il a été classé premier du concours « 24 Hours in Cyberspace ». Il a dirigé des ateliers de photographie comme par exemple au Center of the Eye à Aspen, dans le Colorado, ou encore à l'University of Missouri. Il vit actuellement à Mill Valley et travaille toujours comme photographe free-lance.

DICK SWANSON a commencé sa carrière au sein de Black Star et a été longtemps un des photographes maison. Par la suite, il a étroitement collaboré avec le magazine *Life* avant de devenir un de leurs photographes sous contrat. Il a énormément travaillé au Viêtnam tant pendant la guerre qu'après. Aujourd'hui, il vit près de Washington.

GORDON TENNEY a collaboré avec Black Star pendant 20 ans tout en poursuivant une collaboration étroite avec le magazine *Life* pour lequel il a produit d'importants travaux.

JOHN TOPHAM

JOHN TROHA, né dans le Maryland, a commencé à travailler comme photographe dans les années 70. Il a été amené, tout au long de sa carrière,

JOHN TROHA was born in Maryland. He began photographing in the 1970s. The course of his career has led him to locations and situations that encompass everything from photojournalism to high-tech industrial photography. He is a recipient of numerous awards and lives in Maryland.
326

DAVID TURNLEY

DAVID TURNLEY was born in 1955 in Indiana. He received a B.A. in French Literature from the University of Michigan in 1977. He has been a staff photographer for *The Detroit Free Press* since 1980. He started working with Black Star, based in South Africa between 1985 and 1987. In 1985, his South African work won an Oscar Barnack Award, the Overseas Press Club Award and the Canon Essay Award. Including his numerous awards, the World Press Photo Foundation gave him the 1991 Picture of the Year. He also won five Overseas Press Club Awards. A book of his work from a trip around the ex-Soviet Union called "The Russian Heart," was published in August 1992. In 1990, he was awarded the Pulitzer Prize and the Robert Capa Award for his coverage of the revolutions in Eastern Europe and the democracy movement in China. He collaborated with his twin brother, Peter, on two books, "Moments of Revolution: Eastern Europe" and "Beijing Spring." His work is frequently published in international magazines including *Life, Paris Match, National Geographic*, the London *Sunday Times* and *Geo*. He has lived in Paris since 1988.
110, 111, 112, 113, 116, 117, 118, 119, 120, 121, 122, 123, 132, 133, 140, 141, 142, 143, 152, 153, 154, 161, 207, 208/209, 253, 257, 313, 387, 416, 417, 418, 419

PETER TURNLEY was born in 1955 in Indiana. He is a graduate of the University of Michigan, the Sorbonne of Paris and the Institut d'Etudes Politiques de Paris. He is a contract photographer for *Newsweek* magazine and his pictures are distributed worldwide by Black Star. He has been based in Paris since 1979 and has covered almost every major news event of international significance in the past decade, including the Gulf War, the Bosnia Conflict, Somalia, Rwanda, South Africa, Chechnya, Haiti and the Israeli-Palestinian conflict. His pictures have been recognized by many international awards including The Overseas Press Club and World Press Photo. His work is frequently seen in the world's most prestigious illustrated magazines, including *Stern, Paris Match, Geo, Life, National Geographic* and the London *Sunday Times*. His often tender, humorous and sensual view offers a distinct balance to the challenges of news journalism. He has been one of the few international photographers to maintain a full-time journalistic accreditation to the USSR and Russia since 1984. He covered Mikhail Gorbachev and the introduction of Perestroika and Glasnost more than any other western photographer.
20, 120, 122, 132, 133, 134, 135, 136, 137, 138, 139, 144, 145, 159, 260, 262, 333, 421

UCCLEBIT 257

JOHN FELIX VACHON was born in 1914. As a photojournalist he worked for *Life* magazine.
62

PIERRE VERGER was born in 1902 in France. At the beginning of his career he worked as a photojournalist, then he did documentary work. He was also an anthropologist and specialized in different religions of primitive people.
34

ROMAN VISHNIAC was born in 1897 in Pavlovsk, Russia, to Jewish family. His importance in photography is twofold: he photographed the lives of Eastern European Jews prior to the Holocaust, and he has made significant contributions to the development of the art of microphotography. Vishniac took his first photograph through a microscope in 1906. In

haben durch viele Preise, u.a. vom Overseas Press Club und von World Press Photo international Anerkennung erfahren. Seine Arbeiten wurden weltweit publiziert *(Stern, Paris Match, Geo, Life, National Geographic* und die Londoner *Sunday Times)*. Seine zärtliche, oft humorvolle und zugleich einfühlsame Betrachtungsweise bildet ein Gegengewicht zu den Herausforderungen des Nachrichtenjournalismus. Er gehört zu den wenigen ausländischen Fotografen, die seit 1984 ständig in der UdSSR und später in Rußland akkreditiert waren. Mehr als jeder andere westliche Fotograf hat er über Michail Gorbatschow und den Beginn von Perestroika und Glasnost berichtet.
20, 120, 122, 132, 133, 134, 135, 136, 137, 138, 139, 144, 145, 159, 260, 262, 333, 421

UCCLEBIT 257

JOHN FELIX VACHON wurde 1914 geboren. Er arbeitete als Fotojournalist für *Life*.
62

PIERRE VERGER wurde 1902 in Frankreich geboren. Am Anfang seiner Karriere arbeitete er als Fotojournalist, dann widmete er sich der Dokumentararbeit. Als Anthropologe spezialisierte er sich auf die Religionen indigener Gesellschaften.
34

ROMAN VISHNIAC wurde 1897 als Sohn einer jüdischen Familie in Pawlowsk in Rußland geboren. Er hat sich in zweifacher Hinsicht um die Fotografie verdient gemacht: Zum einen dokumentierte er das Leben der osteuropäischen Juden vor dem Holocaust, zum anderen leistete er einen bedeutenden Beitrag im Bereich der Mikrofotografie. Vishniac machte 1906 seine ersten Aufnahmen durch ein Mikroskop. 1920 promovierte er in Zoologie und Medizin. Im gleichen Jahr floh er aus dem nachrevolutionären Rußland und ging nach Berlin, wo er von 1928 bis 1933 Mikrobiologie, Endokrinologie und Optik studierte. Die Machtübernahme Hitlers und die Ausbreitung des Antisemitismus veranlaßten ihn, mit der Dokumentation der jüdischen Ghettos in Polen, Ungarn und der Tschechoslowakei zu beginnen. 1940 wurde er in einem französischen Konzentrationslager interniert, von wo aus ihm 1941 die Flucht in die Vereinigten Staaten gelang. Dort eröffnete er ein Fotostudio und widmete sich der Porträtfotografie. Während dieser Jahre setzte er auch seine Versuche im Bereich der Mikrofotografie und der Zeitraffer-Mikrokinematografie fort. 1950 begann er als selbständiger Mikrofotograf zu arbeiten. 1956 führte man ihn in der Ehrenrolle der American Society of Magazine Photographers auf. In den Jahren 1961 bis 1964 produzierte er eine Filmserie mit dem Titel »Living Biology«. Seine Fotografien wurden im Louvre, im Jewish Museum und in einer Wanderausstellung des ICP gezeigt.
42, 43, 44

FRED WARD wurde 1935 in Huntsville, Alabama, geboren. Er studierte Geistes- und Naturwissenschaften, Politologie, Journalismus und

FRED WARD

Kommunikation sowie Fernsehproduktion und Geschichte des Fernen Ostens. Als freier Journalist und Fotograf arbeitete er ab 1960 für *National Geographic* über so unterschiedliche Themen wie Edelsteine, Riffe, Computergrafiken, die Everglades, Kuba und Tibet. Zu seinen weiteren Kunden

à traiter de sujets allant du photoreportage à la photographie industrielle high-tech. Il a été couronné de nombreux prix. Il vit dans le Maryland. *326*

DAVID TURNLEY, né en 1955 dans l'Indiana, est diplômé en Littérature Française de l'University of Michigan en 1977. Depuis 1980, il est photographe au *Detroit Free Press*. Il a travaillé avec Black Star pendant son séjour en Afrique du Sud entre 1985 et 1987. Pour ses travaux en Afrique du Sud en 1985, il a reçu l'Oscar Barnack Award, l'Overseas Press Club Award et le Canon Essay Award. Outre de nombreux prix, la World Press Photo Foundation à Amsterdam lui a remis plusieurs Picture of the Year Awards. Un voyage dans l'ex-Union soviétique donne naissance à un livre intitulé «The Russian Heart», publié en 1992. En 1990, sa couverture des révolutions en Europe de l'Est et du mouvement démocratique en Chine lui vaut le prix Pulitzer et le Robert Capa Award. Avec son frère jumeau Peter il a réalisé deux livres, «Moments of Revolution: Eastern Europe» et «Beijing Spring». Ses photos paraissent fréquemment dans des magazines internationaux, entre autres *Life, Paris Match*, le *National Geographic*, le *Sunday Times* de Londres et *Geo*. Depuis 1988, il vit à Paris.
110, 111, 112, 113, 116, 117, 118, 119, 120, 121, 122, 123, 132, 133, 140, 141, 142, 143, 152, 153, 154, 161, 207, 208/209, 253, 257, 313, 387, 416, 417, 418, 419

PETER TURNLEY

PETER TURNLEY, né en 1955 dans l'Indiana, est diplômé de l'University of Michigan, de la Sorbonne et de l'Institut des Etudes Politiques de Paris. Photographe sous contrat avec *Newsweek*, ses photos sont distribuées dans le monde entier par Black Star. Il vit à Paris depuis 1979 et a couvert la plupart des grands événements internationaux de ces dernières années, dont la guerre du Golfe, la guerre en Bosnie, les conflits en Somalie et au Rwanda, l'Afrique du Sud, la Tchétchénie, Haïti et le conflit israélo-palestinien. Ses photos ont été couronnées par de nombreux prix internationaux, entre autres l'Overseas Press Club, du World Press Photo et du concours Picture of the Year. Ses clichés ont fait la couverture des magazines illustrés les plus prestigieux: *Stern, Paris Match, Geo, Life, National Geographic*, et le *Sunday Times* londonien. Son approche souvent tendre, pleine d'humour et de sensualité, vient en contrepoint de la dureté du monde journalistique. C'est l'un des rares photographes à être accrédité sans interruption par les gouvernements soviétiques et russes depuis 1984. Il a couvert le lancement de la *Perestroïka* et de la *Glasnost* par Mikhail Gorbatchev plus que n'importe quel autre photographe occidental.
20, 120, 122, 132, 133, 134, 135, 136, 137, 138, 139, 144, 145, 159, 260, 262, 333, 421

UCCLEBIT 257

JOHN FELIX VACHON est né en 1914. Il a travaillé comme photoreporter pour *Life*.
62

PIERRE VERGER est né en 1902 en France. Il débute comme photoreporter avant de se tourner vers le documentaire. Il est aussi anthropologue, spécialiste des différentes religions des peuples indigènes. *34*

ROMAN VISHNIAC est né en 1897 à Pavlovsk, en Russie, dans une famille juive. Son importance est double dans l'histoire de la photographie: il a fixé sur pellicule les vies des Juifs d'Europe de l'Est avant le génocide; d'autre part, il a participé de manière considérable au développement de la microphotographie. Vishniac prend sa première photo à travers un microscope en 1906. En 1920, il obtient un doctorat en zoologie et un doctorat de médecine. La même année, il quitte la Russie post-révolutionnaire et s'installe à Berlin où, de 1928 à 1933, il étudie la microbiologie, l'endocrinologie et l'optique. L'arrivée de Hitler au pouvoir et l'antisémitisme grandissant le poussent à photographier les ghettos de Pologne, de

1920, he gained a doctorate in Zoology and an M.D. He fled post-Revolutionary Russia the same year and settled in Berlin, where he studied Microbiology, Endocrinology, and Optics from 1928 to 1933. Hitler's rise to power and the spread of anti-Semitism prompted him to begin documenting the Jewish ghettos of Poland, Hungary, and Czechoslovakia. He was interned in a French concentration camp in 1940, but managed to make his way to the United States in 1941. Upon arrival, he opened a portrait studio which he ran until 1950. During these years he continued his experiments with microphotography and time-lapse cinemamicrography. In 1950 he became a professional freelance microphotographer. He was named in the American Society of Magazine Photographers Honor Roll in 1956. From 1961 to 1964 he produced the "Living Biology" film series. His major exhibitions include shows at the Louvre, the Jewish Museum, and a traveling show organized by the ICP. *42, 43, 44*

FRED WARD was born in 1935 in Huntsville, Alabama. He studied arts, Sciences, Political Science, Journalism, Television Production and Far East History. A freelance writer and photographer since 1960, he has written and photographed numerous articles for *National Geographic,* including stories on rubies and sapphires, Florida reefs, computer graphics, the Everglades, Cuba and Tibet. Further clients include the major publications in the world such as *Time, Newsweek, Fortune, Life, Paris Match, Stern, Epoca* and *Geo.* His photographs have won several prizes and are in the collection of the Metropolitan Museum of Art and Library of Congress. His presidential photographs were exhibited by the ICP. Now he regularly creates new images on his own computer system using photographs to make realistic illustrations of things that never were. *77, 242, 322, 329, 362*

NIK WHEELER was born in Hitchin, England. He studied French and Drama at Bristol University in England and French Civilization in Paris. He started world traveling with a year teaching English in Athens, then hitchhiked across North Africa to Nepal. He started his photographic career in Bangkok where he co-published a travel supplement and guide book on Thailand. In 1967, he moved to Vietnam as a combat photographer and joined United Press International during the 1968 Tet Offensive. In 1970, he worked out of Beirut, covering the Jordan Civil War for *Time,* the October War for *Newsweek* and also did assignments for *National Geographic* and *Paris Match.* In 1974, he based himself in Paris and covered such diverse international events as the fall of Saigon, the Montreal Olympics, the U.S. Presidential elections, and the coronation of the King of Nepal. Since 1977, he has been working out of Los Angeles doing assignments for *National Geographic, Geo, International Wildlife,* and later concentrating on travel magazines such as *Travel and Leisure, Travel Holiday* and *Islands.* In 1988, he received an award by the Society of American Travel Writers for the numerous travel books that he has written and published. *101, 194, 197, 217, 313*

ACE WILLIAMS *210*

STEVE WINTER was born in 1956 in Fort Wayne, Indiana. He studied photography at the Academy of Art in San Francisco. After graduation, he started working as an assistant for Magnum Photos. His professional life has included a large concentration of work in Haiti and Central America. His stories have included a hospice for children with AIDS in Haiti and searching for new drugs in the rain forests of Central America. He won the 1992 Lowell Thomas Silver Medal Award for travel journalism on a story about Istanbul for *Travel Holiday* magazine. *23, 325, 405*

WERNER WOLFF was born in Mannheim, Germany. He left Germany for the United States in the Hitler era, in 1936, and started as an apprentice in the Pix Incorporation darkroom. During World War II, he served in the American Army in Italy on *Yank* magazine as a photographer-correspondent, following the Italian campaign. In 1945, he joined Black Star. He was one of the first to enter Hitler's redoubt at Berchtesgaden. He traveled with Eisenhower to thirteen countries and with John F. Kennedy to Europe in 1963. *16, 46/47, 48, 49, 50, 51, 52, 53, 54, 55, 56, 57, 74, 256, 267*

TED WOOD lives in Jackson Hole, Wyoming. In 1978, he graduated in Psychology, in 1985 in Journalism. He worked on assignment for international magazines including *Life, Outside, Stern, Newsweek, Time, National Wildlife, The New York Times Sunday Magazine, The Smithsonian, USA Weekend,* and books. He specializes in environmental and cultural stories where people are as much the focus as the natural world, but where issues threaten to change the balance. *331*

gehören *Time, Newsweek, Fortune, Life, Paris Match,* der *Stern, Epoca* und *Geo.* Sein Werk ist mit zahlreichen Preisen ausgezeichnet worden und gehört zur Sammlung des Metropolitan Museum of Art und der Library of Congress. Seine Porträts von Präsidenten wurden im ICP ausgestellt. Inzwischen entwirft er auf seinem Computersystem unter Verwendung von Fotografien neuartige Bilder, um auf realistische Weise Dinge darzustellen, die es nicht gibt. *77, 242, 322, 329, 362*

NIK WHEELER wurde in Hitchin, England, geboren. Er studierte Französisch und Theaterwissenschaft in Bristol in England und Französische Zivilisation in Paris. Danach unterrichtete er Englisch in Athen, fuhr per Autostop quer durch Nordafrika und von dort nach Nepal. In Bangkok begann er zu fotografieren und veröffentlichte einen Reiseführer über Thailand. 1967 ging er als Kriegsfotograf nach Vietnam. Während der Tet-Offensive 1968 kam er zu UPI. 1970 berichtete er für *Time* über den jordanischen Bürgerkrieg und für *Newsweek* über den Oktoberkrieg, außerdem übernahm er Fotoaufträge für *National Geographic* und *Paris Match.* 1974 ließ er sich in Paris nieder und befaßte sich mit unterschiedlichen Themen wie dem Fall von Saigon, der Olympiade in Montreal, den US-Präsidentschaftswahlen und der Krönung des nepalesischen Königs. Von 1977 an lebte er bei Los Angeles und arbeitete für *National Geographic, Geo* und *International Wildlife.* Später konzentrierte er sich auf Reisemagazine wie *Travel and Leisure, Travel Holiday* und *Islands.* 1988 wurde ihm von der Society of American Travel Writers ein Preis für seine zahlreichen Reisebücher verliehen. *101, 194, 197, 217, 313*

ACE WILLIAMS *210*

STEVE WINTER

STEVE WINTER wurde 1956 in Fort Wayne in Indiana geboren. Er studierte an der Kunstakademie in San Francisco Fotografie. Nach dem Examen arbeitete er als Assistent für Magnum Photos. In seinem Fotografenleben hat sich Winter auf Haiti und Mittelamerika konzentriert. Er berichtete z.B. über ein Hospiz für Aids-infizierte Kinder in Haiti und die Suche nach neuen Medikamenten in den Regenwäldern von Mittelamerika. 1992 wurde ihm für seinen Bericht über Istanbul, der in *Travel Holiday* erschien, die Lowell-Thomas-Silbermedaille für Reisejournalismus verliehen. *23, 325, 405*

WERNER WOLFF wurde in Mannheim geboren. 1936 verließ er Hitler-Deutschland und ging nach Amerika. Dort begann er als Praktikant im Entwicklungslabor von Pix Incorporation. Während des Zweiten Weltkriegs diente er als amerikanischer Soldat in Italien und folgte als Fotokorrespondent für *Yank* den GIs der Italien-Kompanie. Nach dem Krieg kam er zu Black Star und war einer der ersten, die Hitlers Bollwerk in Berchtesgaden betraten. Er reiste im Gefolge Eisenhowers in 13 Länder und mit John F. Kennedy 1963 nach Europa.
16, 46/47, 48, 49, 50, 51, 52, 53, 54, 55, 56, 57, 74, 256, 267

TED WOOD lebt in Jackson Hole, Wyoming. 1978 erwarb er ein Diplom in Psychologie, 1985 schloß er sein Journalismusstudium ab. Er übernahm Fotoaufträge für Magazine wie *Life, Outside,* den *Stern, Newsweek, Time, National Wildlife,* das *New York Times Sunday Magazine,* den *Smithsonian* und *USA Weekend* sowie für Buchpublikationen. Wood konzentriert sich auf Themen, bei denen das bedrohte Gleichgewicht zwischen Umwelt und Mensch im Mittelpunkt steht. *331*

Hongrie et de Tchécoslovaquie. Il est interné dans un camp de concentration en France en 1940, mais parvient à gagner les Etats-Unis en 1941. Il ouvre un studio de photographie où il effectue de nombreux portraits. Pendant toutes ces années il poursuit ses expériences de microphotographie, s'intéressant particulièrement à la microcinématographie, avec prises de vue en accéléré. En 1950, il se lance dans la microphotographie en indépendant. En 1956, il est cité sur la liste honorifique de l'American Society of Magazine Photographers. De 1961 à 1964 il réalise la série télévisée, « Living Biology ». Parmi ses expositions les plus importantes, citons le Louvre, le Jewish Museum et une exposition itinérante organisée par l'ICP. *42, 43, 44*

FRED WARD est né en 1935 à Huntsville, en Alabama. Il a étudié les Sciences et Lettres, les Sciences et Sciences Politiques, le Journalisme et les Communications, Production Télévision et Histoire de l'Extrême-Orient. Photographe et auteur free-lance depuis 1960, il a écrit et illustré de nombreux articles pour le *National Geographic,* sur les rubis et les saphirs, les récifs floridien, l'infographie, les Everglades, Cuba et le Tibet. Parmi ses autres clients, on dénombre les principales publications internationales, dont *Time, Newsweek, Fortune, Life, Paris Match, Stern, Epoca* et *Geo.* Ses clichés, qui ont remporté plusieurs premiers prix, font partie de la collection du Metropolitan Museum of Art et de la Library of Congress. Ses photos présidentielles ont été exposées par l'ICP. Lui-même crée régulièrement de nouvelles images sur son système informatique, utilisant la photographie pour rendre réelles illustrations d'objets inventés de toutes pièces. *77, 242, 322, 329, 362*

NIK WHEELER, né à Hitchin, en Angleterre, a fait des études de Français et de dramaturgie à l'université de Bristol, et de Civilisation Française à la Sorbonne. Ensuite, il enseigne l'Anglais à Athènes, puis fait du stop depuis l'Afrique du Nord jusqu'au Népal. Sa carrière de photographe débute à Bangkok, où il co-édite un guide de voyage sur la Thaïlande. En 1967, il part au Viêtnam en tant que correspondant de guerre, et rejoint United Press International pendant l'offensive du Têt en 1968. En 1970, il couvre la guerre civile en Jordanie pour *Time,* la guerre d'Octobre pour *Newsweek,* en même temps que d'autres reportages pour le *National Geographic* et *Paris Match.* En 1974, il s'installe à Paris et couvre divers événements internationaux, dont la chute de Saigon, les Jeux olympiques de Montréal, l'élection présidentielle américaine et le couronnement du roi du Népal. Depuis 1977, il est basé à Los Angeles et a travaillé pour le *National Geographic, Geo, International Wildlife,* avant de se consacrer plus particulièrement aux magazines de voyages comme *Travel and Leisure, Travel Holiday* et *Islands.* En 1988, il a été récompensé par la Society of American Travel Writers pour ses nombreux recits de voyage. *101, 194, 197, 217, 313*

ACE WILLIAMS *210*

STEVE WINTER est né en 1956 à Fort Wayne, dans l'Indiana. Il a étudié la photo à l'Academy of Art à San Francisco. Après l'obtention de son diplôme, il devient un assistant chez Magnum Photos. Son métier l'a principalement conduit à Haïti et en Amérique Centrale. Il a réalisé entre autres des sujets sur un mouroir pour enfants atteints du sida à Haïti, et sur la quête de nouveaux médicaments dans les forêts tropicales d'Amérique Centrale. En 1992, il a remporté le Lowell Thomas Silver Medal Award, catégorie journalisme de voyage, pour un reportage sur Istanbul pour *Travel Holiday.* *23, 325, 405*

Né à Mannheim, en Allemagne, WERNER WOLFF émigre aux Etats-Unis au moment du IIIᵉ Reich en 1936, et débute comme apprenti dans la chambre noire de Pix Incorporation. Pendant la Deuxième Guerre mondiale, il sert dans l'armée américaine en Italie, dans le magazine *Yank* en tant que photographe-correspondant de guerre. Il a couvert toute la campagne d'Italie avec les GIs. En 1945, il avait rejoint Black Star. Il fait partie des premiers à entrer dans le nid d'aigle de Hitler à Berchtesgaden. Il suit Eisenhower dans 13 pays, et John F. Kennedy en Europe.
16, 46/47, 48, 49, 50, 51, 52, 53, 54, 55, 56, 57, 74, 256, 267

TED WOOD vit à Jackson Hole dans le Wyoming. En 1978, il obtient un diplôme en Psychologie, et en 1985, en Journalisme. Il a travaillé pour des magazines internationaux comme *Life, Outside, Stern, Newsweek, Time, National Wildlife,* le *New York Times Sunday Magazine,* le *Smithsonian, USA Weekend,* et pour plusieurs ouvrages. Il s'est spécialisé dans les reportages où les individus comptent autant que la nature dans un monde dont l'équibre est menacé. *331*